THE ARTS
IN WESTERN
CULTURE

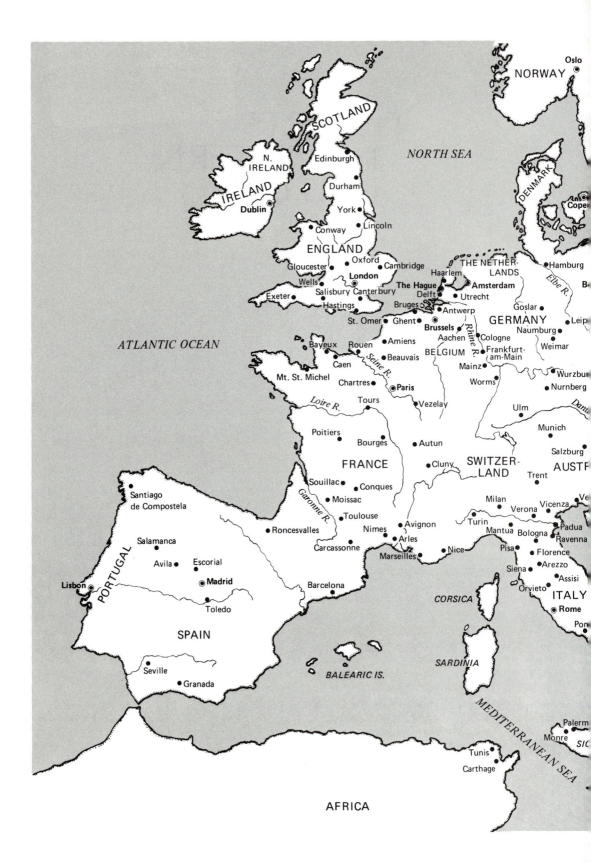

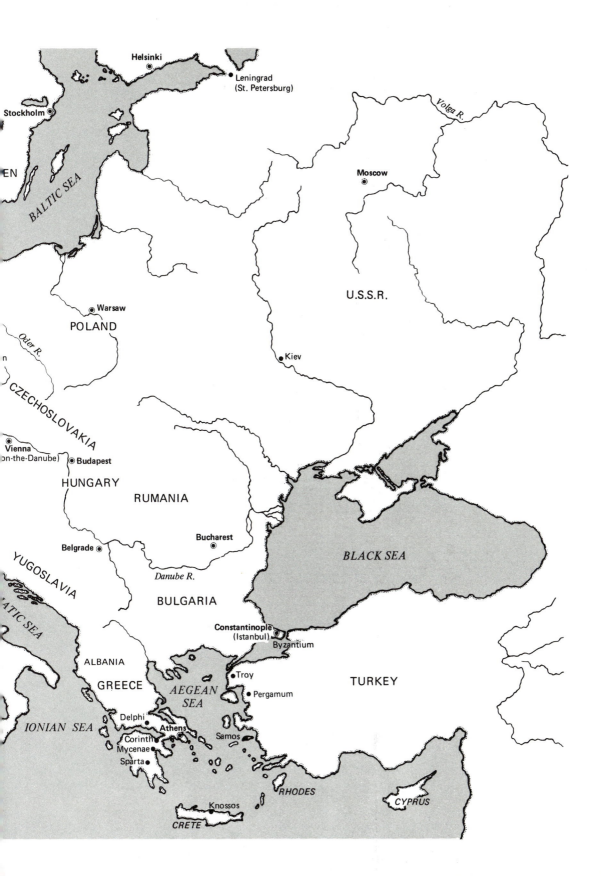

THE ARTS IN WESTERN CULTURE

RALPH A. BRITSCH
and
TODD A. BRITSCH

Brigham Young University

PRENTICE-HALL, INC., *Englewood Cliffs, New Jersey* 07632

Library of Congress Cataloging-in-Publication Data

BRITSCH, RALPH A.
 The arts in Western culture.

 Includes index.
 1. Art—History. I. Britsch, Todd A. II. Title.
N5300.B855 1984 700'.9182'1 84–6874
ISBN 0–13–047812–1

Interior design and editorial/production
 supervision: Lisa A. Domínguez
Page layout: Gail Cocker
Color insert layout: Meryl Poweski
Cover design: Whitman Studio, Inc.
Manufacturing buyer: Harry P. Baisley

Picture Credits: The authors and publisher are grateful to the museums and other institutions named in the captions for providing photographs of works of art and for permitting their reproduction in this book. Except for photographs taken by the authors, sources not mentioned in the captions are listed below.

Wayne Andrews, 15–7; Bildarchiv Foto Marburg, 7–8, 12–2, 12–12; Leo Castelli, 16–9; Art Resources (Alinari), Colorplates 1, 2, 3, 6, 7; 1–2, 1–3, 2–16, 2–18, 3–8, 3–17, 3–18, 4–10, 4–12, 4–13, 4–14, 5–2, 5–15, 5–16, 7–4, 7–22, 7–27, 7–29, 8–6, 8–8, 8–9, 8–11, 8–13, 8–14, 8–16, 8–17, 9–8, 9–14, 9–15, 9–16, 9–19, 9–20, 9–21, 9–22, 9–26, 9–27, 10–1, 10–3, 10–5, 10–7, 10–14, 10–17, 10–21; G. E. Kidder Smith, 5–10,6–3, 8–2, 10–4; D. Harissiadis, 2–3, 2–4, 2–17; Hans Hinz, 1–5; Hirmer Fotoarchiv Munich, 2–25, 3–6, 3–10; A. F. Kersting, London, 6–9,9–2, 12–1, 12–6; Foto MAS, Barcelona, 15–1; National Monuments Record, London, 11–3, 12–5, 13–2, 13–3; Photograf Hans Petersen, Copenhagen, 15–19; Photographie Giraudon, Paris, 6–2, 6–23, 7–32, 9–10, 14–2; H. Roger-Viollet, Paris, 3–14, 4–16, 10–9, 10–11; Mme. Simone Roubier, Paris, 6–13, 6–16, 6–19, 6–20; Service de Documentation Photographique, Paris, 1–1, 8–18, 10–20, 10–27, 11–6, 12–14, 13–12, 13–13, 13–14, 13–15.

Printed in the United States of America

10 9 8 7 6 5 4 3 2 1

0-13-047812-1 01

Prentice-Hall International, Inc., *London*
Prentice-Hall of Australia Pty. Limited, *Sydney*
Editora Prentice-Hall do Brasil, Ltda., *Rio de Janeiro*
Prentice-Hall Canada Inc., *Toronto*
Prentice-Hall of India Private Limited, *New Delhi*
Prentice-Hall of Japan, Inc., *Tokyo*
Prentice-Hall of Southeast Asia Pte. Ltd., *Singapore*
Whitehall Books Limited, *Wellington, New Zealand*

CONTENTS

PREFACE AND ACKNOWLEDGMENTS

This book is a brief history of the arts of Europe and America (specifically the United States). Apart from what interest it may have for the general reader, it has been written with two kinds of college courses in mind: surveys of Western civilization, in which it may be a companion to textbooks dealing with the political, social, and economic history of the Western world; and courses in humanities or general arts. In the latter it is meant to serve as the nucleus for a two–quarter or two–semester course, along with as much supplementary material in and out of class—paperbacks, anthologies of Western literature, slides, prints, and other visual aids, recordings, films, etc.—as the instructor wishes to include.

The Arts in Western Culture, as the title implies, deals only with the arts of the Western world—of Greece, Italy, western Europe, and the United States. Instead of the traditional early chapter on the arts of Egypt and Mesopotamia, which are only indirectly related to the subject, we have devoted proportionately more space than is customary to the writers, painters, sculptors, composers, and architects of America—and of the modern world in general.

Several considerations, including limitations of space, have compelled us to limit ourselves to the traditional major arts—literature, music, architecture, sculpture, and painting—and to omit film and the dance, important as these are. They can of course be added to the program by such means as films, as the instructor desires.

We are grateful to Stephanie Bird, who spent hundreds of hours helping us to obtain many of the more than four hundred illustrations in the book; to Brenda Janson, our skillful and patient secretary; to Sharon Cook, who did the excellent drawings; to Lisa A. Domínguez, our expert production editor; and to our wives, Florence and Dorothy, who have helped us in countless ways.

Ralph A. Britsch
Todd A. Britsch

1

ART AND THE ARTS

The most important fact about the arts is that they give pleasure. They also serve many other purposes. As they relate to history, they tell us more about the past, about what humans thought and felt and created in earlier times, than any other aspect of experience. Even apart from the life of feeling and responding, with which the arts are primarily concerned, they can reinforce almost any study of the various aspects of human existence—our social life, our religious and philosophical searchings, our work as planners, builders, and makers, and even our economic and political interests. The arts, both in themselves and as a part of other areas of experience, can instruct, inspire, and motivate.

But the first purpose of the arts is to give pleasure—to exercise our capacity to respond to sights, sounds, and recreated or imagined experiences. Pleasure, of course, is in no way incompatible with loftiness or profundity. And it is a curious fact that the arts can at once be pleasurable and disquieting or probing or painful. Just as the arts are almost limitless in their variety, so are they in the kinds and degrees of pleasure they can evoke, from the trivial to the deeply felt, from the momentary to the lasting.

"ART" AND "THE ARTS": SOME DEFINITIONS

The word *art* in the everyday sense is easily enough understood: it is what is studied and produced in art (or *fine arts*) departments—painting, sculpture, and ceramics, for example. The term is more broadly used to embrace such activities as music, architecture, literature, drama, and the dance—all of which include among their purposes the giving of pleasure.

But as an abstract, philosophical term, *art* offers real difficulties when one tries to define it. Recent developments in the arts—happenings, found art, minimal art, conceptual art, and other movements—have gone so far beyond traditional limits that many critics and artists see no validity or usefulness in the word *art* itself. But the fact that a term can be extended to embrace new meanings, or that its edges are hazy by their very nature, does not argue for its being abandoned.

Art, Thomas Munro says, may be understood as "including all culturally transmitted skills and products which are commonly used for stimulating satisfactory aesthetic experience. They may or may not

be consciously so intended by the artist." Herbert Read says that art is "most simply and most usually defined as an attempt to create pleasing forms." He adds that the work of art "moves" us, and that the expression "moves" is accurate: it is a release but also a heightening, a tightening, a sublimation; "art is emotion cultivating good form." Suzanne Langer writes of art as "the creation of forms symbolic of human feeling." She asserts that what we call artistic emotion is a "semblance" or illusion of emotion expressed by the work of art itself.

Observe, in these definitions, the recurrence of the word *form;* of *create* or *creation;* and of such words as *satisfactory, pleasing, emotion,* and *human feeling.* We may hazard a definition of art, then, as the creation of forms that have as a central purpose or effect the expression (or stimulation or symbolization) of pleasurable feeling. It is on such a basis as this that the arts, different as they are from each other, can be meaningfully grouped and discussed together. We should add that a secondary meaning of *art*—that is, art as skill (the art of cooking or bookbinding or boxing) is beside our purpose here, though there is a point—in the art of dressmaking, for instance, or flower arranging or hair styling—where the two meanings tend to merge. We should also add that the arts are human creations, distinct from other pleasing or beautiful forms such as natural landscapes.

Major Arts and Combined Arts. Students of the arts generally recognize five major ones: literature, music, architecture, sculpture, and painting. These are the arts with which this book will be primarily concerned. A sixth, the dance, is important in itself but frequently elusive, difficult to illustrate, and more often than not a *combined* art, inseparable from music.

Several important art forms use at one and the same time the materials and methods of two or more of the major arts. These *combined* arts include the staged drama, which incorporates literature with several of the other arts: with staging that involves architecture and often painting; with music in many instances; sometimes with the dance; and with acting—the expressive use of voice, gesture, and movement. (Acting itself, like dancing, is a major performing art—one that lies outside the scope of this book.) Film, the radio play, and the television play are combined arts that are related to but differ importantly from staged drama. The opera, most complex of combined arts, can involve most or all of the major art forms, but music is invariably the central one.

Minor Arts and Applied Arts. The rest of the arts are called minor arts. The term, though commonly used, is not a good one because it tends to downgrade many an excellent work that may be superior to some "major" ones. And it fails in other ways to make valid distinctions: apart from size, which may or may not be a value, there is no real difference between a well-executed statue and an equally well–executed figurine. But the latter is apt to be called minor art.

There are dozens—perhaps hundreds—of minor arts, and the list grows constantly longer as new ones are devised. We can begin with the ancient art of pottery making or ceramics, important both for the forms of the vessels themselves and because their surfaces may provide invaluable evidence of the painting of various eras. Related to pottery making are such art forms as porcelain or chinaware, tilework, and glassware.

Another broad category is metalwork—goldware, silverware, copperware, bronzeware, brassware, ironware—in a great variety of forms, from armor and weapons to delicate ornaments such as rings and brooches. Jewelry itself, which adds to metalwork the cutting, polishing, and mounting of gems, is an important minor art. Another group includes tapestry (which can be classified in a general way with painting), drapery, textiles, lace, costuming, and the like. Furniture making is one of the most significant of minor arts; and one can add to

it interior design, which itself employs innumerable major and minor art objects, such as paintings, candelabra, chandeliers and clocks. Bookmaking—lettering, printing, designing and binding—has long been one of the most respected of minor arts: illuminations and illustrations relate this art closely to painting. Woodcarving and stucco work, both illustrative and decorative, are minor arts that have enriched architecture. And a highly important minor art of the past century or so—some would call it a major art—is photography.

The minor arts can be expanded to include the innumerable crafts old and new that are so popular today, from basket weaving and quilt making to plastic casting and decoupage.

Most of the minor arts are often also called *applied arts* because of their practical, nonaesthetic functions—such as clothing, furniture and dinnerware. Even the major arts, though not often referred to as *applied*, may all have their utilitarian functions. The literary arts, with their ability to communicate social or moral or psychological concepts, are too numerous to mention. Painting and sculpture can also be employed for moral or social or propagandistic purposes. Music, though it is the art least related to the nonartistic world, can have its extramusical functions—in a military march, for instance, or a funeral dirge. As for architecture, its practical functions are so obvious—as shelter, meeting hall, place of business or of worship—that one might easily overlook its high station among the arts themselves.

THE MAJOR FORMS

Literature

In a very broad sense, anything that is written is literature. But in a more limited and especially an aesthetic sense, literature is writing designed primarily to give pleasure. Literature as a fine art, in such forms as poetry, fiction, and drama, is sometimes called *belletristic* (Fr. *belles–lettres*), to distinguish it from scientific, technical, journalistic, or other kinds of writing.

The media or physical materials of literature are the spoken word and, much more importantly today, the written word. The forms or types of artistic literature are many. Poetry, with its numerous subtypes—epic, lyric, narrative, for example—is the most easily identifiable kind of belletristic literature. Artistic prose includes fiction—novels and stories and most drama, though plays can of course be written in poetry; and certain kinds of nonfiction, such as essays, biography, history, and philosophy, when they are so skillfully written that beauty of form and expression is a major attribute.

Music

Music is the purest of the arts, the one least involved with nonartistic concerns. Schopenhauer said that all the arts aspire to the condition of music, by which he meant, according to Herbert Read, that "almost in music alone, is it possible for the artist to appeal to his audience directly, without the intervention of a medium of communication in common use for other purposes. The architect must express himself in buildings which have some utilitarian purpose. The poet must use words which are bandied about in the daily give-and-take of conversation. The painter usually expresses himself by the representation of the visible world. Only the composer of music is perfectly free to create a work of art in his own consciousness, and with no other aim than to please."

The media of music are sounds—generally, except for certain percussive effects, pitched sounds—produced by the human voice or by any of a great variety of instruments. Since words are so often associated with music in, for example, song, oratorio, and opera, it is easy to think of music as a medium of communication. Of course music, even apart from words, can communicate or symbolize moods or feelings, from profound sorrow to the gayest good humor. But it is probably inaccurate to think of it, in

the strict sense, as a language, since it does not have a vocabulary, a grammar, or the more or less specific meanings that words do which make discourse possible.

The forms of music are too numerous for us to list here. Their emergence and development, from chant to symphony and beyond, will be treated in the chapters that follow. Suffice it to remind our readers at this point that music can be classified in two broad categories, sacred and secular, according to purpose and character; and that it can be further classified according to the sources of musical sound—vocal, instrumental, or combinations of the two.

Architecture

Architecture, the designing and erecting of buildings and related structures such as towers and walls, holds a time-honored place as a central art, both in itself and in its relation to the other visual arts, sculpture and painting. Ancient temples were often built primarily to enshrine sacred statues and similar objects. For centuries, designers of buildings were frequently sculptors or painters as well. Phidias, important as a planner of the structures on the Acropolis of Athens in that city's Golden Age, also designed and executed many notable pieces of statuary. Brunelleschi, early Renaissance sculptor and painter, engineered the magnificent dome of the cathedral in Florence (fig. 8-4). Raphael, Michelangelo, and many other painters and sculptors devoted an important part of their artistic powers to the designing of buildings, fountains, and public squares. The architect strictly as designer, distinct from the sculptor, painter, master builder, and engineer, is a fairly recent phenomenon.

To the conventional media—wood, stone and brick—that builders have used for centuries have been added so many new ones in the past hundred years that not even a specialist could name them all. None of the other arts has developed such significant

new forms as has architecture. The principal reason, very probably, has been the availability of new materials such as reinforced concrete, plastics and other synthetics which can strengthen, extend, and lighten structures; and also, mechanical devices such as elevators and lighting, heating, and cooling systems which make multistoried buildings feasible.

Although many aesthetically pleasing private homes have been designed and built in the past as well as the present, relatively few have taken prominent places in the history of the arts. Most great architecture has been an expression of a collective or a public need. Public or semipublic buildings, whether for religious or secular purposes—temples, cathedrals, synagogues and other churches, castles, palaces, town halls, capitols, office buildings and university halls—have been the primary objects of interest for the architect as artist. And they are the most immediate visual evidence of the beliefs, interests, and aesthetic attitudes of the times in which they were built.

Sculpture

From its earliest times, sculpture—the art of shaping forms or figures in three dimensions—has had practical purposes that have often overshadowed its artistic ones. It is believed that the earliest statuettes of animals, from the Paleolithic period (fig. 1-1), were designed as magic devices to assist hunters in their work. To the ancient Egyptians, statues aided in perpetuating the souls of the dead. For other peoples, Christian and non-Christian, they have been objects of worship or veneration, whether idols thought of as literally embodying deity in some sense, or simply representations of deity or holy persons or abstract virtues such as Zeus, Apollo, Aphrodite; Christ and the Virgin; prophets and saints; and Faith, Hope, and Charity. Through the ages, statues have commemorated the great and the prominent, from pharaohs and popes through

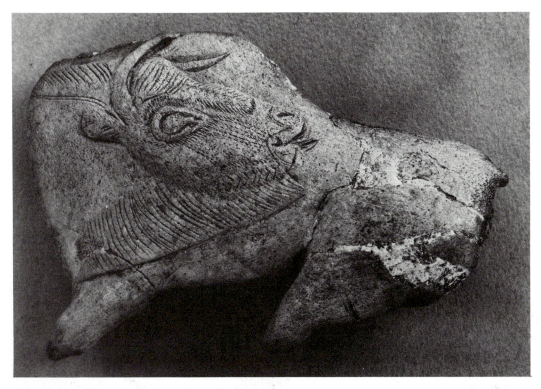

Fig. 1–1. Prehistoric bison from La Magdeleine, France. About 15,000–10,000 B.C. Reindeer horn, 4⅛″ high. Museum of National Antiquities, St.-Germain-en-Laye, France.

statesmen and college presidents. Only in recent centuries has sculpture come prominently into being largely for its own sake, in parks, gardens, and fountains. The purest— that is, least practical, or literary—sculpture has appeared in our century in the work of such semiabstract and abstract artists as Henry Moore and Jean Arp.

Sculpture, evidently from its prehistoric beginnings, has assumed two general forms: *freestanding* (or *in the round*), in which the work is completely three-dimensional and stands free from backgrounds such as walls or niches (fig. 1–2); and *relief*, in which figures emerge only partially from the ground or plane on which they are found, with an effect that lies between two- and three-dimensional art (fig. 4–14). The forms in relief sculpture may be almost in the round (high relief), nearly flattened (low or bas-relief), or somewhere between (mezzo-relief).

Traditionally, the materials of the sculptor have been stone (marble, granite, and limestone, for example) and wood, from which forms are carved by the cutting away of material—the *subtractive* process, (fig. 1–3); clays such as terra cotta and related plastic substances, with which the artist builds up or models his forms—the *additive* process, though some carving or "subtracting" may also occur (fig. 1–4); and metals that may be melted and poured in molds to duplicate a form that has been previously shaped in clay or some other material—the *casting* process (fig. 2-16). Bronze, an alloy

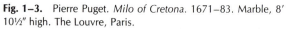

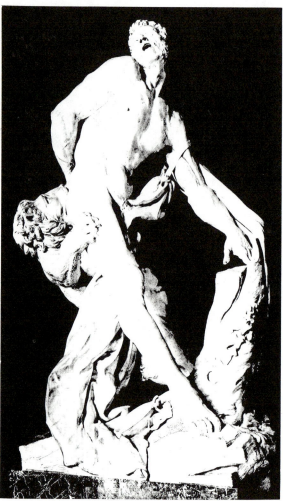

Fig. 1–2. Antonio del Pollaiuolo. *Hercules and Antaeus.* About 1475. Bronze, 18" high. National Museum, Florence.

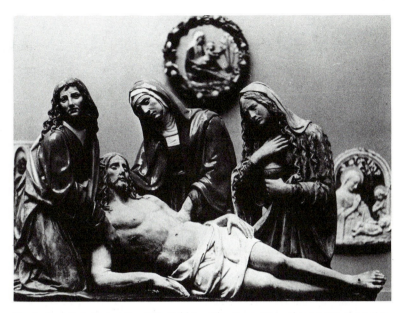

Fig. 1–4. Workshop of the della Robbias. *The Deposition.* About 1480. Painted terra cotta, lifesize. Victoria and Albert Museum, London.

composed mostly of copper and tin, has long been the favorite metal for sculpture. Others include brass, copper, iron, lead, pewter (an alloy of lead and tin), silver, gold, zinc, and platinum. Sculptors shape metals in other ways than by casting—by hammering or pushing and by cutting and welding, for example.

Modern plastics and a variety of other synthetics have added greatly to the sculptor's materials. And many recent artists, in addition to buying sheet metal and pipe, find much of their material—cog wheels, old springs, discarded car parts—in junk heaps and salvage yards (Ch. 16).

For ages the traditional subjects for sculpture have been humans (often as anthropomorphic deities) and animals. Occasionally the two have been combined, in such fantasies as the gargoyles on Gothic cathedrals. In recent years, under the impetus of abstractionism, much sculpture has been created in nonrepresentational forms—angles, cubes, masses, and voids—often with whimsical or enigmatic titles (Ch. 16). Found objects such as discarded bathroom fixtures placed in galleries can also be loosely classified as sculpture.

Painting

Painting has been defined as the art of "making pictures or designs in paint" or of "organizing ideas in terms of line and color on a two-dimensional plane." For convenience the term is expanded to include flat pictorial art in general, whether it involves pigments and a variety of colors or not—drawings, etchings, engravings, mosaics, even stained glass and tapestries.

Remarkable drawings and paintings of bison, deer, horses, bulls, and other animals and of human (usually female) forms, which scholars date as early as 20,000 to even 40,000 B.C., have been found in caves in southern France and northern Spain (fig. 1-5). These drawings and paintings are thought to have had magical or religious meanings. Painting has been a significant art in most of the historical eras that have fol-

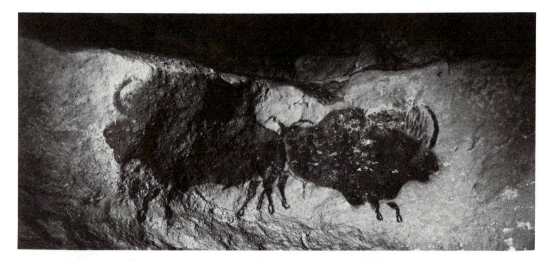

Fig. 1–5. Hall of the Bulls. About 15,000–10,000 B.C. Cave painting. Lascaux (Dordogne), France.

lowed. Often, but less so than with sculpture, its purposes have been practical—religious or commemorative. But from the Renaissance on there have been large numbers of paintings intended mostly to please the eye—depictions of myths and stories, landscapes, genre paintings, and in our time pure abstractions.

The subject matter of painting is vastly larger than that of sculpture. In theory at least, almost anything that can be visualized can be the subject of a painting. The more common subjects have been deities and holy personages, usually in narrative situations; portraits, group or single; landscapes, seascapes, townscapes; animals; still lifes—flowers, fruits, etc.; and domestic and narrative scenes. Recent painters, like recent sculptors, have of course explored the possibilities of works of art without subjects.

The materials, too, of painting are numerous, even if one excludes those pictorial arts that do not use paint. By long odds the earliest known medium is *fresco*—earth or mineral pigments in water, applied to plaster that is damp or fresh (hence *fresco*). The cave paintings in France and Spain were probably done in fresco, usually in a narrow range of colors (mostly black, yellow, and red).

Fresco was also used by the Egyptians, Minoans, Greeks, and Romans. It continued to be a major medium well into the Renaissance: Michelangelo and Raphael did such great works as the Sistine ceiling (fig. 9-20) and *The School of Athens* (fig. 9-23) in fresco. In the meantime the Romans and Egyptians had employed melted wax as a vehicle or liquid in what is called *encaustic* (fig. 4-20). And in the Middle Ages and early Renaissance a popular medium was *tempera,* usually the yolk or sometimes the yolk and white of eggs (fig. 7-27).

The use of oil as a medium goes back only to the fifteenth century. It soon largely replaced tempera and fresco as the chief medium for painting. The origins of water color are lost in antiquity. But water color as we know it—painting with water-soluble colors on paper—was developed during the Renaissance. Modern industrial chemistry has produced such synthetic media as latex (artificial rubber) and acrylics. It has also made available chemically produced pigments in countless hues and intensities, to add to the mineral (and occasionally vegetable or animal) pigments that artists have long employed. As for surfaces or supports for painting, these have usually been plastered walls,

wood panels, painter's linen canvas, stone or metal surfaces, paper, and modern supports such as masonite.

These, then, are the five major arts: literature, music, architecture, sculpture, and painting. Before we trace their historical development in the Western world, we should consider a little more fully how they relate to each other, what they have—and equally important, what they do not have—in common.

THE RELATIONSHIPS OF THE ARTS

The arts, then, are visual or auditory forms designed by humans to give pleasure. Having said this, we can look for more specific common characteristics. One of these is subject matter. Thus a historical era—that of Napoleon, for instance—can provide subjects for a wide variety of artistic expressions: for a poem, "The Two Grenadiers," by Heine, which became a song when set to music by Schumann; for a painting of Napoleon's coronation or of his crossing the Alps, both by David; for Tolstoy's epic novel *War and Peace*; for Chopin's *Revolutionary Etude* and Tchaikovsky's *1812 Overture*; and for Cortot's sculptured eulogy, *The Apotheosis of Napoleon*. Even the church of La Madeleine in Paris, though it has no subject matter as such, reflects the tastes of the emperor and his time. To take another example, the last days and crucifixion of Jesus have been memorialized in countless poems, in song and oratorio, in paintings and sculptured pieces by the thousand. This is to use the term *subject matter* only in a broad sense. When we turn to the differences between the arts, we will see that each art employs—indeed, demands—its own distinct kind of subject.

The arts often derive support from each other. The dependence of vocal music on literature is enormous. Sacred music takes its texts from scripture, religious poetry, and other literary sources. The stories of opera come from classical myths, folk tales, short stories, novels, and plays, usually modified to fit the requirements of sung drama. Secular songs of course involve poetry, and sometimes literary ideas inspire music without words—program music such as Richard Strauss' *Don Quixote* or Dukas' *Sorcerer's Apprentice*. The process of cross-fertilization extends in many directions, both within the major art forms and between them. Plays germinate plays (Eugene O'Neill's *Desire under the Elms* grows out of Euripides' ancient tragedy *Hippolytus*). Hymns expand into cantatas. Literature provides subjects for countless paintings, from Roman frescoes and Byzantine mosaics to Delacroix's great interpretations of scenes from *Hamlet, Faust,* and the *Inferno*. Paintings, in turn, provide material for the poet—for Berryman and others, for instance, who write about Bruegel's pictures. Others write about music, either about specific pieces or about music in general—Browning's "A Toccata of Galuppi," for example. Long stories by Tolstoy, Gide, and Mann revolve around Beethoven's *Kreutzer Sonata* and *Pastoral Symphony* and Wagner's *Tristan and Isolde*.

Experts and laymen alike continually use the terminology of one art to describe another. This tendency has at once strengthened the bonds between the arts and blurred the distinctions. Thus colors may be referred to as shrill, singing, loud, soft, or harsh. Musical sounds are bright, dark, heavy, fiery, golden. Such correspondences are so common that we tend to forget they are not literal but figurative, metaphorical. The process extends further: writers in certain periods, especially the eighteenth and nineteenth centuries, have made much of the apparent similarity between landscape painting and descriptive prose or poetry. They have sometimes seemed to forget that the resemblance, especially if it is extended, is an analogy and not a literal fact. Poets and musicians in the nineteenth century were enthralled by apparent similarities between their arts. Composers wrote *tone poems.* Poets paid close attention to such "musical"

devices (as they called them) as rhythm, rhyme, and alliteration. Some poets, carrying the analogy further, attempted to use such authentically musical devices as counterpoint and symphonic structure—in Mallarmé's *Afternoon of a Faun,* for instance, and Sidney Lanier's *The Symphony.* Other artists exploited analogies between painting and music, in such paintings as those of Whistler that he called *nocturnes* and *symphonies.* And still others found analogies between architecture and music (earlier, Schelling had called architecture "frozen music" and "music in space") and between architecture and literature. The term *architectonics,* borrowed from architecture, was often used to describe the structure of a novel or long poem. Dante's *Divine Comedy* has been compared to a Gothic cathedral. One sees reflected in all this a deep-seated human desire to find resemblances and reduce differences, in the arts as well as in many other areas of experience.

A glance at chapter headings in this and many other books dealing with cultural or art history will call attention to broader relationships among the arts than those we have mentioned. Such terms as *Hellenism,* the *Renaissance,* the *baroque era* or *style, neoclassicism,* and *romanticism* or the *romantic movement* imply that one period or era differs significantly enough from another in its attitudes, beliefs, and traditions, or in the fashions of its arts, to justify our giving it a name and studying it as a distinct cultural phenomenon. As an example, the term *neoclassicism,* often applied to Western arts of the later seventeenth and eighteenth centuries, suggests that those arts share important qualities not dominant in the preceding and following eras—such qualities as restraint, formality, and concern for established standards. Hence we would expect to find these qualities in any typical work of art of the period, whether painting, drama, symphony, or statue.

The use of such labels, common and necessary as they are, presents problems of definition and of dating. In even the least

complex of times, cultural attitudes and artistic styles are never as simple as a one-word label would imply. And in spite of occasional dramatic innovations and bursts of genius, change generally occurs so gradually that it can be recognized only by hindsight. Only rarely can a fixed, indisputable date be established for the emerging of a new style or movement. In spite of all this, however, students of the arts generally recognize the reality of cultural eras and of distinguishable styles and movements in the arts. And they usually accept, sometimes for want of better ones, the names that custom has attached to such styles and eras.

Differences

The ways in which the arts differ from each other can be summarized more briefly. First and most obvious are the differences in media—sounds for music; spoken and written words for literature; stone, metal, and related materials for sculpture; and so on. These distinctions, as we have seen, do not apply strictly to the combined arts, and many artists in our time, working in mixed media, largely ignore such differences or try to eliminate them.

Related to differences in media are those in subject matter. Take, again, the Napoleonic era as a starting point for artistic expression. All the arts can draw from it, but each deals with it in its own way, and each selects its subject matter accordingly. David's *Coronation,* as a painting, deals not with the entire event of the coronation of Napoleon and Josephine, as literature might do, but with one instant, partly historical and partly imagined—that moment when the emperor stretches out his hands to place the crown on his empress's head. Any feeling of continuity, any narrative sense, is supplied only by the viewer. So too with Cortot's sculptured *Apotheosis of Napoleon.* Here the imagined symbolic event occurs in an arrested moment of time. But the nature of Cortot's medium prevents him from choosing David's kind of subject, with its rich ar-

chitectural background and its dozens of faces.

Painting and sculpture, concerned as they generally are with arrested moments depicted in spatial terms, are both often called *visual* or *space arts*. You will notice, however, that they deal with space, or the illusion of space, in markedly different ways. These will be discussed in detail in Chapter 8. As visual or space arts, painting and sculpture are joined by architecture. That art, however, though it shares some materials with sculpture, handles them quite differently and creates its symbols of space in its own way.

Literature can attempt to describe what painting depicts, but the effect is invariably different—more diffuse, quite unlike painting in the imagery it deals with, and never provably the same for any two readers. Literature usually deals not with static physical images but with events in a stream of time— with the illusion of past time remembered, as in most storytelling poems (such as Heine's "Two Grenadiers") and in fiction (as in Tolstoy's *War and Peace*); or with the illusion of the passing of the present moment, as in drama and many lyric poems. Literature is a *time art*, not in the obvious fact of its consuming a period of time in the reading but in the symbolization of time which is one of its major artistic qualities.

Music too is a *time art*. But because of its media—pitched sounds—it cannot of itself narrate or recreate an imagined past or present as can literature. Most kinds of music, however, even short, simple pieces, set up patterns of sound that lead the listener to anticipate some kind of continuity and development that will lead to a logical conclusion. (The same is true, but in quite a different sense, of literature.) Hence music represents, among other things, not time remembered but a time sequence anticipated and completed.

As for musical subject matter, unlike literature and most paintings and pieces of sculpture, music has no subject matter in the usual sense, though that term can be applied

to the themes or motifs that a piece of music develops. Music acquires subject matter in literary, nonmusical ways when words, titles, programs, and the like are attached to it, or when familiar musical materials with their own literary connotations are woven into it. Thus Tchaikovsky's *1812 Overture* makes a powerful patriotic statement only because the composer gives his dynamic music a title that identifies it with Napoleon's invasion of Russia and because he includes in his overture bits of the French "Marseillaise" and the Russian "Czar's Hymn."

ARTIST, OBJECT, AUDIENCE

Any typical art experience involves three principal persons or objects: the artist, the work of art, and the audience—the observer, listener, or reader. (The performing arts— music, theater, opera, etc.—of course involve a fourth, the performers.) The relationships among these three—or four—are complex, and they provoke a number of questions: How do the artist's background and beliefs—aesthetic, social, moral, and otherwise—relate to the work of art? What forces set the creative process in motion, and what is the nature of that process? How do historical data and facts about the artist's life and times bear on the audience's response to the work? Can the art object best be approached solely as an art object, independent of the artist and his world? What standards of value can the observer rely on, apart from his own tastes? How does the artist's awareness of a potential audience affect his work? What qualities might the artist expect of his audience? Can such qualities be developed? Such questions deserve much more detailed and complex answers than we can give them here. Let us touch briefly on only one or two of them.

How valuable are facts about the artist's life and time? So strong and natural is the tendency to identify the artist with the object—to see the work as a *personal* expression—that attention easily shifts from

the object to the artist. This is especially true since artists themselves are often of more than ordinary interest. Obviously, some works of art reflect their creators' own experiences and personal, often deeply felt emotions. But it is not safe to assume that all or even most of them do. It is only safe to assume that they are *artistic* expressions. The key to an understanding of a work is apt to be found, not so much in the artist's personal life as in his artistic intentions—if these can be determined. As an artist, he has probably approached his work with some degree of objectivity. Tchaikovsky, whose music is often regarded as an outpouring of personal emotion, wrote that in a sense "artistic creation is always objective, even musical creation. The idea that the creative artist can represent the emotion that he feels at the moment is mistaken."

Some modern critics insist so strongly on a separation of the creator from the thing created that they deny the value of almost any external information—biographical, historical, or even aesthetic—relating to the work of art. Such a view rightly focuses attention on what counts most—the work itself. But it goes too far. Art is not produced in a vacuum, nor can it be experienced in one. Even advanced students of the arts, sure of their own tastes and critical standards, can misjudge a work if they know nothing about the artist's background or intentions. As for untrained or uninformed observers, many an acknowledged masterpiece has only bewildered or annoyed them until they have learned more about it. And many a hastily formed judgment has been modified when additional facts have shed a clearer light on the work of art.

Though works of art, as we have said, are first of all pleasing forms, their impact is not necessarily either simple or immediate. Our response to them often demands more than the mere act of looking or listening. Any facts and insights that lead to a deeper and more accurate understanding of the work, as we experience and re-experience it, are to be welcomed. Understanding is a big step toward responding and enjoying. A central purpose of books like this is to provide such facts and insights.

2 HELLENIC ARTS

In this survey of the arts of the Western world, we are interested in those arts that can accurately be called Western, as distinct from Asian, African, or Near Eastern.

Historical studies of Western arts sometimes begin with the cave drawings and clay figures of the Old Stone Age. Others start with the arts that had existed thousands of years before Christ in Mesopotamia and Egypt. Still others, including this volume, use as their starting point the arts of Greece and its close forerunners, the Cretan and Mycenaean civilizations. These arts, commonly called classical, ultimately dominated the entire Western world. Other civilizations, including the Assyrian, Babylonian, and Egyptian, reached the end of their development some centuries before Christ and became exhausted. But classical art, the art of Greece, as Giovanni Becatti points out, "spread throughout the provinces of Alexander's great empire, gave form to the art of imperial Rome, and remained the vital inheritance and basic premise for all European art."

Of course the pyramids, massive temple columns, monolithic statues, and wall paintings of the Egyptians are fascinating to us of the Western world, in spite of (or perhaps because of) their essential strangeness and remoteness from our traditions. So too are the five-legged bull-gods and fine relief sculptures of the Assyrians. But, to quote Becatti again, "By comparison with the great Mesopotamian, Assyrian, and Egyptian arts that preceded it, Greek art appears as a completely new and independent phenomenon"—a human-oriented, naturalistic phenomenon that pointed the direction which the arts of the Western world have taken ever since.

Before we consider the arts of the ancient Greeks, let us spend a few minutes with those of ancient Crete and Mycenae (the Aegean civilizations). The art and culture of these places pointed in important ways toward those of Classical Greece.

The Arts of Crete (2000–1400 B.C.) The culture of Crete is often called Minoan, after Minos, a legendary Cretan king or dynasty of kings. Most of what we know about it derives from the brilliant archeological work of Sir Arthur Evans in the early years of this century. At Knossos (or Cnossus), on the island of Crete, he uncovered evidence of an

13

advanced civilization that flourished from about 2000 B.C. to about 1400 B.C. It was destroyed by a great catastrophe of some kind—possibly an invasion, possibly the eruption some miles to the north of the volcanic island of Thera or Santorini, possibly both.

Knossos was one of the chief cities of an advanced, peace-loving people who were expert seamen and skilled craftsmen. They built for their king a spreading palace of stone and wood, with so many chambers above and below ground that it is easy to see how the Greek myth of the labyrinth came to be associated with it. The porticoes and roofs of the larger chambers were supported by wooden columns that tapered from the top and were proportioned with an eye to form as well as to structural purpose. (Those seen at Knossos today, as in fig. 2-1, are reconstructions.)

Even by modern standards, the royal chambers must have been luxurious. Ventilation and light were carefully provided for. Running water was piped through clay conduits into the palace, and sanitary facilities were better than any found in Europe until recent centuries.

The interior and portico walls were covered with fine frescoes, cheerful and sophisticated in subject matter and execution,

and marked by a vitality that one seldom sees in Egyptian art. The action depicted in the famous so-called *Toreador Fresco* (fig. 2-2) probably had some ritualistic significance, but we do not need to know what it was in order to enjoy the young athletes, two boys and a girl, engaged in perilous sport with a rhythmically stylized bull. Other frescoes employ graceful marine and floral designs. Several show dolphins, and one uses the curling tentacles of an octopus for purposes of design. The griffin, a pleasant-looking mythical beast with curled tail and mane and gently curving wings, appears in several frescoes. Human figures such as those in the *Toreador Fresco* are generally more naturalistic than those in Egyptian wall paintings.

The Cretans evidently produced no large-scale freestanding sculpture, but excavations have uncovered many smaller works, some of them exquisitely done, in gold, silver, bronze, carved stone, and terra cotta. These include gold-and-ivory statues such as the *Snake Goddess* in fig. 2-3; vases with rhythmical abstract patterns, others with floral designs, still others ornamented with human and animal figures; small bulls' heads of gold or carved stone; and beautifully executed gold tableware. Very possibly the famous gold Vaphio cups found near Mycenae (fig. 2-4) were made in Crete.

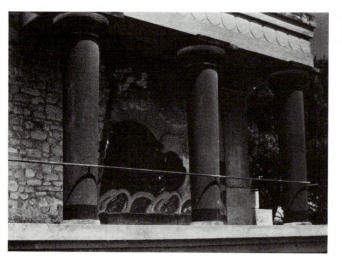

Fig. 2–1. Reconstructed colonnade with fresco. About 1500 B.C. Palace of Minos, Knossos, Crete.

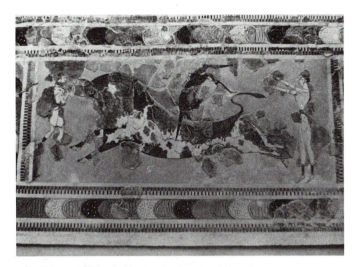

Fig. 2–2. The *Toreador Fresco* from Knossos. About 1500 B.C. Approx. 32″ high. Archeological Museum, Herakleion, Crete.

Fig. 2–3. *Snake Goddess*, Knossos. About 1600 B.C. Faience, approx. 13½″ high. Archeological Museum, Herakleion.

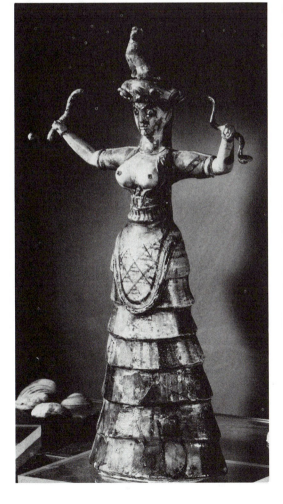

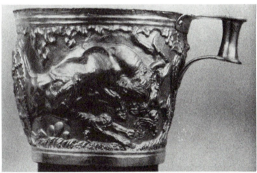

Fig. 2–4. *Vaphio Cup.* About 1500 B.C. 3½″ high. National Museum, Athens.

We know little about Minoan literature, but we do know that the Greeks of later times made Crete the locale of some of their most famous myths. Zeus was supposed to have been born on the island of Crete and to have been the father of King Minos. And there was Daedalus, famous as the legendary architect of the Palace of Minos and as the maker of wings for himself and his son Icarus. The boy flew too close to the sun, the wax holding his wings to his body melted, and he plunged to his death in the sea. Even better known and more important in Greek art and literature is Theseus. He went to Crete to encounter the Minotaur, who was half-man and half-bull and who lived in the depths of the labyrinth. The Greeks, then subject to Crete, had been sending seven youths and seven maidens each year to be sacrificed to the Minotaur. But Theseus, with the aid of the Cretan princess Ariadne, slew the monster and found his way out of the labyrinth. He and Ariadne fled from Crete, but he deserted her on the isle of Naxos. Later he married her sister Phaedra, an incident that became the basis for tragedies written in several Western languages in both ancient and modern times.

The Arts of Mycenae (1600–1100 B.C.) Along with the Cretans, several other peoples inhabited the isles of the Aegean and the mainlands surrounding that sea. They formed a loose relationship, less political than cultural, which is called the Aegean or Minoan civilization. Lacking written evidence, we can only guess that Crete dominated the area politically; possibly Crete was only an outpost of the mainland. We do know, however, that Cretan cultural influence was strongly felt throughout the Aegean world, particularly in the mainland settlement of Mycenae. Discoveries by the nineteenth-century German archeologist Heinrich Schliemann, who earlier had established at least a partially historical basis for Homer's story of Troy, showed a close similarity between the arts and crafts of My-

cenae and those of Crete. In Mycenae he uncovered jewelry, weapons, tableware, statuettes in ivory, and other articles that are strikingly like those of Crete in form and in the subject matter of their ornamentation.

But the Mycenaeans, unlike the Cretans, were a warlike people. This fact reflects itself in literature—in Homer's story of the Trojan wars, for instance, which grew out of what were probably Mycenaean pillaging expeditions around the year 1200 B.C. It also reflects itself in architecture. The traveler who visits the ruins of Mycenae today will climb the hill on which a fortress was erected in ancient times, and pass through the Gate of the Lions (fig. 2-5) and alongside walls built of rough-cut stones so large that the Greeks of later times called them Cyclopean, thinking that only a race of giants could have piled them one on another.

Within the walls of Mycenae one sees the shattered remains of numerous small rooms; of the large circular Treasury, in which hundreds of now-priceless artifacts have been found; and of the Royal Palace itself. This was a large rectangular area, with a hearth in the center and with many columns supporting the roof. The walls, now rough and primitive-looking, were evidently covered with plaster on which frescoes were painted, probably not too unlike those in the Palace of Minos at Knossos. Nearby is a small room which today's guide will identify as Agamemnon's bathroom. Here, if the guide is right, the events that form the dramatic climax of Aeschylus' tragedy *Agamemnon* occurred; here the king, engaged in a ceremonial bath after his triumphant return from Troy, was murdered by his wife Clytemnestra.

Like the Cretans, the Mycenaeans left no evidence of temple building, and their domestic architecture has long since vanished. So too have their wall paintings and most of their sculpture, with the exception of the powerful animal forms in the Gate of the Lionesses and of the Minoan-like small artifacts that we have mentioned. As for litera-

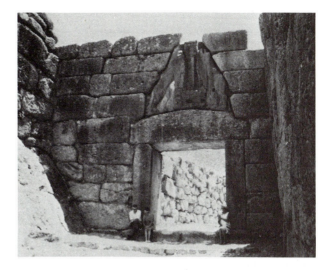

Fig. 2–5. The Lion Gate. About 1250 B.C. Mycenae, Greece.

ture, Mycenae, like Crete, was to become an important setting for Greek myth and legend, but the Mycenaeans themselves left no literary record.

Pre-Hellenic History. Over the centuries the Cretan and Mycenaean peoples were intermittently harassed by invaders who came down from the north. Among these invaders were those ancestors of the Greeks called Dorians, a people whose language was evidently similar to classical Greek. (Some historians believe that the Dorians and not the native Mycenaeans were the conquerors of Troy.) Their invasions became increasingly devastating during the fourteenth century B.C.; possibly it was they who destroyed Knossos and annihilated its people. They invaded the Aegean cities in wave after wave, and by the twelfth century they had largely obliterated Aegean civilization. Historians call the centuries that followed, until about 750 B.C., the Dark Age of Greece. It was a period of social and political disorganization, and our knowledge of it is hazy at best. The term *Dark Age* can easily be misleading, however, and we should hasten to recall that this was the age which produced Homer, himself the greatest representative of a long series of epic bards.

Athens was more successful than the rest of Greece in fighting off the invading Dorians, but even in Athens there was conquest and eventual intermingling. As Athens and the surrounding territory (Attica) became overpopulated, considerable migration to the Aegean islands and the western coast of Asia Minor took place. The migrant peoples came to be called Ionians. As the centuries passed, they remembered their heritage, spoke a form of the dialect of Athens, and retained, basically, the traditions and culture of Attica, including the songs and stories of Greek antiquity. It is with the arts of these Ionians and of the Athenian Greeks themselves that the rest of this chapter is concerned.

Hellenic Art: Its Background. The term *Hellenic* is applied to Greek culture in general, but more strictly to the great period of that civilization, roughly from about 500 B.C. to the death of the Macedonian conqueror Alexander the Great, in 323. The most brilliant part of the period occurred in the last two thirds of the fifth century—a period called the Golden Age, or sometimes the age of Pericles in honor of its greatest political figure.

Time and depredations have destroyed

countless treasures of Greek art—buildings, statuary, paintings, literary works—but enough remain for us to evaluate the Greek accomplishment and inevitably to be astonished by its magnificence. Apart from the great religious and spiritual concepts left us by Judaism and Christianity, no bequest of the past is as significant as that of the Greeks, both in itself and in its effects on later cultures that have become part of our own, including those of Rome and the Renaissance.

How can the achievement of the Greeks be explained? Of course there is no single, conclusive answer, but there are partial answers. There came together in the Aegean world of the eighth to the fourth centuries, especially in Athens and Ionia, a combination of physical, political, economic, and cultural circumstances that was not destined to continue and that has never been duplicated—in Greece or elsewhere. This combination of circumstances and attitudes included:

1. An invigorating climate.
2. What might be called collective good health, physical and emotional.
3. A religious tradition, however limited it was, that invited the creative urge to express itself in statuary, in temples, and in poetry and drama.
4. The development of an essentially democratic form of government, with a resultant sense of freedom which in itself stimulated speculation and creativity.
5. A respect for things of the mind that has never been surpassed and that expressed itself in philosophy, in the arts, and in everyday experience.
6. A belief in the high potential of the human being, an admiration for man that was sometimes excessive (the Greeks were constantly warning themselves against pride) but that encouraged a high level of creative expression.
7. A tradition of excellence in all things—*arete*, the Greeks called it; this tradition can be traced back to the Mycenaeans, but it became almost a slogan during the Golden Age.
8. An admiration for the beautiful—both speculation on the nature of beauty as a philosophical abstraction and an interest in beauty on the part of the common people.
9. A belief not only in the possibility but in the ultimate reality of *perfection* in all things. This belief expressed itself in the strivings of its artists to establish and apply rules (canons) of form and proportion to all the arts—architecture, sculpture, music, drama, and so forth. These rules had value, but at their worst they reduced themselves to too-rigid numerical formulas—the ideal column was so many times higher than its diameter, the ideal sculptured nose had such-and-such a relationship to the distance between the eyes, and so on. The best artists, though they doubtless knew the formulas, had a vital artistic instinct that allowed for innumerable subtleties and much flexibility.

To balance the picture, it should be pointed out that the Greeks as a people had their less admirable attitudes and qualities. They accepted slavery as a normal and morally justifiable institution; few even of their philosophers objected to it. Women held low social status; though as individuals many of them must have been treated with respect and affection, their official place in society was not much higher than that of the slaves. Obviously few of them (Sappho is the only exception that comes to mind) gained fame as creative artists. Democracy was thus a limited concept: since slaves, women, the young, and the foreign-born were not regarded as citizens, the number who participated in the democratic process was relatively small. As to religion, not only were

their polytheistic beliefs surprisingly naïve for an otherwise sophisticated people, but they often gave to their gods standards of moral behavior below those they themselves advocated.

The greatest weakness of Greek religion, as Sir Maurice Bowra points out, was the absence of a concept of love: "Though the Greeks admired order and sought it everywhere in the scheme of things, they did not see that its most enduring basis is to be found in the affections." One further word: someone has said that only a people who were aware of their own pugnacity and tendency to go to extremes would have made so much of the motto, Nothing to Excess. It might be that only a people who often saw in themselves the destructive consequences of over-confidence verging on arrogance would have made arrogance— *hubris*—the sin that motivates many of their tragedies.

LITERATURE

The Epic. The literature of the Greeks begins with Homer, composer of the two earliest epic poems, *The Iliad* and *The Odyssey*. Recent scholarship places Homer closer to our time than earlier scholars had him. He was probably active about 750 B.C. Some even believe that he dictated his long poems to a scribe who employed the alphabet recently borrowed from the Phoenicians. Homer composed in what is called the oral tradition, but he did not extemporize all of the thousands of lines in his two epics. In addition to employing countless stock figures of speech, epithets, descriptive tags, and so on, he incorporated hundreds of lines from a common bardic storehouse—incidental tales, speeches, and even parts of the main stories themselves. His artistic genius lay in selection of incident, in organization, and in providing the "cement" that makes each of these long epics an artistic unit. It lay also in his largeness of spirit, his wisdom, his humor, his insight into character, his sense

of drama, his delight in fantasy, and his sustained poetic skill.

There is a basis of historical fact underlying *The Iliad*. Four centuries passed, however, between the battles of Troy and Homer's time. Whatever facts the earliest tellers of the story began with had been overlaid, long before Homer, with myth, legend, and pure fantasy. Homer lived when the Greeks looked back to their distant past as having been an age of heroes—a time when men were far stronger, wiser, and braver than they were ever to be again; when war, tragic as its consequences were, was men's natural business; when high intelligence, often verging on cunning, was prized; when loyalty to one's fellows was to be matched only by hatred for one's enemies ("The Greeks," says Bowra, "never thought it possible or desirable to love their enemies"); and when the hero's greatest desire was to gain honor in combat and, if the gods decreed, to find death on the battlefield. The ideals embodied in this "heroic" outlook found expression in Homer's epics and became ideals, if not realities, both for his time and for that of fifth-century Greece, when Homer was read almost as scripture.

The gods play important parts in both *The Iliad* and *The Odyssey*. In the former poem they take sides, not always consistently, with the warring factions, put ideas into the minds of the heroes, manipulate the action on occasion, and even get involved in battle themselves. Artistically, they serve as motivation and as relief, sometimes comic relief. They appear less prominently in *The Odyssey*, but they represent there a higher ethical standard. Sometimes their function is both literal and symbolic, as when Athena, the goddess of wisdom, becomes (in disguise) the traveling companion of young Telemachus, who needs special insight.

To the Greeks the recital of an epic was a musical event; epics were not written to be read. The bard declaimed or chanted the rhythmical lines of his poem as a sort of recitative, to the accompaniment of a simple kind of harp called the lyre. Music, more-

over, was important within the epics themselves. Minstrels and their songs occupy prominent places in both of Homer's epics, especially *The Odyssey*. Hector's body is brought into Troy to the sound of a threnody, a funeral chant. The gods themselves are frequently entertained by divine minstrelsy.

The Lyric (700–450 B.C.) Homer was venerated by succeeding generations, but poetic fashion turned from the making of epics to the composing of shorter poems, now loosely classified as lyrics. These poems were written in a variety of established metrical forms—iambic, elegiac, and so forth— according to type and subject matter. At their best, the lyrics demonstrate the ability of Greek artists to imbue form with thought and feeling.

All of the lyrics were sung, to the accompaniment of lyre (hence lyric) or flute. Some were composed for solo performance, others to be sung by a chorus. Always meant for public performance, they had a directness and sharpness often lacking in modern lyric poetry. Their subject matter ranged from philosophical statements through intimate expressions of love to utterances of scorn or sarcasm. Whatever the subject, the true poet was considered to be inspired, and lyric poetry, along with epic and dramatic, became a staple of Greek education. Two of the most celebrated of Greek lyricists were Archilochus, son of an aristocratic father and a slave mother, and the woman poet Sappho of Lesbos.

Tragedy (c. 490–405 B.C.) Greek tragedy, one of the glories of the ancient world, was a form peculiar to the Golden Age and never successfully imitated by later dramatists. The word *form* should be stressed. Though there are marked differences between Greek tragedies, as a body they conform to artistic traditions as clearly recognizable as those of Greek temples. First, they were composed to be presented as musical performances, closer in effect to modern opera than to modern drama. The actors chanted or declaimed their lines to instrumental accompaniment. The chorus, almost always present in the circular *orchestra* in front of the acting area, danced to instrumental music and sang choral odes. Next, the tragedies, regardless of subject, were religiously oriented. They were presented in connection with sacred festivals. In the earlier years, at least, before a secularizing tendency had set in, the experience was essentially a ritualistic one for both performers and audience.

In its beginnings, Greek drama was little more than a dialogue between a chorus leader and the fifty or so members of his chorus. Thespis, about the middle of the sixth century, is the traditional originator of the form. With Aeschylus (c. 525–456 B.C.) we move from tradition to fact. He added a second actor and helped to establish the basic form that Greek tragedy was to follow:

1. The presentation, on each of three days of annual dramatic competition, of four plays by the same playwright—three tragedies on closely related subjects and the fourth a comedy or satyr play;
2. within each play, usually a prologue and then a series of scenes alternating between the singing and dancing of the chorus and the five acts or *episodes* performed by the actors. Aeschylus reduced the number of members of the chorus to twelve.

Sophocles (c. 496–406 B.C.), years younger than Aeschylus but his principal rival as a playwright, increased the chorus to fifteen (this became standard) and added a third actor. Euripides, (c. 480–406 B.C.), last of the great trio, strengthened the prologue but diminished the importance of the chorus.

Tradition soon limited the subjects of tragedy to a handful of stories from Greece's legendary past—the doomed Mycenaean

family of Agamemnon, Clytemnestra, and their children Orestes and Electra; the equally ill-starred Theban household of Oedipus; and a few others. The success of a work lay not in a new and suspenseful plot but in the skillful dramatization of a well-known story. Aeschylus, almost as much a philosopher as a poet, selected incidents involving the consequences of sin and the relationship of human beings to the gods. The seven plays of Aeschylus that remain include the *Oresteia* (the only remaining trilogy) and *Prometheus Bound.*

Sophocles' interest lay in human character and the impact on it of difficult choices and tragic circumstances. His *Oedipus Rex* and *Antigone* are among the supreme artistic creations of the Greek world.

Euripides, often referred to as a radical and modernist, dramatized social and psychological matters—relationships of men and women, the devastating effects of cruelty, of uncontrolled passion, and of immoderation in general. *The Bacchae, Medea, Hippolytus,* and *The Trojan Women* are among his finest plays. Not all of Euripides' tragedies end unhappily; a few are even light-hearted in tone, and several end on a note of happiness, understanding, and reconciliation.

Aeschylus, Sophocles, and Euripides were the master playwrights of the Golden Age. It is very likely, however, that some of the works of their competitors, works that have vanished forever, were not far behind theirs in excellence.

Comedy. Comedy, like tragedy, is an art form invented by the Greeks. Like tragedy it grew out of religious observances, which may seem strange when one considers how much coarseness and often downright indecency were a part of Greek comedy. An explanation is that the earliest comedies developed from rites in honor of Dionysus, god of wine, revelry, and fertility. Phallic symbols and much license of speech and action characterized these rites. By the time they evolved into what can be called

comedy, they were presented only to adult male audiences.

"Old Comedy" was established as an art form by the time the great tragedies were being presented (second half of the fifth century B.C.). In Athens, six comedies were presented annually in competition for prizes, three in the Linnaean festival in January and three in the City Dionysia in March. In form they were somewhat like the tragedies, but they employed a special device called *parabasis,* in which the chorus leader came forward at one point and sang a "speech" to the audience, directly expressing the playwright's views on the theme of the comedy.

We know Old Comedy only through eleven surviving plays by one playwright, the witty Aristophanes (c. 450–385 B.C.). On the surface his comedies are nothing but rollicking, reckless fun—sheer nonsense. But always, as in all good satire, his purpose is serious; and his theme is often great, even lofty. Caring little for plot, he creates fanciful situations to make serious points: in *The Birds* two men go to the land of the birds to build a city morally superior to anything made by man. In *Lysistrata* the women of Hellas enter into a burlesque conspiracy to force their men to end the Peloponnesian War. In *The Frogs* the god Dionysus, dissatisfied with tragedy as it was dominated by the followers of Euripides, goes down to Hades to bring back an earlier, greater poet, Aeschylus. Like many who feel intensely, Aristophanes was not always fair. His utter fearlessness, however, speaks clearly both for his own character and for the freedom given to creative artists in Greece's Golden Age.

MUSIC

How Greek music actually sounded remained something of a mystery for many centuries, but in recent years archeologists have found a small number of Greek songs that have both words and music written

down, with the music in a system of notation that can be followed with reasonable accuracy. These are from the Hellenistic period; they will be discussed in the next chapter.

Greek music and poetry, as we have seen, were almost inseparable. Epic, lyric, and drama were all either sung or performed to instrumental accompaniment. So closely related were the arts of poetry, melody, and dance that the name *mousike* (of the Muses) was given to all. As the name implies, all were thought to have been an expression of divine inspiration.

Greek music was largely melodic. There was no part singing and little of what we call harmony. Instruments accompanied solo voices or choruses, and with few exceptions all sang or played in unison. Melodies were probably composed simultaneously with poetry; the intervals and rhythms of the music strongly reflected the inflections and meters of the verses.

The ancestors of many of our modern instruments were available to the Greeks. These included a straight trumpet called a *salpinx* and other wind instruments such as the flute, the panpipe, the *aulos*, an oboelike instrument (one musician often played two *auloi* at once), and the bagpipe. There were numerous percussion instruments—cymbals, clappers, drums, and others. Stringed instruments included the lute, the lyre (originally a simple affair with a tortoise shell as a frame but later shaped in the now familiar form), and a larger harp called a *kithera*. Eventually there was also an organ, with wind supplied either by bellows or by a water compressor (hence a hydraulic organ). These instruments were usually played alone; there were no ensembles in the modern sense.

The sixth-century philosopher Pythagoras discovered the physical and mathematical relationships of musical pitches. Our awareness of the fundamental intervals of the octave (a vibrational ratio of one to two), the fifth (2:3), the fourth (3:4), and so on goes back to Pythagoras. So enthralled were Pythagoras and his followers by these and related discoveries that they found in them and in other mathematical relationships the keys to the mysteries of the universe.

Today we have two principal scales, the major and the minor. The Greeks had a number of them, based mostly on different arrangements of tones and semitones. The main scales or modes were the Dorian, the Phrygian, and the Lydian. The Greeks discovered early that music, with or without words, can modify and motivate human behavior—moods and even actions. Music became a part of moral philosophy. The doctrine of *ethos*—the relationship of music to moral and ethical behavior—was established, and this aspect of music figured importantly in education. The Dorian mode, associated particularly with the lyre, was thought to be moderate, manly, and, when occasion demanded, warlike. The Lydian was supposed to be seductive and sensuous; and the Phrygian, associated with the *aulos*, was thought to excite its hearers to intense emotion, even to Bacchic frenzy. It is likely that the effect lay more in the surrounding circumstances than in the music itself.

ARCHITECTURE

The Temple. Architecture is of course primarily a "useful" or functional art. Buildings are erected to shelter humans and their possessions, to enclose and protect them, and to provide privacy. But at the same time they can be some of our finest and noblest works of art. Through the centuries the buildings that have most challenged both the practical skills and the artistic abilities of their makers have been the public or semi-public ones—secular structures such as palaces, assembly halls, and capitols, and religious ones such as cathedrals and temples.

Greek temples were shrines that housed images and other objects sacred to

particular deities. The deities became mythological centuries ago, and their worshipers have long vanished. But the temples still delight the eye and lift the spirit. So great has been the artistic influence of Greek temple architecture, in fact, that thousands of buildings erected throughout the Western world from Renaissance times to this—cathedrals, capitols, museums, banks, private mansions, and even railroad stations—echo the ancient Greek traditions. Often the practical suitability of those traditions to such buildings can be questioned, and often the buildings themselves are inferior imitations. But the best of them are impressive and beautiful.

Structures in general can be classified into two broad types: those using vertical and horizontal members (technically called *trabeated*, from *trabs*, a beam), and those using arches or curved elements (*arcuated*, from *arcus*, a bow). Of course many buildings combine the two. The arch as a structural device had been used long before Greek times—in Persia, for instance—but the Greeks preferred the simple trabeated form, with vertical members (posts) supporting horizontal ones (lintels). This method, the post-and-lintel, is perhaps as old as building itself. In historic times it was the one used by the Egyptians, the Minoans, and the Mycenaeans, among others.

The earliest Greek temples were doubtless simple wooden ones, meant merely to shelter wooden or stone images of deities. By the seventh century they had evolved into stone structures in which the characteristics of Greek temple architecture at its best were already evident. We can recognize these seventh-century buildings as belonging to the Doric order, probably most characteristic of the three orders of Greek architecture.

The term *order* is applied to the styles of Greek temple architecture and to others that evolved from them. The earliest order, the dominant one from the seventh through most of the fifth century, is the plain and sturdy Doric. The second, developing a little later than the Doric but used concurrently, is the Ionic; it is more graceful and delicate. Still more delicate and much more ornate is the Corinthian. It became increasingly popular in the Hellenistic era and in Roman times. Numerous combinations and variations of these three developed later. Fig. 2-6 shows the three Greek orders.

The *Doric* column has no pedestal or widened base. It stands on the top step or floor level (*stylobate*) of the temple. The column itself, exclusive of base or capital, is called the *shaft*. It is tapered from the bottom up, and its sides, instead of being completely straight, have a slight convex curve or bulge called *entasis*. Each shaft is made of several sections (*drums*) of stone, held together not by mortar but by their own weight and by dowels in the centers. Some shafts are smooth, but most of them have vertical grooves called *fluting*. These were possibly cut in after the columns were erected. From a distance, fluted columns, with their texture of light and shadow, do not tend to seem flattened out as smooth ones do. The narrowest part of the shaft, at the top, is the *neck*.

Supported by the shaft is the most distinctive part of the order, the *capital*. The Doric capital consists of two parts: a gently curved, cushion-like element called the *echinus*, and, on top of it, a square tablet called the *abacus*. These two give an added feeling of strength to the top of the column and make an effective transition from the near-verticals of the shaft to the horizontals of the entablature.

The first drawing in fig. 2-6 depicts part of the gable end of a Greek temple. All of the horizontal or near-horizontal parts above the columns, taken together, constitute the *entablature*. Continuing from the bottom up, we come to a plain horizontal member, the *architrave*. Above it is a band called the *frieze;* in the Doric it consists of alternating *triglyphs* and *metopes*. The *triglyphs* are rectangles with vertical incisions carved into their surfaces.

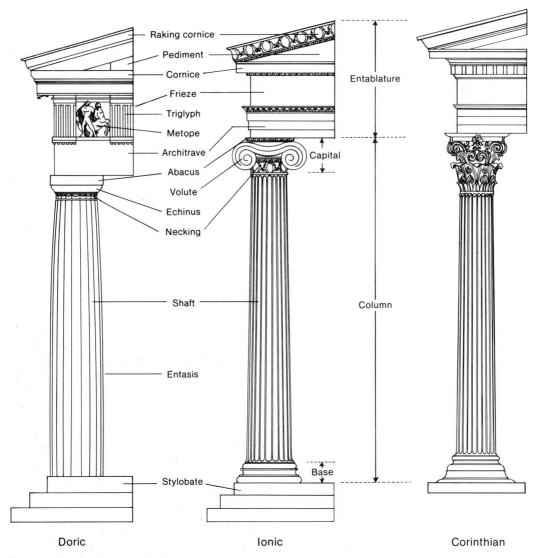

Raking cornice

Pediment

Cornice

Frieze

Triglyph

Metope

Architrave

Abacus

Volute

Echinus

Necking

Shaft

Entasis

Stylobate

Entablature

Capital

Column

Base

Doric

Ionic

Corinthian

Fig. 2–6. The Greek orders of architecture.

They are thought to represent what were the ends of squared timbers in the old wooden temples. Between the triglyphs are *metopes*, slabs of stone either plain or with sculpture in relief. These can be seen in fig. 2-7, which shows the end of the south frieze of the Parthenon.

Above the frieze, protecting it from the weather, is a projecting *cornice*. It intersects

at the corner with another cornice, a low, slanting one, called the *raking cornice*. Between the two is the low gable or *pediment* (a corruption of *pyramid*). The recess formed by this triangular area is deep enough to accommodate freestanding statues.

The *Ionic* order (fig. 2-6) has these distinguishing features: First, the shaft stands on a base or pedestal. Next, the shaft is more

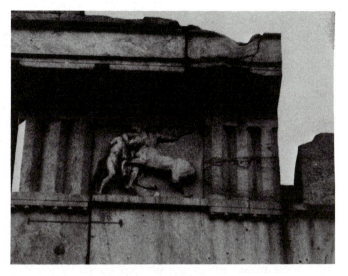

Fig. 2–7. The Parthenon, detail of outer frieze (triglyphs and metope).

slender than the Doric, and the flutings are more pronounced. Ionic capitals vary considerably. Many of them have vestiges of the echinus and the abacus. Most distinctive, however, are the four curling elements, the scrolls or *volutes*. It is conjectured that these pleasing forms were derived either from rams' horns or from curling seashells. The Ionic entablature consists of an architrave with three slightly slanting planes, one above the other, like siding on a modern house; a continuous frieze, often sculptured; and an ornamented cornice.

The *Corinthian* order (actually no more common to Corinth than to Athens or Ionia) is still more slender and feminine-looking than the Ionic. It has a pedestal, and its capital is the most ornate of all. It is an arrangement of large, gracefully curving leaves, supposedly derived from the acanthus plant. Ordinarily these leaves blend into small volutes at the top. The entablature is much like that of the Ionic order. The Romans, whose tastes for both severity and ornateness went beyond those of the Greeks, greatly favored the Corinthian order.

A number of fine Greek temples, including the splendid one at Paestum, in southern Italy, preceded those that remain in Athens. But by common consent the Par-

Fig. 2–8. Ictinus and Callicrates. The Parthenon. 447–432 B.C. Acropolis, Athens.

thenon (fig. 2-8) is the finest expression of Greek architectural genius. It was erected on the Athenian acropolis between 447 and 432 B.C. Earlier temples built on the rock of that sacred hill had been destroyed during the Persian invasion of 480. Under the leadership of the statesman Pericles, the architects Ictinus and Callicrates and the sculptor-architect Phidias erected a new marble temple in honor of the virgin goddess Athena Parthenos. They decided on an octastyle struc-

ture (eight columns on each end), with thirteen columns on each side. Aware of mathematical rules of proportion but far from being bound by them, the architects incorporated numerous subtleties, slight modifications and deviations, all designed to please the eye. All of the columns tilt in slightly. The corner columns and those nearest them are a little closer together than are the rest. There is a slight curving or central bulging in each column. If the visitor sights along the floor, he or she will find that the center is slightly higher than the ends; this is true of all horizontals in the temple. Some maintain that all of these variations were simply accommodations to the uneven terrain of the acropolis. It is more likely that they were meant to compensate for optical illusions—for instance, a long, straight line may seem to sag in the middle—and to avoid monotony.

Fig. 2–9. The Erechtheum. 421–405 B.C. Acropolis, Athens.

The stones of the Parthenon—architectural as well as sculptural—were painted in bright colors. The walls and columns were washed with saffron. Metopes were red, triglyphs were blue, and various details, such as hair, eyes, manes of horses, and harnesses, were painted in realistic colors.

The columns of the Parthenon surrounded two chambers or *cellas* of solid masonry. One housed a large ivory-and-gold statue of Athena, the other the treasury of Athens. These rooms and many of the columns were severely damaged in 1687 when a mortar shell fired by invading Venetians exploded a supply of gunpowder stored in the temple by the Turks.

Almost as impressive is another temple erected on the acropolis a little later in the fifth century, the irregularly shaped Erechtheum (fig. 2-9). This structure, largely in the Ionic order, was built to protect a sacred spring and to honor Erechtheus, legendary king of Athens. It is much admired for its slender-columned north porch and especially for the famous Porch of the Maidens. This is a small portico in Ionic style supported on the heads of six strong, serenely

poised young women called Caryatids. An architectural novelty, the work could easily have been a failure. But the softly draped maidens, each slightly different from the others and possibly meant to represent part of a funeral procession, nobly and gracefully bear their burden.

Equally beautiful is the small Ionic temple of Athena Nike, dedicated to Nike Apteros (the Wingless Victory), which occupies the southwest corner of the acropolis (fig. 2-10). Its solid but light side walls, its porticoes and elegant columns on each end, and its Ionic entablature are all in what is now creamy white marble. As one sees it from the pathway approaching the acropolis from the west, it seems almost suspended in air.

A fourth important structure on the Athenian acropolis is the Propylaea, a gate hall through which one passes on approaching the Parthenon and the Erechtheum from the west. Designed by Mnesicles and begun in 427 B.C., its most important element is an imposing façade that features six sturdy Doric columns. It was never completed.

The Theater. The term "classical simplicity" describes Hellenic art in general, but it applies with particular accuracy to the

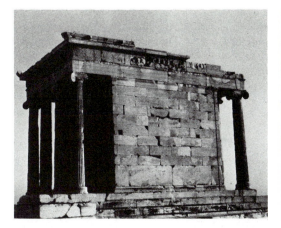

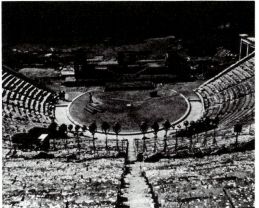

Fig. 2-10. Temple of Athena Nike. 427–424 B.C. Acropolis, Athens.

Fig. 2–11. Theater at Epidaurus, Greece. About 350 B.C. (modern stage).

Greek theater. Here form and function join faultlessly. The curving rows of seats, visually pleasing as they are, enabled large crowds of spectators to see clearly and hear distinctly. The acting areas served the purposes of Greek drama well.

The earliest Greek theaters probably consisted of logs or other wooden seats placed in the slopes of naturally curving hillsides. By the time of the Golden Age, they had developed into the impressive stone structures in which the plays of Aeschylus and the other dramatists were presented. Dozens of them were built, especially during the fourth century, in Attica and throughout the Greek world.

Fig. 2-11 shows the theater at Epidaurus, a few hours south of Athens. This beautiful structure, accommodating about 25,000 spectators, needed only a little reconstruction in order for it to become a modern center for drama festivals. As one looks down from the upper seats, one sees a large circular area which the Greeks called the *orchestra* (literally, dancing place). Here the chorus danced in slow, stately rhythms and sang their choral odes. In the center of the orchestra is a slightly raised stone on which was placed the statue of the deity, usually Dionysus, in whose honor the dramas were presented.

Immediately behind the orchestra one sees the acting area, the *proskenion*. This varied in different theaters. Usually it was one or two broad steps on which the actors could move freely. Back of the *proskenion* is (or was) the *skene*, a structure serving both as a backdrop for the acting area and as a dressing room. Little or no scenery was employed in Greek productions, and no curtain was used. Off each side of the orchestra is a high portal through which the chorus made its entrance (*parados*) and exit (*exodos*).

Sloping up from the orchestra is the more-than-semicircular area containing the stone seats for the spectators. At Epidaurus they were carefully planned for leg room and for drainage in bad weather.

SCULPTURE

Archaic Sculpture (before 500 B.C.). The first sculptures of Greek deities were probably carved from logs, and their cylindrical forms and simple, formalized features and draperies are reflected in early stone statues. This can be seen in the *Hera* from

Samos (fig. 2-12), a work of the early sixth century. Such pieces, like primitive art in general, are currently much admired for their simplicity and for the close identity of material and form. From about the same time comes the *Kouros* seen in fig. 2-13, one of many similar statues of young men, possibly depictions of Apollo. The strong frontal position, the tautness of the clenched fists and slightly bent arms, the simplicity of muscle structure, the flat-footed forward step—all are typical of what is called archaic sculpture. All suggest, if they do not prove, a relationship to Egyptian art.

Another archaic work is the *kore* or maiden shown in fig. 2-14. Noteworthy are the patterned folds of the drapery, the stylized curls, and especially the half-smile—the so-called archaic smile that can be seen on many statues from the seventh and sixth centuries.

Among the treasures of the museum at Delphi are several panels from an Ionian frieze of the late sixth century. The subject is a battle between giants and gods. Some of the figures are rigid, but a fine rhythm is set up between the round shields and the advancing fighters. One of the panels (fig. 2-15) shows a group of three spirited horses pulling a chariot. In every detail, from the high-arching necks to the beautifully patterned feet, they are the essence of controlled energy—not far inferior to the more famous horses of the Parthenon frieze (fig. 2-23).

Transitional Sculpture (early fifth century). Sculpture in the first part of the fifth century was moving from the restricted and formalized figures of the archaic style toward increasing naturalness and freedom of movement. At the same time, a high level of skill was being demonstrated in the use of the lost-wax method of bronze casting.

A famous example of Transitional sculpture is the Bronze Charioteer, a life-sized figure that was found at Delphi in 1896 (fig. 2-16). "By practically universal agreement," says Raymond Schoder, "this splendid bronze is among the noblest achieve-

Fig. 2–12. *Hera* from Samos. About 570–560 B.C. Marble, about 6′ 4″ high. The Louvre, Paris.

ments in the history of sculpture. It is strikingly impressive, with its grave, austere beauty and its subtle humane quality, and is a triumph of artistic mind over matter." Cast in several sections that were carefully joined, the work was originally part of a horse-and-chariot group. Noteworthy are the handsome, slightly bearded head (the eyes have inlays of colored paste), the beautifully patterned drapes of the garment, and the calm posture of a young man in control of the situation.

Another masterpiece in bronze is the big statue of Poseidon (or Zeus) that was recovered from the Aegean in 1928. Few works of art create a stronger impression of power and grandeur than this figure, who extends one arm to balance himself as he prepares to hurl his spear (fig. 2-17).

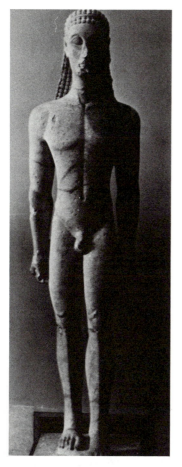

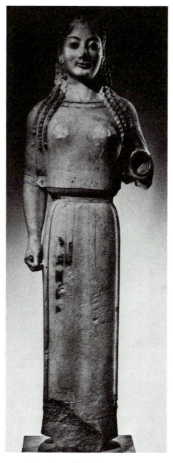

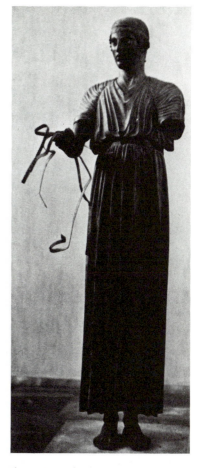

Fig. 2–13. *Standing youth (Kouros).* About 600 B.C. Marble approx. 6' 1" high. The Metropolitan Museum of Art, New York. Fletcher Fund, 1932.

Fig. 2–14. *Kore in Dorian Peplos.* About 535 B.C. Marble, about 48" high. Acropolis Museum, Athens.

Fig. 2–16. *Charioteer* from the Sanctuary of Apollo at Delphi. About 470 B.C. Bronze, 71" high. Delphi Museum.

Fig. 2–15. Chariot Horses. Detail of Ionian frieze. Delphi Museum, Greece.

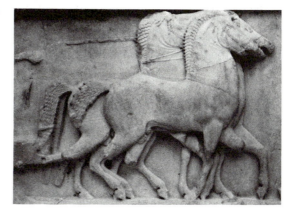

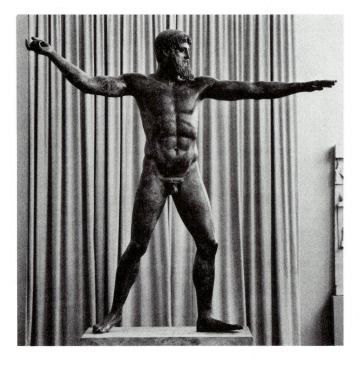

Fig. 2–17. *Poseidon* (*Zeus?*). About 460–450 B.C. Bronze, 6' 10" high. National Museum, Athens.

Sculptors of the early fifth century were developing the concept of *contrapposto* or counterpoising. This involves using a pose in which one part of the body is twisted in the opposite direction from that of the other (usually the twisting is at the hips, but it can be at the neck or elsewhere). Basing this development on the way humans actually stand or move, sculptors added considerable realism and grace to standing statues and a feeling of natural movement to those that were supposed to be in action. A comparison of the Poseidon and the earlier Kouros demonstrates the changing concept.

Classical Sculpture (460 to 400 or later). The term *classical*, though it is applied to Greek and Roman culture in general, can be restricted to the art of Greece's Golden Age. In sculpture, this was a period in which living things—animals, humans, and humanlike gods—were depicted in forms of grace, quiet strength, and idealized beauty. It was also the first period from which the

names of individual sculptors have come down to us. Among the most important are Polyclitus, Myron, and Phidias.

Polyclitus (5th century B.C.), revered by the Greeks, is now little more than a name. We have only one or two Roman copies of his works. One of these is a *Spearbearer* (fig. 2-18). It may seem a bit heavy, especially in the muscles over groin and hips, but its proportions greatly pleased Polyclitus's contemporaries. The pose employs *contrapposto*; it shifts the weight naturally to one leg, which is supported by a tree stump. Polyclitus is supposed to have developed a canon or set of mathematical rules governing the size of each body element in relation to the others.

One of the most familiar of statues is the *Discobolus* or Discus Thrower of Myron (5th century B.C.). This we know, too, only through Roman copies (fig. 2-19). Myron chooses a difficult subject, that moment just before the climax when the athlete is stooping to make the throw. Here is almost the

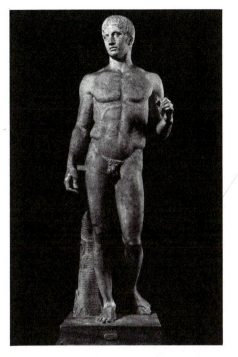 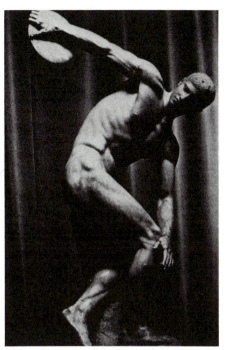

Fig. 2–18. Polyclitus. *Doryphorus (Spearbearer)*. About 450–440 B.C. Roman copy. Marble, 6′ 6″ high. National Museum, Naples.

Fig. 2–19. Myron. *Discobolus (Discus Thrower)*. Roman marble copy after bronze original of about 450 B.C. Lifesize. Museo delle Terme, Rome.

ultimate in *contrapposto;* one can trace two *S*-curves in the work.

The most famous name among the artists of antiquity is that of Phidias (c. 500–c. 432 B.C.), though he too is largely just a name. His contemporaries admired him most for several large works, including the statue of Athena that occupied one cella of the Parthenon. But these vanished long ago, and the copies that remain do them little justice. We know him best as the designer of the statuary ornamenting the Parthenon, but we have no way of knowing which of these works were done by his hand. In any event, the Parthenon marbles probably constitute the greatest body of sculpture ever executed and assembled in one place. Many of them were damaged or destroyed with the passing of time, and most of those that survived to

the early nineteenth century were purchased then by Lord Elgin and taken to the British Museum in London, where they can still be seen.

The statues occupying the two long gables or pediments of the Parthenon were skillfully designed to fit into awkward spaces. In each of these low triangles, over one hundred feet long and about ten feet at the highest point, a mythological story was told in marble. The statues in the west pediment depicted a climactic moment in a contest between Athena and Poseidon to determine which would be patron of Athens. Athena of course won.

In the east pediment a moment from the story of the birth of Athena, who sprang full grown from the brain of her father Zeus, was portrayed. The large central figures are

missing, but the remaining ones, mostly now in London, are masterpieces of the sculptor's art. At the left the reclining figure of Dionysus and the seated figures of Demeter and Persephone responded to the central event—the appearance of Athena in full majesty. At the right were three goddesses (fig. 2-20). They sit or recline in easy, natural positions. Their bodies are covered with rippling draperies that suggest the forms underneath. Near the feet of the reclining goddess was a horse's head (fig. 2-21). This fine animal was depicted as dipping below the edge of the world, exhausted from his exertions, after having pulled the chariot of the moon across the sky.

The outer frieze of the Parthenon consisted, as we have said, of alternating triglyphs and metopes. The metopes, about forty inches square, were filled with sculptures in high relief which depicted the battles of Centaurs and Lapiths. The Centaurs, half man and half horse, often tried without success to make off with the daughters of the Lapiths, a band of Thessalian athletes. The metope shown in fig. 2-22 captures one moment of a hand-to-hand battle.

Around the top of the cellas of the Parthenon ran a continuous frieze of low relief sculpture depicting the Panathenaic procession, the culminating event of Athens' most important religious festival. In the frieze, over five hundred feet long, were citizens on foot, young athletes riding or restraining spirited horses, older people bearing incense and leading animals to the sacrifice, and lovely garlanded maidens—all following the *peplos* or sacred garment as it was being borne to the temple of Athena. Figs. 2-23 and 2-24 show two scenes from the procession. The second is possibly the work that Keats was describing when he wrote, in his "Ode on a Grecian Urn":

Who are these coming to the sacrifice?
To what green altar, O mysterious priest,
Lead'st thou that heifer lowing at the skies,
And all her silken flanks with garlands dressed?

Even in their present displaced and shattered state the Parthenon marbles speak plainly of the triumph they must have been in Greece's Golden Age—the embodiment of simplicity, serenity, and a pure artistic ideal.

Fig. 2–20. *Three Goddesses* (possibly Hestia, Dione, and Aphrodite). About 438–432 B.C. From the east pediment of the Parthenon. British Museum, London; permission granted by the Trustees.

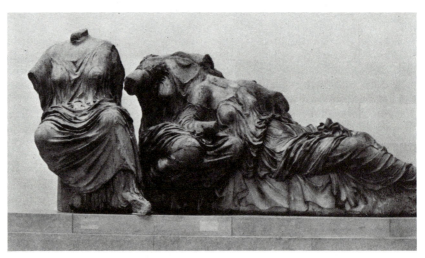

Fig. 2–21. *Horse of Selene.* From the east pediment of the Parthenon. British Museum, London. Permission granted by the Trustees.

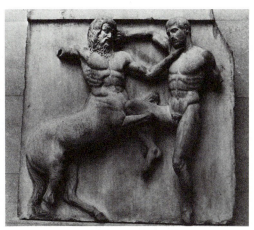

Fig. 2–22. *Centaur and Lapith.* Metope from outer frieze of the Parthenon. British Museum, London. Permission granted by the Trustees.

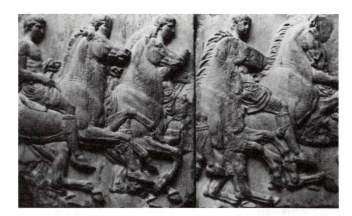

Fig. 2–23. *Horsemen,* Panathenaic Procession. Detail of cella frieze, the Parthenon. British Museum, London. Permission granted by the Trustees.

Fig. 2–24. *Sacrificial Heifer,* Panathenaic Procession. Detail of cella frieze, Parthenon. British Museum, London. Permission granted by the Trustees.

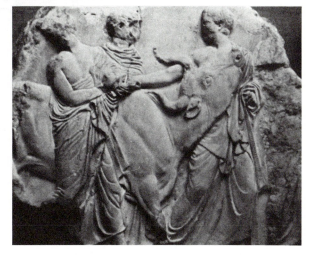

PAINTING

Murals or wall paintings were common in fifth–century Greece. Such artists as Polygnotus, Zeuxis, and Mikon, who did large-scale pictures of heroes and gods in battle or other action, were acknowledged masters, admired as much as Phidias and Polyclitus were. Evidently painting evolved during the fifth century, as did sculpture, from an angular, severe style to a more graceful and life-like one—a classical style—which was capable of depicting emotion in gesture and, to a degree, in facial expressions. For such facts we have to rely almost entirely on literary sources. With the exception of a few fifth-century Greek wall paintings recently uncovered in Paestum, Italy, all such works are lost to us.

Fortunately, however, numerous examples of Greek pottery have survived, and their painted surfaces give us invaluable evidence not only of the pictorial art of Greece but of many aspects of her culture—weapons, armor, chariots, dress, hair styles, dance steps, domestic life, furnishings, and so on—shown in an endless variety of scenes. Greek (especially Attic) vases, many of them major achievements of the potter's art, have survived in a number of forms. These include the *amphora*, a two-handled jar usually used as a storage vessel; the *krater*, a large bowl used especially for mixing wine and water; and the *kylix*, a drinking cup with a wide, shallow bowl and two handles.

The oldest examples of Greek pottery are decorated with linear, largely abstract patterns in the geometric style (fig. 2–25). Later, especially during the archaic period, artisans made vessels of red clay and decorated them with figures in black—the so-called black-figure technique (fig. 2-26). Such figures often have an archaic severity and formalism about them, but at their best they create strong, lively patterns on the surfaces of the vessels. In the later fifth century, colors were often reversed; backgrounds became dark, and figures were done in shades ranging from red to cream—the red-figure technique (fig. 2-27). Now the artist could more easily use lines to show features, draperies, and so on, and a greater softness and fluidity of line prevailed. Often, in these later works, the artist turned from warfare and hunting scenes to more relaxed subjects such as young lovers, cup-bearing servants, and matrons in domestic settings.

Athens' Golden Age reached its zenith under the brilliant political and cultural leadership of Pericles. The arts flourished and peace with Persia was established. But two years before Pericles' death in 429 B.C., long-standing rivalries and bitterness between Athens and Sparta burst into a war—the Peloponnesian War—complicated for the Athenians by a plague that wiped out about a fourth of her people. The battles continued, with victory coming more often than not to Sparta and her allies, until Athens was finally conquered by sea and land attack. After her surrender in 404 B.C., Athens was never again to regain her former glory.

But of course cultural and creative activity did not come to a sudden halt in the Athenian world. Though the great age of Attic drama and architecture had passed, dramas continued to be produced and buildings to be erected—temples, mausoleums, choragic monuments, and especially theaters. Athens continued, in the fourth century, to foster such philosophers as Plato and Aristotle and such sculptors as Praxiteles and Scopas, even though the luster of the Golden Age had dimmed.

The classical Greek attitudes and principles we have been examining were largely limited, in the fifth and earlier fourth centuries, to the Greek states and their colonies in southern Italy, Sicily, and a few other places. It was not until the later years of the fourth century, following Alexander's widespread conquests, that an equally widespread dissemination of Greek art and culture, from Asia Minor to Alexandria in Egypt, began to occur in what we now call the Hellenistic Age.

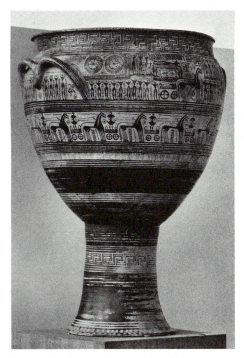

Fig. 2–25. *Dipylon Krater,* National Museum, Athens.

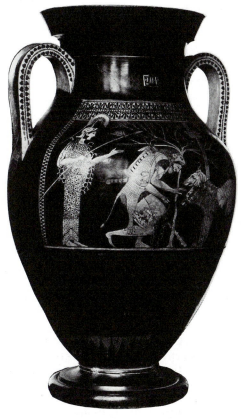

Fig. 2–27. *Amphora* by Euthymides. The Louvre, Paris.

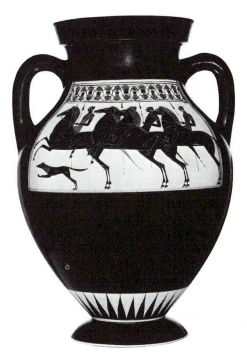

Fig. 2–26. *Attic Amphora,* Amasis Painter. 550–540 B.C. Staatlichen Antikensammlungen. Height 41 cm.

3 THE FOURTH CENTURY AND THE HELLENISTIC PERIOD

Athens fell to Sparta in 404 B.C., and the final Roman conquest of the Greek mainland occurred in 146 B.C. The cultural era between those two dates is variously called the *Hellenistic era* or the *Alexandrian age*. The term *Hellenistic* recognizes the spread of Athenian Greek culture throughout eastern Europe, Asia Minor, and north Africa during that period. *Alexandrian* acknowledges the impact of the military leader whose conquests helped to spread that culture. We prefer the first term; but we must also consider the important artistic and cultural changes that occurred in the earlier fourth century, before the time of Alexander.

The decades that followed the end of the fifth century (essentially the end of Greece's Golden Age) were marked by turmoil and change. The city-state, the political unit that had fostered the arts in the fifth century, was nearing extinction. Some efforts were made to preserve it, but these consisted largely of the establishment of one form or another of minority rule—dictatorship or oligarchy. The concerns of the individual citizen who had previously been involved in public life now turned to personal matters. In the arts, emphasis shifted more and more from universals and idealized forms toward realism and individualized personalities. Even philosophy moved from the abstract, speculative thought of Plato, the intellectual leader of the first part of the fourth century, toward the more practical and scientific interests of Aristotle.

Into this unstable world, in the latter part of the fourth century, came a young man who appeared for a time to be destined to bring peace and stability to Greece and her neighbors, and who did succeed in opening the way for the culture of Athenian Greece to spread throughout the entire known world.

Alexander was born in 356 B.C. at a time when his father Philip was turning the Macedonian army into the strongest military force the Greek world had known. Alexander received his military training from his father and the rest of his education from Aristotle, whom Philip had hired as the royal tutor. The murder of Philip in 336 B.C. thrust the twenty-year-old Alexander into the leadership of the entire force of the League of Corinth, a military alliance that Philip had formed to combat the Persians.

Alexander's military skill is legendary. He defeated the Persians in Asia Minor, con-

quered Egypt and founded Alexandria there, and then invaded Persia itself, where he defeated Darius and had himself declared the Great King. When he died in Babylon of a fever, at the age of thirty-two, he had extended his empire into Russian Turkestan and India. He was never defeated in a major military encounter.

Alexander's empire did not survive him, however, for it was immediately divided among his leading generals; and revolution and intrigue soon destroyed much of the political unity he had established. But as we have implied, the cultural impact of his conquests continued to be felt for centuries. Though he was willing to recognize and even to adopt some of the manners and customs of the lands he conquered, he tried diligently to spread Greek culture throughout much of the Near East and the Mediterranean area. Scholars disagree as to how successful he was in these efforts, but most recognize that he left a permanent imprint even as far as India and China. Statues of Buddha there, as well as in Persia, reflect the influence of the Greek sculpture that he introduced. In the Mediterranean area a Greek-oriented culture arose that persisted even after the Romans took control of the entire area. The Greek culture that was established was not that of fifth-century Greece but was in many respects new, a reflection of a changed world. Nevertheless, during the first part of the fourth century Athens remained an important force, and only gradually did other centers challenge her pre-eminent position.

LITERATURE

The New Comedy. The great age of Greek tragedy ended with the death of Sophocles, and the brilliant *Old Comedy* of Aristophanes and his contemporaries soon faded away in turn. The *New Comedy* of the fourth century never achieved the artistic level of the old, and it comes to us almost entirely in fragments. But the new form had great influence on later comedy, particularly that of the Romans Plàutus and Terence, who in turn helped to determine the course of Western drama in general.

The major creator of New Comedy was Menander (342-c.292 B.C.). His comedy is concerned almost entirely with variations on one basic plot: a young man of a noble family falls in love with a slave girl, whom he has no hope of ever marrying. After a number of complications it is discovered that the girl is really the lost daughter of a citizen, and so of course the marriage can take place. Unlike the comedy of Aristophanes, there is no political or social criticism to be found in Menander's plays. Nor is he concerned with contemporary events. Also lacking are Aristophanes' sharp wit and pointed dialogue. Instead, New Comedy is highly polished situation literature, with little permanent or universal significance. It well reflects the new emphasis on narrowly personal rather than social or political matters.

The Scholar Poets. The Hellenistic era saw the formation of schools and libraries for the study and preservation of literature. The greatest of such libraries was founded by Ptolemy I, whose family ruled Egypt and the eastern part of Alexander's empire. At their capital in Alexandria, Egypt, the Ptolemies established an institution that they named for the Muses—the Museum. Affiliated with it were many of the most famous scholars of the age, often as many as one hundred at a time. There they studied all the known arts and sciences, but especially language, literature, and Aristotelian philosophy.

The library collection at Alexandria was immense for the age. Estimates of its holdings range from 100,000 to over 700,000 volumes. (Another very large library was established during the Hellenistic era in Pergamum, a city in Asia Minor.) With such vast resources and supported by generous stipends from the Ptolemies, the students and scholars at Alexandria were free to pur-

sue whatever subjects they chose. At least two of the most famous writers of the age, Callimachus (c. 310–240 B.C.) and Apollonius of Rhodes (c. 295 B.C.), were connected with the library. Both of them made important contributions to literature as poets and theorists.

Callimachus probably worked as a teacher at the Museum. His critics accused him of being incapable of writing a long poetic work or epic. He replied that the time of the epic was past; society now demanded shorter works, either complete in themselves or as parts of loosely connected longer pieces. Most of his poems illustrate this conviction. They are relatively short, with subjects chosen from common life—social mores, love, marriage, and the interpretation of myth. The most impressive aspects of Callimachus' art are his highly polished use of the Greek language and the extraordinary breadth of his knowledge. Moses Hadas says that "his metrical precision makes Homer slipshod; his erudition, Milton a schoolboy." None of his works has gained universal esteem, but his epigrams have been widely quoted. Shakespeare incorporated translations of Callimachus' epigrams into his plays.

Apollonius was probably a student of Callimachus. He learned the craft of poetry in Alexandria, but after a dispute with his teacher he returned to his home in Rhodes, where he practiced his art. Apollonius disagreed with the idea that epics of the proportions of the *Iliad* and *Odyssey* could no longer be produced, and he proceeded to write one himself. He chose for his subject one of the most famous of traditional myths, the quest of Jason and other Greek heroes for the Golden Fleece. His *Argonautica* (so called after Jason's ship the *Argo*) is at once proof and disproof of Apollonius' theories. The plot does hold together as a good adventure tale and makes interesting reading. But despite the superhuman abilities of its leading characters, it has no true epic heroes. In their places are men who, through cunning rather than courage, depict all too well the skeptical attitudes of the Hellenistic world. They speculate on the causes of mysteries, show their interest in geography, and justify their actions in legalistic terms. The Homeric tradition suffers in other ways. Manifestations of the divine become largely displays of magic and of the occult. Apollonius' language, though it employs some traditional epic phrases, lacks Homer's masculine vigor. Apollonius can be credited, however, with having told the tale of Jason and Medea well. Perhaps he provided the model for Vergil's later story of Dido and Aeneas.

Apollonius had few followers. Most Hellenistic poets preferred to imitate Callimachus in producing shorter works, singly or in related collections. Most famous and admired of such writers—the greatest poet of the Hellenistic era, in fact—was Theocritus (fl. 275 B.C.).

Theocritus was born in Sicily but spent his creative years in Alexandria. The poetic form he perfected was the *idyl*, a short poem combining lyric, dramatic, and narrative elements. Most idyls are pastorals—that is, they deal with life in the country—with rural scenes, shepherds, farmers, and nymphs. Love, rustic celebrations, and the arts of farming are typical subjects. Theocritus brought to his poems a sincere love of nature and an artist's sense of poetic form. His *Idyl II*, "The Incantation," is a fine example of his skill. It is a love story in which a country girl uses magic in a futile attempt to win back the faithless lover who has forsaken her. It is a dramatic monologue that is warm and moving, yet fanciful and imaginative.

The spirit of the Hellenistic era is reflected in the fact that Theocritus' rural poetry was popular with sophisticated city dwellers whose enthusiasm for the simple life was probably less than sincere. The idyl as a poetic form gradually lost favor, but its popularity was revived two centuries after Theocritus by Rome's great poet Vergil, in his pastoral *Bucolics* or *Eclogues* (Ch. 4).

The Philosophers. The two great fourth-century Greek philosophers, Plato

and Aristotle, figured importantly in the history and development of literature. Their philosophical systems strongly influenced contemporary and later literature. In fact, much of the literature of later times, including the Middle Ages and the Renaissance, was concerned with ideas that Plato and Aristotle formulated. But their involvement in literature, as distinct from philosophy, was more immediate: Plato was himself a skillful writer, and Aristotle developed the first important theories of literary criticism.

Plato's dialogues embody both philosophy and art. The semidramatic question-and-answer form in which most of his writings are couched is of course a literary device. The dialogues may sometimes seem repetitious, and the ideas are often difficult to follow—perhaps inevitably so. But there are many very readable and sometimes brilliant passages. Apart from the dialogue form, Plato introduces a variety of other literary devices with which to present his thoughts. The tenth book of the *Republic,* for example, contains a long parable, a mythical and symbolic account of the soul's progress to the next world, an expression of ideas that could not be well said in conventional philosophical language. Plato's celebrated account of the death of Socrates, found in the dialogue called *Phaedo,* is one of the high points of Western literature. In a brief narrative Plato superbly characterizes one of the most remarkable men in Western history. The passage is moving but unsentimental.

We can only guess how well Aristotle might have written had he been concerned with style. What we have of his works are probably lecture notes, either his own or those made by his students. But he did turn his wide-ranging mind toward the arts of literature—the epic, the comedy, the tragedy—and formulated critical opinions of permanent importance. His *Poetics* develops a number of major critical theories, especially regarding dramatic tragedy. He attempts a definition of tragedy—its nature and the effects it has on the viewer. He isolates and defines its major elements as plot, character, thought, diction, music, and spectacle. Basing his analysis chiefly on Sophocles' *Oedipus Rex,* he describes the qualities of the ideal tragic hero. Most writers on tragedy since Aristotle have found it necessary to take positions in regard to his theories, whether in agreement or disagreement.

MUSIC

Much of what was said about music in the preceding chapter could well be repeated here. Our knowledge of Hellenistic music is only fragmentary and is based largely on theoretical treatises written by philosophers and mathematicians of the period. But we do have two Delphic hymns to Apollo from about 150 B.C., a drinking song or *skolion* from a little later, and a few Greek hymns that were written after the Roman conquests. We cannot be completely sure, of course, as to what certain details of Greek notation meant or exactly how the works were performed.

During the centuries following Pythagoras, musical theory underwent considerable refinement. In approximately 330 B.C. a theorist named Aristoxenus wrote what is now the earliest book of music theory, the *Harmonics.* He identified three different systems of music, all based on tetrachords—combinations of four notes in descending order. Aristoxenus differed from Pythagoras in insisting that intervals (the difference in pitch between two tones) should be determined by the ear rather than by mathematical relationships. He divided each full tone into a number of minute pitch gradations—too small, in fact, for most modern ears to hear.

By about 150 B.C. the traditional system of modes had been extensively revised. Another theorist, Ptolemy, reduced the number of modes from about fifteen to seven, one fewer than medieval musicians were later to adopt. Arguments as to how the modes actually sounded are far from settled.

Most of the handful of examples of

Hellenistic music that have survived were found carved in stone and are difficult to read. Moreover, the two earliest, both hymns to Apollo, are incomplete. These Delphic hymns were composed according to the system developed by Aristoxenus. The only complete work, commonly called the "Epitaph of Seikolos," is a very short piece, with words in a modified iambic pattern. Evidently used as a drinking song, it is in the Phrygian mode—the mode, supposedly, of wild exuberance. The words are a melancholy version of the "eat, drink, and be merry" theme, advising listeners to be happy when they can because death will soon end all joy. (It should be mentioned, incidentally, that both Plato and Aristotle commented on *ethos*, the moral and ethical aspects of music and the other arts.)

ARCHITECTURE

The great innovative periods of Greek architecture were the archaic and especially the Hellenic. In these eras the post-and-lintel system employed in the Parthenon and other temples was developed and refined to its highest level. The Hellenistic age offered nothing to equal the creative imagination of these earlier periods; but probably no other age so ably adapted the accomplishments of an earlier age to fit its own social and cultural needs as did the Hellenistic. The great structures of the Hellenic age had been built to celebrate the gods who protected and fostered the Greek city-state; the buildings of the Hellenistic era, on the other hand, were monuments to the founders and preservers of empires. Hence public buildings of the Hellenistic era were larger and more ornately ornamented than were their predecessors. Their designers strove to impress, to symbolize in buildings and other monuments the magnificence of their semidivine rulers. Four of the huge structures that the ancients called the Seven Wonders of the World were erected during the fourth century B.C. or the

Hellenistic era. And of those four—the Temple of Artemis at Ephesus, the Lighthouse (Pharos) at Alexandria, the Mausoleum at Halicarnassus, and the Colossus of Rhodes—all but the last were works of architecture, and even the Colossus served as a lighthouse. (The other three are Phidias' statue of Zeus at Olympia, the Pyramids, and the Hanging Gardens of Babylon.)

The Temple of Artemis at Ephesus was erected in that once-great city as a reconstruction of an earlier temple that had been destroyed by fire in 356 B.C. Itself destroyed in turn centuries ago, it was famous for its impressive size and its sculptured columns, which ancient writers attributed to the great Greek sculptor Scopas.

Scopas has also been associated with the decoration of another of the Seven Wonders—the fourth-century Tomb of Mausolus, satrap of Caria (fig. 3-1). This large monument, 134 feet high, was erected in Halicarnassus (in southwest Asia Minor) by the wife of the dead ruler. Constructed of white marble, it consisted of a high base topped by thirty-six Ionic columns supporting a stepped pyramid. Atop the pyramid was a sculptured work depicting a four-horse chariot. Beautiful friezes, possibly by Scopas, and huge statues of Mausolus and his wife ornamented the building. It stood until the fifteen century A.D., when it was destroyed by an earthquake. Only the statuary remains, much of it badly damaged. The building was widely famous during the Hellenistic era, and its name has of course been adopted in modern times to designate any large monument or other structure built to house the dead.

Alexander's conquests led to the founding of many new cities throughout the Mediterranean region—Greek-oriented cities which reflected the Hellenic cultural attitudes that Alexander admired and promoted. Several of them, each built in a relatively short period of time, furnish compact evidence of Hellenistic thinking in regard to architecture and the other arts. Alex-

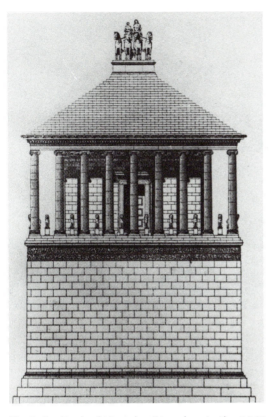

Fig. 3–1. Tomb of Mausolus (Mausoleum). About 350 B.C. Halicarnassus, Asia Minor. (Reconstruction drawing).

Because its ruins were discovered in a reasonably good state of preservation, the city of Pergamum in Asia Minor gives us a better idea of what a Hellenistic city was like. It served for several centuries as the capital of a part of Alexander's portioned-out empire that was ruled by the Attalids, descendants of one of his conquering generals. Except for its temple area, which grew somewhat haphazardly, the whole city of Pergamum seems to have been planned as a monument to its kings. The buildings and streets were laid out so that the eye was led to the palace and the surrounding royal buildings. Unlike the typical Hellenic city, in which individual structures had little relationship to one another, Pergamum was designed and built according to strict plans—one of the earliest instances of city planning in the modern sense. Rooflines, façades, building materials, and other details were carefully regulated.

The best-known single structure from Pergamum, once a part of the elaborate temple complex that topped its principal hill but now located in East Berlin, is the Altar of Zeus (fig. 3-2). This temple was dedicated to the gods but celebrated the Attalid kings as well. The builders of the altar employed the Ionic order, and in its many columns they held strictly to that order. In other parts of the temple, however, changes are readily observable. The large staircase in front provided a dramatic entrance for priests or royalty. In order to emphasize the staircase, the architect partly enclosed it by bringing both of the side wings of the building forward to the point where the bottom step begins. Even more unusual than the sweeping stairway are the position and size of the frieze. Instead of being part of the entablature, the frieze stands below the level of the stylobate and under rather than above the columns; and its size has been greatly increased to accommodate heroic-sized relief sculpture.

The largest of Hellenistic temples on the Greek mainland, the Temple of Olympian Zeus (fig. 3-3), was begun in Athens in

andria, though it was (and is) the most famous of these cities, offers less evidence than some of the others because it has undergone innumerable changes and the ancient city has largely vanished. But its famous lighthouse, another of the Seven Wonders, was described in ancient writings in enough detail that we have a reasonably accurate idea of how it looked. It was a work of huge dimensions, reaching three hundred feet into the air and consisting of three great stories—the first square, the second hexagonal, and the third round. The building was crowned by a large statue. Construction took approximately twenty years; the colossal work was completed in 280 B.C.

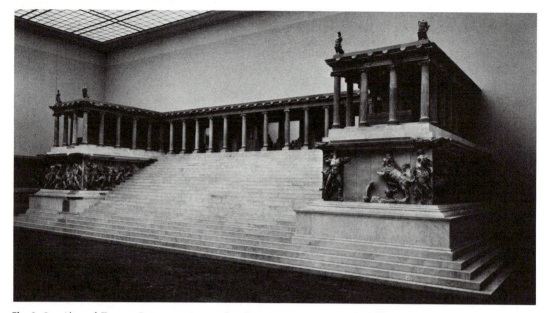

Fig. 3–2. Altar of Zeus at Pergamum (restored). About 175 B.C. State Museums, Berlin.

Fig. 3–3. Temple of Olympian Zeus, Athens. Begun 174 B.C.

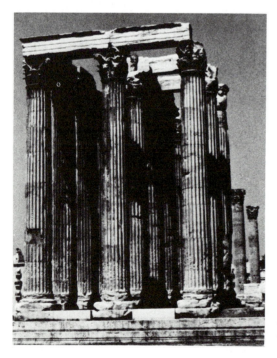

174 B.C., at a time when the Romans were beginning to consolidate their power in Greece. Although it was not completed until A.D. 131, it was Hellenistic in plan and construction. As the ruins show, the order was Corinthian; the towering columns, higher than any other structure in ancient Athens (56½ feet high), were proportionately narrower and their capitals more elaborate than those in most Hellenic structures. The temple had two rows of columns on each side and three at each end; of these hundreds of columns only a few remain standing. The building measured an incredible 354 feet long by 135 feet wide. Although its deviations from Hellenic principles were much less radical than those of many other Hellenistic structures, its overwhelming size and grandeur were characteristic of its age.

SCULPTURE

The Fourth Century. The works of Greek sculpture that attracted the admiration of European artists from the time of the

Renaissance until fairly recently were not the masterpieces of the Golden Age but those of the fourth century and the Hellenistic era. And even today, though critics may prefer the earlier works, most of us are apt to think of the familiar and popular later works when we think of Greek sculpture—of the *Venus de Milo*, the *Winged Victory of Samothrace*, the *Laocoön*, or even the *Belvedere Torso*. All of these and many other well-known works were produced during the age of Alexander and his followers.

The sculpture of this period is as diverse as the few examples we have named would indicate and can be described only in general terms. Yet the changes that led to these varying styles were gradual and often conscious and can be traced in some detail.

The idealized statuary of the Hellenic age reflected an effort to depict the human body in perfect form. Hellenic sculptors, as we have shown, attempted to discover and employ canons, mathematical rules of proportion that were supposed to govern the size of parts of the ideal body as they related to each other. Fourth-century sculptors continued the search for perfection and developed different systems, most of them variations on the canon of Polyclitus. Perhaps best known of the sculptors who followed a formalized scheme was Lysippus of Sicyon (fl. 340–300 B.C.). Like some who preceded him, he is known primarily because of what admiring contemporaries wrote about him. We do have a few copies of his works, but none of his original sculpture has survived. Lysippus believed that true human beauty was best expressed in taller and slimmer bodies than those depicted in earlier statuary, with heads smaller in proportion to bodies. It is thought that he considered a perfect human form to have a head one-eighth the size of the entire body. The *Apoxymenos* (fig. 3-4), a marble Roman copy of the bronze original, illustrates well these new proportions.

Even before Lysippus, however, changes had begun that would move sculpture away from a concern with idealized

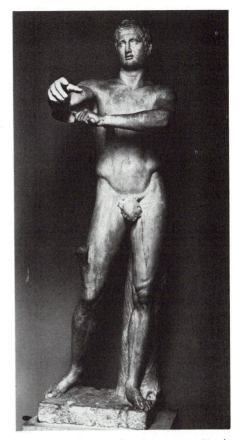

Fig. 3–4. Lysippus. *The Apoxymenos* (Youth Scraping Himself). About 325–300 B.C. Roman copy. Vatican Museums.

forms and toward the realism and emotional intensity that were to distinguish the sculpture of the Hellenistic era. A leader of the new movement was Scopas (fl. c. 360 B.C.), the architect and sculptor whom we met in connection with the Tomb of Mausolus. Art historians believe he did the huge statues for that building and also the statuary for the Temple of Athena at Tegea, in Lebanon. If so, his work can be described as tending toward pathos and violent action, with twisting forms and individualized, strong-featured faces. The relief sculpture called *Maenads* (fig. 3-5), with three bacchantes bearing dismembered spoils of the chase, has been attributed to Scopas.

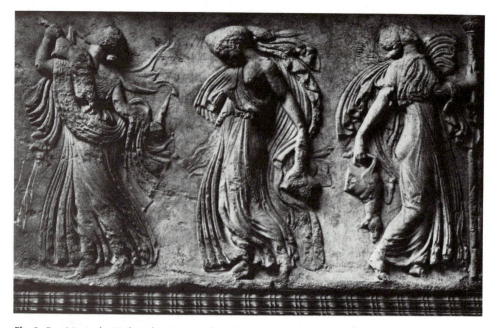

Fig. 3–5. *Maenads.* Attributed to Scopas. About 340 B.C. Museo Barracco, Rome.

Even more influential than Scopas was his contemporary Praxiteles (fl. 350 B.C.), who was equally innovative but whose work pointed in a different direction. Avoiding violence or even intensity, he strove to create in marble the effect of soft, natural flesh. He accomplished this feat both in male figures and, for the first time, in nude females. *Hermes and the Infant Dionysus* (fig. 3-6, probably the original), is a striking example of his skill. Here are no powerful, bulging muscles; the parts of the body are not sharply distinguished. Nothing detracts from the smooth, soft finish of the figure. In his statues of nude goddesses such as the *Aphrodite of Cnidos* (fig. 3-7), one can see the same qualities: graceful transitions from limbs to torso, highly polished flesh, and soft, flowing lines. It is symptomatic of cultural change that from the time of Praxiteles on, the female figure became the favorite subject for sculptors.

Hellenistic Sculpture. The Hellenistic era produced large amounts of statuary, and a surprising number of works from the period have come down to us, both in the original and in Roman copies. With few exceptions, however, the identities of the artists have disappeared, and even of the exceptions we usually know no more than their names and places of residence. Hence it is more useful to discuss the trends of the period than the works of individual artists.

Sculptors of Alexander's time and later adopted the innovations introduced by Scopas and Praxiteles—emotion, intense action, naturalism, and the exploitation of the nude figure—and added others, including portraiture, group statues, emphasis (often overemphasis) of muscle structure, and the use of genre subjects, those drawn from common life. Each of the examples that follow illustrates one or more of these characteristics.

The portrait of Sophocles (fig. 3-8) is a Roman copy of a Greek work produced sixty or seventy years after the playwright's death in 406 B.C. We cannot be sure how much it resembles the great tragedian, but the

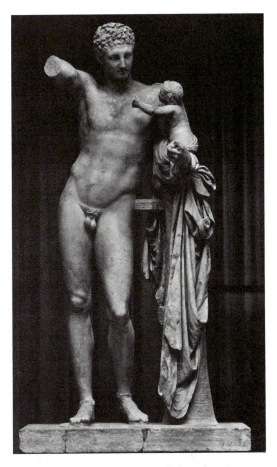

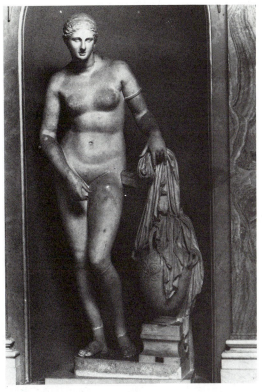

Fig. 3–7. Praxiteles. *Aphrodite of Cnidos.* Roman copy (original about 330 B.C.). Marble, 6′ 8″ high. Vatican Museums.

Fig. 3–6. Praxiteles. *Hermes and the Infant Dionysus.* About 330 B.C. Marble, approx. 7′ high. Museum, Olympia, Greece.

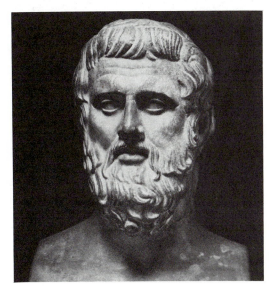

Fig. 3–8. *Sophocles.* Roman copy of Greek original sculpted about 340 B.C. The Louvre, Paris.

change from earlier statuary is obvious. The features are those of an individual: deep-set eyes, furrowed brow, a rather large nose, and a beard, a feature seldom seen in earlier sculptured faces. Realism is carried even further in the statue of an *Old Woman* seen in fig. 3-9. Here the artist turns sharply away from the artistic ideal of female beauty, and depicts age in the cruelest detail—stooped posture, sagging flesh, weathered skin, and bony features that emphasize the old woman's tense anxiety. Although not a portrait in the strict sense, the work illustrates the acute powers of observation that were common to the better Hellenistic sculptors. It also illus-

Fig. 3–9. *Old Market Woman.* 2nd century B.C. Marble, approx. 4' 1" high. The Metropolitan Museum of Art, New York. Rogers Fund, 1909.

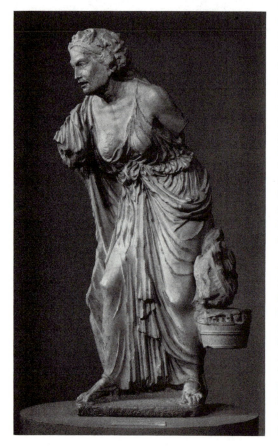

trates their willingness to turn away on occasion from deities and famous athletes and choose as their subjects real people, often from the poorer classes of society. Obviously there was a viewing audience that shared their interest in such subjects, one that admired an art produced largely for artistic rather than religious or commemorative purposes.

When the *Laocoön Group* (fig. 3-10) was discovered in Rome in 1506, it was hailed by Renaissance artists as the most beautiful work of sculpture ever produced. Although this evaluation would be shared by relatively few modern viewers, it is easy to see why the work aroused such admiration. In a complex arrangement of forms it depicts three figures, all free-standing yet all part of one large conception. The lines and volumes of each figure are integrated closely with those of the other two. The anatomical features of the priest Laocoön (a tragic figure drawn from the story of the fall of Troy) are somewhat exaggerated; but they show with remarkable realism a moment of intense exertion, with muscles bulging and with veins and ribs forcing themselves to the surface. The emotional impact of the work, even if one does not know the story of Laocoön and his sons, is immediate. We know now that the work was crafted by Agesandros, Athanodoros, and Polydoros, three artists of the school of Rhodes, and was completed sometime between 160 and 140 B.C. For many years after its discovery, however, its admirers tried to date it at an earlier, more "noble" time.

Another important example of group statuary is the famous frieze of the Altar of Zeus at Pergamum, the *Battle of the Gods and Giants* (fig. 3-11 shows a detail). Relief sculpture depicting groups of figures was not new; one need only recall, for example, the friezes of the Parthenon. But here the artists achieved markedly different results. The wide frieze surrounds the base of the temple, and the high-relief figures, almost all of them in violent action, are more than life-sized. Here the sculpture becomes almost a narrative, with the names of the participants

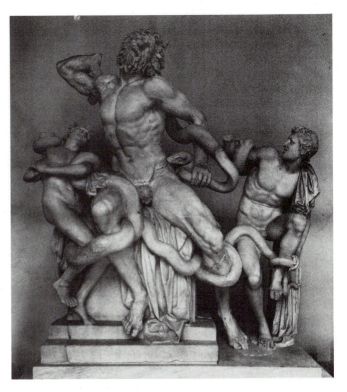

Fig. 3–10. Agesander, Athenodorus, and Polydorus of Rhodes. *The Laocoön Group* (partly restored). Late 2nd century B.C. Marble, 7′ high. Vatican Museums.

Fig. 3–11. *Zeus Hurling Thunderbolts,* detail of Altar of Zeus frieze. About 180 B.C. Marble, 7′ 6″ high. State Museums of Berlin.

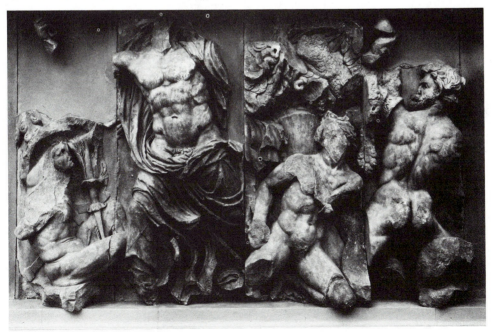

in the battle inscribed below and with figures moving at extreme angles, their hair and draperies flying in the fray.

Two statues that illustrate well the continuing tradition of the nude sculptured figure are the *Youth of Antikythera* (fig. 3-12) and the *Pugilist* (fig. 3-13). The muscle structure of the *Youth* seems exaggerated when one compares him with Praxiteles' *Hermes* or other earlier male figures. But he seems restrained and even idealized in comparison with the *Pugilist*. The tired body and bulging muscles of the scarred boxer involve a paradox: his pose and facial expression betray exhaustion and even fear; but his oversized physique seems somehow unrealistic in its suggestions of power and even confidence.

The *Capitoline Venus* (fig. 3-14) and the *Aphrodite* (or *Venus*) of Melos (fig. 3-15) demonstrate some of the changes that were occurring in depictions of the female figure. The *Aphrodite* is, of course, one of the most popular statues ever created. Despite the strong contrapposto resulting from the forward thrust of the left knee, the full, noble beauty of the body and the calm dignity of the face have become for many an ideal of feminine beauty. Amateurs and professionals alike have speculated about the possible positions of the long-missing arms, and scholars have tried without success to determine the identity of the artist. In the Capitoline figure there is greater emphasis on smooth forms and the illusion of soft flesh— a reflection of the influence of Praxiteles and his followers. Both faces are essentially idealized, in contrast to those of many other Hellenistic works of art.

Many of the figures we have discussed illustrate the desire of Hellenistic sculptors to depict action in stone and bronze; but no works demonstrate this tendency more vividly than the *Winged Nike* (or *Victory*) *of Samothrace* (fig. 3-16) and the *Gaul Killing Himself and His Wife* (fig. 3-17). The *Nike*, another of the celebrated masterpieces of the age, was probably carved by an artist from Rhodes. Fashioned about 180 B.C. to celebrate a naval victory, it shows Nike, goddess

of victory, alighting on the prow of a ship. Her draperies, agitated by wind and movement, cling tightly to the figure to reveal the dynamic form beneath. Most exciting are the windswept wings, thrown back at an angle which captures that moment when motion is stopped. Motion has also suspended momentarily in the *Gaul*. Here the power of the male figure, raising his knife at a strong angle to plunge it into his own heart, is in stark contrast to the limp form of his wife. There is some idealization in the *Nike* statue, but none at all in the Gaul group except perhaps in the draperies. The faces of these figures are those of barbarian invaders. Realism, narrative, and drama permeate the work.

Fig. 3–12. *Youth of Antikythera.* Hellenistic era. Bronze, lifesize. Courtesy National Archeological Museum, Athens.

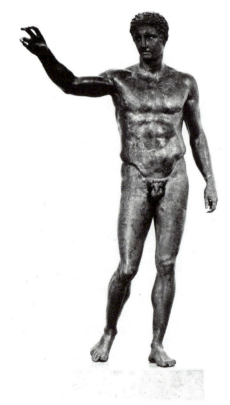

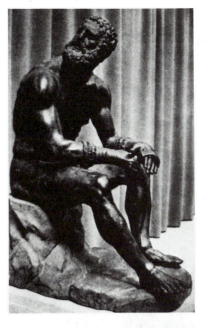

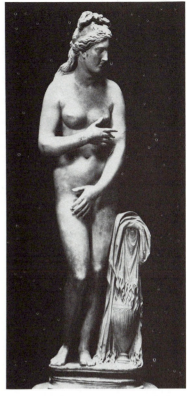

Fig. 3–13. Apollonius (?). *Seated Boxer* (*Pugilist*). About 50 B.C. Bronze, 4′ 2″ high. Found in Rome. National Museum, Rome.

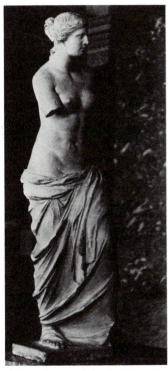

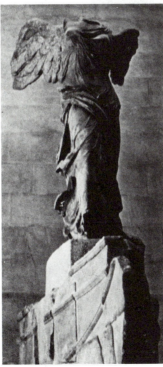

Fig. 3–14. *Capitoline Venus* (Aphrodite). About 320–380 B.C. Roman copy. Capitoline Museum, Rome.

Fig. 3–15. *Aphrodite of Melos.* About 150–100 B.C. Marble, 6′ 10″ high. The Louvre, Paris.

Fig. 3–16. *Nike* (*Victory*) *of Samothrace.* About 200–190 B.C. Marble, 8′ high. The Louvre, Paris.

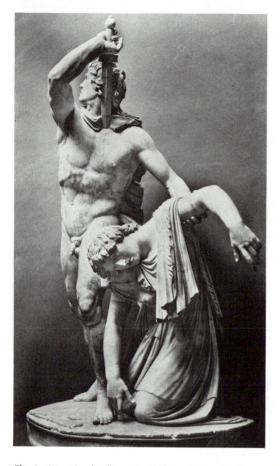

Fig. 3–17. *Gaul Killing His Wife and Himself.* Roman copy after bronze original of about 225 B.C. Marble, 6' 11" high. National Museum, Rome.

PAINTING AND MINOR ARTS

Paintings that adorned the walls of palaces and mansions in Pergamum, ancient Alexandria, and other Hellenistic cities have long since disappeared. But Roman or Romanized artists admired such paintings and often copied them, especially in mosaic, on walls in such cities as Pompeii and Herculaneum. It is from such copies, as well as from commentaries by writers of the post-Hellenic era, that we can get a fairly clear picture of what fourth-century and Hellenistic painting was like.

From the writers we learn that painters of the fourth century strove to depict reality as accurately as possible. In doing so they developed a number of devices that were designed to fool the eye of the viewer. Most important of these were attempts to create the illusion of a third dimension in flat painting. Foreshortening, the use of shadows, modeling, and other devices relating to perspective were developed during the centuries preceding the Roman conquests. Pre-Christian artists never discovered the mathematical relationships of linear perspective, but by constant experimentation they often approximated its effect.

The *Battle of Issus* was a large and evidently very popular wall painting in Pergamum that depicted Alexander's victory over the Persian king Darius III in 333 B.C. The so-called *Alexander Mosaic* (fig. 3-18) from Pompeii is believed to be an accurate reproduction of the painting. It shows how far the development of foreshortening had progressed; the artists had no problem depicting horses or men facing in any direction. It also shows how skillfully mosaic could be employed to show rounded forms and to depict large scenes and widespread actions.

In addition to the *Alexander*, Pompeii's ruins contained many other works of Hellenistic origin—mosaics and frescoes of birds, flowers, and human figures. One of the finest is the *Musicians* (fig. 3-19), probably copied from a painting done in the third century B.C. Here the use of shadow is particularly noteworthy.

Postclassical Greek artists made a number of important contributions to the media of the visual arts. One of these was the development of mosaic, a technique which in its earliest stages consisted of embedding or inlaying small water-smoothed pebbles in mortar. Naturally the range of colors of the early pebble mosaics was limited—whites, grays, browns, blacks and the like—and three-dimensional subjects were difficult to depict.

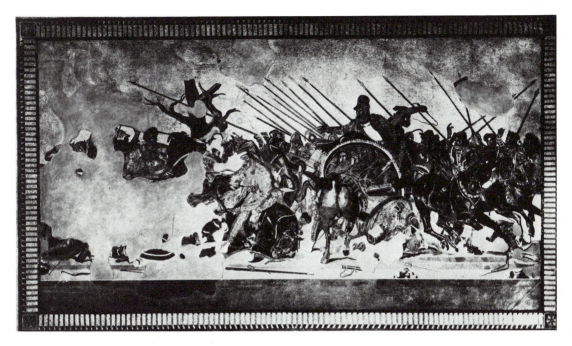

Fig. 3–18. *The Battle of Alexander,* from the House of the Faun, Pompeii. 3rd–2nd centuries B.C. Mosaic, approx. 8′ 10″ × 16′ 9″. National Museum, Naples.

Fig. 3–19. *Street Musicians.* Mosaic from Herculaneum (near Pompeii). About 100 B.C. National Museum, Naples.

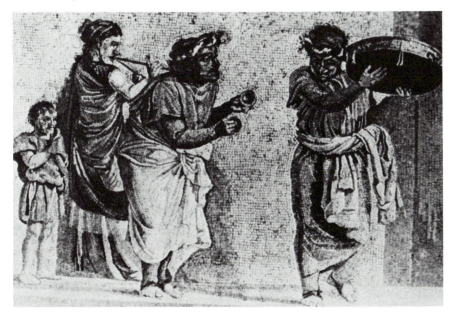

Fig. 3–20. *Griffins Attacking a Horse.* 4th century B.C. (?). Sea pebble mosaic. Museum, Corinth.

But still, many fine pebble mosaics were produced in Pella (Alexander's birthplace), in Corinth, and elsewhere. The mosaic in fig. 3-20 depicts two vividly imagined griffins, creatures that were half-lion and half-eagle, attacking a terrified horse. Later mosaicists replaced pebbles with a variety of *tesserae* or colored fragments of such materials as marble, glass, and pottery. These developments also occurred in the Hellenistic era.

Encaustic, a type of painting that used melted wax as the vehicle, was an important development of the fourth century. It was then the medium most capable of showing texture and depth. Although we have record of several major painters who used encaustic, the only examples that remain are from a later age.

As we have said, the final date of the Hellenistic period is not easy to establish. Though the Romans completed the conquest of the Greek mainland in 146 B.C., that conquest by no means meant the end of Greek culture. If anything, the fall of Greece to Rome actually continued the spread of Hellenistic art, for the Romans admired and adopted much of what they found in Athens and the rest of the Greek world. So blurred are the cultural lines, in fact, that it is customary and logical to refer to much of the art of the two centuries immediately before Christ as Greco-Roman. But by the end of the first century B.C. there was little or no independent Greek political activity, and Hellenistic culture had become merely another—albeit important—facet of the Roman Empire.

THE ARTS OF ROME

When the achievements of the Romans are summarized, it is customary to emphasize their practical genius—their military science, empire building, applied science, engineering, systematizing of law, and similar accomplishments. The facts support such an evaluation, and probably most modern Americans can identify more readily with the Roman genius than with that of the Greeks. As a people the Romans were much less interested than the Greeks in intangibles, in abstract thought, and in beauty for its own sake. But they did practice the arts, and on a large scale at that. In at least two of them, literature and architecture, they were eminently successful.

HISTORICAL BACKGROUND

The history of Rome can be divided into three periods: (1) from the beginnings to the establishment of the Republic in 509 B.C.—what has been called the *legendary period*; (2) the *Republic*, from 509 to 27 B.C.; and (3) the *Empire*, from 27 B.C. to the fifth century after Christ.

1. *The Legendary Period.* Roman legend has it that the Trojan hero Aeneas and his followers left Troy after its fall and ultimately reached Italy. Here they conquered certain native tribes and established themselves not far from the site of Rome. It is this legend that forms the basis for Rome's greatest epic poem, Vergil's *Aeneid.* Several centuries later (753 B.C. is the traditional date) a descendant of Aeneas named Romulus founded Rome.

 The sixth century B.C. brings us nearer to verifiable history. At this time Rome and other Latin villages were dominated by the Etruscans, a people from farther north in Italy about whom little is known. The last of the Etruscan kings of Rome, Tarquin the Proud, was expelled in 509 B.C., and a republic was established.

2. *The Republic.* Probably a more accurate name for this period would be *The Oligarchy.* In actuality most of it was an era of rulership by the powerful few. The period saw the growth of Rome from a small village to a large

city, the dominant political force in the Western world. Wars were frequent—wars against invading barbarians, against Greek colonists in southern Italy, and especially against Carthage, Rome's powerful North African rival. These last, the three Punic Wars, were fought intermittently from 264 to 146 B.C., with Rome the ultimate victor.

The last years of the Republic were marred by administrative problems in Rome's provinces and by tensions between the lower classes (plebeians) and the aristocrats (patricians) that often erupted into violence. In the first century before Christ, a series of devastating civil wars led inevitably to autocracy and dictatorship. In 44 B.C. the brilliant general Julius Caesar had himself appointed dictator for life and in the same year was assassinated. Further civil wars concluded with the defeat of Mark Antony and his consort Cleopatra by Octavian in 31 B.C.

3. *The Empire.* Octavian, one of the most successful political leaders in history, disclaimed any desire for monarchy, but in 27 B.C. he became Caesar Augustus, the first Roman emperor. The 500-year-old republic came to an end, and the nearly 500 years of the Roman Empire began. By force of will and administrative ability, Augustus stabilized the Roman world, extended its boundaries, and brought to it a measure of peace (the *Pax Romana*) that was to continue until about A.D. 180.

So strong were the social and economic forces set in motion by Augustus that the Empire continued to prosper after his death in A.D. 14—even during the reigns of such misfits as the mad Caligula and the depraved Nero. With Trajan, who ruled from 98 to 117, began a series of able rulers (Hadrian, An-toninus Pius, and Marcus Aurelius were the others) who brought the Western world an era of stability and peace that was almost unique in history. It ended with the death of Marcus Aurelius in 180, and the century that followed was a period of social, moral, and economic disaster. Diocletian, who ruled from 284 to 305, shifted the seat of empire from Rome to Milan and attempted a series of economic reforms that did more harm than good. But the celebrated emperor Constantine brought a temporary measure of stability to the Empire. He also gave religious freedom to the long-persecuted Christians in 313, and, in another act that was to have world-shaking consequences, he transferred the capital of the empire to Byzantium, which became Constantinople. Rome, which had been periodically attacked by barbarian hordes for centuries, was sacked by the Visigoths in 410 and by the Vandals in 455. The once-powerful Empire gradually disintegrated. "But Rome could not be destroyed," says Moses Hadas. "It lived on as the seat of the Church and as a great monument; even in ruins it outshone the rising cities of Europe until the days of the Renaissance."

The Arts. Except for some intriguing statuary made by the Etruscans, the Romans' early fellow inhabitants of Italy, there was no Roman art of any consequence until the third century before Christ, two full centuries after Greece's Golden Age. Roman architectural and engineering skill began to manifest itself in the cities, roads, and aqueducts of the third century and after. At about the same time Rome produced its first two important literary artists in Plautus and Terence, writers of comedy. But it was not until the last decades of the Republic and the first years of the Empire that a great flowering of literary genius occurred, in what is called Rome's Golden Age (70 B.C.–A.D. 14). This was the era that produced such writers as Vergil, Lucretius, Horace, Ovid, and Catullus. The silver age, following the death of Augustus, saw a decline in the quality of

Roman literature—an emphasis on style at the expense of content.

Rome's other major art, architecture, reached a high level during the reign of Augustus, who boasted that he turned Rome from a city of brick to one of stone. Building continued at a rapid pace throughout the two centuries that followed. The Empire, from Scotland to Syria, was alive with building projects—walls, aqueducts, theaters, temples, amphitheaters, baths, mansions, forums, apartment houses, even whole cities laid out and built according to plan. The Roman passion for luxury, size, and grandeur in architecture reached its peak during the reigns of Trajan and Hadrian in the second century after Christ.

LITERATURE

Roman epic, drama, lyric, and other forms were borrowed from the Greeks, but the borrowing was done consciously and with pride. Roman writers were as aware of their debt to Greece as we are of ours to England, and they quoted from their Hellenic predecessors as we do from Shakespeare.

But in spite of that the Latin writers were innovators. If they did not originate the letter, they made it a literary form. The novel can be traced to Latin beginnings in the long fiction of Petronius and Apuleius.

Latin literature from the shortest epigram to the weightiest epic tends to be moralistic—to teach, to instruct. When it philosophizes, the philosophy is seldom abstract or metaphysical. It is primarily concerned with meeting personal problems of living and dying.

Roman literature usually employs classical forms, forms that suggest restraint and balance. There is, however, a strong current of romanticism flowing through Roman writing. It can be seen, among other places, in the passion of Catullus' love lyrics, in the bitter personal feeling of Juvenal's satires, and in the intense emotionalism and heightened effect of many parts of Vergil's *Aeneid*.

The Epic. Homer's *Odyssey* was translated into Latin in 240 B.C., and Roman epics in imitation of Homer were written shortly after. The first great one is Vergil's masterpiece, *The Aeneid*. This poem, probably Rome's finest literary achievement, was published shortly after Vergil's death in 19 B.C.

The Aeneid tells of the legendary ancestor of the Roman people, the Trojan hero Aeneas. After the fall of Troy and the death of his wife, Aeneas and his followers set out to fulfill his heaven-ordained destiny—to found a new Troy in a distant land. The incidents of their journey include a dramatic encounter with Dido, queen of Carthage. They reach Italy, their land of destiny, make alliances and create enemies, and ultimately establish themselves in Latium. There Aeneas's son is to establish the Troy-like city of Alba Longa, and there Romulus and Remus are eventually to be born.

Vergil modeled the first half of his epic on *The Odyssey* and the second half on *The Iliad*. But the differences between his work and Homer's are more significant than the resemblances. The incidents of the story, even those set in motion by hints from Homer, bear the stamp of Vergil's own genius. His hero is no Achilles, wrathful because his pride and other men's injustice keep him from the fray. Aeneas is a man who knows from the first his high mission, to lay the foundations for the greatest of empires. As valiant in war as Achilles, he fights because he has to.

Vergil, like his hero, has a sober purpose: to remind the Roman people of their great past and to predict for them, if they are worthy of it, a glorious future. He keeps constantly before their eyes Roman ideals of discipline, courage, and above all *pietas*—reverence for the family, for the state, and for the gods. The religious tone of the work and the ideals it embodies made it natural for later Christian peoples to rank it next to the Bible in popular esteem.

Drama. Rome produced no great

writer of tragedy. The only surviving Roman tragedies are ten by Seneca (4 B.C.–A.D. 65), a wealthy Stoic philosopher and writer of moral epistles, who committed suicide at the command of Nero. His plots were derived from Greek tragedy—the stories of Medea, Agamemnon, and others. Filled with melodrama and long, emotional speeches, Seneca's plays were probably not written for production and would be almost intolerable if produced today. Ironically, it was their influence and not that of Greek tragedy that was felt by the playwrights who preceded Marlowe and Shakespeare in the sixteenth century.

Roman comedy we know through the works of the two earliest important Roman writers, Plautus (c. 254–184 B.C.) and Terence (c. 190–159 B.C.). Not only do they follow most of the traditions of Greek New Comedy, but they borrow numerous characters, plots, and even whole scenes from Menander and other Greek forerunners. Moreover, in order to get around the strict censorship of the time, their scenes are laid in Greece, and their dissolute young heroes are usually Athenians.

Plautus liked comic irony, the device that lets the audience in on all secrets. His characters are often paper-thin, but a few are excellent portraits, especially the old man in *The Pot of Gold* who was Molière's model for *The Miser*. Shakespeare also owed his debt to Plautus: his *Comedy of Errors,* with its hilarious confusions of identity, is based on the Roman playwright's *Menaechmi.*

Terence wrote a less robust, more subtle kind of comedy than did Plautus. Unlike Plautus, he keeps identities and other secrets from the audience as well as from the characters; hence his plots are more suspenseful and his tone is more modern. The best plays of Terence, *The Brothers* and *The Woman of Andros*, in particular, have been highly influential since the Renaissance, especially in France.

Shorter Poetry. Many upper-class Romans greatly enjoyed poetry, sometimes composed it themselves, and often had poets as members of their households. Among their favorite forms were the pastoral, the lyric, the ode, the satire, and the short narrative. By the time these forms were well established, in the first century before Christ, the intimate relationship between poetry and music had weakened. Songs continued to be sung, but poetry was essentially what it is today—something to be read silently or aloud.

1. *The Pastoral.* We have met this form in the charming verses of Theocritus (Ch. 3). In his earlier years Vergil modeled ten short poems—he called them *Bucolics* or *Eclogues*—on the verses of Theocritus. Always the speaker is a shepherd. The poems sing of disappointment in love, of courtship, of grief over the death of a fellow shepherd, and similar matters. Like *The Aeneid* they display that felicty of word music that led Tennyson to call Vergil "writer of the stateliest measure ever molded by the lips of man."

2. *The Lyric.* Best of Roman lyric poets, one of the greatest of all writers of love poetry, was Catullus (c. 84–54 B.C.). A sensitive, gifted young man from Verona, he fell in love with a sophisticated older woman named Clodia, who evidently encouraged what she thought was merely a pleasant flirtation. In a series of lyrics called *Poems to Lesbia* Catullus sets forth his rapture, his doubts, his vacillation between love and hatred, and his vain attempts to achieve a complete renunciation. Seldom has poetry expressed a love relationship with greater intensity.

3. *The Ode and Satire.* Horace (65–8 B.C.), who was blessed with a philosophical if not highly original mind and a keen sense of the beautiful, wrote 108 odes on a variety of sub-

jects. In a pleasant, warmhearted way he reminded his fellow Romans of the beauty and brevity of life, of the need for moderation, and of the value of contentment and wise enjoyment. His *Satires* make the same points but are more amusing in tone. The objects of his satire are usually not individuals but types or groups—the social climber, for instance, in his poem "The Bore."

4. *The Short Narrative Poem.* It would be hard to over-estimate the impact Greek and Roman myths have had on the arts of the Western world. No one did more to assemble these myths and give more or less permanent form to their stories than did Ovid (43 B.C.–C.A.D. 17), Roman poet of the early Empire. Ovid's earlier work, including the *Amores* and the famous *Art of Love*, reflected the profligate circles in which he traveled. Later he turned to more serious but still quite shallow subject matter for his *Metamorphoses*. Here he brought together hundreds of myths and cleverly arranged them according to the four ages of man—gold, silver, bronze, and iron. Almost all of them involve transformations—the changing of Daphne into a laurel, of weeping Niobe into a column of stone and a spring, of Narcissus into a flower, of Pygmalion's statue into a beautiful woman. The old tales, elegantly retold, were familiar to Ovid's readers, who probably took them no more seriously than we do. One of the most familiar of them, the story of Orpheus and Eurydice, has provided creative impetus for many artists ancient and modern, in most of the media of art.

Philosophical Poetry. Most famous of philosopher-poets is Lucretius (c. 96–55 B.C.) He wrote, in *De Rerum Natura* (On the Nature of Things), about such subjects as the atomic theory, the origin of man, immortal-

ity, and the nature of deity—and managed to make good poetry of it all. Some of his observations—those on the atom as the basis of matter, for instance—are strikingly modern.

Lucretius was an admirer of the third-century Greek philosopher Epicurus, who believed that the senses are the only infallible guide to truth. He also believed that pleasure should be the goal of life—pleasure which can be found only in simple living, tranquility, and the avoidance of pain. Neither Lucretius nor Epicurus was an epicurean in the popular modern sense of that word.

Letters and Meditations. The Romans raised letter writing to the level of a literary art. Among its numerous practitioners two are of special importance.

The first of these is Cicero (106–43 B.C.). Statesman, lawyer, and perhaps the greatest orator of a nation that deeply admired eloquence, Cicero found time to write countless letters (over nine hundred survive). Some of them, evidently written for public consumption, deal with the dramatic political issues of his time. Others are actually essays, such as the *Offices*, written to strengthen the character of his good-for-nothing son Marius. They deal with such Stoic—and universal—ideals of conduct as justice, faithfulness, and fortitude.

Another writer of letters is Pliny the Younger (A.D. 62–113). This wealthy aristocrat evidently hoped that his letters, polished with utmost care, would be read and admired by future generations. In a lifetime of government service he wrote frequently to friends and superiors. One famous letter, directed to the emperor Trajan, is an inquiry as to how he should punish any Christians that he might encounter. Another gives an invaluable description of the eruption of Vesuvius that destroyed Pompeii in A.D. 79. Still another describes Pliny's luxurious Tuscan villa and reveals the enormous pride he took in his station and possessions.

The meditation is not a recognized literary form, but the celebrated *Meditations* of

Marcus Aurelius have almost made it such. Later writers such as Pascal and Thomas à Kempis employed basically the same form. It consists of condensed, simply written statements, philosophical and religious in tone and meant to serve as guides for personal living.

Marcus Aurelius (A.D. 121–180), in personal character probably the greatest of Roman emperors in spite of his misguided persecution of Christians, took what time he could from his military and administrative duties to jot down counsel directed toward himself. He was a Stoic, as were Cicero and Seneca before him, and his writings constantly reflect the convictions of that philosophy: true freedom as obedience to God and responsiveness to high principles; the brotherhood of man; the calm acceptance, not the avoidance, of pain; and the supreme importance of the inner man—the soul as one's true sanctuary. These high-minded ideals seem to have had little impact on the attitudes of Rome in general. Herein lay, perhaps, the tragedy of that decaying empire. His own son and successor, Commodus, proved to be one of the most debased rulers in history. He boasted of having slain thousands of men in gladiatorial combat, using only his left hand. He neglected to mention that only he was protected by armor.

MUSIC

It has been said that in music the Romans were entirely unproductive and depended on the Greeks, whom they had made their subjects. It is true that the musical forms and most of the instruments of the Romans were borrowed from the Greeks (as, in some respects, are ours). But music, probably much of it original, played a large part in their public and private lives. In early times, the guild of pipers—native Romans, not slaves—was highly respected. Later, music lovers organized themselves into clubs for their own entertainment. Virtuoso soloists who sang and accompanied themselves on the kithera

were much respected. It was this kind of musician that Nero aspired to be. He was criticized, not because he made music, but because he considered himself a professional.

In addition to the Greek instruments mentioned in chapter 2—auloi (oboes), pipes, flutes, cymbals, organs, and others—the Romans particularly favored the *tuba*, a long, straight, trumpetlike instrument, usually of bronze. Another favorite was the *scabellum*, hinged flapping metal plates or boards worked by the foot as a rhythm instrument. Music, whether made by slaves (often of Greek origin) or by freemen, entered into many parts of Roman life. Small bands of instrumentalists played in the streets. Trumpeters and percussionists led the processions when emperors returned home in military triumph or when performers marched into the arena. Pipers and trumpeters played dirges for funerals. The wealthy sponsored indoor concerts, and the commoners sang and played for their own pleasure. On the stage, music was an essential part of Roman comedy, both in the plays themselves and during the interludes between acts. Such music probably deteriorated in quality as the plays became increasingly vulgar and obscene. Finally, music was a part of religious ritual, especially in the rites of the Eastern mystery cults that became highly popular in the days of the Empire.

How good any of this music was, we have no way of knowing. None of it was written down in any system of notation that has come down to us—not so much as a Delphic hymn. There is no reason to assume that the best of it, at least, was much inferior to the traditionally great music of classical Greece.

ARCHITECTURE

Thousands of buildings in Europe and America, as we have said—capitols and courthouses, for example—echo the traditions of Greece. They also echo those of

Rome; and many others, especially churches, owe more to Rome than to Greece. Both traditions reached us, not directly but largely through their impact on intervening eras such as the early Christian, the Romanesque and the Renaissance.

Roman Temples. The Romans borrowed from the Greeks a rather rare temple form called a *tholos*, a circular building. The most famous Greek tholos is at Delphi. The Romans enlarged the tholos and ornamented it in the Corinthian order. One beautiful example is the Circular Temple by the Tiber, in Rome. It consists of a round cella surrounded by a circle of columns—tall, elegant ones with ornate capitals (fig. 4-1). More common were small Roman temples that housed statues of the gods and of famous generals. Sometimes, like Greek temples, they were used as public treasuries. One of these, in a good state of preservation, is at Vienne, in France. Another, even better preserved, is the famous Maison Carrée at Nîmes, in southern France (fig. 4-2). Thomas

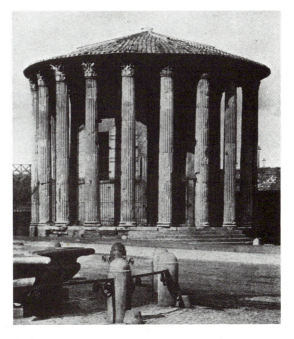

Fig. 4–1. Circular Temple by the Tiber. 1st century B.C. Rome.

Fig. 4–2. Maison Carrée. Roman temple, 16 B.C. Nîmes, France.

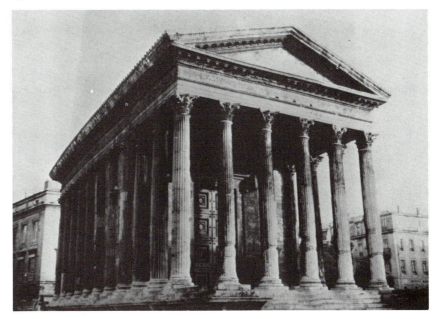

Jefferson wrote in his journal that the Maison Carrée was the most beautiful thing he saw in his travels in Europe. As exquisitely proportioned as the best Greek temples, it shows again the Roman preference for the Corinthian order.

Many Roman builders employed the Greek orders largely for decorative purposes. They ornamented solid walls with half-circular *engaged columns*, and they also developed the *pilaster*, which amounts to half of a square column, attached to the wall and capped with a capital, usually Corinthian. Ordinarily neither the engaged column nor the pilaster serves any structural purpose—that is, it does not support or bear weight.

The Roman Theater. Roman theaters, of which there were hundreds, were also a carry-over from Greek traditions, with two significant modifications: the *skene* or backdrop became very high and elaborate, and the orchestra was reduced from a circle to a semicircle. Most of the theaters from antiquity that one can see in Europe today are in the Roman style. The theaters at Arles in southern France and at Ephesus in Asia Minor are typical.

Other Structures: the Arch. The impression one gets in looking at Greek architecture is that of verticals and horizontals or near-horizontals in balanced tension—trabeated construction. But Roman architecture in its most original forms is quite different: the effect depends on mass, and imposed on the horizontals and verticals are the rhythms set up by the round arch (the arcuated form). Many Roman buildings are aesthetically satisfying, but on their own terms—not perfect balance and pure harmony but strength, vigorous rhythms, and often the sheer impact of size.

Roman life called for big structures—circuses, amphitheaters, aqueducts, forums, baths—and these were feasible because of developments in both materials and methods. The Romans used wood, stone, and brick, but they also employed great amounts of an excellent concrete, sometimes in huge structures such as the Colosseum. As for methods, the most important development was the arch. The Romans did not invent it—they probably borrowed it from the Etruscans—but they were the first to realize its possibilities. In post-and-lintel construction the *thrust* or pressure of weight is downward. The length of the span between the posts is limited to the tensile strength of the material itself. But an arch can be wider than the tensile strength alone would permit, since the thrust is lateral rather than straight down. The round arch made possible the spanning of large areas; an eighty-foot span was not at all uncommon in Roman times.

Fig. 4-3 shows several main types of arches. In (a) we have a round arch. This is usually a semicircle made up of wedge-shaped blocks called *voussoirs;* the top one, sometimes larger than the others, is the *keystone.* There are a number of variations of the round arch—some flatter, some higher, some shaped like horseshoes. The second drawing (b) shows a pointed arch, which is made by the intersecting of two arcs. A pointed arch can be very high, because the thrust is in a more nearly horizontal direction than with the round arch. The pointed arch was to become one of the distinguishing features of the Gothic style, a thousand years after the Roman era, but the Romans themselves used it on occasion.

Arches were constructed over a temporary wooden framework called a *centering.* When a series of arches was being built, as in an aqueduct, the centering could be removed intact and moved along for further use. The weight of the rounded Roman arch, plus whatever it supports, exerts considerable pressure on the wall or columns that it rests on. For this reason supporting walls were often made very heavy.

A dome is simply a round arch extended through 360 degrees. The Romans learned how to erect domes, though they never found out how to put a dome on a

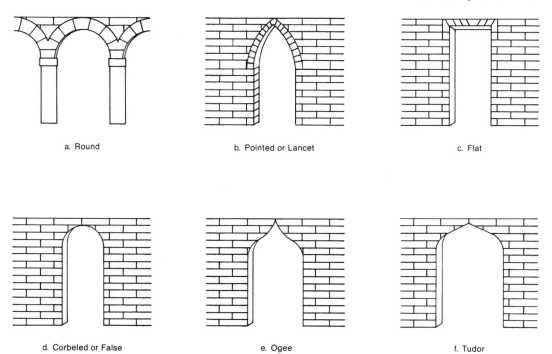

a. Round

b. Pointed or Lancet

c. Flat

d. Corbeled or False

e. Ogee

f. Tudor

Fig. 4–3. Common types of arches.

square. Some of Rome's most impressive buildings were capped with domes.

A typical excavated railroad tunnel has the shape of an extended arch, with the thrust absorbed by the earth itself. When the principle of the extended arch is applied to building, we have the *tunnel* or *barrel vault* (fig. 4-4A). (The term *vault* or *vaulting* applies to arched masonry that forms the ceiling of a building.) This kind of vaulting made possible very large enclosures, but because the walls were so heavy, it was hard to get much light inside. The Romans, however, developed a technique of crossing or intersecting two barrel vaults, creating a structural element called *groined vaulting* (fig. 4-4B). Here the weight of the vaulting was borne by heavy piers at the four corners. The walls themselves, now simply curtains of masonry, could be pierced with windows. This method of construction was to have far-reaching consequences.

These developments—the arch, the dome, and the groined vault—find expression in many extant works of Roman architecture, including the following:

1. ***The Pont du Gard.*** *Arcades,* extended series of arches, have long served both useful and aesthetic purposes, from the aqueducts of the Roman Empire (at Spoleto, and Caesarea in Israel, for example) to the arcades on college campuses such as those at Stanford and Virginia. There is probably no finer example of such uses of the arch than the Pont du Gard, between Nîmes and Arles in France (fig. 4-5). It was built by the Romans early in the first century after Christ, to serve both as a bridge (a road runs along one side of the second row of arches) and an aqueduct

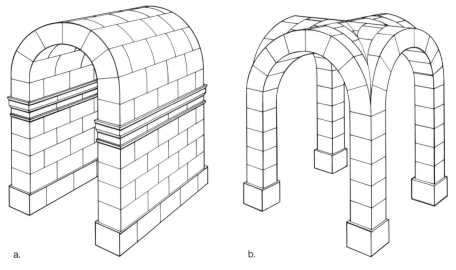

Fig. 4–4. A. Barrel or tunnel vault. B. Cross or groined vault.

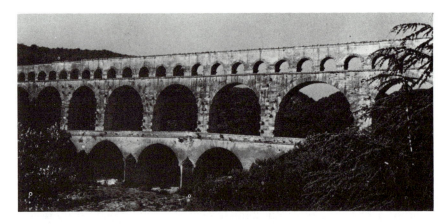

Fig. 4–5. Pont du Gard, near Nîmes, France. 1st century B.C.

to carry culinary water across the Gard River.

2. ***The Pantheon*** (*built A.D. 120–130*). Built in what was then a large plaza, the Pantheon (fig. 4-6) is now almost touched by some of the buildings that shoulder each other in crowded modern Rome. Its exterior surface was once covered with polished marble,

and the high pediment above its entrance (typical of Roman pediments) was filled with statuary; this disappeared long ago. But it is still impressive, particularly in the vast solemnity of its interior (fig. 4-7). Here one sees the inside surface of a heavy circular wall or drum, twenty feet thick, which rises to a height of seventy feet. Then begins the upward and in-

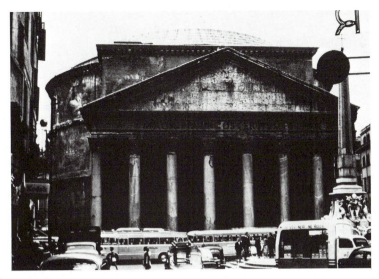

Fig. 4–6. The Pantheon, Rome. A.D. 118–25.

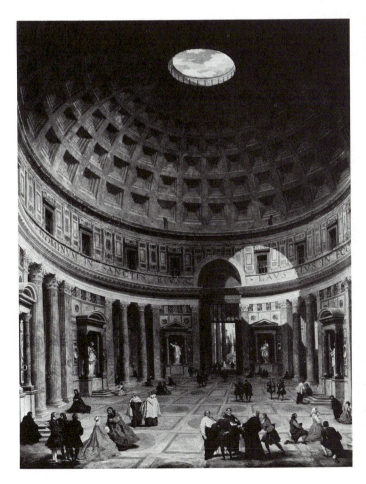

Fig. 4–7. Giovanni Pannini. *Interior of the Pantheon* (painting, about 1750). National Gallery of Art, Washington, D.C. Samuel H. Kress Collection.

ward curve of the hemispheric dome that crowns the structure. The interior height of the building is about 142 feet, which—probably not by coincidence—is also its diameter at the base. The source of light in the temple is a great circular opening (*oculus* or *eye*) at the very top, so arranged that its light focused at various times of the day on some of the statues of deities (the name "Pantheon" means "all gods") that occupied niches in the wall. The inner surface of the dome is enlivened by a pattern of recesses called *coffers*.

3. *The Colosseum.* Probably no people ever had a greater craving for entertainment than did the Romans. This craving, which expressed itself both in harmless pastimes and in some of the most brutal sports ever conceived, called forth the erection of many places of amusement all over the Empire, especially theaters, amphitheaters or arenas, circuses, and baths. Most famous of these is the Colosseum, model for football stadiums, bullfighting rings and other sports arenas (fig. 4-8). The Colosseum, named after a colossal column nearby that carried a statue of Nero, was built about A.D. 80 to provide for the entertainment of up to 60,000 spectators. They sat on marble seats in three sections according to social status. The central oval was a big stage in which even miniature naval battles took place. The understructure of the seating areas was an architectural feat—a complex of supporting arches, with numerous passageways for movement of traffic. Concrete, brick, and stone were the basic structural materials. They were faced with a veneer of polished marble that was later removed, over the

Fig. 4–8. The Colosseum, Rome. A.D. 70–82.

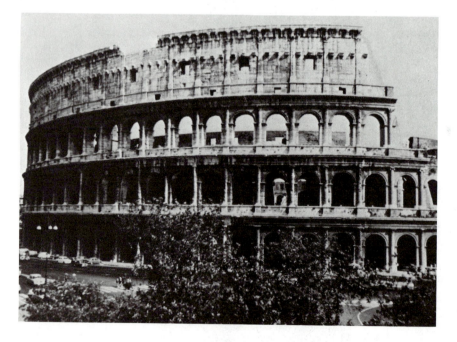

centuries, for other building and for burning in lime kilns. The exterior of the Colosseum originally rose in three levels of arches, the masonry between which was ornamented with engaged columns (Doric, Ionic, and Corinthian, from the bottom up). Later a fourth story was added, in solid masonry with Corinthian pilasters.

Remains of about seventy other Roman amphitheaters survive. Three of the finest of these, all in better condition than the Colosseum, are at Arles and Nîmes in France and at Verona in Italy.

4. *The Baths of Caracalla.* Another favorite center for public entertainment was the bath—which was much more than its name implies. In addition to bathing pools of various temperatures and many small chambers for sweat baths and the like, the larger baths provided game rooms, libraries, lecture rooms, and other areas where the Roman with leisure time could spend many pleasant hours. The most famous bath was the great complex of structures begun by the emperor Caracalla in A.D. 212. Its nucleus and most interesting architectural feature was a large central hall in which the groined vault was used as a ceiling (fig. 4-9). This ceiling, of solid masonry, was supported by huge piers, over five feet in diameter, spaced along the sides. Other Roman *thermae* or baths built near hot springs, such as Baden Baden in Germany and Bath in England, are well-known tourist attractions.

5. *The Arch of Constantine.* A native Roman art form was the triumphal arch. Originally a temporary wooden structure under which victorious warriors passed in a kind of purification rite, it evolved into great stone structures that became the focal points of "triumphs." These were

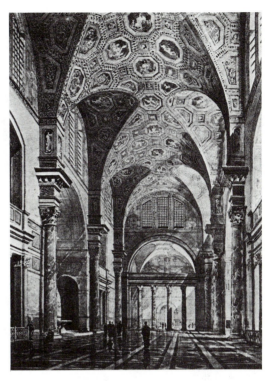

Fig. 4–9. Tepidarium, Baths of Caracalla, Rome. About A.D. 215. (Reconstruction drawing).

processions that, in Republican Rome, honored victorious generals on their return home. In the days of the Empire, only the emperor and those generals who were his relatives were so honored.

A simple, well-proportioned triumphal arch built in Rome by Titus remains in good condition. Another, not far from the Colosseum, honored the emperor Constantine (fig. 4-10). Like triumphal arches in general, it combines the Roman arch with Greek elements—Corinthian columns and a considerable amount of relief and other sculpture, some of it borrowed from other monuments and some in a curious, stubby-figured style that seems to revert to a primitive era.

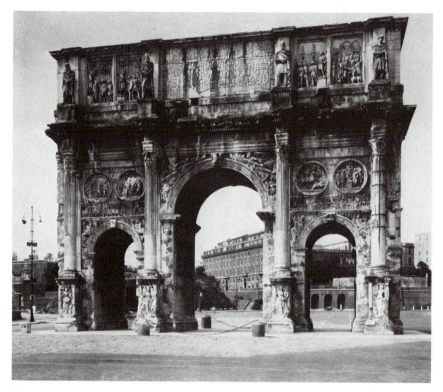

Fig. 4–10. Arch of Constantine, Rome. A.D. 312–15.

Cities, Forums, Dwellings. A historian has said that Rome gave to history one major art form, the capital city. Earlier nations had their great cities, but none on as grand a scale as Rome. As foreigners walked through that city, especially in its heyday as capital of the Empire, they must have been almost overwhelmed by view after view of grand marble temples, basilicas, arches, and other structures crowning the hills and surrounding the squares. All of this, of course, reflected centuries of construction. Emperors strove to outdo their predecessors by adding new and greater monuments in stone.

And while Rome was growing, other towns and cities were springing up throughout the broad reaches of the Empire. Some were laid out according to preconceived design. The concept of city planning that developed in the Hellenistic era moved forward with vigor in imperial Rome. Usually employing the forum as the focal point, planners made careful use of natural terrain in placing streets and buildings to greatest advantage.

The forum was the heart of the Roman city. Originally a marketplace, it became the center of political and social life. Courthouses and other public buildings gradually crowded out the fish, meat, and vegetable markets. Rome's most famous forum was the Forum Romanorum, in use before the establishment of the Republic in 509 B.C. and gradually augmented with temples, government buildings, and other public edifices. Julius Caesar and several emperors, especially Trajan, added their own forums to

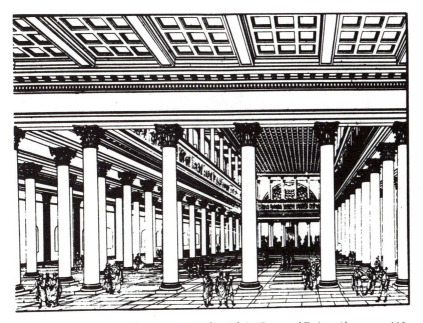

Fig. 4–11. Apollodorus of Damascus. Basilica Ulpia, Forum of Trajan. About A.D. 112. (Reconstruction drawing).

the complex of plazas and structures. The Forum of Trajan was the largest and most elaborate of these additional forums. In it were incorporated a large open court or *atrium*, with market booths on each side; two libraries; a temple modeled after the Maison Carrée in France; and a great rectangular basilica or hall, its roof supported by dozens of Corinthian columns (fig. 4-11). Of this nothing remains except some shattered ruins and a high commemorative pillar, the Column of Trajan.

As a whole, the dwellings of ancient Rome, like those of Greece, were inferior by our standards. The simple houses of the poor became increasingly miserable as the population grew and dwellings were crowded along narrow streets. Tenement districts came into existence, with multi-storied apartment houses not greatly different from those in modern cities. But the homes of the wealthy were luxurious. The upper classes had their private dwellings in the city and often their villas in the country.

City dwellings of the well-to-do were sometimes duplexes of one or two stories, sometimes luxurious mansions in a style called the *domus*. In this style the home was built around a large court (the *atrium*), with a shallow pool in the center.

Imperial palaces carried the concept of size and luxury to its ultimate extreme. One of the largest of these was the palace of Diocletian, in Spalato (present-day Split, Yugoslavia). Another was Hadrian's Villa, the ruins of which occupy hundreds of acres near Tivoli, east of Rome.

SCULPTURE

Pieces of statuary in almost incredible numbers occupied prominent positions in Rome and other parts of the Empire. They could be seen in plazas, on monuments and arches, in temples, baths, and forums, and in the homes of the wealthy. How good their overall quality was, we can only speculate. Many

of them, especially in the days of the Republic and the early Empire, were copies of Hellenic and Hellenistic works. We have no piece of authentic Roman sculpture that can be dated earlier than the first century before Christ.

Portrait Sculpture. Fairly early in their history, Romans adopted the practice of having death masks of their relatives made. These were probably treasured for their naturalness, and no attempt was made to minimize wrinkles, bulbous noses, and other less attractive features. This tradition, with some modifications, carried over into portrait sculpture. Many Roman busts are striking likenesses of real people, not idealized or intellectualized, and to that extent at least they are successful portraits. Some of the best give clear indications of character. The portrait bust of Caracalla, for instance, suggests the cruelty of that murderous monarch (fig. 4-12).

Though identifiable likenesses were desired in portrait sculpture, that fact did not prevent some rulers and others from insisting that they at least look their best; after all, some of them were officially considered deities, and they could expect a bit of idealization. Thus Julius Caesar, though bald, was generally depicted with a good head of hair. Augustus, while he is recognizable in the hundreds of statues of him that were made, was given the physique and bearing of a demigod. It is not surprising that portrait busts of aristocratic ladies were often glamorized. Some of them even had removable marble wigs, so that coiffures could keep pace with changing fashions.

A type of portrait sculpture that was to retain its popularity throughout the centuries was the equestrian statue. A famous example is the bronze statue of Marcus Aurelius on the Piazza del Campidoglio in Rome (figs. 4-13 and 9-2). The emperor is shown astride a fine, spirited horse. The energy of the animal contrasts oddly with the benevolently outstretched hands and contemplative, almost sad face of the Stoic philosopher. The fact that it was once thought to depict Constantine, the first Christian emperor, saved it from being smashed by the Christians, who destroyed many such pagan works.

Fig. 4–12. Portrait bust of Caracalla. About A.D. 215. Capitoline Museum, Rome.

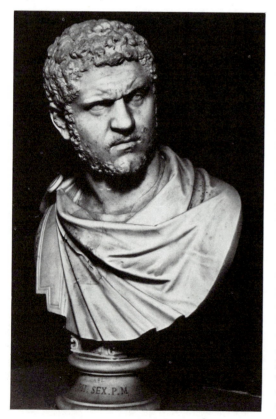

Relief Sculpture. Because of its narrative value, relief sculpture appeared in many places, such as on altars and shrines, on triumphal arches, and on sarcophagi or tombs. Some of it strongly reflected Hellenistic tendencies—for instance, in the use of rounded, almost freestanding forms. But since Roman reliefs were meant to be pictures in stone, their sculptors developed new illusionistic techniques to create a feeling of depth—figures in receding planes, with some of them

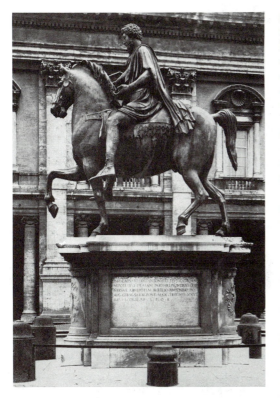

fading into the background. Generally there is less vigor and intensity in Roman than in Hellenistic relief. The detail from a sarcophagus shown in fig. 4-14 is typical: a crowded group of figures, all competently carved but basically static even in a battle scene. The same is less true of the columns of Trajan and Marcus Aurelius (fig. 4-15). Here the exploits of the emperors and their troops are narrated in continuous, "comic strip" fashion in spiral bands winding more than five hundred feet to the tops of the columns. The sculptors, here using low relief and few illusionistic devices, created consistently vigorous, often dramatic narrative effects.

One of Rome's finest monuments is the *Ara Pacis* or Altar of Peace, built in honor of Augustus after he had "pacified" certain enemies in the west. A panel from the altar is shown in fig. 4-16. The central figure is Tellus, Mother Earth; the other two personify water and air; and the animal and vegetable life around them represents the abundance of the earth. The serene figures are harmoniously balanced, and the carving is exquisitely done. The draperies billowing rhythmically over the two side figures were copied by many later artists.

Fig. 4–13. Equestrian statue of Marcus Aurelius. About A.D. 165. Bronze. Capitoline Hill, Rome.

Fig. 4–14. *Battle of Romans and Barbarians.* Marble sarcophagus relief. National Museum, Rome.

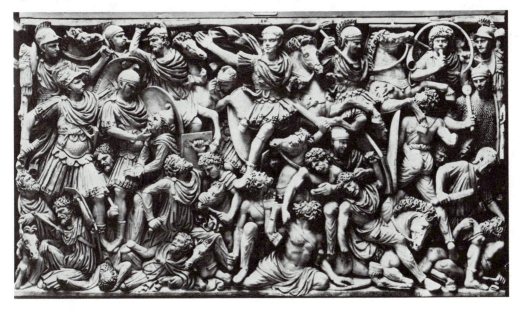

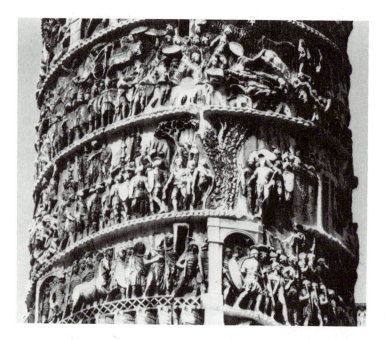

Column of Marcus Aurelius (detail). About A.D. 165. Rome.

Fig. 4–16. *Tellus Relief.* Panel from the Ara Pacis Augustae, Rome (Marble altar, 13–9 B.C.).

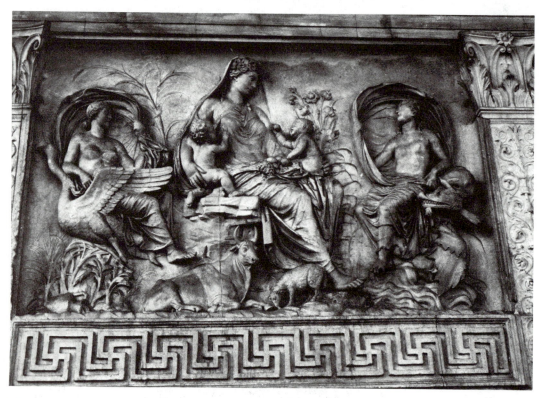

PAINTING AND RELATED ARTS

Mosaic, developed during the Hellenistic era, continued to be a popular form of painting in the Roman world. Excavators have uncovered countless examples of mosaic in such Roman or Romanized places as Delos, Corinth, Verona, and Pompeii, where they served as floors or as wall decorations. Many were in geometrical patterns. Others were representational; fig. 4-17 shows the use of mosaic to depict a country scene. Still others combined representation with abstraction, as in the Dolphin Mosaic at Delos (fig. 4-18). Here leaping dolphins and stylized waves combine to form a delightful pattern.

The greatest treasure house of mosaic in the Roman period is at Pompeii. The catastrophe that destroyed that small city left intact many walls and floors decorated with works of art that have been uncovered in the past two centuries. Most famous is the huge mosaic now in Naples that depicts the *Battle of Issus*, in which Alexander defeated Darius (Ch. 3).

Many walls in Pompeii and other Roman communities were adorned with paintings in fresco. Like most of the art we have mentioned, fresco was practiced in Rome and her provinces by Greek or Greek-trained artists. Even the more modest homes in Pompeii and other Roman cities had their wall paintings. The larger homes were virtual art galleries in which landscapes, human figures, floral designs, and architectural objects such as columns were depicted.

Fig. 4–17. Pastoral scene. Roman mosaic. Museum, Corinth.

Fig. 4–18. Dolphins. Detail of floor mosaic. Delos, Greek Isles.

Some of them show that their creators were aware of modeling, foreshortening, perspective, and other devices that create an illusion of depth. Fig. 4-19, a Roman painting now in the Metropolitan Museum in New York, demonstrates techniques that were not to be revived to any significant degree until the Renaissance.

As for portrait paintings, the best ones remaining from the period were painted in Egypt while that country was under Roman rule. They were done on wood panels (ordinarily the covers of caskets) in encaustic, a technique in which melted wax was used as the vehicle (Ch. 3). Their subjects are usually depicted with slightly turned heads and with large, gentle eyes. A famous example is the portrait of a boy shown in fig. 4-20. This small painting, with its modeled cheeks, patrician nose and mouth, and softly luminous eyes, looks at us with an appeal that eighteen passing centuries have not diminished.

Fig. 4–20. *Portrait of a Boy.* Egypto-Roman painting, 2nd century A.D. Encaustic on wood, 13 × 7¼″. The Metropolitan Museum of Art, New York. Gift of Edward S. Harkness, 1917–18.

Fig. 4–19. *Lady Playing the Cithera.* Wall painting from a villa at Boscoreale. 1st century B.C. The Metropolitan Museum of Art, New York.

5 THE EARLY MIDDLE AGES: CHRISTIANITY AND THE ARTS

Though the Middle Ages are closer to us in time than are ancient Greece and Rome, probably most of us feel more at home with classical than with medieval art and culture. Leaving aside modern abstract art, most of us prefer art whose traditions we have come to accept as "real"—art that looks natural to us. And whatever our religious affiliations, most of us lean toward the secular in art and are often unfamiliar with the religious attitudes expressed in the arts of the Middle Ages.

It is true, however, that specialists find in the art of the Middle Ages a symbolic richness and spiritual intensity that outbalance the "realism" and the more immediate appeal of the arts of other ages. Nineteenth-century critics such as Carlyle and Ruskin considered the Middle Ages the greatest of all historical periods. And in this century the American Henry Adams and the Dutch historian Huizinga have called the Renaissance simply the "twilight" or the "waning" of the Middle Ages.

In this chapter and the two that follow we will be concerned with the arts of the thousand-year period that historians since the seventeenth century have called the Middle Ages. There is much disagreement as to the beginning and ending dates of the period, but it can probably best be thought of as extending from the end of the Roman Empire to the beginning of the Renaissance. The dates 476 (the last Roman emperor) to 1453 (the fall of Constantinople) are often used as beginning and ending points, but strong manifestations of the Renaissance spirit can be clearly seen at least one hundred years before the latter date.

The Middle Ages can be divided into two main periods: the early Middle Ages, from the fall of the Empire to about 1000; and the later Middle Ages, from 1000 to the Renaissance.

THE EARLY MIDDLE AGES

The most significant development in the early Middle Ages was the rise and spread of Christianity. (Equally important for parts of eastern Europe, as well as much of Asia and north Africa, was the rise of Islam.) In spite of harassment and sporadic persecution, there were many thousands of Christians

throughout the Empire when Constantine, in 313, declared official toleration of the sect. Before the end of the fourth century, the emperor Theodosius made Christianity the official religion of the Empire and began persecuting the pagans. The spread of Christianity continued, until by the end of the early Middle Ages virtually all of the European continent was nominally Christian.

Shortly after the conversion of Constantine to Christianity, in what was to prove one of the most momentous actions in history, he moved the seat of government from Rome to the East: in 330, the then-small city of Byzantium, on the beautiful harbor called the Golden Horn near the Bosporus and the Black Sea, was renamed *Constantinople* and dedicated as the capital of the Empire. Ties between the eastern or Byzantine and western or Rome-centered sectors of the Empire began to weaken almost immediately. Though Constantinople exercised control over parts of the West, by the seventh century the two halves of what had been the Empire were largely independent of each other. By the time Charlemagne was crowned emperor of the West in 800, the Western empire had effectively become a separate political entity. A similar division occurred in the Church. In 451, when the Roman patriarch Leo the Great announced that he was a direct successor to Peter and hence entitled to the office of pope, the Eastern sector refused to recognize him. The gap widened. Significant differences in doctrine and ritual developed, and in 1054 the Byzantine or Greek Orthodox church became a separate entity. Weakening of political and ecclesiastical ties led naturally to marked differences in culture and art.

The West

The fifth century saw the most devastating events in the downfall of Rome—the sacking of the great city by barbarian armies from the north and east, first the Visigoths (410) and then the Vandals (455). In 476 the last of the Western emperors, Romulus Augustulus, was deposed by Odoacer, chieftain of the Heruli, a people allied to the Goths. Centralized administration of the widespread Empire ended. Germanic and other tribes, by invasion and mass migration, occupied large parts of what had been Roman territory. The invaders (themselves less primitive and more culturally advanced than was long supposed) often admired and emulated Roman ways; but partitionings and civil wars continued to weaken the fabric of western Europe. Roads deteriorated, communication dwindled, and secular learning largely disappeared. Historians argue about the term *Dark Ages*, once commonly applied to the second half of the first millenium; but there is little doubt that a pall, figuratively speaking, hung over western Europe for several centuries.

Moslem invasion compounded the problems of southern Europe. In the eighth century Saracens established themselves in Spain and pressed north into France. Their defeat by Charles Martel at Poitiers in 732 pushed them back beyond the Pyrenees into the Iberian peninsula, where they exerted a powerful influence on the arts and culture of Spain and Portugal.

Western Europe had its periods of relative stability and cultural advancement in the early Middle Ages. Most important was the advance in civilization stimulated by Charles Martel's grandson Charlemagne. Before he was crowned Emperor of the West by the pope in 800, the great Frankish king had established his capital in Aix-la-Chapelle (now Aachen). Here he brought such men of learning as Alcuin, a famous English scholar, and began a cultural, artistic, and educational movement that is called the Carolingian Renaissance. The movement he fostered pointed clearly toward the great upswing that was soon to follow in the culture and civilization of the West.

The true stabilizing force of the period was the Christian church. One striking indication of its effectiveness as a great mission-

ary and evangelical force lay in the rapidity with which pagan and barbarian tribes throughout Europe adopted one form or another of the faith. The vacuum left by weakened political leadership was at least partially filled by the papacy and other church leaders. Church and state remained essentially separate—their power struggle was to develop later—but even the stronger kings such as Charlemagne found it wise to cultivate the favor of the pope.

Most important in the long run, the church won its way into the lives and hearts of ordinary people. In innumerable ways, material as well as spiritual and cultural, the church entered into the lives of common men and women. To most of them, illiterate as they were, the doctrine and developing liturgical formulas of Catholicism must have been hazy concepts at best. But what they could not comprehend intellectually they doubtless absorbed in part, at least, emotionally. As the centuries passed, the traditional symbolism and ceremonies of the church, the familiar stories from the Bible and those about saints and martyrs, all became intimate parts of the lives of rich and poor alike. They were accessible not through words alone but through song, the symbolism of architecture, and (especially in the later Middle Ages) painting, sculpture, and drama. The ritual of worship provided for the members of the Western church a degree of congregational participation that was unknown in the East.

The literature and other arts of Christianity were preserved and nourished by two groups whose lives were dedicated to the church: the *secular* clergy—the clerics, who could read and write and who were to provide the professional leadership of the church; and the *regular* clergy—the monks, who lived cloistered lives dedicated to learning and the service of the church. Sometimes at odds with each other, these groups helped to preserve remnants of Latin culture and to establish the patterns of Christian civilization.

The East (the Byzantine Empire)

Byzantium was little more than a village when Constantine recognized its potential as a seat of government. As Constantinople it grew rapidly; by the tenth century it had over one million inhabitants. In spite of conflicts with Persians, Arabs, Turks, Egyptians, and Christian crusaders, it was to remain a stronghold of Christian civilization and culture—for western Christians a remote, romantic, semioriental stronghold—for eleven hundred years.

Most famous of Byzantine rulers was Justinian, a commoner who became emperor in 527 and ruled for thirty-eight years with his equally celebrated wife Theodora. Formerly an entertainer and courtesan, Theodora became as strong an advocate of strict civic and personal morality as her austere husband. During their reign Constantinople reached a high level of economic and cultural development. The city experienced one of the several brilliant periods of growth that were to make it for some centuries the most magnificent capital in the Western world, with public squares, palaces, and dazzling domed churches that rivaled the Rome of the second century. Justinian promoted the codification of Roman law; under his sponsorship the famous legal compilation *Corpus Juris* was made. His influence was felt in the West more strongly than that of any other emperor. His general Belisarius was conqueror of Ravenna, a temporary capital of the Western empire and the site of great monuments of Christian architecture that were built both before and during Justinian's time.

Circumstances brought together in Constantinople some of the strongest elements of Greek, Latin, and Christian culture. Latin was the official tongue of the Eastern Empire in early times, but it was soon replaced by Greek, which became both the vernacular and the literary language. The Eastern empire, far more than the Western, valued education and treasured its Greco-Roman

heritage. We can thank the Byzantines for preserving many of the great classics of Greek literature, most of which re-entered the stream of Western culture only after the fall of Constantinople in 1453.

The concept of a separation of church and state had no place in Constantinople. Justinian and his successors promoted *caesaro-papism*—the belief that the emperor, however he might have gained office, was semidivine. He was also the chief priest, with near-absolute powers in both realms. An aura of mystery, of the supernatural, attached itself to the emperor-priest, as it did to other aspects of Byzantine religious tradition.

LITERATURE

As Roman civilization declined, literary production naturally diminished both in quantity and in quality. But during the early Middle Ages, an amount of literature both religious and secular was produced that was quite remarkable considering the circumstances. Much of what remains is of little interest, but a handful of masterpieces from the period remain literary treasures.

Literature in Latin: Fathers and Philosophers. As early as the second and third centuries after Christ, when Christianity was still under a cloud, a group of writers who were able interpreters and defenders of the faith began to emerge in northern Africa. They included Lactantius and Tertullian. These and other intellectual leaders among the early Christians, most of them administrators as well as writers and preachers, were called the *Fathers*. Others who were to follow were such figures as Augustine, Gregory, and Ambrose. The latter two, Gregory and Ambrose, made their impression on the arts both in their writing and in their fostering of church music. Augustine, powerfully influential in consolidating the position of the church during the fourth and fifth centuries, was a highly gifted and original writ-

er. His two principal works were *The City of God* and his *Confessions,* one of the world's great autobiographies.

Augustine was born in 354 in north Africa to a devout Christian mother and a pagan father. Early in life he began a career as a teacher of rhetoric that took him to the major cities of Africa and Italy. He underwent a series of often unadmirable experiences and several shifts in religious philosophy before being converted to Christianity as he was approaching his middle years. All this he recounts in his *Confessions.* Addressing his confession to God in language that often rises to poetic intensity, Augustine tells of his infancy, of his idleness as a young student and his early dislike for learning, and of his boyhood escapades, such as robbing a pear tree. He relates his youthful experiences in Carthage, "a cauldron of illicit love," and he confesses with shame his early passion for plays. He tells about his mother Monica's anxieties concerning him, of his taking a mistress, and of his later soul-searchings—in short, of the often painful journey that brought him to his intellectual and spiritual home in the Church.

The most momentous literary events of the early Christian era were the composing of the books of the New Testament and the translation and compilation of them, along with the Old Testament, into a single volume in the Latin language. Most responsible for this Vulgate (popular or common) Bible was another church Father, Jerome (see fig. 9-30), a gifted scholar and one of the founders of monasticism. He completed his monumental work in the early years of the fifth century; and it was at this time that the Bible, with all of its implications for the spiritual, intellectual, and artistic life of the world, may be said to have entered the stream of Western culture.

Non-Latin Literature. The greatest piece of early medieval literature in a vernacular, non-Latin tongue is the Old English epic *Beowulf.* It was written in the eighth century by a gifted and well-read cleric whose

name we do not know. Probably modeling his poem to an extent on Vergil's *Aeneid*, he chooses a hero from a remote past and a distant land, one traditionally associated with the poet's nation, as Troy was associated with Rome. As the *Aeneid* is based on ancient Roman legend, so *Beowulf* uses folk tales from western Europe (of which there were hundreds) for its plot material. In the first half of the epic the young hero Beowulf, mild-tempered but a mighty warrior, cleanses the Danish king's mead-hall by wrestling and killing the monster Grendel, a troll that has long haunted the hall. He then slays Grendel's mother, a water-hag who tries to avenge her son's death. In the second part of the epic Beowulf, now a wise old king, goes out to defend his kingdom from the ravages of a fire-breathing dragon. He slays the monster but falls in the fight. The two parts of the work, comparing the heroic life in youth and in old age, are effectively balanced. The picture it gives us of a heathen but honor-bound society, with Beowulf as its high-minded hero, is deeply revealing of the outlook and the imagination of the eighth century.

MUSIC

The first Christians were of course drawn from the Jewish communities of Palestine. As they worshipped together they incorporated into their services the singing of hymns and psalms in the tradition of the temple and the synagogue. As Christianity spread, the musical practices that were to become a part of Christian worship gradually developed. These included (1) the singing of psalms to simple melodies, often with the leader intoning the main line and the congregation inserting short repeated passages called *versicles;* (2) the use of hymns based on free paraphrases of texts from the Bible; (3) solo singing or chanting of more difficult and ornate melodies, often using simply the word *Alleluia* as the text; and (4) *antiphonal* singing—a kind of choral singing in which two choruses chanted alternately. All of this music, like that of the early Middle Ages in general, was *monodic*—that is, sung by a solo voice or by voices in unison, with no harmonizing parts. There was no instrumental accompaniment; many early Christians felt that instrumental music was pagan or barbaric.

In the fourth century, after Christianity had become the official religion of the Empire, worship services moved from private homes and catacombs to basilicas or churches built for the purpose. The powerful Bishop Ambrose of Milan now encouraged the practice of hymn singing as a basic part of the expanded worship service or liturgy. He may have composed hymns himself. In any event, Milan was one of the centers where the ritual of western Catholicism, including its use of music, took shape.

Another center was Rome. Here Pope Gregory (590–604), one of the ablest of early church Fathers, contributed much to the development of music—as a sponsor and codifier, if not as a composer. So strong was his influence that most of the church music of the early Middle Ages is called *Gregorian chant.* Another name for it is *plainsong,* from the fact that it *is* plain, without harmonic embellishment, and from the further fact that its rhythms are free, in contrast to the measured music that we are more familiar with.

Gregorian chant is essentially diatonic: its melodies are composed in scales or *modes* based on varying sequences of whole and half tones. Putting it in modern terms and oversimplifying somewhat: if we use only the white keys of the piano and play each note from D, say, to the D an octave above, we are in one possible scale or mode in which a melody may be composed; if we go from E to E we are in another, and so on. Early liturgists recognized eight different modes.

Chant melodies, as we have said, were simple. Usually they were limited in range to an octave or less, and usually they moved stepwise up and down the scale.

As liturgical practices became fixed,

congregations participated less in the actual celebration of the worship service; this was especially true in the Eastern Orthodox church. Singing was now performed primarily by solo voices and by choirs. Three types of chants developed as a consequence: (1) The simpler ones, sung by a choir, tended to have a single note for each syllable of the text; these are called *syllabic*. (2) The more elaborate ones, for solo voices, had numerous flourishes and often many notes sung on one syllable—the *melismatic* type. And (3) somewhere between these were chants in which two or three notes were sung to one syllable; these are called *neumatic*. All three of these forms appear in modern music as well.

The daily musical requirements of the Roman liturgy were—and are—considerable. They include the Mass, which is the central rite of the church, and a number of separate *hour* services—matin, lauds, prime, terce, and so forth. The hour services make extensive use of psalms set to music—plainsong in the early centuries, more elaborate forms in later times. In a sung Mass, some parts are chanted in solo at the altar with choral response, some are read, and some are sung as hymns by the choir. Elaborate musical settings of the Mass have been made by many composers from medieval times to the present. The Mass has a number of sections but is divided into two main kinds, the *proper* and the *ordinary*. The proper varies according to the occasion being celebrated such as Christmas or Easter. The ordinary is invariable and consists of five sections: Kyrie eleison (Lord, have mercy); Gloria in excelsis (Glory to God in the Highest); Credo (Creed); Sanctus (Holy, Holy, Holy); and Agnus Dei (Lamb of God).

The modern system of writing down music evolved in a roundabout way from a method of pitch notation that developed in the eighth century or earlier. As a means simply of prompting their memories, singers used symbols known as *neumes*, originally slant lines more or less like accent marks over syllables to indicate an upward or downward movement of the melody. Later, as the neumes were written in a more cursive style, they came to look much like shorthand notes. The system was far from perfect—musicologists are still uncertain whether given neumes indicate pitch intervals or rhythm signals or both—and the linear method that began to develop in the eleventh century was a great step forward.

The seventh and eighth centuries were the great era of plainsong. As music became more sophisticated and as methods of setting it down in writing were developed, plainsong suffered decay. By the eleventh century it was losing its identity. Many of its simple, often hauntingly beautiful melodies, however, lived on and were used both in secular song and in the polyphonic music of the later Middle Ages, and have even been used in modern compositions.

ARCHITECTURE

The homes of common men and women in the early Middle Ages, whether in city or village, probably provided even less comfort or pleasure for the eye than had those of Greece or Rome. Except for Constantinople and a few other large centers, even the upper classes knew little of the luxury of the Roman town house or country villa. Castle and fortress architecture, which was to develop powerful forms of its own in the later Middle Ages, was then only in its relatively primitive stages—for the most part rude structures, mostly of logs and other impermanent materials that were destroyed long ago by fire or decay.

The important architectural developments of the early Middle Ages, as one would expect, centered around the church. The first Christians met and worshipped wherever they could find safety and privacy. But as congregations grew and the ritualistic aspects of worship expanded, church buildings came into being—many of them impos-

ing and beautiful structures, of which a surprising number still exist.

Church buildings of the early Middle Ages took two main forms: the oblong or *basilica* form, found mostly in the West, and the *central* form, favored in the East. With few exceptions the church buildings of the western world, whether ancient or modern, Christian, Jewish, or Moslem, Catholic or Protestant, conform basically to one or the other—or a combination of both—of these two plans. Probably no place in the world displays these two forms to greater advantage than does the small Italian city of Ravenna.

The Architectural Treasures of Ravenna. A fortunate event in cultural history during the middle centuries of the first millennium was the erection in Ravenna, a city in northern Italy, of a number of outstanding early Christian church buildings—chapels, mausoleums, and baptistries—in both basilica and central-type form. Equally fortunate is their present state of preservation. Today they look essentially as they must have fourteen hundred years ago; even the splendid mosaics lining their walls are largely intact.

Ravenna lies in the plains area of northern Italy, a few miles from the Adriatic Sea. Now a quiet agricultural center and tourist town, it was once the capital of the Western Empire. During its most brilliant period, the fifth and sixth centuries, it came under three strong cultural influences—those of the Romans, the Christian Goths, and the Byzantines. The Roman emperor Honorius made Ravenna his capital in 402. (The tomb of his daughter, the empress Galla Placidia, is one of the architectural treasures of the city.)

After the fall of the Empire and the deposing of Romulus Augustulus in 476, his conqueror Odoacer made Ravenna his capital. Odoacer, a Christian Goth, was succeeded in 493 by the Ostrogothic king Theodoric, a ruthless but able ruler. Theodoric was a member of the Arians, a heretical Christian sect who believed that Christ was not of the same substance as the Father and hence was subordinate to him. Under Theodoric's direction the great basilica church of S. Apollinare Nuovo, originally an Arian sanctuary, was largely completed. His tomb, on the outskirts of the city, is another of its architectural showplaces.

The third influence, the Byzantine, began to assert itself when Belisarius, a brilliant general serving under the emperor Justinian, conquered Ravenna in 540. Though Justinian and his queen Theodora probably never set foot in Ravenna, they made it the seat of the Byzantine government in Italy, and they sponsored the building of such edifices as the Church of San Vitale, a central-type chapel with a fine dome and magnificent mosaics. During this period, too, was erected the second of Ravenna's great basilica churches, S. Apollinare in Classe.

The Basilica; S. Apollinare in Classe. Most churches in western Europe and America, reflecting the traditions of Roman Catholicism and Protestantism, are in the oblong or *basilica* form. Both the name and the form are derived from such public halls as the Basilica of Trajan in Rome (Ch. 4). From the fourth to the sixth centuries the basic characteristics of the Christian basilica were firmly established, especially in such Italian cities as Milan, Rome, and Ravenna. They include (in addition to those in Ravenna) San Clemente, the Basilica of St. Paul, and Santa Sabina, all in Rome.

Fig. 5-1A shows a ground plan and 5-1B a cross section of a typical early Christian basilica. Let us apply the related architectural terms to a particular building, the church of S. Apollinare in Classe.

The visitor gets an almost unobstructed view of this edifice. On approaching it one is struck by the feeling of timelessness, almost of modernity, that it conveys (fig. 5-2). The exterior, though not unattractive, is plain and unadorned. On entering the building, however, one quickly becomes aware that its builders lavished their attention on the inte-

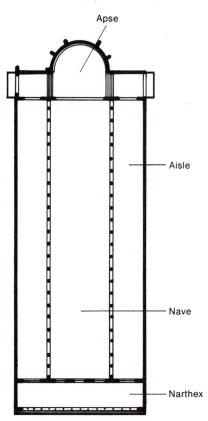

Fig. 5–1. A. Plan, Early Christian basilica church (Santa Maria Maggiore).

Apse

Aisle

Nave

Narthex

Fig. 5–1. B. Cross section, Early Christian basilica church.

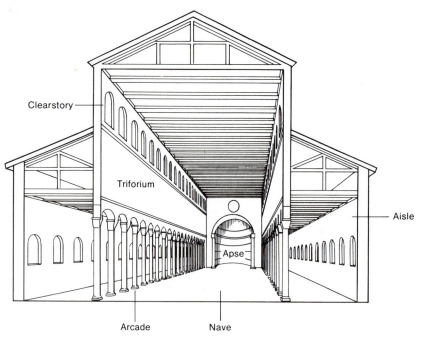

Clearstory

Triforium

Apse

Aisle

Arcade

Nave

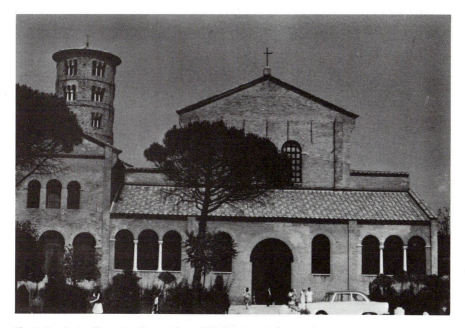

Fig. 5–2. S. Apollinare in Classe. About 530. Ravenna, Italy.

rior, which is meant to provide an inviting and visually appealing sanctuary for the worshiper. This external-internal relationship is of course the reverse of that in the Greek temple. It underscores the marked differences in personal and spiritual involvement in worship between Christian believers and their classical pagan predecessors.

The longitudinal axis or main line of vision of S. Apollinare in Classe, like that of Christian basilicas in general, runs east and west. Entering from the west, one faces in the direction of Jerusalem and the rising sun, symbol of resurrection; going into the chapel one passes first through a vestibule or *narthex* and then through one of three doorways into the basilica itself.

The first impression of the congregational hall is of spaciousness and simplicity. The form is merely that of an extended oblong box; but the proportions are balanced, the colors of tile and mosaic are harmonious, and the arcades—the rows of columns and arches—provide formal variety.

The congregational hall, the *nave* (after *navis*, a ship), is filled with light from a number of windows. Looking toward the sides, one can see the *aisles*, the spaces that are separated from the nave by the arcades. The columns of the arcades themselves are of smooth marble, topped by basket-shaped capitals that are ornamented with lacelike floral patterns.

Above the arcades one can see a space of wall, the *triforium*, which in most early basilicas is filled with paintings or mosaics. (In later basilica churches it is occupied by a second arcade.) Above this space of wall is a row of windows—the *clearstory* (or *clerestory*). Directly above is a flat, decorated ceiling that conceals wooden trusses and a wooden roof. Arched or vaulted ceilings were to come later.

S. Apollinare in Classe is so designed that one's eyes and one's steps are directed toward the east end. Here is the *apse* (from *apsis*, an arch), a semicircular extension covered by a half-dome. This is the focal point of

the worship service and, artistically, the climax of the edifice. In it or in front of it is the altar, traditionally placed over the tomb of the saint or martyr to whom the church is dedicated. The apse of S. Apollinare in Classe, covered as it is with some of the finest of early Christian mosaics, is particularly beautiful and impressive (Colorplate 1).

The Central Plan; Some Examples. The nave of a central-plan church is round, square, or polygonal (usually octagonal), and the axis or dominant line of vision is vertical, rather than horizontal as in basilica churches.

Imperial Rome produced a number of circular, often dome-covered buildings such as the Pantheon, the Mausoleum of Hadrian, and the Circular Temple on the Tiber (Ch. 4). The form had aesthetic advantages, but it was obviously less suitable than the basilica for assemblies of worshipers or citizens.

But the domed building, which invites the eye to look heavenward, appealed to both the symbolic and the aesthetic sensibilities of early Christian builders, especially in the East. Since they wanted to escape the practical limitations of the circular building, they struggled with the problem of putting a circular dome over an octagon—or better still, over a square. They found the solution in the *pendentive*, which is in essence a triangular segment of a sphere (fig. 5-3A). Four such pendentives, each with one of its tips resting on one of four strong corner piers, make a circle on which a dome can be placed. Fig. 5-9, which shows part of the dome structure of the Blue Mosque in Istanbul, illustrates the pendentive and its function.

Architectural ingenuity found another way to put a dome on a square or octagon or other many-sided form—the *squinch*, which makes a transition from an angle to a wider angle or a curve (figs. 5-3B and 5-4). The octagonal form was used effectively in a number of early Christian churches, such as San Vitale in Ravenna (fig. 5-5) and Charlemagne's chapel in Aachen, Germany.

A logical outgrowth of the dome-covered square was the *cruciform* plan, which became and has remained the basic pattern for Orthodox churches throughout the Western world. In this plan a Greek cross (with its

Fig. 5–3.

a. Dome on Pendentives

b. Squinch

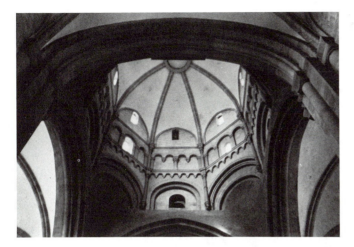

Fig. 5–4. Squinches, Mainz Cathedral, Germany (making transition from square arcade to octagonal dome).

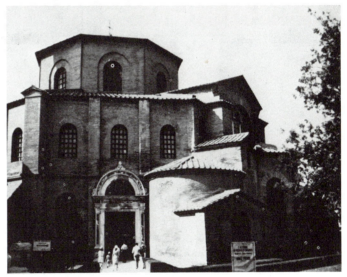

Fig. 5–5. The Church of San Vitale, Ravenna. 526–47.

four arms of equal length) is enclosed in a square. Over the crossing is placed a dome or cupola, ordinarily on pendentives. The four arms of the cross are roofed over with barrel vaulting, and often four smaller cupolas cover the corner areas between the arms of the cross. Fig. 5-6 shows the ground plan for such a structure, with circles to indicate the placement of the cupolas. This cruciform plan or variations of it—sometimes with a narthex as an addition on one side, sometimes without the corner cupolas—can

be seen in hundreds of Orthodox churches throughout the world.

Three fine central-plan churches—Hagia Sophia in Istanbul, San Vitale in Ravenna, and St. Mark's in Venice—will serve well as examples:

Hagia Sophia (popularly called *St. Sophia*). At the height of Justinian's reign, in 532, the principal church of Constantinople burned down. The emperor immediately engaged Enthemius and Isodorus, two ar-

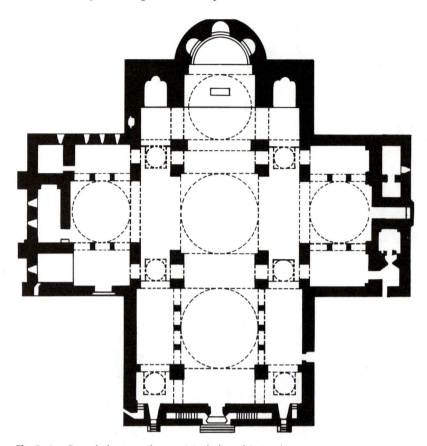

Fig. 5–6. Central plan (cruciform; original plan of St. Mark's, Venice). Drawing after Sir Banister Fletcher.

chitects from Asia Minor, and ordered them to erect an edifice that would surpass anything ever built. In less than six years, using workers and materials from all over the eastern European world, they finished a building that would cost many millions if it were to be erected today—the magnificent Hagia Sophia. In December of 537 the church was dedicated, not to a saint but to Hagia Sophia or Sancta Sophia—Holy Wisdom. Justinian, when he entered the completed church, is said to have exclaimed, "Glory to God, who has deemed me worthy of fulfilling such a work. O Solomon, I have surpassed thee!" It is still easy to share his awe and understand his pride.

The great stone and brick structure is built around four concealed piers. Above these are the pendentives, which support the less-than-hemispheric but still high-soaring dome. A ring of arched windows circles the base of the dome, and ribs in its inner surface draw the eye to a large circle at the top. Now filled with Arabic characters, this climactic part of the church once contained a huge mosaic of Christ as Pantocrator or Lord of the Universe, a traditional feature of Orthodox churches. Fig 5-7 shows the nave of Hagia Sophia.

The north and south sides of the vast room are solid walls, with aisle columns at the bottom, a gallery halfway up, and window-pierced masonry at the top. Reaching far out from the east and west sides are semi-

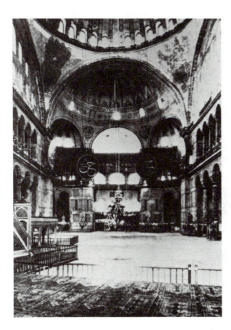

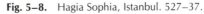

Fig. 5—8. Hagia Sophia, Istanbul. 527–37.

Fig. 5—7. Interior, Hagia (Sancta) Sophia, Istanbul. 527–37.

circular, half-domed extensions, so that the overall shape of the nave is that of a large oval.

The columns of Hagia Sophia are of green and white marble. All other interior surfaces were originally covered with a sheath of marble veneer or (especially in the upper areas) of mosaic, mostly in tones of gold and porphyry (purple). When the building was taken over by the Turks in 1453, it was converted into a Moslem mosque. Most of the mosaics, especially those depicting human figures of any kind, were covered over, and large circular shields were hung here and there on the walls. The shields remain, but in 1935 the Turkish government turned the

mosque into a museum and authorized the uncovering of the Christian mosaics. Several centuries ago the Moslems erected tall, slender minarets that actually enhance the exterior appearance of the building (fig. 5-8).

So impressed were the Moslems by Hagia Sophia that they imitated it in countless mosques; there are almost seven hundred in Istanbul alone. Among the finest ones are the seventeenth-century mosque of Ahmet I—the Blue Mosque—with its richly patterned stained glass and lavish ornamentation, mostly in blue tile (fig. 5-9); and the monumental Mosque of Sultan Suleiman I, more impressive in its relatively simple interior design than the more opulent ones.

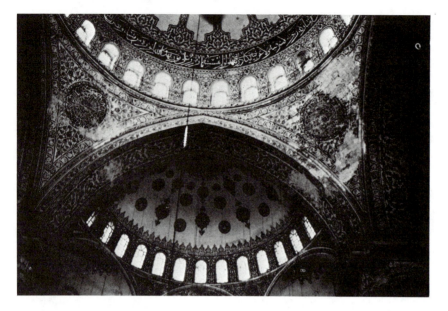

Fig. 5–9. Half-dome and pendentives, Mosque of Ahmed I (Blue Mosque), Istanbul. 1609–17.

San Vitale. Justinian was also the moving force behind the erection of several structures in his Western subcapital at Ravenna. One of the finest of these is San Vitale. Its ground plan is that of an octagon within a larger octagon, with a narthex attached at an off angle on the southwest side. Fig. 5-10 shows the nave. This high, narrow central area would seem cramped if it were not for a series of openings that extend the view into the aisle. On the east side, one of the openings enlarges to become a compartment for the altar. Above the aisles is a second story, a gallery that looks into the nave. In earlier times this gallery was reserved for women. Natural light enters only dimly into San Vitale, but the mosaics that cover nearly the entire interior with their tones of green, white, and gold seem almost to supply their own illumination.

St. Mark's. The ornately imposing church of St. Mark's (San Marco) in Venice, largely completed in the eleventh century, was inspired by a Byzantine model built five hundred years before, Constantinople's Church of the Holy Apostles. For centuries the city-state of Venice had been strongly influenced by the culture and arts of the Byzantine empire. Even much of the later architecture of Venice, whether Gothic or Renaissance, has a strong Byzantine cast. It can be seen in the palaces along the canals, in many of the churches, in the great Ducal Palace, and elsewhere.

St. Mark's is dominated by its five domes, one in the center and one at each of the four corners. From ground level the domes are largely hidden by a number of statue-topped pinnacles and by the high façade of the cathedral. The façade itself is an incredible profusion of portals, arches, statuary, tabernacles, and mosaics (fig. 5-11). The great arches over the entrances are round Romanesque ones. On the second story of the façade one sees five *ogees,* oriental-looking arches with reverse curves at their tops. In the tympanums of almost all these arches are narrative scenes in mosaic, against sparkling gold backgrounds.

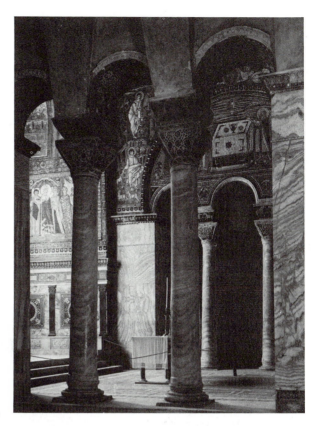

Fig. 5–10. Interior, San Vitale, Ravenna.

Fig. 5–11. St. Mark's (San Marco) Cathedral, Venice. Begun 1063.

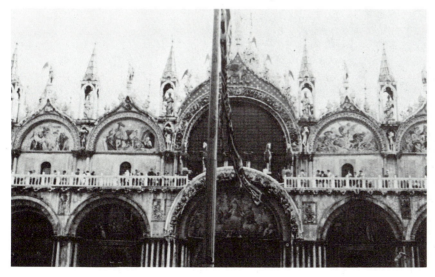

Four famous bronze horses stand on the terrace above the arch of the central portal. Of classical origin, they were brought from Constantinople in 1204, and they adorned St. Mark's until Napoleon, a hungry collector of art treasures from conquered lands, had them taken to Paris. Following his overthrow they were returned to their present places.

The opulence of the façade of St. Mark's is carried into its interior (fig. 5-12). The large narthex glows with mosaics, and the entire multidomed vaulting of the church is covered with Biblical and other scenes against a gold background. As in San Vitale, but to a greater degree, the walls and ceiling seem to diffuse their own shimmering light.

SCULPTURE

The Biblical injunction, "Thou shalt not make unto thee any graven images," has been subject to varying interpretations. Early Christians evidently took the commandment quite literally. Not only did they make few sculptured representations of deity, but they were uneasy about three-dimensional images in general. No large-scale statues from the period have come down to us. A few small figures of Christ as the Good Shepherd, probably from the third or fourth century, still remain. When peace came to the Christians in Rome, some of the wealthier ones were buried in sarcophagi adorned with relief sculpture, in Roman style but

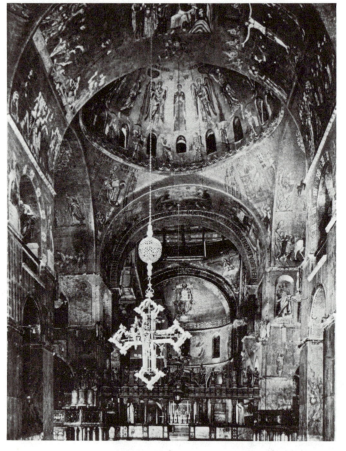

Fig. 5–12. Interior, St. Mark's, Venice.

with Christian themes. Some of these have survived, as have a few other early Christian pieces of sculpture such as ivory carvings, some of them exquisite, and a small equestrian statue of Charlemagne.

PAINTING AND MOSAICS

Even during the worst times of persecution the early Roman Christians were evidently unmolested in their digging of passageways and burial chambers (catacombs) in the soft tufa stone underlying the outskirts of Rome. In three centuries more than five hundred miles of such subterranean excavations were made, to accommodate perhaps six million bodies. Some of the burial chambers were fairly large, with arched ceilings. Often their walls were ornamented with fresco paintings done in vivid colors; some of them can still be seen quite clearly. A number of them are full-length portraits of the deceased. Others depict a few selected Old Testament stories—of Noah, Jonah, Moses, and Daniel—interpreted as symbolic of resurrection and salvation. A few others depict scenes from the life of Christ. There were also early Christian symbols; for instance, since the initial letters of the words *Jesus Christ of God the Son, Savior* written in Greek spell *icthys* or *fish*, the fish became a symbol of Christ and was so used in the catacombs. More importantly, Christ as the Good Shepherd was also depicted.

Mosaics

The mosaicists of Greece and Rome passed the secrets of their craft along to the artists of the early Christian era. They saw in mosaic more durability, intensity, and creative challenge than in fresco. The walls of all the early Christian churches we have discussed are covered with mosaics, many of them brilliantly executed.

There are relatively few early Christian mosaics in Istanbul—Constantinople—partly because of bitter controversies that plagued that city over several centuries regarding the use of *icons* or religious images, and partly because many mosaics that the Moslems plastered over in Hagia Sophia and elsewhere were damaged beyond recovery. Early Christian mosaics therefore exist mostly in Ravenna and other parts of the Byzantine empire that were less affected by the so-called Iconoclastic Controversy and by the ravaging of invading Moslems.

The Ravenna Mosaics. The early Christian mosaics in Ravenna constitute one of the greatest bodies of Western religious art. Though mosaics are considered here as a type of painting, in one sense their function, in Ravenna and elsewhere, is architectural. Especially in central-type structures, mosaics cover most or all interior surfaces, and in many instances they form a unity of color and light. Though the viewer will single out individual figures and scenes, they are not "pictures" but part of the totality of the church's interior.

The Mosaics of the Mausoleum of Galla Placidia. This small, cross-shaped building in Ravenna, a few steps away from the church of San Vitale, was built (in advance of her death) to house the remains of the Roman empress Galla Placidia, who died in 450. It is doubtful that she was buried there. The plain exterior, like those of the other Ravennate buildings, heightens by contrast the beauties within. Light enters only dimly through small windows of thin alabaster, but one can see that almost every surface is covered with a mantle of blue—lighter tones on the walls and a dark, star-sprinkled blue overhead. Emerging from this background are a number of figures and images: St. Lawrence approaching his martyrdom of fire; a Latin cross in the dome; deer drinking at a spring, an image based on the 42nd Psalm; the twelve Apostles; doves by a fountain, and so on. Every small surface is adorned with exquisite designs—spirals, festoons of fruit and flowers, tendrils of vines.

Perhaps the finest detail in the mausoleum is the representation of Christ as the Good Shepherd (fig. 5-13). Clearly influenced by Roman traditions of realism in wall paintings, the artist uses his tesserae like paint to create a naturalistic scene. A beardless Christ sits relaxed, his eyes glancing to one side and his hand reaching gently toward a sheep. Light fills the scene; its direction is clearly indicated by small shadows and by the modeling of the sheep and the limbs of the Savior. Behind is a landscape with rocks, plants, and sky. The work reflects tendencies that were soon to give way to the two-dimensional, traditionalized Byzantine forms that dominated Christian art, especially in the East, for the next eight or nine hundred years.

The Mosaics of San Vitale. Beautiful mosaic work, mostly in shades of green, gold, and white, covers the wall areas of San Vitale. Artists were doubtless brought from Constantinople to do the work, and a strong Byzantine flavor predominates. Scenes that would have been treated realistically by the Galla Placidia artist are more abstract here. Bodies are more flattened and elongated; flowers and trees are stylized. Above all, figures whether of deities or of men are majestic, remote, and calculated to inspire awe.

Most famous of the San Vitale mosaics are two large panels facing each other in the apse or altar compartment. One shows Justinian in a royal procession. The other depicts his consort Theodora, in regal splendor, about to enter the church of San Vitale. Fig.

Fig. 5–13. *Christ as the Good Shepherd.* Mosaic. Mausoleum of Galla Placidia, Ravenna. 425–50.

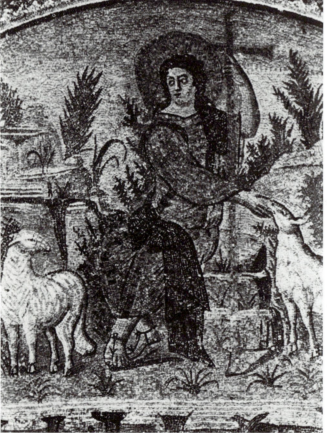

5-14, a detail of the latter panel, shows the face of the empress. Since the royal pair never visited Ravenna, the panels were probably intended to suggest the political and religious oneness of that town and its conqueror, Constantinople. Justinian's status as emporer-priest (fig. 5-15) is symbolized by his crown and the faint halo around his head. The scene is handled in typical Byzantine fashion: figures are in frontal poses, heads are in line, faces are only partly individualized, and large eyes gaze into those of the viewer.

The Mosaics of S. Apollinare Nuovo. This sixth century church in Ravenna was erected during the reign of the Ostrogothic king Theodoric, who leaned toward Roman ways. Hence the upper bands of mosaic, done during his lifetime, are fairly realistic if naïve; they are scenes from the life of Christ. But the bands under the windows, done after the Byzantine conquest, clearly show Eastern influence. Here are two processions, of the kind that occurred regularly in the rit-

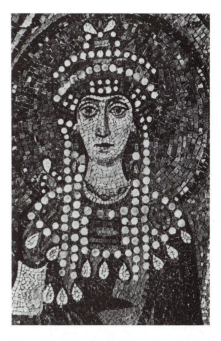

Fig. 5–14. *The Empress Theodora.* Detail of mosaic panel. San Vitale, Ravenna. 526–47.

Fig. 5–15. *Emperor Justinian and Attendants.* Mosaic panel. San Vitale, Ravenna. 526–47.

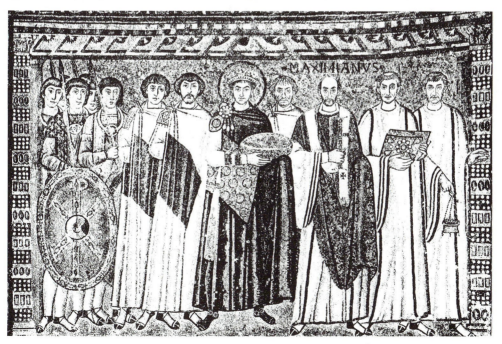

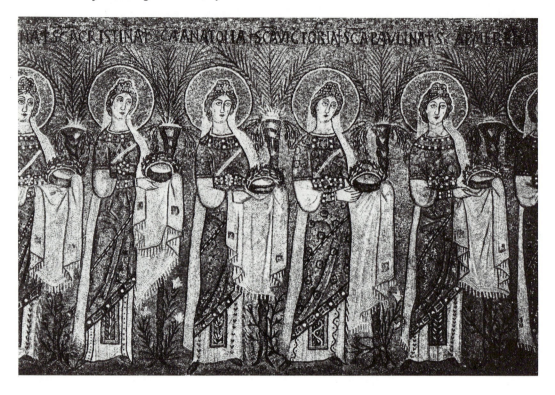

Fig. 5–16 *Procession of Female Martyrs.* Mosaic. S. Apollinare Nuovo, Ravenna. About 504.

ual of the church. But these are no ordinary men and women: on one side are tall, white-robed male martyrs and on the other luxuriously gowned virgin martyrs (fig. 5-16), all moving along in a solemn repetition of attitudes and gestures. The virgins, led by the three Wise Men, move toward the throne of the Virgin Mary; the male martyrs approach the enthroned figure of Christ (fig. 5-17). In both processions, naturalism is largely ignored. Stylized flowers and palm fronds create only a shallow background. The martyrs, though presumably marching, are all in near-frontal poses, and little attempt is made to individualize them. But the panels are impressive in their oft-repeated rhythms of color and gesture and in the glow of light they reflect from the high windows of the basilica.

The Mosaics of Hosios Loukas in Greece. One of the finest of ancient Eastern Orthodox churches is the monastery church of Hosios Loukas (St. Luke) in the hilly countryside of Phocis, Greece (fig. 5-18). Built in the eleventh century and dedicated to a hermit named Luke, it has been called a "picture-book church, a treasure house of Middle Byzantine art."

Hosios Loukas is a complex of small rooms surrounding a square, domed nave. Arched doorways, domes, and half-domes are all aglow with mosaics. In the Byzantine tradition, figures of saints and deities are seen against golden backgrounds; there are no landscapes or other scenes to remind the beholder of the things of this earth. The figures, however, are much less rigid and austere than those in most Ravennate mosaics.

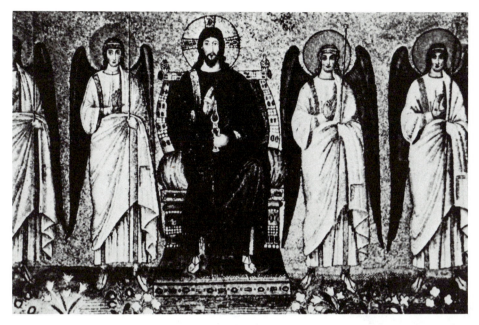

Fig. 5–17. *Christ and Angels.* Mosaic detail. S. Apollinare Nuovo, Ravenna. About 504.

Fig. 5–18. Monastery of Hosios Loukas (the holy hermit Luke). Phocis, Greece. Eleventh century.

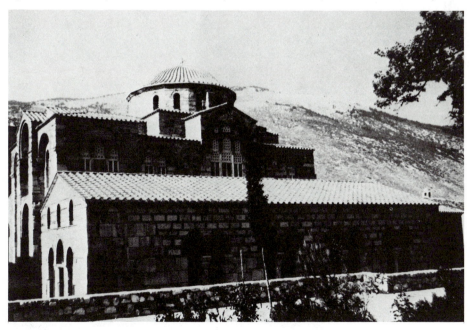

One narrative detail, for instance, depicts Christ vigorously leading the souls of Adam and Eve from Hell following His resurrection, with King David and King Solomon looking on (fig. 5-19). Another is a simple portrayal of the Savior washing the feet of Peter, as another apostle begins to remove his sandal. The forms are accommodated remarkably well to the half-dome they occupy.

In a lunette above the central doorway is one of the finest of the church's mosaics, a sensitive portrayal of Christ as Lord of the Universe (fig. 5-20). His right hand points to the passage in John 8:12 that says, "I am the light of the world: he that followeth me shall not walk in darkness but shall have the light of life."

The monastery church of Hosios Loukas was erected, as we have said, in the eleventh century, during what has been called Byzantium's second Golden Age. This era came to a disastrous end in 1204, when the soldiers of the Fourth Crusade, turning against their fellow Christians, captured and pillaged Constantinople. So weakened was Byzantium that it never fully recovered. The following centuries saw a succession of invasions by Ottoman Turks, the fall of Constantinople and the Moslem takeover in 1453, and the dwindling of a great culture.

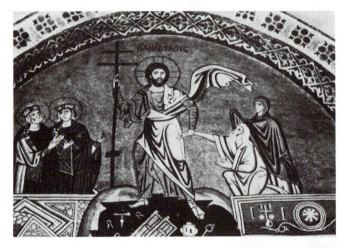

Fig. 5–19. *Christ Leading Souls from Hell.* Mosaic. Hosios Loukas, Phocis.

Fig. 5–20. *Christ.* Mosaic. Hosios Loukas, Phocis.

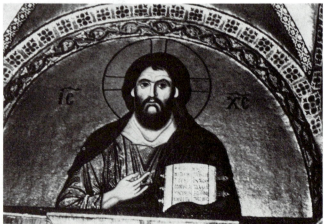

THE LATER MIDDLE AGES: ROMANESQUE ARTS

The term *Romanesque* means *Roman-like*. It is applied particularly to European architecture of the eleventh and twelfth centuries, but by extension it is used to designate the other arts of the period. We have seen that two characteristics of Roman architecture are (a) massiveness and solidity and (b) the use of the round arch and vault. Both of these appear prominently in the architecture of the eleventh and twelfth centuries, whether religious or secular and whether by imitation or by coincidence. As for the other arts, the relationship between the Roman and the Romanesque periods is much less clear. In fact, it is remote as far as painting, sculpture, and especially music are concerned, and the name *Romanesque* becomes largely a term of convenience. Regarding the dates of the period, here again round numbers serve largely for convenience, and our review of Romanesque arts will range both before and after the eleventh and twelfth centuries.

The arts of southern and eastern Europe—Italy, Greece, and Byzantium—have occupied most of our attention thus far. From this point on the scene shifts to the West. Italy continues to figure importantly in the world of the arts, but western and north-

ern Europe, including the British Isles, now begin to play what are to become dominant parts in Western culture.

THE CHURCH

Papacy and Monasticism

Though the educational and cultural revival fostered by Charlemagne was in the long run a foreshadowing of better things to come, his death in 814 was followed by two centuries of political disorganization and moral decadence. Leaders of the church from the papacy on down contributed to the atmosphere of divisiveness and moral dissolution. It was not until the eleventh century, under such able and high-principled popes as Gregory VII and Urban II, that the church reasserted itself as a strong unifying and stabilizing force in Europe. The curbing to an extent of corrupt practices like simony (the buying and selling of sacred or spiritual things such as church offices), the induction of abler men into positions of church leadership, an intensification of religious interest and conviction on the part of common men, reforms in the

monastic system—all of these led to a strengthening of church influence in both spiritual and temporal affairs. So important, in fact, were the church and the attitudes it fostered that many have called the period *The Age of Faith*. Others, more concerned with the human injustices of the time and the extent to which common men must have been afraid of physical dangers in this life and the threat of hellfire in the world to come, have wondered whether the term adequately describes the age.

Contests between throne and church were the order of the day, as they continued to be for several centuries. Civil governments were unstable in most parts of Europe, but the church's strength manifested itself, in the eleventh and twelfth centuries, in a remarkable burst of cultural and religious activity. Hundreds of churches and cathedrals were erected, monasteries were built or enlarged, abbey and cathedral schools were established, and techniques in church music were markedly advanced. In short, the great cultural and intellectual accomplishments of the thirteenth and fourteenth centuries—the *High Middle Ages*—were clearly anticipated. It was in this period that veneration of the Virgin Mary became an important part of Catholic worship and hence of artistic expression. And a secular literature of great significance, it should be added, came into being in the Romanesque period.

Monasticism. Of great importance in the religious and cultural life of the period were the *regular* clerics, the monks. Monasticism had been practiced, largely by individual hermits, from the earliest centuries of the Christian era. But it was Benedict—St. Benedict of Nursia—who more than any other established the collectivist pattern that monasticism was to follow from the sixth century on. In about 529 Benedict founded what was to become the renowned abbey of Monte Cassino, on a mountainside in central Italy. To his followers he gave what came to be called the Benedictine Rule, a set of reg-

ulations for daily conduct that became the model for rules established by most subsequent monastic orders. Though the Rule would seem impossibly severe to most of us today, it was quite moderate in medieval terms. Benedict warned against extreme asceticism—prolonged fasting, self-punishment, or other abuses of the body. His main requirements were that the monks adhere to vows of chastity, poverty, and obedience. And he insisted above all that they dedicate their lives to prayer, worship, and spiritual meditation. Work was not to be neglected, however, and a fair share of each day was to be spent in manual labor—gardening, farming, building, and the like.

Monasteries patterned after Monte Cassino quickly sprang up throughout Europe, including the British Isles, all of them theoretically under the control of the bishops of the various dioceses.

As the centuries passed, abuses both of extremism and of laxity crept into monasticism. In 910 a strong reform movement was instituted with the establishment of the Cluniacs, a new branch of the Benedictines who organized a convent at Cluny, in Burgundy (in what was to become France). The Cluniacs revived and revitalized the Rule, and soon they had established themselves as a powerful religious and economic force in central Europe. Some of the brothers rose to high positions in the church; Pope Gregory VII, for instance, had been a Cluniac monk.

Hundreds of branches of the Cluniac order were established throughout France and elsewhere. In fact, by the twelfth century there were over two thousand Cluniac and other monasteries, some of them now so wealthy and worldly that reforms were once again necessary. From the eleventh century on, various monastic orders such as the Cistercians and Carthusians came into being, and some are still in existence. Related, but somewhat different, are the orders of mendicant monks—the Franciscans, the Dominicans, and others—that were founded in the thirteenth century and later.

The cultural contributions of the

monks were considerable. They were the principal preservers, in the Western church, of classical learning and some elements of classical literature. They saved and copied many manuscripts. As will be seen later, they developed the beautiful art of manuscript illumination. They established monastic schools, which preserved learning even if they did not advance it to any great extent. Along with the secular clerics they helped to establish and develop the musical practices of the church. And some of them were original and creative builders.

Feudalism. A generation after Charlemagne's death, his kingdom was parceled out among his grandsons, and the strife and semianarchy that were to characterize the feudal period now began. By the end of the first Christian millenium, Europe became almost fully feudalized.

Medieval men yearned for order. They saw it exemplified, at least to a degree, in the organizational pattern of the church—the hierarchy of pope, patriarch, archbishop, bishop, priest, and so on down to the lay member, who accepted the authoritarian pattern as God-ordained. They thought they saw it repeated on a temporal level in the political system of feudalism that had evolved from Roman and Germanic origins—that is, king, duke, baron, knight, and on down to the serf at the bottom of the scale.

In fact, however, the unifying force of the church was largely counteracted by the divisiveness of feudalism. In theory the king possessed all the lands in his domain (he received them from God), and he gave part of them as *fiefs* to his vassals, the nobles, in return for certain economic and military benefits. The process was repeated on succeeding levels of the feudal hierarchy. In practice, the great dukes were often more powerful than their kings. They and the barons, in their manors or castles, though they were subject to military call, were otherwise practically independent. Warfare, on a petty or a large scale, was a way of life. Knights, or-

dinarily younger sons of noble families, attached themselves for military purposes to their superiors or to the king himself.

An outgrowth of the system was the code of chivalry that was attached to knighthood. It was an ideal that promoted a warlike spirit, a love of adventure, and a thirst for glory. It also encouraged a sense of obligation to the weak and needy and an unswerving devotion to God, the church, and the Virgin—and hence to women in general. The chivalric code found expression in literature—in the medieval epic, song, and romance—more than it did in life. The ideal knight was largely a fictional creation, but the conventions of chivalry were strongly imbedded in feudalism.

A more vital element of religious purpose was added to the chivalric traditions of knighthood by the Crusades, which, beginning in 1095 and continuing intermittently until 1291, called thousands of knights and other warriors into the service of church and country. Out of the Crusades grew powerful orders of knights who banded together for military and religious reasons—the Order of St. John of Jerusalem (or Hospitalers), for example, and the Knights Templars—but who later became wealthy and often corrupt.

At the bottom of the medieval ladder were the serfs. In that part of the feudal system that is called *manorialism*, they shared the products of their labor with the lord of the manor, who in turn offered them a measure of protection. Their lives were hard at best, but doubtless they accepted their lot as part of the eternal scheme of things. They found their pleasures in simple activities, and their glimpses of beauty and hope in the church and the promises it held out for them.

Education. The relatively few people of the Middle Ages who learned to read and write were trained in monasteries, cathedral schools, and universities, in that historical sequence. Monasteries from the beginning provided a kind of formal education; the cathedral schools were established by the elev-

enth century; and the first university, that at Bologna in Italy, was founded about 1157, followed shortly by those in Paris and a number of centers on the continent and in the British Isles.

Religious and moral training, of course, lay at the base of all such education. But secular learning, including the traditional seven liberal arts that were derived from ancient Greece by way of Rome, was also preserved to an extent. These seven consisted of the *trivium*—grammar, rhetoric, and dialectic or logic, all dealing with the arts of language—and the *quadrivium*, which included arithmetic, music, astronomy, and geometry, all concerned with numerical and quantitative matters. In actual fact the curriculum was sometimes extended well beyond these limits.

There was little in all this that encouraged investigation or original thought. The great majority of the clergy believed that faith should be accepted as sufficient in itself and that rationalism was heretical.

The right—in truth the obligation—of thinking men to reason and question was first prominently advocated in this period by the French scholar Abélard (1079–1142), whose tragic love affair with Héloïse is one of the world's celebrated romances. With Abélard began the intellectual and philosophical movement known as Scholasticism. It was a study aimed basically at reconciling the doctrines of the church with Aristotelian logic, faith with reason. It reached its highest point in the thirteenth century, in the writings of such great Schoolmen as Thomas Aquinas, Albertus Magnus, and Duns Scotus.

LITERATURE

Most of the writing that has survived from the medieval period is significant for religious, historical, or other nonliterary reasons. A number of artistically important works have come down to us, however, some of which stand comparison with the masterpieces of any time or place—*The Song of Roland;* the *Nibelungenlied;* the Arthurian romances, particularly reflected in Malory's *Le Morte d'Arthur* and in *Sir Gawain and the Green Knight;* Dante's superb *Divine Comedy;* the poetry of Chaucer; and others. Most of these, composed in the last centuries of the Middle Ages, will be discussed in the next chapter. *The Song of Roland* and the Arthurian romances, which embody feudal ideals and traditions, concern us at this point.

The Song of Roland (Chanson de Roland). The *chanson de geste* or song of deeds, a type of narrative poem popular in medieval France, can be considered a short epic. Like most epics, the *chanson de geste* uses historical fact at least as its starting point; it employs materials that oral tradition has long made familiar; it is concerned with the exploits of a hero; it expresses the ideals of a nation or period; and (like the folk epic) it is designed to be sung by a minstrel.

Minstrelsy was a popular art in medieval Europe. In addition to the *jongleurs* (jugglers), who included the singing of songs among their accomplishments, there were the *troubadours*, aristocratic poet-singers of southern France whose chief theme came to be love, often the illicit love of a knight for a married lady. There were also the *trouvères*, the more virile northern counterparts of the troubadours; it was they who composed and sang the *chansons de geste*.

Most famous of all such *chansons* is *The Song of Roland*, the best literary exemplar of the feudal and heroic traditions of the Middle Ages. Both its author and its date of composition are unknown. Tradition long held that it was sung to William the Conqueror, before the Battle of Hastings in 1066, by a minstrel named Taillefer, who possibly even composed it. It is now generally believed, however, that the poem was composed sometime between 1066 and 1095.

As in Homeric epic, the basic story of *Roland* was a long-familiar and often-told one. In 778 Charlemagne engaged in some

minor campaigns against the Moors in Spain and was on his way home through the Pyrenees when his rear guard was cut off and destroyed by Basque mountaineers. Among those killed was Roland, a nobleman; little more is known of him than this. From these meager shreds, storytellers and trouvères of the next three centuries constructed a full-blown epic: Roland becomes a hero who exemplifies the highest of Christian and feudal virtues but who also has his tragic flaw, an overconfidence that brings disaster to himself and to many others. The Basque mountaineers become Saracen hordes. A knight who betrays the feudal ideal of loyalty is provided in the treacherous Ganelon, Roland's stepfather; and his opposite, a hot-blooded fighting prelate, is seen in the Archbishop Turpin. Roland is given a close companion in Oliver, who represents the stability and discretion that Roland lacks. Charlemagne, actually in his thirties when the events at the pass of Roncesvalles occurred, is made to be two hundred years old, with the wisdom of his years.

Much of the artistic success of *Roland* lies in its simplicity—one might almost say its naïveté. Character and episode are presented directly and vigorously, as are the feudal ideals and attitudes they embody— the harshness and intolerance as well as the courage and loyalty. Several incidents, especially the deaths of Roland and Oliver, are genuinely moving.

Arthurian Romance. The medieval romance, which flourished in the twelfth and thirteenth centuries, was originally a story of adventure, often involving the marvelous or the supernatural, in either verse or prose. But enough even of the early romances were concerned with love for the word to take on its present connotations. French was the language of most early romances, even of those written in England. For subject matter the romancers turned to the classical world of Trojan heroes and Al-

exander, to the France of Charlemagne and Roland, and above all to the so-called *matter of Britain*—the stories of Arthur and his Round Table.

The stories of the legendary king Arthur, his queen Guinevere, the heroes Lancelot, Gawain, Percival, and the others have become probably the most familiar and most celebrated body of fiction in the Western world. In the Middle Ages these tales, Celtic in origin, became widely known through oral repetition but also through the writings of Geoffrey of Monmouth, Chrétien de Troyes, Wace, Layamon, and others, writing in French, Latin, and English. Later the Grail legends and the tragic romance of Tristan and Isolt were added to the Arthurian cycle. The stories were condensed and compiled in Malory's great *Le Morte d'Arthur* (1469), one of the first books printed in England. Malory, a good storyteller, related the Arthurian romances to each other by means of their chivalric themes of courage, courtesy, and gentility. If Malory and the romancers are little read today, everyone knows the stories in one or more of their many modern versions: by Tennyson in his *Idylls of the King;* by Arnold, Swinburne, Morris, and Robinson in their narrative poems; by Wagner in his passionate operatic version of Tristan; by T. H. White in his fine novel *The Once and Future King;* by Lerner and Loewe in *Camelot,* on stage and screen; and by many others.

Medieval romances, including the Arthurian ones, have some epiclike qualities, especially in their concern with the heroic life. But often they have neither the unity of structure nor the developed characters of a good epic. A brilliant exception is *Sir Gawain and the Green Knight,* finest of all Arthurian romances. Its author, a fourteenth-century cleric whose name we do not know, was a poet of real genius who took two familiar plots, one involving a chivalric quest and the other a temptation, and joined them in an artistic unit. But the suspenseful plot is only one of the delights of the poem.

Action and incident are elaborated in just enough detail to be vivid without becoming tedious. Descriptions—of the passing seasons, of castle, field, and forest—have a charm that has been compared with the best of medieval tapestries or manuscript illuminations. Hunting scenes, three of them, become exciting details of the narrative. Dialogue, particularly that between Sir Gawain and the Lady, is natural and witty. Underlying it all is a basis of chivalric Christian idealism that the poet never overstresses but never ignores.

MUSIC

Medieval attempts to write down music, as we have seen, employed *neumes*, symbols like those of shorthand, which were placed over the syllables of the text; they were of little use except to prompt the memory. A forward step was made when someone began using a single horizontal line to which pitch intervals could be related. Two other advancements were made in the early eleventh century, both attributed to a musician whom tradition calls Guido of Arezzo (he was probably born near Paris). First he developed a system of writing musical symbols on four parallel lines, so that tonal relationships were henceforth much more definitely indicated. Second, Guido is credited with having invented the technique called *solmization*, the giving of a name to each note in the scale. Using the first syllables of six phrases of an old Latin hymn to St. John the Baptist, he came up with *ut, re, mi, fa, sol,* and *la.* In the seventeenth century the name of the seventh, the note leading to the completion of the octave, was derived from the initials of *Sancta Ioannes.* In most countries the more singable *do* was substituted for *ut.*

Secular Music: Minstrel Songs.
French *chansons* such as *The Song of Roland* were originally sung, to what were evidently very simple tunes; only one of these sur-

vives. But we have nearly 1700 of the short lyrical melodies that were sung by the knightly troubadours and trouvères of the twelfth and thirteenth centuries. Many of them are in the major and minor scales, but many others are in the church modes. The melodies are simple and narrow in range, and the words, like those of most popular songs down through the ages, deal with love, usually unrequited. The same subject preoccupied the German *Minnesinger,* aristocratic poets and singers who frequently exploited the conventional theme of a knight's chivalric (if platonic) love for a married lady. Some of the songs of the Minnesinger, however, were concerned with nature, and others were narrative and even religious.

Instruments.
Instrumental music was highly popular during the Romanesque period and after. The jongleur, the professional minstrel, was usually able to play a variety of instruments, such as the viele (a forerunner of the viol and violin), the lute, the harp, and the psaltery (a harplike instrument with a shallow sound box). Other instruments of the period were the hurdy-gurdy (barrel organ), the horn (often made of horn, as well as of wood), the rebec (a three-stringed, bowed instrument), bagpipes, trumpets, and a number of percussion instruments such as kettledrums, tabors, cymbals, and bell chimes. All of these were used almost exclusively to play (or to accompany) secular songs. The organ, except on rare occasions, was the only instrument used in the services of the church, and this not often until after the fourteenth century.

Church Music.
In the Romanesque era, music continued to strengthen its position as a basic element of church ritual, and it continued to become increasingly complex and sophisticated. Plainsong did not disappear, but it was modified and absorbed into other forms. Plainsong, as we have seen, was monodic—that is, it was sung either as a solo or in unison. Some musicologists believe that an elementary kind of part-sing-

ing, especially of folk songs, had existed for centuries before the Romanesque era, but this hypothesis cannot be proved. We have written evidence, however, that in the tenth century or perhaps earlier the church began to use two-part music, employing a technique called *organum*. One voice (or group in unison) would sing a plainsong and another would sing the same melody in a rather rigid parallel motion a fifth or a fourth above or below. Both of these lines were often doubled in the octave. Sometimes, in what is called *free organum*, the two voices moved in a basically contrary pattern, one ascending as the other descended and vice versa.

Out of these first attempts at part singing grew the harmonic and polyphonic music that was to become one of the glories of European culture. In what must have been an exciting period of experimentation and innovation, leadership was provided by the masters and students of the cathedral schools, especially Notre Dame in Paris. One of the new developments was the holding or stretching out of the notes of a plainsong melody in what was called the *cantus firmus* or *tenor* (from *tenere*, to hold), while the organum sang an independent and more elaborate melody, mostly above the tenor.

As the art of polyphonic composition expanded, some individual names at last emerged in the later twelfth century and thereafter, and took their places in musical history. Two of them, both at Notre Dame in Paris, were Leonin and his successor Perotin, whose works are found in one of the earliest of music books, the *Magnus Liber Organi* (*Great Book of Organa*). Perotin in particular was a composer of real significance.

Tropes and Music Drama. It became a common practice in Catholic worship from the ninth century on to insert into the liturgy short phrases, set to new music, that explained or amplified the service. These insertions were called *tropes*. Sometimes they were in dialogue form. For instance, in a trope that was part of the Easter service, a voice representing an angel would sing

"Whom seek ye?" Another, representing the three Marys, would reply in song, "Jesus of Nazareth." The angel would then sing, "He is not here; he is risen." This trope, called the *Quem quaeritus*, was highly popular. Soon additional incidents were added to this rudimentary music drama, other tropes for other seasons (especially Christmas) were created, and the art of drama began to revive in the western world after a lapse of centuries.

From such simple beginnings the tropes expanded into true music dramas, which found such favor that hundreds were composed between the tenth and thirteenth centuries. Initially they were simply a part of the liturgy, but by the thirteenth century they had become essentially "free" theater and had established an independent existence that was to move them out of the church and into the square or other public places.

New Testament stories relating to the Christmas and Easter seasons continued to provide the main subject matter for church music dramas. A few Old Testament stories were used, however; we have incomplete versions of *Esau and Jacob* and *Joseph and His Brethren*. We also have a complete *Play of Herod* (drawn, of course, from the New Testament) and two *Daniel* plays, both written in rhymed Latin verses that show exceptional poetic skill and a fine sense of drama. For one of these we have only the words; for the other, the Beauvais *Play of Daniel*, we have both words and music, the latter written clearly on a four-line staff.

The Play of Daniel was produced on the first day of some year in the twelfth century, in the town of Beauvais in northern France, as part of the Office of Matins. It was evidently composed by the students of the Cathedral school; its opening lines say:

In your honor, Christ,
This Daniel Play
Was written at Beauvais,
The product of our youth.

There is reason to believe that it was a brilliant production, full of color and pageantry that accorded with the visual splendor of priestly vestments and of the church in which it was presented. It was also absorbing; the students chose and skillfully developed a Biblical story that is inherently dramatic. In sung dialogue, processional pageantry, and some visual action, the play tells the story of Belshazzar, Darius, and Daniel—the prophet's interpreting of the words of doom written on the wall, his friendship with Darius, and his being protected from harm in the den of lions. The play ends with Daniel prophesying the birth of the Savior, an angel announcing the birth, and the chorus singing "Te Deum Laudamus," Praise be to God. The rhymed Latin verses of the play are set to music that is definitely rhythmical—sometimes, as in the processional, infectiously sprightly, and in others, such as Daniel's lament and prayer, genuinely moving. The play has been successfully revived in recent years.

ARCHITECTURE

Church Buildings: Romanesque and Gothic

Apart from a few edifices such as the octagonal chapel built in Aachen for Charlemagne, not much church building of consequence was done in western Europe during the last centuries of the first millenium. But after the year 1000 a remarkable urge to build expressed itself all over Europe. One theory explains it this way: most Christians were expecting the end of the world in the year 1000; when it did not come, men felt that they had a new lease on life, and pent-up creative energies were released. There were other, probably more important reasons: the strengthening of the monastic movement, with a resulting demand for splendid abbey churches; the increased economic power of bishops, as well as of princes who were willing to support the church-

building desires of their ecclesiastical leaders; and natural rivalries—the desire to keep at least abreast of others by building in honor of patron saints and of God.

Western Christian churches of the later Middle Ages are grouped according to time and style in two broad categories: Romanesque and Gothic. There is considerable overlapping and much variation; but in general the Romanesque style, which dominated from about 1000 to about 1150, is marked by its essential plainness and solidity, its heavy interior columns, its small windows, and especially its use of the rounded—usually semicircular—Roman arch and vault. During the later years of the Romanesque period certain new tendencies—the use of buttresses, of pointed arches, and of larger amounts of stained glass—began to appear in one church or another. By the middle of the twelfth century these tendencies had merged, in one or two churches, to produce a distinctively new style that became widely popular in a short time and that later ages were to give the name *Gothic*. This style will be our main interest architecturally in the next chapter. Understandably, dozens of churches that were started in Romanesque style were finished decades or even centuries later in Gothic.

The Romanesque Church. The Romanesque exterior consists of several clearly differentiated and yet integrated masses. The "westwork," often hardly distinctive enough to be called a façade, is generally quite unadorned, with strong horizontal lines to counterbalance any vertical thrust. Strong towers often rise either singly or in pairs, above the crossing or the western wall. The eastern or apse end, though much larger than that of the early Christian basilica, is modest by comparison with those that follow in the Gothic. All in all, the exterior of the Romanesque church impresses by its strong simplicity.

Fig. 6-1 shows the ground plan of a typical Romanesque church. Though it resembles its early Christian models, there are two

Fig. 6–1. Plan of Romanesque church (St. Sernin, Toulouse, about 1080–1120).

important differences: one is that the apse end (often called the choir) is considerably enlarged to accommodate the altar, the bishop's throne in a cathedral, and seats for the officiants, the singers, and other participants in the liturgy. The second is the addition of the *transept*, the two wings that extend north and south at the point where nave and choir join and that give many churches the shape of a Latin cross. Transepts vary greatly, as we shall see. Tombs of saints, church leaders, and prominent lay persons soon came to occupy places in many parts of the church—crypts, nave, aisles, choir, and transepts, both above and below the floor level.

The interior side walls of Romanesque and Gothic churches show another impor-

tant new development. The space between the nave arcade and the clearstory is now pierced with arched, colonnaded openings, often ranged in groups of three. This area is called the *triforium* space; back of it, often but not always, is a walkway or gallery. Triforiums vary greatly, sometimes overshadowing the other two zones, sometimes all but disappearing.

Ceilings in the Romanesque churches of Tuscany—Pisa, Lucca, Florence—are flat (fig. 6-4) and relatively light. But most Romanesque churches elsewhere have groined stone vaulting, as in fig. 6-2. Since the walls must support such heavy masses of stone, they are very thick, often thicker than they need to be.

Big as many Romanesque churches

Fig. 6–2. Romanesque nave and vaulting (Fréjus Cathedral, France; begun about 1064).

are, the interior axis is largely horizontal; they do not soar as do typical Gothic churches. And the interior light is subdued; the Romanesque mood is one of hushed solemnity.

Italian Romanesque. Probably the finest Romanesque church in Italy is the great cathedral at Pisa, begun in 1068 (figs. 6-3 and 6-4). Occupying (with the Baptistry, the Camposanto, and the Leaning Tower) a broad plaza called the Piazza del Duomo, the cathedral is most fortunate in its situation. Its exterior, ornamented with marble arches and colonnettes, is at once simple and elegant. Its interior is also of marble, in alternating horizontal bands of soft white and gray-green. Above the tall nave columns and a small triforium, the walls rise to support a patterned, gilded wooden ceiling. The apse, with a splendid mosaic of Christ in its half-dome, is rather shallow, but the high wings of the transept, ornamented with half-domes, mosaics, and statuary, are most imposing. There is enough window space to give the cathedral an unusually cheerful, airy feeling.

West of the cathedral stands the round, high-domed Baptistry, begun at about the same time as the cathedral but completed later with elegant Flamboyant Gothic ornamentation. The Leaning Tower (campanile or bell tower), near the southeast corner of the cathedral, was begun about 1173, in Romanesque style, and finished two centuries later. Its dramatic tilt tends to draw attention away from its very real beauty. North of the

Fig. 6–3. Baptistry, Cathedral, and Leaning Tower. Pisa, Italy. 1053–1272.

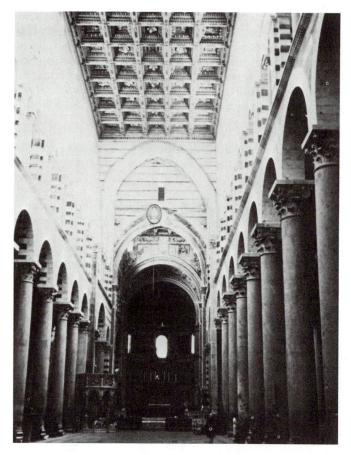

Fig. 6–4. Nave, Pisa Cathedral.

cathedral a few steps is the Camposanto or cemetery, a cloisterlike enclosure that adds still another impressive detail to the Piazza del Duomo.

French Romanesque. Most famous and most imitated of French religious edifices in its time was the great abbey church at Cluny. Begun in 1088, it served for centuries as a center of worship and a place of pilgrimage until its almost total destruction during the French Revolution. Actually the third abbey church to be built at Cluny, it was a hugh structure, with a big narthex, double aisles on each side of the nave, two transepts (a minor one east of the major one), and a prominent apse with five semicircular chapels extending out from it.

Powerful towers rose over crossing and transepts.

The fine interior of the abbey church of La Madeleine at Vézelay, though smaller than the neighboring one at Cluny, resembles it in a general way (fig. 6-5). Most noteworthy are the transverse arches in the vaulting in varying colors of stone, set at right angles to the long groined ceiling.

A highly picturesque French Romanesque edifice is the church of Mont-St.-Michel, the central feature of a Benedictine monastery that was founded in the eighth century (fig. 6-6). High on a hill of rock—actually an islet—on the Normandy coast, the abbey and the church, along with the small town on the hillside, have for centuries attracted pilgrims, scholars, and tourists.

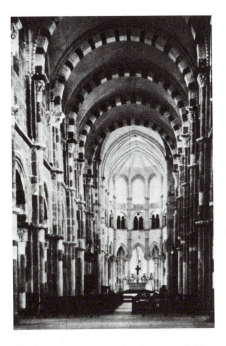

Fig. 6–5. Nave, Church of La Madeleine. Vézelay, France. 1120–32.

The chapel, begun in the twelfth century in simple Romanesque style, had an incongruous Flamboyant Gothic apse added to it a couple of centuries later. So strategically situated is Mont-St.-Michel that it has served as a fortress in several conflicts, including the Hundred Years' War.

German Romanesque. Of a number of similar Romanesque churches in Germany and Scandinavia, three are especially admirable—the imperial cathedrals of Worms, Speyer, and Mainz, all in the Rhineland. The finest interior is at Mainz. The most interesting exterior is at Worms, the great cathedral of the city so closely associated with Martin Luther. The cathedral of Worms, like that at Mainz, has a choir at each end, one for the bishop and one for the abbot and monks. Construction began early in the Romanesque period; but the cathedral was not completed until 1248, and it reflects changes of style. Fig. 6-7 shows the majestic west end, with two tall, fortresslike towers that flank a shorter, heavier octagonal one.

Fig. 6–6. Monastery of Mont St. Michel, France. Present abbey church begun 1203.

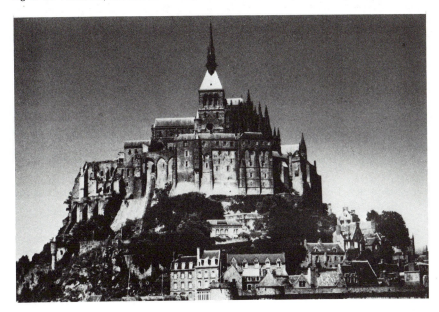

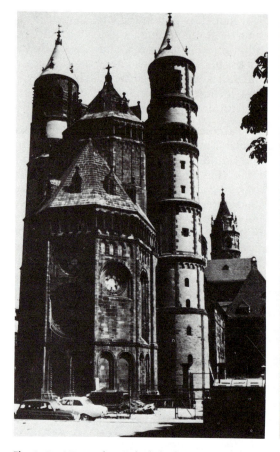

Fig. 6–7. Westworks, Cathedral of Worms, Germany. 1018–1234.

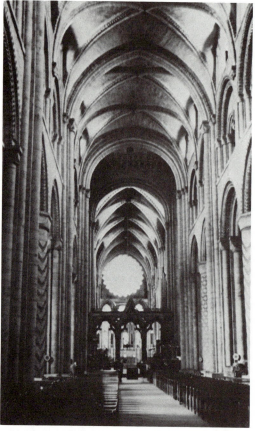

Fig. 6–8. Nave, Durham Cathedral, England. Begun about 1093.

English (Norman) Romanesque. Most truly Romanesque of English churches is the great cathedral at Durham, near the east coast and the Scottish border. (Because of its Norman-French derivation, English architecture of the period is generally called Norman rather than Romanesque.) Beautifully situated above the curving Wear River, Durham is imposing in its length (498 feet), its twin western towers, and the great square tower rising over the crossing. Its interior, with rounded arches in nave arcade and triforium and with simple groined vaulting, is a fine example of true Norman-Romanesque (fig. 6-8).

Standing on an eminence in the otherwise flat plains of Lincolnshire is another of England's great churches, the cathedral of Lincoln (fig. 6-9). Though most of the church is Gothic, its westwork is predominantly Norman. Its broad façade sweeps out from large rounded arches that were part of the original construction. The square towers combine Norman and Gothic forms.

Monastic Architecture. A typical monastery was a complex of a number of buildings large and small, some of them almost as distinctive as the abbey church.

Travelers, the wealthy as well as the

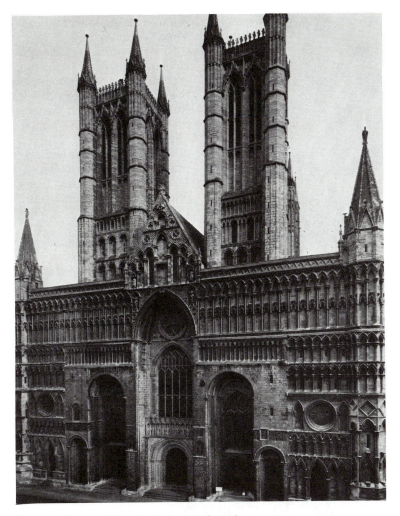

Fig. 6–9. Lincoln Cathedral, England. 11th–14th centuries.

poor, often stopped at the monasteries. Hospices for the poor were provided. Guest halls, comfortable and even luxurious by medieval standards, accommodated those of higher rank. The Hall of Knights, a guest hall at Mont-St.-Michel, is seen in fig. 6-10. Its well-proportioned but sturdy columns and graceful vaulting mark the transition in the early thirteenth century from Norman-Romanesque to Gothic in monastic architecture.

Near the abbey church was a square or rectangular open area, usually planted with grass or flowers. This was the *garth.* Surrounding the garth, and looking out on it, was a covered walkway, the *cloister.* Often it was one of the most pleasing features of the monastery complex. The cloister served both as a sheltered walkway from the church to the refectory or some other building and as a place where the monks could walk, meditate, or pray. A fine Spanish Gothic cloister,

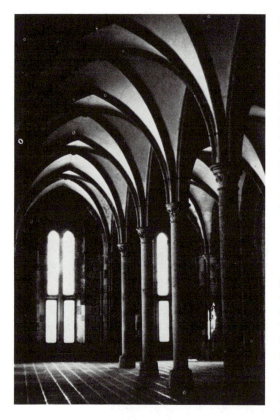

Fig. 6–10. Hall of Knights (Guest Hall). Mont St. Michel, France.

removed from Spain to the Cloisters in New York, is shown in fig. 6-11.

Apart from the abbey church, the principal meeting place of the monastic community was the chapter house, so named from the practice of having a chapter of Benedict's Rule read there each day to the assembled monks. The room or "house" was often an impressive structure. The exquisite vaulting of the Salisbury chapter house, fanning out from a tall, slender column, is seen in fig. 7-14. Chapter houses, like cloisters, were often added to nonmonastic churches, especially in England.

Secular Architecture

Castles and Walled Towns. Castles, much more than churches, remind us today of the Middle Ages and all the romantic connotations of the Age of Chivalry. Castles were built in even greater number than were churches during the Romanesque period. It is estimated that there were over four hundred castles in England alone by the end of the twelfth century. Hundreds of them still remain in varying states of ruin or repair—in strategic spots along riverbanks, on islets, on cliffs and mountainsides, or perched atop high hills. Romantic and picturesque as they

Fig. 6–11. Cloister, transferred from Spain. The Cloisters, New York.

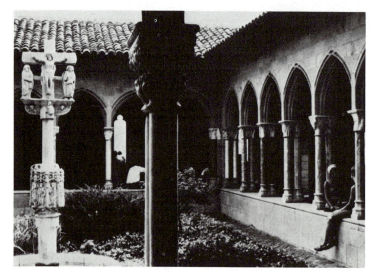

seem to the modern traveler, in their own time they were strictly practical, often grimly so. Some of their structural devices have figured prominently in later nonmilitary architecture up to our own time, from turreted churches to battlemented college buildings.

Castles, a dominant feature of the feudal system, were the private residences and fortresses of lords, whether kings or barons. In early medieval times the castle consisted of a wooden stronghold on a low hill, often man-made, with a larger timber stockade nearby to enclose buildings such as stables, storehouses, a hall, and a chapel. Serfs, whose huts clustered around the castle, crowded into the stockade or *bailey* in times of danger. As time passed, stone replaced wood and the lord's stronghold was moved inside the bailey. These changes led to the typical medieval castle, the *keep and bailey.*

The keep, the lord's residence and the final point of defense, was now a powerful stronghold. The enlarged bailey was surrounded by a great, thick stone wall topped by a platform and by *battlements*, notched walls consisting of alternating open spaces or *crenels* and solid masonry or *merlons.* The merlons were often pierced by vertical slits called *loopholes*, through which missiles could be launched. As a further refinement, the battlements often projected out beyond the main wall, with openings at their bottoms called *machicolations* through which stones or hot oil or water could be dropped. Battlements and machicolations are illustrated in fig. 6-12, a rather elaborate turret of the Scaliger castle in Sirmione, Italy.

One of the most famous keep and bailey castles, and one of the earliest, is the historic Tower of London, begun in 1073 by

Fig. 6–12. Scaliger Castle. Sirmione, Italy.

order of William the Conqueror (fig. 6-13). In the center is the keep, the White Tower, built of grey rock with white stonework (*quoins*) at the corners. Built into a corner of the White Tower is St. John's Chapel, a fine Norman Romanesque church.

Round or polygonal turrets at the corners or along the sides of both keep and bailey walls provided additional strength and visibility. Impressive turrets of the great Welsh castle of Conway, built late in the thirteenth century by Edward I, are shown in fig. 6-14.

The strongest fortification built into the outer wall was at the gatehouse. Fig. 6-15 shows the great gatehouse at Carcassonne, France. Sometimes the outer wall was surrounded by a water-filled moat that was crossed by a drawbridge. Sometimes, in *concentric* castles, an extra wall, battlemented and turreted, completely surrounded the

Fig. 6–14. Turrets. Conway Castle, Wales. Late 13th century.

Fig. 6–15. Gatehouse. Carcassonne, France. 13th century.

main one, with a space of dry ground between.

The best medieval castles served their purposes superbly. They were almost impregnable—some were never conquered—and could withstand long sieges. In the later Middle Ages, as military tactics changed, noblemen built mansions with a minimum of fortification, but they often added battlements and turrets for decorative purposes.

In many places throughout Europe, larger groups of houses clustered around a fortified place, a *burg,* and were themselves protected by a surrounding wall. Overcrowding forced additional building outside the wall; another, longer wall was built, and so the process continued. Those living in walled towns were *burgesses* in England, *bürgers* in Germany, and *bourgeois* in France. Out of these beginnings developed many of the towns and cities that were soon to enter into commercial rivalry with the older established centers of Europe.

Several medieval walled towns have been largely preserved or restored. Among them are Aigues-Mortes, in southern France, founded in the thirteenth century by St. Louis; and Carcassonne, also in southern France, one of the picturesque showplaces of Europe.

SCULPTURE

After a lapse of centuries, sculpture on a large scale enjoyed an extraordinary revival in the Romanesque period. The carving of three-dimensional figures had long been frowned on by some, but now many influential clerics agreed with a colleague who wrote that a picture (which could mean a sculptured figure as well) "is as literature to the illiterate." In this period, especially in southern Europe, clerics commissioned both painters and stone carvers who decorated the new Romanesque churches in a splendid display of creative energy. The artists, whether monks or laymen, were simply anonymous craftsmen, and their subject matter was largely prescribed: familiar Bible stories, incidents from saints' lives, and depictions of holy figures, all designed to glorify their subjects and instruct and admonish their viewers. Within such prescribed limits the best sculptors demonstrated remarkable inventiveness. They incorporated many details from daily life, legend, animal lore, popular symbolism, and demonology in their sculptured works.

Some Romanesque sculptors of southern Europe were doubtless acquainted with the smooth, often idealized forms of classical

sculpture, but there was little imitation of these forms until the Gothic era was well underway. Romanesque artists were concerned not with perfect proportion but with religious emotion and psychological reality. They discovered the expressive values of distortion—of elongated bodies, sometimes in rigid postures that suggested an unearthly stillness and remoteness, sometimes with arms and legs bent in a restlessness of angular movement. Most later generations were to dismiss their work as crude and inept. In the eighteenth century, in fact, many important works of Romanesque sculpture were defaced or plastered over. Only in recent times has their extraordinary intensity found a receptive audience.

The otherwise plain facades of Romanesque churches are sometimes enhanced by well-designed porches or by sculpture around their portals. Sometimes sculpture also adorns the portals leading from the narthex into the basilica. Figure 6-16, a grand piece of art in the narthex of La Madeleine in Vézelay, illustrates well the main elements of portal sculpture. The principal feature is the *tympanum*, the half-moon area of high-relief sculpture above the doorway. In this instance the tympanum is dominated by a seated but animated figure of the Christ. He extends his hands over his apostles, who are receiving his blessing as they set out to preach the Gospel to all nations. Their postures, though dictated in part by the shape of the

Fig. 6–16. Interior portal, Church of La Madeleine. Vézelay, France. 1120–32.

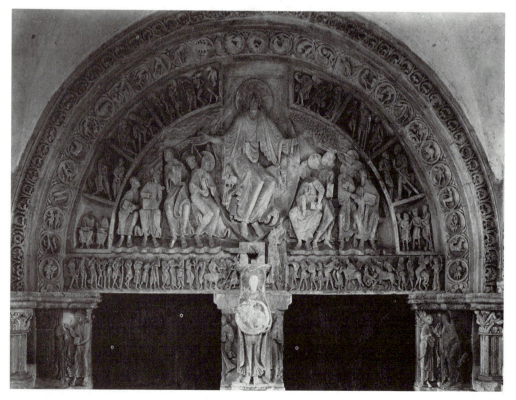

tympanum, are individualized and full of vitality. Draperies are characteristically suggested by thin, narrow folds. The bands above this central panel contain numerous sculptured details, as does the lintel above the doorway.

The *trumeau*, the supporting column between the double doors, is often embellished with a sculptured figure; in the Vézelay portal it is largely obliterated (but see fig. 7-19). The spaces on both sides of the doors, occupied at Vézelay by fluted columns, are often filled with more or less freestanding figures. Such statues were to become an important part of the elaborate portals of Gothic churches. The two Old Tes-

tament kings and the queen in fig. 6-17, though they grace the great west central portal of the Gothic cathedral at Chartres, are Romanesque in both time and spirit. These elongated figures, with hands raised in blessing, are clad in the simplest of stylized draperies. Their physical forms reduced to the minimum, they seem almost weightlessly suspended in air. Only their faces are warmly human.

Doors themselves were sometimes adorned with relief sculpture, in bronze panels bolted or nailed to the heavy wood. Such doors are among the treasures of San Zeno, in Verona. Often naïve but remarkably forceful, the door panels depict a variety of incidents from Scripture and from the early history of Verona. In fig. 6-18 St. Zeno is driving a devil from the daughter of the Emperor Galen. As she writhes in torment, her anxious father and St. Zeno restrain her while the saint expels the demon, seen rushing from her mouth. This dramatic panel is followed by another in which the grateful emperor offers his imperial crown to the saint.

Fig. 6–17. Old Testament Kings and Queen. Jamb statues, Royal Portal, Chartres Cathedral. 12th century.

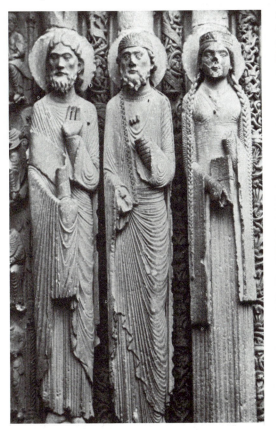

Fig. 6–18. *San Zeno Expelling a Demon.* 11th or 12th century. Bronze on wooden door. Church of San Zeno, Verona, Italy.

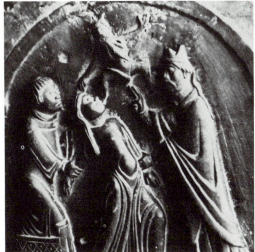

Fig. 6–19. *Eve.* Church of St. Lazare, Autun, France. About 1130.

A highly gifted and original Romanesque sculptor, one of the relatively few whose names we know, was Gislebertus (Gillebert). He probably helped with the work on the Third Abbey Church at Cluny and with La Madeleine at Vézelay. Quite certainly he did most if not all of the four hundred figures that adorn the church of St. Lazare at Autun in southeastern France. (He chiseled *Gislebertus made this* below the main tympanum.) Probably a lay artist, he worked from 1125 to 1135 on the Autun sculptures. The tympanum, as fine as any in the world, was plastered over by eighteenth-century "classicists" but was restored in 1858. One splendid figure, an Eve that originally graced the north portal of the church, is now in a museum in Autun (fig. 6-19). Here Eve, her seductiveness emphasized by the sinuously curved plants that surround her, whispers to Adam (a figure now missing) as she reaches back almost casually to pluck the forbidden fruit.

The capitals of many Romanesque columns at St. Lazare and elsewhere in nave arcades and in cloisters, are ornamented with small sculptures, many of them fanciful (animals, demons, and so on) and many scriptural. One of the most charming is Gislebertus' *Flight into Egypt* in St. Lazare. A tired and anxious Joseph, his tools on his shoulder, leads a spirited donkey that carries the Mother and Child.

PAINTING AND RELATED ARTS

Frescoes. In the western countries, especially France, the flat interior surfaces of Romanesque churches were often decorated with fresco paintings. Most of them have faded away; others were painted over by eighteenth-century clerics. But those that have been preserved or uncovered prove religious painting to have been at a high level in the Middle Ages. The best examples can be found in the French Romanesque church of St. Savin-sur-Gartempe. Here a painter or team of painters decorated the porch of the church and its high barrel vault with a series of frescoes that have been called the Bible of St. Savin or the Romanesque Sistine Chapel.

Fig. 6–20. *Noah's Ark.* Detail of nave fresco. Church of St.-Savin-sur-Gartempe, France. Early 12th century.

Using mostly yellows, browns, and greens in a flat, linear style, the painters depicted incidents from the Old Testament (the Ark scene, fig. 6-20, is one of the best) and from the New Testament. The Book of Revelation particularly stimulated the imaginations of the St. Savin masters. In swirling, energy-filled lines and vivid colors they pictured such symbolic episodes as the woman "clothed with the sun" and the plague of locusts shaped "like unto horses prepared unto battle."

Illuminated Manuscripts. Among the most valued of art treasures are the illuminated manuscripts that have come down to us principally from the Middle Ages. The term *illumination* applies to designs and pictures in medieval books and manuscripts, done in inked lines, colored paints, and gold and silver. They *illuminate* or brighten the pages of the work they adorn. More broadly, any manuscript or book with ornamented pages or margins is illuminated.

One of the main rooms of the medieval monastery was the *scriptorium*, where manuscripts, especially the Gospels and Psalms (Psalters), were copied and illuminated. Such work gave the monks an opportunity for creative expression. Time was no prob-

lem, and many manuscripts were lettered and illuminated with especially painstaking care because they were to be used for liturgical purposes. Writing surfaces were thin but durable sheets of vellum or parchment made from the skins of calves, lambs, and other animals. In earlier manuscripts the ornamentation consisted largely of capitals and first lines done in red—*rubrics*—by a monk called the *rubricator*. As time passed, initial capital letters were expanded and elaborated until some of them occupied almost entire pages, and often their open spaces were filled with small paintings (miniatures, from *minium*, red lead used in painting); this work was done by *miniators*. Other pages were enlivened with borders ranging from abstract geometrical designs to intricate patterns of leaves, tendrils, and wild flowers, with occasional *drolleries*, whimsical animal and human figures, included.

Fine illuminations were made all over the Christian world, from Byzantium to the British Isles. One of the most celebrated of all early Christian manuscripts, dated variously between the sixth and ninth centuries, is the *Book of Kells*. This great Irish work is an illuminated Latin manuscript of the four Gospels. It is in the *decorated* rather than the *historiated* style—that is, the illuminations are ornamental but not narrative or pictorial. Figures of animals and humans, often grotesque ones, do appear; but most of them are all but lost in a maze of intertwining, lacelike design that invites the eye to follow any given line as it curves almost endlessly through the pattern (fig. 6-21). The *Book of Kells*, often called the most beautiful manuscript in the world, is now in the library of Dublin College, where a new page of it is turned each day for the admiration of visitors.

Illuminations of the Romanesque period bear resemblance both to the Byzantine mosaics discussed in Chapter 5 and to the stained glass of the later Middle Ages. Backgrounds, often in gold, are simply decorative; figures seem detached from natural space. The figures themselves are flat, with

Fig. 6–21. A page from the *Book of Kells* (the letters XPI, a monogram for Christ's name). 9th century illumination. Courtesy of the Board of Trinity College, Dublin.

little modeling, and are painted in bright colors.

By the fourteenth and fifteenth centuries, before the invention of printing brought a gradual end to the art of making completely handcrafted books, illumination had become an important art, practiced by both monks and laymen. Many books other than religious ones—law books, for instance—were now illuminated. Highly popular were Books of Hours, almanacs of a sort filled with psalms, prayers, and calendars of saints' days. One of the finest of such works is the Book of Hours of the Duke of Berry (fig. 7-32). Another is one made for Catherine of Cleves, daughter of a wealthy Dutch nobleman. In addition to exquisite border decorations, almost half of her book's small pages are illuminated with portraits of saints and with narrative scenes from scripture. Details are often so small—fish in a pond, for example—that they can be seen only with a magnifying glass. Fig. 6-22 depicts Christ carrying a T-shaped cross. Domi-

Fig. 6–22. *Christ Carrying the Cross.* Illuminated page from *The Book of Hours of Catherine of Cleves.* 14th century. Courtesy of the Pierpont Morgan Library, New York.

nating the scene by his size and position, he is aided by Simon of Cyrene, as sour-faced soldiers push him forward.

The relationship of manuscript illumination to the other visual arts—stained glass, fresco painting, tapestry, relief sculpture, and panel painting—is a close and important one. Artists working in the larger forms derived many of their ideas of form and color from the sensitive, precise work of the illuminators.

The Bayeux Tapestry. Of considerable importance for both artistic and historical reasons, and thoroughly delightful in it-

self, is France's famed Bayeux Tapestry (detail, fig. 6-23). This unique work was probably made in England sometime between 1066 and 1100 and was brought to the Norman town of Bayeux to grace the newly consecrated cathedral there. Since the design is not woven into the fabric itself, it is not a true tapestry. Actually, it is a piece of linen 20 inches wide and 231 feet long, with embroidered pictures, stitched in colored wool threads, running in continuous or comic strip style the full length of the material.

For centuries a pleasant tradition had it that Queen Matilda, wife of William the Conqueror, made the Bayeux Tapestry her-

Fig. 6–23. *The French and English Fall in Combat.* Detail of the Bayeux Tapestry. Late 11th century. With the special permission of the City of Bayeux, France.

self. It was probably commissioned, however, by Bishop Odo of Bayeux (William's half-brother), designed by an unknown artist of singular imaginative power, and worked by a number of hands. Possibly even children helped with some of the whimsical animals in the borders.

The Tapestry recounts, from the Norman point of view, the events leading up to and including one of history's most significant military encounters, the Battle of Hastings (1066). Edward, the English king, promises that the successor to his throne will be his cousin, Duke William of Normandy, and he sends his brother-in-law Harold to Normandy to confirm the pledge. Harold crosses the Channel, but his ships are blown off course, and he is taken captive by the hostile Count Guy. William frees him, however, and the two cousins have a friendly time together. After renewing Edward's pledge, Harold returns to England, and soon the aged Edward dies. Now, as the French—and the Tapestry—tell the story, Harold betrays his trust and has himself crowned king. This

is sufficient reason for William to assemble an army of cavalrymen, transport them and their horses across the Channel in a great fleet of long, narrow ships, and encounter Harold's armies. The battle is a fierce one, but William's lance-bearing horsemen conquer the British foot soldiers, and Harold himself is slain.

All of this is related in the Tapestry. The seeming naïveté of the work—figures that are awkward, horses that may have green or blue bodies and varicolored legs—is soon forgotten as one considers its remarkable narrative power and its fascinating details. With the aid of Latin superscriptions, the panel tells the story as clearly as one could wish, with cinematic vividness and a fine sense of conflict and climax.

Individual events are skillfully narrated: Harold and his men, with falcons on arms and hounds running ahead, riding forth to Bosham, where they will embark for Normandy; Harold performing a feat of heroism near Mont-St.-Michel, where he rescues one of William's soldiers from quick-

sand; the death and funeral of Edward; the Norman fleet crossing the Channel; scenes of violent combat; and many others.

Taken together, the two borders and the central panel contain an incredible amount of detail, all involved in action: birds and animals; castles and churches; people at work; warriors, alive or dead, in authentic armor of the time; lances, maces, swords, broadaxes, and other weapons; ships, abuilding and at sea; and above all horses— horses prancing gallantly in procession, galloping into battle, and plunging and tumbling in the thick of the fray.

The earliest written mention of the Bayeux Tapestry is found in an inventory made in the cathedral in 1476. Though it had admirers over the centuries, it came close to destruction during the French Revolution when soldiers wanted to use it for wagon covering. It was rescued, however, and in 1803 Napoleon had it brought for a time to Paris. Today, in the Museum of Queen Mathilde near the square of Bayeux cathedral, it is on display in a large room, where visitors with multilingual listening devices get a running account of the story as they view the Bayeux Tapestry.

We could wish for many more examples of secular Romanesque art, if only to give us a more rounded view of the overall content and quality of that art. The comparatively few works that have survived give us intriguing glimpses of the creative forces stimulated by feudalism, with its military and chivalric traditions. But the all-pervading cultural influence of the church can be seen much more clearly in the hundreds of examples of Romanesque religious art that have come down to us—cathedrals and abbey churches, relief sculptures, bronze doors, murals in fresco, music drama, illuminated manuscripts, and many more.

The artist, whether cleric or layman, was not given the recognition that was to be his in later centuries. It is true that master builders occupied positions of dignity and respect, and doubtless many other artists were admired in their own lifetimes for their special skills. But the idea that a stone carver or painter or composer of music was in any way different from other makers of things, or that his name deserved to be perpetuated along with his creations, was only beginning to emerge.

7

THE LATE MIDDLE AGES: GOTHIC ARTS

To seventeenth-century men and women, fond of the elegant symmetry of Renaissance palaces and churches, probably few things were more unpleasing than the towering, pointed cathedrals that had long been the centers of many European cities. Almost every feature of these buildings must have seemed ugly: the high vaulting, the buttressing that extended far out from the walls, the stiff, angular sculpture, the strange creatures that served as watchguards of waterspouts. To express their distaste for this earlier style, later Renaissance humanists coined a name for it—"Gothic"—derived from that of the barbarian Germanic tribes that had invaded the Roman Empire centuries before. To apply this term to any work of art was to brand it, of course, as barbarous, unclassical, uncivilized. Though a great enthusiasm for so-called Gothic arts—especially architecture—reasserted itself in the Gothic revival of the later eighteenth and nineteenth centuries, the initially negative term has not been abandoned, and we now apply the term *Gothic* to all of the arts produced during the High or late Middle Ages.

As we have said before, the beginning of the Gothic period is usually set sometime toward the middle of the twelfth century, when certain architectural features such as pointed arches, flying buttresses, and stained glass came prominently into use. But the Gothic became more truly an international European style in the thirteenth century. The terminal date of the period is more difficult to fix. In the South the new movement we call the Renaissance was beginning in the second half of the fourteenth century; but in northern Europe the Gothic style continued for another century or more.

The Church and the New Orders. Political and even military clashes between the church and the state, particularly the Holy Roman Empire, were commonplace during the Romanesque era. They became even more frequent and severe in the Gothic age. Probably no emperor was more feared and hated by popes and their supporters than was Frederick II, former king of Sicily, who reigned from 1215 to 1250 as emperor of the Holy Roman Empire. But the same period was in many ways the high point of papal power. Innocent III (1198–1216) was able to consolidate more churchly and secular power than any other pope. He succeeded in

securing more firmly for himself the right to name bishops (investiture), and he became the leading arbitrator in conflicts between the monarchs and the other nobles of western Europe. He also gained the support of the bishops and monastic leaders of the church, some of whom had not always shown unwavering loyalty to the bishop of Rome. During the papacy of Innocent III the Fourth Lateran Council was called; it instituted several reforms, including a ban on the sale of relics.

The strengthening of the papacy corresponded to reform and growth among monastic orders. Most important was the founding, in the early thirteenth century, of two mendicant (begging) orders of monks that were to play significant roles in the religious and cultural life of Europe. Both of them, the Franciscans and the Dominicans, were dedicated to active service of their fellowmen. The Dominicans, following the admonitions of their founder, St. Dominic (1170–1221), believed they could best serve by stressing the intellectual and doctrinal aspects of the faith. St. Francis of Assisi (1182–1226) and his followers emphasized the simple, humanitarian, evangelical approach to service and conversion. In time the two orders became serious rivals and opponents in doctrinal matters. In fact, the strongest opposition to the teachings of the great Dominican schoolman St. Thomas Aquinas came from the Franciscans Duns Scotus and William of Occam.

Toward the end of the Gothic period the Catholic church suffered perhaps its most troubled years—at least until the time of Luther. With the encouragement of the French king, the pope was persuaded to move the seat of the church from Rome to Avignon, in southern France. The worldly ways of the popes and their adherents in Avignon raised such a chorus of criticism that the spiritual authority of the church became increasingly difficult to sustain. Italian churchmen finally refused to acknowledge the popes as true followers of St. Peter. Be- cause the "exile" in France reminded the faithful of the conquest and exile of the ancient Israelites, the period from 1305 to 1378 was called the *Babylonish Captivity*. The consequences of this stay in France were to prove deeply serious for the papacy. For the next century or more, leaders of the church were embroiled in continuous struggles for power—even for existence.

Decline of Feudalism, Growth of Nations. Political and civil life in the Romanesque era had been unstable and disorganized. It continued to be so in the Gothic age, especially in what are now Italy and Germany. The political and military power of feudalism, never strong except in isolated areas, continued to decline. Kings were often weaker than their noble subjects. The Holy Roman Empire was more often a divisive than a unifying force.

But powerful kings began to emerge in two states in particular—France and England. In France a new dynasty was founded with the election to the throne of Count Hugh Capet of Paris. Kings of Capet's line were gradually able to add new territories to their kingdom. Moreover, they weakened their vassals by coming to the aid of the barons' natural enemies, the church and the middle-class inhabitants—the *bourgeoisie*— of the cities. By various means, such as limiting the barons' rights to tax, the French kings became the most powerful rulers on the continent. Among those most prominent in fostering the growth of monarchy were Louis VI (the Fat), Philip II (Augustus), Louis IX (St. Louis), and Philip IV (the Fair).

The progress of English kings toward political power was quite different from that of the French rulers. The Norman Conquest established a powerful monarchy in England that became even stronger under Henry II, a Norman prince who also controlled much of southern France as a result of his marriage with Eleanor of Aquitaine. Using techniques similar to those of the French kings, Henry established a royal judicial system; the be-

ginnings of English common law can be traced to his efforts. After Henry II, however, the English kings met with a number of setbacks that ultimately led to the formation of a constitutional monarchy. Richard I (the Lionhearted) was too busy with adventures and crusades to be much concerned with affairs in England. His brother John, who succeeded him, met with strong resistance when he tried to impose high-handed and arbitrary rule on his subjects. In 1215, after having made a number of concessions to the church and the nobles, he was forced to sign the famous Magna Charta. This document, though in no sense a democratic manifesto, did establish the principle that even the king was subject to the basic laws of the land. England experienced a great many political problems in the centuries to come, but the precedents established during this period helped to promote a genuine and continuing sense of nationhood.

Education and the Universities. Universities continued to grow in numbers during the thirteenth and fourteenth centuries. Especially important were the new German universities, the first to be established outside of Italy, France, and England. The curriculum remained largely as it had been during the Romanesque era, but the trivium and quadrivium were now supplemented (or sometimes even replaced) by three major fields of study—law, medicine, and theology. Some changes also occurred in the study of the natural sciences. Roger Bacon (c. 1214–1294), an English Franciscan, developed a basically empirical approach to scientific knowledge; he asserted that earthly truths were more accessible through observation than through reasoning.

Latin was the universal academic language. Students often wandered from land to land, visiting universities where their chosen subjects were emphasized and where famous scholars lectured. Bologna became known for the study of law, Paris for theology, and others for medicine. All students were theoretically trained to enter religious orders, but this assumption did not divert them from their chosen fields of study or from what was quite often a nonreligious way of life. The students' quarters gained a reputation for boisterous parties, heated debates, and defiance of civil authority. (The Latin quarter of Paris, still famous for its bohemian life, is so called because Latin-speaking students once resided there).

The most important philosophical development of the Middle Ages, a product of the universities, was *scholasticism*. Though it had its beginnings in earlier centuries, it reached its greatest flowering during the Gothic period. The most influential figure in the movement was St. Thomas Aquinas (c. 1225–1274). Though Italian by birth and early education, he is most closely associated with the University of Paris, where he settled after first studying with the German scholar Albertus Magnus in Cologne.

Thomas was by no means the first Christian to study and admire the works of Aristotle, even though Aristotelian thought was held by many Christians to be in basic conflict with Christian faith and dogma. Thomas, however, felt that Aristotle had demonstrated a greater awareness of truth than any other "uninspired" person who ever lived. Hence he adopted many of Aristotle's teachings as supports for Christian doctrine. But his opponents felt that any attempt to explain church teachings by rational means led Christians away from faith. In reality Thomas always stressed the primacy of faith and revelation, but he believed they were buttressed by reason. Thus, although he employed rational and dialectical methods in setting forth his views in his huge *Summa Theologica*, he always arrived at conclusions already sanctioned by the church. In 1879 Pope Leo XIII officially established Aquinas' authority in doctrinal matters. In fact, however, he had been considered the church's leading theologian since shortly after his death.

The influence of scholasticism went far

beyond the study of theology. Architecture, sculpture, painting, and other arts were all involved in an attempt to synthesize the knowledge of this earth with faith in God.

LITERATURE

Unlike the literature of the preceding age, much of which was produced by minstrels or by generations of unlettered storytellers, much literature of the later Middle Ages was written by well-educated men who were conscious of literature as an art. Even St. Francis, though he wrote in a simple, seemingly spontaneous style, was far removed from the unknown singers of the previous age.

Theological writers such as Aquinas still employed Latin, but poets and writers of fiction whether in prose or verse—such writers as Dante and Chaucer—were making innovative use of their vernacular tongues.

St. Francis of Assisi is one of the most fascinating of religious figures, and he has long been the most popular of saints of postbiblical times. After a rather careless early life, he chose to renounce his father's wealth and to devote his life to the service of the poor. He became a teacher and leader of humble men. In fact, if we can accept tradition, he took literally Christ's admonition to "preach the Gospel to all creatures" and even gave sermons to birds and wild beasts. He was persuaded by Innocent III to form a religious order, and his followers eventually became known as Franciscans.

Francis's writings, such as his beautiful "Canticle to the Sun," are simple and moving. His prayers and hymns demonstrate the power of a complete faith. This prayer is typical:

Lord, make me an instrument of thy peace.
Where there is hatred, let me sow love;
Where there is injury, pardon;
Where there is doubt, faith;
Where there is despair, hope;

Where there is darkness, light;
Where there is sadness, joy;
 Grant that I may not so much seek to be
 consoled as to console,
To be understood as to understand;
To be loved as to love;
For it is in giving we receive;
It is in pardoning that we are pardoned,
And it is in dying that we are born to eternal
 life.

In addition to Francis's own writings, his life inspired others to record his experiences and the legends that attached themselves to him. These were collected a century after his death in a volume entitled *The Little Flowers of St. Francis*. The stories of miracles, the sermons, and the other matters related in this book provide some of the most charming personal glimpses we have of a dedicated man of God. Particularly appealing are the stories concerning his experiences with wild animals and birds—the story, for instance, of his rebuking a wolf that had been terrifying a city.

The Florentine poet Dante towers above all the literary figures of the Middle Ages—or, with few exceptions, of any other age. Despite problems of translation and the growing secularization of our time, his great religious poem the *Divine Comedy* remains one of the most widely admired of all literary masterpieces.

Dante was born in Florence in 1265. Blessed with a remarkable memory, he perhaps came as close to a complete mastery of the learning of his time as any man has ever done. At an early age he began writing poetry and philosophical treatises in both Italian and Latin, but he soon became involved in the complex and often turbulent political affairs of Italy and especially of Florence. As a city official he tried to remain impartial in a struggle between two bitter factions, the Blacks and the Whites (he even voted to banish two close friends of his who were leaders of the factions), but he later became associated with the Whites. This action led to his own banishment; while away from Florence

on a diplomatic mission, he was tried *in absentia* and sentenced to exile, upon threat of death should he return. From 1301 until his death in 1321 he never again saw his native city. In his banishment he spent much of his time as an honored guest of one nobleman or another. He died in Ravenna, and his remains are entombed there.

While living in exile Dante wrote his masterpiece, the *Divine Comedy*. But before his banishment he had composed a smaller work, *La Vita Nuova*, which recounts in poetry and prose the circumstances (perhaps more allegorical than real) of his love affair with Beatrice Portinari. He loved her from afar, and she married another. When he was twenty-five she died suddenly, and he was overcome with grief. Beatrice, whose name signifies blessedness, was to become one of the major allegorical characters of the *Divine Comedy*. In that poem it is at her bidding that the poet Vergil guides Dante through Hell and Purgatory, and she herself directs and instructs him as he visits Paradise.

Though generally called an epic, the *Divine Comedy* differs from other epics in several important respects, including its overall structure and the fact that it has no epic hero in the usual sense. But it is epiclike in the grand sweep of its action; and the extended, adventure-filled journey that constitutes its plot is also a familiar part of the epic tradition. But basically the poem is an allegory. The entire journey is one large symbol—the progress of the individual soul away from sin, through penance, into salvation and grace. Moreover, almost every person, object, number, or action in the poem represents something in addition to itself—be it a quality of character, a virtue or vice, or a political or social attitude. Thus Dante himself is both the Italian poet and a symbol of all humanity. Vergil represents Reason, and Paolo and Francesca the vice of sexual incontinence, for example. The symbolic characters are drawn from everywhere—classical mythology, scripture, history, and contemporary Italian political life.

In the first and most dramatic of the poem's three large sections (*canticles*), Vergil guides Dante through the Inferno or Hell. They descend through a series of gradually narrowing concentric circles, under the surface of the earth and reaching to its center. Here the damned, the unrepentant, are punished according to the gravity of their sins (the punishment is often the sin itself in its starkest form). Nearest the top and receiving lightest punishment are the incontinent. Further down are the violent—the suicides, for instance, encased in leafless trees. At the bottom are those guilty of fraud, the misuse of man's God-given mind, in its various forms—deceivers, thieves, hypocrites. At the very bottom, frozen in ice and separated forever from their fellows, are the traitors to their masters, to their countries, and to God. In their midst, eternally fanning his batlike wings in the bitter cold, is the three-faced figure of Satan himself.

The Mount of Purgatory, up which Dante and Vergil climb in the second canticle of the *Comedy*, is a terraced mountain reaching up from the Southern Hemisphere. Here the pace is more deliberate and the tone more cheerful. Here are penitent men and women who are in the process—sometimes a very painful one—of purging themselves of all sin and preparing themselves for eventual salvation. Our travelers move through circles or terraces representing all the seven deadly sins (pride, covetousness, lust, anger, gluttony, envy, and sloth); Dante himself finds it most difficult to get through the Circle of Pride. At the top of the mountain they come to the Earthly Paradise, an Eden-like place where Beatrice, having been instructed by Mary, meets them and prepares Dante for the ultimate journey to Paradise, with Beatrice herself as guide.

In the *Paradise*, the third canticle, drama and vivid imagery give way to spiritual profundity and mystic vision. Dante tells us he is incapable of recounting the glory and rapture he experienced there. As he and Beatrice travel from one heavenly body

to another—the moon, Mars, the sun, Jupiter, and so on—they visit and converse with persons who represent the seven virtues—prudence, justice, fortitude, temperance, faith, hope, and charity. At the end Dante is granted a vision in which he sees great masses of the Blessed arranged like petals of a white rose, with God in the center.

Geoffrey Chaucer, England's greatest poet before Shakespeare, was born about 1340. The son of a prosperous wine merchant, he traveled widely as a businessman and diplomat. His journeys took him to France and then to Italy, where he became acquainted with the writings of Boccaccio, great early Renaissance storyteller. He later retold in verse some of Boccaccio's tales, including the story of the patient Griselda. Chaucer himself was in some ways a transitional figure—more a man of the world than most of his English contemporaries, but still a reflection of the Middle Ages in his basic attitudes.

As a medieval man Chaucer was capable of being as didactic as Dante on occasion, but at least as often he was the keen-eyed, good-natured observer of his fellow men and women, recording their foibles ironically but tolerantly. His writing, which he seems to have done as a avocation, is concerned with the life of his own day or with retelling classical tales in medieval settings. His first great work was *Troilus and Criseyde*, a long narrative poem based on a legendary incident in the Trojan War. Though related to the medieval knightly romance, Chaucer's poem is far more profound in its probing of character than are typical medieval narratives.

Chaucer's masterpiece, his *Canterbury Tales*, is a collection of stories, mostly in verse, of astonishing variety. The frame for the tales is a pilgrimage to Canterbury, to which cathedral town devout English men and women often journeyed to see the relics of the murdered St. Thomas à Becket. The host of the London inn where the pilgrims assemble proposes that they take turns telling stories to pass the time as they travel.

They agree, but before they begin, Chaucer introduces each of them in his marvelous Prologue, perhaps the high point of the entire work, with such unforgettable characters as the poor parson, the genteel prioress, the rascally pardoner, the oft-married Wife of Bath, the bawdy miller. The stories they tell match their characters—noble, pious, bawdy, pedantic. Among the most popular of the stories are "The Wife of Bath's Tale," "The Nun's Priest's Tale," "The Pardoner's Tale," and "The Prioress's Tale." All superb examples of the storyteller's art, they are written in a variety of verse forms, some of which were original in their time.

MUSIC

Leonin and Perotin, composers mentioned in the last chapter, lived during the period of transition from the Romanesque era to the Gothic. In fact, Perotin's works were composed during the first four decades of the fourteenth century. As we have seen, the greatest change these earlier composers introduced was to prolong the notes of a chant, which now became the *cantus firmus* or *tenor*, and to add another melody—even two melodies—above it, the *duplum* and the *triplum*. The whole was called an *organum*. Scholars believe that the *cantus firmus* was generally played on an instrument rather than sung. It remained important, however, because it furnished the base upon which the rest of the piece was built. The *cantus firmus* also figured in a new development of the twelfth and thirteenth centuries, the polyphonic *conductus*. This form was similar to the multivoiced organum, but the *cantus firmus*, instead of being held out for long stretches, was now divided into shorter, more rhythmic sections. The upper voices of the *conductus* also had strict rhythmic patterns, and the piece created the effect of a series of chords. There was no chordal progression, however; one chord did not lead naturally to the next.

During the early decades of the thirteenth century, French composers developed a form that was to dominate music for the next half-century or more. This was the *motet*. The term *motet*, which comes from the French *mot* or *word*, refers to the fact that new textual passages were added to the upper voices in polyphonic music. These new words were sometimes hymns or secular verses in Latin, sometimes French love poems, and often a combination. A particularly popular combination had a Latin chant in the tenor, a Latin hymn to Mary in the middle part, and a French love song in the upper or triplum line. Historically, the rhythm of the motet was more important than the words: it was inevitable that multi-voiced music, unless it was to be sheer chaos, had to be more regular in its rhythms than the earlier plainsong. This new regularity set the pattern, rhythmically, for Western music in general through the centuries.

Motets, though they were composed by musicians connected with the church, were more secular than religious. In fact, much of the music composed at the end of the thirteenth century was intended for secular performance, often in the courts of the French kings. Many new forms were invented, including the *rota* or round. The development of new secular styles continued so rapidly that after the first quarter of the fourteenth century a French composer named Philippe de Vitry termed the music of the time *ars nova*, the *new art*.

Ars nova contributed several important innovations. For the first time in serious music, composers used a meter based on two beats (duple time) rather than three. Often, at least in secular compositions, they eliminated the *cantus firmus* and stressed the melodic line, keeping the other parts as harmonic accompaniment.

The most famous composer of *ars nova* was Guillaume de Machaut (c. 1304–c. 1372). Machaut composed a great number of secular works and contributed to the development of the *ballade* and other new types of songs. More than most composers of the time he related the mood of the words to that of the music. His melodies are written in phrases; that is, they are divided into small, recognizable melodic sections, as most modern songs are.

Machaut's most famous work, however, is not one of his many secular pieces but a mass, the *Messe de Notre Dame*. It is especially important because it is the first known mass that was composed as a single musical entity, rather than being made up of parts created by different composers. Machaut's mass was not only composed as one work, but it is unified by the repetition and variation of melodic patterns in each of its sections. It may be said that the development of the mass as a unified musical form began with the work of Machaut.

A minor but intriguing form of medieval secular music is found in the popular songs that the goliards, the wandering students of the later Middle Ages, composed in large numbers. Ranging from the romantic to the racy, their texts were written in Latin and a variety of vernacular tongues. Most of them have been lost, but a number have gained great popularity in recent years in Carl Orff's modernized collection called *Carmina Burana*.

ARCHITECTURE

The outburst of church and cathedral building that began during the Romanesque era continued with increased fervor in the Gothic age. Much of the stimulus came from national and communal pride that was developing throughout Europe. This enthusiasm for building great religious edifices manifested itself among all classes of people and in many interesting ways. When the Abbot Suger was building the Abbey Church of St. Denis near Paris (usually considered the first Gothic church), he recorded some incidents that happened at the rock quarry:

Whenever the columns were hauled from the bottom of the slope with knotted ropes, both our own people [of the abbey] and the pious neighbors, nobles and common folk alike, would tie their arms, chests, and shoulders to the ropes and, acting as draft animals, draw the columns up; and on the declivity in the middle of the town the diverse craftsmen laid aside the tools of their trade and came out to meet them, offering their own strength against the difficulty of the road, doing homage as much as they could to God and the Holy Martyrs.

The first Gothic churches were built in the Ile de France, the area around Paris, but by the thirteenth century the style was popular in Germany, England, and to some extent Italy.

As we have mentioned before, most of the features that characterize Gothic architecture—pointed arches and windows, ribbed vaulting, rose windows and other stained glass, flying buttresses, and elaborate façades—developed individually during the Romanesque era. Only when several of them were combined, always including ribbed vaulting,, did true Gothic come into being. (We are speaking here almost exclusively of church building. Secular architecture, including castles, changed little from the Romanesque.)

The first impression one gets in a Gothic cathedral is one of almost incredible size—length, but especially height—height that seems remarkable even in this age of superdomes and other huge sports and convention centers. The side walls of the Gothic cathedral are in three parts, as they were in the Romanesque and early Christian, but the overall effect is now quite different (fig. 7-1). The nave arcade is much higher and lighter; the high, pointed arches are less massive, and there is increased light from the side aisles. Usually the triforium also has pointed arches, often called lancet arches. The Gothic clearstory is high—much higher than the Romanesque. Stained glass windows occupy almost all the upper space in each bay, be-

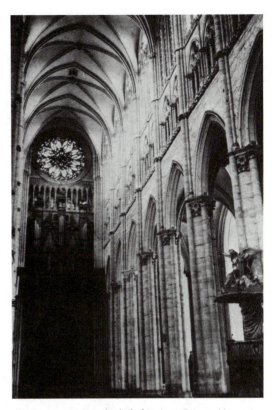

Fig. 7–1. Nave, Cathedral of Amiens, France. Nave completed in 1243.

tween the supporting columns. The masonry of the walls is thin, too thin to cut off much light at the sides of windows. All in all, most northern Gothic cathedrals, when one allows for the dimming effect of stained glass, have much better natural illumination than Romanesque buildings. This reflects not only increased technical skill but changing religious and philosophical attitudes: among the most popular scholastic symbols for God were space and light. Space and light were everywhere and yet were intangible and incomprehensible. Builders were ready to symbolize these concepts in their huge edifices and to add to them the dazzling beauty

and pictorial significance of stained-glass windows.

The vaulting of a typical early Gothic church is illustrated in fig. 7-2. The groined vaults over each bay or section are divided by ribbing into curved sections, usually either four (quadripartite) or six (hexapartite). Because of the ribbing and because the vaulting is pointed rather than rounded, the effect is one of increased height and lightness. The transverse arches that separate one bay from another are also pointed. The support for the vaulting comes from powerful piers, often carved to appear like clusters of columns. These piers and the curved vaulting above draw the eye heavenward; the effect was observed and applauded by medieval churchmen.

The floor plans of Gothic cathedrals vary greatly. Most of them are basically shaped like a Latin cross, but that plan is often obscured in a number of ways. The floor plan of Notre Dame in Paris (fig. 7-3) shows quite blunted transepts. The huge choir, occupying almost all the eastern half of the building, is furnished with an ambulatory where religious processions and visitors can circle behind the high altar. In other churches the transepts are extended and the choir diminished. Attached to the choir or apse end of the typical cathedral are several rooms or recesses called chapels, each of which has its own altar and is used for special services. The largest of these, directly east of the main altar of the cathedral, is the Lady chapel, dedicated to the Virgin Mary.

The exterior of the Gothic church reflects in part the plan of the interior, but it is often less vertical in its feeling, and its outlines are somewhat obscured by the *buttressing*, both *engaged* and *flying*. As walls became thinner and were pierced with more windows, they were less capable of supporting heavy stone vaulting. Hence it became necessary to support the walls from the outside. Some of the buttresses were built against the wall (engaged) to support its lower sections. Some ingenious builder devised a scheme for supporting higher walls by building but-

tresses some distance away from the walls and connecting them to the walls with half-arches. These flying buttresses were developed for practical reasons, but their striking appearance soon became an important aesthetic feature of Gothic churches. Certainly the exterior of the choir of Notre Dame in Paris (fig. 7-4) would lose a great part of its dramatic impact if the famed flying buttresses were removed.

During the Gothic age the west side of the cathedral developed into a true façade. Though there is much variety in Gothic façades, one can usually recognize in them three fairly distinct divisions. In the bottom section are three great portals, recessed doorways under high, sculpture-filled pointed arches. The middle section, which is sometimes separated from the bottom one by a row of statues, is dominated by a huge stained-glass window, often forty feet or more in diameter—the *rose window*. Usually there are other windows at this level—narrower, pointed ones called *lancet windows*. Climaxing the façade are the towers and spires. Some of these soar to great heights; others are quite blunt. Often the blunted towers simply reflect the fact that building plans were never completed. Frequently the two west pointed towers or spires do not match; one was erected decades or even centuries after the other, when styles had changed. In fact, Gothic churches in which a single master plan was carried out from beginning to end are quite rare.

French Gothic. Many of Europe's most famous Gothic churches are found in the Ile de France, the area that surrounds Paris. St. Denis, which we have mentioned as the first Gothic church, is of special historical significance. The choir (fig. 7-5) is particularly noteworthy, because here we see the upward thrust that was to typify the new style. The ribbed vaulting and the stained glass in the large lancet windows are also true Gothic.

Chartres, about fifty miles southwest of Paris, is probably the most widely ad-

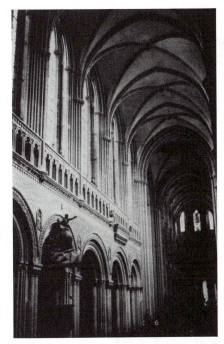

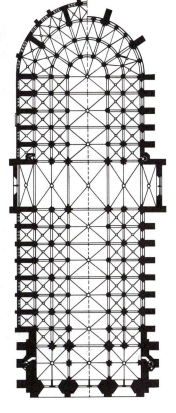

Fig. 7–2. Interior, Cathedral of Notre Dame, Bayeux, France. 12th–15th centuries. Romanesque arcades, Early Gothic clearstory and vaulting.

Fig. 7–3. Plan, Notre Dame Cathedral, Paris.

Fig. 7–4. Cathedral of Notre Dame, Paris.

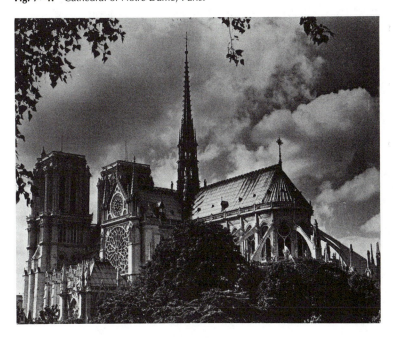

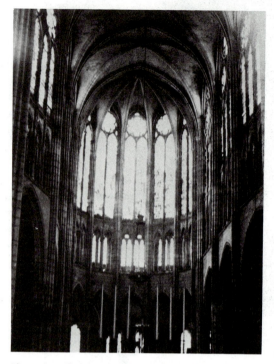

Fig. 7–5. Choir windows and vaulting, Abbey Church of St. Denis, France. 1140–44.

mired of all Gothic structures—distinguished, among other things, for its setting, its magnificent sculptured portals, its two great western towers, and above all the superb stained glass that suffuses its interior with constantly changing colored light. In many respects it is a self-contained record of the transition from Romanesque to Gothic, for it consists of parts of several churches that were partially destroyed and then rebuilt. The façade (fig. 7–6), with its two unmatching yet balanced towers, is especially interesting. The tower on the right, the simpler and older one, makes a perfect transition from its square base to the octagonal spire. The left tower, built several centuries later, is taller and more elaborate, and its stonework is pierced with open spaces. The late Romanesque portals, perhaps some-

what small for the rest of the building, nonetheless blend beautifully into the whole façade.

Notre Dame of Paris (fig. 7–7) has become linked with romantic literature and is itself the subject of several admiring books. Few façades are more familiar, nor are many more symmetrical or better balanced. The interior vaulting is especially important, as is the grand, high choir with its ambulatory and small radiating chapels, culminating in a beautiful Lady chapel.

The façade of Rheims (fig. 7-8) is an especially fine example of the French Gothic style. At first glance the portals appear to be recessed into the building, but actually they are built out from the west wall, and a porch has been constructed to cover them. The pointed gables on the porch and the elongated lancet windows give the façade at once a feeling of richness and of lightness and an upward reach.

Although the great cathedrals were dedicated to God and the saints, the builders often added decoration that reflected a more ordinary human interest. The towers of Laon cathedral are ornamented with large statues of oxen, animals that were honored by churchmen and townspeople because of their faithful service in pulling huge stones many miles from the quarries. Similar tributes can be found on many Gothic structures. Since the Gothic world unified the sacred and the secular, no one found these images from the profane world at all unusual.

German Gothic. Strictly speaking, there was no Germany during the Gothic period; there were simply a number of German-speaking kingdoms and principalities. And there was no distinct German form of Gothic architecture. Many German churches, especially those along the Rhine, were evidently copied almost directly from French cathedrals. Others, however, are more characteristically "German" in style.

Most famous of Gothic churches in

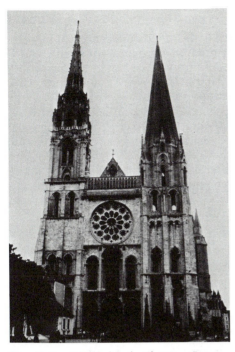

Fig. 7–6. Cathedral of Chartes, France. Begun 1194.

Fig. 7–7. Cathedral of Notre Dame, Paris. Detail of façade.

Fig. 7–8. Cathedral of Rheims, France. About 1225–90.

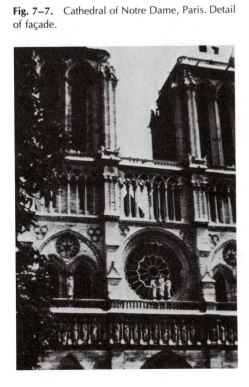

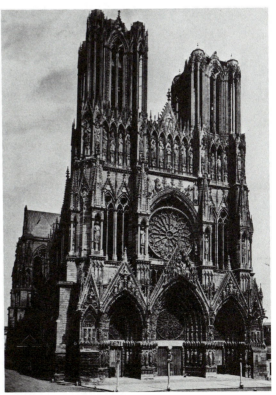

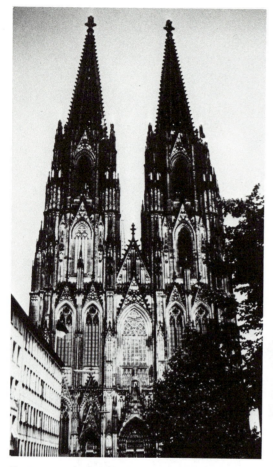

Fig. 7–9. Cathedral of Cologne, Germany. Begun 1248.

finished in the nineteenth century. Only one other church in Germany—or in the world, for that matter—exceeds it in height; that is the Minster at Ulm, whose single spire soars 528 feet into the air.

The façade of the Strasbourg cathedral (this one-time German city is now in France) exemplifies the final stages of the late Gothic *flamboyant* style, so called because of the elaborate, flamelike stone tracery projecting up from the portals and ornamenting the windows (fig. 7-10). The cathedral was to have had two high open-work spires, but only the north one was erected.

English Gothic. A number of English churches—Lincoln cathedral, for instance

Fig. 7–10. Strasbourg Cathedral, France. Detail of façade. (Lower façade begun 1272).

Germany is the cathedral of Cologne (fig. 7-9). Though basically in the French Gothic style, its massiveness would dwarf almost any French cathedral that was placed alongside it. In floor space it is the largest of all Gothic buildings. Its façade, which has no rose window, is almost overwhelming, with two towers that reach over five hundred feet in height. Much of the Cologne cathedral is actually quite new; the original builders ran out of funds, enthusiasm for great churches diminished, and the cathedral was left half completed for hundreds of years until it was

(Ch. 6), St. Albans and others—were begun in the Norman Romanesque style and completed in the Gothic. The first essentially authentic French Gothic cathedral in England is the historic Canterbury cathedral, begun (after an earlier Norman choir had been destroyed by fire) about 1170. Gothic cathedrals and other churches began to rise all over England, and soon English master masons introduced innovations. They lowered and lengthened the buildings. They often eliminated the rounded choir or apse. And as time passed they developed a "decorated" style of stonework, especially of vaulting (fig. 7-11) that became one of the glories of English architecture.

Figure 7-12 shows the façade of the cathedral at Wells. The portals are far smaller than those of French cathedrals, and the lines are strongly horizontal. Inside, however, the cathedral has the familiar Gothic up-

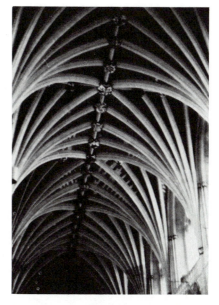

Fig. 7–11. Fan vaulting of Exeter Cathedral, England. 14th century.

Fig. 7–12. Wells Cathedral, England. Begun about 1176.

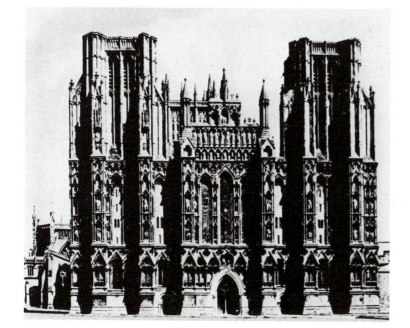

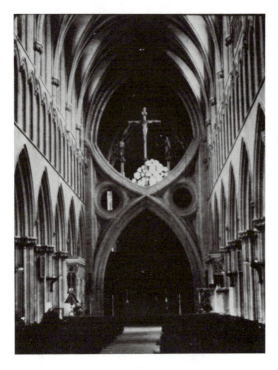

Fig. 7–13. Nave, Wells Cathedral, with inverted (scissors) arches.

ward thrust. Apart from its extraordinary *strainer arches* (or *scissors vaulting*), added when a heavy tower overhead threatened to buckle the walls (fig. 7-13), the most beautiful feature of Wells is the *fan vaulting*, so called because the ribs spread out like those of a fan. A variation of fan vaulting, here called umbrella vaulting, is found in the beautiful chapter house of Salisbury cathedral (fig. 7-14). Other examples of England's decorated style can be seen in Winchester, Bristol, Bath, and Exeter cathedrals and in the Chapel of Henry VII in London's historic Westminster Abbey.

Italian Gothic. In Italy, where Christian church architecture had its beginnings, builders largely went their own ways during the Gothic age. They adopted some of the stylistic features of French Gothic but modified them to suit their own climate and traditions. In Assisi, for example, where a complex of two churches, the Basilica, was built in honor of St. Francis, they pointed the arches of windows, vaulting, and doors but reduced flying buttresses to a minimum and built a flat, plain-looking façade with a very

Fig. 7–14. Vaulting of Chapter House, Salisbury Cathedral, England. 1220–70.

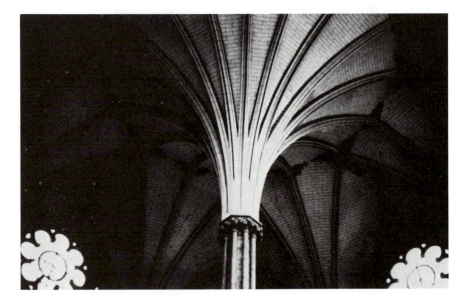

small rose window. The interiors do have some feeling of height, but the windows are few and plain, and there are no nave arcades or side aisles. Instead, there are large areas of wall space, covered with famous frescoes mostly depicting incidents from the life of Assisi's favorite son. These two simple Italian Gothic churches blend beautifully into their surroundings—the stone walls and stuccoed houses of the charming hillside town.

The facade of Orvieto cathedral (fig. 7-15), one of the most admired works of architecture in Italy, comes a little closer to the French Gothic. The portals, though rounded, have pointed, Gothic-like gables above

them. The triangular form of these gables, duplicated by other triangles at the apex of the façade, gives the front of the cathedral a vertical feeling. The rose window is an exquisite piece of glass and stonework. The mosaics, though unusual in Gothic architecture, add depth and richness to the façade.

The cathedral of Florence is an interesting blending of styles. It is basically Italian Gothic, but its dome, added long after the rest of the building was completed, is celebrated as an early example of Renaissance architecture (fig. 8-4). The cathedral of Milan (fig. 7-16) is the largest Gothic church in Italy; it is also the least Italian. Its principal designers, brought from France and Ger-

Fig. 7–15. Portion of façade, Orvieto Cathedral, Italy. Begun 1290.

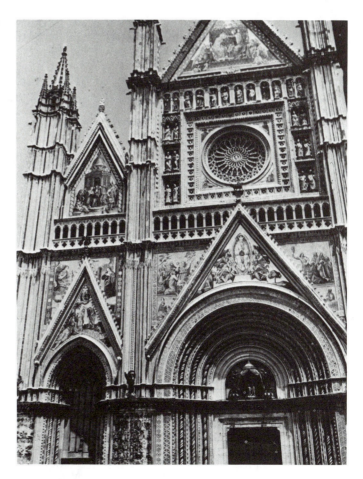

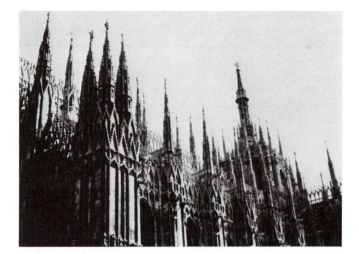

Fig. 7–16. Spires of Milan Cathedral, Italy. Begun 1386.

many, seemed determined to out-Gothic the Gothic. Building in the late flamboyant style, they did everything they could to add ornamentation to the huge building. The layers of windows, the hundreds of statue-topped pinnacles, the complex buttressing, and the overall excess of decoration dazzle tourists but evoke little enthusiasm from art critics and historians.

SCULPTURE

Romanesque sculpture was almost always an adjunct of architecture, as ornamentation and as symbol. During the Gothic period, sculpture and architecture continued to be closely associated, but sculpture also began to take on an independent life of its own, for the first time in many centuries. Large numbers of sculptured figures on the exteriors of churches were now essentially freestanding. More importantly, some elements of classical sculpture—idealized faces, contrapposto, natural draperies, anatomical correctness—appeared again in Western art. Though many of these "classical" elements were probably a result of natural evolution, there is evidence that at least a few Gothic sculptors had opportunities to study ancient works.

The sculpture at Chartres, completed over a relatively long stretch of time, demonstrates several developments. We have seen earlier (fig. 6-17) the Romanesque jamb statues of Old Testament kings and queens in the west portals, with their columnlike figures and warm human faces. The tympanum of the west center or *Royal* portal, sculptured a little later, shows Christ as judge of the universe (fig. 7–17). Instead of surrounding him with distorted figures of the damned and saved, as a typical Romanesque sculptor would have done, the artist here has created an orderly arrangement of the signs of the four evangelists surrounding a serene Savior, mounted above a lintel ornamented with small figures of the apostles, and surrounded in the receding arches or *archivolts* by the elders of the apocalypse. The simplicity and order of the arrangement contrast with earlier styles.

The jamb statues of the south portals (fig. 7-18) were completed during the first quarter of the thirteenth century, about fifty years after the west portals. Notice how the figures, though still somewhat columnlike, have become more realistic and individualized. The robes are not yet natural, but they do seem to drape over human bodies. Still later and still more realistic—a strikingly warm, graceful human figure, in fact—is St. Modeste, in the north porch of Chartres.

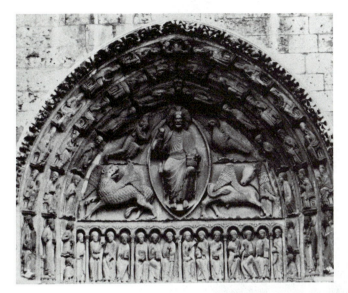

Fig. 7–17. *Christ as Judge.* Tympanum, Royal Portal, Chartres Cathedral, France. About 1145–70.

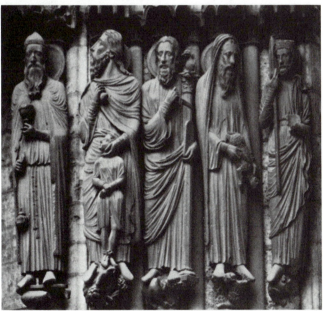

Fig. 7–18. Jamb statues of South Portal, Chartres Cathedral. 13th century.

A famous trumeau statue, the Golden Virgin of Amiens (fig. 7-19), illustrates how the trend toward naturalism continued. The Golden Virgin is almost Grecian in its contrapposto. The smile on the Virgin's face, seen again on the faces of many Gothic statues, twinkles with a humanness that is almost startling.

Another very common use of sculpture in Gothic churches was in the ornamentation of tombs—recumbent figures of kings, knights, wealthy merchants, bishops, and so on—typically with hands raised in prayer. Such figures indicated the rank of the deceased, but probably seldom were they meant to be actual likenesses. Figure 7-20

Fig. 7–21. *Ekkehard and Uta.* Naumberg Cathedral, Germany. About 1260–1270.

Fig. 7–19. *The Golden Virgin.* Cathedral of Amiens, France. 13th century.

Fig. 7–20. Tomb of a Bishop. Salisbury Cathedral, England.

shows the tomb of an English bishop in the cathedral of Salisbury.

German Gothic sculpture was atypical in that it was designed for the interiors of cathedrals. One of the most skillful of German sculptors was the Naumberg Master, who carved a series of fine works for the Naumberg Cathedral. *Ekkehard and Uta*, German king and queen (fig. 7-21), are two of the best. Their clothing leads one to believe that the sculptor was acquainted with classical sculpture, and their royal faces are solidly human.

Italian Gothic sculptors are especially famous for their relief sculpture, which they developed to a high level of excellence. In Pisa two artists, father and son, sculptured some remarkable pieces for the cathedral and baptistry. Nicola Pisano, the father, was probably the most classically oriented of all Gothic Italian sculptors. His *Nativity* (fig. 7-22), though its faces are more individualized than are those in typical Roman relief sculptures, is strikingly classical in most respects. The draperies remind one of Roman togas, the Virgin's reclining posture is of Roman derivation, the proportions are carefully balanced. In fact, the work as a whole reminds one of a late Roman sarcophagus or of the famous Tellus Relief (Ch. 4).

Nicola's son Giovanni worked with his father on the Pisa sculpture, but he did his most important work elsewhere. In Pistoia he carved on a pulpit a *Nativity* that used many of the same motifs his father had employed. But he chose here to abandon his father's classical principles and to replace restraint and balance with more clearly Gothic movement and emotion. His figures and faces are not idealized; gestures are vigorous and facial expressions are intense. The relief is very high; figures in relatively small panels sometimes stand six or eight inches from their backgrounds.

In Orvieto, remarkably fine relief sculpture ornaments the large flat areas surrounding the doors of the cathedral. It is believed that Lorenzo Maitani did most of the work. The subjects of the large relief panels are derived from Genesis, the Life of Christ, and the Last Judgment. One famous detail, *Cain Killing Abel* (fig. 7-23) shows both the weaknesses and the strengths of the work.

Fig. 7–22. Nicola Pisano. *Nativity.* Detail of pulpit, Pisa Baptistry. Marble. 1259–60.

Fig. 7–23. Lorenzo Maitani *et al.* *Cain Killing Abel.* Detail of relief sculpture, façade of Orvieto Cathedral. Sculpture begun 1310.

The foreshortened arms of Abel are awkward and disproportioned, and the upper body is out of position in relation to hips and legs. But even with these shortcomings the work has a singular force and dramatic intensity.

STAINED GLASS AND PAINTING

Stained glass is closely identified with Gothic architecture. Although glassmaking and the coloring of glass are ancient arts, and although some Romanesque churches had stained-glass windows, the glass craftsmen of the Gothic age raised their art to a level not equaled before or since.

Many cathedrals contain masterpieces in glass, but the windows of Chartres are exceptional both in their beauty and in their state of preservation. Colorplate 2, the famous *La Belle Verrière,* with its superb colors and impressive central figure, is typical of the great twelfth-century windows of Chartres. The large bars that support the glass are of iron, and the individual pieces of glass are held in place by strips of lead. Modern viewers should be aware that the lead strips were not necessarily meant to play a part, as in fact they do, in the aesthetic aspects of the windows. In fact, much of the leading was added years after the windows were completed, in order to repair cracks.

The colors of Gothic glass are difficult to photograph accurately, even—or especially—when sunlight is shining directly through them. But the reproduction shown here gives at least an impression of the colors of *La Belle Verrière.* The blues have a cool, heavenly quality, especially the lighter blues of the Virgin's robe. The red is strong and rubylike. There is evidence that the jewel-like quality was produced by a *flashing* technique, a method medieval jewelers used to make imitation gems. Flashing involved dipping clear glass several times in liquid colored glass before it was blown and laid in sheets. This technique allowed more light to penetrate than could come through solidly colored glass. Details were usually painted onto the glass.

Gothic windows were constructed in two basic shapes: long, pointed lancet windows and round rose windows. Often the two were combined, as in fig. 7-24, which shows windows in the north transept of Chartres cathedral. Often the beauty of such windows was enhanced by stone tracery in a variety of floral, leaf-shaped, or flamelike patterns. Apart from ornamental borders, etc., the windows were pictorial: each window or section depicted a religious scene or sacred figure, often identified by name. The iconography, the subject matter of such works, was often dictated by the donors—a

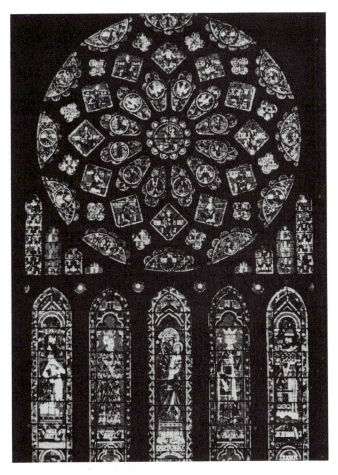

Fig. 7–24. North Rose and Lancet Windows, Chartres Cathedral.

noble family, a craftsmen's guild or some other such group. This was also true of the statuary of the church.

Painting. In the earlier years of the Gothic era, painting was still largely limited to manuscript illumination and some frescoes in churches. But early in the thirteenth century the Byzantine or "Greek" style of painted icons was introduced to western Europe by returning crusaders who had looted such works from Constantinople and elsewhere in the East. The *Enthroned Madonna and Child*, painted in Constantinople in the early thirteenth century, is an example (fig. 7-25). Painters in Italy were enthralled by the style and were soon copying

its every detail (as painters in the Greek Orthodox church still do)—the symmetrical composition; the Virgin's posture and head, including the three-quarter pose; the round, coifed head with its halo, the aquiline nose, and the almond eyes; and the Christ Child, a miniature man poised on his Mother's knee. The unrealistic, two-dimensional quality of the painting, with its shallow, gilded background, was often imitated, as were the symbolic gestures of the two figures. Mary's hand points to the Child to indicate that he is the Way. His right hand is raised in benediction, and the left is placed on the scroll of the Word of God. Even the drapery is stylized, with darts of gold suggesting folds.

Paintings of this kind were usually

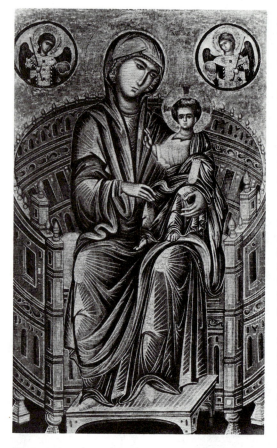

Fig. 7–25. *Enthroned Madonna and Child.* Byzantine School, 13th century. Wood panel, approx. 32 × 19". National Gallery of Art, Washington, D.C. Andrew Mellon Collection.

done on wooden panels that had been covered with linen strips and then with a plasterlike substance called *gesso*. The artist mixed his pigments in a vehicle of egg yolk. This *egg tempera* method, which provided good color and a relatively fast drying time, was widely used until oil painting became popular in the early Renaissance.

Although Italian painters imitated the Byzantine style, by the end of the thirteenth century they were making changes, often quite subtle, that led to a new and more realistic style of painting. The least revolutionary

of the new painters but one of the greatest was Duccio of Siena (c. 1260–c. 1318). Duccio made use of many of the Byzantine conventions—the gold background, the symbolism, and the formalized poses of his figures. He painted icons, but he moved away from them to do such large works as his masterpiece, the *Maestà*, a thirteen-by-fourteen-foot painting in Siena that made him a celebrity. Dismantled long ago (parts of it are now in various museums), the *Maestà* consisted of forty panels depicting the lives of saints and of Jesus and Mary.

A smaller masterpiece by Duccio, *The Calling of Peter and Andrew* (fig. 7-26), shows an interesting contrast between the formalized mountain, the gold background, and the rather weightless figures—all Byzantine characteristics—and the individualized features of the subjects and attempts at naturalism in the fish and the net.

Older than Duccio but considerably more revolutionary was the Florentine painter Cimabue (c. 1214–c. 1302). Only a few of his works survive, but we know that he was the most respected painter in Florence before Giotto. Dante, his contemporary, mentioned his fame. *The Madonna of the Angels* (fig. 7-27) still has its Byzantine attributes, but one now gets the feeling that there are flesh and bones underneath the natural-looking draperies. The child is still a miniature adult, but he is not suspended in air; he puts weight on his mother's lap. Moreover, there are traces of shadowing and modeling that suggest a third dimension, in spite of the gilt background and the conventional composition.

Cimabue's fame has endured partly because of his association with Giotto (c. 1266–1337), a painter from the Tuscan countryside who became the most celebrated artist in Florence and then in all of Italy. Legends have accumulated around him, including one that tells of Cimabue's having become his first teacher after he found the lad drawing figures of sheep on stones in the meadow. If so, Giotto cared little for his master's style.

During Giotto's early life the churches

Fig. 7–26. Duccio. *The Calling of Peter and Andrew*. Sienese, active 1278–1318. Wood panel, approx. 17 × 18″. National Gallery of Art, Washington, D.C. Samuel H. Kress Collection.

Fig. 7–27. Cimabue. *Madonna of the Angels* (*Madonna Enthroned*). 1270–85. Tempera on wood, 12′ 6″ × 7′ 4″. Uffizi Gallery, Florence.

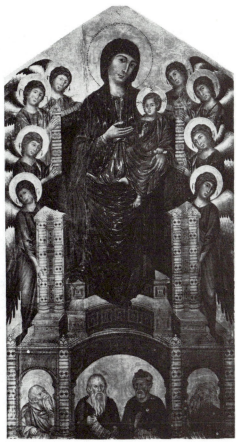

dedicated to St. Francis in Assisi were built and decorated. According to tradition, Giotto painted the great series of frescoes there dealing with Francis's life. Modern scholars disagree strongly as to who did paint them; some believe that Giotto was one of a number of painters who decorated the walls. Whoever did the St. Francis narratives, they are remarkable for their vitality and drama. The *Sermon to the Birds*, (fig. 7-28), one of the more subdued and poetic of the paintings, captures the gentleness of the saint and makes the legend quite believable.

In 1305 a chapel was donated to the city of Padua by a wealthy moneylender, Enrico Scrovegni. The Scrovegni chapel, usually called the Arena chapel, owes its fame to the

Fig. 7–28. Giotto (?). *St. Francis Preaching to the Birds.* About 1300. Fresco. Upper Church of St. Francis, Assisi, Italy.

great frescoes that Giotto painted there. The chapel has three cycles of paintings—the Life of Mary, the Life of Christ, and the Passion of Christ—plus a depiction of the virtues and vices. *Joachim's Vision,* as an example of the first cycle, demonstrates the psychological insight and mastery of form that Giotto now exhibited. The landscape is sparse, in contrast to those of the Assisi paintings, and all attention is focused on the brooding form of Joachim, traditionally the father of the Virgin, as he spends forty days of fasting and prayer in the wilderness.

Most famous of the Arena frescoes is the *Lamentation* (fig. 7-29). No painting has ever captured more successfully the essence of profound grief, as it is reflected in the faces, postures, and gestures of angels and disciples, as well as in the stark background with its one leafless tree. Departing from traditional symmetry, Giotto achieves balance in his composition by placing heavier, more brightly colored figures at the right and compelling us to look, with them, toward the recumbent body of Christ in the lower left. He places the scene outside and adds to its naturalism by devoting a third of the painting to open sky; this in itself was an innovation.

Giotto was also a sculptor and architect. He was appointed chief master of building in Florence a few years before his death and designed the famous Campanile near the Florentine cathedral. His design can be seen in the lower sections of the bell tower; other builders modified his plans after his death.

Painting after Giotto. As the most famous artist of his day, Giotto attracted a number of talented young painters to his studio. Some of them, especially Bernardo Daddi and Taddeo Gaddi, established their own permanent reputations. But despite the reputation that Giotto and his followers enjoyed, the mainstream of painting shifted after his death to Siena and toward less experimental painters. The Sienese tradition, with its emphasis on delicacy and sheer visual beauty, became very popular. Among the

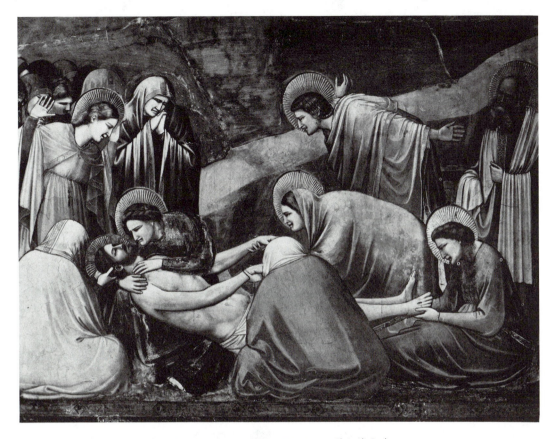

Fig. 7–29. Giotto. *Lamentation*. Detail of fresco. About 1305. Arena Chapel, Padua.

best known Sienese painters were Simone Martini and the Lorenzetti brothers.

Simone Martini (c. 1284–1344), perhaps a student of Duccio, was strongly influenced by the older painter. Martini's most famous work is the *Annunciation* (fig. 7-30), one of the best-known treatments of that very popular subject. Martini bows to tradition in the gold background, the Byzantine head of the Virgin, and other details. The symbols—the lilies, the olive branch, the dove—are also traditional. The painter elongates the blue-clad figure of Mary in a graceful, sinuous curve. Despite these traditional and stylized elements, the Virgin is a girl, startled and awed by the news she hears. The angel is intense and in turn impressed by the maiden to whom he is appearing.

In his later life Simone Martini went to Avignon, where he painted for the popes and their courts. Soon painters combined his Sienese style with the warmth of French Gothic sculpture to create a new style that became popular throughout Europe—the *International Gothic*. Some of Simone Martini's paintings, including the *Annunciation*, approach the International Gothic; it becomes an authentic style in the work of such painters as the Italian Lorenzo Monaco and the three Flemish Limbourg brothers. Lorenzo's *Coronation of the Virgin* (fig. 7-31) is typical. The architectural frames—round or pointed arches with underlying points or *cusps*—create a feeling of depth, as do the skillfully overlapped, modeled figures. Colors are bright, and much is made of such elements

Fig. 7–30. Simone Martini. *Annunciation.* 1333. Tempera on wood, 8′ 8″ × 10′. Uffizi Gallery, Florence.

Fig. 7–31. Lorenzo Monaco. *Coronation of the Virgin.* 1413. Uffizi Gallery, Florence.

Fig. 7–32. Limbourg Brothers. *February,* from *Les Très Riches Heures du Duc de Berry.* 1413–16. Approx. 8 × 5″. Musée Condé, Chantilly, France.

as crowns, jewels, and golden staffs. All in all, the effect is one of elegance and sheer physical beauty rather than spiritual profundity.

The Limbourg brothers, painting early in the fifteenth century, reflected the International Gothic style in their illuminations, possibly the most beautiful works of this kind ever created. Working in France for the duke of Berry, they created a series of miniature masterpieces for his Book of Hours, the *Très Riches Heures du Duc de Berry.* These include rural scenes depicting the twelve months, with foreground actions ranging from homely country life (fig. 7-32) to the elegant ways of lords and ladies riding to hounds.

The International Gothic style maintained its popularity in northern Europe throughout much of the fifteenth century. In Italy, however, Renaissance styles were becoming more and more dominant.

8 THE EARLY RENAISSANCE (1350-1500)

The Italian poet Petrarch, writing about 1350, proclaimed, "After the darkness has been dispelled, our grandsons will be able to walk back into the pure radiance of the past." The darkness, as he saw it, was the long stretch of time, ten or more centuries, between the passing of Rome's greatness and the coming of his own age. These centuries, as Petrarch and his followers saw them, were the Dark Ages, or at best the Middle Ages, that lay between the grand world of antiquity and their own modern era of rebirth—of renaissance. And in 1492 the Florentine philosopher Ficino declared, "It is undoubtedly a golden age, which has restored to light the liberal arts that had almost been destroyed: grammar, poetry, eloquence, painting, sculpture, architecture, music. And," he adds proudly, "all that in Florence."

It is true that the Renaissance was initially an Italian, if not strictly a Florentine, phenomenon. It appeared somewhat later in France and the Germanic and Flemish countries and still later—not until the latter part of the sixteenth century to any significant degree—in Spain and Portugal and the British Isles. Initially the rebirth was mainly literary and linguistic, but it was to extend itself rapidly in other directions.

We now think of the Renaissance as the period of approximately two hundred years beginning about 1350 and ending in the mid-1500s, when the tendencies now called mannerism and the baroque began to dominate the arts. The Renaissance can logically be divided into two parts: the early Renaissance, revolving around Florence and extending from about 1350 to 1500; and the later or High Renaissance, centering in Rome and embracing roughly the first half of the sixteenth century.

The Middle Ages were of course by no means as benighted and culturally barren as Petrarch, Ficino, and their fellow humanists chose to think. But their view was the common one for several centuries. In fact, the tendency to glorify the Renaissance at the expense of the Middle Ages reached its climax in the nineteenth century, when such historians as Jacob Burckhardt saw the Renaissance not simply as a great cultural and artistic movement but as a political, social, and psychological phenomenon in which man first discovered both the physical world and himself.

Present-day historians tend to discount Burckhardt. They see strong evidence of individualism and an awareness of an expanding universe occurring as early as the thirteenth century. They find the Renaissance not so much a rebirth as a development and a shifting of emphasis. But most would agree that the period was one of artistic activity, zest for life and knowledge, sensory delight in opulence and magnificence, and spectacular individual achievement.

The Renaissance reflected a variety of changing conditions, some of them well under way before the end of the Middle Ages. They include:

1. The breaking down of the feudal system and the decline in power of the feudal knights.

2. The weakening, in practice if not in theory, of the concept of the Holy Roman Empire.

3. The growth of nationalism. Italy and Germany continued to be fragmented into city-states much like those of ancient Greece, but strong monarchies developed in Britain and what are now Spain and France.

4. A movement away from an almost wholly agricultural economy toward one in which commerce, manufacturing, mercantilism, the use of gold coinage, and banking became increasingly important—in short, the growth of capitalism.

5. The coming of the age of exploration—the excitement of discovery, both of the far places of this globe and of the rest of the universe. It was more than coincidental that Ficino looked around him and saw a golden age in the same year that his fellow Italian Columbus discovered the New World. And Copernicus, the father of modern concepts of astronomy, was also a contemporary of Columbus.

6. The increasing worldliness of the papacy and of churchmen in general.

7. The invention, about 1450, of printing by means of movable type. Though some scholars at first scorned and resisted the new method of bookmaking, its development was rapid and its effects were profound.

8. A rapid growth of interest in the arts of antiquity, of Greece and Rome, which expressed itself especially in the movement called humanism.

Humanism. The Italian humanists, who began to assert themselves strongly in the middle years of the fourteenth century, were at first a small and select group, united in their love for the things of the classical past and in their dislike for medieval art, literature, and philosophy. Initially, humanists were teachers of the humanities, those subjects designed to prepare young aristocrats to distinguish themselves, to serve their communities, and to communicate fluently and gracefully in speech and writing. Their medium of communication, for all but the commonest of occasions, was Latin. By extension the name *humanist* was applied to others with classical leanings, whether political leaders, men of the church, or members of the nobility themselves. All of them were steeped in visions of antiquity, and all of them were dedicated to the revival of classical Latin. Prized as much as the language was the literature of antiquity—a pagan literature that enthralled Christian humanists.

Equally important and more dramatic was the rediscovery of Greek language and literature. It is traditional to say that this rediscovery occurred when Greek scholars fled westward after the conquest of Constantinople by the Turks in 1453. This tradition has a basis in fact; the Medici of Florence, for instance, welcomed and sheltered such scholars. But Aristotle and other Greek masters had been known and venerated in the West for centuries, if only in Latin translations.

The humanists as a whole considered themselves Christians, bound to Christian doctrine and dogma, and some of them were deeply devout men. But many were only marginal Christians, whose true interests were pagan and secular. They were not humanitarians, and in no sense were they advocates of a democratic way of life.

As might be expected, their influence on the artists of the Renaissance was most strongly felt in literature, with architecture and sculpture close behind. The painters of the early Renaissance as a whole were affected only superficially by humanism, but their successors in the sixteenth century—Michelangelo, for example—came strongly under its influence.

Power and Patronage. In varying degrees all of the ruling powers of Europe, religious as well as secular, were patrons of the arts. In Milan the powerful and unscrupulous Sforzas stimulated a brilliant burst of creative activity that brought to the city such men of genius as Leonardo da Vinci. In Urbino the admirable Federigo da Montefeltro, a man of high moral character who embodied the best of Renaissance values, promoted art and education. Above all, in Florence the renowned Medici sponsored the most important of all Renaissance movements.

The Medici were the most influential of a number of powerful merchant families in Florence. They first asserted themselves strongly in the fifteenth century. Two of them did much to foster the early Renaissance. The first, Cosimo the Elder (1389-1464), vastly increased the family fortune, mostly through banking and wool merchandising, and spent much of it on the beautification of Florence and other parts of Tuscany. He built churches, villas, and palaces. He founded the Medici Library and the Platonic Academy (a group of humanists under the leadership of Ficino). And he supported and encouraged such great artists as Fra Angelico and Ghiberti.

The second, Lorenzo the Magnificent (1449–1492), not only equalled his grandfather Cosimo in the sponsorship of artists—Botticelli, the composer Heinrich Isaac, and others—but was himself a poet and story writer of considerable ability. Later the great collections of art accumulated by Cosimo, Lorenzo, and other Medicis were to be the foundations of the magnificent galleries—the Uffizi and the Pitti, for example—that have made and kept Florence one of the art centers of the world.

The Church: Secularism. In every significant respect—in political life, in literature and other arts, in philosophy, in education, and even in religious matters—the outlook of Western men and women became increasingly secular during the Late Middle Ages and the Renaissance. This secularization, encouraged by the material prosperity of the middle and upper classes, by the flowering of the humanist movement, and by the weakening of the spiritual and political leadership of the church, expressed itself vigorously in all of the arts. At the same time, however, religious forces continued to exert themselves strongly in architecture, in music, in painting, in sculpture, and to a lesser extent in literature.

A number of popes, beginning with Nicholas V in the mid-1400s and running through the papacies of Julius II and Leo X in the early sixteenth century, did much to foster the literary and artistic interests of the Renaissance. The values they espoused were essentially those of the humanists: an earthly, aesthetic code that weighed values in terms of their effectiveness, harmony, and beauty.

The abuses and problems of doctrine within the church that led to the Protestant Reformation had asserted themselves before the time of the early Renaissance. By 1414, the teachings of the reformer John Wycliffe had been condemned by the Catholic church as heretical; and Jan Hus, another forerunner of the Reformation, had been burned at the stake. But the strongest influences of the

Protestant Reformation and the subsequent Catholic Counter Reformation were not to be felt until the sixteenth century, when they were related in important ways to the humanistic and aesthetic developments of the High Renaissance.

LITERATURE

The most exciting literary events of the early Renaissance, for educated Italians of the time, were the rediscoveries of hundreds of classical manuscripts. Many of them were of great value—letters of Cicero and the younger Pliny; historical writings of Livy and Tacitus; the great *De Rerum Natura* of Lucretius; and many other masterpieces. In addition there were newly discovered ancient Greek writings of a variety of types—drama, lyric poetry, and philosophy.

Humanist writers attempted to produce works such as epics, pastorals and histories, of their own in the classical languages. Incidentally and sometimes apologetically they also produced literature in colloquial or vernacular Italian (Dante, of course, had done so earlier). It is this vernacular literature that has come down to us as the great writing of the Renaissance.

Petrarch (1304–1374). Italians consider Petrarch their country's greatest writer with the exception of Dante. He called himself a Florentine, but he was born in Arezzo, where his parents had fled from the bitter political turmoil in Florence that had caused the banishment of Dante. Apart from long periods spent in travel throughout Europe as a humanist scholar and seeker of manuscripts, Petrarch lived most of his life near Avignon in France, then the seat of the papacy. Here he pursued the career as scholar and writer that was to initiate the humanist movement and bring him great honor during his lifetime.

In Avignon, when he was twenty-three, Petrarch first met his Laura, the woman who was to provide the inspiration for one of the greatest collections of love poems in any language. She was young, blonde, beautiful, serenely poised, and happily married. The poems, written in the Italian vernacular, bear evidence that she felt nothing more for him than respect and an occasional mild impatience. But he continued, over a period of more than twenty-five years, to write love lyrics in her honor. Some of the best were composed after her death in the plague year of 1348. He was later to dismiss his *Canzoniere*, his poems to Laura, as trifles, but they were trifles to which he had devoted an important part of his great poetic powers.

In the *Canzoniere* are 366 poems, most of them sonnets and all but a few concerned with love, with Laura, and above all with the effects of love on the poet himself. Petrarch celebrates Laura not allegorically but as an admirable and beautiful woman. His feeling for her is powerfully human and real. He recognizes it initally as a profane love, a love frustrated by her chastity and only gradually purified by her virtue. But ultimately, in what humanists following Petrarch made a central doctrine of Renaissance Neoplatonism, his love is transformed; Laura's beauty is itself idealized, and love and beauty both point the way to God.

In verse that is unfailingly musical, Petrarch touches on almost all of the themes that have become a familiar part of the tradition of love poetry: love's bittersweetness, its cruelty, its transience, its destructive passions, its paradoxes, and so forth. Sonnet after sonnet is inspired by Laura's "supreme beauty"—her fair hands, the potency of her glance, the virtue of her eyes (in the Renaissance tradition the eyes were the doorways to the soul), and her golden hair. The immense popularity of the sonnet form in the Renaissance and later eras owes itself more to Petrarch than to anyone else. Many of the greatest poets have used the form, in single poems or in sequences that reflect the man-

ner or themes of Petrarch: Ronsard, Spenser, Sidney, Shakespeare, Milton, Keats, Wordsworth, Elizabeth Barrett Browning, and many others.

Boccaccio (1313–1375). Petrarch, both as classical scholar and as poet of love, reacted against the traditions and ideals of the Middle Ages—even those of Dante, whom he deeply admired. Giovanni Boccaccio lectured on Dante and wrote a biography of him, but he was even further from Dante than was Petrarch. Boccaccio was the exemplar of a new society founded as Morris Bishop says, "on erudition, art, business, and pleasure; its portrait was Boccaccio, gay, erudite, a courtier and an artist."

Boccaccio's life was divided rather sharply into two parts by its central event—the writing, shortly after the plague year of 1348, of the *Decameron*. The first part, following his childhood in Florence, was spent largely in Naples, where he gained fame for himself as a scholar, courtier, and man of letters.

The second part of Boccaccio's life is marked by his first meeting in 1350 with Petrarch, whose writings and scholarly attainments he greatly admired. Petrarch urged him to "direct the mind toward eternal things, leaving aside the delights of the temporal." Accepting this advice, he devoted most of his remaining years to long works that he wrote in Latin. But the world remembers him only for the work that he himself later condemned as worldly—his highly popular *Decameron*.

The terrible Black Plague of 1348 doubtless seemed to most people of the time a clear sign of God's anger, and it inspired numerous works of art, especially paintings and poetry, intended to warn and exhort. But to Boccaccio it provided the pretext for relating a completely worldly collection of tales designed for readers—idle ladies, he says in his introduction—who wished only to be amused.

The plague, which Boccaccio describes

vividly and quite accurately in the introduction to the *Decameron*, provides a framework for his collection of tales. A group of young aristocrats, seven women and three men, escape from the ravages of the plague in Florence to a country villa nearby, where they while away the time telling stories. Each relates one tale on each of ten days—hence the title "Decameron."

Some of the tales were Boccaccio's own inventions, but many he retold from folk tradition. All are written in a flowing, crystal-clear style that was to be the model of Italian prose for centuries to come. A few of the tales are dull and others are tasteless, but at their best they are delightful—witty, ironical, and rollicking. They revolve around disguises, practical jokes, deceptions, surprise endings, revenges, neglectful husbands, unfaithful wives, and rascally friars. Men of the church and men of medicine are among his chief targets.

The work ends with a series of stories designed to leave the reader with an impression of Boccaccio's fundamental seriousness by illustrating greatness of character in both nobleman and commoner. Chaucer, in his tale of the patient Griselda, retold one of these. Like many another writer, Chaucer found the *Decameron* both a rich source of plot material and a guide to the techniques of storytelling.

MUSIC

Renaissance music was less affected by the humanists' enthusiasm for things of the ancient past than were the other arts. Scholars had long been aware of the philosophical and mathematical implications of ancient Greek music, but no examples of such music were available. In fact, none were discovered until the nineteenth century.

Italian composers of the fourteenth century adopted some of the devices of French *ars nova* (Ch. 7), but they largely rejected the rhythmical complexities and ar-

tificialities that had crept into the French movement and emphasized instead cheerful, flowing polyphony and bright melodic lines.

Music was closely identified with poetry, and composers developed further the tendency seen in some *ars nova* music to relate the feeling of the music more closely to that of the text. Secular music became more sophisticated, and it grew in importance both in itself and in its effect on the music of the church.

The greatest of fourteenth century composers was Francesco Landini or Landino (1325-1397), a blind Florentine organist and poet. He was greatly admired in his own lifetime by such artists as Petrarch, who participated in awarding him a victor's laurel for his poetry. The melodic line of his music was graceful and beautiful, and his three-part compositions anticipated the harmonic, chordal music that was to come. He took little interest in church music but composed large numbers of secular pieces. These included at least 140 in the *ballata* form, which was based on popular dance rhythms. One of these is "Che piu le vuol sapere," which sings of young women: "Who wishes to know them more will know them less."

The *ars nova* style in both France and Italy faded during the early 1400s. Italy continued to dominate the other arts, but the center of musical activity shifted to northern France and what are now Belgium and the Netherlands, and it remained there for a century and a half. Many northern musicians spent large parts of their lives in Florence, Rome, Paris, and other such centers, serving in the papal choir, the great churches, and the courts of princes. Here they exerted a powerful influence and were influenced in turn by the sensuousness and clarity that typified the arts of southern Europe.

Much Renaissance music has an immediate appeal for listeners today, and many of the characteristics that relate it quite directly to modern music were introduced by the northern composers: more clearly defined rhythms, more smoothly flowing melodic lines, more skillful use of repetition and imitation, and a preference for the major and minor scales that are familiar to our ears.

One of the most gifted of these composers from the North was Guillaume Dufay (c. 1400–1474). Born in Heinault in what is now Belgium, he was welcomed to the courts of France and Italy as a fine tenor singer. But he returned to the North and spent most of his life in the cathedral of Cambrai, north of Paris. "Thereafter he developed his own individual style—a gentle, mellifluous, almost feminine art of a clarity unknown to past French music." Dufay was one of the first to use popular secular tunes of the day as the melodic basis for sacred compositions, especially for masses (more than anyone else, Dufay initiated the great period of mass composition). Following his lead, many composers based their sacred compositions (parody masses) on popular melodies with such names as "Adieu, mes amours." Probably Dufay's most famous work is the Kyrie from his mass *Se le face ay pale.* It is based on his own secular chanson beginning "If my face is pallid, know the cause is love."

A generation after Dufay, another group of northern composers came into prominence and gained fame for themselves in the South. Their leader was Johannes Ockeghem (1425-1495). We are told that his skill as a composer inspired awe in his contemporaries, and they spoke of him as the "Prince of Music." He made use of a number of imitative devices such as augmentation (doubling the length of notes). These were carried to such extremes of complexity by some of his followers that he gained an undeserved reputation in later times as a dry, pendantic composer. Actually the best of his religious compositions are imaginative and moving. A fine example is the *Missa Prolationum* (Prolation Mass), in which four voices sing simultaneously in four rhythms, two of them duple and two triple.

Most serious music of the early Renaissance, whether sacred or secular, was com-

posed for vocal rather than instrumental performance. Instruments were used; indeed, they were very popular. But usually they simply doubled the voice parts or repeated vocal passages without change. The instruments that became most popular during the Renaissance were the recorder (a mouthpiece flute in a variety of sizes) and the lute, a many-stringed instrument related to both the mandolin and the guitar.

ARCHITECTURE

Though literature was the first of the arts to be profoundly influenced by the humanist movement, the visual arts soon followed. In the first part of the fifteenth century a group of highly gifted Florentine artists developed what we now recognize as a truly Renaissance style in architecture, as well as in sculpture and painting. The movement spread quickly, and by the mid 1400s other northern Italian cities such as Mantua, Urbino, and Arezzo were enjoying their own bursts of creative activity. Rome's artistic heyday was to come later; but long before the High Renaissance it attracted many artists from all over Italy and even from northern Europe who came to study and admire the ruins of ancient buildings and the antique statues that were being excavated in large numbers.

Among those who ardently studied the ruins of Rome was Filippo Brunelleschi (1377-1446), a versatile Florentine artist who was to have an important impact on painting, sculpture, and especially architecture. In fact, he can be accurately called the first true Renaissance architect. (He is one of the earliest of those to whom the term *Renaissance man*, the man of many talents and a consuming thirst for knowledge and achievement, can be applied.)

Brunelleschi, like most Italians, disliked and avoided the northern Gothic style, with its pointed arches, towers, stone trac-

ery, and upward reaches. Actually, his designs were partly transitional and partly original. They embodied some of the traditions of Italian Romanesque and Gothic, especially those of the Baptistry of San Giovanni in Florence (fig. 8-1), some of the qualities of classical architecture that he saw in the Pantheon and other ancient buildings in Rome, and some of his own ideas. The finest and most characteristic of his smaller works is the beautiful Pazzi Chapel, the chapter house of the church of Santa Croce in Florence. Here the proportions of both interior and exterior are based on simple mathematical relationships, straight lines and half- or full-circles. The interior is basically a dome-covered square (fig. 8-2). On the east side, opposite the entrance, is a chancel exactly half the size of the central square; and on the north and south sides are extensions or transepts one-fourth the size of the square. These careful proportions are emphasized by Corinthian pilasters and outlines in dark stone. Mathematical relationships also govern the proportions of the façade (fig. 8-3), with its pleasing balance of verticals and horizontals. The round arches, Corinthian columns and pilasters, and pediment over the door are classical, but the chapel has a lightness and grace that typify Renaissance Italy rather than antique Rome.

Brunelleschi's finest achievement was the building of the huge dome over Florence's *duomo* or cathedral (fig. 8-4). The large octagonal opening over the transept crossing had remained open to sun and storm since the building was otherwise completed a century before. After a bitterly contested competition during which some of Florence's most influential citizens laughed at Brunelleschi's proposals, he was awarded the contract in 1420. With a minimum of scaffolding he was able to raise a dome with inner and outer shells that soars, with its surmounting spire or *lantern*, more than three hundred feet from the floor. In the process he invented ingenious devices for hoisting the heavy stones to their places in the dome.

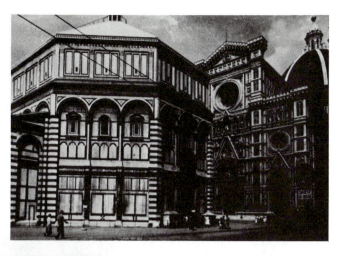

Fig. 8–1. The Baptistry, Florence. 11th century.

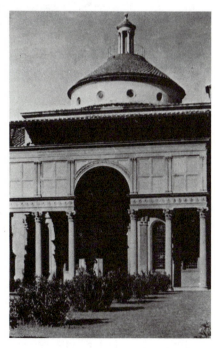

Fig. 8–3. Brunelleschi. Pazzi Chapel. Begun about 1430.

Fig. 8–2. Brunelleschi. Interior, Pazzi Chapel, Santa Croce, Florence. Begun about 1430.

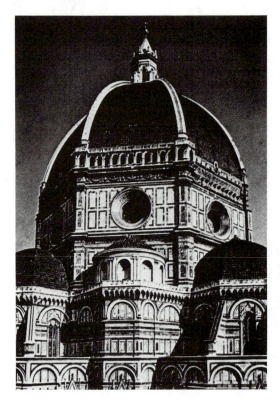

Fig. 8–4. Brunelleschi. Dome of Cathedral (Duomo), Florence. 1420–36.

Fig. 8–5. Michelozzo. Medici-Riccardi Palace, Florence. Begun 1444.

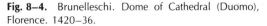

Brunelleschi's dome has remained a model for all later ones. When Michelangelo was designing the dome for St. Peter's in Rome, he said he could make a bigger one than Brunelleschi's, but not a more beautiful one.

The fifteenth century saw the erection in Florence of many of the great palaces that grace that city. One is the Medici-Riccardi palace, designed in 1444 by Michelozzo (fig. 8-5). Like most Italian palaces of the time, it is a combined fortress and mansion. The bottom story, though ornamented with classical touches, is built of heavy, rustic stone in the fashion of a medieval fortress. The second story is of smooth stone with carved edges (rusticated), and the top story is of smooth stone. The interior, with several courtyards surrounded by graceful arcades and with many elegant rooms, reflects more clearly its classical inspiration. The stories are separated from each other by clearly defined bands of masonry called *stringcourses*.

Another of Florence's great palaces is the Palazzo Rucellai, which was designed in 1446 by one of the most remarkable men of the Renaissance, Leon Battista Alberti. He was the first Renaissance designer to differentiate clearly the three main orders of Greek architecture. Alberti, even more a "Renaissance man" than Brunelleschi (he was a painter, sculptor, architect, organist, composer, mathematician, athlete, and prolific writer), was the principal formulator of the new theories of architecture, theories that he expressed both in his buildings and in a famous book on the subject.

SCULPTURE

In early Renaissance sculpture there was no such abrupt, even dramatic break with the past as there was in architecture. As we have seen, the Pisanos and the artists who carved such graceful and natural-looking works as the Golden Virgin of Amiens and the later sculpture of Chartres were aware of the statuary of the classical world and were eager to recapture its beauty. On the other hand, even the most gifted and original of early Renaissance sculptors, though they were dedicated students of antique Roman statuary, cherished the expressiveness and spiritual intensity of Gothic sculpture.

But they also observed minutely every attitude of the human body, in action or at rest, and they began dissecting bodies in order to master the details of human anatomy. By the end of the fifteenth century they had worked out almost every means of achieving naturalism and the illusion of vitality, movement, and emotional expression. Outstanding among such innovative sculptors were Ghiberti, Donatello, and Verrocchio.

At the beginning of the fifteenth century, Lorenzo Ghiberti (1378–1455) was named one of seven young artists who were to compete for the honor of designing a set of bronze doors for the north side of the Baptistry of San Giovanni in Florence (fig. 8-1). As Vasari tells the story, Ghiberti was one of the three finalists; but the other two, Brunelleschi and Donatello, withdrew when they saw Ghiberti's fine design for the test subject, the sacrifice of Isaac (fig. 8-6).

From 1403 until 1424 Ghiberti worked on the north doors. He produced a series of

Fig. 8–6. Lorenzo Ghiberti. *The Sacrifice of Isaac.* 1401–02. Gilt bronze, 21 × 17". National Museum, Florence.

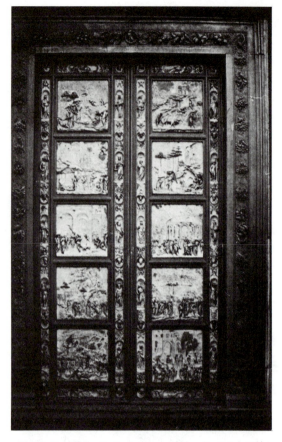

Fig. 8–7. Ghiberti. East doors of the Baptistry ("The Gates of Paradise"), Florence. 1425–52. Gilt bronze, approx. 17' high.

including Ghiberti himself. Each panel tells a composite story from the Old Testament— the Creation and Expulsion, the stories of Noah, of Abraham, of Joseph, of Moses, of Saul and David, and others. With one exception—King Solomon receiving the Queen of Sheba—Ghiberti uses the ancient device of relating in a single panel several events in the life of one Biblical figure. Thus the sixth panel shows Joseph being put into a well, being sold in turn to merchants and to Pharaoh, interpreting Pharaoh's dreams, counseling the Egyptians, recognizing and pardoning his brothers, and meeting his father Jacob (fig. 8-8). In each instance much narrative detail is incorporated in a panel that creates the effect of an uncluttered painting, with depth suggested by gradations in the sizes of figures and by variations in the amount of relief, from almost freestanding figures to very low relief. Figures are animated and lifelike; and some, like that of Eve in the first panel, have a classical smoothness and grace (fig. 8-9).

Ghiberti's fellow Florentine Donatello (c. 1386–1466) was a highly original and productive artist. He worked equally well with bronze, stone, or wood, and with full figures or relief panels. With few exceptions Donatello's works illustrate sacred themes. He is in the company of the greatest artists in any medium—Michelangelo, Bach, and Rembrandt—in spiritual profundity and conviction.

Among Donatello's major works are a series of large statues of Old Testament prophets designed for niches high on the walls of the cathedral of Florence. One is an impressive Jeremiah, with firm-set jaw and piercing eyes. Another is Habakkuk (sometimes called *Zuccone* or *Baldpate*)—tall and angular, with his head leaning forward and his strong mouth almost ready to speak (fig. 8-10). In these and others of Donatello's statues we see an animation of facial expression that no earlier sculptor had been able to capture.

Perhaps even better known that the Habakkuk is Donatello's wooden statue of

twenty-eight scenes in relief sculpture, mostly on subjects from the New Testament. His true genius, however, asserted itself in the work to which he devoted the next twenty-seven years of his life—the celebrated east doors of the Baptistry (fig. 8-7), of which Michelangelo is supposed to have said, "They are so beautiful that they would grace the entrance to Paradise."

Ghiberti fashioned these east doors in ten large, square panels, their surrounding frames incorporating statuettes of prophets and sybils and small busts of various artists,

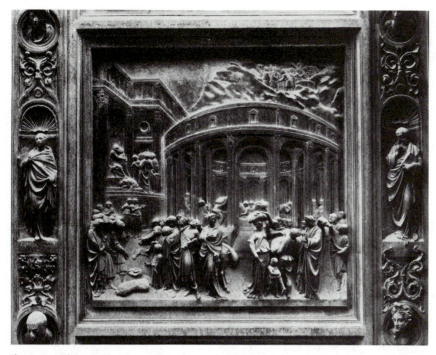

Fig. 8–8. Ghiberti. *The Story of Joseph,* Panel 6 of the east doors.

Fig. 8–9. Ghiberti. *The Creation of Adam and Eve,* Panel 1 of the east doors.

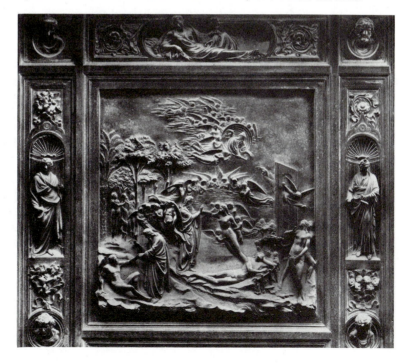

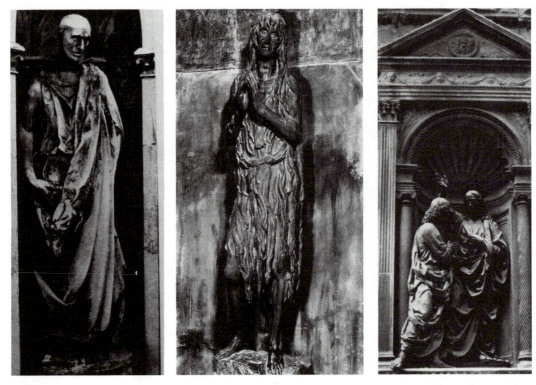

Fig. 8–10. Donatello. *The Prophet Habakkuk* (*Zuccone*). 1423–25. Marble, 6′ 5″ high. Cathedral Museum, Florence.

Fig. 8–11. Donatello. *Mary Magdalene*. About 1454–55. Wood, 6′ 2″ high. Baptistry, Florence.

Fig. 8–12. Verrocchio. *Christ and Thomas*. About 1465–83. Bronze. Or San Michele, Florence.

Mary Magdalene (fig. 8-11), a work of his later years which was seriously damaged by the flood that ravaged Florence in November 1966. The expressiveness of this figure, with its ragged clothes and unkempt hair, emaciated limbs, and eyes staring from a haggard face, is a startling contrast to the smooth classicism of most early Renaissance statuary. Others of his statues are a bronze David, a great figure of Saint George, and his equestrian statue of Gattamelatta in Padua, the first of its kind since the classical era and one of his few nonreligious works.

Tradition has it that Verrocchio (c. 1435–1488), an accomplished goldsmith, sculptor, painter, and musician, gave up painting when his pupil Leonardo da Vinci surpassed him in parts of a painting on which they collaborated. In any event, Verrocchio left few paintings and not many pieces of sculpture. Among the latter, however, are several masterpieces. One, a depiction of Christ and Saint Thomas (Church of Or San Michele in Florence, fig. 8-12) incorporates perhaps the most beautiful figure of the Savior ever sculptured. Another, the bronze statue of Colleoni in Venice (fig. 8-13), though dismissed by some as melodramatic, is very likely the greatest of all equestrian statues. In the Venetian plaza of Saints John and Paul one sees, high on a pedestal, the powerful, restive horse, with neck straining and one forefoot raised (itself at the time a remarkable sculptural feat of balance); and the imperious figure of Colleoni planted firmly astride, courage that approaches arrogance in the turn of the head and in the face with its jutting jaw and fiery eyes.

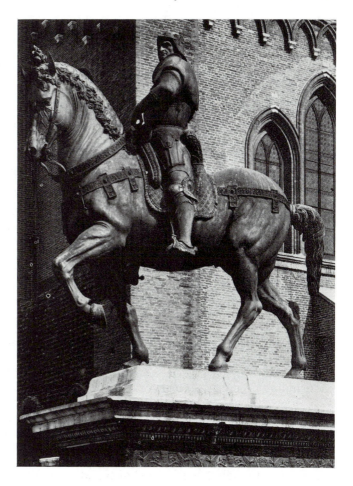

Fig. 8–13. Verrocchio. *Bartolomeo Colleoni.* About 1483–88. Bronze, approx. 13" high. Campo dei Santi Giovanni e Paolo, Venice.

PAINTING

The painters of the early Renaissance, with few exceptions, were unlearned men, only indirectly familiar with the attitudes and enthusiasms of the humanists. It is true that classical ruins found their way into the backgrounds of paintings depicting, say, the Annunciation or the Nativity. And it is also true that late in the fifteenth century Botticelli and others satisfied their wealthy patrons by deriving subjects from classical mythology. But the real impact of classical humanism on painting was to come later.

But early Renaissance painters, whatever their subject matter, shared with the humanists a delight in physical beauty—beauty of forms and faces, of colors and backgrounds. Along with a passion for beauty came a concern for reality—for creating, on a flat surface, the illusion of depth and volume, of three-dimensional forms occupying space in a real if idealized world. Giotto, a century before, had painted solid-looking figures in compositions that were often masterfully conceived. But the churches in his paintings look no larger than sheds, and his mountains, dotted with disproportioned trees, resemble masses of rock seen at close hand. His followers in the fifteenth century were not content to concentrate alone on volume and solidity of figures, though they de-

veloped techniques of modeling and shading that were to reach their culmination in the sculpturesque figures of the High Renaissance.

Perspective, the illusion of depth in a two-dimensional painting, became almost an obsession with early Renaissance painters and their followers. Applying the theories of Brunelleschi, Uccello, and others, who elevated linear perspective from guesswork to mathematical precision, they drafted converging lines that made streets, buildings, and other objects look correctly proportioned and that drew the eye accurately back into the picture. They mastered foreshortening, in which perspective is applied to a single object. They paid careful attention to the fact that objects appear smaller as they retreat farther from the observer—perspective of size. They made skillful use of overlapping, a simple device that helps to create the illusion of depth. They developed aerial or atmospheric perspective, based on the fact that the farther away one looks, the more indistinct appear the objects seen, and the more muted become the colors of earth and sky. They observed more carefully the intensity of light, the direction of its sources, and the effects of light and shadow (*chiaroscuro*). They were doubtless aware of the fact that some colors seem to advance and others to recede. And though they idealized men and women and their world, they strove for accuracy of form and proportion. Flemish and Dutch painters of the period carried their desire for realism in another direction. They painted with minute precision such things as the faces on coins in a countinghouse or the details in a glimpse of landscape seen through the window of a living room.

Italian Painters. The works of Tommaso Guidi (1401–1428), commonly known by his nickname "Masaccio" (meaning Clumsy or Sloppy Tom) were largely ignored for centuries, but he is now considered one of the greatest painters of his time and a key figure in the history of art. Influenced as no others of his fellows were by Giotto's monumental forms, he also made the new developments in perspective his own, and he handled light as no one before him had done.

Most of Masaccio's works (there are not many, because he died at about twenty-seven) are painted on the walls of the Brancacci Chapel in the Carmelite church of Florence. These frescoes include his *Expulsion from the Garden of Eden* (fig. 8-14) and *The Tribute Money* (fig. 8-15). *The Expulsion* is masterfully done, in spite of minor flaws in a hand or leg: the two nude forms (themselves an innovation in early Renaissance painting) are depicted with complete naturalness—solid, unidealized human figures occupying space in a world of sunlight and shadow. The light striking their bodies comes from a single source and creates dramatic effects of chiaroscuro. The painting is even more remarkable for its emotional and psychological expressiveness. Every gesture and movement—the plodding footsteps, the rounded shoulders, the half-hidden face of Adam, Eve's pitiful attempt to conceal her nakedness—all reflect the shame and remorse of the first parents.

Equally powerful is *The Tribute Money*, in which Jesus, surrounded by his disciples and others, counsels them to render unto Caesar the things that are Caesar's. Each carefully individualized face registers astonishment, especially that of Peter (who can scarcely conceal his indignation) and the young man in the foreground who expresses his disbelief in word and gesture. All of the heads are in line, in the age-old tradition of isocephaly, and are on an eye level with the viewer; but depth is suggested by differences in body size, by overlapping, and by the indistinct, receding background.

Masaccio's fellow painters of the fifteenth century, much as some of them admired him, did not imitate him. They preferred brighter colors, more precise drawing, sharper lines, and more nearly two-dimensional effects. It remained for artists such as Leonardo and Michelangelo almost a cen-

Fig. 8–14. Masaccio. *The Expulsion from Eden*. About 1425. Fresco. Reproduced with permission of La Chiesa del Carmine, Florence.

Fig. 8–15. Masaccio. *The Tribute Money*. About 1427. Fresco. Reproduced with permission of La Chiesa del Carmine, Florence.

tury later to study his methods and incorporate them in their own work—methods that were to dominate the art of painting until the advent of impressionism in the late ninetenth century.

Some of the finest examples of Christian art are to be found in the paintings of Fra Angelico (c. 1387–1455), a monk who was given the nickname by which he is known—the Angelic Brother—by his fellow monks and the townspeople of Florence. In some ways his paintings, with their luminous, gem-like colors, diffused light, and slender forms, seem an archaic return to techniques of a century before. Clearly enough, however, he was aware of the developments of his own time and employed them as he saw fit. He used perspective of all kinds with confidence. His figures, though not monumental

as are those of Masaccio, occupy space in a real-looking world. In some ways, particularly in the inspiration he drew from nature, he was ahead of his time.

Fra Angelico's *Annunciation* (fig. 8-16) is the epitome of gentle piety. Everything in the picture contributes to the effect—the pure, singing colors, the beautiful faces, the Virgin's gentle gesture of surprise, the cheerful garden. The composition of the work, horizontal and vertical lines carefully balancing the graceful curves of the arcaded porch and of the two figures, is also noteworthy.

According to tradition Fra Angelico, having begun each work day with a prayer for guidance, never changed or corrected a brush stroke. Whether the story is true or not, the painter's love for God and His world shines through all his paintings.

Fig. 8–16. Fra Angelico. *Annunciation*. About 1440–45. Fresco. San Marco, Florence.

As worldly as Fra Angelico was devout was another Florentine painter-monk, Filippo (Lippo) Lippi (c. 1406–1460). (Interestingly, the two collaborated on at least one painting.) Lippo was far more concerned with physical beauty than with insight or spiritual depth. His figures are natural, he handled light and shadow skillfully, and his colors, like Angelico's, are bright and lovely. His *Madonna with Babe and Angels* (fig. 8-17) is a somewhat crowded treatment of a familiar subject. An exquisite madonna lifts her hands to adore the infant Jesus, who is held up by two small angels. The Christ Child, unlike those in many earlier depictions of the subject, is a real baby, not a miniature adult. In fact, he and his mother and even the an-

Fig. 8–17. Fra Filippo Lippi. *Madonna with Babe and Angels.* About 1455. Approx. 36 × 25″. Uffizi Gallery, Florence.

gels are quite human figures, placed before an imaginary mountainous landscape of the kind Lippo and many of his fellow painters fancied.

The work of Piero della Francesca (c. 1416–1492), like that of Masaccio, was long neglected, but he is now probably the most admired painter of the fifteenth century. Piero carried to an even greater degree of perfection than Masaccio the new theories of perspective, on which he wrote important treatises in his later life (he became blind some years before his death). Piero's concern for composition, symmetry, and spacing went far beyond the practices of his day. There is a feeling of suspended motion, almost of timelessness, in his figures, which are carefully placed in settings permeated with a calm, even light.

Piero's most important large-scale achievement is a series of frescoes that adorn the walls of the Church of St. Francis in Arezzo; they tell the story of the True Cross. But his masterpiece is *The Resurrection* (Colorplate 3), the pride of his native town of Borgo San Sepulcro. The novelist Aldous Huxley writes of it: "The best picture in the world is painted in fresco on the wall of a room in the town hall. . . . Its clear, yet subtly sober colors shine out with scarcely impaired freshness. The whole figure is expressive of physical and intellectual power. . . . Piero achieves grandeur with every gesture he makes." The face of one of the sleeping guards who form the base of the pyramidal composition—the one seen almost full-face—is thought to be Piero's own. The strong, masculine figure of Christ, itself something of a departure from tradition, is seen against a background of daybreak and of trees that symbolize, on the one side, the sorrow of the Crucifixion and on the other the hope of the Resurrection.

The most gifted and original of northern Italian painters of the early Renaissance was Andrea Mantegna (c. 1431–1506), who was born in Vicenza and spent most of his life in the important cultural centers of Padua and Mantua. He demonstrated bril-

liance as an apprentice in Padua, soon mastered the newly discovered rules of perspective, and displayed what was to be a lifelong interest in rendering foreshortened views of the human figure. His strong, incisive style caught the fancy of patrons all over Italy, and he executed a number of large murals in tempera or fresco, ranging from group portraits of remarkably lifelike, elegantly dressed aristocrats and classical and mythological subjects to numerous religious paintings. Typical of his style, though a relatively small painting in this instance, is his dramatic *Crucifixion* (fig. 8-18). Here are solid, sharply defined figures of persons and horses, some of these in foreshortened stances; rocklike mountains arching and curving into the distance; and three crucified figures high against a cloud-flecked sky.

The last of Italy's great fifteenth-century painters was Sandro Botticelli (c. 1445–1510). More than any other he was instrumental in opening up, under the impetus of humanism, a big new body of subject matter that was exploited by artists for generations after him—the stories and characters of classical mythology.

Botticelli was a Florentine whose native gifts were sharpened by his training as a goldsmith and as an apprentice to Fra Lippo Lippi. He was instructed by his wealthy patrons (especially the Medici) and other humanists in the lore of classical mythology. He employed it, in ways that more clearly reflected Renaissance Italy than classical Greece, in such paintings as the celebrated *Birth of Venus* and the *Primavera* (fig. 8-19), a complex allegory of the coming of spring.

Fig. 8–18. Andrea Mantegna. *Crucifixion.* 1456–59. 26 × 35". The Louvre, Paris.

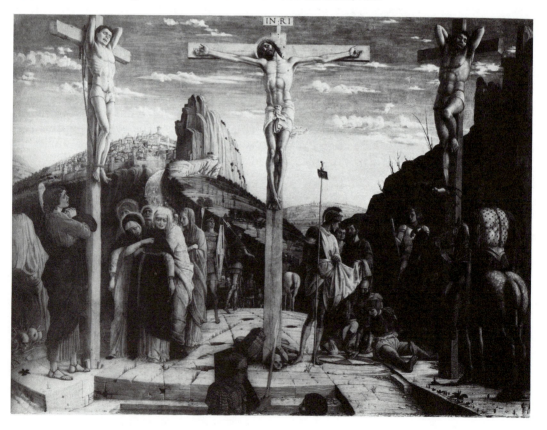

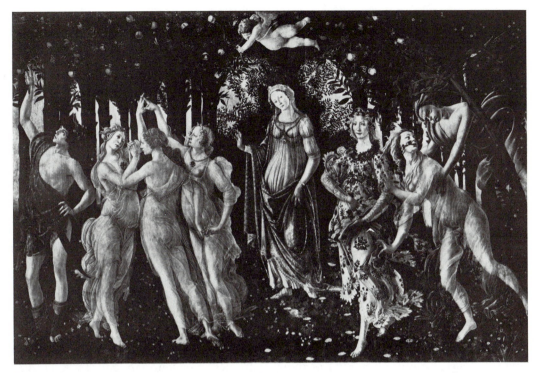

Fig. 8–19. Sandro Botticelli. *Primavera (Allegory of Spring)*. About 1478. Tempera, 80 × 123″. Uffizi Gallery, Florence.

But he also painted numerous religious works, which made him wealthy, in fact, including some of the frescoes on the walls of the Sistine Chapel in Rome.

Botticelli employed the new naturalistic devices with complete assurance. But he ignored them, when he saw fit, in favor of sheer pictorial beauty. Every delicate, nervous line in his paintings is part of a rhythmic whole. Every feminine form (he chose female subjects more often than not) moves with a lightfooted if sometimes languid grace. His figures express emotion by movement rather than by facial expression. Thus the Virgin in the Uffizi *Annunciation* (fig. 8-20) responds to the angel's message with a balletlike movement of surprise, her lovely face the same expressionless, faintly melancholy one that we see so often in Botticelli's paintings.

In his middle years Botticelli became a profound admirer of Savonarola, especially

Fig. 8–20. Botticelli. *Annunciation* 1489–90. Tempera, 59 × 61½″. Uffizi Gallery, Florence.

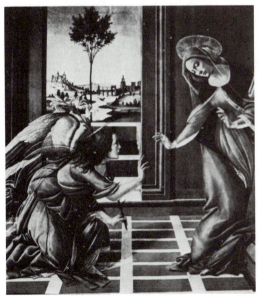

after the hanging and burning of that famous reformer in 1498, and the few paintings of his remaining years are in a devout, mystical vein.

Northern Painters. The lands across the barrier of the Alps, especially the Netherlandish and German states, had their own renaissance in painting, though its origins and its characteristics are less clearly defined than those in Italy. Northern painters, though many of them were aware of what was going on in Italy, found their own paths toward naturalism. They employed linear perspective, but not with the mastery that had made it an Italian—almost a Florentine—trademark. And only gradually did their human figures move away from a somewhat naïve simplicity toward the solid, monumental ones of Giotto, Masaccio, and their followers.

To the painters of the North, realism came early to mean the depiction of all objects with fidelity and accuracy—household utensils, tools, furniture (the kind of thing Italian artists seldom troubled themselves with), as well as all the objects of nature such as flowers, trees, and animal life. Landscapes in Italian paintings of the period are apt to be generalized though often beautiful backgrounds before which a narrative or portrait is placed. But in Northern paintings they are as important as the figures themselves and are painted with as much care and precision. So detailed are they that the viewer gets the impression, as critics have remarked, of looking at them through a telescope and a magnifying glass at the same time.

As for faces, those in Northern paintings are seldom beautiful in the Botticellian sense of the word, but they have a vitality and an inner life that often makes them more appealing.

The Northern painters of the fifteenth century occasionally incorporated bits of classical architecture into their works, but rarely did they concern themselves with mythological subjects. They were essentially religious painters, who sometimes invented imaginary mountainous landscapes quite unlike anything in their native land, but who, all in all, reproduced their own world and their own people in narratives from the Bible and the lives of the saints.

One of the greatest of early Flemish masters was the long-unknown painter called the Master of Flémalle (probably Robert Campin, c. 1378–1444). His masterpiece, now in the Cloisters in New York City, is a triptych or three-panel work, the Mérode Altarpiece, which depicts the Annunciation. The central panel shows a placid, round-faced Virgin, not yet aware that an angel is visiting her (fig. 8-21). The linear perspective of the painting is imperfect, but the work is full of delightful details, many of them symbolic. Both the angel and the Virgin wear gowns that have the voluminous, intricate folds which Northern artists loved to paint.

The Master of Flémalle's greatest contemporaries were Jan van Eyck and Roger van der Weyden. Jan van Eyck (1370?–1440?), a court painter, was a technician of almost unsurpassed skill. Until recently he and his brother Hubert were credited, probably inaccurately, with having invented oil painting. In any event, they perfected a process of painting with oil and varnish that allowed for greater subtlety and that has left their brilliant colors as fresh as if they were applied yesterday. Jan van Eyck's greatest single work, perhaps begun by his brother Hubert, is a huge altarpiece in St. Bavon Cathedral in Ghent, Belgium. Called the *Worship of the Lamb,* the work contains, among many other details, Christ as King; a choir of earnestly singing angels; St. Cecilia and other angelic musicians (fig. 8-22); the Adoration of the Lamb; groups of crusaders and pilgrims; and unglamorized nude figures of Adam and Eve. All, including bejeweled figures of saints and angels, are painted with extraordinary clarity.

Countless reproductions have made van Eyck's *Double Portrait of Giovanni Ar-*

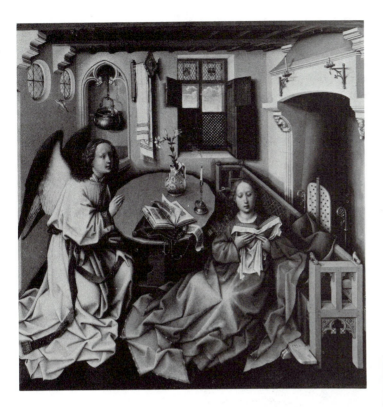

Fig. 8–21. Master of Flémalle (Robert Campin?). Active by 1406. *Annunciation,* center panel of the *Mérode Altarpiece.* Oil on wood, approx. 25 × 25″. The Metropolitan Museum of Art, New York. Cloisters Collection.

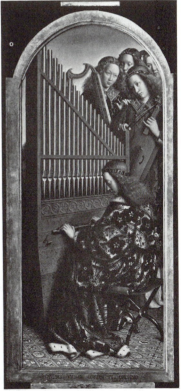

Fig. 8–22. Hubert and Jan van Eyck. *St. Cecilia and Angelic Musicians.* Detail of Ghent Altarpiece. Completed 1432. St. Bravo, Ghent. Copyright A.C.L., Brussels.

nolfini and His Bride (Colorplate 4), one of the most familiar paintings of the Renaissance. This work is a wedding portrait, commissioned in 1434 by a wealthy merchant from Lucca, Italy, who married a Flemish bride. Every detail is painted with consummate skill: the warm light suffusing the room, the chandelier, the mirror, the rich folds of the skirt that the bride holds up before her in the fashion of the time, and the little dog. Almost every object has some religious or legal significance, from the dog itself, symbolizing fidelity, to the shoes that have been removed to show that the room in which the sacred ceremony is taking place is now holy ground. As the mirror and the writing on the wall in the background show, Jan van Eyck himself was present as a witness to the wedding.

The honor of being the most imitated and perhaps most influential of early Flemish painters belongs to Rogier van der Weyden (c. 1400–1464) whose technique was less complex and whose style was warmer and more emotional than those of the van Eycks. When Rogier's fellow artists saw his *Descent from the Cross* (fig. 8-23), they were evidently astonished by the poignancy that it expressed in paint, and it was soon known throughout Europe in many copies. The poetic rhythms of its composition and many of its details, particularly the sorrowing women, were imitated by generation after generation of painters.

Fig. 8–23. Rogier van der Weyden. *Descent from the Cross (The Escorial Deposition)*. About 1435. Tempera on wood panel, approx. 7′ 3″ × 8′ 7″. The Prado, Madrid.

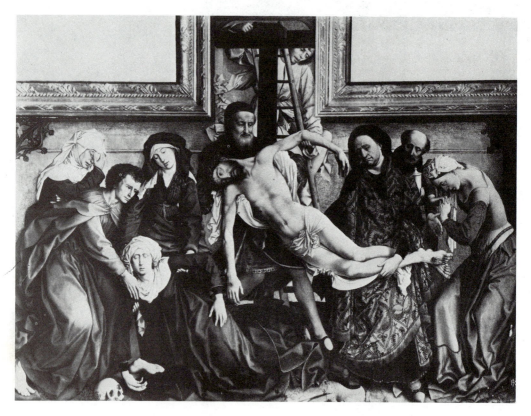

Another of Rogier's works, his *Portrait of a Lady* (fig. 8-24), exemplifies a type of painting that was becoming increasingly important both in Italy and in the Northern countries during the early Renaissance. Many portraits were incorporated in religious paintings, either as participants (the Medici, for instance, as the Magi) or as patrons or donors. We have also seen a fine double portrait in the *Arnolfini Wedding*. Rogier's, however, is a highly individualized single portrait of a lady—full-lipped, strong-jawed, pensive; not beautiful but remarkably alive.

The life span of Hieronymus Bosch (c. 1450–1516) extended well into the later Renaissance, but as an artist he was far away from that era in almost every way. Born in

the Netherlands, Bosch had a lifelong interest in the strange, pessimistic, and grotesque aspects of life. His paintings are much in vogue now because of their apparent relationship to surrealism and the world of dreams and the subconscious. Even in Biblical works such as *The Crowning with Thorns* he creates a strange world of terror, in which human faces become caricatures of cruelty.

Bosch's most famous works are allegorical paintings such as *The Haywain, The Temptation of St. Anthony,* and the triptych called *The Garden of Delights*. The panels of the last-named work (fig. 8-25) depict the Garden of Eden, worldly life, and hell. Painted in delicate hues of pinks, greens, and blues, in a light that has been compared to that of an aquarium, the three land-

Fig. 8–24. Rogier van der Weyden. *Portrait of a Lady*. About 1455. Wood panel, approx. 14 × 11″. National Gallery, Washington, D.C. Andrew Mellon Collection, 1937.

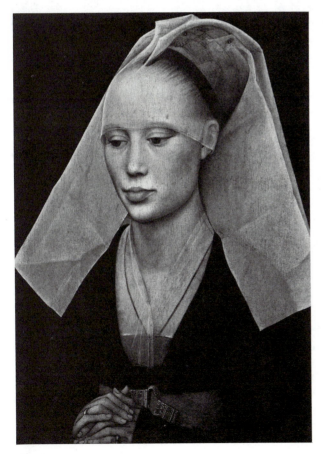

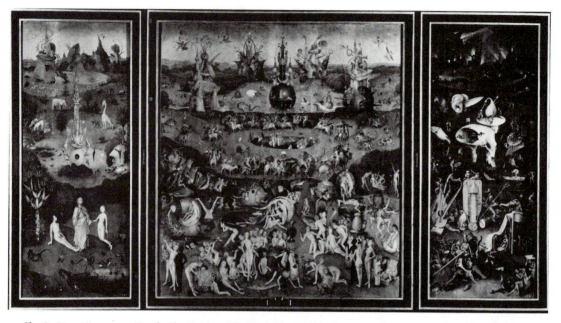

Fig. 8–25. Hieronymus Bosch. *The Garden of Delights*. About 1500. Center panel approx. 86 × 77″. The Prado, Madrid.

scapes are filled with bizarre details. In the central panel are numerous naked beings riding in procession on curious beasts (some of them symbols of lust), eating or playing with huge strawberries and other fruits, dallying in great crystal balls, and engaging in various acts of implicit or explicit sexuality. Hell, the third panel, has a fantastic variety of tools of torture—everything from egg-like trees to grotesque musical instruments—but strangely little physical torment. The *Garden of Delights* and similar works, probably intended as much to satirize and to instruct as to frighten, were highly popular in their time. There is little in them that can be called surrealistic if that term is meant to suggest an "automatic," irrational evocation of a dream world. The details are systematically worked out and have symbolic or allegorical meanings that would have been understood by Bosch's contemporaries. He derived his details from then-common sources such as Flemish parables, fortune-telling cards, traditions of magic and witchcraft, the signs of the zodiac—and, of course, his fertile imagination.

If we cannot accept the humanist Valla's assertion that literature and the visual arts had almost died during the Middle Ages, neither can we deny the reality of the Renaissance, that upsurge of creativity that began in Italy and that was in large part inspired by classical influences, especially in literature, architecture, and sculpture. Medieval or at least nonclassical traditions continued to express themselves, especially in the visual arts of northern Europe. But in Italy the classical revival, with medieval influences largely eliminated, was soon to reach its climax in the era commonly called the High Renaissance.

9

THE HIGH RENAISSANCE

The last ten years of the fifteenth century were filled with as many momentous events as any decade in history, at least until recent times. In that decade were born three princes who were destined to become three of Europe's most powerful and colorful rulers—Francis I, Henry VIII, and the Holy Roman Emperor Charles V. In that period Columbus, Vasco da Gama, John Cabot, and Pedro Gabral made voyages that reshaped the world. Savonarola brought to a climax his dramatic religious reforms in Florence and went to his death at the stake.

In that decade Charles VIII of France invaded Italy, drove south to Naples, and turned Italy into a battleground on which several nations fought for domination of that land and the rest of Europe. This series of conflicts was to last for sixty-five years. The mercenaries and recruits who fought in these wars took home with them to their various lands memories of the great cities of Italy, and impressions of Italian art, music, architecture, and culture in general.

And in that same decade Leonardo da Vinci painted his great *Last Supper* on a monastery wall in Milan, an event that has been called the beginning of the High Renaissance.

The term *High Renaissance* is applied to the short, brilliant flowering of the visual arts in Rome during the first two or three decades of the sixteenth century. It can be logically extended to embrace at least the first half of the century and to include northern Italy, especially Milan and Venice, and the cultural centers of northern Europe.

Florence was the cultural center of Europe during the fifteenth century, but in the High Renaissance, largely because of papal influence, the center shifted to Rome. Though that city produced no native-born poets, painters, or musicians of consequence, it became a great importer of talent—some of it from Florence, whose cultural fortunes waned as Rome's grew.

Venice, a second major center of creative activity in the early sixteenth century, had already begun its long period of economic decline; but in that century it was to produce or support brilliant painters such as the Bellinis, Giorgione, and Titian, architects such as Sansovino and Palladio, and composers such as Willaert and the Gabrielis.

The royal courts of the era strove to outdo each other in opulence and elegance. Francis I acquired the services of Leonardo, Andrea del Sarto, and Cellini. The Sforzas

and other powerful families in Italy commandeered their own corps of artists, as did the rulers of the Germanic states and Britain.

University centers such as Paris, Basel, and Oxford made their impact not on the visual arts but on music and literature. And the universities of northern Europe, though they were still burdened by heavy traditions of medieval thought and educational method, helped to foster a humanistic movement that was to have as profound consequences as the earlier one had had in Italy.

Reports of the humanist movement in Italy filtered north during the fifteenth century and caught the interest of scholars such as the Dutch writer Erasmus, the Englishmen William Grocyn and Thomas Linacre, both of whom traveled and studied in Italy, and Thomas More, most celebrated of English humanists.

The humanists of the North, like those of Italy, loved the classics with a fervor that roused the suspicion and anger of their more conservative fellows. But with an equal fervor that must have seemed incomprehensible to more worldly Italian humanists they employed their classical learning in studies of the Bible and of the Church Fathers. Erasmus, for one, sought for and found in the classics much that he could harmonize with his own Christian concepts. Northern humanism, in short, took on a strong moral and religious coloration that was to influence the literature, music, and visual arts of the Northern Renaissance in a number of ways.

The great Protestant Reformation was a phenomenon of the sixteenth century which occurred at the same time as the High Renaissance. Historians differ as to the relationship of humanism and the Reformation, but there is general agreement that the revival of learning set in motion by humanism stimulated men to think for themselves as they had not done for centuries about religious as well as other matters. The invention of printing, an adjunct if not a result of humanism, prepared the way for the direct and widespread study of the Bible that

was an important part of the Protestant movement. In general, however, humanism and Protestantism were far apart and sometimes at each other's throats: Renaissance humanism, especially in southern Europe, was essentially secular, tolerant, and often skeptical. Its view of man was optimistic as a whole; it encouraged belief in his natural goodness and his high potential. Protestantism of course was intensely religious; it tended toward intolerance and toward a view of man as basically depraved and capable of salvation only through the grace of God.

In general, Protestantism was less favorable to the arts than was Catholicism. Of the great reformers, Calvin was the least friendly to art. Though he recognized it as "one of God's gifts," he forbade the singing of "man-made" hymns and other liturgical music, and he allowed his congregations to sing only metrical versions of the Psalms.

As for Luther, his extremist followers destroyed paintings and smashed stained-glass windows in some of the churches of Germany and elsewhere. But Luther himself strongly objected to such practices. He wrote: "I do not hold that the Gospel should destroy all art, as some superstitious folk believe. On the contrary, I would fain see all arts, and especially that of music, serving him who hath created them and given them unto us." In general, however, it must be said that Protestantism did not foster what can be called an art movement, and the great Protestant artists—the Bachs and the Rembrandts—were to come several generations after the Renaissance.

The popes of the fifteenth and sixteenth centuries were among the principal sponsors of humanism and of the arts, beginning with Nicholas V, who was greatly admired for his pious character and his generosity to artists. Another was Sixtus IV, under whom the chapel that bears his name, the Sistine Chapel, was begun. Pope Julius II is famous for his stormy relations with Michelangelo and for founding the basilica of the new St. Peter's. His encouragement of

the sale of indulgences as a means of raising funds for building projects was one of the immediate causes of the Protestant rebellion.

Rome reached the apex of its magnificence under Pope Leo X (1515–21), a good man but an incompetent ruler, during whose reign the Protestant Reformation began. Most of the great artists and architects of Italy—Bramante, Raphael, Michelangelo, and others—were brought to Rome at this time, and numbers of fine palaces both papal and private were built and decorated. The university and the Vatican Library flourished, and artists of all kinds, including musicians and men of letters, benefited from the generosity of Pope Leo.

LITERATURE

Poets were numerous and prolific during the first half of the sixteenth century, and they wrote in a variety of forms—epic, lyric, and dramatic. Few of them, however, were of permanent importance. The great poets of the age were to emerge primarily during the second half of the century; they will be considered in later chapters.

The major writers of the High Renaissance expressed themselves in a variety of prose forms: Castiglione in dialogues on the social graces; Machiavelli in a celebrated treatise on politics and statesmanship; Cellini in a famous autobiography; Thomas More and Erasmus, balanced, urbane humanists, in fantasy and satire; and Rabelais in robust comic fiction. All of them were aware of their humanistic milieu. Machiavelli measured his political values against those of antique Rome. For Cellini, the greatest praise he could give to a piece of contemporary sculpture—his own or anyone else's—was to say that it compared well with the work of "the ancients."

Few books have ever gained greater immediate popularity than did the *Book of the Courtier*, by Baldasar Castiglione (1478–1529). It was promptly translated into a number of languages, including English, and it had a strong effect on such writers as Spenser, Sidney, and Shakespeare. Its success lies in its graceful style, its fascinating glimpses into the lives of the aristocracy, and its appeal as a guide to self-improvement. Written in the form of a Platonic dialogue, it brings together a number of aristocratic humanists, actual people who discuss such subjects as personal appearance, bodily skills, social manners, and above all, grace. Grace is the hallmark of the gentleman; it means both gracefulness and graciousness. The true courtier is to do everything in a manner that seems natural, unaffected, poised. Even such informal qualities as nonchalance are to be formally cultivated and practiced with the "art that conceals art."

Castiglione's cheerful description of the ideal courtier contrasts strikingly with another celebrated literary portrait—Machiavelli's depiction of the ideal political-military leader in *The Prince*. Both the courtier and the prince are men of high ambition. But whereas the courtier desires chiefly to hold the esteem of his fellow aristocrats, the prince aspires to gain and hold political power by whatever means. Though both Castiglione and Machiavelli were dedicated humanists, Machiavelli is almost antihumanistic in his cynicism and near-despair.

A middle-aged diplomat and statesman when he wrote *The Prince*, Machiavelli (1469–1527) had seen the worst aspects of European military and political maneuvering. He had seen men of honor overwhelmed by the unprincipled. Politically, he concluded, the most successful man of the era was the unscrupulous Cesare Borgia.

During a period of exile from Florence Machiavelli wrote *The Prince*, to instruct and to gain the favor of the Medici duke to whom it was addressed. In swift-flowing prose that has an oratorical ring and that is filled with illustrations from ancient and contemporary life, he examines the bases upon which a ruler can maintain power at home and against foreign rivals. His basic premise is a

completely cynical one: "There is such a difference between the way men live and the way they ought to live, that anyone who abandons what is for what ought to be will learn something that will ruin rather than preserve him. . . . If a prince wishes to maintain himself, he must learn how to be not good, and to use that ability or not as it is required." Hence the prince, the statesman, will practice the vice of stinginess rather than the virtue of generosity, since generous rulers have seldom succeeded. He will choose to be feared rather than to be loved. Machiavelli's book gained a notorious kind of fame; "Machiavellian" became a common synonym for "crafty" or "deceitful."

An autobiography as cynical in its way as *The Prince* was written about forty-five years later by another Florentine, Benvenuto Cellini (1500–1571)—goldsmith, sculptor, soldier, and storyteller. Writing his memoirs as an old man, Cellini digresses often from his accomplishments as an artist to give us embellished accounts of his other exploits. He pictures himself almost single-handedly defending the ancient Castle of Sant 'Angelo during the sack of Rome ("In my enthusiasm I strove to achieve the impossible; let it suffice to say that it was I who saved the castle that morning.").

In his quieter moments Cellini engaged in intrigue in the courts of the cardinals and princes who employed him, quarreled with his rivals and other enemies—he killed two of them, according to his own account—and made excellent works of art. This last cannot be disputed; we have a number of them to prove it, from the famous salt cellar he made for King Francis I (fig. 9-1) to the great bronze statue of Perseus that graces the Loggia dei Lenzi in Florence (fig. 9-13). Cellini's account of the casting of this statue is probably the best—certainly the most exciting—account we have of the creation of a major work of art.

Another prose masterpiece of the period is the fantastic satire *Gargantua and Pantagruel,* by François Rabelais (c. 1494–1553).

Rabelais, born in the Loire valley, lived a strange life as a monk, a student of the classics and of law, a secular priest, a physician, and a writer whose work was condemned by the theologians of the University of Paris and praised by laymen and kings.

Fantasy and exaggeration lie at the heart of Rabelais's fiction. Gargantua and Pantagruel, father and son, are a pair of enormous giants (they shrink to human size when the plot demands), great in spirit as in body, whose adventures provide an incredible number of tales and illustrate Rabelais's ideas on a multitude of subjects—education, marriage, war, women's rights, and many others. The rollicking, often boisterous tone of the work can cause one to lose sight of the stratum of serious and original thought that underlies the nonsense. A preposterous incident like the mock-heroic warfare that grows out of a quarrel over some cakes is as devastating an attack on war, in its way, as Euripides' *Trojan Women.* And Rabelais's views on education, which find their way to the surface of an endless flood of biological humor, are humane and enlightened. He gloried in the new learning introduced by the humanists and never ceased to resent the pendantry and the repetitious, mind-dulling exercises that had constituted his own early education.

When the Dutch humanist Erasmus (1466?–1536) was nearing the end of his life, Rabelais saluted him in a letter as the source of all the knowledge and inspiration of his time. This extravagant but doubtless sincere praise was addressed by the age's most robust humorist to one of its gentlest and subtlest. In our time Erasmus has been called "one of the most vividly alive of the strongly marked individualists of a brilliant age" and one of the greatest representatives of the Renaissance spirit in northern Europe.

Erasmus of Rotterdam, as he called himself, was the son of a priest who disregarded his vows of celibacy. After a period of schooling which introduced him to the classics, he began a career as a traveling

Fig. 9–1. Benvenuto Cellini. *Saltcellar of Francis I.* 1539–43. Gold, 10 × 13". Kunsthistorisches Museum, Vienna.

scholar that took him all over Europe. Some of his happiest years were spent in England, where he established lifelong friendships with Sir Thomas More, John Colet, and other English humanists.

Erasmus's greatest contribution to his own time was the editing of the first printed New Testament in Greek. Much as he admired the classics, he wrote that "it is madness to compare Christ with Zeno or Aristotle, for only He is a doctor sent from heaven, and none teaches like Him."

Erasmus's best-known work is an amusing and puzzling little book, *In Praise of Folly*, that he wrote at the home of Thomas More in England. It is a speech of self-praise by Folly, personified as a woman. First she traces her ancestry. Then she enumerates her powers, which cause men to be married, have children, willingly suffer the calamities of life, delude themselves and each other by self-love and flattery, grow old, hide their baldness with wigs, obtain false teeth "from heaven knows where," become infatuated with young girls, and say, "It's good to be alive." Next Folly describes and pokes fun at her followers—common people, merchants,

lawyers, doctors, scholars, poets, cardinals, and popes. The last section, in which the mood changes sharply, has puzzled readers for centuries, but it seems to say this: Those who are foolish in the eyes of the world—children, women, people who are filled with Christian piety and who overlook injuries, those who prize simplicity—are wise in the eyes of God. Theirs is the "folly" that should truly be praised.

MUSIC

In sixteenth-century Italy the performing of music was essentially a professional or aristocratic art, but in the North and in England it was practiced increasingly as a part of daily life in middle-class homes. Groups sang madrigals as they sat around tables with their printed notes before them, and many could play lutes, recorders, and various kinds of viols.

The invention of printing was a major stimulus to music. Printed copies of compositions, however, remained expensive luxuries for a long time, and relatively few

original copies of sixteenth-century music are still in existence. Written music, whether put down by hand or printed, was—and remained until the time of Bach—only a rather general guide for the performer.

Musical styles and techniques of the High Renaissance continued to move in the direction of those that are familiar to us today: more easily recognizable rhythms, clearer melodies, a greater concern for harmony, and more frequent use of the major and minor tonalities. Harmony was of special importance; harmony either literal or figurative became the philosophical keystone of all the arts of the period. Music continued to be polyphonic—to weave together threads of melody sung or played by the various voices. But there was an urge to move away from a horizontal conception of flowing and interweaving melodies toward a vertical one of related chords—a single melody supported by harmonizing parts.

Musical instruments were highly popular, and there were many different kinds that were forerunners of all the types we have—strings, brass, woodwinds, percussion, organs, and other keyboard instruments.

Music of the Church. Church music of the period lacked the intensity and power that were to come later, but it had its own beauty and even grandeur. Its mood as a whole was that of mysticism, devoutness, and awe rather than of dramatic fervor.

The two principal forms of religious music continued to be the motet and settings of the Mass. The motet developed during the Gothic era, but it reached its highest point during the sixteenth century. Such eminent composers as Josquin des Pres, Orlando di Lasso, and Palestrina used the form with great frequency and skill. The motet became the basis for much experimentation. Josquin employed it to develop the practice of word-painting—that is, of trying to suggest in the music itself the images or emotions of the text.

Great settings of the Mass, some of them still often performed, were composed by Josquin, Orlando, Palestrina, Victoria, and other musicians of the era. Though the masses of such composers as Bach and Mozart are more familiar to modern listeners, they owe their debt to the great sixteenth-century works on which they were modeled. In fact, Palestrina's famous *Missa Papae Marcelli* (Pope Marcellus Mass) served as the chief model for all later writers of masses.

Some leaders of the Reformation, especially Luther, encouraged congregational singing of hymns in the languages of the people. He himself wrote the words for some. For others he composed the music. For still others he selected music from various sources and helped to edit several collections of hymns "for the glory of God and His Christian people." The simple, solid, basically rhythmical music of his hymns ("A Mighty Fortress," usually attributed to him, is typical) helped to set the pattern for hymn singing from that day to this. The German chorales, some of them later magnificently harmonized by Bach, have continued to be an important part of the literature of religious music.

Secular Music. The secular music of the era was more daring and experimental than the religious. It ranged from the charming and delicate to the dramatic; it foreshadowed, in fact, the operatic form that was to come as a revolutionary development at the beginning of the next century.

Two forms of secular music that were especially important in the period were the *chanson* and the *madrigal*. The chanson is a form of vocal chamber music developed in France from an earlier form that was erotic and often risqué. The chanson at its best is melodic, elegant, and distinguished for its delicate craftsmanship. Sometimes it was performed by groups of four singers, sometimes by a solo voice with instruments playing the other parts. A famous composer of

the chansons was Clement Jannequin, who wrote descriptive works about hunts, battles, birds, the seasons, and other subjects. One of his delightful chansons is a spring song, "Ce mois de Mai."

The Italian equivalent of the chanson was the madrigal, the most important secular musical form of the era. It is much like the motet, but its words, usually about love or some pastoral theme, called forth a lighter and simpler musical setting. Most composers of madrigals paid the utmost attention to the words and tried to match the music to their emotions and images; word-painting meant even more to the madrigal than to the motet.

Toward the end of the century, as the madrigal began to lose favor in Italy, it had a great flowering in England. The first great English madrigalist, one of the greatest of all English composers, was William Byrd (1540?–1623), who wrote much important sacred music as well. The English madrigal is more tuneful and less consciously dramatic than the Italian. Love, nature, and the seasons are the usual themes, sometimes treated seriously but more often gaily, with lilting refrains of the "fa, la, la" or "ding, dong, derry" type. Some of the best and most familiar of the hundreds of English madrigals that are sung today by choral groups are "Sing We and Chant It" and "Now Is the Month of Maying," by the gifted Thomas Morley, and "Fair Is the Rose" and "The Silver Swan," by Orlando Gibbons.

Two Late Renaissance Composers. Josquin des Pres and Orlando di Lasso, the last important representatives of the Flemish school, stand out in this era of fine musicians. (The Counter Reformation composers Palestrina and Victoria, who owed much to Josquin and Orlando, will be discussed in the next chapter.)

Josquin des Pres (c. 1450-1521) was the greatest composer of the early sixteenth century. Born in Condé, a little town in northern France, he learned the devices of counter-point from Ockeghem and Obrecht. Then he went to Italy, where he served in the ducal courts and his genius flourished. He developed a simpler but richer style, with soaring, balanced lines. He was a modernist in his time, anticipating much that was to come later. Luther, his contemporary, wrote of him that "he is the master of the notes, which must express whatever he wants them to. Other composers can do only what the notes want."

Among Josquin's surviving works are about thirty masses, over one hundred motets, and a number of secular pieces. His motet "Ave Maria," with voices entering imitatively, soaring melodies, clearly woven texture, and emotional profundity, is characteristic.

The age of Flemish musical brilliance closed with the work of Orlando di Lasso (c. 1532–1594), perhaps "the mightiest Netherlander of them all"—certainly the most versatile and prolific. His travels took him to Italy, France, England, and finally Germany, where he served the Duke of Bavaria in Munich for years as head of a large group of highly trained musicians. He mastered the styles of every kind of composition, sacred or secular, and created German lieder, French chansons, and Italian madrigals that reflected the musical tastes of those countries and yet were distinctly his own. "Matona mia cara" is a madrigal, a gay love song to an Italian text. In contrasting mood, "Mon coeur se recommande à vous" (My heart is offered still to thee) sings of the sorrows of love in a beautifully melodic chanson for mixed voices. The motet "Tristis est anima mea" (My soul is sorrowful) reflects the somber mood of much of Orlando's later religious music.

ARCHITECTURE

In sixteenth-century Rome, old buildings were cleared away and new ones—palaces, churches, and other public and private

Fig. 9–2. The Campidoglio (top of Capitoline Hill), Rome. Center, the Senatorial Palace. Plaza and exteriors designed by Michelangelo.

buildings—were built at a pace never witnessed since the days of Augustus. Rome's imported architects admired the symmetry of Brunelleschi's fine edifices in Florence. But they strove for grander scale, in the ancient Roman fashion, and they expressed their own taste for more elegance and ornamentation. Fig. 9-2, one of the beautiful façades on the Capitoline Hill designed by Michelangelo, illustrates some of the directions that architecture was to take in the sixteenth century. These include the impressive staircase in front of the high, rusticated base; the stringcourse separating the base from the first story; the tall pilasters with their Corinthian capitals; the alternating arched and triangular pediments over the

windows; the ornamental *cartouches* over the doorway and two inner windows; and the projecting cornice, topped by a balustrade and statuary. Even the square upper windows were admired and copied throughout Europe.

Many High Renaissance buildings reflected the Neoplatonic theories that the learned were expounding. These theorists sought perfection in perfect forms—in the harmony of music and in such geometrical forms as the square and the circle. The circle, as a symbol of completeness, became a dominant motif. Builders whose predecessors for centuries had built oblong basilicas now began to design centralized ones with domes and rotundas. Michelangelo built a dome-

covered mausoleum for the Medicis. Leonardo drew several plans—none of them executed—for churches much like San Vitale in Ravenna (Ch. 5).

One of the most gifted of such architects was Donato Bramante (1444–1514). "Whoever departs from Bramante departs from the truth," Michelangelo once said. Bramante began his career as a painter but turned to architecture in Milan. There he designed the graceful church of Santa Marie Della Grazie, the east end of which is a great circle surrounded on three sides by semicircular transepts and choir. He demonstrated his love for the circle even more clearly in his first important work after he moved to Rome—the Tempietto (fig. 9-3), a small temple that is the essence of Renaissance classicism.

In 1506 Pope Julius II commissioned Bramante to make plans for a new St. Peter's, to be built on the site of the centuries-old one that had been destroyed. Because of many problems the new St. Peter's was not completed until 1626, almost a century and a quarter later. In the meantime a number of Italy's greatest designers had taken their turns as chief architect—Raphael, Sangallo, Michelangelo, and Maderna among others— each adding to or changing Bramante's original design.

The first commission of Michelangelo (1475–1564) as an architect was to put a façade on the church of San Lorenzo that Brunelleschi had built in Florence. He spent several years designing the façade and getting marble for it, but the Medici, his sponsors, cancelled the contract. The façade is still unfinished. The Medici hired him immediately, however, to erect a family mausoleum for them near San Lorenzo. This, the Medici Chapel, is a beautiful small memorial chapel, softly lighted by four windows under its coffered dome (fig. 9-4).

In 1546, when he was seventy-one, Michelangelo received two important commissions. The first was to redesign the Capitol (fig. 9-2), which he made into an impressive plaza with an ancient bronze statue of

Fig. 9–3. Donato Bramante. The Tempietto. About 1502–03. San Pietro in Montorio, Rome.

Fig. 9–4. Michelangelo. Interior of dome, New Sacristy (Medici Chapel), San Lorenzo, Florence. 1519–34.

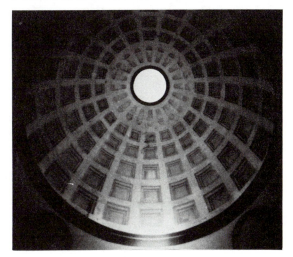

Marcus Aurelius in the center (see also fig. 4-13).

The other commission was to take over as chief architect of St. Peter's. He worked intermittently and without charge on the project until his death eighteen years later, and it embodies his most profound artistic and religious convictions. He returned basically to Bramante's scheme for the central part of the building but redesigned it and added his own plan for the great dome. The walls of the west end of St. Peter's (which, unlike most cathedrals, faces east) show clearly his sculpturesque approach to architecture—strongly curved volumes, with high pilasters creating effects of light and shadow (fig. 9-5). He left his plans for the dome in the form of a scale model which was followed, with some modifications, by his successors. Rising from a high drum surrounded by paired Corinthian columns, it soars in a steep, ribbed, almost Gothic pro-

file to a summit crowned by a high lantern and cross. Other builders added to St. Peter's the huge barrel-vaulted nave extending to the east.

Architecture in Venice and Vicenza. Before the Renaissance two famous buildings, the Cathedral of St. Mark's and the Ducal (Doge's) Palace, already faced what was to become Venice's large *L*-shaped plaza. In the sixteenth century the work of surrounding the "square" with impressive buildings continued, particularly with the erection of Sansovino's Library of St. Mark's, facing the Ducal Palace. Some of the more graceful of the bridges crossing the canals were built at this time, and many of the splendid *palazzi* (palaces) that face the Grand Canal and the other waterways—for instance the Grimini Palace—were erected. These palaces, their façades blending Gothic, classical, and oriental touches, reflect the cosmopolitanism and sophistication of sixteenth-century Venice.

Jacopo Sansovino (1486–1570) added to the beauty of Venice with a number of structures, including the Library and the Mint nearby. The Library is one of the most impressive buildings in Europe (fig. 9-6). Both inside and out, in the typical northern Italian manner, it is rich and elegant without being overloaded. Dramatic contrasts of light and shadow play across its exterior. The long arcade of Roman arches on the ground level complements the Gothic ones of the Ducal Palace across the plaza. A cornice and balustrade separate the second level from the first, but the levels are tied together by the repeated arches and engaged columns. Statuary, carved garlands, and small obelisks add to the richness of surfaces and roofline.

Greatest of late Renaissance architects was Andrea Palladio (1508–1580). Many of his palaces, villas, and churches grace northern Italy—his native Padua, Venice, and especially the small city of Vicenza, where he spent most of his life. Out of Palladio's studies in Rome and Venice emerged his own style, basically classical but varied and origi-

Fig. 9–5. Michelangelo. Dome, St. Peter's Cathedral, Rome.

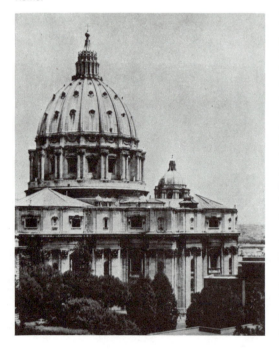

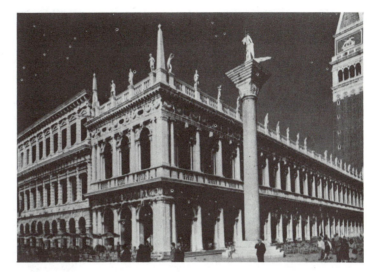

Fig. 9–6. Jacopo Sansovino. Library of St. Mark's, Venice. 1537–54.

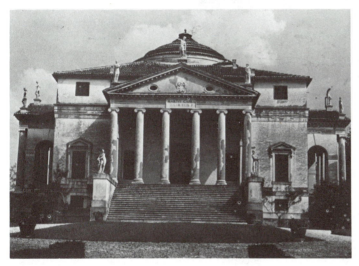

Fig. 9–7. Andrea Palladio. Villa Rotonda, Vicenza, Italy. Begun about 1550.

nal. His country villas combined the functions of mansion and farmhouse without losing the identity of either. His most famous villa (not a country one in this instance) is the Villa Rotonda, on the outskirts of Vicenza (fig. 9-7). The building is absolutely symmetrical; it is built in the form of a large square, with a rotunda in the center capped by a low dome. Four identical porticoes approach it from the four sides, each with a sweep of stairs, six Ionic columns, and a strong pediment topped with statues. The Villa Rotonda exemplifies the nobility and serenity that make the Palladian style distinctive. Few buildings have been copied more often; Thomas Jefferson's Monticello, for instance, owes much to it.

Palladio designed several of the fine churches of Venice. Of these the most consciously splendid is San Giorgio Maggiore, built on a small island in the harbor for the wealthy Benedictine order (fig. 9-8). Its fa-

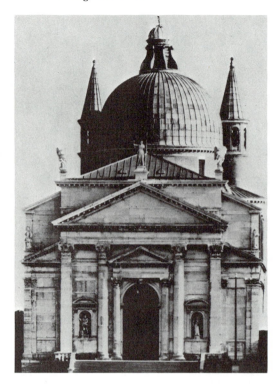

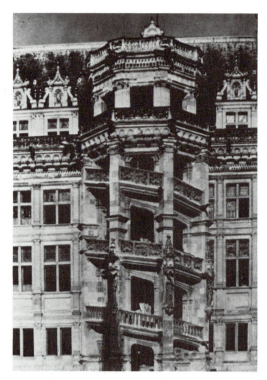

Fig. 9–8. Andrea Palladio. San Giorgio Maggiore, Venice. 1565.

Fig. 9–9. Interior-exterior stairway, Francis I wing of Château Blois, France 1515–24.

çade can be described as a wide classical temple front topped by a high, monumental one. Giant Corinthian columns on high pedestals tie the two stories together. The interior of San Giorgio, dominated by high arches flanking its long nave and flooded with the soft sunlight for which Venice is famous, is especially impressive. In addition to the examples set by Palladio's greatly admired buildings, his *Four Books on Architecture* had far-reaching effects throughout the Western world.

French Architecture; the Château. In the Middle Ages the French château was a fortified castle. By the sixteenth century the term had come to be applied to the palatial mansions that monarchs and aristocrats were building as country seats, particularly in the beautiful Loire River valley.

Châteaux are an interesting mixture of Italian classicism and French Gothic traditions. In about 1520, for instance, Francis I added a new wing to the old château of Blois. This addition (fig. 9-9), dominated by an inside-outside spiral stairway, is built in what is called the *transitional style.* The overall effect of the building is that of an Italian palace, and some details such as the pilasters and the cornice are classical. Others, such as the steep roof and the gargoyles, are authentically Gothic.

Other examples of French châteaux are Chenonceaux, which picturesquely spans the River Cher; Amboise, where Leonardo spent his last years and died; and Chambord, in a wooded area near the Loire. Of these, Chambord (fig. 9-10) is most intriguing. If one ignores for a moment the fantastic array of towers, high gables, and

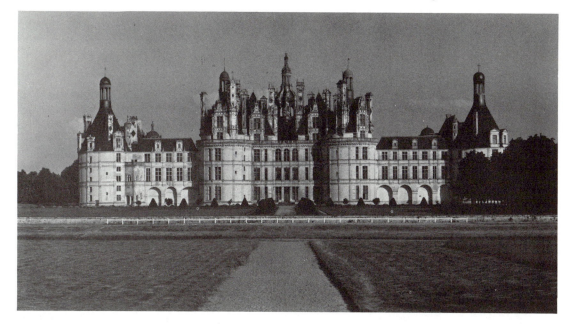

Fig. 9–10. Château Chambord, France. Begun 1519.

chimney pots, it becomes apparent that the rest of the château is basically classical Italian. But the towers are part of its Gothic heritage. So too are the rounded turrets at the corners. In fact, from the courtyard or the air Chambord looks very much like a medieval castle of the keep and bailey variety.

Spanish Architecture. Spanish architecture of the Gothic period was basically like that of western Europe but was strongly influenced by a centuries-old Spanish taste for ornamentation and elaborate detail. In the early sixteenth century Spanish architects developed a new style called the *plateresque* (from *platero,* silversmith). Though they made use of classical motifs, they filled almost every square inch of wall space with ornamentation—arabesques, grotesques, Moorish geometrical patterns, and other details. At its worst the plateresque style was almost frantically extravagant; at its best it was delicate and refined. A fine example is the Ayuntiamento or town hall in Seville (fig. 9-11).

In the second half of the century Spanish royalty and nobility, aware of what had been happening in Italy, began to want more austere, Roman-like structures. The most remarkable building of this period is the immense Escorial Palace, built on the edge of a low mountain range some thirty miles from Madrid (fig. 9-12). The Escorial was erected by the architects Toledo and Herrera for Philip II, who became ruler of Spain and the Netherlands after the abdication of his father, the emperor Charles V, in 1555. A man of some cultural sensitivity but a harsh suppressor of Protestantism, Philip was responsible for some of the cruelest aspects of the Inquisition and the long war between Spain and the Netherlands, as well as for the ill-fated Spanish Armada.

The vast Escorial is laid out in the form of a gridiron, symbolizing the manner of martyrdom of San Lorenzo, to whom it is dedicated. The exterior walls of the complex, which are over twice the length of a football field, have an austere kind of grandeur. Inside, the structure contains, among other

Fig. 9–11. Ayuntiamento (City Hall), Seville. Begun about 1520. (Portion of façade).

things, a monastery chapel with a great, richly ornamented altarpiece; directly under the altar an ornate octagonal marble-and-gold mausoleum containing the remains of Charles V and Philip II, among others; and a splendid library. There are hundreds of framed paintings, frescoes, and tapestries, many of them masterpieces; endless corridors; and about four thousand rooms, most of them empty. In fact, a large part of the great, solemn structure has remained unused for much of the time since the death of the melancholy Philip II.

SCULPTURE

Large numbers of sculptors, many of them very competent, supplied Rome's (and Italy's) desire for statuary to ornament palaces, churches, gardens, and tombs during the late Renaissance and the years following. A few stand out, including Sansovino, who designed Venice's Library of St. Mark's, and Cellini, whose great bronze statue of Perseus

Fig. 9–12. Escorial Palace and Monastery. Near Madrid. 1563–84.

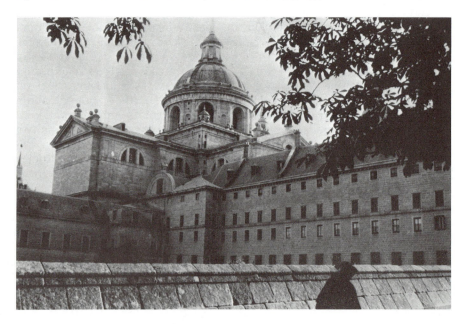

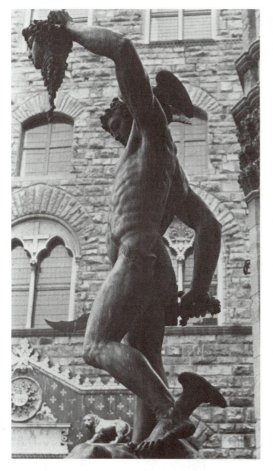

Fig. 9–13. Benvenuto Cellini. *Perseus.* 1545–54. Bronze, 10′ 6″ high. Loggia dei Lanzi, Florence.

(fig. 9-13) reflects his strong admiration for Michelangelo's *David.* Cellini's *Nymph of Fontainebleu,* made for Francis I, has the nervous and elongated forms that are associated with Mannerism (Ch. 10).

The supreme sculptor, of course, was Michelangelo. He signed some of his works—even some of his paintings— "Michelangelo Buonarroti, Sculptor." It was on this facet of his extraordinary genius that he most prided himself.

At fourteen Michelangelo became a pupil in a school for artists sponsored by Lorenzo the Magnificent and conducted in the Medici gardens. Here he developed his lifelong passion to "free figures from the living stone." He also studied and admired the sculpture of Ghiberti, Verrocchio, and especially Donatello, and he was enthralled by the Greek and Roman marbles such as the *Laocoön Group* (fig. 3-10) that were being found in increasing numbers.

His first major work, completed when he was about twenty-five, is the *Pietà* at St. Peter's (fig. 9-14), a blending of Greco-Roman concepts of beauty with his own responses to the Bible. As he was to do many times, he chose a Biblical theme that evoked strong feelings, but he treated it with classical restraint. He arranged the figures harmoniously in a pyramid, with large billows of drapery forming the base. The mother, youthful and serenely sorrowful, easily holds the body of the Savior. The eye of the observer adjusts willingly to the fact that though the Christ is lifesize, his mother is considerably larger. The work has a softness, serenity, and exquisite finish not found in most of his later sculpture.

Michelangelo's next major work was his celebrated *David* (fig. 9-15). This colossal statue, nearly eighteen feet high, he carved from a piece of marble that another sculptor had started on and abandoned. Unlike Donatello's boyish bronze *David,* Michelangelo's is a powerful young athlete, standing in a graceful contrapposto and eyeing his adversary with a mixture of apprehension and confidence. The *David* is the embodiment of Michelangelo's conviction that the body, though sometimes a hindrance and a source of corruption, need not be incompatible with the spirit.

The largest assignment that Michelangelo accepted as a sculptor was to build a grandiose tomb for Pope Julius II, to be placed in St. Peter's. The radically compressed final version, in the Church of St. Peter in Chains, is a rather sorry affair except for one magnificent detail, the statue of *Moses* (fig. 9-16). A statue of Paul, who was to be paired with Moses as the greatest examples of those "who achieved spiritual im-

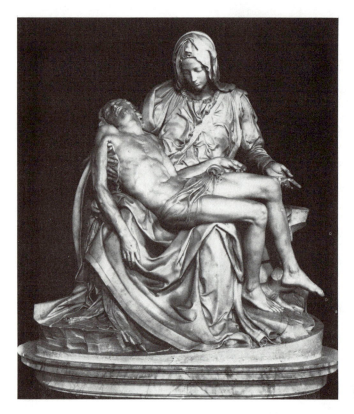

Fig. 9–14. Michelangelo. *Pietà*. About 1499. Marble. St. Peter's, Rome.

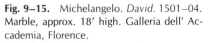

Fig. 9–15. Michelangelo. *David*. 1501–04. Marble, approx. 18' high. Galleria dell' Accademia, Florence.

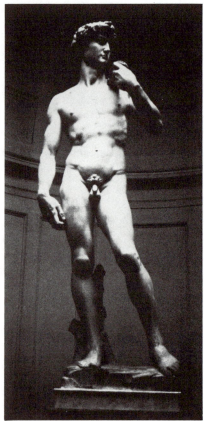

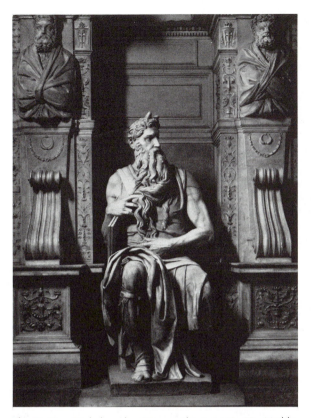

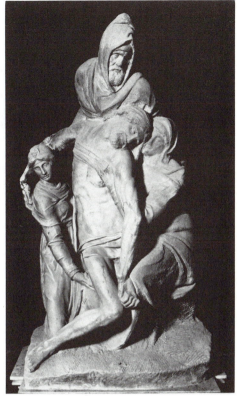

Fig. 9–16. Michelangelo. *Moses*, About 1513–15. Marble, approx. 8′ 4″ high. San Pietro in Vincoli, Rome.

Fig. 9–17. Michelangelo. *Deposition*. 1550–55. Marble. Florence Cathedral.

mortality through action and vision,'' was never made. The Moses, now the central figure of the tomb, is the embodiment of intelligence and prophetic vision. He is not angry, as many observers conclude; he is intense. He sees what the Neoplatonists called ''the splendor of the light divine.''

In his old age Michelangelo was haunted by the thought of death. He wrote, ''No project arises in my mind that hath not the figure of death graven upon it.'' He returned to the theme of the *pietà* in several late works. One of these, the *Deposition* (fig. 9-17), which he worked on over a period of ten years with the intention of having it a part of his own tomb, is a massive and tragic work, dominated by the sagging figure of the dead Savior and by the cowled old man at the back,

whose sad, compassionate face resembles Michelangelo's own. The work, which he smashed in a fit of impatience but allowed an assistant to repair, is in the Cathedral of Florence. Michelangelo's body lies in the Church of Santa Croce, not far away.

PAINTING

The individual styles of Leonardo da Vinci, Michelangelo, and Raphael, the three greatest of High Renaissance painters, are not hard to recognize. But they shared a number of attitudes and abilities. All demonstrated, especially in their large-scale works, a profound concern for the intellectual content of their paintings and for their emotional and

psychological implications. All created human figures, whether in secular or religious paintings, that are individualized and yet representative of universal concepts. All were masters of the most difficult techniques of painting; they were capable of more flexible and varied artistic expression than had been true of even the greatest of their predecessors. All were masters of composition, the art of arranging and balancing the figures and other objects of a painting in a harmonious whole. Figures in a High Renaissance painting are often arranged in a circle or oval, a parallelogram, a pyramid, or some other geometrical pattern, with no loose ends or unrelated elements. Moreover, all figures are psychologically and physically related by expressions, glances, postures, and gestures. All is self-contained, a closed concept of composition.

Leonardo da Vinci (1452–1519) was considerably the oldest of the three. No one except possibly Michelangelo ever demonstrated more clearly the then-new concept of *genius*—of extraordinary creative and intellectual power given by God to a very few of his children. He was interested in almost the entire range of human knowledge. Concrete mathematics fascinated him—mathematics dealing with forms, shapes, and spatial relationships. He was almost obsessed with proportion; he saw it manifested in numbers, measurements, lines, spaces, and weights. He made minute studies of plants, fossils, and animal and human anatomy and recorded his findings, in words or drawings, in dozens of notebooks. His notebooks also contain hundreds of drawings of inventions—gears, boats, clocks, hydraulic jacks, ball bearings, military tanks, machine guns, flying machines, and so on. He was a gifted musician and conversationalist. In a sense the incredible breadth of his interests diminished his contributions as an artist. He left behind him only his notebooks and drawings and a dozen or so paintings, some of them unfinished.

When Leonardo was twenty he was granted membership in the Florentine guild of master painters. Representative of his style at that stage is an intriguing if slightly repellent portrait of a young lady named *Ginevra*, now in the National Gallery in Washington, D.C., the only Leonardo in America. In his first version of the *Madonna of the Rocks* (fig. 9-18) one sees the developed Leonardesque style: the triangular composition; the closed arrangement of figures, their psychological unity heightened by the interplay of hands pointing, praying, and blessing; the beautiful human forms, accurate but suffused with poetic sentiment; and the mysterious landscape, purely imaginary and yet accurate in botanical and other details. We also observe the *chiaroscuro*, the contrasts of light and shadow, with figures merging softly with the background; the harmonious blending of colors; and the *sfumato*, the mist that permeates the atmosphere and plays softly around eyes, cheeks, and lips.

Within a year or so of the discovery of America, Leonardo began his masterpiece, *The Last Supper* (fig. 9-19), a work whose sublime spiritual content has made it perhaps the most famous religious painting in the world. This fresco, painted on the wall of a monastery in Milan, depicts the disciples in four carefully arranged but natural groups, each man sharply individualized and each reflecting in posture as well as expression his reaction to the words, "One of you shall betray me." Judas's isolation is not physical but psychological. He sits staring darkly, his right hand grasping a money bag and his body recoiling from the Christ. Details such as the perspective lines, the natural halo of the center window, and the glances of the disciples draw the eye toward the indistinct face of the Savior.

Leonardo's *Mona Lisa* has had the misfortune, perhaps, of having been reproduced and written about too much, and some critics dismiss it as overrated. Whether it is or not, it remains a masterpiece, and viewers will doubtless continue to be intrigued by the strange two-level landscape,

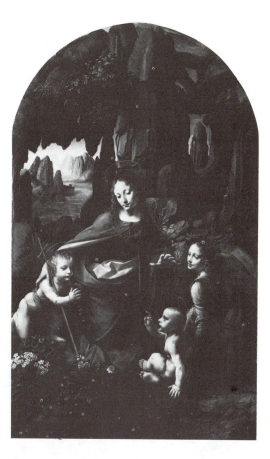

Fig. 9–18. Leonardo da Vinci. *The Virgin of the Rocks*. About 1485. Oil on wood, approx. 75 × 43″. The Louvre, Paris.

Fig. 9–19. Leonardo da Vinci. *The Last Supper*. About 1495–98. Fresco. Santa Maria delle Grazie, Milan.

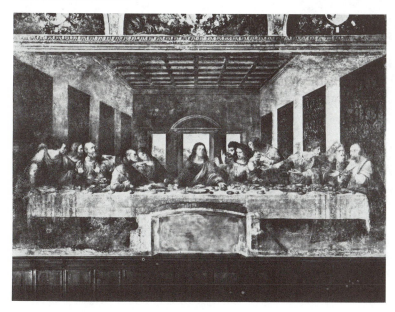

the soft, monochromatic lights and shadows, and the lady's enigmatic half-smile.

The influence of Leonardo's contemporary, Michelangelo, has been as great upon painting as it has upon sculpture. In the first decade of the sixteenth century, he bowed reluctantly to the command of Pope Julius II and spent almost four years adorning the ceiling of the Sistine Chapel with fresco paintings (fig. 9-20). The work, which occupies the curved ceiling of a room measuring 134 by 44 feet and contains hundreds of figures in a great variety of postures, demonstrates Michelangelo's mastery of the human form. Basing his thematic structure on a combination of Biblical narrative and Neo-platonic concepts, Michelangelo arranged his design in this way: In the four corners are large paintings depicting Old Testament incidents in which God helped the righteous to conquer their enemies—for instance, David slaying Goliath. The eight triangles over the windows are filled with crowded, darkly colored figures of Christ's Biblical ancestors, who represent man in an unenlightened, uninspired state. This is the first of the three zones of the ceiling.

In the second zone, occupying the spaces between the triangles, are Old Testament prophets alternating with pagan sib-

Fig. 9–20. Michelangelo. Ceiling of Sistine Chapel, Rome. 1508–12.

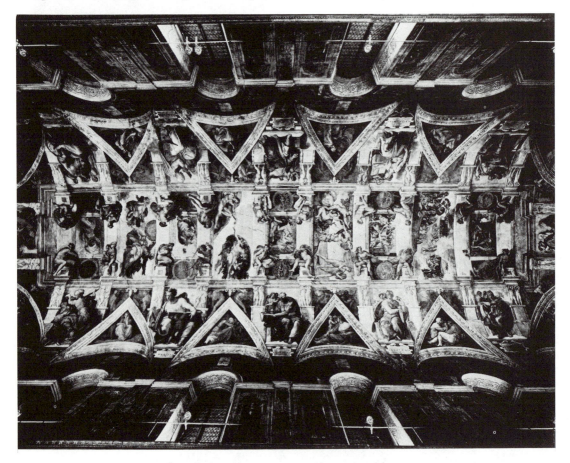

yls, all representing enlightened and inspired man. These are among the noblest figures in the ceiling. Jeremiah (fig. 9-21), sorrowfully pondering the transgressions of God's children, is especially impressive.

The third zone, the large center area, is filled with scenes from Genesis, alternately larger and smaller. These scenes, if we read them in the order in which they were painted, reverse chronological order. The first four show Old Testament personages in various acts or states of sinfulness, from the drunkenness of Noah to the temptation and expulsion of Adam and Eve. The other five are Creation scenes. The figures grow larger and more dynamic when read in this anti-chronological order. Considered in this manner, the scenes develop another Neoplatonic idea—life as a journey from the sinful body to freedom of the soul in God. Read in the natural order, the panels can suggest how soon and in what ways man can depart from the divine circumstances of his creation. Most impressive of these central panels are *God Creating the Sun and Moon* and *God Creating Adam*—in the latter a benign God reaching to give the touch of life to the supine, perfectly modeled body of Adam. A cleaning of the ceiling, underway in 1982, shows that its original colors are much brighter and more strongly contrasting than they have long been thought to be.

The ceiling was finished in 1509. Thirty-two years later Michelangelo completed another enormous fresco on which he had worked for six years, again by papal command. This was the *Last Judgment* that occupies an end wall of the Sistine Chapel. The work reflects a spirit of pessimism that seems to have been widespread in mid-sixteenth-century Rome. But the overall conception and interpretation are uniquely his own. He portrays huge, almost muscle-bound figures in a convulsion of movement and emotion (fig. 9-22). To the sound of trumpets the dead rise from their graves to appear before Christ the Judge. He sits with an arm raised, his condemning gesture checked by reflective sadness. Around him

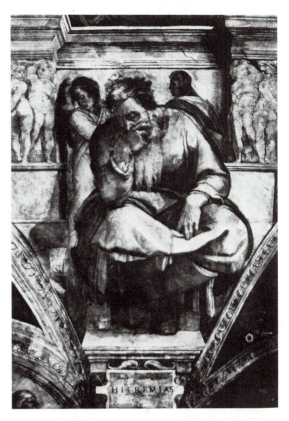

Fig. 9–21. Michelangelo. *Jeremiah.* Sistine Ceiling, Rome.

are saints and martyrs; even the redeemed seem joyless. His mother cowers under his raised arm. At the lower right are Dantesque damned souls being driven to their doom; others are ferried by Charon across the Styx.

The youngest of the three great High Renaissance painters, Raphael (1483–1520), was for four hundred years probably the most popular. Like Leonardo and Michelangelo, he did paintings on the grand scale, but they were (and are) largely unknown to the millions who have responded warmly to his fifty or more Madonnas. Though current critical fashion has tended to turn its back on these Madonnas, dismissing them as insipid and sentimental, they are masterfully executed works that still have great general appeal.

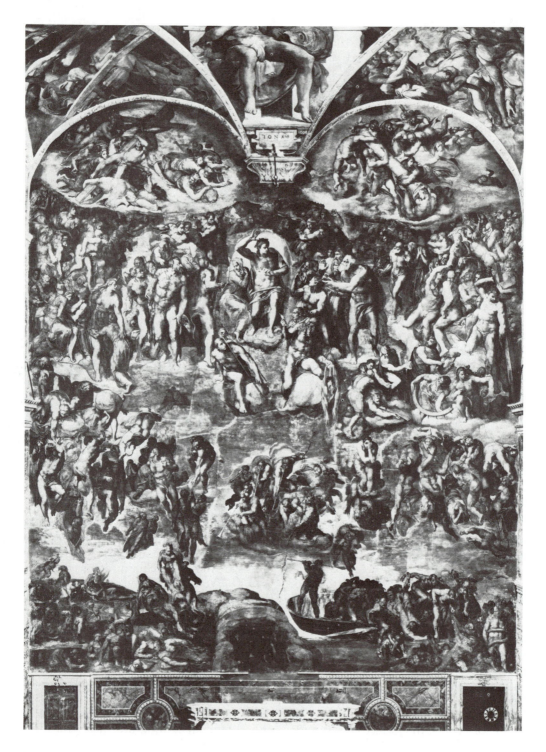

Fig. 9–22. Michelangelo. *The Last Judgment.* 1534–41. Fresco, altar wall of the Sistine Chapel.

Born in the small city of Urbino, Raphael went to Florence when he was twenty-one after having received his early training from his father and other painters. In Florence he soon became popular and was quickly deluged with commissions, as he was to be throughout his short life. In Florence he painted numerous portraits and many of his Madonnas. The *Alba Madonna* (Colorplate 5) is representative. Within a circular frame (*tondo*) Raphael has placed his figures in a parallelogram, with one line running from the tip of the Madonna's head and down past her left elbow, the second from that point to her toes, and so on around.

More evident than the symmetry is the poetry—the softly rounded but clean-edged figure of the Babe, the rich color harmonies, and the subtly modeled, serene faces, all placed in an idealized landscape.

Raphael's first commission in Rome was to redecorate the papal apartments in the Vatican for Julius II. Here he and a corps of assistants painted many large murals. Representative of these is his great *School of Athens* (fig. 9-23), a work embodying the theme of Philosophy. Raphael puts his philosophers and scientists in an architectural setting, behind a sweeping half-circular proscenium with classical barrel-vaulted arches

Fig. 9–23. Raphael. *The School of Athens*. 1509–11. Fresco. Stanza della Segnatura, Vatican Palace, Rome.

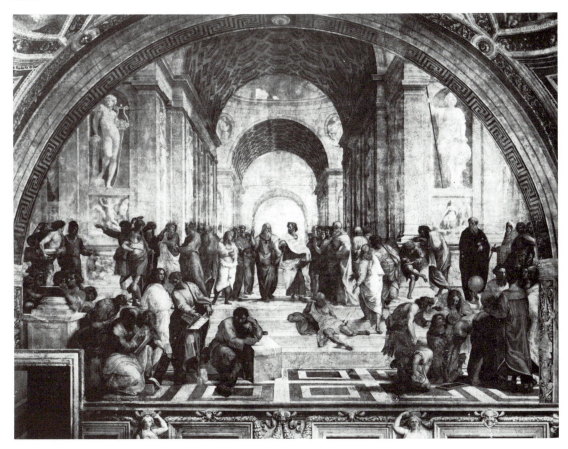

receding into the distance. The philosophers are arranged in a variety of animated but easy postures. Among them are many of the great classical minds, including Diogenes sprawled on the steps and the aged Archimedes stooping over a geometrical diagram. The central figures are the aging Plato (a portrait of Leonardo?) and Aristotle. Plato points heavenward, while Aristotle extends his hand over the earth—symbols of ideal and practical thought. The calm, harmonious work embodies the best of Raphael and of the grand style of the High Renaissance.

Painting in Venice. As varied as the art of the High Renaissance was in Rome, it was essentially an intellectual art, meticulously designed, dignified, often monochromatic. But in Venice the appeal was more to the eye and the emotions than to the mind. Colors were brighter and more glowing. Oil, which had replaced tempera as the favorite medium of Venetian painters, made possible richer tones and more subtle gradations of color and texture, particularly the warm flesh tones that became a hallmark of Venetian art.

Giovanni Bellini (c. 1430–1516) was probably the greatest of an illustrious Venetian family of painters. A gentle, humane man, he was the finest of Venetian Madonna painters, as versatile and imaginative as Raphael and considerably more devout. As a careful observer of nature he gave many of his religious paintings landscape backgrounds that combine accurate detail with warm poetic feeling. One of his best is *St. Francis in Ecstasy* (fig. 9-24). The saint emerges from his cave and greets the morning with outstretched arms (one is reminded of his "Canticle to the Sun"). Nearby are the humble things that St. Francis loved—a donkey, a heron, a shepherd with his dogs and sheep; and not far away is a hillside town, not too unlike Francis's own Assisi, glowing in the early sunlight.

Giorgione (c. 1476–1510) has been ranked with Leonardo as one of the founders of modern painting. But while the High Renaissance painters in Rome followed Leonardo's lead in emphasizing design and balanced composition, Giogione led the way for his fellow Venetians in using color to unify his paintings.

Few of Giorgione's paintings remain, and the meanings of these few have long puzzled his admirers. Perhaps it is best, as someone has said, simply to call them "landscapes of the mind." One of the most celebrated is the *Tempest* (fig. 9-25). The human figures in the foreground, whose relationships to each other defy explanation, become simply parts of a total scene, in which earth, trees, buildings, and human forms are blended into one by a permeating light. Another of Giorgione's masterpieces is his *Sleeping Venus* (fig. 9-26), a lyrical treatment of a theme on which variations were to be played for centuries by hundreds of followers, from Titian to Manet.

One of the giants of painting was Titian (c. 1488–1576), whose productive career spanned most of the sixteenth century. A pupil of Giovanni Bellini, Titian ranged freely from religious subjects to mythological ones, from sensuous allegories to penetrating portraits. His style varied almost as much: poetic early works hardly distinguishable from those of Giorgione; full-blooded paintings of his middle years; and more deeply felt if less meticulously painted works of his old age.

For wealthy patrons such as the devout Philip II, Titian painted works narrating the amorous adventures of gods and goddesses. He painted innumerable variations on the Venus theme, all notable for their warm flesh tones and subtle gradations of color. Typical are his *Venus with the Organ Player* and *Venus with a Mirror* (fig. 9-27).

Titian painted portraits of many of the most famous persons of his time—Charles V, Philip II, Pope Paul III, and many others. He allowed the character of his sitter to determine the composition of the portrait, and

Fig. 9–24. Giovanni Bellini. *St. Francis in Ecstasy*. About 1485. Panel, 48½ × 55″. Copyright the Frick Collection, New York.

Fig. 9–25. Giorgione. *The Tempest*. About 1505–08. 32 × 29″. Gallerie dell' Accademie, Venice.

Fig. 9–26. Giorgione. *Sleeping Venus*. About 1508–10. Approx. 46 × 69″. Staatliche Kunstsammlungen, Dresden.

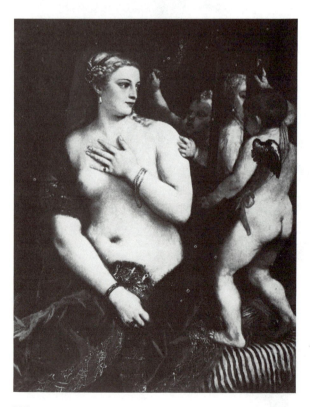

Fig. 9–27. Titian. *Venus with a Mirror*. About 1555. 49 × 41½″. National Gallery of Art, Washington, D.C. Andrew Mellon Collection.

he employed a great variety of poses. He also varied his style, from sharply defined works to the looser, less distinct brushwork of the *Self-Portrait* that he painted in his old age. Here we seen him as a solemn, almost priestly-looking man, with little of the assurance that shows through his earlier self-portraits.

Titian made a number of religious paintings, some of them colossal, for the churches of Venice. Most profound of these, in the darker, less precise style of his last years, is his *Christ Crowned with Thorns* (fig. 9-28), a work that anticipates the great religious paintings of Tintoretto and Rembrandt.

Northern Painters. Northern Europe in the sixteenth century had its masters whose fame has gradually overtaken that of the Italian artists of the period. Of these, three are of special importance: the Germans Albrecht Dürer and Hans Holbein the Younger, and the Flemish master Pieter Bruegel the Elder.

The first German painter of primary importance, Albrecht Dürer (1471–1528), was born in Nuremberg, a flourishing German city. Trained as a goldsmith, he became fascinated by the newly developing arts of the woodcut and the engraving; and during several long stays in Italy, where he was befriended by the Bellinis, he learned the secrets of Venetian and Roman Renaissance styles—color, design, perspective of all kinds, and the skillful and accurate depiction of the human body. He learned to combine the supple, modeled forms of the Italian humanist painters with the minute detail and emotional expressiveness of his own Northern Gothic traditions.

Dürer produced more than a thousand woodcuts and engravings. Among his woodcuts is a series called the *Apocalypse*. Of these the best known is the fourth (fig. 9-29), which depicts the Four Horsemen of the Apocalypse as they ride over the earth destroying the powerful as well as the humble. The last in the series, remarkable for its in-

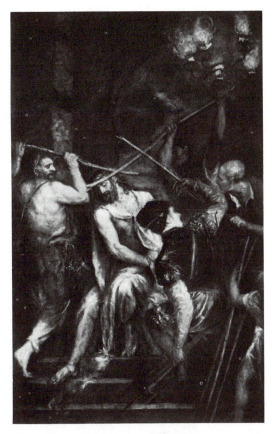

Fig. 9–28. Titian. *Christ Crowned with Thorns.* About 1573–75. Approx. 9 × 6'. Alte Pinakothek, Munich.

tensity and detail, shows the final overcoming of evil. An angel imprisons Satan while another shows John the way to the New Jerusalem—a city much like Dürer's own Nuremberg. Among his engravings, many of them among the supreme masterpieces in this medium, one of the most representative is *St. Jerome in His Study* (fig. 9-30). In an engraving that is a marvel of subtle and varied textures, Dürer depicts the scholarly saint in his study. Sunlight plays softly on the walls, the table, and other objects, with the traditional skull in the window, and the lion, which Jerome has befriended by pulling a thorn from his paw, keeping guard over his master.

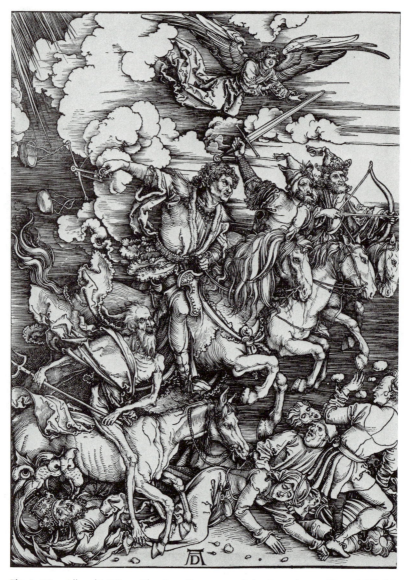

Fig. 9–29. Albrecht Dürer. *The Four Horsemen of the Apocalypse.* About 1497–98. Woodcut. The Metropolitan Museum of Art, New York. Gift of Junius S. Morgan, 1919.

In his later life Dürer was celebrated for his paintings as well as his prints, and he made numerous portraits and religious paintings in oil. Shortly before his death he painted one of his masterpieces, the double-panel depiction of *Four Apostles* (fig. 9-31)—four sharply characterized stalwarts of the early church (John, Peter, Mark, and Paul) as they react to each other's personalities and convictions.

Our visual impressions of some of the famous people of northern European histo-

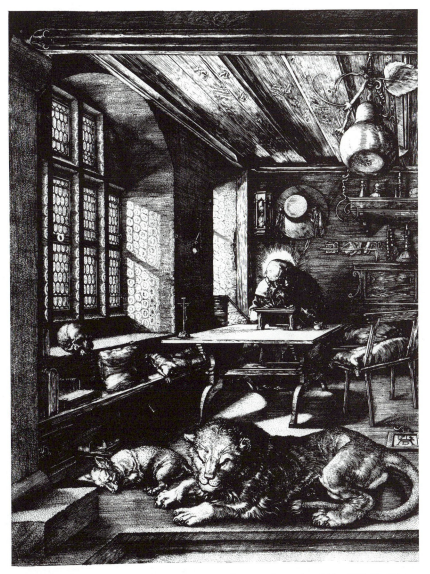

Fig. 9–30. Albrecht Dürer. *St. Jerome in His Study*. 1514. Engraving, 9½ × 7½″. The Metropolitan Museum of Art, New York. Fletcher Fund, 1919.

ry—Henry VIII, his wives, Thomas More, Erasmus, and a number of others—we derive from the great portraits of Hans Holbein (c. 1498–1543). He was born in Germany, spent part of his young manhood in Switzerland as an illustrator of such works as the Luther Bible, and left for England on the recommendation of Erasmus, whose portrait he had painted. In England he painted a group portrait of Sir Thomas More's family and a celebrated portrait of More alone. Holbein returned to Basel for a short time, and while

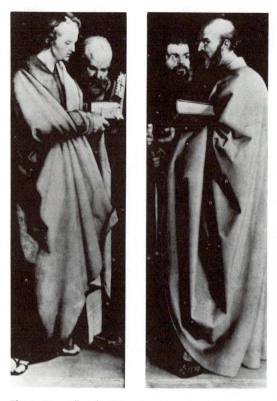

Fig. 9–31. Albrecht Dürer. *Four Apostles.* 1526. Oil on panels, 7½' high. Alte Pinakothek, Munich.

of Dutch country life. Only in fairly recent times has his unique vision become recognized as significant truth and also as beauty.

Bruegel's first important works were drawings of allegorical subjects such as the virtues, from which craftsmen made engravings for popular sale. These drawings, many of them filled with fantastic and grotesque details—fish eating fish that are in turn eating fish, flying reptiles brandishing swords —are as imaginative as Bosch's work and were probably more immediately understandable.

When he turned to painting, Bruegel created his most famous works, the paintings of country life such as the *Wedding Dance* and *Peasant Wedding* (fig. 9-34). The humor of these storytelling scenes is less satirical than sympathetic. The atmosphere of what must have been an infrequent holiday heightens the liveliness of the scene. If individual faces look coarse and weather-worn, Bruegel is only reporting facts. Closely related to these scenes of country life are several pictures that illustrate Flemish folkways—*Children's Games,* for instance, in which today's viewer discovers that most of our popular games of childhood were common four hundred years ago.

More clearly satirical and didactic are depictions of proverbs and parables—*The Bird's Nest, The Blind Leading the Blind.* In a more serious vein are Bruegel's religious paintings such as *The Massacre of the Innocents,* and *The Tower of Babel* with its incredible detail.

Bruegel painted some of the first true landscapes, and some of the greatest. A few critics, in fact, have called his *Hunters in the Snow* (Fig. 9-35) the greatest landscape ever painted. Not only the tonally unified composition but every detail, from the stark trees, hunters, and dogs in the foreground, the skaters on the ponds, the frozen river, and the distant castle near the alpine crags, to the church tower against the far horizon, epitomizes the cold, still beauty of a late afternoon in winter.

there he painted a portrait of his sad-eyed, ill-looking wife and their two children (fig. 9-32). Again in England, he entered the royal service and painted many portraits of Henry VIII and members of his court—those of Henry all elegantly dressed but with no sparing of the king's cold eyes and obvious capacity for cruelty (fig. 9-33).

Pieter Bruegel the Elder (c. 1525–1569) was the greatest Flemish painter of the sixteenth century and one of the supreme masters of his art. The complexity and scope of his genius have come to be recognized only within the past century. In his own time he was known essentially as an imitator of Bosch. In succeeding centuries he was regarded as an unimportant painter of scenes

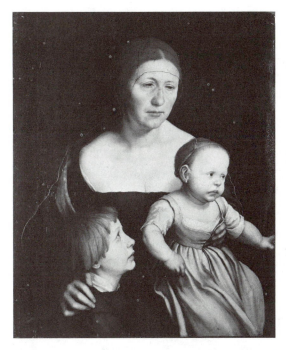

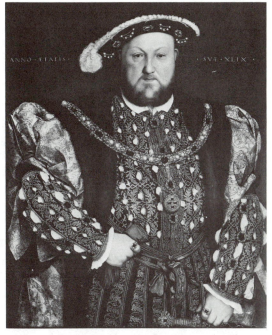

Fig. 9–32. Hans Holbein the Younger. *Holbein's Wife and Two Older Children*. About 1528. Kunstmuseum, Basel.

Fig. 9–33. Hans Holbein the Younger. *Henry VIII.* 1540. Panel, 32½ × 29″. National Gallery, Rome.

Fig. 9–34. Pieter Bruegel the Elder. *Peasant Wedding*. About 1565. Panel, 45 × 64″. Kunsthistorisches Museum, Vienna.

Fig. 9–35. Pieter Bruegel the Elder. *Hunters in the Snow*. 1565. 46 × 64". Kunsthistorisches Museum, Vienna.

A reaction against the ideals and principles of High Renaissance art surfaced strongly in the middle years of the sixteenth century, in a short-lived but important movement now called Mannerism. At the same time the Catholic church was launching its response to the Protestant Reformation—and to the need for internal reform—in the Catholic Counter Reformation. This movement was to have a powerful impact on the arts and culture of Europe. The Protestant Reformation itself was continuing to have its own strong if diffuse influence on the arts. And the Holy Roman Empire, though waning as a political force, still affected the cultural life of Europe, especially of Spain and Flanders. Soon the strong monarchies of central and northern Europe, especially the absolutist court of Louis XIV in France, were to exert their influence on all aspects of life. Europe, in short, was moving toward the century-and-a-half-long era that has come to be called the baroque age—in many respects a second Renaissance.

10 MANNERISM AND THE BAROQUE: SOUTHERN EUROPE

The seventeenth century was one of religious, economic, and political dissension and unusually bloody warfare. Moslems continually harassed southeastern Europe and were harassed in turn. The Thirty Years' War (1618–1648), as devastating as any ever fought, involved most of the Western world. Spain struggled to regain her hold on the Netherlands. France fought a number of wars of expansion. England, with absolutist kings and dissenting Puritans, had insurrections and civil wars. In fact, it has been said that in the seventeenth century Europe narrowly escaped plunging into a new Dark Age.

But in other respects it was one of the greatest of centuries. In science there were the monumental achievements of such men as Galileo, Brahe, Kepler, Harvey, and Newton, and in philosophy the writings of Descartes, Pascal, Spinoza, Hobbes, and Locke, among others. Cervantes wrote the immortal *Don Quixote*. Drama rose to great heights in the plays of Calderón, Corneille, Molière, Racine, and the later works of Shakespeare. Milton, Donne, Dryden, and others joined Shakespeare in advancing England's literary renaissance. Music expanded in several important directions, including opera. In painting, sculpture, and architecture there were many major figures. Add to these the achievements of explorers and colonizers, and one can say that the intellectual and physical horizons of Western man expanded more widely and rapidly in the seventeenth century than they had done in any other era, including the Renaissance.

In this chapter we will consider the arts of Italy, Spain, and France in the later sixteenth and the seventeenth centuries, emphasizing the flowering of mannerism and of baroque styles in those essentially Catholic countries that were most strongly affected by the Counter Reformation. In the next chapter we will be concerned with the same period in the largely Protestant countries of the North—the Germanic states, the Low Countries, and England.

Counter Reformation and the Arts. The Catholic Counter Reformation was first of all an organized effort to resist the spread of Protestantism and to combat the heresies, from the Catholic point of view, that threatened to destroy orthodox Catholicism. Out of it came conflicts that were initially verbal

207

and then physical—such bloody clashes as the Massacre of St. Bartholomew's Day in Paris in 1572, which resulted in the killing of more than ten thousand Huguenots (French Protestants); and the War of the Spanish Armada in 1588, which Philip II considered a holy war against English Protestantism. In the first half of the seventeenth century Europe was torn apart by the terrible Thirty Years' War, in which religious issues were as momentous as were political and economic ones.

Second, the Counter Reformation was a movement to reform and rejuvenate the Catholic church from within, both religiously and culturally. Early in the sixteenth century, in an attempt to breathe new life into the old institutions of Catholicism, a number of monastic groups reformed and revitalized themselves. Enthusiasm for monasticism was especially strong in Spain. A leader of the movement there was St. Teresa of Avila, who was at once a mystic and a practical and aggressive organizer. Another was Ignatius Loyola, who founded the Society of Jesus; this militant organization, commonly called the Jesuits, had a marked influence on the arts, especially architecture.

Another manifestation of the Counter Reformation was the Inquisition, which in its milder aspects was meant only to enforce the dogmas of the church. But at its worst, especially in Spain, it was not only repressive, culturally as well as religiously, but incredibly cruel.

On the papal level a change came with the papacy of Paul III, who began a reform of the Curia (the papal court) and established a council that led to the famous Council of Trent.

The Council of Trent was a series of councils of Catholic churchmen that met intermittently in Trent (Trento) in northern Italy over a period of eighteen years, from 1545 to 1563. The Council expressed its opposition to almost every doctrine of Lutheranism, codified Catholic dogma, and looked for ways to eliminate some of the abuses that

had called forth bitter Protestant criticism—traffic in indulgences, for instance.

The Council also concerned itself with the arts. It took to task those church composers whose works had become too complex, and it encouraged the simpler and clearer polyphony of Palestrina and his followers. Though the Council officially discouraged image-worship, it insisted on the value of visual, physical acts of worship—rituals of piety that led to the veneration of statues and paintings of holy personages. In answer to Protestant attacks on adoration of the Virgin Mary as being idolatrous, Catholic artists made countless paintings and statues honoring her, as well as countless others representing the saints and martyrs in the church. Such works emphasized both the happiness and pain of this earth and the joys of eternal glory.

Mannerism. It was not for a half-century after the Council of Trent that Counter Reformation art gathered real momentum. In the meantime the movement known as *mannerism*, a phenomenon basically distinct from both High Renaissance and baroque styles, came into being.

Only in the last forty or fifty years has mannerism come to be regarded as an authentic and significant style, especially in the visual arts and in literature. Mannerism is the expression of attitudes that recur at particularly restless and unstable periods in history—in the Hellenistic era, for instance, and in our own. As the Renaissance was wearing itself out, Europe was shaken by tremors of unrest that are recognizable in the impacts of the Reformation and Counter Reformation, in the increasing skepticism of humanistic thought, in the new worldviews imposed by the scientific discoveries of Copernicus, Galileo, and others, and in the heightened violence of war. From such circumstances as these, as well as the natural desire of artists to escape what must have seemed to them artistic dead ends, came mannerism.

In the visual arts, mannerism ex-

pressed itself as a reaction to the classical ideals of the High Renaissance, the ideals of harmony, proportion, and balance that are most clearly seen in such works as Raphael's *School of Athens.* We see in mannerist art a lack of symmetry and stability; a strained, often ambiguous emotional and moral atmosphere; a feeling for the subtle, the eccentric, the strange. Mannerist art often has remarkable intensity of a nervous and uncertain kind.

The Baroque. The term *baroque* applies to the arts of the era beginning early in the seventeenth century and ending about a century later. These are very general guidelines. In literature the new classicism began to take over in the second half of the seventeenth century. In music, baroque styles continued to be dominant until the middle of the eighteenth century.

The word *baroque* was originally a term of disparagement. It was probably derived from the Portuguese *barroco,* a large, irregularly shaped pearl. The term was first employed by the rationalists of the eighteenth century, who regarded the arts of the previous century as overelaborate, grotesque, and lacking in taste.

The baroque era in southern Europe was almost a re-enactment of the High Renaissance. It had basically the same kind of patrons—the church, the royal courts, the wealthy. And it had the same source of inspiration, the antique world. Probably most baroque artists considered themselves classicists; one can find an element of logic, order, and balance—if not restraint—in almost all baroque art. In fact it has a real kinship to the "grand style" of the High Renaissance. The baroque, however, is in a higher key; it is more colorful, more decorative, richer in texture. It tends to overstate, to try to impress by size, spectacle, and grandeur. In church architecture it obscures its classical elements with ornamentation, scrollwork, convex and concave forms. In the architecture of the courts it impresses with its size, the ornate elegance of its interiors, and its sweeping vistas. In painting it employs light and shade and color with more controlled power than did the mannerists. It combines and fuses the arts, so that in a baroque church one finds it hard to separate architecture from painting and sculpture. In music it adds richness, ornamentation, and dramatic power that bring polyphonic music to its greatest heights. Baroque art is designed to express its optimistic emotional and intellectual content in unmistakable terms and to stimulate a similar response.

LITERATURE

As one might expect, a number of poets, both in the Renaissance and in the mannerist era, attempted to write in the greatest and most demanding of classical forms, the epic; and two did so with real success. The first of these, the Italian Ludovico Ariosto (1474–1533), composed a long romantic epic, *Orlando Furioso,* which is based on the story of Roland (Orlando), Charlemagne, and the Saracens. It is distinguished for its swift-paced narrative and for the depth and psychological insight of its characterization. The work strongly influenced such English poets as Milton and Byron. The second, Torquato Tasso (1544–1595), wrote what has been called the greatest poem of the Counter Reformation, *Jerusalem Delivered.* Tasso, like Ariosto before him, was a skillful storyteller who found more interest in chivalry and romance than in warfare. His epic, based on the exploits of Godfrey of Boulogne in the First Crusade, has a strong undercurrent of religious sentiment.

Spanish Literature. The term *mannerism* has been applied most often to the visual arts, especially painting. But its characteristics—ambiguity, paradoxes, unresolved tensions—can also be seen in literature, and nowhere more clearly than in the literature of

Spain in the later sixteenth and seventeenth centuries—Spain's golden age.

Except for El Greco's religious paintings, no works of art expressed more intensely the spirit of the Counter Reformation, especially its early manneristic tendencies, than did the writings of two of Catholicism's most famous saints, the Spanish mystics St. Teresa and St. John of the Cross.

St. Teresa (b. 1515) lived an unremarkable life in a convent in Avila until her early forties, when she began to have a series of trances and visionary experiences that she recounted later in her *Life*. Among these was one in which she was visited by an angel who "had a long dart of gold in his hand, and at the end of the iron below methought there was a little fire. And I conceived that he thrust it some several times through my very heart after such a manner as that it passed the inwards of my bowels, and when he drew it back methought it carried away as much as it had touched within me and left all that which remained inflamed with a great love of Almighty God. . . . This is no corporal but a spiritual pain."

The same paradoxical blending of pain and ecstasy dominates the poetry of St. John of the Cross (1542–1591), a brilliant young theologian who was associated with St. Teresa. Like her he was attracted to the intense, sensuous imagery of the Song of Solomon, and he echoed that imagery in a number of lyrics, including "O Flame of Living Love." In this poem he exclaims:

O burn that burns to heal!
O more than pleasant wound!
And O soft hand, O touch most delicate,
That dost new life reveal,
That dost in grace abound,
And, slaying, dost from death to life translate!

The autobiography of St. Teresa and the lyrics of St. John, with their intense emotionality and reliance on sensuous, even sensual, imagery for spiritual purposes, are authentically mannerist.

Spain during its golden age produced many playwrights, some of them incredibly prolific. There were plays of every kind—comedies, fantasies, realistic plays, tragedies, and so on. Comedy mixed freely with tragedy, realism with fantasy. It was a theater of entertainment, with colorful costumes, much extravagant posturing and gesturing, and considerable improvisation. Dancing and singing were often incorporated.

Lope de Vega (1562–1635), priest, soldier, and playwright, invented the "cloak-and-dagger" drama and wrote numerous melodramas and religious plays, in all of which plot is the most important element. Best known of his five hundred surviving plays is *Fuente Ovejuna* (*The Sheep Well*), a melodrama of peasant life in which several women of the village of Fuente Ovejuna are driven to kill a villainous commandant who had been tormenting and attacking them.

The plays of Pedro Calderón (1600–1681) were almost as numerous and as wide-ranging as those of Lope. Two of Calderón's most famous plays are clearly mannerist. The first, *The Great Theater of the World*, develops a theme that is at least as old as Plato and that appears often in mannerist writing—life as a dream or illusion, or as a theater with its implications of unreality. In the second, *Life Is a Dream*, a king has kept his son imprisoned and ignorant of his identity because it has been predicted that the son will develop evil tendencies and overthrow his father. To test the soundness of the prophecy the king has the young prince drugged and brought to court, where he behaves so wildly that he is taken back to prison and is persuaded that his period of freedom was only a dream. Freed again later, he conquers his passions and assumes the throne, wondering to the end whether this episode, like the earlier one, is simply a delusion. Underlying the drama is the conviction that life *is* a

dream, that death is the awakening; but though life is only illusion, good deeds and right living are not in vain.

The novel *Don Quixote* is the greatest artistic creation of Spain's golden age and probably the most widely read novel ever written. It has been translated into more than one hundred languages, more than any other book except the Bible. Sainte Beuve has called it "the Bible of humanity."

The creator of *Don Quixote,* Miguel de Cervantes y Saavedra (1547–1616), saw his country's military and economic fortunes rise and fall; and certain ultra-idealistic, "quixotic" tendencies in his own character were brought to earth by the realities of his time and of his own life, including his wounds and his imprisonment as a soldier. Cervantes was not a typical Renaissance writer; he had little formal education and was only slightly acquainted with the classics. He knew remarkably well, however, the lives and ways of common people, and he found an attractive model for the structure of his work in the popular *picaresque* novels of his time—novels about the adventures of roguish vagabonds. *Don Quixote* won immediate popularity, and he could soon say that "children handle it, youngsters read it, grown men understand it, and old people applaud it."

The story of La Mancha's gaunt, middle-aged country gentleman who read romances of chivalry until "his brain dried up and he went completely out of his mind" is still familiar to young and old. Best remembered are the adventures of Part I—Don Quixote's encounter with the windmills, the battles with a herd of sheep and with skins of wine, his freeing of a convoy of hardened criminals, the numerous beatings he receives from those whose everyday world he invades. As the story progresses, one finds oneself laughing less and wincing more at the Don's misadventures; and one delights more and more in the deeds and words of the Don's squire, the wise-foolish peasant Sancho Panza, one of the most amusing characters in all literature.

Probably no literary creation except *Hamlet* has provoked as many different interpretations as this apparently simple tale. The Don himself has been considered everything from an amusing clown to a deeply tragic figure. Cervantes' own attitude toward his hero has been much debated: Did he sympathize with Don Quixote, or was he at odds with him? Doubtless Cervantes' feelings, like those of his readers, were ambivalent. In this ambivalence and ambiguity, as well as in other qualities of the novel, critics find reason to call it a key example of mannerist literature. Cervantes, says one critic, complicates his perspectives by improvising, swerving, yielding to the moment, shifting abruptly from realism to fantasy. Another says that *Don Quixote* was epoch-making in its confrontation of two realities, unworldly idealism and commonsense, and in its author's misgivings about where truth ends and illusion begins, misgivings that are fundamental to mannerism.

MUSIC

Counter Reformation Composers. Giovanni Pierluigi da Palestrina (c. 1525–1594) has been called "the first Catholic church musician." Palestrina admired and followed the practices of his great Flemish forerunners, Josquin des Pres and Orlando di Lasso, but he modified them to meet changing conditions: he was the first composer to reflect the spirit of the Counter Reformation, especially its mysticism and sense of awe. Palestrina was a devout man who wrote only a handful of secular pieces and is said to have repented of those few. He pleased the leaders of the Counter Reformation by moving away from an earlier tendency of religious composers to give the texts of masses such complex settings that they were hardly intelligible. In his celebrated *Missa Pa-*

pae Marcelli (Pope Marcellus Mass) he showed the way for all who followed; the text is clearly heard in the highest voice, or it is initially sung simultaneously by all the voices.

Within the limits of religious devotion that he imposed on himself, Palestrina expressed a wide range of emotion, and his music is notable for the clear, serene beauty of its sound. He is well represented by such shorter works as the lovely motet *Alma redemptoris mater* and the "Agnus dei" from the Mass *Veni sponsa Christi*.

More intense and passionate than the works of Palestrina were those of his pupil and friend, the Spanish composer Tomás Luis de Victoria (c. 1548–1611). Victoria's devotion to his faith was as profound as Palestrina's. His warm, intense music contains melodic hints and harmonies that seem to reflect his native Spain. Among his shorter works, the motet "O vos omnes," with its darkly colored harmonies, chromatic effects, and dramatic exclamations, is an expression of deep sadness—"O all you who pass by the way, look and see if there be sorrow like unto my sorrow." Similar in its poignancy is "O Magnum Mysterium."

Mannerism in Music. The term *mannerism* has proved less useful in historical studies of music than of literature and the visual arts. It has been applied to the works of a few composers, including Gesualdo, an Italian prince whose madrigals were unusual for their dramatic power and for their unconventional harmonies and modulations.

Gabrieli: Prebaroque Venetian. A highly original composer whose works foreshadowed the main tendencies of baroque music was Giovanni Gabrieli (c. 1554–1612). Like his uncle Andrea before him, he was organist of St. Mark's, and he gained international fame as a player and as an innovative composer. Making the most of Venice's delight in pomp and festivity, and also of the unique acoustical qualities of St. Mark's, he composed for that great cathedral many works that exploited the full colors of instruments and human voices. He had a particular enthusiasm for brass instruments, and for them he wrote some of the first strictly instrumental compositions. He was the first to plan contrasts of volume; one of his sonatas, *Pian e Forte,* (to be played soft and loud) is an exercise in varying dynamics.

Gabrieli's works for large combinations of musicians—soloists, two or three choirs, one or two organs, and instrumental ensembles—display his remarkable inventiveness. (Several of them have been recorded recently in St. Mark's itself.) An example is *In ecclesiis* (in fifteen parts for three choirs), in which passages for unison voices alternate with increasingly powerful, brass- and organ-supported "Alleluias." The liturgical titles of such works are somewhat misleading; the works themselves are essentially secular in spirit—dramatic, colorful, exuberant forerunners of the baroque age.

Baroque Music. The word *baroque* is applied to the music of the century and a half from 1600 to 1750—from the beginnings of opera through the climactic years of Bach and Handel. It is more accurate to speak of the *baroque age* than of the *baroque style* in music. There is no single baroque style. Some of the main characteristics of baroque music are these:

1. As in the music of Orlando, Palestrina, and some other Renaissance composers, increasing emphasis was placed on a dominating melody. Harmony as we know it today was being established. Polyphony did not disappear; in fact, it reached its highest level in the latter part of the era. But homophony—music in which one voice carries a melody and others provide an accompaniment in chords—became increasingly important. Now the composer often produced a melody for a solo voice and wrote below it a single bass line for the accompani-

ment, with figures (the *figured bass*) indicating what chords should be filled in. Out of this grew a very important baroque development, the *basso continuo*, in which a keyboard instrument and a string bass provided a continuous accompaniment for many types of music.

2. Old instruments were improved and new ones were invented. By the seventeenth century the organ had acquired tone qualities that are still much admired. Other keyboard instruments, especially the clavichord and the harpsichord, gained popularity. The more robust and versatile piano (pianoforte) was invented early in the eighteenth century.

 The violin and the members of its family (the viola, the cello, and—more distantly—the double bass) are all products of the baroque age—descendants of the earlier and weaker-toned viols. Many of the instruments played by virtuosi today were made in the baroque era by the Amati, Guarnieri, and Stradiveri families in Cremona, Italy.

3. Baroque composers wrote fewer instructions as to tempi, dynamics, and so forth than we are accustomed to. Hence there was much improvisation, and performers took many liberties with rhythm and other matters. Embellishments—trills, turns, grace notes, and other flourishes—were essential to baroque music; if they were not indicated, they were improvised.

4. Dynamics as we think of them today were largely unknown; there were few gradual or isolated gradations of volume. Instead they were "terraced" dynamics—abrupt shifts of volume resulting from sudden increases or decreases in the number of instruments or voices performing (as in Gabrieli's *Pian e Forte*).

5. A typical passage of baroque music moves forward with urgency and unflagging rhythm toward its last note, with no significant retards or sustained rests and no variation in the forward drive.

6. The major and minor scales as we know them today had become largely standardized.

The Opera. Late in the sixteenth century a group of learned musical amateurs in Florence set out to revive the original style of delivery of Greek tragedy—the plays of Aeschylus and his fellows. Since no one knew (or knows) what that style was, there is little likelihood that their attempts resembled the originals. They developed a kind of musical declamation, the forerunner of operatic *recitative*, and set certain classical stories to music, with solo voices and a simple basso continuo carrying the thread. In 1600 they produced *Euridice*, a work that is considered the first opera. It was evidently a pallid performance of a feeble work.

Claudio Monteverdi (1567–1643), one of the major formative figures in musical history, recognized the possibilities of the Florentines' experiments. Already an important church musician, he composed the first opera of genuine importance, *Orfeo*, which was performed in Mantua in 1607. It is a remarkable pioneering effort. Its basic ingredient is the recitative employed by its forerunners, but it is much more dramatic and powerful, with passages of sustained melody that point toward the arias of later operas.

Monteverdi had a fine sense of drama, and his music expressed a wide range of emotions. An innovator in other ways, he introduced into *Orfeo* frequent choruses and many instrumental interludes. Shortly after his success with *Orfeo* he went to Venice to become chapel master at St. Mark's. There he composed much sacred music, led the way in popularizing the opera in Venice, and wrote many secular operas, including *The Return of Ulysses* and *The Coronation of Poppea*.

The first major school of operatic composers sprang up in Naples. Its founder was Alessandro Scarlatti (1660–1725), a highly versatile composer and performer. He developed the Italian overture, a short orchestral introduction to an opera, and he gave the operatic aria a fixed form. Scarlatti's most famous operas are *Il Tigrane* and *The Triumph of Honor*.

The operas of Scarlatti and his fellow Neapolitans were in the *opera seria* (serious opera) style, but these were soon rivaled by the *opera buffa*, the comic opera. This form grew out of what were called *intermezzi*, small, entertaining pieces performed between acts of literary dramas. The most successful *intermezzo* was *La Serva Padrona*, a little comic opera presented in 1733 by a young composer named Giovanni Pergolesi. So ingratiating was *La Serva Padrona*, with its simple contemporary plot, its witty recitatives, charming arias, and lively accompaniment, that it was produced all over Europe with great success after Pergolesi's early death. In fact, it was the principal cause of a "war" in France in the 1750s between those who preferred Pergolesi's melodic, lively style and the supporters of the conventional, undramatic French opera.

Opera was brought to France primarily by an Italian, Giovanni Battista Lulli, who changed his name to Jean Baptiste Lully and became a French citizen. An unscrupulous man but an able musician and dramatist, Lully (1632–1687) won the favor of the court of Louis XIV and became virtually the musical dictator of France. Under him, French baroque opera solidified into a stereotyped pattern, with elaborate costumes and spectacular staging; dozens of recitatives and arias; dancing or madrigals after each act, sometimes with the bluebloods, including Louis himself, participating; and a weak thread of plot derived from classical mythology or history. Typical Lully operas are *Alceste* and *Armide*. More spectacle than opera, they are almost redeemed by Lully's competently written music. Better, musically, are the operas of Jean Philippe Rameau (1683–1764), who composed beautifully flowing melodies and had a fine feeling for harmony.

Oratorio and Cantata. Two important new forms of sacred music, the oratorio and the cantata, were created in the seventeenth century. The first true oratorios were composed by the Italian Giacomo Carissimi (b. 1604). Making the first clear-cut distinction between opera and oratorio, he put aside theatrical presentation and acting, gave a Narrator the responsibility for dramatic detail, and emphasized the function of the chorus. He based all of his short and interesting oratorios—*Job, Jonah,* and others—on Bible stories.

The term *cantata* has come to mean a small oratorio in any of a variety of types. This form was also created by Carissimi, who wrote many cantatas for performance in smaller churches. Most of them were for soloists alone and were in one movement, usually combinations of three recitatives and three arias. The cantata form took hold especially in the Lutheran church, and such composers as Telemann and Bach wrote enormous numbers of them.

Baroque Instrumental Music: the Sonata. The term *sonata* was first applied to any composition that was played or "sounded" rather than sung. But after about 1650, musicians began to apply the name more narrowly to pieces for a small group of instruments or for a solo instrument with accompaniment. These baroque sonatas were of two basically different kinds: church sonatas, serious compositions performed as a part of worship services, and chamber sonatas, which consisted of lively groups of short dances.

The church sonata was made popular by Arcangelo Corelli (1653–1713). The first famous violin virtuoso, Corelli was a modest and simple man who became immensely popular as a performer and composer. Not many of his compositions remain. They in-

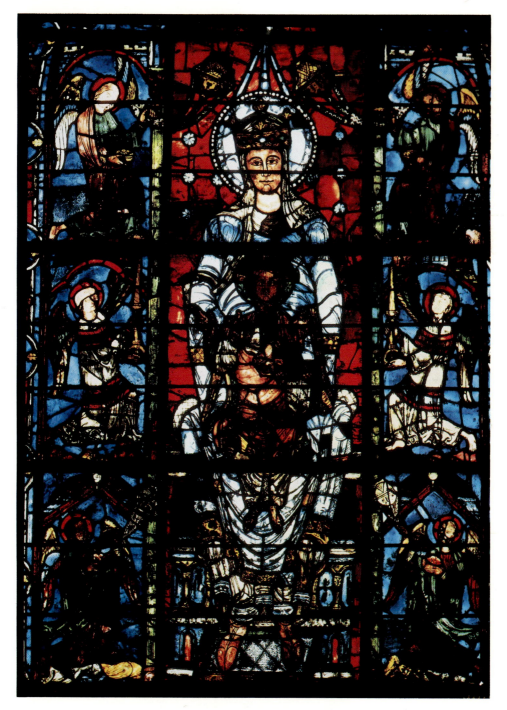

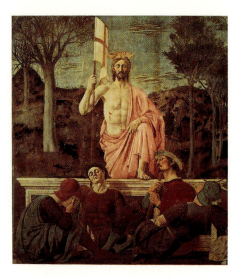

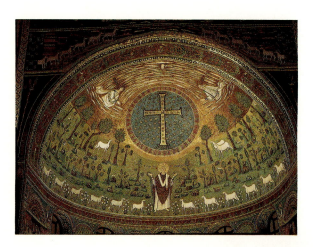

Colorplate 1. (*above*) Interior, S. Apollinare in Classe. About 530. Ravenna, Italy.

Colorplate 3. (*above right*) Piero della Francesca. *Resurrection*. About 1463. Fresco, detached. Picture Gallery, Borgo San Sepulcro, Italy.

Colorplate 4. (*right*) Jan van Eyck. *Giovanni Arnolfini and His Bride*. 1434. Oil on wood panel, approx. 32 x 22". Reproduced by courtesy of the Trustees of the National Gallery, London.

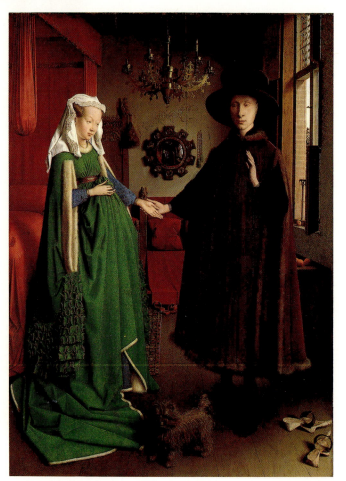

Colorplate 5. Raphael. *The Alba Madonna*. About 1510. Oil, diameter 37″. National Gallery of Art, Washington, D.C. Andrew Mellon Collection, 1937.

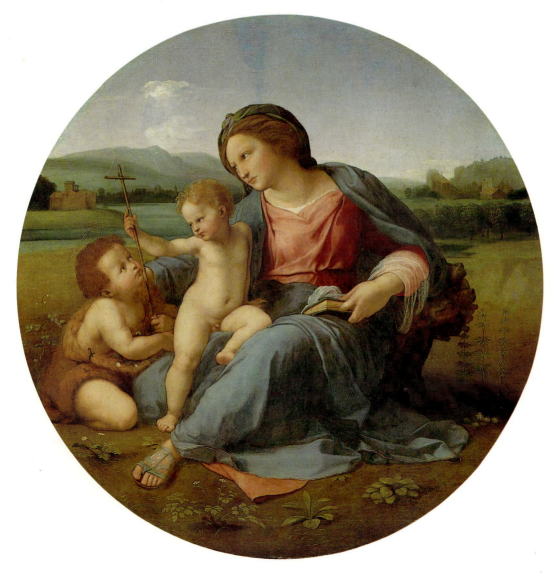

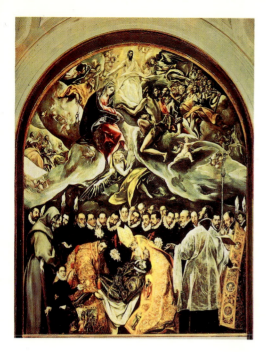

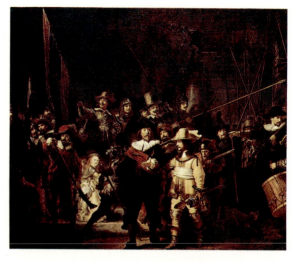

Colorplate 6. (*above*) El Greco. *The Burial of Count Orgaz.* 1568. 16′ x 11′10″. Santo Tomé, Toledo, Spain.

Colorplate 7. (*above right*) Rembrandt. *The Night Watch (The Company of Captain Frans Banning Cocq).* 1642. 12′2″ x 14′7″. Rijksmuseum, Amsterdam.

Colorplate 8. (*right*) Jan Vermeer. *Young Woman with a Water Jug.* About 1663. 18 x 16″. The Metropolitan Museum of Art, New York. Gift of Henry C. Marquand, 1889.

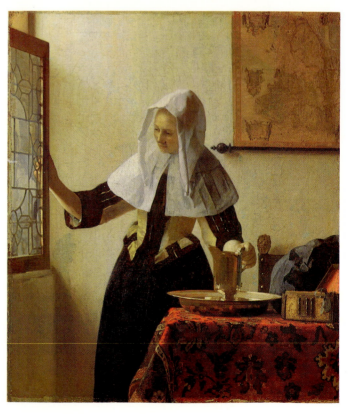

clude a number of sonatas that are still appealing, especially in their noble slow movements. Among them are his sonatas for violin and continuo (keyboard accompaniment), one of which is a familiar favorite called *La Folia*.

Hundreds of sonatas of a quite different kind—chamber sonatas composed in this instance for a single keyboard instrument such as a harpsichord—were written by Domenico Scarlatti (1685–1757), son of the Neapolitan composer of operas, Alessandro Scarlatti. Born the same year as J. S. Bach and Handel, Domenico Scarlatti ranks not far behind them among the great composer-performers of the late baroque period. His keyboard sonatas are brilliant virtuoso pieces, technically demanding, with vivacious melodies, wide leaps and rapid runs, much crossing of hands, powerful chords, and piquant rhythms. Fine examples are the *Sonata in D Minor (108)*, called *The Lover Passionate and Sentimental*, and the *Sonata in B-flat Major (327)*, which is full of fireworks.

The Concerto Grosso. The violinist Corelli also helped to establish another major form of baroque instrumental music, the concerto grosso. In this form, a small group of instruments called the *concertino* combines with a larger orchestra, playing part of the time with the full group and part of the time alone. Such an arrangement made possible interesting variations in volume—terraced dynamics—and in musical texture. Out of the concerto grosso was to grow the concerto, a work for solo instrument and orchestra.

Corelli's best-known concerto grosso is the *Christmas Concerto*. Its last movement is a charming pastorale, a religious melody that suggests the birth of Christ, with the angels hovering over Bethlehem. It was the model for the pastorales in Handel's *Messiah* and Bach's *Christmas Oratorio*.

Greatest of Corelli's followers was the Venetian Antonio Vivaldi (c. 1675–1743). Vivaldi was a small, red-bearded one-time priest who became a teacher of the violin at a foundling school for girls and a highly prolific composer of concertos and other works. Bach greatly admired Vivaldi's works; in fact, the powerful, irresistible beat of Bach's own concertos has been traced to Vivaldi's influence.

Perhaps the most striking characteristic of Vivaldi's concertos is their unfailing vitality and vivacity. His most famous work is *The Four Seasons*, a group of four short concertos—one, of course, for each season. It is one of the first important pieces of program music, with passages that are imitative—bird calls, for instance—and others that are symbolic or suggestive. In "Spring," one hears a "concerto" of birds, the murmur of a river, and a pastoral dance of shepherds. The other concertos depict such seasonal incidents as a thunderstorm, the merrymaking of farmers, a hunt with its shouting and chasing, and an icy winter, with stamping feet and chattering teeth. Through it all runs a stream of melody played on the solo violin.

ARCHITECTURE

A few Italian palaces and other structures built in the sixteenth century, including some of Michelangelo's works, are so unclassical and deliberately eccentric that they can best be classified as mannerist. The Palazzo Massimi in Rome (fig. 10-1), begun in 1535 by Peruzzi, is typical. Almost everything in the palace except the Tuscan Doric columns is unclassical—the strange proportions, the dark entranceway, the odd-shaped upper windows with their curious "surrounds," and especially the curve of the entire façade. The overall elegance and sophistication of the building are essentially mannerist. Such buildings, though not greatly significant in themselves, helped to prepare the way for the individuality and expressiveness of baroque architecture.

Though many of Europe's most famous palaces were constructed during the baroque era, it was above all a church-build-

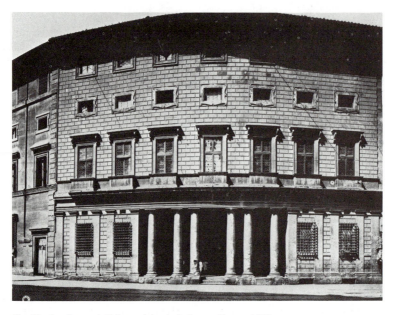

Fig. 10–1. Peruzzi. Palazzo Massimi, Rome. Begun 1535.

ing age. Thousands of religious edifices, from village chapels to cathedrals, were built in the seventeenth and earlier eighteenth centuries—the Jesuit baroque churches of southern Europe, the more classically inspired buildings of Christopher Wren and others in England and northern Europe, and the baroque-rococo churches of southern Germany and Austria. As for palaces and other secular buildings, some were truly baroque in their complexity of surface and richness of ornamentation. Most of them, however, in the pattern of Versailles, are in what can be called the classical baroque style.

Baroque Churches. In the early Renaissance, the humanist Alberti designed an unusual façade for the church of Santa Maria Novella in Florence. Confronted with empty right angles on the façade resulting from the placing of a narrow second story over a wide lower one, he filled the angles with large scrolls or volutes. Then he capped the whole with a classical pediment.

Countless imitations and variations of that façade are found throughout the Chris-

tian world, especially in the Jesuit baroque churches of southern Europe. It was the long curve of the scroll that particularly attracted the gifted Giacomo Vignola (1507–1573) a hundred years later. He in turn was to have a powerful influence on other church architects. His Church of Il Gesu in Rome, the mother church of the Jesuit order, is typical of his style. The balance and quiet dignity of its façade (fig. 10-2), with its Corinthian columns and pilasters, are classical enough. But the elements that draw the eye toward the center—the larger middle portal and upper window, the varying curved and triangular pediments, and the ornamental shields—all foreshadow one of the main characteristics of the baroque façade, the creation of a dramatic central point of interest.

The interior of Il Gesu was equally far-reaching in its influence (fig. 10-3). Departing from the central type preferred in the High Renaissance, it has a high, barrel-vaulted nave, softly illuminated by small windows piercing the sides of the vault. A high dome reaches above the transept crossing, its strong light a contrast to that of the nave.

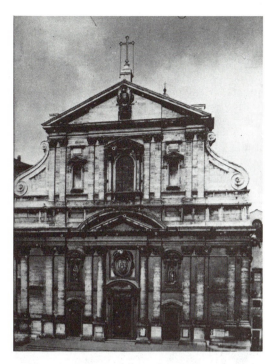

Fig. 10–2. Vignola and della Porta. Church of Il Gesù, Rome, 1568–84.

Fig. 10–3. Interior, Church of Il Gesù, Rome.

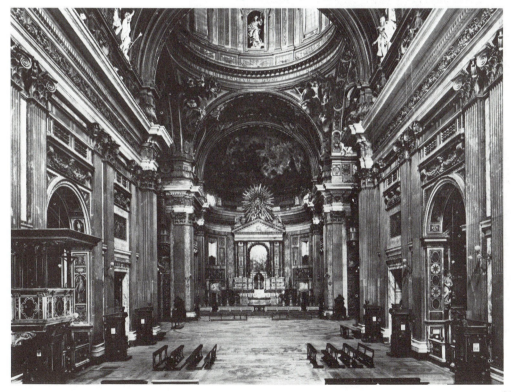

Most parts of St. Peter's in Rome, built over a period of many decades, are clearly baroque in feeling, beginning with the elements designed by Michelangelo—the sculpturesque exterior of the western segment and the dome (fig. 9-5). Also baroque are the tremendous barrel-vaulted nave (fig. 10–4) and the façade with its giant columns, both designed by Carlo Maderna.

Just as clearly baroque are the additions to St. Peter's made by Maderna's successor, the versatile Gianlorenzo Bernini (1598–1680). Bernini was still a young man when he designed the great tabernacle or *baldachino* (fig. 10-4) that stands directly beneath Michelangelo's dome and over the tomb of St. Peter. Over ninety feet high, the tabernacle is dominated by four powerful, twisting bronze columns, luxuriant sculptural ornamentation, and curving forms at the top, that join to support a cross. The same taste for grandeur displays itself in the colossal plaza or "square" in front of St. Peter's (fig. 10-5), a project on which Bernini spent most of his time for over twenty years.

Another important successor to Maderna was Francesco Borromini (1599–1677). One of Borromini's finest works is the majestic façade of S. Agnese in Rome (fig. 10-6). Here we see, fronting an oval-shaped interior, a classical central portal, with curving arms that reach out from it on each side, the whole capped by twin baroque towers and a dome.

Another of Borromini's buildings, one of the most celebrated of Italian churches be-

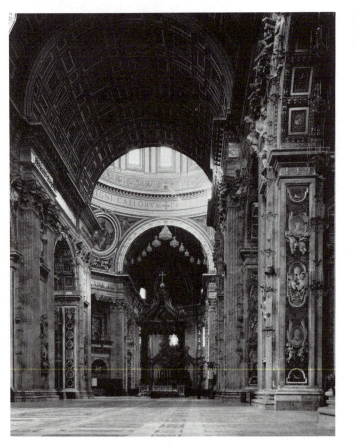

Fig. 10–4. Baldachino (Bernini) and portion of nave, St. Peter's, Rome, 1624–33.

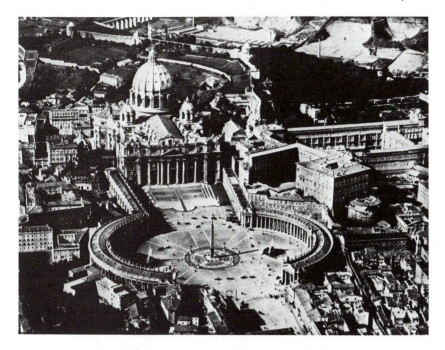

Fig. 10–5. Aerial view of St. Peter's, Rome, with Bernini's piazza.

Fig. 10–6. Francesco Borromini. Church of S. Agnese, Rome, 1653–63.

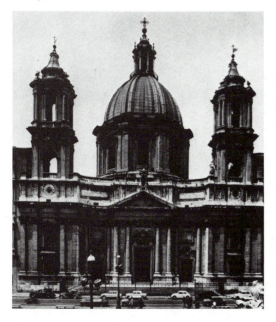

cause it displays the Southern baroque style at its most obvious, is the church of S. Carlo alle Quattro Fontane (St. Charles of the Four Fountains). It is a very small church, so small that it could fit into one of the piers that support St. Peter's dome. Here the oval appears, to give the church (familiarly called San Carlino) its basic interior form. Overhead is a beautifully coffered, oval-shaped dome, with small windows that admit a soft amber light. The façade of San Carlino (fig. 10-7) is a striking example of the baroque era's love for curves and strong angles.

Baroque architecture, especially its more ornate aspects, caught on quickly in Spain, and many churches were built in what is called the Churrigueresque style (after the Churrigueras, a family of architects), in which almost every inch of surface is decorated—even more than in the earlier plateresque. One of the most famous examples is the façade added in the seventeenth century to the ancient Romanesque pil-

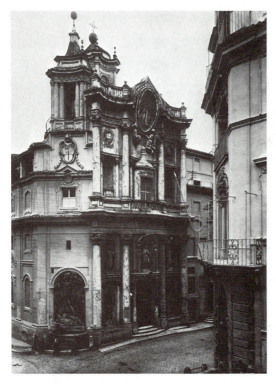

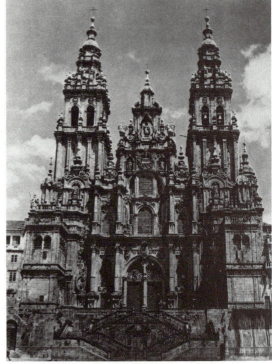

Fig. 10–7. Borromini. S. Carlo alle Quattro Fontane (San Carlino), Rome. 1665–67.

Fig. 10–8. Cathedral of Santiago de Compostela, Spain. Late baroque façade begun 1738.

Fig. 10–9. François Mansart. Orléans wing, Château Blois, France. Early seventeenth century.

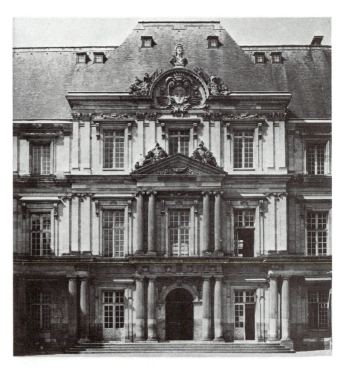

grimage church of Santiago de Compostela (fig. 10-8). The style was echoed in countless other churches throughout the Spanish-speaking world, including many in the Americas.

Baroque Palaces. The baroque taste for ovals and curves and rich ornamentation carries over from religious to secular architecture, especially in the heavily ornate interiors of palaces and other large structures. The exteriors of European baroque palaces are often restrained and essentially classical. If they have a baroque feeling, it is because of their size and grandeur and their sumptuous, often spectacular settings, with parks, gardens, sweeping vistas, and magnificent views. European palace architecture of the period can, in fact, best be called classical baroque.

The principal prototypes of baroque palace architecture can be found in France. In the early seventeenth century François Mansart added to the Château Blois what is called the Orleáns wing (fig. 10-9). Its overall effect is almost severely classical, but Mansart added a few baroque touches such as the ornaments resting on the second-story pedi-ment, the larger ornament above the third-story window, and the curved colonnades on the ground floor. The roof is in the hipped style that still bears Mansart's name.

Another great French palace, one that grew over a period of centuries, is the Louvre in Paris. This huge building was begun in 1204. Over the centuries it underwent much reconstruction and received many additions, especially in the seventeenth century. Under Napoleon it became what it is today—a museum housing many of the world's art treasures. In 1667 Louis XIV invited a number of French and Italian architects, including Gianlorenzo Bernini, to submit plans for the east front of the Louvre. Bernini's grandiloquent plan, with sweeping curves projecting from a semicircular central portal, was rejected, partly because it did not appeal to the more classically oriented French and partly because his arrogance annoyed them. He returned to Italy in a huff. The classical east front of the Louvre that was built (fig. 10-10) has served as a model for countless governmental and other public buildings in Europe and America. Its architects were two Frenchmen, Louis Le Vau and Claude Perrault.

Fig. 10–10. Le Vau and Perrault. East front of The Louvre, Paris. 1667–70.

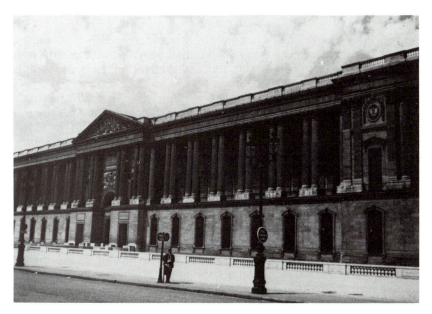

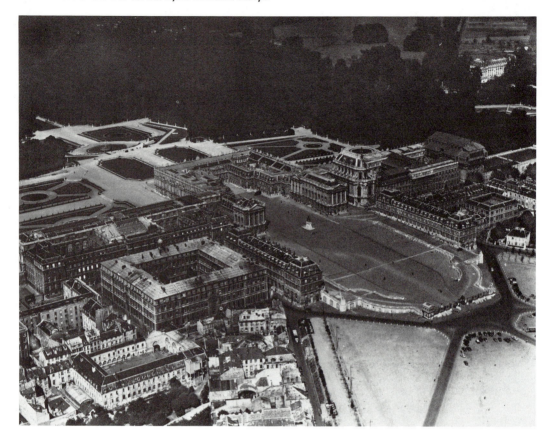

Fig. 10–11. Versailles Palace and a small part of the surrounding park.

Versailles, some twelve miles from Paris, is the most celebrated classical baroque palace (fig. 10-11). This vast complex, which stands alone among palaces for sheer size, epitomizes the passion for grandeur and self-glorification that characterized the absolutist monarchs of the baroque age. It was built to replace a royal hunting lodge. Its first architect was Louis Le Vau; he had completed only part of the project when he died in 1670. Jules Hardouin-Mansart, who succeeded him, can be given credit for most of Versailles as one sees it today—the long west front of pink and cream stone, the main elements of the north and south wings, the famous Hall of Mirrors, the chapel, the royal apartments, and other features. The palace became the seat of the French government, and many chambers and apartments were built for government officials as well as courtiers.

The baroque interior of the palace is filled with reminders of Louis XIV, the Sun King. Representations of the sun are motifs in the gilt stucco work of the staterooms. Whole ceilings are covered with gold to suggest the sun's illumination. The monogram *L* appears everywhere. A painting of Louis on horseback dominates the Salon of Hercules, and the Hall of Diana features a bust of Louis by Bernini. Even the Hall of Mirrors, Versailles' most beautiful room (fig. 10-12), pays its tribute of flattery to the king: covering the ceiling are large paintings that tell alle-

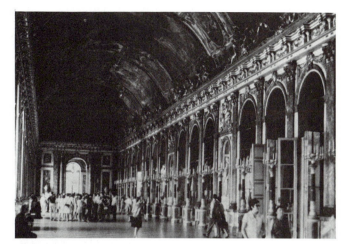

Fig. 10–12. Mansart and Le Brun. Hall of Mirrors, Versailles. About 1680.

Fig. 10–13. Cascades and reflection pool, Palace of Caserta, Italy. 1752–74.

gorically of Louis's glorious accomplishments.

Almost as impressive as the great palace are its grounds, with formal gardens, reflection pools, and an artificial lake almost a mile long, where Louis held boating parties. To the east, reaching toward Paris, is a man-made vista that carries the eye far into the distance.

The fame of Versailles spread throughout the Western world. Its layout was adopted by such newly made capitals as Washington and St. Petersburg (Leningrad). Its general magnificence was imitated all over Europe, from Queluz in Portugal to the huge Winter Palace in Leningrad. Caserta, a large Bourbon palace near Naples, is distinguished for the tree-lined gardens, statuary, reflection pools, and cascades that stretch far to the north of the palace (fig. 10-13).

SCULPTURE

Thousands of statues of humans and animals ornamented the churches and palaces of the baroque era. Only a few of the sculp-

tors are remembered today. Of these, the best known and most important is Gianlorenzo Bernini. Bernini was the Michelangelo of his age, an artist who distinguished himself as sculptor, architect, painter, playwright, poet, and composer. As a child of ten Bernini was doing mature sculpture. When he was thirteen he did portrait busts that are searching character studies. In his early twenties he made the great baldachino for St. Peter's (fig. 10-4). With his workshop of assistants, including his father, he created at least 130 major works of sculpture and designs for many others, a number of fountains, and many buildings. In fact, the Rome one sees today owes more to Bernini than to any other one person.

As a sculptor Bernini was influenced by the work of Michelangelo and by the animation and intensity of mannerist and baroque painting. But he discarded Michelangelo's concept of a statue as being confined within a block; in fact, he strove to extend it, to make it reach out into space and draw the spectator into the action. As one of the chief exponents of illusionism, another important baroque development, he combined variegated marble, bronze, stucco, paint, gilding, and even stained glass in single works to make them seem more animated. He exaggerated gestures and intensified facial elements—deep-set eye sockets and hollow cheeks, half-open mouths, dilated eyes—to heighten expressiveness and suggest passion and spiritual intensity.

All of these qualities are displayed in a celebrated work that Bernini executed for the Cornaro chapel in the church of Santa Maria della Vittoria in Rome. At the top, in a painting on the ceiling, clouds separate to reveal the Holy Ghost in the form of a dove. A little further down, a high window with shafts of gold reaching down from it seems to shed a radiance of light on the sculptured figures below. The center of interest, a complex piece of statuary, is *St. Teresa in Ecstasy* (fig. 10-14), Bernini's conception of the incident from St. Teresa's journal quoted earlier.

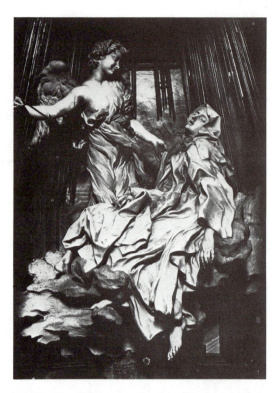

Fig. 10–14. Gianlorenzo Bernini. *The Ecstasy of St. Teresa.* 1645–52. Marble, lifesize. Cornaro Chapel, Santa Maria della Vittoria, Rome.

Though the artist takes liberties with literal fact—St. Teresa was a middle-aged woman when the visionary experience occurred—the work recreates the mysticism and sensuousness of the experience itself. In this and other statues Bernini demonstrated that though he did not equal Michelangelo in power and profundity, he was without a peer as a creator of illusion, drama, and spectacle.

PAINTING

The Florentine Mannerists. In painting, the term *mannerist* is sometimes applied to painters of the later sixteenth century who followed the styles and techniques of the great High Renaissance artists; these were

the *academic mannerists*. More important were the *free mannerists*, those who reacted against the balance, proportion, closed forms, and basic intellectualism of the High Renaissance. Free mannerism reached its climax in the work of such great artists as Tintoretto and El Greco, but it was first clearly evident in the paintings of the Florentine mannerists, led by Pontormo, Rosso, and Parmigianino. The Florentine mannerists exploited extremes of perspective, distortion, bizarre poses, and vivid, often harsh and "sour" colors that were chosen for emotional rather than naturalistic purposes. Because they accepted the strange and enigmatic as a legitimate part of artistic expression, they often chose to treat conventional religious subjects—nativity and crucifixion scenes, for example—in bewildering ways. All of them, like their modern descendants the surrealists, were notable for their skill as painters.

Pontormo (1494–1556) was a fine portrait painter and gifted draftsman, but he is known today for such curiously expressive works as *The Descent from the Cross (The Deposition)* (fig. 10-15), in which figures stare in fear and sorrow past—but not at—the spectator and move almost convulsively as they carry the body of Christ to the tomb. Even less conventional is his *Story of Joseph*, in which several seemingly unrelated groups of people play their parts, not in the center of the canvas but around its sides. Figures stand in clusters or mount a steep, curved stairway that leads nowhere (stairways were a favorite device of the mannerists). Perspectives are illogical and arbitrary. Several nude statues on high pedestals add a further note of strangeness.

Pontormo's friend Rosso Fiorentino (1495-1540) painted probably the most expressive of Florentine mannerist paintings, his *Descent from the Cross* (fig. 10-16). This is a very large painting that seems even higher because of the point of view of the spectator. The intense emotionalism of the work is effected by the strong patterns of the ladders and the cross against a leaden sky, by the

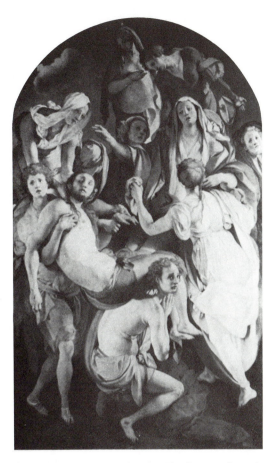

Fig. 10–15. Jacopo Pontormo. *The Descent from the Cross (The Deposition)*. 1525–28. About 11′ by 6′6″. Caponi Chapel, Santa Felicitá, Florence.

angular posture of every figure in the painting, from the big-bearded, red-clad man at the top to the woman weeping below, and by the discordant colors of flesh and draperies. As in mannerist paintings in general, the composition is open, with one figure seeming to force her way out of the picture.

Most famous of all Florentine free mannerist paintings, as distinctive for its sensuous elegance as is Rosso's *Descent* for its tensions and harsh angularity, is *The Madonna with the Long Neck* (fig. 10-17) by Parmigianino (1503–1540). Parmigianino has

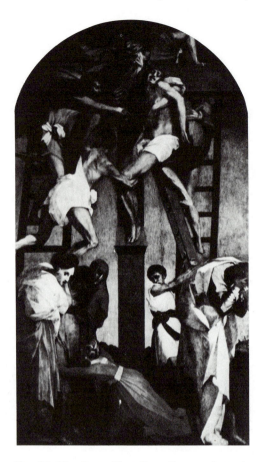

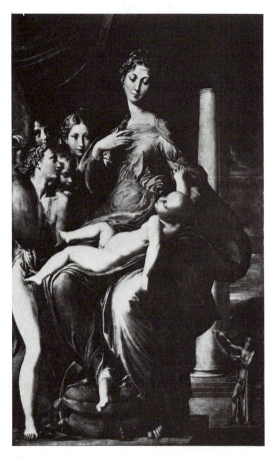

Fig. 10–16. Rosso Fiorentino. *Descent from the Cross.* 1521. 11′ × 6′5″. Picture Gallery, Volterra.

Fig. 10–17. Parmigianino. *The Madonna with the Long Neck.* About 1535. 7′1″ × 4′4″. Uffizi Gallery, Florence.

given a curious verticality to the painting and has elongated not only the Virgin's neck but almost everything else—the hands, the legs, the youthful faces, the columns, and especially the body of the sleeping Babe. He has provoked a number of questions—about the posture of the Virgin, the interior-exterior setting, the curious perspective, the small, half-nude figure with the scroll, and the tall, unfinished columns. The unity of the work comes from tone and haunting mood rather than from conventional forms or narrative content.

There is an atmosphere of decadence and incipient tragedy in the works of these three Florentine mannerists. Many lesser painters imitated them, and they influenced a number of greater ones, in Venice and elsewhere in Europe.

Venice: Mannerist and Prebaroque Painters. Venice, in the later years of the sixteenth century, had its painters who carried on the great traditions of the Bellinis, Giorgione, and others. Titian, though an aged man, was ever innovative. His two

greatest followers, both of whom admired him but went essentially their own ways, were Tintoretto, Venice's master of mannerism, and Veronese, its painter of opulent, eye-filling religious works that anticipated the baroque age.

Tintoretto (1518–1594) was born in Venice, spent his life there, and died there, after a highly productive career, when he was seventy-six. By the time Tintoretto was twenty-four he had his own workshop, which grew to be one of the largest in Italy. In his early twenties he painted, in the free mannerist style, such works as his *Conversion of St. Paul* (fig. 10–18), which is filled with violently contorted shapes of men and animals, patches of vivid yellow, red, orange, pink, and blue, with horses and men plung-

ing into a stream and other horses bolting furiously out of the picture. Large groups of people in tumultuous action continued to be one of his great interests.

Many of Tintoretto's greatest works are murals painted on the walls of public buildings in Venice. These include two superb series, one on the life of the Virgin and the other on the life of Christ, that fill the walls of two large rooms in the Scuola of San Rocco. All of them reflect his inventiveness and spiritual profundity. Not a San Rocco painting but typical of his later manner is his *Last Supper*, in the church of San Giorgio Maggiore (fig. 10–19). Here one sees the mannerist devices that Tintoretto made his own: asymmetrical composition; oblique, off-centered perspective lines; a few brighter colors

Fig. 10–18. Tintoretto. *The Conversion of St. Paul.* About 1542. 60 × 93". National Gallery of Art, Washington, D.C. Samuel H. Kress Collection, 1951.

Fig. 10–19. Tintoretto. *The Last Supper*. 1592–94. 12′ × 8′8″. San Giorgio Maggiore, Venice.

Fig. 10–20. Veronese. *The Marriage at Cana*. 1562–63. 21′10″ × 32′5″. The Louvre, Paris.

absorbed into the dominating deep browns; flickering and flashing lights illuminating the edges of objects and creating animated shadows; and figures in motion, some of them solidly realized, some of them wisps of phosphorescent light. His human figures are ordinary men and women, caught up and magnified by a moment of spiritual drama.

As an old man Tintoretto joined with Veronese in redecorating many walls and ceilings of the Ducal Palace, some of them huge, with mural paintings. He and his assistants painted, among other things, what was for centuries the biggest painting in the world, a 23-by-70 foot *Paradise* in the main hall of the palace. In this and similar works he and Veronese anticipated the baroque taste for the spectacular.

Tintoretto's principal rival, apart from the aging Titian, was his friend and occasional collaborator Veronese (c. 1528–1588). The two shared an enthusiasm for large-scale paintings; but where Tintoretto's characters are often commoners, housewives, soldiers, and officials in everyday garb, Veronese's are aristocrats dressed in the height of fashion. Typical are his two most famous paintings, *The Feast in the House of Levi* and *The Marriage at Cana* (fig. 10–20). Both are huge (the *Feast* is eighteen feet high and forty-two feet long), and both are wonderfully appealing to the eye—filled with light, color, magnificent architecture, sumptuous costumes, handsome people, and aristocratic pageantry. In spite of the titles one has to search for spiritual significance in either painting, just as one has to search in *The Marriage at Cana* for the figure of Christ, largely hidden among courtiers, onlookers, animals, servants, and oriental potentates. Veronese was clearly indifferent to historical accuracy: the settings of these paintings are classical, and the people, in dress and manner, are his fellow Venetians. He gets himself into both paintings, standing in front of a column at left of center in the *Feast* and playing a lap viol in the *Marriage.*

Veronese also distinguished himself as a painter of illusionistic ceiling paintings that seem to reach high into heaven; and in such works as *The Crucifixion*, with its psychological balancing of crucified figures at one side and a storm-filled sky at the other, he demonstrates an unexpected tragic power.

Another great northern Italian master of the period—not a Venetian in this instance—was Caravaggio (1571–1610), one of the most gifted and influential painters of the early baroque era. He was born in Milan, but the adventures of his short and stormy life took him to Rome, among other places, where he was sued for libel and stabbed an opponent in a tennis match; to the island of Malta, where he was made a Knight of the Order of St. John but later expelled; and back to Italy, where he died of malaria while he was on his way to Rome to seek a pardon.

Caravaggio's paintings were as dramatic and controversial as his life. His first masterpiece, *The Calling of St. Matthew* (fig. 10–21), is a quite original work, lighted in what has come to be called the Caravagesque style, with most of the scene in semi-darkness but with strong light playing on the most significant details—the face and beckoning hand of Christ and the startled faces of Matthew's companions. Only the face of Matthew, who is absorbed in counting his share of the tax money and is still unaware of his great calling, is in shadow. The persons in the painting, including the gentle-faced Savior, are unidealized and realistic. They sit or stand close to the foreground and establish almost a physical contact with the viewer.

Caravaggio chose shopkeepers, peasants, beggars, and other common people as the figures in his religious works, and he painted directly from living models rather than from sketches. In doing so he gave his paintings an immediacy and poignancy seldom found in more conventional religious works. But time and again his paintings were rejected by those who had commissioned them. Such was the fate of his *Death of the Virgin*. In this large painting, light from a high window touches the bald heads of poorly dressed mourners and draws the eye

Fig. 10–21. Caravaggio. *The Calling of St. Matthew.* About 1597–98. 11′1″ high. Contarelli Chapel, S. Luigi dei Francesi, Rome.

toward the figure of the Virgin, lying serene in death. The fathers of the church rejected the painting as vulgar, but the Flemish painter Rubens, who happened to be in Rome, greatly admired it and persuaded his Italian patron to buy it.

Caravaggism swept across Europe. The realism, dramatic power, and chiaroscuro techniques of the Italian master influenced countless painters, including Velázquez and Ribera in Spain, La Tour in France, Rubens in Flanders, and Rembrandt in Holland. It was Rembrandt who perfected the style, giving warmth and depth to the shadows and softening the outlines of human forms.

Spanish Painters

Mannerism and Realism. Spain's Golden Age of literature was also her golden age of painting. It was the era of El Greco,

Velázquez, Murillo, Ribera, Zurburan, and other masters, all of them touched in fundamental ways by the religious zeal of the Counter Reformation in Spain.

El Greco ("the Greek," 1541–1614), whose true name was Domenikos Theotokopoulos, was the greatest of Spanish mannerists. He was born and spent his youth on the Greek island of Crete, where he learned to paint in the Byzantine tradition, with its mysticism and nonrealistic, jewel-like colors. He continued his training in Venice, where he was excited by the technical innovations and emotional intensity of Tintoretto and other mannerists. After a period in Rome he went to Spain, a man of thirty-five with no important works to his credit. He spent the remaining half of his life in Toledo. Counter Reformation Spain proved to be El Greco's spiritual home; there he produced hundreds of religious paintings in an increasingly ecstatic and visionary

mode that was in full accord with the mystical fervor and zeal of St. John of the Cross, St. Teresa, and the Jesuits.

One of his first important commissions was for a large altarpiece for the church of Santo Tomé in Toledo, *The Burial of Count Orgaz* (Colorplate 6). This painting, based on a legend of two saints descending to bury a benevolent count, is generally considered El Greco's masterpiece. It embodies the extremes of his style, from the precisely painted robes of Saints Stephen and Augustine at the bottom, on past the realistic but manneristically lengthened faces of the mourners, and up to the ecstatic and freely painted vision of heaven that fills the upper half of the painting, where the infant-sized spirit of the count is borne heavenward by an angel. Here minute details are forgotten in a swirl of cloud forms and attenuated figures of saints and angels, among them the Virgin

and the elongated form of John the Baptist, all illuminated by the light of Christ's radiance. Light, as it transfigured bodies and transformed their solidity into weightlessness and pure color, increasingly became El Greco's means of expression.

The Vision of St. John the Divine (fig. 10–22) is the epitome of El Greco's mannerist style, from the massive, half-kneeling, half-soaring figure of St. John in the foreground to the lengthened wraiths of men, women, and children reaching, dancing, and flying about before yellow and green curtains under a turbulent sky. The colors are El Greco's own—sharp greens and yellows, cold blues, vivid pinks and reds.

El Greco's contemporaries evidently understood his intentions and valued his paintings; he had many commissions. But following his death his works were severely criticized. His long-faced portraits seemed

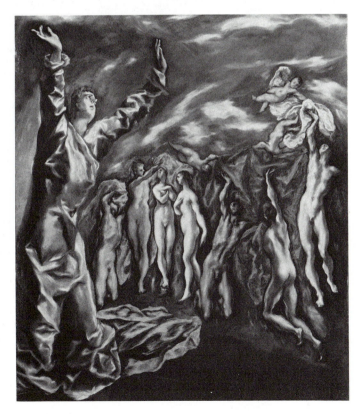

Fig. 10–22. El Greco. *The Vision of St. John the Divine.* About 1610. 88 × 76". The Metropolitan Museum of Art, New York. Rogers Fund, 1956.

only caricatures, and he was thought by some to have been mad. It was not until modern expressionists taught the public not to look simply for literal "correctness" that he was appreciated again.

In the century following El Greco, the intense religiosity of the early Counter Reformation diminished somewhat, and Spain was ready to welcome the more conventionally beautiful and sentimental religious

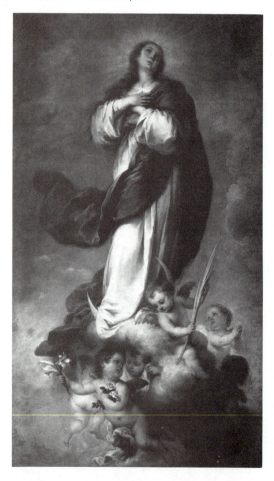

Fig. 10–23. Murillo. *The Immaculate Conception.* About 1670. Oil on canvas, 87 × 50". The Cleveland Museum of Art. Leonard C. Hanna Bequest.

works of painters like Murillo (1617–1682). Typical is Murillo's *Immaculate Conception* (fig. 10–23), a version of a subject that he painted many times.

If El Greco was Spain's principal mannerist and visionary among painters, Diego Velázquez (1599–1660) was its supreme realist, its greatest technician, and its most discerning observer of character. Born and trained in Seville, Velázquez went to Madrid in his early twenties and was attached for the rest of his life to the court of Philip IV, grandson of the Philip who built the Escorial. Philip IV greatly admired Velázquez, gave him important political commissions, and made him a Knight of the Order of Santiago. In return Velázquez painted numerous portraits of the king, somewhat flattering but sharply individualized, and of his two queens. He also painted a number of portraits of the royal children. One of them is a very familiar work showing the heir apparent Baltazar Carlos astride a plump pony. Others depict the Infanta Margarita, a charming blond child who seems to have touched the artist's heart as no other subject did. He also painted the court jesters and dwarfs, not as objects of ridicule but as sensitive humans to whose predicament he responded more warmly than to the apparent assurance of most of his royal patrons.

Velázquez's masterpiece is *Las Meninas* (The Maids of Honor), a large work that occupies a room by itself in Madrid's Prado Museum (fig. 10-24). The artist has arrested a moment in time to show himself painting the king and queen, who stand, presumably, where the viewer does. He looks out at us in an almost disconcerting way that is characteristic of many of his portraits. So too do the female dwarf at the right, the man in the doorway at the back, and the five-year-old princess Margarita, with her maids of honor curtsying at each side. One's eye is carried to the back of the large room by perspective lines, by the subtle gradations of light and color, and by the mirror, in which we see the dimly reflected faces of the king and queen.

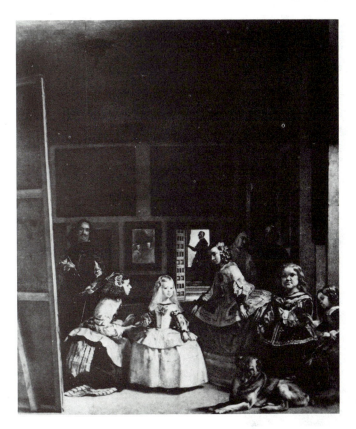

Fig. 10–24. Diego Velázquez. *Las Meninas (The Maids of Honor)*. 1656. 10′5″ × 9′. The Prado, Madrid.

French Painters

Classical Baroque. Early in the reign of Louis XIV the French Royal Academy was founded under the leadership of Charles Le Brun (1619–1690), who became Premier Painter. Le Brun was a virtual dictator of the arts. He established rigid rules and saw to it that court painters, at least, painted approved subjects in an approved style.

The artists of the time who have worn best, however, were those who were least inhibited by academicism—for instance the Le Nain brothers, who painted realistic religious paintings and scenes of country life; and Georges de La Tour, who specialized in challenging chiaroscuro effects in such paintings as *St. Joseph the Carpenter* (fig. 10-25), in which candlelight beautifully illuminates and softens the faces of Joseph and the young Christ. Best of all French painters of the period were Nicolas Poussin, a true classicist but on his own terms, and Claude Lorrain, whose glowing landscapes and seascapes look toward the romantic era of the nineteenth century.

The works of Poussin (1594–1665) were admired and imitated by the French Academicians, but Poussin found himself most at home in Rome, with its architectural monuments, age-old classical and Christian traditions, and quiet neighboring countryside. Here he developed his own cool, noble style. A careful student of religious and classical literature, he painted a number of sacred works such as *The Holy Family on the Steps*

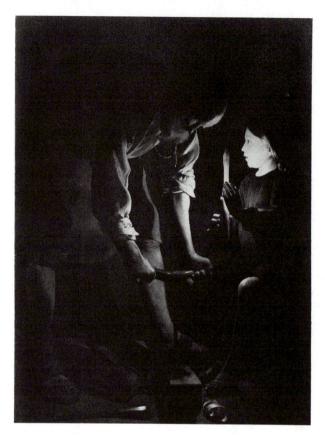

Fig. 10–25. Georges de La Tour. *Joseph the Carpenter.* About 1645. Approx. 38 × 27". The Louvre, Paris.

(fig. 10–26). Here he places his serene, beautifully modeled figures in a classical setting, with every element harmoniously balanced and clearly defined. Though he said that color tended to divert the mind from the artist's thought, he was a fine colorist, as this painting demonstrates.

Poussin is best known for his paintings based on classical mythology and history. Most familiar but not most typical of these is *The Abduction of the Sabine Women,* with its careful balancing of colors and of diagonal movements. A more characteristic work is his *Landscape with the Burial of Phocian* (fig. 10-27), a restrained, almost austere treatment of a classical subject, with an "ideal landscape" as the setting. (The "ideal landscape," a form that hundreds of painters were later to employ, usually has a large tree

on one side in the foreground, balanced by a smaller cluster of trees at the other side and in the middle distance. In the frontal plane, in relatively small scale, are people; in the middle plane is a meadow or lake or river, often with a classical building on its edge; and in the distance is a dim range of mountains.) It has been observed that Poussin, in such paintings, "made classicism into a serious, expressive, and deeply moving pictorial language as perhaps never before or since."

Poussin's friend Claude Lorrain (1600–1682) started life as a pastry cook, but by the time he was thirty he was highly popular as a painter, and his reputation has continued undimmed. Like Poussin, Claude spent most of his life in Rome, and like Poussin he loved classical architecture and the Italian

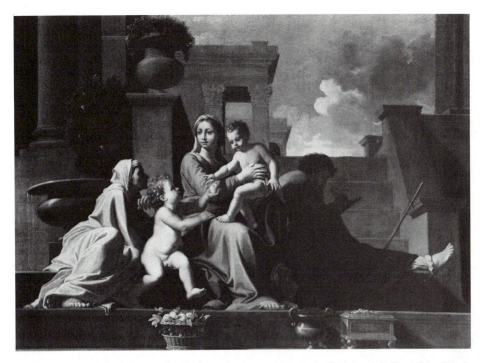

Fig. 10–26. Nicolas Poussin. *Holy Family on the Steps.* 1648. 27× 38″. National Gallery of Art, Washington, D.C. Samuel H. Kress Collection, 1952.

Fig. 10–27. Nicolas Poussin. *Landscape with the Burial of Phocian.* 1648. Approx. 70 × 47″. The Louvre, Paris.

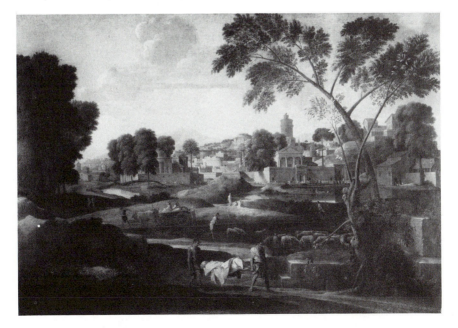

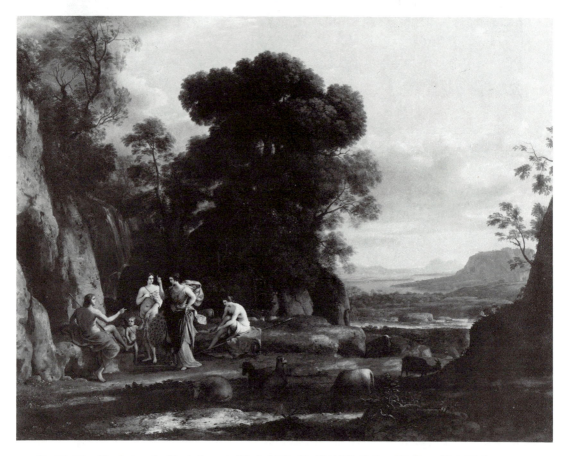

Fig. 10–28. Claude Lorrain. *The Judgment of Paris*. 1645–46. 44 × 59". National Gallery of Art, Washington, D.C. Ailsa Mellon Bruce Fund, 1969.

countryside. In painting after painting he used the compositional pattern that Poussin had developed, the ideal landscape; but he suffused his works with a warm light that gave them a romantic glow and soft outlines, and that carried the eye past indistinct objects in the foreground to a glow of light in the distance. His *Judgment of Paris* (fig. 10-28) is typical. Claude's paintings of seaports at sunset, filled with a flood of golden and orange light, had a strong influence on England's J. M. W. Turner and the French impressionists of the nineteenth century.

Italy lost her centuries-old position of supremacy in the arts as the baroque era waned. Of course that country continued to make major contributions to all the arts, but by the end of the seventeenth century Paris, not Rome or Florence or Venice, was asserting herself as the cultural capital of Europe. England, however, was at least holding her own with France in literature and architecture. The Low Countries were rounding off a century of superb painters. And most of the great composers of the later baroque era were products of Germany.

11

MANNERISM AND THE BAROQUE: NORTHERN EUROPE

The wars and political turmoil of the earlier seventeenth century were especially devastating in the Germanic countries, and the arts were severely depressed. Until later in the century, architecture stagnated, few painters and poets of consequence emerged, and only an occasional important composer such as Heinrich Schütz appeared until the great days of Bach and Handel after the turn of the century.

The Flemish and Dutch provinces had their own military and political problems, especially in the first half of the seventeenth century, but they were not so paralyzing as those in the Germanic lands. In fact, the Dutch provinces in particular entered a period of economic prosperity that helped to make possible Holland's greatest era of cultural and educational activity. In the Dutch and neighboring Flemish provinces emerged such painters as Rembrandt, Rubens, and others who helped to make the seventeenth century in the North one of the great eras in the history of painting.

In England the arts of literature and to a lesser extent music flourished during the expansive period of Elizabeth's reign, which ended in 1603. Most of the seventeenth century was marked by political turmoil and by civil and religious warfare under the Stuart kings and the Commonwealth. Literature continued to flourish, however, in the work of Donne, Milton, and others. England's two greatest architects, Inigo Jones and Christopher Wren, designed a number of public and private edifices. And Henry Purcell, perhaps his country's greatest composer, made important contributions to baroque operatic and religious music.

LITERATURE

The literary renaissance in Italy that began with Petrarch and Boccaccio had come and largely gone before England moved into her great period of creativity. England's time of literary flowering, her particular manifestation of the Renaissance spirit, began about the middle of the sixteenth century, during the age of Elizabeth. It was primarily a time of great poetry and drama.

Lyric Poetry. Lyric poets, mostly aristocrats who wrote for their own amusement and that of their friends, enjoyed a heyday

237

during Elizabeth's reign. They composed, among other short poems, great numbers of sonnet cycles, many of them of high quality. Sir Philip Sidney (1554-1586), a soldier, scholar, court favorite, and poet, wrote one of the first important Elizabethan sonnet cycles, *Astrophel and Stella*. These are lucid, musical poems in the Petrarchan tradition. Edmund Spenser wrote a sonnet sequence of enduring beauty, the *Amoretti*. Samuel Daniel composed his *Delia* sonnets, which have a quiet intensity and eloquence.

William Shakespeare (1564-1616) was the supreme lyricist of his age. He incorporated dozens of lyrics into his plays, most of them to be sung. He also wrote his own set of 154 sonnets. They are a varied set of poems, ranging from memorable treatments of conventional themes—the shortness of life and love, the transience of beauty, the sorrows of parting—to works of deep psychological and moral insight.

Other lyrics besides the sonnet were produced in abundance. The playwright Ben Jonson wrote lyrics that have the classical elegance of Catullus and Horace, as in his famous "Song to Celia" ("Drink to me only with thine eyes") or in this stanza from "Queen and Huntress," sung to the goddess Diana:

> Queen and huntress, chaste and fair,
> Now the sun is laid to sleep,
> Seated in thy silver chair,
> State in wonted manner keep;
> Hesperus entreats thy light,
> Goddess excellently bright.

Mannerism in the Lyric. Mannerist tendencies appear in much English literature of the earlier seventeenth century. In contrast to the often bland, melodious, and symmetrical verse of Elizabeth's time, much of the new poetry, especially that of Donne and his followers, the metaphysical poets, is pitched in a higher emotional key. Its moral tone is often ambiguous, and it is marked by shifting and conflicting modes of feeling, sometimes from mockery to anguish in the

same poem. Love remains the main theme, but death is seldom far away. Paradoxes are its stock in trade. Its figurative language is personal and sometimes obscure. Metaphor is employed by the mannerist poets to infuse new color and meaning into words, to suggest striking and sometimes intensely moving relationships. The exaggerated and extended metaphor called the *conceit* was carried to extremes of ingenuity.

Two of the greatest lyrics in the language, both from the seventeenth century, demonstrate mannerist traits: Andrew Marvell's "To His Coy Mistress" and John Milton's "Lycidas." "To His Coy Mistress" begins mockingly: the speaker tells his mistress that if there were enough time, she could continue endlessly to play hard to get; but, in an abrupt shift, "at my back I always hear / Time's wingèd chariot hurrying near"; then he says sardonically, "The grave's a fine and private place, / But none, I think, do there embrace"; and at the end, almost desperately, "Let us tear our pleasures through the iron gates of life." As for "Lycidas," a critic calls it the greatest mannerist poem, "and one where the planes of reality are so interchanging and complex that we shall never be able to 'read' it better than we 'read' *Hamlet*."

The poet and preacher John Donne (1572-1631) was the most clearly mannerist of English poets. Reared in the Catholic tradition by a devout mother, he was converted to the Anglican faith and ultimately became dean of St. Paul's in London. He was known in his younger days as "a great visitor of ladies, a great frequenter of plays," but he devoted his mature years to scholarship and to the church, gaining distinction as one of the great preachers of his age. He wrote cynical love poems, some in praise of inconstancy, but he was a devoted and faithful husband.

It has been observed that Donne's mind was nourished on the paradoxes of Christian faith—the last shall be first, he who would be master must be a servant, to save one's life one must lose it—and that a

juxtaposing of seeming opposites became a habit of his thought and style. Paradoxes permeate both his love lyrics and his religious poems. In Holy Sonnet XIV he asks God to

Divorce me, untie or break that knot again;
Take me to You, imprison me, for I,
Except that You enthrall me, never shall be free,
Nor ever chaste, except You ravish me.

Others of Donne's better-known poems are the mocking "Song," the moving Holy Sonnet beginning "Death be not proud," and "A Valediction: Forbidding Mourning," in which he develops a conceit that compares his relationship with his beloved to the form and movements of a draftsman's compass.

Donne's mannerisms affected the styles of many religious poets who followed him, including George Herbert, Henry Vaughn, and a gifted American Puritan poet, Edward Taylor.

The Epic in England. One of England's greatest masters of poetic language following Chaucer was Edmund Spenser, two hundred years later. Spenser (c. 1552-1599), in addition to composing much lyrical and philosophical poetry of high quality, found time from his duties as a public official to write the first half—a very large first half—of what was to have become a twelve-book epic, *The Faerie Queene*. The work reveals Spenser's familiarity with the epics of Homer and Vergil, the allegories (epic and otherwise) of Dante and other medieval writers, the romantic Renaissance epics of Ariosto and Tasso, and above all his love for the Arthurian romances of the Middle Ages. All of these had their bearing on the *Faerie Queene*, and to their influence Spenser added his own remarkable imagination and his mastery of poetic rhythm and imagery.

In his epic Spenser proposed to depict allegorically the qualities of an ideal Englishman, "a gentleman or noble person in virtue and gentle discipline"—perhaps a Sir Philip Sidney at his best, or a Sir Walter Raleigh. Each of the books was to set forth in story and character one of twelve moral virtues— Holiness, Temperance, Truth, Friendship, and so on. The story line is shifting and complex, and only the specialist is apt to work through the dense symbolic meanings of the poem. But for others the *Faerie Queene* can be a treasure house of romance, of fairy tales on an adult level, some of them genuinely enthralling, and of a dream world of medieval scenes and poetic music.

England's next epic, a religious and philosophical one, was *Paradise Lost,* by John Milton (1608-1674). Already behind Milton when he began writing *Paradise Lost* at the age of fifty was a distinguished career as a humanist scholar, poet, statesman, political pamphleteer, and spokesman for the Commonwealth. By this time he had been totally blind for about six years. As he composed what was to be perhaps the greatest epic in the language, he had to rely largely on his prodigious memory for the wealth of Biblical, historical, and classical allusions that fill the poem.

Milton chose a subject of tremendous scope and inherent grandeur, as suitable to the tastes of the baroque age as a Bernini plaza: the War in Heaven and the casting out of Satan and his legions, and the story of Adam and Eve from their creation to their expulsion from the Garden. His theme is the war between good and evil in the universe and in the individual soul. In a sense it is also a justification of the evil in the world which makes possible personal responsibility and man's free moral character. Paradise is lost, but knowledge, faith, and love will make possible for Adam and Eve, as the Angel Gabriel says, "a Paradise within them happier far."

Paradise Lost has the underlying structure of the classical epic, but it is baroque in its wealth and splendor of detail, its magnificent spectacles, and its accumulation of sensory impressions. It is baroque in its piling up of historical and mythological allusions.

And it is baroque in the vastness evoked by many of its descriptions. Milton could be concrete when he needed to be, but he could also suggest the expanses of unimaginable space between heaven and hell and the hugeness of such beings as Satan. The most appealing parts of the epic, however, are those in which the grand style is least evident and the human drama of Adam and Eve is the poet's concern: their gentle companionship in the Garden, their quarrel after the temptation and fall, their prayers of repentance, and their departure from the Garden:

They looking back, all th' Eastern side beheld
Of Paradise, so late their happy seat,
Wav'd over by that flaming Brand, the Gate
With dreadful Faces throng'd and fiery Arms:
Some natural tears they dropp'd, but wip'd
 them soon;
The World was all before them, where to choose
Their place of rest, and Providence their guide:
They hand in hand with wand'ring steps and
 slow,
Through Eden took their solitary way.

Drama in England. The age of Elizabeth was a stirring one, and the drama of actual events—Elizabeth's colorful career as sovereign, the defeat of the Spanish Armada, the adventures of explorers and privateers—was matched by a taste for drama on the stage. Enthusiasm for the theater had carried over from the popular allegorical dramas, the so-called mystery and miracle and morality plays, of the Middle Ages. And in the Renaissance, students in the universities became excited about the ancient Roman comedies of Plautus and Terence and the tragedies of Seneca, and attempted to imitate them.

From the universities came a gifted group of young men such as Christopher Marlowe, Robert Greene, and Thomas Kyd who went to London and launched careers as professional writers. At the same time, professional acting troupes came into being, and in 1576 the first permanent playhouse was built on the outskirts of London. By the end of the century London had five or six theaters, including the famous Globe, home of Shakespeare's company. The theaters helped to create a permanent, stable audience, which in turn called forth plays in great numbers.

An Elizabethan taste for violent action, intense passions, and black villainy was fed by such playwrights as Thomas Kyd, with his highly popular *Spanish Tragedy*, and by his brilliant friend Christopher Marlowe (1564-1593), next to Shakespeare the greatest dramatist of the age. In a short, turbulent career Marlowe turned out a half dozen successful plays. He had an almost obsessive interest in heroes who had a passion for power and were destroyed when that power came into conflict with moral law and the realities of life.

Marlowe's best-known play is *The Tragical History of Dr. Faustus*. In this drama Marlowe made use of the legends that had grown up around a German Dr. Johann or Georg Faust, notorious for having sold his soul to the devil. Marlowe makes his doctor a credible human being, a tragic figure whose own nature, a compound of high ambition and self-deception, leads to his downfall. The play, written in the blank verse form that he popularized, is filled with memorable passages of poetry, and—perhaps the most important thing that can be said of a play—it is dramatic.

Marlowe has been called the first true Elizabethan playwright. But gifted as he was, he did not possess the breadth of comic and tragic vision, the understanding of character, the poetic genius, or even the sense of theater that made William Shakespeare (1564–1616) the greatest playwright of his time or any other.

Shakespeare was first of all an artist, a maker of dramas whose quality reflects his own genius and the aesthetic responsiveness of his age. He wrote not for readers but for a playgoing audience. To satisfy that audience he sought suitable dramatic material wherever he could—in the biographical writings of Plutarch, in the histories of Holinshed, in novels, in Italian stories, in narrative

poems, and elsewhere. He seldom if ever concocted a plot of his own, but he reworked his source materials with great skill, sometimes (as in *The Merchant of Venice*) weaving two or three stories into one dramatic unit. A number of his plays, including *Hamlet, King Lear*, and *The Taming of the Shrew*, are reworkings of older plays. He drew constantly on the life around him for details of human behavior, but he had curiously little interest, dramatically at least, in contemporary events. Earlier history, however, was a vein of gold that he worked for many of his finest plays, including the *Henry IV* and *Henry V* plays and the dramas based on classical history such as *Julius Caesar, Antony and Cleopatra*, and *Coriolanus*. He was essentially but by no means completely true to the facts of history as he knew them; but the characters of history, as he conceived them, came to life in his dramas.

Nothing that was human was foreign to Shakespeare's interests, but as a maker of plays he was little concerned with realism in the literary sense. Given the circumstances of his time, the "slice of life" concept of drama would have been distasteful if not incomprehensible to him. All of his plays, the histories included, deal with unusual persons doing far from ordinary things. Hinging as many of his dramas do on disguises, mistaken identities, miraculous rescues, ghostly warnings, fairytale choices and chances, and innumerable coincidences, it is remarkable that they make contact with the everyday world as often as they do. His settings are wind-blasted heaths, battlefields, gloomy castles, enchanted woodlands, palaces, seacoast towns with romantic names, foreign cities—only occasionally anything as ordinary as a tavern or a country home. As for his characters, though it is a commonplace to say we know them better than we do our friends, few of them—at least among the major ones—are much like people we know. Even the Portias, Rosalinds, and Violas of the comedies, with their wit and charm, are unusual women in basically unreal situations. He chose the Othellos,

Hamlets, Macbeths, and Lears for his protagonists not because they are like us, but because they and their stories are dramatic, intense, magnificent, terrible—and exceptional. They are, as someone had said, magnified images of our humanity—enough like us that they and the moral and psychological worlds they inhabit take on a transcendent reality, and we turn to them for insight and wisdom almost as we do to scripture.

Some modern critics have found mannerist elements in several of Shakespeare's plays, including *Romeo and Juliet*, with its profusion of metaphors, paradoxical figures of speech, and plays on words; and in the ambiguous tone and puzzling moral implications of *Measure for Measure*, which moves back and forth across the line between comedy and tragedy. And some find the baroque spirit in the rich rhetoric and visual imagery of such plays as *Othello*. It would be inaccurate, however, to label Shakespeare either a mannerist or a baroque playwright.

Most eminent of the playwrights who followed Shakespeare, in the years before the Puritans shut down the playhouses in 1642, was his friend Ben Jonson (1572-1637), who wrote witty, satirical plays such as *Volpone* and *Every Man in His Humour*. Also important—a true dramatic genius, in fact—was John Webster (c. 1580-c. 1625), who was influenced by Shakespeare's dramatic methods if not by his view of life. He is remembered for two darkly brooding, strangely gripping revenge tragedies, *The White Devil* and *The Duchess of Malfi*.

MUSIC

The major Northern composers demonstrated once again that music was and is the most international of the arts. Bach copied down and studied the works of Vivaldi, Corelli, and other Italians. Handel studied in Italy as a young man, gained a reputation there as a keyboard performer and composer, and exerted an influence in turn on Italian opera. Purcell learned much from Ital-

ian composers and from such French composers as Lully.

The Northern composers used the forms we have met in the South—the opera, the cantata, the concerto grosso, the sonata. And they led the way in the development of other important baroque forms, especially the suite, the fugue, the chorale prelude, and the Passion.

1. *The Suite.* In its simplest sense the *suite* is a set of dance tunes. Popular dance melodies had long had their impact on more serious forms. In the baroque era, Italian composers like Corelli and Domenico Scarlatti worked dance tunes into their lively chamber sonatas. Out of these grew what came to be called "suites," groupings of dance melodies for keyboard instruments, lutes, or ensembles. Some suites incorporated dances from a number of countries, arranged to contrast with each other in rhythm, mood, and tempo. Such dances included the German allemande, the French courante and minuet, the Polish polonaise, the English jig and hornpipe, and the French or Spanish bourrée. The arrangement is not greatly different from that of a mixed group of modern dance pieces heard on a radio. Bach, Handel, Purcell, and many others composed suites.

2. *The Fugue.* The *fugue* is both an independent form and a technique employed within other larger forms such as the symphony and the oratorio. The fugue (a name derived from *fuga,* meaning a flight) grows out of the centuries-old practice of imitation, in which one voice introduces a melody, another picks it up and repeats it, and so on. The round is a common form of imitation.

In its simplest form a fugue is put together like this: one voice (whether instrumental or vocal) announces the subject or theme and then continues on with its melodic line, while a second voice states the subject a fifth higher or a fourth lower (not on the same pitch, as in a round); this second voice is called the *answer.* Then the next voice enters, and so on until (usually) three, four, or five voices have stated the subject. In the meantime each voice has gone on with a countersubject, a melodic continuation that grows out of the subject. One of the great secrets of fugal composition is the invention of a strong, quickly recognizable subject. After that, the composer can play innumerable changes on the subject and countersubject, expanding them in ways that create a mounting excitement.

The Dutch organist Jan Sweelinck and the Danish-German composer Diedrich Buxtehude are credited with having originated and developed the fugue. J. S. Bach, who listened to and warmly admired Buxtehude's playing, was himself the greatest of all composers of the fugue.

3. *The Chorale Prelude.* Another important baroque instrumental form, the *chorale prelude* grew out of the Protestant practice of hymn singing. In the seventeenth century it became a practice for the organist to play an elaborated version of the hymn for the day, usually as an introduction to the singing. This came to be called a chorale prelude. Again the pioneer was Sweelinck and the greatest practitioner was Bach.

4. *The Passion.* The sufferings of Jesus between the night of the Last Supper and the Crucifixion are often referred to as His *passion.* These events, related in the last chapters of

the Gospels, are recounted in a type of oratorio called the *Passion.* The first great composer of Passions was Heinrich Schütz (b. 1585). A devout Lutheran, he composed many works for liturgical purposes, including Passions according to St. Matthew, St. Luke, and St. John. In these a narrator or evangelist sings the continuity; others such as Jesus, Peter, and Pontius Pilate speak for themselves in recitatives or arias. In contrast to their single voices are groups—high priests, soldiers, populace—that sing for the most part polyphonically. Schütz was a highly original composer; his Passions are dramatic and often moving. They influenced the style and structure of the great Passions according to St. John and St. Matthew that Bach composed a century later.

Northern Composers. Largely ignored during the eighteenth and nineteenth centuries, Henry Purcell (1659–1695) is now recognized as a major baroque composer. In the thirty-six years that he lived, Purcell produced an astonishing amount of good music. He composed prolifically even as a youth—suites, sonatas, anthems, songs, and a number of works for the stage—operas and semi-operas.

English composers before Purcell had written much music for masques, elaborate but usually undramatic stage "spectaculars." When the Restoration brought Charles II to the throne in 1660 and theatrical productions were no longer banned, theatrical producers turned, not to masques but to Italian and French operas. It was Purcell, with his *Dido and Aeneas,* who composed what is generally considered the first English opera.

Dido and Aeneas is a delightful work in spite of a libretto that is a near disaster. Using Book Four of the *Aeneid* as a takeoff point, the librettist Nahum Tate turns Vergil's awe-inspiring deities into sorceresses and witches and makes Aeneas a pa-

thetically weak hero who tells Dido of his intention to leave her, changes his mind when she rebukes him, and leaves at last when she drives him away. Purcell makes the most of this: his choruses sing in a variety of musical forms and dance to the accompaniment of sprightly tunes—a rollicking sailors' dance, a dance of witches and sailors, and so on. But the high points of the opera are the soprano arias. In them Purcell skillfully employs the popular baroque device of word-painting, with music shaped to suggest the meanings of words. He uses daring chromatic effects, large skips, and fresh and dramatically suggestive melodies. The best of these songs is Dido's final aria, her "Lament," in which the heroine, above an accompaniment that intensifies her cry of grief, sings, "Remember me, but ah, forget my fate!"

Dido is a true opera. The story moves forward entirely in music, with no spoken dialogue. Purcell also composed a few semi-operas, including *King Arthur,* which has an undramatic libretto by the famous poet John Dryden.

Johann Sebastian Bach (1685–1750), the greatest of baroque composers—perhaps of all composers—has been more widely respected than listened to because many have thought his music to be formidably difficult. But many listeners, especially younger ones, are being attracted to the impelling rhythms of even his more complex works. They are discovering that he composed dozens of simple, lovely melodies. And they are learning to accept both the intellectual and the emotional challenge of his more profound works.

J. S. Bach was the best of the many good musicians in his family. His father and older brother were musicians and so were a number of his own twenty children. Indeed, by the time of his death four of his sons were much better known than he. Mendelssohn and others in the nineteenth century restored him to his rightful place.

In his early years as a church organist, Bach composed a number of his finest chorale preludes, some based on melodies from

his cantatas. One of these is *Jesu, meine Freude* (Jesus, My Joy), a lovely, serene work that elaborates an old hymn tune by Johann Cruger.

Bach's fugues number in the hundreds, some of them composed as independent pieces, some not. The student can find no better introduction to the form than in many of the fugues in the *Well-Tempered Clavier*, an inspired set of pieces, ranging in mood from pathos to joy and lightness, that were meant to demonstrate the sounds of keyed instruments tuned equally well for all keys. Number 3 of Book I (in C-sharp Major), for example, has a fresh, lilting subject whose development in three voices can be easily followed. Bach's great *Art of the Fugue*, nineteen fugues based on a single subject, illustrates the range of the fugue from its simplest to its most complex forms. Of the fugal works Bach composed for the organ in his earlier years, one of the best is the powerful *Fantasia and Fugue in G Minor*, often called "The Great."

Bach's lifelong resolve as a devout Lutheran to serve God through his gift of music did not prevent him from serving as a court musician and composing hundreds of secular pieces. These include works for instrumental groups—suites, sonatas, concertos. One of these is the well-known *Suite No. 3 in D Major*, with its characteristic overture followed by a series of dance tunes, one of which is the familiar "Air on the G String," as it has come to be known. An unforgettable instrumental work is the *Concerto in D Minor* for two violins and orchestra. A critic has said of its slow movement, "It is quite possible that it stands absolutely in the front rank of all of Bach's movements whose reason for existence is pure, beautiful melody." Also memorable among Bach's ensemble compositions are the six concertos—the Brandenburg Concertos—that he composed in honor of the Margrave of Brandenburg.

For many listeners Bach is at his greatest in his choral works. These include one of the most profound of all masses, the *B Minor*

Mass; several hundred cantatas; and the two great Passions.

The cantatas are in a great many forms, some for solo voices, some primarily for a chorus. One of the best known is Cantata No. 4, *Christ lag in Todesbanden* (Christ Lay in the Bonds of Death), a moving and dramatic Easter cantata for chorus and orchestra based on a hymn by Martin Luther. Another, based on the parable of the wise and foolish virgins, is No. 140, *Wachet auf* (Sleepers, Wake), with a sublimely beautiful passage for unison tenors moving with a counter-melody for strings. From the cantatas come such often-performed choral works as "Sheep May Safely Graze," from Cantata No. 208, and "Jesu, Joy of Man's Desiring," from Cantata No. 147. In both of these a lovely pastoral countermelody moves along with solid masses of choral harmony.

Bach's *Passions According to St. John* and *According to St. Matthew* owe a debt to Heinrich Schütz for their structure, but they are far larger than his. As in Schütz's Passions the narrative thread is provided by an evangelist, a tenor; and various characters move the action forward. The words of Christ are sung by a bass, to orchestral accompaniment. In both of Bach's Passions the chorus plays a vital part. In the *St. Matthew*, for instance, the opening scene (the Procession to the Cross) is built around a powerful double chorus—one group representing mourners, the other, curious bystanders. Written in twenty-four scenes, the *St. Matthew Passion* is an unparalleled religious drama, ranging in mood from quiet contemplation through profound grief to exaltation.

George Frederick Handel (1685–1759), unlike Bach, had no musical antecedents in his family. He traveled much more widely than Bach—in fact, he was a musical man of the world. And he devoted a far larger part of his creative energy to secular music, especially to the opera, a form Bach never attempted.

Handel spent his early twenties in

Italy, where he gained fame as a performer and as a composer of Italian-style operas. By 1710 he was in London; there his opera *Rinaldo* was a great success. England became his permanent home. He won the favor of the royal court, became a director of the Royal Academy of Music, and devoted a number of years mostly to opera; he wrote more than thirty of them. These operas are filled with magnificent music, but with one or two exceptions such as *Julius Caesar* they are seldom produced today. A number of fine arias, however, such as "Where'er You Walk," have survived and are heard often on the concert stage.

Gradually Handel gave more attention to other musical forms—concertos, suites, and especially oratorios. Earlier he had composed his celebrated *Water Music* suite for England's new king, George I. Like Purcell he gave great musical settings to Dryden's poems honoring St. Cecilia—"Alexander's Feast" and "Ode for St. Cecilia's Day."

The oratorio became Handel's main interest during his later years—*Saul, Samson, Messiah, Judas Maccabaeus,* and others, with which he brought the oratorio to its highest level as a baroque form. At least several of these oratorios, curiously, are more dramatic than his operas. Great as are their arias, their choruses are probably Handel's finest achievements. They vary considerably according to the moods and ideas of their texts, which they follow with great sensitivity. Within themselves they alternate freely between polyphonic and homophonic structure.

Handel's *Messiah* is the most familiar of all oratorios and for many the greatest. Employing a text selected from the Old and New Testaments (especially Psalms, Isaiah, and Revelation) by a friend of his, he composed the work in twenty-three days. He did, however, use some materials from his earlier operas and other compositions. It was first performed in Ireland, with four soloists, a small orchestra, and a chorus of fourteen men and boys. The Irish audience appreci-ated the work, but it was slow to gain favor in England. Handel conducted it in a number of performances, even after (like Bach) he had lost his eyesight. In all the early performances the singers and instrumentalists improvised embellishments in the baroque tradition, and they probably kept tempos moving.

Messiah is not a life of Christ or a Passion. Its three parts are an artistic interpretation of the Redemption—the advent of Christ, the attainment of redemption, and songs of thanksgiving for the overthrow of death. A number of the solos, especially the tenor aria "Every Valley Shall Be Exalted," demonstrate Handel's sensitive response to his scriptural texts and his skill at word-painting. The choruses include the powerful prophetic statement, "For unto Us a Child Is Born"; the celebrated "Hallelujah" that concludes Part Two; and the concluding shout of triumph in "Worthy Is the Lamb," followed by an elaborate "Amen."

ARCHITECTURE

The long period of Gothic church construction largely came to an end about 1500. The town halls, palaces, and other big structures of the North in the sixteenth century, from the imposing Town Hall in Antwerp to the massive Hampton Court Palace in England, were local blendings of the Gothic and the classical Renaissance styles, often with baroque towers and other ornamentation added later on.

Impressive large-scale architecture flourished during the baroque period in the Low Countries, as did the building of picturesque private dwellings with their high gables. Germany was a cultural desert in the seventeenth century, during and after the devastating Thirty Years' War. But the revival in the early eighteenth century led, among other things, to the building of great palaces in Germany and Austria on the order of Louis XIV's Versailles.

In sixteenth-century England, the expanding age of the Tudor rulers (especially of Henry VIII and Elizabeth), dozens of large structures were built, including university halls at Oxford and Cambridge, elegant manor houses and palatial mansions such as Wollaton Hall and the stately Hatfield House, and the earlier parts of England's largest palace, Hampton Court—all with their sweeping lawns and beautiful gardens. Their architectural style, the Tudor style, is a blending in varying proportions of England's ornamental *Gothic perpendicular* style with the classical Italian Renaissance style. The term *Tudor style* also loosely embraces the distinctive half-timbered houses that add their charm to the older parts of Stratford, Canterbury, and many other English cities and towns.

Two men are chiefly to be credited for giving shape, in the seventeenth century, to England's late Renaissance and baroque styles of architecture—Inigo Jones and Christopher Wren.

An imaginative stage designer and theater architect in his earlier life, Inigo Jones (1573-1652) made two long visits to Italy, where he responded warmly to the arts of antiquity and the buildings of Palladio in Vicenza and Venice. After his appointment as Royal Architect in England, he designed a number of public buildings that, as a historian puts it, "shone out like good deeds in an otherwise naughty late medieval world" and that helped to establish the direction of English architecture for the next two hundred years.

Jones's first important work was the Queen's House at Greenwich (fig. 11-1). It is noteworthy as the first of hundreds of mansions built with clear, simple surfaces, plain horizontal lines, and a number of Palladian touches. These include the loggia or porch (shallower than Palladio would have made it), the Ionic columns, and the balustrade surrounding the flat roof.

Another of Jones's famous works is the Banqueting House at Whitehall in London, meant to be part of a large group of palatial buildings that Jones designed but that were never built. The Banqueting House is modeled after Palladio's Palazzo Chiericati in Vicenza but is plainer and sturdier looking. Jones wrote that a building, like a man, ought to be outwardly grave, that it ought to be "proportionable to rules, masculine, and unaffected." The Banqueting House is all of these. But the inside, Jones said, should be intense and full of feeling. Again the Banqueting House complies: its interior, a single large hall meant for great social events, is a splendid example of English baroque—less ornate than many staterooms on the Continent, but capped by a ceiling of elegant

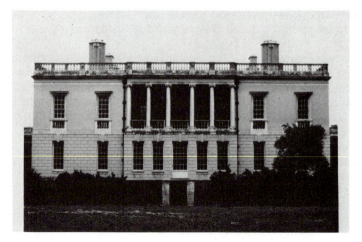

Fig. 11–1. Inigo Jones. The Queen's House, Greenwich, England. South exposure. About 1625.

framework inset with allegorical paintings done for the hall by the celebrated Peter Paul Rubens.

If Bernini changed the face of Rome, just as strikingly did Sir Christopher Wren (1632-1723) leave his mark on the city of London. Wren, a brilliant scientist who turned to architecture, came on the scene at the time of the Restoration, when England's men of influence were demanding grander buildings to match those on the Continent.

Wren's big opportunity grew out of disaster—the Great Fire of London in 1666 that destroyed thousands of homes and hundreds of churches and other public buildings, including St. Paul's, the city's old cathedral. As one of three commissioners appointed to make plans for rebuilding London, Wren devised a daring layout for an entire new city which was rejected as too costly and too utopian. He was involved, however, in the building or rebuilding of over fifty churches. And as architect for the new St. Paul's he had the rare opportunity of overseeing the complete construction of an edifice of immense proportions.

Among several sets of plans for the new St. Paul's designed by Wren he had his own favorite, a central-type building in the form of a Greek cross. But he gave in to the wishes of the clergy, who wanted a traditional Latin-cross basilica. He created a long, high nave (fig. 11-2), with a series of saucer domes over the bays of both the nave and the choir. Everything leads the eye toward the great dome over the crossing, which is supported by eight huge piers. The dome is beautiful both inside and out. It is a triple structure, weighing over eight hundred tons; between the inner and outer shells is a hidden cone that supports the heavy lantern atop the dome.

From the outside St. Paul's is an impressive blending of classical and baroque features. The dome is basically classical, but it is capped by a baroque lantern. The façade

Fig. 11–2. Sir Christopher Wren. Interior, St. Paul's Cathedral, London. Begun 1675.

Fig. 11–3. Sir Christopher Wren. St. Paul's Cathedral, London. Begun 1675.

(fig. 11-3), with its sweeping stairway, paired Corinthian columns and pilasters, and symmetrical pediments, is in the best classical Renaissance tradition; but the baroque towers add an effect that transforms the design into an impressive work of art.

Wren's steepled churches became a famous part of London's skyline. Built basically in a boxlike form that he may have derived from Dutch churches of the period, they differ greatly in their interior forms; they are classical and baroque in varying degrees.

Next to Wren, England's greatest builder of churches was a Scotsman, James Gibbs (1682-1754). He went to Rome as a

Fig. 11–4. James Gibbs. Church of St. Martin-in-the-Fields, London. Begun about 1710.

young man to train as a missionary but soon turned to painting and architecture. In London, where he came under the influence of Wren, he designed such fine churches as St. Martin-in-the-Fields (fig. 11-4), with its great steeple towering over a Roman Renaissance portico. His churches and his illustrated books on architecture were the inspiration for many churches built in America during colonial times and after.

SCULPTURE

Sculpture has held a much less important place in Protestant art than in Catholic, and public buildings of the baroque age in the North are plainer and less adorned with statuary and other ornamentation than those in Italy, Spain, France, and the southern Germanic regions. But there is much fountain and park statuary, architectural sculpture and stucco work, and commemorative statuary from the baroque era in the North—much of it done by highly competent artists. Europe would not be the same without their work; but no Berninis or other baroque sculptors of the first rank emerged from the craftsmen of the North.

PAINTING

The Low Countries, as we have seen, had their first great age of painting in the early Renaissance, with the work of such masters as the van Eycks and Rogier van der Weyden. Bruegel and others continued the tradition in the sixteenth century. The seventeenth century produced a remarkable number of major artists, of whom only a few can be considered here. They divide themselves naturally into two groups: the Catholic baroque painters of the Flemish or Southern Provinces, often called the Spanish Netherlands—essentially what is now Belgium; and the Protestant baroque painters of the Northern Provinces or Dutch Republic, now the Netherlands.

Catholic Baroque Painters. Though the Low Countries in the early sixteenth century were part of the vast empire of Charles V, they were largely independent. But when that powerful ruler abdicated in 1556, he gave the Netherlands to his son Philip II. Philip, a devout Roman Catholic, disliked the Netherlands and hated what he considered the heresies of Protestantism. He soon had both himself and his subject states in deep trouble when he sent Spanish troops and a Spanish governor who harassed the Low Countries in many ways, executed hundreds of citizens, and stirred up wide rebellions even in the predominantly Catholic provinces. The Northern Provinces resisted more successfully, under the leadership of William of Orange, than did the Southern. By the end of the sixteenth century a number of Northern Provinces—Holland, Zeeland, and others—were essentially independent.

The Southern Provinces were not able and in some respects not willing to join the Northern War of Independence. They retained their Catholic orientation and remained under Spanish domination for many more years. Antwerp, their chief city, was to be the home of the greatest of Catholic baroque painters, Peter Paul Rubens, his brilliant student Anthony van Dyck, and his collaborators Frans Snyders and Jacob Jordaens.

Peter Paul Rubens (1577-1640) was born in western Germany of Flemish parents but spent his youth in Antwerp. There he received an excellent humanistic education and completed his apprenticeship as a painter. At twenty-two he went to Italy, where he painted for the Duke of Mantua, traveled constantly, and studied the great masters—Michelangelo, Tintoretto, Veronese, Caravaggio, and especially Titian, all of whom influenced his style. When he returned to Antwerp, his reputation had gone before him, and he was immediately appointed court painter to the Spanish governor of the Netherlands, a position he held the rest of his life.

Rubens built himself an elegant Italian-style palace, married Isabella Brandt, daughter of a wealthy citizen, and launched into what was to be a dazzlingly successful career as perhaps the most productive major artist of all time and the most characteristically baroque of all painters. His personal life was serene, marred only by deaths in his family that included the loss of his wife Isabella in 1627. In 1630, when he was fifty-three, he married a sixteen-year-old girl named Helena Fourment, who served as a model for many portraits and mythological paintings.

Unlike most artists of northern Europe, who tended to be narrow specialists, Rubens did almost every type of painting. He also made hundreds of the best drawings ever executed. He had a number of assistants and apprentices, as well as well-known collaborators such as Jan Bruegel and Frans Snyders.

The overall feeling of Rubens's paintings is one of action, vitality, and energy. He knew and used the Carvaggesque devices of light and shadow, he was a superb colorist, and he could paint as subtly as Leonardo or as freely as Hals. But he used techniques only as they contributed to the recording of an intense moment of experience. Burckhardt called him the greatest storyteller in the world next to Homer, and there is a strong narrative element in picture after picture. His sense of drama was supported by his mastery of composition, with figures—sometimes large groups of them—moving in curves, spirals, ovals, diagonals, or other strong forms favored by baroque artists.

Rubens's forte was the human form—powerful male figures that seem athletic even in agony or death, and robust female nudes. His models were characteristically buxom—partly, perhaps, because of the fashions of his time and partly because they embodied the vibrant good health that he enjoyed depicting. *The Toilet of Venus* (fig. 11-5) has glowing skin color and subtle modeling that rival similar works by Titian.

Representative of Rubens's many commissioned works as a court painter is *The Presentation of the Portrait* (fig. 11-6). This is

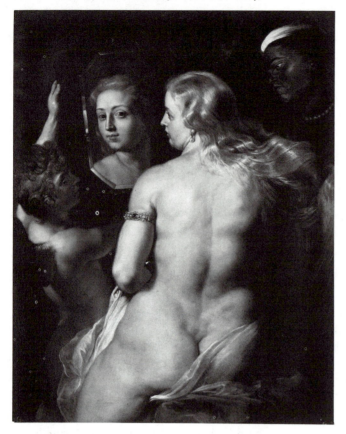

Fig. 11–5. Sir Peter Paul Rubens. *The Toilet of Venus*. 1612–15. Collection of the Principality of Liechtenstein, Vaduz.

Number 4 of twenty-one huge, opulent paintings, now in the Louvre, that Rubens did for the Luxembourg Palace at the request of Marie de Medici, widow of the French king Henry IV. Though Marie was not distinguished for either beauty or intelligence, Rubens produced a dazzling series of allegorical paintings based more or less on her life. The works are a completely confident blending of pagan and Christian elements. Number 4 shows Henry looking at a portrait of his future wife which has been sent by Juno, goddess of marriage, who sits above between Jupiter and a peacock.

Rubens received many honors (for one, he was knighted by Charles I of England for his work in that country), and his influence was immense. His immediate followers imitated the noisier and more melodramatic side of his artistry. Later painters, from Watteau to Delacroix and Renoir, were impressed by his figures, his compositions, and his command of technique.

Next to Rubens, the greatest Flemish baroque painter was Anthony van Dyck (1599–1641). Like Rubens he spent his early twenties in Italy, especially Genoa, where he developed a portrait style that was to make him the most successful portraitist of his age. In Genoa, in Flanders, and in England (where he spent his last years and like Rubens was knighted by Charles I), his subjects were images of elegance—handsome men and beautiful women, aristocrats for whom suave grace and personal adornment had become a way of life. They are shown in formal and yet relaxed poses, usually from a low viewpoint that enhances their statures,

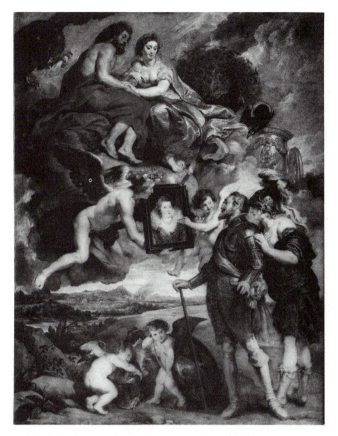

Fig. 11–6. Rubens. *Henry IV Receiving the Portrait of Maria de' Medici.* 1622–25. 13 × 10'. The Louvre, Paris.

and are highlighted against a dark background or a romantic landscape. Their hands and faces are small, and their features bear a touch of what was evidently van Dyck's own melancholy. Most famous are his equestrian portraits of Charles I, such as that shown in fig. 11-7, which have made the face of that ill-fated monarch almost as familiar to the world as that of Henry VIII.

Protestant Baroque Painters. The Dutch Republic rapidly became one of the great powers of western Europe. In a peaceful sense, at least, it ruled the seas and became the principal shipper and freight handler of Europe. It founded a colonial empire and took the lead in banking and other financial matters. It was, in fact, one of the first great nations, with a strong, democratic middle-class society as its foundation. It prized education; Dutch universities developed outstanding humanists, scientists, and other scholars.

The Dutch burghers placed a high premium on stable, well-regulated home life and on dwellings that were symbols of their owners' prosperity. There was little ornamentation in their churches, but they adorned their homes with exotic fabrics, paintings, and other costly objects. Painters came forth to meet the demand, and Holland entered her greatest era of artistic achievement. It was a true golden age if a short one, lasting only about three generations.

The tastes of the purchasers helped determine those of the painters, and vice versa. Portraits were in demand, as were landscapes, seascapes, interiors, genre paint-

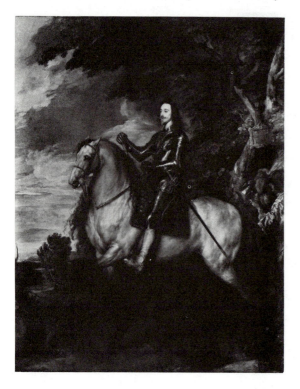

Fig. 11–7. Anthony van Dyck. *Equestrian Portrait of Charles I.* About 1635. Reproduced by courtesy of the Trustees of the National Gallery, London.

ings, still lifes, and occasional religious paintings. Many of the the secular paintings had semireligious or moral implications, but in the main they were cheerful and realistic.

Frans Hals (c. 1580-1666) is one of many baroque artists whose reputations, dimmed for a couple of centuries after their deaths, have revived strongly. Born in Antwerp, he spent almost all of his long life in Haarlem, which now has the world's finest collection of his paintings. He was a brilliant, erratic artist who gathered a large school of assistants and students around him but who lived so recklessly that he and his family (at least a dozen children by two wives) spent most of their lives in poverty.

Few paintings are better known than Hals's *Laughing Cavalier.* He painted many other persons in various stages of merriment—a laughing, gap-toothed child with a flute; a *Smiling Girl* (in the Louvre); and different portrayals of *Malle Babbe,* an old innkeeper with an owl on her shoulder and a half-mad grin on her face. These are Hals's genre or character portraits, done largely as experiments in technique. They show his almost uncanny ability to catch a fleeting expression as his subject turns toward or away from the viewer with a glance from the corner of an eye and an arrested gesture of the hands. They are drawn with the brush; Hals made no preliminary outlines on the canvas. He painted with quick, loose, but controlled brush strokes that do not copy reality faithfully but simply suggest it, letting the viewer's eye complete the illusion. One of the best of these is *Young Man and a Woman in an Inn* (fig. 11-8).

Less familiar but profounder in their insights are Hals's commissioned portraits, some of them as somber and meditative as Rembrandt's. His greatest works are large group portraits. The earlier ones are mass portraits of officers of militia, engaged in traditional convivial banqueting. Hals composed these baroque paintings so that each person is given more or less the prominence he paid for, each retains his individuality, and each is posed naturally as part of a rhythmic composition. A fine example is the *Assembly of Officers and Subalterns of the Civic Guard of St. Hadrian* (fig. 11-9). Hals's last group portraits, painted when he was almost eighty, are revealing portrayals of the tight-lipped, cold-eyed governors and lady governors of the old men's home in Haarlem.

Rembrandt van Ryn (1606-1669), an artist of the stature of Shakespeare and Bach, is almost overwhelming in the sheer number and variety of his masterpieces. From his boyhood until he died at sixty-three he practiced his art tirelessly, with an increasingly quick hand. He left about 1400 drawings (probably as many more have been lost or destroyed), a large number of etchings, and several hundred paintings of all kinds, many of them of the first rank.

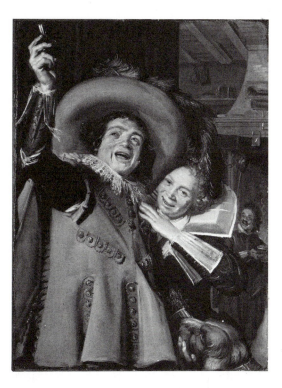

Fig. 11–8. Frans Hals. *Young Man and a Woman in an Inn*. About 1630. 41½ × 31¼″. The Metropolitan Museum of Art. Bequest of Benjamin Altman, 1913.

Fig. 11–9. Frans Hals. *Assembly of Officers and Subalterns of the Civic Guard of St. Hadrian*. 1633. Frans Hals Museum, Haarlem, Netherlands. Photo A. Dingjen.

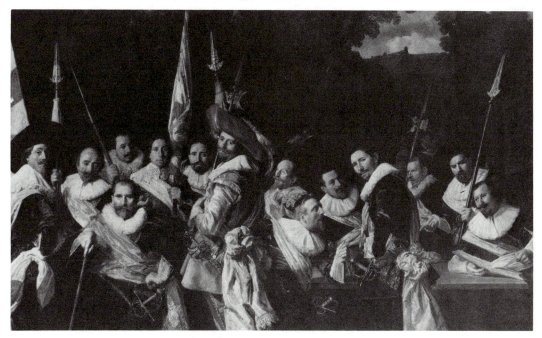

Born in Leyden to a prosperous miller and his wife, Rembrandt had his principal training in Amsterdam and spent most of his life there. He made a name for himself with a group portrait, *The Anatomy Lesson of Dr. Tulp,* and became a prosperous painter of highly finished portraits and dramatic, often theatrical narrative paintings. He married Saskia van Uylenborch, a pretty, blond-haired young woman who brought him a large dowry and who modeled for him many times. She bore him four children, three of whom died in infancy, and she herself died in 1642 after eight years of married life. The circumstances of the artist's later life were less happy, aggravated by changing fashions in art and by the fact that his increasing profundity was not understood or appreciated. His common-law wife during these last years was Hendrickje Stoffels, a pleasant-faced woman who served as model for many of his paintings, including the great *Bathsheba.*

Rembrandt is unsurpassed in his use of chiaroscuro. He creates a world of light and shadow, inhabited by the human beings who are always his central concern. He was influenced by Caravaggism; but where Caravaggio's dark shadows limit space, Rembrandt's rich golds and browns extend it. His later works owe less to Caravaggio; edges are less distinct, contrasts are less abrupt, and shadows are warmer and more evocative. Like other great artists before him—Michelangelo and Titian, for example—he painted more freely as he grew older. And as the years passed he became more and more concerned with character and personality.

Rembrandt painted dozens of portraits, some of them commissioned, many of family members and friends, and as many as eighty of himself. In the earlier self-portraits he gives way to an urge to "mug"; even in the later ones he often attired himself in one or another of the exotic costumes that he gathered by the trunkful; but he always seems to probe himself honestly and deeply. One of the best is the *Self-Portrait* in the Metropolitan Museum (fig. 11-10). A grizzled old man, he looks at the viewer with calm, searching eyes.

His greatest financial successes were his group portraits, which include the celebrated *Company of Captain Frans Banning Cocq,* popularly called *The Night Watch* (Colorplate 7). The picture is not a night but an early morning scene; a recent cleaning of the work has made this fact more clear. Doubtless Rembrandt's contemporaries were struck, as modern viewers are, by the drama of the work, the skillful arraying of lances, banners, muskets and drum, and the figures of militiamen and children, some highlighted, some partly in shadow, all in a highly animated but controlled composition. A profounder work is his last large commissioned painting, *The Syndics* (fig. 11-11), in which five dignified officers of the respected wool merchants' guild, with their servant, look from their elevated table toward the viewer and involve him in the scene, in a manner reminiscent of Velázquez' *Maids of Honor.*

At a time in Calvinist Holland when religious paintings were banned from Protestant churches, Rembrandt created over eight hundred paintings, drawings, and etchings dealing with religious subjects. He did these for himself and a few appreciative friends. He has been quoted as saying that the Savior was at the focus of his search for "the deepest inward emotion," and he depicted with great insight both the human and the divine characteristics of Christ. He saw the interaction of the human and the divine in hundreds of incidents in scripture, and he drew from them not simply traditional annunciations, nativities, and the like, but spiritual and emotional confrontations—Samson and Delilah, Saul and David, David and Bathsheba, the denial of Peter, the Agony in the Garden, and so on. *The Return of the Prodigal,* painted in the year of Rembrandt's death, is a moving statement of penitence and forgiveness, the central theme of the artist's religious paintings. His *Christ Healing the Sick* (fig. 11-12), with its painterly contrasts

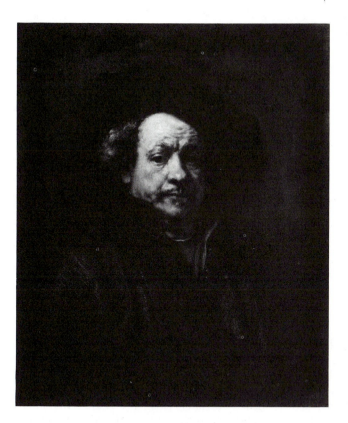

Fig. 11–10. Rembrandt. *Portrait of the Artist*. 1660. 31⅝ × 26½". The Metropolitan Museum of Art, New York. Bequest of Benjamin Altman, 1913.

Fig. 11–11. Rembrandt. *The Syndics*. 1661. 6'3" × 9'2". Rijksmuseum, Amsterdam.

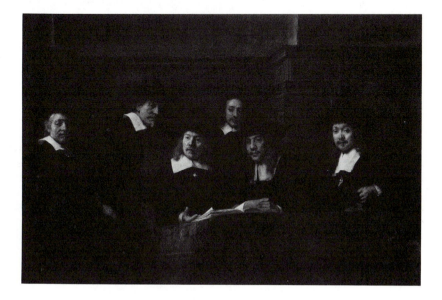

of light and shadow, is a familiar etching—another medium, incidentally, in which he is unsurpassed.

Dutch Genre Painters. The *genre* is a type of painting, usually small, that depicts everyday situations and surroundings. Though it reflects the manners and costumes of a time and place, it often conveys an impression of timelessness and of familiarity. Its characters—peasants, merrymakers, young girls, housewives—are not romanticized. There is often narrative content in the picture—a Christmas celebration, a tavern brawl, a mother caring for a sick child. Sometimes there is moralizing, as in Steen's *Wine Is a Mocker*, in which a young woman in a drunken stupor is surrounded by jeering men.

There are elements of genre in many earlier works of art, and Bruegel, in his great peasant scenes, created authentic genre paintings. But the seventeenth century produced the great genre specialists. In the earlier part of the century they favored boisterous scenes of country life—taverns, peasant dances, and so on. Later, tastes moved toward more refined and genteel scenes—interiors with winsome girls, elegantly dressed ladies, or cavaliers courting their maidens. The best representatives of these two groups are Jan Steen and Jan Vermeer.

Jan Steen (1626–1679) painted dozens of scenes of revelry that reflect his own genial attitude toward life. He painted, for example, wedding celebrations; a painfully amusing Christmas anecdote with adults laughing at a weeping youngster who has found a whip in his stocking; and a crowd of merrymakers laughing at a peasant and a cavalier who are quarreling over a card game. Recent critics have admired Steen's technical skill as much as his narrative gifts and high good humor. *The Dancing Couple* (fig. 11-13) is typical: country people of all ages in a sunlit arbor eating, drinking, talking, playing with children, and casually watching a young

couple do a rustic dance. Light plays subtly on faces, clothing, and other surfaces, and the details in the foreground—the pitcher, the vase, the overturned keg, the egg shells—are meticulously painted.

Jan Vermeer (1632–1675), the great genre painter from Delft, gives us the quieter, more meditative moments of Dutch life. He has none of the vitality of Hals and Steen and little of the breadth or profundity of Rembrandt. But within his narrow range he came as close to perfection as any artist in history.

Of the fewer than forty paintings by Vermeer that can be authenticated, the typical subject is a woman in a small kitchen or living room, holding a water jug or pouring milk or adorning herself or (the favorite subject of Vermeer and many of his contemporaries) reading or writing a letter. There is little narrative content except in the letter paintings—the missive may be a letter of rejection—but there are numerous symbolic allusions. One of them, a marvel of technical skill called *An Artist in His Studio* (fig. 11-14), is clearly allegorical; it depicts an artist painting a modest-looking young woman crowned with laurel who holds other objects that identify her, somewhat ironically, as Fame.

Vermeer's *Young Woman with a Water Jug* (Colorplate 8) has an almost spiritual serenity; one feels, as the young woman pauses to daydream in the crystalline light from the casemented window, that a moment of time has been suspended. Light, one of the secrets of Vermeer's magic, plays on the small panes of the window, the varying surfaces of the pitcher and tray, the metal upholstery buttons, the young woman's cap and collar, and the whitewashed wall behind her. Light defines the textures of everything in the room, from the windowpanes to the map on the wall and the wall itself. The composition is a careful balancing of rectangles against the soft curves of the woman's form.

Vermeer painted a few portraits, mostly of his own children. He also painted a

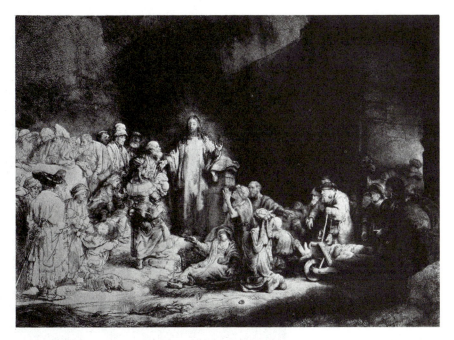

Fig. 11–12. Rembrandt. *Christ with the Sick Around Him, Receiving Little Children.* About 1648–50. Etching, 10⅞ × 15½". The Metropolitan Museum of Art, New York. Bequest of Mrs. H. O. Havemeyer, 1929. The H. O. Havemeyer Collection.

Fig. 11–13. Jan Steen. *The Dancing Couple.* About 1665. Approx. 40 × 56". National Gallery of Art, Washington, D.C. Widener Collection, 1942.

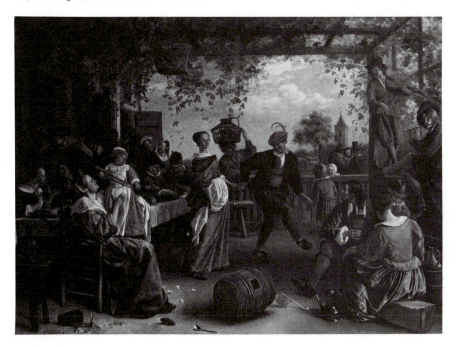

Fig. 11–14. Jan Vermeer. *An Artist in His Studio*. About 1665–70. 52 × 44″. Kunsthistorisches Museum, Vienna.

Fig. 11–15. Jan Vermeer. *View of Delft*. About 1660. 38½ × 46″. Royal Picture Gallery, "Maurits-huis," The Hague.

few landscapes. In his *View of Delft* (fig. 11-15) he helped to make famous the soft light of that Dutch town as well as its skyline, which has changed little in three hundred years.

Dutch Landscape Painting. A number of Dutch masters devoted their skills to the painting of the pleasant if unexciting Dutch countryside and the more picturesque seacoast. Working in their studios from sketches or from memory, they rendered the more romantic aspects of land and sea, but they seldom strayed far from a basic realism.

Dutch landscape painting reached its highest point in the work of Jacob van Ruisdael (c. 1628-1682). Born in Haarlem, he studied with his uncle Salomon (whose works are sometimes confused with his) and lived most of his solitary, withdrawn life in Amsterdam. Ruisdael painted only landscapes, some depicting nature in her warmer moods, more reflecting the melancholy and even tragic aspects of the physical world.

Though Ruisdael used a wide range of colors and could paint objects with precision, his works are primarily expressions of mood: a Jewish cemetery with brooding stormclouds overhead; or forests, with clouds billowing over huge oak trees, and with a stream or pond and a storm-shattered birch in the foreground, as in *A Forest Scene* (fig. 11-16). Ruisdael's seascapes are just as evocative. He painted them from a low an-

Fig. 11–16. Jacob van Ruisdael. *Forest Scene.* About 1650. National Gallery of Art, Washington, D.C. Widener Collection.

gle, so that a structure such as a windmill or a castle tower looms gigantically on one side or the other, with clouds sweeping dramatically across a great sky.

Meindert Hobbema (1638-1709), a pupil of Ruisdael, had none of his master's philosophical inclinations and, apparently, little of his passion to paint; he largely gave up painting at about thirty and spent the rest of his long life as a minor official. But he had already done a number of works that remain popular today. They are warm, inviting scenes of the countryside, with farm buildings surrounded by heavy masses of trees and foliage. One of the most famous if less typical of his works in his *Avenue* (fig. 11-17), a straight country road in the center with tall, slender trees on each side.

Still Life. The *still life* is a type of painting—a highly popular one in the baroque era—that grew out of the Low Countries painters' delight in rendering objects such as coins, books, textiles, flowers, fruit, fur, and silver vessels as accurately as possible in narrative or other paintings. Still lifes consist of such objects painted for their own sakes, sometimes with symbolic meanings. A painting of fruit and other food, for example, might include a skull or an hourglass to suggest the transience of earthly things. Flowers, in this land of flower lovers, had their own numerous and complex meanings.

Apart from meanings, the aims of a still life painter were to fool the eye, to create an illusion that would tempt the viewer to reach out and touch the painted objects, to show

Fig. 11–17. Meindert Hobbema. *The Avenue*. 1689. Reproduced by courtesy of the Trustees of the National Gallery, London.

Fig. 11–18. Jan Davidsz de Heem. *Still Life with a Lobster*. Late 1640s. 25 × 33¼". Toledo Museum of Art, Toledo, Ohio. Gift of Edward Drummond Libbey.

how well the painters could imitate forms, colors, and textures, and their interplay in varying lights and shadows. Another aim was to arrange the objects in an effective composition.

Jan Davidsz de Heem (1606–1684) was one of the best still life painters. His *Still Life with a Lobster* (fig. 11-18) is a faultless rendering of fruit, fabrics, glassware, and other objects, with a red lobster as an eyecatcher and with a watch to remind us, perhaps, of the transitoriness of physical things. Another was Willem Kalf (1619-1693), whose goblets, chinaware, and half-peeled lemons sparkle from a dark rich background.

Another school of still life painting, quite different from the Dutch, developed in Flanders. There such painters as Frans Snyders created very large works for which the term *still life* takes on another meaning— the booty of the hunt such as full-sized, eviscerated deer, rabbits, and game birds, usually with one or two live animals such as monkeys included to add to the feeling of animal vitality. Snyders' *Still Life with Monkey* (fig. 11-19) is a fine example.

The baroque age merged gradually into the next cultural eras, the neoclassical and the rococo. In fact, French playwrights such

Fig. 11–19. Frans Snyders. *Still Life with Monkey*. About 1630. 44 × 71". National Museum, Stockholm.

as Racine and Molière were developing an important new dramatic style, the neoclassical, when the baroque age was at its height. And by the end of the seventeenth century English literature was moving into its neoclassical period. In the early eighteenth century, as a more or less conscious reaction against the grander and more pompous aspects of the baroque, architects and other artists developed the delicate, elegant style called rococo. In music, though foreshadowings of the classical style were to be heard fairly early in the eighteenth century, the baroque continued to prevail until the mid-1700s, well into the neoclassical era, the Age of Enlightenment.

12

THE ENLIGHTENMENT: ROCOCO AND NEOCLASSICAL STYLES

Renaissance humanists and other scholars eagerly sought knowledge of both the antique world and the world around them. Leonardo employed what was to be one of the main techniques of science—careful, objective observation—in recording many phenomena of botany, geology, and anatomy. Copernicus made observations and mathematical deductions that led him to challenge the centuries-old Ptolemaic concept of the universe. Galileo and Kepler, in the seventeenth century, used the newly invented telescope to make startling discoveries that supported Copernicus's theories.

In the same century Isaac Newton, applying mathematical models to the solving of scientific problems, was able to announce some of the most revolutionary discoveries ever made by one man. His method, careful observation of facts and rational arrangement of what he observed, became a model for all who sought truth. Scholars were stimulated to re-examine all areas of knowledge—political, social, even aesthetic and theological—as well as physical. This upsurge of intellectual curiosity and daring speculation took place in what is called the Enlightenment or (especially in England) the Age of Reason—the later seventeenth and eighteenth centuries.

THE ENLIGHTENMENT

The term *Enlightenment* was probably first used in Germany. The effects of the movement were felt all over western Europe, but they are associated most directly with France. French intellectual leaders—*philosophes*, as they were generally called—attempted to employ scientific methods in all areas of physical experience, from medicine to mechanics. They were also convinced that they could solve the world's social, political, and moral problems by the exercise of reason and scientific observation. As they looked for political models they were especially impressed by the government of the Roman Republic and by the limited monarchy of England.

Most *philosophes* were prolific writers, and their ideas poured forth almost daily in pamphlets that were often published anony-

mously. Their views were also brought forth and tested in *salons*, social and intellectual gatherings presided over by cultivated ladies who invited respected thinkers to dine, and who drew out their opinions in formal but often brilliant conversations.

The *philosophes* were not members of a philosophical school; within their ranks were men of the most diverse opinions. They agreed, however, on the fundamental importance of reason, and they rejected ideas based solely on tradition or arbitrary authority. Quite naturally they were also critical of many aspects of organized religion. They were not necessarily skeptics; some were atheists or agnostics, but others were devout believers. But even the more religious among them objected to the practices of the dominant churches. Dogma that failed to meet the test of reason must therefore, they thought, be false. More importantly, they were convinced that many religious leaders were using their positions to support unjust political and social institutions.

The greatest intellectual project of the Enlightenment was undertaken by Denis Diderot (1713–1784). A popular visitor of salons, he led the way in gathering and recording all extant knowledge in one great collection, the *Encyclopedia*. Diderot and more than two hundred other scholars contributed to the huge project, which required over twenty years for completion. The *Encyclopedia*, marred by much needless editorializing, reflects the scientific, democratic spirit of the philosophes. Its great scope and brilliant illustrations provided the model for all subsequent works of its kind.

Political Developments. The power of the French monarchy continued to increase for a while after the death of Louis XIV in 1715, even though his two successors were far less capable than he. The split between the aristocracy and the lower classes widened. The intellectuals, though they somtimes defended monarchy as an institution, looked with increasing concern on the judicial corruption, unjust taxation, and general disregard for human rights that the system of absolutism demonstrated—abuses that led to the Revolution of 1789.

In England a change of dynasties gave the throne to the royal family of Hanover, Germany. In conferring the English crown on German kings, Parliament demanded and received concessions that strictly limited the power of the monarchy. Although the English had difficulties with Stuart pretenders to the throne as well as problems on the Continent, the eighteenth century was calm in comparison with the two preceding ones. Most Englishmen did not immediately recognize the American Revolution as being particularly significant.

The most important monarchies on the Continent, apart from the French one, were those of Frederick the Great of Germany, the model of the "enlightened despot"; Catherine the Great of Russia, who encouraged philosophy, the arts, and culture in general but did little to ease the sufferings of Russian peasants or to institute needed reforms; and Maria Theresa of Austria, whose genuine attempts at reform were hampered by external problems—frequent and often disastrous wars with Prussia, Bavaria, and France.

The Classical Revival. The appreciation for the arts of Greece and Rome that was renewed in the Renaissance has never died away. Even the movements often considered least classical—the baroque and the romantic—had their Greek or Roman elements. In the eighteenth century, however, admiration and enthusiasm for the cultures of classical antiquity reached such levels that we call the age, in its cultural aspects, the Classical Revival.

The revival received its strongest stimulus from the rediscovery in the mid-eighteenth century of the ancient Roman cities of Pompeii and Herculaneum, not far from Naples. Both were destroyed in A.D. 79 by the eruption of Mt. Vesuvius, and they had lain

under volcanic ash for over seventeen hundred years. Since the main object of their early excavators was to discover sculpture or frescoes that could be given to the Queen of Naples or sold to art collectors, digging was at first unsystematic, and many important archeological objects were destroyed. But as the work progressed, scholars became increasingly excited by the magnitude of the findings. They gradually became aware that these long-buried cities had preserved many elements not only of Roman but of Greek culture. Herculaneum may have been a Greek colony; in any event the layout of the city indicates that it was modeled on a Hellenistic prototype.

In both cities good Roman copies of Greek sculpture were found, along with frescoes that were probably painted by Greek or Greek-trained artists. Long-undisturbed remains of both the familiar Roman and the less-known Greek cultures became available for study and imitation. More and more scholars tried to describe the principles upon which the arts of classical antiquity were based, and to establish classical norms for literature, architecture, painting, and sculpture. Even home furnishings, costumes, and hair styles of the revival era often imitated the classical traditions that were revealed in Pompeii and Herculaneum.

A German named Johann Joachim Winckelmann (1717–1768) was the writer who most strongly stimulated the new interest in Greek arts. He was the first serious student of the discoveries in Pompeii and Herculaneum, and his book, *The History of Ancient Art*, was the first attempt to classify Greek art, especially sculpture, according to style and period. He argued that modern artists could arrive at principles of true beauty by studying Greek sculpture, which, he said, displayed "noble simplicity and quiet grandeur." Winckelmann's enthusiasm for the arts of the ancients and the beauty of his descriptions of Greek masterpieces combined to make his writings highly popular and influential.

LITERATURE

Winckelmann's first reports of the spectacular discoveries near Naples were published in the 1760s, and their impact on contemporary sculpture and the other visual arts soon followed. A century before that, however, the first strong currents of the classical revival in another art—that of literature—were being felt throughout Europe. The poets and playwrights of the Renaissance, from Ariosto to Shakespeare, had been more impressed by the spirit of Greek and Roman literature than by its rules and styles. But during the seventeenth century and on into the eighteenth, writers and literary theorists in almost every Western country—especially France—concluded that modern writers succeeded only to the degree that they imitated the practices and rules of the ancients, especially Horace, Vergil, and other writers of the age of Augustus.

French Neoclassicism

In France, drama was the most popular and most important form of literature of the period. The French variety of Italian opera, as we have seen, was produced in the opulent baroque courts of Louix XIV and his fellow aristocrats. Because many of the plays of the times were staged in similar settings, they are often called baroque, but in form and spirit they are essentially neoclassical.

As the theater became increasingly popular, playwrights in large numbers came forth to meet the demands for new dramas. Close behind were theoreticians and critics, many of whom argued strongly for classical principles of play writing and production. They cited early Latin writers, who in turn had looked to Aristotle, for rules governing drama, especially tragedy. Most important of these rules, based in part on a misinterpretation of Aristotle, were the three unities—of time (a drama should cover a time span no longer than that of the actual production, or at most one day); of place (the

incidents of the play should all take place in one setting); and of action (all parts of the drama should be closely integrated into a single whole). They argued for other rules governing the number of acts, the relationship of each act to the development of the whole, and so on. Naturally they had trouble accepting the plays of Shakespeare and other playwrights who ignored such rules or modified them to suit their purposes.

Only a few French playwrights were able to produce permanently important drama within the confines of the rules. These few included Pierre Corneille and Jean Racine, who perfected neoclassical tragedy and raised its poetic language to a level never again reached in France—and seldom achieved elsewhere.

Pierre Corneille (1606–1684) put aside a successful career as a lawyer to become a playwright. He wrote some comedies, now mostly forgotten, and many tragedies, one or two of which rank among the masterpieces of dramatic literature. One of the earliest of these was *The Cid*, an immediate and brilliant theatrical success based on the legendary exploits of one of Spain's greatest heroic figures. It was followed by other triumphs such as *Cinna* and *Polyeucte*, moving and often sublime works that deal with the psychological aspects of political power. His contemporaries recognized the immediacy and the timelessness of his classically historical subject matter. The powerful, sonorous, rhythmical language of his best works remains a model of dramatic rhetoric.

Jean Racine (1639–1699) is considered the master craftsmen among writers of French classical tragedy. More careful than Corneille, he adhered strictly to the unities. His verse, if less powerful than Corneille's, is more carefully polished; but his concern for style did not diminish his interest in strong characterization, dramatic plots, or important social and moral ideas.

As a young man Racine had studied Greek and developed a profound admiration for Sophocles and Euripides, from whom he

derived most of his plots. He used the old stories to shed light on the social, psychological, and theological issues of his own day. Probably most popular of his tragedies is *Phèdre*, his version of a story that had been told in plays by Euripides and the Roman author Seneca. In Euripides' version, called *Hippolytus*, Phaedra is married to the hero Theseus but is in love with Hippolytus, Theseus's son by an earlier marriage. Hippolytus rejects her love because he is entirely dedicated to the service of Artemis, virgin goddess of the moon and the hunt. When her advances are thwarted, Phaedra kills herself, leaving a note that accuses Hippolytus of having tried to seduce her. Theseus impetuously curses his son and banishes him; Hippolytus is killed as he drives away in his chariot. In Racine's version Hippolytus is not uninterested in women; he is in love with a young princess. Hence Phaedra burns not only with passion but with jealousy. More important from Racine's point of view, she is consumed by guilt; she recognizes her sinful nature but cannot overcome it. Racine's tragedy becomes an examination of an issue central to Christian thought: What accounts for the sinfulness of human nature, and how can it be overcome? Racine's interest in such questions was probably prompted by his early affiliation with, and lifelong interest in, the Jansenists, a Catholic faction that followed Augustine and Calvin in insisting on the fallen nature of humanity and on salvation by predestination and grace alone.

After the success of *Phèdre*, Racine abandoned the theater for some years but returned to write *Esther* and *Athalie*, dramas based on Old Testament stories. They were often performed in the church schools of France and are still revived on occasion.

Molière (1622–1673), at work in the theater at the same time as Corneille and Racine, was to French classical comedy what they were to tragedy. Molière's father, an upholsterer, made it possible for his son to have a classical education, but the young

man joined a group of traveling actors and soon formed his own company. He and his company won a place at the court, where they performed both tragedies and comedies. Most successful of these were the comedies Molière wrote himself.

Molière's comedies of manners satirize not only French society but the weaknesses of the human race. In characterizations that manage to be remarkably like real humans in spite of absurd situations and language that is often artificial, he pokes fun at everything from the affectations of the court to the hypocrisies of churchmen. *The School for Husbands* and *The School for Wives* satirize marriage, a frail institution in seventeenth-century France. Several deal not too gently with medical doctors. *Tartuffe,* perhaps the least farcical and most thoughtful of his comedies, exposes religious hypocrisy. *The Miser* treats an old subject in a thoroughly delightful manner: Harpagon, the miser, is so stingy that he refuses to feed or shoe his horses. He allows only one candle to burn for meals, and he will not provide a dowry for his daughter or bequeath his estate to his children because he intends to outlive them all. This and all the lighter comedies call for all kinds of stylized "sight gags" and other farcical behavior.

Molière's delightful and very popular play *The Bourgeois Gentleman* involves enough music and dancing to make it almost a musical comedy. The butt of the comedy is a newly rich, stupid middle-class French gentleman who is determined to acquire the social graces of the nobility. He hires teachers of music, dancing, fencing, and philosophy, all of whom are there to milk his purse as much as possible and who argue heatedly about the merits of their particular skills. The whole matter disintegrates into hilarious monkey business.

French Philosophical Literature. One of the most remarkable French writers of the seventeenth century was Blaise Pascal (1623–1662). Though he was a brilliant and original scientist and mathematician, his major literary work, the *Pensées,* is a defense of religious intuition against the onslaughts of science and rationalism. Pascal argued eloquently that science is able only to scratch the surface of truth and that it does not provide answers to the basic human questions. Such answers are to be found in religion—more specifically, in the Bible. He had been converted to religion by a mystical experience; like Racine he was a Jansenist, and he spent much of his later life defending religious faith. "The heart," he said in an oft-quoted statement, "has its reasons that reason does not know."

Eighteenth-century France produced a number of eminent thinkers, two of whom, Voltaire and Rousseau, dominated the age.

Voltaire (1694–1778), born François Marie Arouet, adopted his famous pen name during a stay in the Bastille in 1718. He was there because he had been accused of writing verses that slandered various royal personages. Though the charge in this instance was false, he often boldly attacked the powerful and spent a good part of his life countering the repercussions of such attacks.

Voltaire's literary output was large and varied. He wrote plays, stories, epic poems, tracts, philosophical discourses, and witty letters. The plays and poems are largely forgotten today, but he is still remembered for his devastating wit, his fearless attacks on corrupt public officials and bigoted church leaders, and a few of his stories, especially the remarkable philosophical novel *Candide.*

He engaged in a heated and prolonged battle with the clergy, who, he believed, distorted true Christianity in ignoring God's merciful and loving concern for mankind and preaching of Him only as a God of vengeance. He ended each of his religious tracts and books with "Ecrasez l'infame!"—"Crush the infamy"—a cry that became his watchword.

Voltaire believed in "natural" religion. He agreed with the deists of his age that such

principles as truth and justice, like physical principles, are inherent in the universe, and that humanity's age-old social and political problems could be solved by the discovery and application of those principles. His faith in this optimistic philosophy was shaken by reports of the terrible earthquake in Lisbon on All Saints' Day in 1755 that killed thousands of people, most of whom were attending church. How benevolent in reality, he wondered, are the laws of the universe, and why would God allow such tragic events to happen? He dealt with such questions in several works, most famous of which is *Candide.*

Candide satirizes the kind of optimism that sees good in everything. The satire is aimed especially at the optimistic philosophy of Leibnitz, a German writer whose ideas deserve more respectful treatment than Voltaire gives them in *Candide.* The novel relates the misadventures of a naïve young German named Candide, his teacher Pangloss, and his fiancée. The adventures of these three, which range from the hilarious to the horrible, take them to all parts of the world. Pangloss insists that each catastrophe in turn happens for the best, for this is "the best of all possible worlds." At the end Candide doubts the soundness of this belief and concludes that one's proper occupation is to cultivate one's own garden—the world runs best if immediate tasks are attended to and philosophical speculation avoided.

Jean Jacques Rousseau (1721–1778) was born in Geneva. As a young man he spent several years wandering through Switzerland and the rural areas of eastern France, where he developed an intense love for simple living and the beauties of nature. He supported himself as a baker, a clerk, and a music teacher (he was a gifted performer and composer). At thirty he traveled to Paris, where he associated with Diderot and other young intellectuals. In 1749 Rousseau published his first important philosophical essay, in which he set forth ideas that remained central to his thought. People, he

asserted, are by nature good and innocent; their weaknesses and depravities are a consequence of the social institutions that are imposed on them. Since every human heart knows instinctively the laws of virtue, all humanity should be allowed to return to a natural, innocent state.

Rousseau wrote two widely acclaimed novels that propound his philosophy. The first, *The New Héloïse*, probably the most popular novel of the eighteenth century, is an emotional account of a girl who falls in love with her young teacher and is seduced by him. Though the experience nearly destroys her, she lives a noble life and marries an older man who recognizes her virtues. She dies of a fever after having saved her son from drowning. *Emile*, the other novel, is a long treatise on education. Both books glorify the natural human being and insist that nature itself is the best teacher.

Rousseau, who was troubled by a persecution complex, had few harmonious years with his friends of the Enlightenment. Even before *Héloise*, he had aroused the resentment of Diderot and others by his attacks on the society of which they were a part, and he in turn was troubled by their attacks on religion. Eventually he became the leading intellectual opponent of the Enlightenment. Voltaire attacked him bitterly, others ignored him, and he responded with strong denunciations of his old friends.

The works for which Rousseau is best remembered are his *Social Contract* and his *Confessions.* The *Social Contract* is another plea for human freedom, this time based on philosophical and legal grounds. Its influence touched almost every political thinker. The *Confessions* is one of the world's great autobiographies. Ardent, frank and imaginative, it provides penetrating insights into the thoughts and feelings of a most unusual man.

Rousseau was the most influential forerunner of romanticism. His love of nature, his defense of emotion, his pleas for freedom and for sincere religious faith were all central

concerns of the cultural and intellectual movements that followed.

English Neoclassicism. The classical Renaissance came late to England and was never particularly "classical" in its effect on English literature; English authors looked less to the ancients than to the French for inspiration.

The earliest prominent writers of English "classical" literature were John Dryden, Jonathan Swift, and Alexander Pope. Dryden (1631–1700) was a celebrated playwright, poet, satirist, and critic. His dramas are often marred by feeble plots and by rhetoric that is more bombastic than moving. But many of his contemporaries hailed the plays, with their polished meter and rhyme, as superior to those of Shakespeare. His best play, *All for Love*, is a noble retelling of the story of Mark Antony and Cleopatra, written in grave and dignified blank verse rather than in Dryden's usual rhyme. Many passages are simple and moving, but the complex plot of the drama suffers from being squeezed into the confines of the so-called unities.

Dryden was for a number of years poet laureate, until his conversion to Catholicism and the deposing of his sponsor James II brought him into disfavor. One of his finest long poems, *The Hind and the Panther*, is an allegory written in defense of the Catholic faith.

Dryden was one of the first great masters of the plain, direct style both in poetry and prose. His long satirical poems such as *Absalom and Achitophel* are still interesting in spite of their concern with now-obscure political matters. His critical writings are models of clarity and sound judgment. And such shorter poems as the vigorous and rhythmical "Alexander's Feast" and "Ode for St. Cecilia's Day" continue to delight, partly because of the fine musical settings that Purcell and Handel gave them.

Jonathan Swift (1667–1745), Irish prose writer and clergyman, wrote what is still probably the greatest and most widely read satirical novel in the English language, *Gulliver's Travels*. The story, probably inspired by such popular adventure tales as Defoe's *Robinson Crusoe*, purports to be a straightforward record of the journeys of Lemuel Gulliver, a British sailor, to theretofore undiscovered lands. The story is exciting enough to have made it a children's classic, but the great merit of the work lies in the satire that it directs at human foibles of all kinds. Swift once wrote that he loved individual people but hated "that animal called man." *Gulliver's Travels* illuminates that conviction in four series of adventures. In the first, Gulliver visits the Lilliputians, persons six inches tall, whose pettiness—they distinguish their political parties by the height of their shoe heels—underscores the meanness of politics in Gulliver's own country. In the second he meets with giants (to them he is six inches tall) whose hugeness of stature is matched by their greatness of mind and soul. In the third adventure Gulliver visits several lands where the pedantry and pretensions of scientists and philosophers are brought home to him. In the fourth, the traveler goes to a land of educated and virtuous horses, the Houyhnhnms. These marvelous creatures contrast vividly with their humanlike servants, the Yahoos, who are filthy, drunken, and greedy. Incorporated in the novel are parodies of well-known persons who would have been recognized instantly by Swift's contemporaries.

Swift's *Tale of a Tub* is another satirical work of major importance; and the shorter *Modest Proposal*, in which he ironically proposes to solve the problem of hunger in Ireland by having children slaughtered for food, is possibly the bitterest piece of satire ever written.

Like Swift, Alexander Pope (1688–1744) suffered much from ill health, and that fact, along with other personal problems, is probably reflected in the ironical, sometimes bitter tone of much of his writing. He was badly crippled and often found it difficult to

move from his bed. His social relations were frequently strained, and he spent much time in literary battles with those who dared to cross him. In spite of all this he managed to produce a body of critical and philosophical writing, all expressed in heroic couplets of unmatched beauty, that remains a major literary achievement. At twenty-three he wrote his important "Essay on Criticism," a long poem that expresses his theories concerning poetic beauty and that demonstrates those theories in the perfection of his own verse.

The "Essay on Criticism" is the best poetic statement of neoclassical literary theory. Pope's "Rape of the Lock" is probably the foremost example of eighteenth-century wit. The poet develops his story, which revolves around an actual incident—the stealing of a lock of a lady's hair by an ardent admirer—as a condensed mock epic, with all the Homeric conventions, including a great battle. Pope's exaggerated style delighted the literate English of his day, who recognized the artificiality of the social customs he satirized.

Pope tried his hand at many types of literature, including a once very popular translation of the *Iliad*. His lasting fame rests above all on his "Essay on Man," in which he expresses in clear and simple terms the main tenets of the Enlightenment. Obviously influenced by deism, Pope describes a world created by God but into whose affairs God does not choose to enter, a world in which humanity is capable of achieving order. The "Essay," like most of Pope's writings, contains many lines that have become familiar epigrams:

Know then thyself, presume not God to scan;
The proper study of mankind is man.

Hope springs eternal in the human breast:
Man never is, but always to be blest.

It has been said, in fact, that except for one or two books of the New Testament and possibly *Hamlet*, the "Essay on Man" is probably quoted more often than any other piece of literature.

English Novelists. The novel quickly developed in the eighteenth century into a very popular literary form. It had its antecedents in long Roman prose tales and in such seventeenth-century works as Cervantes' *Don Quixote* and Defoe's *Robinson Crusoe* and *Moll Flanders*. But Samuel Richardson, Henry Fielding, Laurence Sterne, and Tobias Smollett gave the novel its impetus toward the huge popularity it has enjoyed since the eighteenth century.

Samuel Richardson (1689–1761) wrote long novels that depict the triumph of virtue over vice. Published in serial form, they had thousands of readers awaiting the next episode. *Pamela*, a sentimental novel in the form of letters, relates the efforts of a young woman to preserve her honor. *Clarissa*, which ran to over two thousand pages, is concerned with the same problem. Though epic-sized novels are popular today, probably few modern readers get through *Pamela* and *Clarissa;* but they were once widely read both in England and on the Continent.

Henry Fielding (1707–1754) was more worldly and cynical—and probably more aware of reality—than was Richardson. If Fielding's heroes are virtuous, it is generally through no fault of their own. *Joseph Andrews*, his first novel, is a satire purporting to be the story of Pamela's brother. It becomes largely an account of the adventures of the likeable and virtuous but pugnacious Parson Adams. Fielding's *Tom Jones* remains one of the most popular of all English novels. The story of its lusty, good-natured hero is told in a series of picaresque adventures that are ingeniously tied together at the end. It is a rowdy and robust novel, with a hero whom critics consider one of the best-developed characters in all literature.

Tristram Shandy, by Laurence Sterne (b. 1713) is a rambling but continually amusing commentary in novel form on every imaginable subject. It has no unifying plot; even the

title character is often ignored for hundreds of pages at a time. The structure of the work is unpredictable; the preface follows Chapter XX of Volume III. The strength of the book lies in the comments it makes on human behavior. As the work came out in serial form, London society waited eagerly to see which vice would next be exposed. Citizens of his native York, thinking that many of his characters were Yorkshiremen, also swarmed to buy each new set of volumes. Sterne was a clergyman, and English intellectuals were especially surprised and delighted to read his earthy comments.

MUSIC

As we have seen, there is little relationship between the music we call *classical* and the music of the Greeks and Romans. We use the term *classical* to identify a style of music that has many of the characteristics we attribute to classical art in general—restraint, adherence to form, clarity, beauty, and simplicity.

The classical age in music was relatively short-lived. It began about 1750, the year of Bach's death, and ended not long after the beginning of the nineteenth century. Some musicologists use 1827, the year of Beethoven's death, as the terminal date.

The fifty or sixty years of the classical movement were of great importance in the history of music. Many of the musical forms still employed by composers were developed then—the symphony, the sonata and the concerto in their modern forms, and the string quartet. The opera also underwent considerable change and development, and classical composers were largely responsible for moving secular music from the court to the concert hall. In addition, a large share of the music performed in today's concert halls and opera houses was composed during the classical era.

The major change, as music moved from the baroque to the classical style, was a continued emphasis upon homophony. Many baroque composers, especially Handel, had incorporated homophonic passages in their works, but during the classical age, homophony became the standard. Classical composers like Mozart and Beethoven continued to make use of counterpoint, but only rarely and for special effects. There were probably many reasons for this new preference. For one, the clarity of homophony was an expression of one of the ideals of the Enlightenment. It should not be inferred, however, that classical forms are simple; often they develop a complicated pattern. But because the melody is almost always exposed and obvious, classical music typically appears to be relatively simple.

Instrumental Forms. Classical composers developed most of their new forms for instrumental music from the suites and concerto grossi of the baroque period. Almost all classical compositions for instruments are in three or four movements and make use of what is called the *sonata* or *sonata-allegro* form for their first movements. We are not sure exactly who was resonsible for the development of the sonata-allegro form, but the Italian Sammartini and two of Bach's sons, Carl Philipp Emanuel and Johann Christian, were influential in its evolution. (Beethoven's Symphony No. 5 and Mozart's *Eine Kleine Nachtmusik* provide good examples for analysis.)

The *sonata-allegro* form for the first movement is usually in a fast tempo and consists of three major sections, the *exposition*, the *development*, and the *recapitulation*. In the *exposition* two principal themes are introduced. The first theme (theme A) is played in the key of the sonata (tonic key). Then there is a bridge or transition passage that changes (modulates) to a contrasting key, in which the second theme (theme B) is played. After theme B, the exposition is often concluded with a *codetta* or closing theme. The second section, the *development*, is a free section in which the composer elaborates on themes A

and B in any fashion he wishes. Usually he employs several different keys, modulating frequently. The length of the development section varies greatly according to the length of the whole movement. The *recapitulation* differs from the exposition only in that both themes are played in the same key. A free section called the *coda* (literally "tail") is often added to complete the movement.

The second movement of most classical instrumental works is in a slow tempo and is written in a different key from the first movement. There is no set form for this movement. Often it is a set of variations on a single theme, and often it is a *rondo*. The rondo consists of a major theme that alternates with one or more secondary themes.

The third movement in a four-movement work is usually a *minuet and trio*. Derived from a popular dance form, the minuet and trio is moderately fast and in three–four time. The *trio*, the middle part of the movement, was originally a true trio, but it came to be simply a contrasting passage.

The *finale*, the last movement, is in a lively tempo. It is most often a rondo, but other forms are often used instead.

The major instrumental compositions that employ the multiple movements described above are the *symphony*, the *concerto*, the *string quartet,* and the *sonata*. The *symphony* is a work written for an instrumental ensemble, with string instruments forming the core of the orchestra. It is usually in four movements. The *classical concerto* is much like a symphony except that it features a solo instrument or two—usually a violin or piano—along with the orchestra. The *string quartet* is a composition in the same three- or four-movement form for two violins, a viola, and a cello. The term *sonata*, since the age of Mozart, has been applied specifically to three- or four-movement works for one or two instruments, most often the piano or violin and piano.

The Opera. Few operas of the earlier eighteenth century are performed today. Their stories are complex and undramatic, and arias overshadow whatever plot there might be. The arias themselves, however, are often beautiful, and many of them are performed today on the concert stage.

The opera itself might have languished away if it had not been for such gifted and original composers as Pergolesi (Ch. 10) and the German Christoph Willibald Gluck (1714–1787). Gluck admired clarity and simplicity; he turned to Greek drama for his libretti and selected plots with few characters and direct, dramatic development. He eliminated many of the ornaments—runs, trills, and so on—that singers loved, and emphasized the recitative as a dramatic element. The orchestra, to which he gave some of the most ravishingly beautiful music ever composed, became for him a means of reinforcing the emotional values of the opera.

Gluck's first and most familiar work in the new style was *Orfeo ed Euridice* (*Orpheus and Eurydice*). Though he gave the tragic old Greek tale a happy ending, he created dramatic characters with whom one can become involved, and he did not dilute the pathos of the story. Though written to be performed in Vienna, it was sung in Italian, the quasi-official operatic language.

When Gluck moved to Paris he started writing operas to French libretti. Of these *Iphigénie en Tauride* (*Iphigenia in Tauris*), based on a tragedy by Euripides, is probably the greatest. *Iphigénie* and *Orfeo* are still performed, and a number of arias from Gluck's operas, including "Che faro senza Euridice" (What is left without Eurydice?) are standard concert pieces.

Composers. Three eighteenth and early nineteenth century composers who are especially identified with classical music are Franz Joseph Haydn, Wolfgang Amadeus Mozart, and Ludwig van Beethoven.

Haydn (1732–1809) was born in Lower Austria, the son of a wagon repairman. He received some musical training in his home and was then chosen a member of one of

Vienna's fine boys' choirs. After his voice changed he continued to support himself as an instrumental performer and composer. His early compositions were not particularly astonishing, but he developed rapidly. He soon obtained a position with the Esterhazys, one of Austria's noble families, and he continued to be a court composer for some years. As an older man he became a relatively independent composer and made several trips abroad. He was warmly received in London, where he was hailed as the greatest living composer.

Apart from the large number of Haydn's works that are still performed, he made a number of other contributions to music. He became known as the "father of the symphony" not simply because of the great number he composed (over one hundred) but because of refinements he made in the symphonic form. He is credited with having added the minuet and trio as the third movement. He did much to improve the sonata-allegro form of the first movement; above all he recognized the possibilities of a well-planned development section and sought for themes that could be varied and modulated in an interesting fashion. Thus the development became the core of the movement, and the recapitulation became a genuine restatement of the initial themes. The symphonies of Haydn most often performed today are those numbered from 90 to 104. These include the popular "Surprise" and "London" symphonies.

Haydn also produced much instrumental music in other forms—fine string quartets and other pieces of chamber music, and shorter orchestral works such as serenades. In much of his instrumental music Haydn used lively, sturdy folklike tunes that reflected his Lower Austrian origins.

During one of his stays in London Haydn became aware of Handel's very popular *Messiah*. Though he was quite old he turned enthusiastically to this new form and composed two splendid oratorios. The first, *The Creation*, takes its text from the early passages of Genesis. With beautiful solos and rousing choruses following one after another, it is perhaps the most joyous major work in the entire repertory of sacred music. *The Seasons*, based on German translations of some popular poems by the Scottish poet Thomson, is a secular celebration of the glories of nature. Like *The Creation*, it is often performed by modern groups.

The story of Mozart (1756–1791) is an amazing and tragic one. He was born in Salzburg, Austria, the son of a fine musician. At the age of three he could play small pieces on the keyboard. He started composing at four, and at eight he completed his first short symphony. He not only composed as a child, but toured the courts of Europe as a virtuoso pianist, in company with his father and his older sister, who was also an accomplished musician.

In his travels Mozart met the leading musicians of the day and learned quickly from each of them. The wide variety of styles in his early compositions reflects the breadth of his contacts and his willingness to experiment. His first opera, written when he was twelve, is in the traditional Viennese style; a little later he composed operas in the popular Neapolitan style. He demonstrated over and over that he could master almost effortlessly the most complex rules and practices of counterpoint, harmony, and musical form.

Despite the widespread fame he enjoyed in childhood, Mozart fell upon hard times as an adult. He was largely the victim of fickle musical tastes in Vienna; acclaimed one season, he would be largely neglected the next. When he died at thirty-five, possibly of malnutrition, his body was buried in a pauper's grave under one of Vienna's churches. Only one or two people followed the body to its resting place.

In his short life Mozart composed at least forty-one symphonies, twenty-five piano concertos, eight violin concertos, more than a dozen concertos for other instruments, sixteen masses, and between fifteen

and twenty operas. He also wrote a great amount of music for chamber groups and soloists.

Even more impressive than the number of Mozart's compositions is their quality; he left masterworks in every genre. Of his symphonies the last three are particularly striking compositions. Number 40, in G Minor, is one of the supreme masterpieces of classical music. Its balancing of formal control and emotional content anticipates the direction that the symphony would take from Beethoven on. Almost all of Mozart's piano concertos are of high quality. Their clarity and transparency make them seem simple, but a good performance of a Mozart concerto is the ambition of many a fine pianist.

Mozart's sacred compositions range from the theatrical to the profound. His great *Requiem Mass*, completed by his students after his death, is one of the major works in this form. The choruses are powerful, and the mood is one of deep reverence for the dead.

Mozart composed the only eighteenth-century operas that are still performed regularly. Their music is unfailingly beautiful, their characters are three-dimensional, and their stories, with one or two exceptions, are fast-paced and dramatic. Five are especially well known: the amusing *Abduction from the Seraglio* and *The Magic Flute*, both in German, and *The Marriage of Figaro*, *Don Giovanni*, and *Così Fan Tutte*, all in Italian. *The Magic Flute*, an opera with philosophical overtones, was highly successful and is the opera most frequently performed on the German stage. Mozart's Italian operas involve complicated love intrigues, but the first two have good libretti and understandable plots. *Don Giovanni*, neither a comic opera nor an *opera seria*, is a masterful blending of comic and serious—even tragic—elements. In addition to some of the greatest operatic passages ever composed, *Don Giovanni* has an unforgettable cast of characters whose personalities and emotions are delineated as much by the music as by their words and actions. Many critics consider it the greatest of all operas.

Beethoven (1770–1827) was the last of the great classical composers as well as the first of the romantics. His adherence to form, which he never lost sight of even in his stormiest pieces, is definitely classical; but in his increasing emotionalism and individualism he anticipated some of the main qualities of the romantic age.

Beethoven's drunken father tried to exploit him as a child prodigy, but he was no Mozart. As a youth he left his native Bonn, in Germany, and went to Vienna, where he studied with Haydn for a short time. He served for a while as a court musician but eventually severed all ties with the patronage system and became one of the first musicians to live entirely on what he made as a composer and performer.

Few artists have lived stormier or more troubled lives than did Beethoven. His relationships with patrons, relatives, servants, and friends—especially women friends—were more often than not unhappy. Part of his emotional turbulence was a result of his gradually losing his hearing; eventually he could hear his compositions only in his mind. His temperament also reflected the romantic attitudes of his time, including the passionate longing for freedom from the tyranny of despots that occupied the German mind at the end of the eighteenth century. It was not by accident that his only opera, *Fidelio*, is concerned with political freedom or that he chose Schiller's "Ode to Joy," a hymn to freedom, for the words sung in his last symphony.

Beethoven's early music, especially the melodic First Symphony and the first piano sonatas, is quite traditional; one can easily see in them the influence of Haydn and Mozart. The Third Symphony, however, the *Eroica* or "heroic" symphony, announced a musical revolution. Beethoven intended to dedicate it to Napoleon, the presumed hero

who would preserve the French Republic. But when Napoleon named himself emperor, the angry and disappointed composer cancelled the dedication and simply titled the work *Eroica*. The music of the symphony matches its title. The first movement develops two strong themes that can be interpreted as proclaiming the heroic thesis. The slow movement is a funeral march, perhaps in honor of those who have died for freedom. The third movement is not a genteel minuet but a vigorous, even powerful *scherzo*. And the final movement is a dramatic dance in celebration of liberty.

The strength of the *Eroica* also characterizes the Fifth and Ninth Symphonies. The beautiful Sixth or "Pastoral" Symphony is quite different; it is the only symphony by Beethoven that is programmatic—that is, that tries to create mental pictures or tell a story. In one lovely melody after another it depicts varying scenes and moods in nature. The intense, dramatic Ninth or "Choral" Symphony is Beethoven's last and most original symphonic work. Its most important innovation is the inclusion in the last movement of singing by four soloists and a mixed chorus. This finale is remarkable in its structure: it begins with a résumé of the themes from the first three movements, themes that suggest doubt and despair. But then the baritone enters with the admonition, "Brothers, leave these tones," after which the quartet and chorus begin a celebration of joy and freedom that mounts to a tremendous climax of vocal and instrumental sound.

Beethoven's total output was relatively small, but most of his works are masterpieces that continue to hold central places in concert after concert. His string quartets, his single violin concerto, and his piano concertos (including Number 5, the so-called "Emperor" Concerto) are all major works. So too are his few large-scale pieces of vocal music, including his opera *Fidelio* and the mass called *Missa Solemnis*.

ARCHITECTURE

Shifts in taste in the early eighteenth century brought into popularity the architectural style called *rococo*, which was employed mainly in palaces, mansions, and German Catholic churches.

The term *rococo* is probably a pun on the Italian word for *baroque* and the French for *shell*; the shell was a popular late baroque decorative motif. It is not easy to distinguish rococo from other late baroque architecture. Rococo is prettier and more delicate and refined than the heavier, more masculine baroque. It leans toward white, ivory, bright gold, and pastel colors. It carries even farther than baroque the tendency to unify and blend together sculpture, painting, and architectural forms. Rococo architects loved scrolls, sunbursts, shell forms, floral and leaf patterns, tendrils, and similar motifs.

Curiously, most eighteenth-century palaces were built in the smaller states. In Germany, for instance, which was fragmented into many largely independent principalities, each prince wanted his own Versailles, his own symbol of absolutism. Impressive examples of the late baroque or rococo palaces built during this era are Schönbrunn and Belvedere in Vienna, the Zwinger in Dresden, the Residenz in Würzburg, and the Nymphenburg Palace near Munich.

The magnificent Schönbrunn palace in Vienna was designed by J. B. Fischer von Erlach, a talented sculptor and architect. The detail in fig. 12-1 of one of the smaller staterooms of Schönbrunn illustrates well the elegance of the earlier rococo style, still basically restrained in spite of the dramatic ceiling mural. The delicate gold decorations enhance the ivory white of the walls and arches.

The Zwinger, a huge palace in Dresden, exemplifies the more theatrical effects that painting, sculpture, and architecture in combination can create. This fusing of media

Fig. 12–1. Fischer von Erlach. A room in Schönbrunn Palace, Vienna. Begun 1656.

Fig. 12–3. Jacob Prandtauer. Monastery of Melk-on-the-Danube, Austria. Begun 1702.

Fig. 12–2. Cuvilliés and others. The Amalienburg (interior detail), Munich. About 1750.

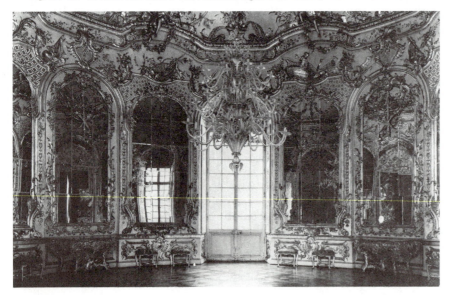

is carried even further in the Residenz that Baltasar Neumann designed for the Prince-Bishop of Würzburg. Here the dominating feature, as it is in most such palaces, is a magnificent staircase, which starts in a low chamber and expands dramatically at the top. There the plasterwork makes a transition to a fresco on the ceiling painted by the celebrated Italian artist Gianbattista Tiepolo (fig. 12-12).

In the authentic rococo work of the large Nymphenburg Palace in Munich we see again the fusing of media. A detail of the interior of the Amalienburg, a summer house on the grounds of the palace, is shown in fig. 12-2. By employing mirrors, gold trim, stucco figures of angels and of the spoils of the hunt, of birds, tendrils, and other motifs all together, the architect Cuvilliés has made it almost impossible to distinguish between structure and ornamentation.

Many rococo devices were also employed in central European churches of the period, especially in southern Germany, Switzerland, and Austria. But church designers looked not to Versailles but to the baroque churches of Italy—for example, Borromini's Church of the Four Fountains (fig. 10-7)—for models. They responded especially to the oval floor plans and undulating walls of such edifices.

The exteriors of most Germanic churches of the period are quite simple, but many of them are most fortunate in their locations on hills or high riverbanks. None is more beautifully situated than the Benedictine monastery church of Melk, in Austria (fig. 12-3). From across the Danube one can see the river, the rocky hill, the curved wall surrounding the terrace in front of the church, and the undulating walls and baroque towers of the church itself. The effect is incomparable.

Inside, such churches are amazing syntheses of form and color. Two of the most fascinating were designed by two pairs of brothers. One is the small church of St. Johannes Nepomuk in Munich, the work of Cosmas and Egid Quirin Asam. The other,

the pilgrimage church "*Die Wies*" (fig. 12-4), by the Zimmermann brothers, is probably the ultimate expression of this last phase of the baroque. The oval-shaped nave is surrounded by coupled columns with ornate Corinthian capitals. The altar, even more ornate, is in a chancel extending from one end of the oval. The windows of this chancel, hardly visible from the nave, seem to cast a more-than-earthly light on the altar. All the elements of the church—filigrees, white and gold plasterwork, sculpture, bursts of color in the ceiling—unite to express the faith of these artists, who were isolated from the doubts that raged in the Europe of the En-

Fig. 12–4. Zimmerman. Interior of "Die Wies," Pilgrimage Church, Upper Bavaria. 1745–54.

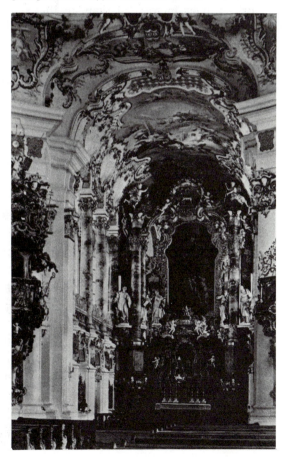

lightenment and who strove to express in physical terms their visions of the glories of heaven.

Neoclassical Architecture. The neoclassical architecture of the eighteenth century had its beginnings in England. In 1715, some years before the classical revival stimulated by the excavations at Pompeii, an architect named Colin Campbell published a book that praised the theories of the ancient Roman writer Vitruvius. He believed those theories could best be seen exemplified in the works of Palladio. Suiting his own practice to the word, Campbell designed Mereworth Castle (fig. 12-5), a close copy of the Villa Rotonda. As a theorist and practicing architect, Campbell strongly stimulated the English enthusiasm for Palladianism that had first been seen in the Banqueting House and other works by Inigo Jones (Ch. 11).

Later in the century, largely because of the influence of Robert Adam, some English designers sought inspiration from older sources such as Rome, Pompeii, and Spoleto. Adam's own light, elegant work had a strong influence in America.

In France a number of large public buildings were constructed along classical lines. One of these is the Panthéon (fig. 12-6), which houses the tombs of Voltaire, Rousseau, Victor Hugo, and many others. A huge, cross-shaped building, it was designed by J. G. Soufflot, who added a dome over the crossing in what has been called a coldly neoclassical version of St. Peter's.

The popularity of the neoclassical style spread to America, where Thomas Jefferson employed a number of Palladian touches in Monticello, his home in Virginia, and designed the state capitol of Virginia (fig. 12-7) along the lines of his favorite building, the

Fig. 12–5. Colin Campbell. Mereworth Castle, Kent, England. About 1720.

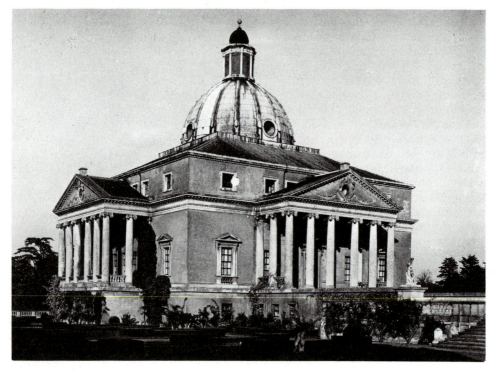

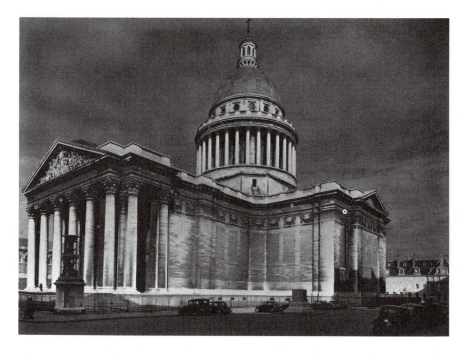

Fig. 12–6. J. G. Soufflot. The Panthéon (Ste. Geneviève). Paris. 1755–92.

Fig. 12–7. Thomas Jefferson and Charles-Louis Clérisseau. State Capitol, Richmond, Virginia.

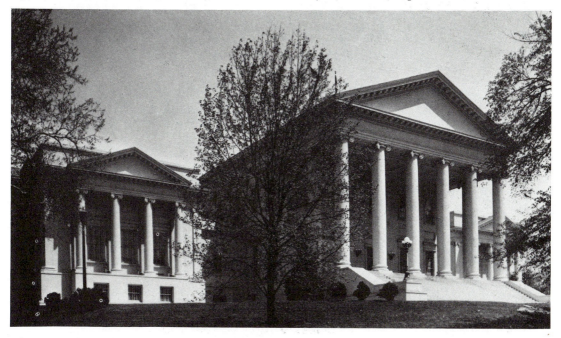

Roman Maison Carrée. The classical style can be seen, of course, in the U.S. Capitol and many other public buildings in America, where it remained popular throughout the nineteenth century.

SCULPTURE

The eighteenth century, like the seventeenth in northern Europe, produced dozens of competent sculptors of court and architectural statuary, but only a few of them are remembered. The most popular court sculptor was Claude Michel, called Clodion (1738–1814). Most of his works are highly refined statuettes of nymphs, shepherds, and the like. The *Intoxication of Wine* (fig. 12-8) is typical. Clodion's skillfully executed statuettes fell out of favor after the Revolution, and he turned to more heroic and monumental subjects.

Jean-Antoine Houdon (1741–1828) is known today for his portrait sculpture, in which he depicted a remarkable number of the important figures of his day. During a stay in Rome he came under the influence of Winckelmann and adopted a style that is at once classical and realistic. Houdon's statue of Washington (fig. 12-9) shows his preference for simplicity and clarity. His renowned bust of Voltaire, with its sardonic smile,

Fig. 12–8. Clodion. *The Intoxication of Wine* (*Bacchante and Faun*). About 1780. Terra cotta, 23¼″ high. The Metropolitan Museum of Art, New York. Bequest of Benjamin Altman, 1913.

Fig. 12–9. Jean-Antoine Houdon. *George Washington.* State Capitol, Richmond, Virginia.

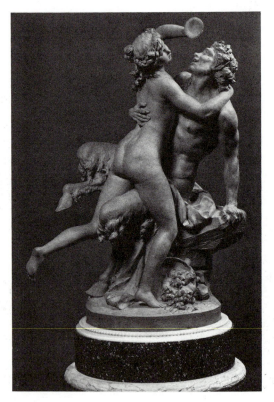

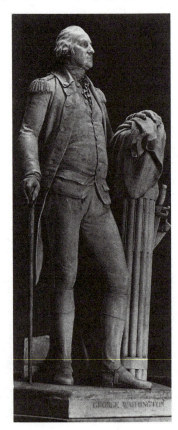

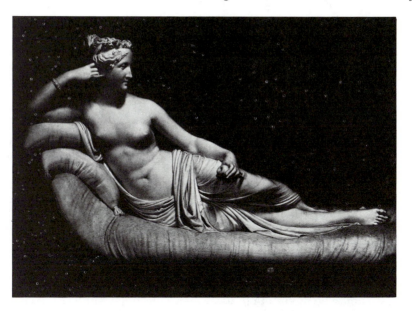

Fig. 12–10. Antonio Canova. *Pauline Borghese as Venus*. 1808. Borghese Gallery, Rome.

Fig. 12–11. Bertel Thorvaldsen. *Christus*. About 1830. Marble, approx. 10' high. Cathedral, Copenhagen.

demonstrates his ability to capture character and the illusion of vitality in marble. Houdon also made fine busts of American leaders, including Franklin, Hamilton, Jefferson, and Robert Fulton.

Two neoclassical sculptors who were celebrated in their own day were an Italian, Antonio Canova, and a Dane, Bertel Thorvaldsen. Canova (1757–1822) created remarkable effects of texture, and he polished his works to a high finish; but he often deprived them of vitality by imitating too slavishly the forms of ancient statues. His *Pauline Borghese as Venus* (fig. 12-10), ostensibly a portrait statue of Napoleon's sister in a Roman or Pompeiian setting, demonstrates both his strengths and his weaknesses.

The statues of Thorvaldsen (1770–1844), who spent a number of years in Rome, are also derivative. He chose not only to depict classical subjects but to apply neoclassical principles to Christian subject matter. His large *Christus* (fig. 12-11), often reproduced in America and elsewhere, is an impressive depiction of the resurrected Christ.

PAINTING

Rococo Painting. The painting of Giambattista Tiepolo (1696–1770) related closely to late-baroque and rococo architecture. Tiepolo, a Venetian, first painted in a heavy late-baroque style. But in his travels throughout Europe he became acquainted with the newer developments in painting and adopted a lighter, more colorful manner. Specializing in frescoes, he received commissions throughout Europe to decorate palaces and churches. Tiepolo often did paintings on large ceilings that presented complex problems in perspective, especially in the foreshortening of human figures, but he handled them with remarkable skill and confidence. Like Veronese and other illusionist artists, he painted ceilings in which human figures seem to be mounting to vast heights and others are soaring off into the heavens. His subject matter includes scenes from classical mythology and the more spectacular events from Christian tradition such as the Assumption and the Crowning of the Virgin. His ceiling frescoes in the Residenz in Würzburg create an overwhelming impression of light and movement. Fig. 12-12 shows a detail of this massive undertaking.

In France three skillful rococo painters reflected most successfully the tastes of the court, and each in turn was the favorite artist of the aristocracy. Jean Antoine Watteau (1684–1721) was a painter whose works have the fine color but none of the vigor of Rubens and his school. Many of his paintings resemble pastoral scenes, but they depict gatherings of elegantly dressed aristocrats in parks, gardens, or rural settings—*fêtes galantes,* they are called. The *Embarkation for the Isle of Cythera* (fig. 12-13) is a famous example of the genre. Its quiet, subtle colors help to suggest the mood of the courtiers who have gathered to worship the goddess of love—a mood less

Fig. 12–12. Giambattista Tiepolo. Ceiling mural over the Great Stairway of the Residenz, Würzburg, Germany. 1751.

Fig. 12–13. Antoine Watteau. *Embarkation for Cythera*. 1717. 51 × 76½". The Louvre, Paris.

Fig. 12–14. Antoine Watteau. *Gilles*. About 1719. 73 × 59". The Louvre, Paris.

gay than wistful and dreamlike. Deeper melancholy pervades Watteau's superb painting of the Pierrot figure *Gilles* (fig. 12-14), an expressive portrayal of loneliness and isolation amid a scene of gaiety.

The artificiality and remoteness from life of much rococo painting was most evident in the paintings of François Boucher (1703–1770). Boucher delighted Mme. de Pompadour and other aristocrats with his graceful, delicately painted Venuses and Dianas and other nude goddesses reclining voluptuously in an endless variety of mythological settings. Their sensuality, to which some of Boucher's contemporaries objected, is as superficial as that of porcelain dolls. *The Toilet of Venus* (fig. 12-15) is typical.

The French Revolution and the shift in taste that accompanied it cut short the court career of Jean Honoré Fragonard (1732–1806), third of the important rococo painters. Fragonard gained his first fame as a painter of large historical pictures, but he is best remembered for his depictions of lovers in elegant garden settings. *The Swing* (fig. 12-16) is a well-known example. Typically these

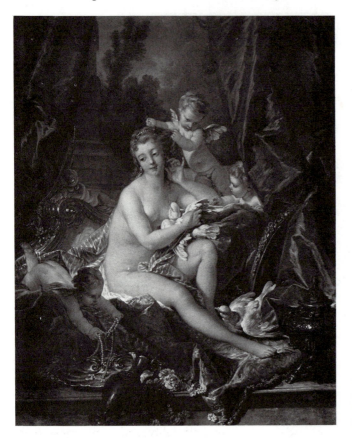

Fig. 12–15. François Boucher. *The Toilet of Venus.* 1751. 42⅞ × 33½". The Metropolitan Museum of Art, New York. Bequest of William K. Vanderbilt, 1920.

works are soft-toned landscapes with billowing clouds and high, rustling trees that dwarf the human figures on the lawns below. Fragonard was an excellent draftsman, and his pencil and chalk studies are highly prized. After the Revolution he chose more ordinary subjects like the popular and beautiful *Young Girl Reading* (Colorplate 9).

Genre Painting. Though the rococo painters enjoyed the approval of the aristocracy, they were not so well accepted by the intellectuals. Diderot was especially critical of Boucher's sensual canvases; painting, he said, should strengthen the moral fiber of the public. One of the painters who did this best, in Diderot's opinion, was Jean Baptiste Chardin (1699–1779). Though trained in the rococo tradition, Chardin turned at an early age to such simple and modest subjects as children playing with tops or building houses of cards, servants returning from market, and a small girl offering grace before a meal. *The Kitchen Maid* (fig. 12-17) is a fine example. At the same time he became a master of color and texture, and ultimately rivaled the better Dutch painters both of still lifes and of genre paintings. His draftsmanship was superb, and he learned to render reflected light so accurately that Diderot claimed his still lifes appealed to the sense of touch as much as to sight. More importantly his paintings, typically depicting a single quiet figure in an everyday setting, evoke the calmness and order of happy domestic life.

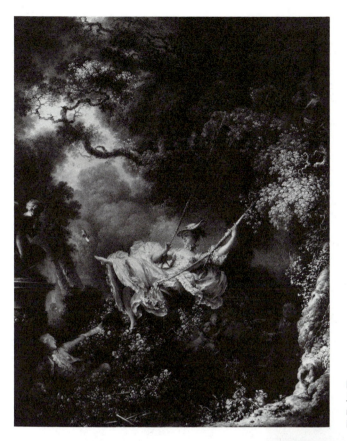

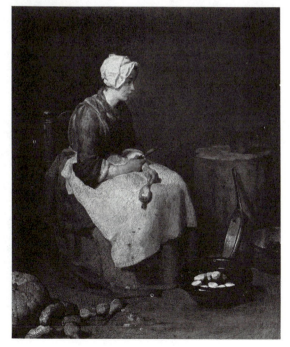

Neoclassical Painting. The enthusiasm for Greek and Roman art that had begun with Winckelmann and others was soon reflected in painting, but it took a painter of real genius to employ classical principles with true originality. That painter was Jacques Louis David (1748–1825). David's talent became evident when he was a youth, and he received training from Joseph Vien, a disciple of Winckelmann and himself a classical painter. David later won a prize that enabled him to go to Rome, where he studied and sketched many statues and other classical works. While in Rome David began his work in portraiture, a form in which he was to have great success.

David became famous almost immediately upon his return to Paris. There, under the impetus of the classical revival, he painted several large canvases devoted to incidents of Roman history. One of them, *The Oath of the Horatii* (fig. 12-18), which was commissioned by Louis XVI, became an overnight sensation. It depicts three brothers receiving swords from their father Horatius and swearing to defend the Republic with their lives. The subject excited the French public, many of whom saw in it a reflection of their own longing for political liberty. They also praised the new pictorial style. The flat colors, linear draftsmanship, and clear, classical arrangement of figures and background were pleasing to viewers who were tired of the artificialities of the rococo. Finally a painter had arrived who could depict heroic virtue in stark and militant terms. David's countrymen were evidently not troubled by the stiff postures; perhaps they were part of an accepted theatrical tradition.

The turmoil of the Revolution brought David to prison for a time, but when the Republic was established, he became its semi-official painter. His devotion to the new po-

Fig. 12–18. Jacques Louis David. *Oath of the Horatii.* 1784. Approx. 14 × 11'. The Louvre, Paris.

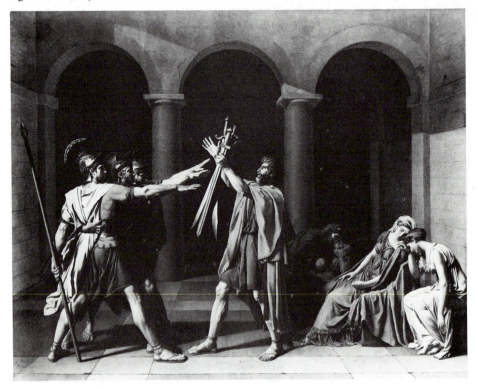

litical order is most strikingly portrayed in the *Death of Marat* (fig. 12-19), painted as a tribute to the slain leader, whom David had seen just the day before his murder. The painting was revolutionary in its simplicity—the limp, highlighted body of Marat seen against a stark, flat background.

David rode the waves of change with remarkable agility. When Napoleon came into power, he chose David to paint his portrait and to do a number of works that commemorated his triumphs. Most spectacular of these is *Le Sacré* or *The Coronation*. This huge painting, crowded with portraits of actual persons, shows Napoleon crowning the Empress Josephine, although in reality he crowned only himself.

Despite the political upheavals of the age, the tradition of a French Academy of Art was maintained both by the Republic and by Napoleon. David's style became the official model for French painters, but only one con-

tinued the tradition with any degree of imagination and originality. That was Jean Auguste Dominique Ingres, a student of David (see Ch. 13).

By 1768 England had its own Royal Academy of Art, dedicated in theory to the preservation of neoclassical ideals. At first the Academy had only a limited hold on English painters. What gave it some prestige was the intelligence and talent of its first president, Sir Joshua Reynolds (1723–1792). Reynolds was a most articulate artist; his addresses to the Academy were masterful discourses on the theories of neoclassicism. His influence might have led to many large mythological and historical canvases if the British paying public had not demanded portraits and little else. Hence the painters of the period adapted neoclassical principles to a less austere portrait style. Many of the world's fine portraits—Lawrence's *Pinky*, Gainsborough's *Blue Boy*, Reynolds' *Age of*

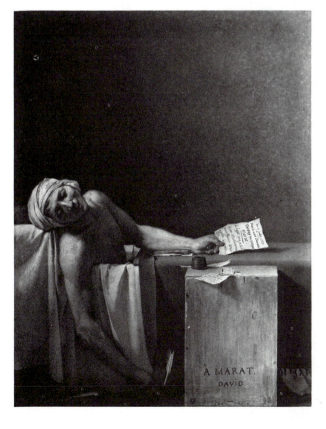

Fig. 12–19. David. *The Death of Marat.* 1793. 65 × 50½". Royal Museums of Fine Arts, Brussels.

Innocence (fig. 12-20), and many other works by those three masters as well as by Raeburn and Romney—were produced during this era. Gainsborough also won distinction as a painter of romantic landscapes and scenes of country life.

Most English neoclassical portraits place their subjects, usually beautifully gowned ladies, in outdoor settings, more often than not close to a classical column. Behind them, as a contrast to their formal dresses and coiffures, are gently billowing clouds and trees. Gainsborough's portrait of the beautiful, haughty *Mrs. Graham* and Reynolds' *Diana, Viscountess Crosbie* are notable examples.

The most atypical painter of the age in England was William Hogarth (1697–1764).

As much a reformer as a painter, Hogarth campaigned against the ills of his day—political and moral corruption, social injustice, and the evils of poverty—by writing political tracts but more effectively by painting several series of pictures that illustrated the vices of his time. He then made engravings of them and distributed them widely. The engravings became so popular that the first copyright laws governing pictures were passed to protect him from imitators. The most famous series are *A Rake's Progress, A Harlot's Progress,* and *Marriage à la Mode.* Fig. 12-21 shows the final engraving of *A Rake's Progress.* The Rake, having squandered his fortune, is now in Bedlam (Bethlehem Hospital), where he and other mad inmates amuse fashionable Londoners.

Fig. 12–20. Sir Joshua Reynolds. *The Age of Innocence.* About 1775. The Tate Gallery, London.

Fig. 12–21. William Hogarth. *The Mad House*, final scene of *The Rake's Progress*. About 1734. 24½ × 29½". Reproduced by courtesy of the Trustees of Sir John Soane's Museum, London.

Apart from such moralizing series, Hogarth was a fine portrait painter who chose to paint the faces of common people, including his servants. His gay *Shrimp Girl* is a familiar example.

Neoclassicism, as we shall see in the next chapter, continued well into the nineteenth century, especially in the architecture of public buildings throughout Europe and America. But even during the eighteenth century, in the art of Chardin, Gainsborough, Hogarth and others, as well as in the writings of a number of poets, playwrights, novelists, and other writers from all parts of the Western world, attitudes were developing that led to the coming romantic movement.

13 THE ROMANTIC AGE

The Romantic Age roughly parallels the Age of Revolution in Europe and America—the latter part of the eighteenth century and the first half or two-thirds of the nineteenth. This era was marked by a series of events that radically changed the Western world: the American Revolution, with its immense political and economic consequences; the series of French revolutions; the movements toward independence in Greece and Italy; the struggle for a constitutional government in Russia; the movement toward national unity in Germany; and the powerful impact of the Industrial Revolution. In numerous and complex ways the romantic attitude, as it was reflected in the arts, both stimulated and was stimulated by the spirit of change that swept across the Western world.

The romantic spirit, as Pater has said, is "an everpresent, an enduring principle, in the artistic temperament." It is a spirit, however, that recedes in certain eras—the Age of Reason, for example—and reasserts itself in others. Romanticism reacts against the formalism and restraints of classicism. It encourages spontaneity and free expression of emotion. As one would expect from the popular meaning of the word *romance,* the emotion of love in its many forms is a central interest of romanticism.

Further, the romantic spirit places intuition above reason ("Trust thyself," exclaimed Emerson). The self is one of the principal concerns of the romanticist. On one level the romanticist searches himself or herself for the answers to universal questions; on another the search ends in his or her own self. It follows that romanticism prizes the individual; it extols liberty and democracy. In the arts it encourages experimentation and personal expression. It makes much of common men and women, especially those of the country—their supposed simplicity and natural virtues. It dwells, sincerely or superficially, on the picturesque aspects of the countryside.

Nature is a principal interest of the romanticist—not the "universal nature" or "human nature" of the rationalist, but the nature of mountain, stream, and forest. The romanticist responds both to the serenity of nature's gentler moods and to the drama and terror of its darker ones.

The romantic spirit finds pleasure in the remote—in faraway places and long-ago times—the Orient, Arabia, and other exotic

regions; the Middle Ages, with castles, Gothic churches, crusades, and chivalry; the grotesque and the supernatural; and beauty that has an air of strangeness or mystery about it.

These are attributes of the romantic *spirit*; there is no romantic *style* as such. The very diversity of romanticism—its distaste for rules and its enthusiasm for individuality—does not lend itself to a clearly recognizable aesthetic style.

LITERATURE

Along with the vast increase in size of the reading public during the past two hundred years or more has come a flood of reading matter of all kinds, including a large amount of permanently important literature. In this chapter and those that follow we can touch on only a relative handful of representative major writers.

The Earlier Romantics. As we have seen, there were strong stirrings of the romantic spirit throughout most of the eighteenth century. In Scotland, as early as the 1720s a talented young poet named James Thomson wrote a series of poems called "The Seasons" which avoid the artifices of neoclassicism and show a real sensitivity to nature in all its moods. (In Ch. 12 we mentioned the Haydn oratorio based on these poems.) A little later the poems of the gentle, devout William Cowper expressed his love for the English countryside. And Thomas Gray's famous "Elegy Written in a Country Churchyard" and Oliver Goldsmith's "Deserted Village" reflected the idyllic, picturesque, and melancholy aspects of country life.

Toward the end of the eighteenth century Robert Burns (1759–1796) won the hearts of the English-speaking world with his Scottish lyrics and ballads. Some were humorous, some passionate or tender or otherwise romantic, and all were musical—

"Flow Gently, Sweet Afton," "Ye Flowery Banks o' Bonie Doon," and many others. At about the same time William Blake (1757-1827), an English painter and engraver, was writing poems in his own highly original and quite unclassical fashion. Best known are a number of short pieces from his *Songs of Innocence* ("The Lamb," "The Divine Image," "The Little Black Boy") and *Songs of Experience* ("The Tiger," "A Poison Tree," "London"). These deceptively simple poems are charged with symbolism that escapes a casual reading. Some are gentle; others reflect intensely personal, visionary religious experience; and still others are indictments of "the mind-forged manacles" of society.

Romanticism in Continental Literature. The Frenchman Rousseau (Ch. 12) proclaimed doctrines that did much to generate the romantic movement and stir up enthusiasm for modern democratic concepts of government. But the romantic spirit came more naturally to Germany than to France. The critic and dramatist Gotthold Lessing (1729-1781) looked ahead to the romantic movement (and in a sense to the age of realism) by involving ordinary people and everyday situations in *Miss Sara Sampson,* a tragedy, and *Minna von Barnhelm,* a delightful comedy. Johann Herder (b. 1744–1803), a preacher and teacher who was also a versatile man of letters, collected and translated folk literature from a number of nations which, he felt, reflected the true soul of the people.

Both Lessing and Herder helped to stimulate what came to be known as the *Sturm and Drang* (Storm and Stress) movement of the 1770s in Germany. Rebelling against the rules of French neoclassicism, the participants in this short-lived but important movement were convinced that the emotions should override the intellect, that sentiment and passion are the essence of great literature. The two greatest of the group were Schiller and Goethe.

Friedrich Schiller (1759-1805) is probably most loved of German poets and dramatists. In the nineteenth century, in particular, his high-minded idealism and patriotic fervor were deeply admired throughout the Western world. Best known of his poems is the "Ode to Joy," which Beethoven used as the text for the stirring choral movement of his Ninth Symphony.

Schiller's plays are theatrically effective, and they are still often produced in German-speaking countries. They range from his early, melodramatic drama *The Robbers*, whose central character is a Robin Hood-like idealist, to *William Tell*, the patriotic drama that he bequeathed to the Swiss people in his last year.

Schiller's last illness-plagued years were brightened by his friendship with Johann Wolfgang von Goethe (1749-1832), whom Germans rank with Dante and Shakespeare. A man of extraordinary breadth of genius, Goethe distinguished himself as a scientist, a public administrator, and a writer in almost every form of poetry and prose. Early in life he wrote a short novel, *The Sufferings of Young Werther*, that helped to make him a leader of the *Sturm und Drang* movement. Based in part on one of Goethe's own many love affairs, it tells of a neurotically sentimental young man who falls in love with the fiancée (later the wife) of another man and whose unrequited love drives him to suicide. It was an immediate sensation. Its emotional power and its descriptions of the wilder aspects of nature make it still worth reading in spite of its sentimentality. Goethe's admirers point to *Wilhelm Meister*, a product of his later years, as a greater novel, one that is essentially classical in its restraint and philosophical depth.

Goethe's masterpiece is his great tragic drama *Faust*, on which he worked intermittently for sixty years. He makes of the familiar old Faust legend a huge drama in which he expresses his deepest convictions. Central is the belief that the universe, and humanity as part of it, are not finished and finite, but organic and dynamic; that people justify themselves not in their achievements but in their yearnings, strivings, and even apparent failures. Goethe's Faust does not make the traditional bargain with Satan in which he exchanges his soul for youth and its gratifications. Instead, the drama is based on two grand "wagers": In the first, God allows Satan to try his destructive powers on men, knowing that "a good man with his groping intuitions/Still knows the path that is true and fit." In the second the aged Faust wagers that Mephistopheles cannot provide for him a moment of experience that will satisfy him. Mephistopheles restores the doctor's youth and leads him through a variety of experiences, including a tragic love affair with Marguerite, a village girl. Faust's experiences end, when he is an old man, with his attempt to reclaim a large tract of swampland for the benefit of humanity. This great philanthropic effort is his highest moment, and he says the fatal words, "Linger a while!"— but with a qualifier that shows he is still not satisfied. As Faust dies and Mephistopheles attempts to take his soul, it is escorted to heaven by angels that sing of love and aspiration.

After Goethe the most important figure of German romanticism was Heinrich Heine (1797–1856). Heine was a complex, unstable person of Jewish ancestry who was a Lutheran for a while and spent most of his adult life, the last part of it bedridden, in Paris. Alternately bitter and gentle, he wrote ironical criticism and a large number of lyrics, including the ballad of the alluring Rhine maiden, "The Lorelei," which has become almost a folk ballad. Many of Heine's poems were set to music by Schubert, Schumann, and others.

Paris, when Heinrich Heine made that city his home is 1831, was moving toward the climax of a short but brilliant outpouring in all the arts. Among the many writers who made the French capital their home was Victor Hugo (1802-1885). The preface he wrote for his romantic play *Cromwell* helped to

make Hugo the leader of the French romantic movement. He argued, among other things, for the importance of the grotesque as a complement to the sublime. In rejecting the neoclassical doctrine of the unities he declared:

> Let us take the hammer to theories and poetic systems. Let us throw down the old plastering that conceals the façade of art. There are neither rules nor models; or, rather, there are no other rules than the general rules of nature, which soar above the whole field of art.

Hugo turned out many plays, much poetry, and a number of novels. Most famous of the novels are *Notre-Dame de Paris*, with the great Gothic cathedral as its principal setting and the hunchback Quasimodo as the most fascinating of the many characters involved in its melodramatic story; and *Les Misérables*, a long, sentimental, but still powerful novel of war, social injustice, expiation for crime, and the healing power of love. Hugo's poetry includes several memorable instances of the grotesque and fantastic, such as "The Dance of the Demons" and "The Djinns."

Last of the major nations to produce literature of worldwide importance was Russia. After her own neoclassical period, Russia came forth with her first internationally significant romanticist, Alexander Pushkin (1799–1837). Often referred to as "the Byron of Russia," Pushkin produced a great amount of writing—plays, stories, poetry, history—much of it of high quality, in his short, dramatic life (he was killed at thirty-eight in a duel with his wife's brother-in-law). Pushkin's masterpiece is *Eugene Onegin*, a novel in verse that combines strong characterizations, witty social commentary in the manner of Byron, realistic scenes of Russian life, and a romantic story that reaches its climax in a duel between Onegin and a close friend.

Romanticism in English Literature.
In 1798, sometime after the foreshadowings of literary romanticism in the poetry of Thomson, Gray, and others, an event occurred that is generally accepted as the beginning of the romantic age in England—the publication by William Wordsworth and Samuel Taylor Coleridge of a small volume of poems called *Lyrical Ballads*. Two years later Wordsworth wrote, for a second edition, a preface that is often called the literary manifesto of romanticism. Rejecting the basic premises of neoclassicism, he declared that "poetry is the spontaneous overflow of powerful feelings"; it "takes its origin from emotion recollected in tranquility." The poet should employ no special "poetic" diction—only a selection of the "language really spoken by men." Wordsworth's own object, he said, was to choose "incidents and situations from common life . . . and throw over them a certain coloring of imagination." But Coleridge's poems, continued Wordsworth, were designed to present convincingly the strange and the supernatural.

Wordsworth (1770-1850) spent most of his long life in the Lake District, where he absorbed the sights and sounds that he later incorporated into his distinguished body of nature poetry. But he seldom responded to nature for its own sake; almost always it led him to philosophize or moralize. In "The Tables Turned," after a lovely description of a sunset, comes this stanza:

> One impulse from a vernal wood
> May teach you more of man,
> Of moral evil and of good
> Than all the sages can.

And the first mild day of March, which he describes in a lyric "To My Sister," inspires what might be a motto for romanticism:

> Love, now a universal birth,
> From heart to heart is stealing,
> From earth to man, from man to earth;
> It is the hour of feeling.

Feeling, in fact, lies at the core not only of human relations but of nature itself: in

"Lines Composed a Few Miles Above Tintern Abbey," the poet says he has learned to look at nature, while hearing "the still, sad music of humanity," and feel "a presence that disturbs me with the joy/Of elevated thoughts." Similar perceptions run through all of Wordsworth's poems, from his hundreds of short lyrics to such long philosophical and autobiographical poems as *The Prelude.*

Coleridge (1772-1834), a brilliant and unstable man, wrote much important literary criticism but only a handful of significant poems. The best of these explore the world of fantasy and of the subconscious. One, the celebrated long ballad "The Rime of the Ancient Mariner," continues to mesmerize readers as it makes Coleridge's moralistic point: One violates the natural order of God's universe at the peril of his soul. Another, "Christabel," is an unfinished but enthralling ballad romance. Still another, also unfinished, is "Khubla Khan," which Coleridge says came to him in a dream. Its descriptions of the great Mogul's exotic pleasure dome with its gardens, fountains, and "deep romantic chasms" helped to stimulate a romantic interest in the magic and mystery of the Orient.

All three of Coleridge's poems reflect the influence of the Gothic novel, a form of romantic fiction that was highly popular at the time. Horace Walpole had established the form in 1764 with his *Castle of Otranto*, a novel of horror and mystery. Its setting is a medieval castle (hence "Gothic") abounding in underground passages, trapdoors, ghosts, clanking chains, shrieks in the night, and other melodramatic devices. The novel has had innumerable descendants, from Mary Shelley's *Frankenstein* to the latest horror story.

Born within a year of Wordsworth and Coleridge was Sir Walter Scott (1771-1832), whose long narrative poems *The Lay of the Last Minstrel* and *The Lady of the Lake* tell suspenseful romantic tales in vigorous verse. Scott's major contribution to romantic literature lies, of course, in many excellent novels based on Scottish and English history: stories of border warfare such as *Rob Roy;* the moving story of a courageous Scottish girl, Jeanie Dean, in *The Heart of Midlothian; The Bride of Lammermoor*, a tragic love story; *Ivanhoe*, a novel of medieval times that is perhaps still the greatest historical romance; and many others.

Asserting herself good-humoredly in the midst of England's upsurge of romanticism was Jane Austen (1775-1817), whose fine novels are in no sense romantic. Witty, perceptive, and unsentimental, such novels as *Pride and Prejudice, Sense and Sensibility,* and *Emma* have continued to delight readers since they were first published early in the nineteenth century.

A generation after Wordsworth, Coleridge, and Scott, English romanticism reached its climax in the work of another trio of poets, Byron, Shelley, and Keats. In both his poetry and his unconventional life George Gordon, Lord Byron (1788-1824) created the image of the "Byronic hero"—arrogant, moody, cynical, darkly handsome, magnetically attractive. The Byronic hero appears in several of his larger works, including the autobiographical *Childe Harold's Pilgrimage* and the poetic dramas *Manfred* and *Cain.* Another facet of Byron's personality, more neoclassical than romantic, shows up in his last long poem, *Don Juan.* In this poem, under the satirical, mocking surface, is an undercurrent of serious criticism and a genuine concern for human freedom. More typically romantic are a number of Byron's lyrics, carefully musical in their meters, such as "She Walks in Beauty" and "Stanzas for Music."

More intense both in his lyricism and in his rebellion against conventions was Percy Bysshe Shelley (1792-1822). Some critics think of him, within the framework of his passionate idealism, as the most searching and original intellect among nineteenth-century poets. For most readers Shelley is at his best in his lyrics, with their flowing music,

precise imagery, and emotional intensity. Among them are the graceful short lyric "Music, When Soft Voices Die"; the sonnet "Ozymandias"; and the "Ode to the West Wind," an intense poem that ends on a note of prophecy.

The lyricism of John Keats (1795-1821) is less passionate but more warmhearted than that of either Byron or Shelley. He disliked Byron's cynicism and he was not philosophically inclined as was Shelley. Keats was extraordinarily responsive to colors, lights and shades, perfumes, sounds and touches. He worshipped beauty as intensely as did Shelley, and he responded to nature with as much delight as did Wordsworth, and with more directness. He was like Coleridge in his enthusiasm for the enchantment of the Middle Ages ("La Belle Dame sans Merci" and "The Eve of St. Agnes"). But he wrote fresh sonnets and odes on a variety of subjects, among them his celebrated romantic tribute to classical beauty, the "Ode on a Grecian Urn."

Romantic Poetry in the Victorian Era. The latter part of the romantic age in England merges with the Victorian era, which roughly parallels the reign of Queen Victoria (1837-1901). Probably no period has displayed more marked extremes of literary temper, from romantic sentimentality to stark realism. The three greatest poets of the era were Tennyson, Browning, and Arnold. All three, but especially Tennyson and Browning, were essentially romanticists.

Alfred, Lord Tennyson (1809–1892) was for more than forty years poet laureate of England and its most admired literary figure. Some critics in this century have dismissed him as superficial and sentimental. He was in fact a sure-handed craftsman who experimented with form and was sensitive to the visual and especially the auditory aspects of poetry. He composed hundreds of short poems with subject matter ranging from classical myth to Victorian social problems. A few of them, such as the fine dramatic monologue "Ulysses," are vigorous calls to action. Many, including "The Lotus Eaters," "Mariana," and "The Lady of Shalott," are musical, pictorially lovely, and tinged with sadness. Another few, such as the *Northern Farmer* poems in country dialect, are earthy and humorous. Most of them tend to moralize, but not so much as do the longer works—for instance his famous elegy "In Memoriam," in which he sets forth his emotional and spiritual responses to the death of his friend Arthur Henry Hallam. Other long poems, again with their philosophical and moral overtones, are his *Idylls of the King*, retellings in blank verse of the medieval romances of Arthur and his Round Table.

Robert Browning (1812-1889) is one of the most original and intriguing of nineteenth-century poets—romantic in his philosophical optimism and in the wide range, in time and place, of his subject matter. His chief poetic form, the dramatic monologue, and his metrical language—vigorous, elliptical, intellectually challenging—have strongly influenced the methods of twentieth-century poets, including Robinson, Eliot, Pound, and Frost.

Browning was little concerned with nature; men and women (not humanity in the abstract) were his consuming interest. The dramatic monologue, in which a character speaks his thoughts aloud to an assumed listener, was his device for telling the truth about human beings in all their moral and psychological complexity—or more accurately, for having them tell the truth, often unconsciously, about themselves. In Browning's large cast of characters, drawn from many times and places, are few well-adjusted, successful persons. Most of them are weak or unsavory or worse: a Renaissance painter who gropes toward reasons for his profound sense of failure ("Andrea del Sarto"); a duke who bargains for a new wife after jealousy had driven him to have his first duchess murdered ("My Last Duchess"); a Renaissance bishop who remains a dedicated voluptuary to the end ("The Bishop Orders His

Tomb"). Even in these poems, but especially in such poems of faith as "Rabbi Ben Ezra" and "Saul," Browning communicates his optimistic philosophy, which is based on a steady faith in the saving power of love and a belief in striving, aspiration, and imperfection as tokens of human spiritual worth and as foretokens of immortality.

Romanticism in American Literature. America's first important writers in the romantic vein were Philip Freneau, who produced a few fine nature poems such as "The Wild Honey Suckle"; Washington Irving, who wrote such favorite romantic tales as "Rip Van Winkle" and who was the first American writer to win an international audience; and James Fenimore Copper, an American admirer of Scott who cast over his fine Leatherstocking novels, stories of Indian and frontier life, a peculiarly American aura of romance and myth.

William Cullen Bryant (1794–1878), by profession a journalist, was America's first poet of near-major rank. Though his early work echoed the language of England's neoclassicists, he developed a natural, restrained style of his own in which to treat the themes that he returned to often in his long life: freedom, death and the transience of life, religious faith, and the beauty and healing power of nature. Among his best-known poems are "Thanatopsis" ("A View of Death"), which he wrote when he was seventeen; poems of nature such as "The Yellow Violet" and "The Fringed Gentian"; and his best religious lyric, "To a Waterfowl."

The reputation of the once immensely popular Henry Wadsworth Longfellow (1807–1882), which faded in the earlier part of this century, has brightened again as readers have come to recognize genuine strengths in his work. An unabashed patriot, he demonstrated his love for America in such poems as "Paul Revere's Ride" and "The Building of the Ship." He proved himself a skillful storyteller in the long narrative "Evangeline," with its well-sustained idyllic and elegiac moods, and in the fine narrative movement of the *Hiawatha* legends. Longfellow also did much to familiarize his fellow Americans with the lore and literature of Europe through such poems as "The Belfry of Bruges" and "A Dutch Picture." And he achieved a clear, quiet flow of music in lyrics like "Hymn to the Night" and "My Lost Youth."

America's most important philosophical exponent of romanticism was Ralph Waldo Emerson (1803–1882). As essayist, lecturer, and poet he preached the doctrine of Transcendentalism, an idealistic philosophy that reflected the ideas of Plato, Carlyle, and others, as well as his own Unitarian background and strongly individualistic convictions. He believed that human beings have within them a power derived from God, who is present in all humanity and all nature as an omnipresent Over-Soul; and that this intuitive power is one's true self, which should be trusted above all else. These and related ideas he expressed in loosely constructed but highly quotable essays that have stimulated generations of readers. So too have some of his terse poems, with their short lines, harsh rhythms, homely diction, and epigrammatic statements. Typical is "Each and All," in which the poet argues that in their variety the things of earth have beauty only as they relate to one another in natural oneness. Less typical is his most finished poem, the classically clear "Days."

Edgar Allan Poe (1809-1849) produced a fair-sized body of important poetry, many stories and sketches, and a large amount of criticism, some of it very good—all exemplifying his conviction that good literature is art, that it is concerned, not with the "moral sense," but with beauty. Concerned as few poets have been with the sounds of poetry, he made use of every auditory device—repetition, alliteration, tone coloring, onomatopoeia, subtle shifts of rhythm, and

others—to create haunting verbal music. The music and the emotional effects he most often sought—terror, melancholy, mystery—can be found in such works as "The Raven" and "Ulalume." More thought is implicit in "Israfel" and in the classical symbolism of "To Helen."

Poe's short stories embody his theory that a tale, like a poem, is a working out of a "certain unique or single *effect*." The theory does less than justice to his skill as a plotmaker in such detective stories as "The Gold Bug" and "The Murders in the Rue Morgue." But effects are there in abundance—Gothic terror in "The Pit and the Pendulum," the workings of the neurotic mind and the horrors of premature burial in "The Fall of the House of Usher," and the supernatural—death itself incarnated—in "The Masque of the Red Death." Poe's fictional world, when it is of this earth, is European; and his very real influence on the writers of the later nineteenth century was felt most strongly in Europe, especially in France.

Poe's often-harsh criticism of American writers largely spared Nathaniel Hawthorne (1804-1864), whom he praised as "a man of truest genius." Since Poe's theory of composition allowed "Truth" to be an aim of prose fiction, he accepted the strong current of moral concern that runs through Hawthorne's fiction, while he applauded Hawthorne's artistry as a prose stylist and storyteller.

Hawthorne, like Poe, was intrigued by the macabre and the supernatural, but he had more than a literary interest in the workings of the mind. He was fascinated by the psychological and emotional consequences of sin, and he found a rich vein of subject matter in what he saw as the sin-obsessed world of his Puritan American ancestors. The dominant theme of his allegorical stories is alienation. His characters sever themselves or others from normal human intercourse in a number of ways—by guilt and

bigotry in his superb romantic novel *The Scarlet Letter*; by cold intellectuality in "Ethan Brand"; by suspicion in "Young Goodman Brown"; and by self-centered ambition in "The Wedding Knell."

MUSIC

A great public demand for operatic and concert music encouraged—and was encouraged by—the romantic movement, one of the great eras of productivity in music. The musical forms that had been shaped in the eighteenth century and earlier continued to be employed, but they were modified by innovative composers, and a few new ones were added.

The most important difference between the music of the later eighteenth century (the classical era) and the nineteenth (the romantic era) was one of emphasis—on form in the classical tradition and on individuality and emotional expressiveness in the romantic. The difference can easily be overemphasized; emotion, on the one hand, lies at the core of all music, classical or otherwise; and on the other, probably no significant romantic composer lost sight of the importance of form, however much he may have experimented.

In no era has there been a closer affinity among the arts, especially between literature and music, than in the romantic age. Nineteenth-century composers derived inspiration and ideas from poets and playwrights. Romantic poets provided lyrics for the countless songs produced by Schubert and others. Plays, novels, and stories furnished plots for romantic operas. Even instrumental music had literary ties: "program" music, in theory at least, narrated stories or described romantic landscapes: symphonic poems attempted to reproduce the ideational and emotional content of poems. Even the titles of many works, whether given by the composers or by others, were essentially liter-

ary—"Scotch" and "Italian" symphonies, "raindrop" preludes and "revolutionary" études.

The flavor of much romantic music is suggested by the names of popular forms of the period—the prelude, the impromptu, the rhapsody, the fantasia—each suggesting spontaneity or improvisation, the composer's response to the flow of emotions and poetic moods.

Apart from new forms, romantic composers experimented with new instruments, especially with tympani and other percussive instruments and with the new valve-type horns and trumpets that were being developed. The piano, with its dynamic range and breadth of tone color, became a major solo instrument. And the orchestra grew greatly in size and in the complexity and variety of its sound.

Vocal Music

Choral Forms. The religious movements of the later eighteenth and nineteenth centuries in Europe and America produced large numbers of hymns, many of them still used in worship services today. Relatively fewer large-scale sacred compositions were composed than in previous centuries, but a number of important romantic composers tried their hands at oratorios, cantatas, and masses. These included Felix Mendelssohn, whose *Elijah* is one of the most popular and frequently performed of oratorios. It is memorable for several powerful choruses and for melodic and moving arias such as "If with All Your Hearts" and "O Rest in the Lord."

The French composer Hector Berlioz composed two important religious works, the music drama *L' Enfance du Christ* ("The Childhood of Christ," or better, "The Infant Jesus"), a beautiful work for the Christmas season based on events in the life of Jesus from Herod's dream to the flight of the Holy Family to Egypt; and a *Requiem* (Mass for the Dead). The latter work, which calls for a vast array of musicians, was originally criticized

for its sensationalism, but it is in fact mostly restrained and elegiac. The entire long work, except for one brief tenor solo, is for chorus and orchestra.

Later in the century the Italian opera composer Giuseppe Verdi composed several major religious works, including a *Requiem* that has probably outdone Berlioz's in popularity. At about the same time Johannes Brahms composed his own memorable *German Requiem*, so called because its text, drawn from the Lutheran Bible, is sung in German, rather than the traditional Latin.

Songs and Song Cycles. The song is possibly the oldest form of music. A number of important composers from Bach to Beethoven wrote songs. But it was Franz Schubert (1797-1828) who perfected the art song or *lied*, in which words and music are blended as a lyrical and dramatic entity. It is not too much to say that Schubert, who lived out his short life in poverty and obscurity in his home city of Vienna, was the greatest of all song writers. Schumann, Brahms, Wolf, Mahler, Richard Strauss and other illustrious masters followed him, but they did not surpass him.

At seventeen Schubert set to music a poem from Goethe's *Faust*, "Gretchen at the Spinning Wheel," in which the piano accompaniment suggests the slow or fast whirring of the wheel as it reflects Marguerite's emotions. At eighteen he composed one of his masterpieces, "The Erl-King." Based on an eerie ballad by Goethe, it tells of a father carrying his sick child on horseback through a wild winter night. The piano depicts the night winds and the furious gallop of the horse, and the melodic line alters to suggest with chilling vividness the voices of father, child, and erl-king, king of the evil elves.

Schubert set to music about six hundred poems, not all of them great; but from them came a surprising number of great songs. He had an almost uncanny ability to catch the essence of a poem and reflect it in lovely melody. The piano part invariably reinforces the voice, if only with simple

chords. Schubert also composed three song cycles that became great favorites some years after his death: *Die Schöne Müllerin* (The Pretty Miller Maid) and *Winterreise* (Winter's Journey), both having to do with unrequited love, and *Schwanengesang* (Swan Song). The last includes "Stänchen" (Serenade), possibly the best-loved song of its kind.

The Romantic Opera. Romantic composers of opera found their stories, not in classical myths but in dramatic episodes from history or in contemporary novels and plays—the writings of Goethe, Hugo, Schiller, Scott, and lesser figures. Even the best of such plots were often melodramatic—accounts of violence, intrigue, and seduction; of stolen children, heroines driven mad by deception, and so on. The better librettists and composers were often able to retain whatever dramatic values the originals possessed and employ the power of music to add depth to characters, emphasize dramatic highlights and shadows, and intensify the expression of emotion.

Italy, France, and the Germanic countries continued to lead the way in the creation of operas. Italy's first important composers of romantic opera were Rossini, Bellini, and Donizetti. Gioacchino Rossini (1792-1868) was a witty and urbane man who composed operas at a furious rate in his earlier life and retired at thirty-seven to live another thirty-eight years in comparative idleness. Rossini broke away from the stiffness of older operas, supplied lively, natural-sounding dialogue, developed ensembles such as trios and quartets that were musically and dramatically alive, and wrote many beautiful arias, especially for coloratura sopranos. His practices were quickly adopted by others. Two of his operas remain important: the sprightly, lighthearted *Barber of Seville*, still one of the most popular of comic operas; and his last opera, *William Tell*, with its familiar overture.

Gaetano Donizetti (1797-1848) was even more prolific. A few of his operas survive—*Don Pasquale* and *L'Elisir d'Amore* (The

Elixir of Love), both fine comic operas, and *Lucia di Lammermoor*, a tragic opera loosely based on Scott's novel *The Bride of Lammermoor*. *Lucia*, though its plot must have seemed impossibly melodramatic even in Donizetti's time, has much pleasant music—coloratura solos that include a famous but rather mild "mad scene"; some expressive orchestral writing; and a famous sextet, a fine example of the operatic ensemble.

The first important writer of romantic opera in France was Giacomo Meyerbeer (1791-1864), a composer of grand-scale operas, usually semihistorical, such as *Les Huguenots* and *L'Africaine*. Another French composer, Charles Gounod (1818-1893), composed one of the most popular of all grand operas, *Faust*. The opera, based on Goethe's drama, is true neither to the spirit nor to the letter of its source, and some modern critics discount its music as obvious and sentimental. The work continues to hold the stage, however, and a number of its solos and ensembles are still effective.

Germany's important composer of the era was Carl Maria von Weber (1786-1826). Weber is considered the father of German romantic opera. After having imitated the Italians for a while, he set out consciously to write an opera that was genuinely German in story, setting, and musical feeling. This he did in *Der Freischütz* ("The Free Shooter"), which embodies the essence of German romanticism in its folktale plot and in its power, both visual and musical, to evoke a peculiarly German feeling for nature.

Towering above all other composers of romantic opera was the Italian Giuseppe Verdi (1813-1901). Born of peasant stock in a northern Italian village, Verdi was soon impressing his fellow townspeople with tunes he composed for the town band. After some hit-and-miss training in music, he presented his first opera, *Oberto*, at La Scala in Milan in 1839. It was an immediate success.

The great period of Verdi's career began in 1851. In a three-year span he composed three of the greatest of grand operas in the romantic tradition—*Rigoletto, Il Tro-*

vatore, and *La Traviata.* A decade later he reached another peak in *Aïda,* a "spectacular" that was commissioned by the Egyptian government and was first produced, in Cairo, in 1871. Much later, after years of semiretirement, Verdi was persuaded to set to music a libretto, *Otello,* derived from Shakespeare's *Othello.* At eighty, in a marked departure from the brooding, violent stories that he had long preferred, he wrote *Falstaff,* a comic opera with a libretto taken from Shakespeare's *Merry Wives of Windsor* and parts of *Henry IV, Part 1.* These Shakespearean operas, written in a freer style than Verdi had employed before, demonstrate a remarkable understanding of Shakespeare's characters and of his dramatic intentions.

Verdi's personal favorite among his operas was *Rigoletto.* Based on a melodrama by Hugo, *Rigoletto* tells of a malevolent hunchbacked jester by that name, and of the curse placed upon him after he has taunted an outraged father whose daughter has been violated by Rigoletto's master, the profligate Duke of Mantua. The curse is fulfilled when Rigoletto hires an assassin to eliminate the Duke but finds, to his horror, that his own daughter Gilda has been killed instead. *Rigoletto* has the usual set pieces of Italian romantic opera—recitatives, ensembles, choruses, ballets and arias. These include cynical arias by the Duke and a celebrated quartet. The music anticipates, especially in several of Rigoletto's solos, the free forms that dominate Verdi's last works.

Instrumental Forms

The Romantic Symphony. After Beethoven, the greatest composers of more or less conventional romantic symphonies were Schubert, Schumann, and Mendelssohn. All were proponents of the classical sonata-allegro form, but for all of them the melodic, descriptive, and emotionally expressive aspects of orchestral music were paramount.

Schubert (1797-1828) had composed two symphonies before he was eighteen, and he included a number of others among the compositions that poured from his pen during the remaining eleven years of his life. His best symphonies are the C Major, No. 9 (also called No. 7) and the B Minor, No. 8, the "Unfinished." Schubert composed the C Major Symphony during his last months, when he was chronically ill; he never heard it performed. It bears evidence of his deep admiration for Beethoven. Its first movement is a Beethovenesque sonata-allegro, alternately solemn and stirring. Of the other three movements the third, the scherzo, is also in the style of Beethoven; it is one of the finest scherzos ever composed.

The two movements of Schubert's familiar, melodic "Unfinished" symphony were written several years before the C Major. No one knows why the work was left uncompleted; possibly the composer thought of the two movements as a completed whole.

Robert Schumann (1810-1856) has been called the arch-romanticist, partly because as a music critic he wrote scathingly of the slavish imitators of the great "originals" of classicism. In addition to many songs and works for piano, he composed a number of larger works, including four symphonies. Most familiar of these is the first, the Symphony in B-flat Minor. Composed during the happy months following his marriage to Clara Wieck, a famous pianist who did much to make his music known to the world, the First Symphony was called by its composer a "Spring" symphony. Its music, more programmatic than most, does have suggestions of the happiness of the spring season, of "whispering winds and running brooks," as the composer expressed it.

Felix Mendelssohn (1809-1847) was another prodigy in an age of prodigies. Before he was fifteen he had written twelve symphonies (not numbered among his major ones) and an immense amount of other juvenilia. At seventeen he composed his first masterwork, the charming, fairytale-like

overture to Shakespeare's *Midsummer Night's Dream*. In the remaining years of his short life he found time, along with his work as a teacher, conductor, and writer, to produce an incredible number of compositions, including his five principal symphonies. Of these, two are most frequently performed—Symphony No. 3 in A Minor ("Scotch") and Symphony No. 4 in A Major ("Italian"). Though his titles imply that he intended these symphonies to be descriptive, he preferred not to explain them, and listeners have sought without too much success for hints of national color in the works. Some have heard in the "Scotch" symphony "pastoral, idyllic, elegiac, and bardic moods" that have directed their imaginations toward Scotland. More important than descriptive elements are the faultless form, the clear, clean symmetry, and the melodic charm and buoyancy of these and other of Mendelssohn's works.

The French musician Hector Berlioz (1803-1869) was a remarkably innovative composer who extended the expressive and psychological implications of music as few others have done. He also extended the resources and size of the orchestra and invented tonal colorings that had never been heard before. Berlioz wrote several works that he called symphonies, none of which conform to traditional patterns. One is his *Romeo and Juliet* symphony, a combination of choral and instrumental music that is heard today mostly in abbreviated orchestral form. It includes a love scene (a vivid dialogue between the lovers) and a brilliant Mendelssohnian scherzo based on Mercutio's "Queen Mab" speech.

Most familiar of Berlioz's orchestral works is his *Symphonie Fantastique* ("Fantastic Symphony"), probably the ultimate expression of romanticism in instrumental music. Some listeners call it psychological realism. Lecnard Bernstein described it as a "trip," an anticipation of a modern psychedelic experience. Someone else, perhaps more accurately, has called its music lyrical and translucent, almost Mozartean, with a classically structured final movement. Berlioz supplied a written program which helps us to understand the five movements as the drug-induced dreams of a despairing lover. He sees the image of his beloved time and again in what Berlioz calls an *idée fixe*, an obsession, here a musical theme that comes back insistently. The work ends with the tolling of funeral bells and a powerful statement by the brasses of the medieval hymn "Dies Irae" ("Day of Wrath").

Other Instrumental Forms. The major romantic composers produced other instrumental compositions, such as concertos and string quartets, in quantities too great for us to elaborate on here. In such works, more consistently than in their symphonies, they adhered quite firmly to the conventional three- or four-movement sonata-allegro form.

An orchestral form that gained great popularity in the romantic age is the *overture*. In the classical era the term usually referred to the first movement of a suite, but nineteenth-century composers applied it to the orchestral introduction or preface to an opera. Some overtures, even for operas that did not succeed, were effective enough to be used as independent concert pieces. They vary in form; some, like Rossini's highly familiar overture to *William Tell* and his sparkling, witty overture to *The Barber of Seville*, relate only in spirit to the opera itself. Others such as Weber's *Der Freischütz* and *Oberon* introduce thematic materials from the operas. Overtures were also composed as introductions to plays—Mendelssohn's overture to *A Midsummer Night's Dream*, for example. Another type, the concert overture, was composed as an independent piece commemorating an occasion, such as Brahms's *Academic Overture*, written to express his gratitude for an honorary doctorate, and Tchaikovsky's *1812 Overture*, celebrating Napoleon's defeat in Russia. Another short orchestral form is the *symphonic poem*, a one-movement work based on a poem or a short, usually poetic, piece of prose. Franz Liszt

wrote a dozen symphonic poems, best known of which is *Les Preludes.*

Music for the Piano. Romantic composers discovered that the piano, with its long, strong strings and hammer action, gave the keyboard instrumentalist all the dynamic range he could wish for. Equally important was the pedal, which made possible the sustained but fading tone that is unique to the piano and that allows one note or chord to blend with another.

Beethoven made brilliant use of the piano in many compositions that include concertos and sonatas—among the latter the famous "Moonlight" and the highly romantic Sonata No. 23 in F Minor, the "Appassionata," aptly named by his publisher. He was followed by Schubert, whose poetic moods expressed themselves in many piano works, including the charming pieces he called *Moments musicaux* (musical moments) and the twenty-seven sonatas for piano.

Mendelssohn also wrote much piano music, including a number of short pieces he called "Songs without Words." Some of them are light, airy pieces; one or two, such as the "Spring Song," are perhaps overfamiliar; and a few others—the "Funeral March," for example—have greater depth. The piano compositions of Robert Schumann are more innovative; he made much use of dislocated accents, continual syncopation, dotted rhythms, and similar devices. Under the title *Carnaval* he brought together twenty-two brilliant pieces for the piano, some of them depicting carnival figures and some paying tribute to friends such as Chopin and Paganini. The gentle side of Schumann's nature permeates his *Kinderszenen*, (Scenes of Childhood), which include the most familiar of all of Schumann's compositions, "Traumerei" (Revery), and such whimsical pieces as "Child Falling Asleep."

Franz Liszt (1811-1886), Hungarian-born pianist and composer, was the most spectacular musical personality of his age, the embodiment of romanticism in his personal life as well as his music. A consciously dramatic performer who overwhelmed his audiences with the speed and power of his playing, Liszt was also an innovative composer who exploited the possibilities of the piano to their utmost. He is remembered today (in addition to the symphonic poems mentioned earlier) for his dazzling, sometimes bombastic *Hungarian Rhapsodies;* his transcriptions of compositions by Bach, Beethoven, Berlioz, Donizetti, and others; and such familiar pieces as his *Liebestraum.*

Greatest of romantic composers for the piano was Frederic Chopin (1810-1849). Born in Poland of a French father and Polish mother, he remained a staunch Polish patriot but spent almost all of his adult life elsewhere. He was widely popular as a pianist, not as dazzling as Liszt but more intimate and poetic.

Chopin explored more thoroughly than any other romantic composer the subtler coloristic possibilities of the piano. His style, which changed little during his lifetime, is essentially that of an improvisator, and there is a feeling of spontaneity, freshness, and unexpectedness in his work.

Though plagued by ill health, Chopin continued to produce almost to the end of his short life. He left about two hundred compositions, most of them of superior quality. He employed a number of forms, of which the main ones are these:

1. The *polonaise* and the *mazurka*. Both of these reflect Chopin's Polish background. The polonaise is a dance in triple time, with strong syncopations and in a variety of moods. One of the best known is the so-called "Military Polonaise" in A Major, Op. 71, No. 1. The mazurka is also in triple time, much like a waltz except that its accents often fall on the second or third beat. Among Chopin's fifty-six mazurkas are some of his finest compositions; typical is the familiar

Mazurka in B-flat Major, Op. 7, No. 1.

2. The *waltz* (*valse*). Less distinctive than the mazurkas are the fourteen waltzes, intimate pieces in a variety of moods. They range from the imposing Waltz Brillante in E-flat Major, Op. 18, to the very familiar "Minute Waltz" in D-flat Major, Op. 64, No. 1.

3. The *nocturne*. This, like the polonaise and mazurka, is a form that Chopin made familiar. As the name implies, it is a "night piece"—poetic, intimate mood music in free form.

4. *The étude*. Chopin wrote two sets of études, supposedly studies but in reality some of his most enduring works. Perhaps the loveliest piece he ever wrote is his Etude Op. 10, No. 3 in E Major. Another memorable étude is the powerful Etude Op. 10, No. 12 in C Minor, the "Revolutionary Etude."

5. The *prelude*. Chopin wrote a set of twenty-four preludes, one in each of the major and minor keys. Not actually preludes to anything, they are free forms that vary greatly in length, mood, and texture. Some are very familiar, including the sustained "Raindrop" Prelude, No. 15 in D-flat Major.

ARCHITECTURE

The term *eclecticism*, which suggests the choosing of forms and styles from a variety of sources, is often applied to the architecture of the romantic age. The eclecticism of the nineteenth century, which reflected the strong interest of romantic artists in reviving the forms of the past, went off in a great number of directions—neoclassical, neo-Renaissance, neobaroque, neo-Gothic, even Moorish and Oriental—sometimes as individual styles and sometimes in combination.

They appeared in every kind of building, public and private, from churches and mansions to railway stations and warehouses. Increasingly, interiors were planned with utility and efficiency in mind, but the trimmings—façades and so forth—were in one revival style or another, or often more than one. Of these the classical (with the Renaissance closely related) and the Gothic were most preferred.

Romantic neoclassicism continued to be a strong force through the first third of the nineteenth century; it asserted itself in such buildings as the German Walhalla high on a hill in Regensburg, a revived Parthenon, and in the Church of the Madeleine in Paris (fig. 13-1). The latter building, which Napoleon meant to be his Temple of Glory, has the outside appearance of a large Roman Corinthian temple. Its interior is a successful combination of several styles: a large basilica with chapels along the sides in Catholic baroque fashion; numerous classical details—columns, pediments, and so forth; and three domes on pendentives overhead, each with an oculus admitting light in the style of the Pantheon in Rome.

As the century passed, many architects continued to use the classical style, but taste gradually shifted toward the greater richness of Italian Renaissance; and many public buildings in Europe and America—capitols (including the U.S. Capitol), courthouses, townhalls, banks, libraries, museums—have their classical features combined with balustrades, pedimented windows, and other Renaissance devices.

In contrast to the neoclassical revival style and more obviously romantic in its impulses was the neo-Gothic. The Gothic style had never been entirely dead in England; in fact there are outcroppings of it in mansions and garden houses built during the baroque and rococo periods. About the middle of the eighteenth century, when Horace Walpole started the vogue of Gothic fiction with his *Castle of Otranto*, he had his mansion at Strawberry Hill remodeled in a whimsical

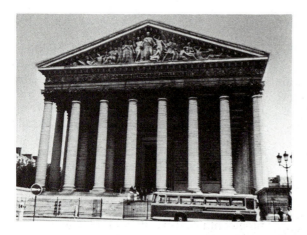

Fig. 13–1. Vignon. Church of the Madeleine, Paris. Begun 1804.

Fig. 13–2. Fonthill Abbey, Wiltshire, England. Begun 1796.

Fig. 13–3. Barry and Pugin. Houses of Parliament, London. Begun 1835.

Gothic style. Still more whimsical was Fonthill Abbey (fig. 13-2), built half a century later by a wealthy, dissolute young eccentric named William Beckford. He started Fonthill as a "folly," a replica of a Gothic ruin, but it grew, at a cost of millions of dollars, into a large mansion theoretically in the style of a medieval abbey, with a great hall 120 feet high that was heated by perfumed coal. The tower, reaching up nearly three hundred feet, collapsed in 1826, and Fonthill became a real ruin that attracted thousands of visitors.

The neo-Gothic movement was taken over by less sentimental and better-informed builders, including Augustus Pugin (1812-1852), a dedicated medievalist who believed that Gothic was the authentic Christian style. Pugin assisted Sir Charles Barry (1795-1860) in designing one of the great public buildings of the nineteenth century, the British Houses of Parliament (fig. 13-3). Barry leaned toward plainer forms (the interior of the Houses is quite modern); but Pugin designed the Gothic details, such as the rich façade and the numerous towers.

Gothicism had its effect later in the century on the fancywork—turrets, ornate scrollwork, stained glass, etc.—of Victorian mansions, a style that was belittled a generation ago but is now quite admired. Gothic-style churches were also built throughout Europe and America—Ste. Clotilde in Paris, the Votive Church in Vienna, Trinity and St. Patrick's in New York, Grace Cathedral in San Francisco, and hundreds of others.

SCULPTURE

The neoclassical revival in sculpture, with romantic overtones, continued well into the nineteenth century in the work of such artists as Houdon, Canova, and Thorvaldsen (Ch. 12). The romantic spirit dominated the rest of the century, culminating in the work of one of the greatest of all sculptors, Auguste Rodin (Ch. 14). Several other French romantic sculptors stand out, including Rude and Barye. Francois Rude (1784-1855)

studied sculpture in Paris and mastered the techniques of Canova and other Academicians but was not inhibited by them. Commissioned to do one of the two huge high-relief sculptures on the east side of the Arc de Triomphe in Paris, he gave his work, called *The Departure of the Volunteers of 1792* or *La Marseillaise* (fig. 13-4), some classical touches, including details of arms and armor and the charging figure of the Roman war goddess Bellona. But the work is strongly romantic in its intensity and in its powerful sense of motion.

Antoine Barye (1796-1875) moved away from classicism in another direction.

Fig. 13–4. François Rude. *La Marseillaise (Departure of the Volunteers of 1792)*. 1833–36. Approx. 42 × 26 '. Arc de Triomphe, Paris.

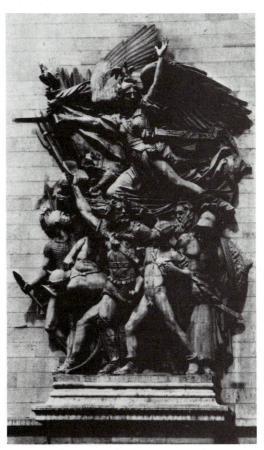

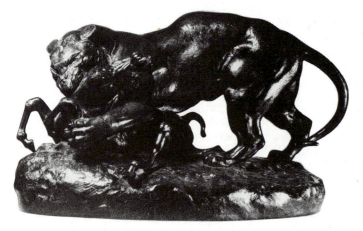

Fig. 13–5. Antoine-Louis Barye. *Tiger Devouring an Antelope.* About 1830. Bronze, approx. 11 × 21″. Hirshhorn Museum and Sculpture Garden, Smithsonian Institution.

He first gained fame with a dramatic piece depicting a tiger devouring a crocodile. Critics scorned him but the public applauded, and he continued to do sculptures—mostly statuettes, candelabra, and other small, beautifully executed pieces—that feature animals in violent action—a tiger devouring an antelope (fig. 13-5), a lion hunt, a lion and snake, and many others.

PAINTING

In the Napoleonic era, while many established painters in Europe and America were doing mostly portraits of the wealthy or works in the grand style—the death of General Wolfe, for instance, or the coronation of Napoleon—others were responding immediately to the romantic spirit. Earlier in the eighteenth century an Italian architect and painter named Piranesi (1720-1778) had done a series of etchings of immense, nightmarish prison interiors, filled with spiral stairways, torture engines and tiny human figures, all in the darker moods of Gothicism. Equally macabre are the works of Henry Fuseli (1741-1825), a Swiss-English painter who exploited fear and romantic horror in such works as his *Nightmare* (a copy of which, we are told, hung in Freud's study). The painting depicts an evil-eyed fiend squatting on

the body of a sleeping girl, with the head of a nightmare (in the literal sense) hovering in the background.

The romanticism of William Blake's works is visionary rather than fear-inspiring. He usually painted with water color over prints to produce some highly imaginative works of art, clean-edged and simple in form but enigmatic in content. Best known of these is his *Ancient of Days* (fig. 13-6), a small work that has been variously interpreted as Blake's symbolic vision of God the Creator, based on a passage from Proverbs 8:27 ("I was there: when he set a compass upon the face of the depth"), or as a satire on the rationalists' conception of God as an alien and remote lawmaker, a divine supermathematician.

A number of painters of portraits turned on occasion to romantic subjects. Gainsborough devoted most of his last years to idyllic landscapes and to scenes of country people in rustic settings, painted from memories of his native Suffolk. The American painter John S. Copley (1738-1815), who spent most of his mature life in England doing portraits of political figures and wealthy matrons, is best known for his *Watson and the Shark* (fig. 13-7), an exciting, romantic-realistic work based on an actual incident that occurred in Havana harbor. The American-born Benjamin West (1738-1820),

Fig. 13–6. William Blake. *The Ancient of Days.* 1794. Metal relief etching, hand colored. Lessing J. Rosenwald Collection, Library of Congress, Washington, D.C.

Fig. 13–7. John Singleton Copley. *Watson and the Shark.* 1778. 72½ × 90¼". Museum of Fine Arts, Boston.

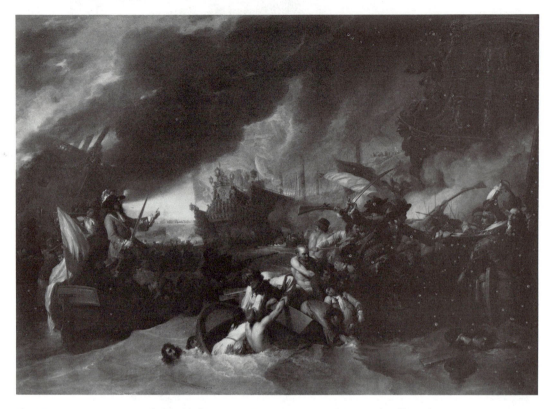

Fig. 13–8. Benjamin West. *The Battle of La Hogue.* 1778. 60⅛ × 84⅜″. National Gallery of Art, Washington, D.C.

another expatriate, a founder and later president of England's Royal Academy, developed what he called his "dread manner." His *Battle of La Hogue* (fig. 13-8), with its contrasts of light and darkness, strong diagonals, smoke-filled sky, and violent action, shows how thoroughly West had adapted himself to the new mode.

Romantic Painters

England. John Constable (1776-1837) was a romantic painter only in a limited sense. He painted the unspectacular, quietly beautiful countryside of southern England as he saw it, without sentimentality and with an accurate eye for natural phenomena—shifting and interacting colors, lights and shadows of trees, meadows, brooks, watermills, farmhouses, and especially the phenomena of atmosphere and of everchanging clouds. But suffusing all his paintings is a deep affection for the regions that he painted over and over again—his native Suffolk, Hampstead Heath, Salisbury, and the east and south coasts of England. "Painting," he once said, "is only another word for feeling."

As a young man Constable studied and admired the works of the Dutch landscapists, especially Ruisdael and Cuyp, as well as those of Gainsborough and Claude Lorrain. One of the first to do most of his painting out-of-doors, he made many quick preliminary sketches in oil, some of them as highly regarded now as his finished work. He was

nearing fifty when he painted some of his most popular works, including *The Lock on the Stour* and *The Hay Wain.* The latter (Color-plate 10), perhaps the most frequently re-produced of landscapes, shows a hay wagon fording the River Stour on a summer day, with a cottage nearly hidden by foliage, and a large sky filled with billowing, moisture-laden clouds—all held together by a harmo-ny of color, light, and shadow. Others of his better-known works are *The Cornfield, The White Horse,* and his views of Salisbury, es-pecially of the cathedral from the bishop's garden, its high spire framed by magnificent trees.

Constable's great rival Joseph M. W. Turner (1775-1851), though less attractive as a person, was more daring and imaginative and ultimately more far-reaching in his influ-ence. Turner gained admittance to the Royal Academy art schools at fourteen and became a full member of the Academy at twenty-seven. In his twenties he began to develop a luminous, poetic style that was profound in its influence on the painters of the latter part of the century. His first major work, *The Pier at Calais,* is basically realistic, with objects clearly defined. He was increasingly fasci-nated, however, not by forms but by the ele-mental phenomena of nature—snowstorms, sunbursts, misty sunrises, and particularly by dramatic or cataclysmic events involving both humans and nature—coal barges burn-ing on the Thames, the spectacular fire that destroyed the old Houses of Parliament in 1834, and naval battles, with masts engulfed in flame and smoke.

Turner became more and more preoc-cupied with dramatic and poetic effects of atmosphere and light; his forms dissolved until they threatened to disappear entirely, in anticipation of abstract art. The viewer sees Turner's *Interior at Petworth* (fig. 13-9) as if he has walked from a dark room into one so blindingly light that all objects are mo-mentarily obliterated. The burning of the Houses of Parliament yielded several spec-tacular paintings, including one in which ev-

Fig. 13–9. J. M. W. Turner. *Interior at Petworth*. About 1837. 36 × 48″. The Tate Gallery, London.

erything—sky, water, bridges, vessels—is drenched by a yellow-orange glow (Colorplate 11). Probably Turner's greatest *tour de force* is *Rain, Steam, and Speed: the Great Western Railway*, whose title indicates the phenomena the painting combines—a train, its engine trailing steam, speeding through a driving rainstorm.

Spain

Goya. Francisco Goya (1746-1828) who was born a generation before Constable and Turner, was little concerned with landscapes. To him they were only backgrounds, sometimes bright but more often bleak or brooding, for the doings of men. Goya painted and etched court portraits, festivals, bullfights, a few nudes, scenes of war and carnage, and fantasies that explore the darkest reaches of mental and emotional experience.

Early in his career Goya became a court painter and was attached to the royal household off and on throughout his life. Madrid, when he arrived there, was at the peak of a short-lived period of cultural growth. But after the death in 1788 of the able King Charles III, Goya and his fellow Spaniards saw their country plunged into near-chaos by the policies of Charles IV and his queen María Luisa and by the even more inept reign of Ferdinand VII. As First Painter to the King, Goya painted the royal household in some of the most extraordinary portraits ever made. A number of his royal patrons were singularly unattractive, physically and otherwise, and he depicted them pitilessly as an empty, arrogant, almost moronic set.

The reign of Ferdinand VII was disturbed by the Napoleonic Wars and the French invasion of Spain. On May 2, 1808, French troops and Egyptian mercenaries ruthlessly put down an uprising in Madrid, and the next day they cold-bloodedly executed all who were suspected of having been involved. Six years later Goya memorialized these events in two large, powerful paintings, the more famous of which, *The Third of May, 1808*, shows peasants being shot down at close range by soldiers who themselves seem horrified by their task (fig. 13-10).

Fig. 13—10. Francisco Goya. *The Third of May, 1808.* 1814—15. 8'9" × 13'4". The Prado, Madrid.

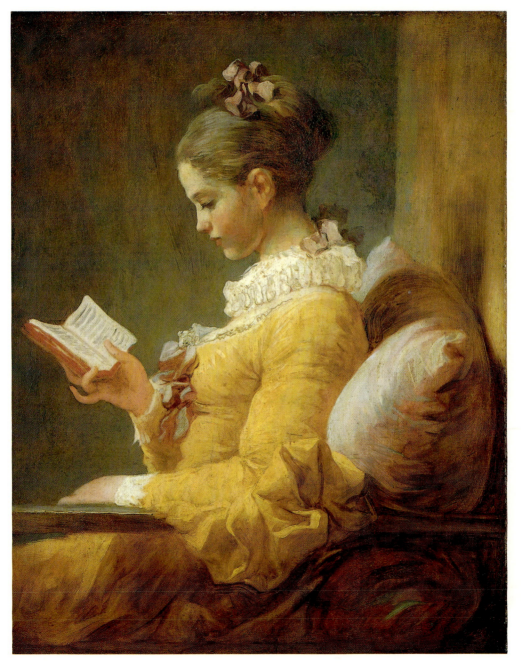

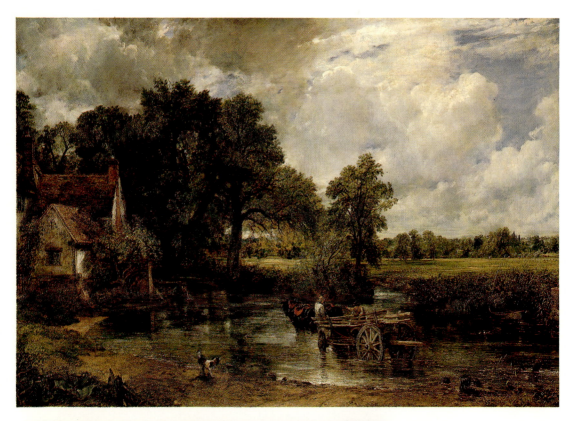

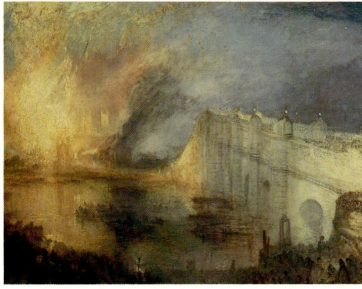

Colorplate 10. (*above*) John Constable. *The Hay Wain*. 1821. 4′2½″ x 6′1″. Reproduced by courtesy of the Trustees of the National Gallery, London.

Colorplate 11. (*left*) J. M. W. Turner. *Burning of the Houses of Lords and Commons*. 1835. Philadelphia Museum of Art.

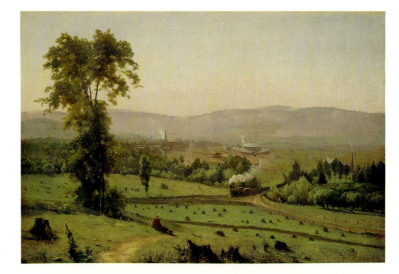

Colorplate 12. (*right*) George Inness. *Lackawanna Valley*. 1855. 34 x 50". National Gallery of Art, Washington, D.C. Gift of Mrs. Huddleston Rogers, 1945.

Colorplate 13. (*below*) Vincent Van Gogh. *The Night Café*. 1888. 28½ x 36¼". Yale University Art Gallery. Bequest of Stephen Carlton Clark.

Colorplate 14. (*top*) Henri Matisse. *The Red Studio*. 1911. 71¼ x 72¼". Collection, the Museum of Modern Art, New York. Mrs. Simon Guggenheim Fund.

Colorplate 15. (*left*) Mark Rothko. *Blue, Orange, Red*. 1961. 90¼ x 81¼". Hirshhorn Museum and Sculpture Garden, Smithsonian Institution, Washington, D.C. Photo by John Tennant.

Colorplate 16. (*below*) Frank Stella. *Darabjerd III*. 1967. Synthetic polymer, 120 x 180". Hirshhorn Museum and Sculpture Garden, Smithsonian Institution, Washington, D.C. Photo by John Tennant.

In those troubled years Goya's life was filled with tragedies, including an illness that resulted in total deafness. He continued to do portraits, but he turned more and more to what is regarded as his most original work—etchings that satirize the follies and superstitions of mankind and that depict the more bestial aspects of war, and a series of "Black Paintings," strange, unsettling works done on the walls of his home. The latter include gigantic figures hovering over a rocky landscape; a mad crew worshipping a goat in a Witches' Sabbath; and a monstrous, madly staring Saturn devouring his children (fig.

Fig. 13–11. Francisco Goya. *Saturn Devouring His Children*. 1813–23. 4'9" × 2'8". The Prado, Madrid.

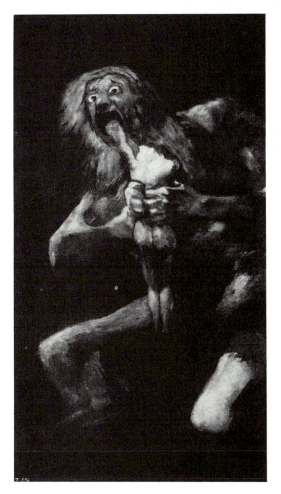

13-11). In these works Goya turned to the macabre and demonic not to induce romantic thrills—indeed, there is little of the romantic in Goya except his dramatic intensity—but to reflect his fascination with the more tragic aspects of mental and emotional life. In both his subject matter and his method—flat, almost two-dimensional figures, distortion, an arbitrary simplification of light and color—he pointed clearly toward modern art.

France

The French clung longest to neoclassicism in the face of the rising romantic movement. The Academy continued as a powerful conservative force. David remained the most influential of painters during his lifetime, and after his death in 1825 his friends and followers Ingres and Gros became the leaders of the classical school.

Jean Auguste Dominique Ingres (1780-1867) remained the bulwark of French neoclassicism until his death, the recognized leader of those who opposed Delacroix and the new trends. Ingres developed a clear, precise linear style from which he never deviated. Though he belittled the importance of color, he handled it subtly in many portraits of almost photographic accuracy, as well as in such works as *The Bath* (fig. 13-12). Though he was a classicist, Ingres exploited the popularity of the exotic Orient to paint, in his cool style, harem scenes teeming with voluptuous nudes.

Eugene Delacroix (1798–1863), one of the greatest painters of the romantic age, was an exceptionally versatile artist whose works ranged from huge murals to searching portraits. He called himself a classicist, but he revived and adapted the romanticism of the baroque age, especially that of Rubens—dramatic lighting, diagonal and spiraling movements, and brilliant use of color to define form and express emotion.

Delacroix often derived his subject matter from masterworks of Western literature—the writings of Dante, Scott, Goethe

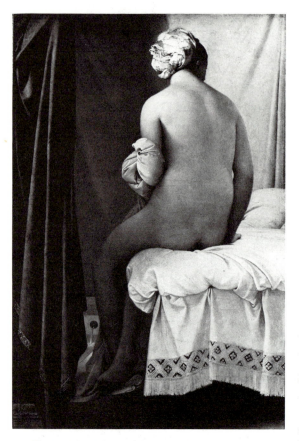

Fig. 13–12. Dominique Ingres. *The Bath* (*La Baiqneuse de Valpinçon*). 1808. The Louvre, Paris.

Delacroix also concerned himself with contemporary political and social matters. One of his paintings, *Massacre at Chios* (or *Scio*), is based on a brutal episode in the Greek war of independence. Another, probably his most famous work, is a semiallegorical painting called *Liberty Leading the People*—a bare-breasted, powerful figure of Liberty leading the people of Paris, businessmen, youths, and students, in the July Revolution of 1830 that overthrew King Charles X.

In 1832 Delacroix spent four months in Morocco as official painter for a diplomatic party. His painting thereafter took on greater brilliance of color, and he did dozens of works based on his African sketches and memories: *The Sultan of Morocco; The Women of Algiers* filled with rich texture and glowing colors that won the praises of the great painters of later generations, including Renoir and Picasso; *A Jewish Wedding* with its color and life; and paintings of scenes that combined his enthusiasm for action and conflict with his lifelong interest in animals—*Lion Hunt, Tiger Devouring a Horse,* and others. The effect on all later painting of Delacroix's vital forms and intense colors was immense. "We all paint differently because of him," said Cézanne, who was in turn one of the most influential of modern painters.

In the mid-nineteenth century a group of landscape painters, all admirers of Constable and the Dutch landscapists, became identified with the little French village of Barbizon. The group, who came to be known as the Barbizon school, included Theodore Rousseau and Jean François Millet. Associated with them are such notable painters as Corot and Daubigny. The most sentimental but at times the most starkly realistic of the Barbizon painters was Millet (1814-1875), who specialized in scenes of peasant life. His famous *Angelus* (fig. 13-15) is often cited as an extreme example of romantic sentimentality; but his *Man with the Hoe* became a celebrated denunciation of the brutalizing effects of unrewarding labor.

During his last years Camille Corot (1796-1875) was probably the most popular

(whose *Faust* he illustrated in a series of lithographs), Shakespeare, Byron, and others. From Dante's *Inferno* he selected a dramatic incident in which Dante and Vergil are ferried across the marsh of Styx as wrathful spirits tear at each other and gnaw the boat in their rage. This work, *The Bark of Dante* (fig. 13-13), with its lurid light, powerfully painted nude bodies, and intense emotionalism, was Delacroix's first major success. It was followed by another masterwork, *Hamlet and Horatio in the Graveyard* (fig. 13-14), with Hamlet and his friend under an eerie, cloud-streaked sky as the gravedigger hands out a skull.

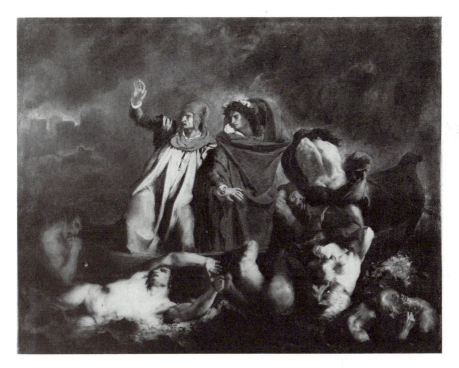

Fig. 13–13. Eugène Delacroix. *The Bark of Dante*. 1822. The Louvre, Paris.

Fig. 13–14. Delacroix. *Hamlet and Horatio in the Graveyard*. 1839. The Louvre, Paris.

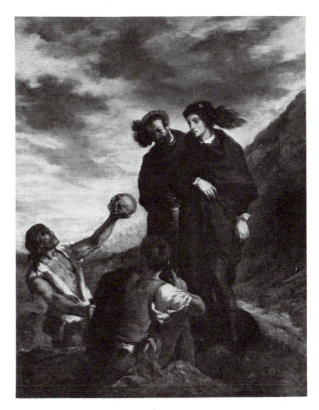

Fig. 13–15. François Millet. *The Angelus*. About 1850. The Louvre, Paris.

Fig. 13–16. Camille Corot. *View of Genoa*. 1834. Approx. 12 × 16″. Courtesy of the Art Institute of Chicago. Mr. and Mrs. Martin A. Ryerson Collection.

painter in France, both with the public and with his fellow painters, whom he often encouraged in financial and other ways. As a young man he spent a few years making sketches around Rome, Genoa, and other Italian cities, and these are now considered his finest work. His *View of Genoa* (fig. 13-16) is an example of his early style, in which he suggests light and perspective by gradations of tone rather than by color and line. In his middle years, departing from the clear lighting and defined forms of his earlier work, Corot developed a popular poetic style—misty gray-green landscapes inhabited sometimes by people, sometimes by nymphs and other woodland creatures.

Later Romanticism in England

The Pre-Raphaelites. England's last important romantic painters were a group of youthful artists and writers—Dante Gabriel Rossetti, William Holman Hunt, John Everett Millais, and others—who first mystified the public by calling themselves the "P. R. B." Their aim was to return to what they thought was the simplicity and sincerity of Italian painting before Raphael. In a few instances they achieved that aim, painting with bright, pure colors and with extreme concern for accuracy of detail. Public response, favorable at first, turned against them when it was learned that the initials meant "Pre-Raphaelite Brotherhood" and that the young artists evidently considered themselves superior to Raphael, than the supreme idol among painters. Charles Dickens attacked as blasphemous Millais' *Carpenter Shop* (fig. 13-17), an attempt to depict in modern but quite reverent terms the youthful Christ in the shop of Joseph. Much more typical of the movement than *The Carpenter Shop* were paintings that treated literary themes, especially medieval ones such as Hunt's visualization of Tennyson's *Lady of Shalott* (fig. 13-18), an intricate work in which one can

Fig. 13–17. Sir John Everett Millais. *Christ in the House of His Parents (The Carpenter Shop)*. 1850. The Tate Gallery, London.

Fig. 13–18. William Holman Hunt. *The Lady of Shal-ott*. 1889. Courtesy Wadsworth Atheneum, Hartford. The Ella Gallup Sumner and Mary Catlin Sumner Collection.

find little of the simplicity or the sincerity that the movement claimed for itself. A veiled sensuality, sometimes combined with religiosity, underlies most Pre-Raphaelite painting. Though Hunt alone stayed true to its initial ideals, its dreamy world of medieval romance strongly appealed to other artists such as Sir Edward Burne-Jones and William Morris.

American Romantic Painters. After the American Revolution many young painters went to Europe to study and travel. Some of them stayed, but most of them came home, and they were joined by painters from England, Germany, and elsewhere who emigrated to America. Among those who returned were John Trumbull, who did patriotic paintings (some of them very familiar), of such subjects as the surrender of Cornwallis and the signing of the Declaration of Independence; Gilbert Stuart, painter of over a thousand portraits, who made Washington's face familiar to the world; and Charles Willson Peale, one of the most gifted

of earlier American artists and father of four or five successful painters. Others were Washington Allston, a painter of dreamy, sometimes allegorical landscapes, and Samuel F. B. Morse, a successful portrait painter.

Thomas Cole (1801-1848), an English-born itinerant portrait painter who came to America when he was eighteen, helped to establish the first real tradition of American landscape painting. He, along with Thomas Doughty, Asher Durand, and others, founded the informal group called the Hudson River school—painters of the native scene, not only in New York but eventually even the Far West. Looking at the natural, often untouched landscape of the New World with religious awe and with the eye of a romantic poet, Cole captured the serenity of summer days in the Catskills—vistas of water, forest, and mountain. Cole sometimes looked back to Europe and to earlier ages for his subjects, but not so his friend and follower Asher Durand (1796-1886). With the adventurous, optimistic vision of a pioneer, Durand found all the inspiration he needed in the American

scene. A romantic striving for sublimity shines through such works as his *Kindred Spirits* (fig. 13-19), which shows the poet William Cullen Bryant and the painter Thomas Cole pausing, on a walk through the Catskills, to respond to the beauty of a rugged mountain gorge.

Others loosely associated with the Hudson River school are such diverse painters as Frederic Church (1826-1900), who painted vast, panoramic scenes of dramatic natural phenomena such as Niagara Falls, spectacular sunsets, and the mountains of South America; and Alfred Bierstadt (1830-1902), German-born artist who gained international fame as a painter in the German romantic style and who gave Easterners some of their first awe-inspiring impressions of the Rockies and Yosemite.

More of a poet and mystic, less concerned with fidelity to nature on the grand scale than the Hudson River painters, was George Inness (1825-1894), America's greatest landscapist before the present century. An admirer of Corot and a deeply spiritual artist, he invested his tranquil scenes (both of Europe and of America) with a quiet intensity, a dreamlike quality that blends earth, trees, and sky into a harmonious whole. Typical are his *Autumn Oaks; Peace and Plenty*, a soft green and gold evocation of the harvest season; and *Lackawanna Valley* (Colorplate 12).

While America was developing its first important group of landscapists, other painters such as George Caleb Bingham and William Sidney Mount were depicting river boatmen, election scenes, barn dances, and other American activities and ways of life in a vigorous fashion that anticipated the realism which was to dominate the arts, in America as well as elsewhere in the Western world, during the later nineteenth century.

Fig. 13–19. Asher Durand. *Kindred Spirits*. 1849. New York Public Library (Astor, Lenox and Tilden Foundations).

14 REALISM AND IMPRESSIONISM

The era that began about 1850 and ended early in this century has been given a number of labels. Historians have given it such seemingly contradictory titles as the Age of Nationalism and Imperialism, the Age of Science and Doubt, and the Age of Progress. Students of English history and literature call it the Victorian Age. More broadly, literary and cultural historians have designated it the Age of Realism (or Realism and Naturalism). Each of these is valid in its own way. It is the last, however, the Age of Realism (to which we would add Impressionism) that concerns us here.

The romantic spirit of the first half of the century continued to be an important force in the second; often it moved toward extremes of sentimentality in poetry, fiction, and painting. But other powerful forces influenced the romanticism of the era or ran counter to it. The most important of these was realism.

A number of forces contributed to a shift toward realism in the arts. One was science, which focused increasing attention on the physical world and the physiological aspects of the human being. Scientists' interests had been largely theoretical and philosophical before the nineteenth century, but they suddenly shifted toward invention and technology as numerous advances were made in the areas of power, transportation, communications, industrial and agricultural machinery, medicines, synthetics, building materials, and instruments of war. Such developments remade the environment in which people lived and largely deromanticized it in the process. Though the manmade aspects of the world we know today are chiefly products of the twentieth century, their foundations were laid in the nineteenth.

The Industrial Revolution reached a peak in the first half of the nineteenth century with the introduction of new inventions in the cotton industry, the development of steam power, the growth of the factory system, and the beginnings of the railroad age. It reached a second peak in the latter part of the century, when new sources of power such as electricity and oil were developed.

Along with mechanization and the burgeoning of industry came the growth of a large working class and massive shifts of

population from farms to mining towns or to cities and, by immigration, from country to country. Though some observers looked upon the situation with complacency, others were alarmed by what they saw: disease, illiteracy, crowded and filthy living conditions, long working hours, near-starvation wages, child and female labor, and mass exploitation in general.

Reforms were inevitable. They were set in motion by working people themselves as strikes became increasingly powerful weapons; by the efforts of an occasional enlightened employer such as Robert Owen; by acts of legislation such as the reform bills in England; and by the efforts of writers like Ruskin and Dickens and of painters like Daumier and Courbet, who helped to arouse the public conscience. The life of the common people, which earlier writers and artists had generally glamorized if they had been interested in it at all, now became a principal concern.

Other developments drew people's eyes toward the social and economic matters that lie at the core of much realistic art. One was an increasing *nationalism,* reflected in the unrest of smaller nations struggling for independence and in the emerging of larger political units such as Germany and Italy. A second was *expansionism,* especially evident in the westward movements of the United States and Canada. A third, by no means a new movement, was *imperialism,* and with it, *colonialism,* the powerful competitive impulse that led the major Western nations to lay claim to large areas of the world—partly in the name of a desire to "civilize" and Christianize backward peoples, but more often for materialistic and political reasons. A fourth development, and one which became the most pervasive intellectual force behind the realist movement, was the advent of *biological science,* especially the Darwinian theory of evolution and Freudian psychology. The moral, religious, and aesthetic questions provoked by the theories of Darwin and Freud powerfully affected the

art and thought of the world and continue to do so.

Realism and Other Movements. In its simplest sense *realism* is an attempt by the artist to reproduce or imitate reality as it is seen or imagined, unmodified by the idealizing of either the classicist or the romanticist. The realist is generally concerned with the here-and-now, with the world as he or she knows it. Since it is impossible to reproduce in its entirety even the briefest moment of real experience, the realist must be selective. Those experiences or situations must be chosen that most clearly represent or symbolize actuality as it is seen. However dedicated the realist may be to truth and accuracy, the fact that ultimately "actuality" is seen only through his or her own eyes is a limiting factor.

Realism, like romanticism, is as much an attitude as a style. The Hellenistic sculptors of the *Gaul Killing His Wife* and of the *Old Market Woman* were essentially realists. Velázquez, in an age of baroque romanticism, was an almost unwavering realist. Balzac, first of France's important creators of realistic fiction, wrote when the romantic movement in Europe was it its height. In short, the style, if it is a style, is not necessarily dictated by the times. A few periods, however, such as the one we are now concerned with, have been dominated by the realistic outlook.

Naturalism, a literary movement of the last years of the century led by the French novelist Emile Zola, went beyond realism in applying scientific notions to fiction. In theory it regarded its characters as objects in a laboratory experiment, will-less products (more often victims) of environment and heredity. The naturalists were concerned, not with beauty but with what they considered scientific truth. They were fascinated by the theories of the new sciences of psychology and sociology, and they were often active supporters of reform movements.

Impressionism, a term applied especially to painting, music, and literature, relates to science in a way quite different from that of the naturalists. The impressionists had no sociological theories to promote or causes to support. Impressionist painters were intrigued by the science of optics, of the phenomena of color—colors of objects in the world around them and techniques of applying color to canvas in new and exciting ways. Impressionism was essentially an "art-for-art's-sake" movement, concerned with beauty, with fleeting moments of sensory experience, with capturing the essence of such moments in color, sound, and verbal symbols.

Another "art-for-art's-sake" movement was symbolism, an international movement that centered around several French poets. Symbolism was a romantic reaction against realism that tried, in effect, to express the inexpressible, the ineffable, by means of complex and often quite private methods of symbolizing. The symbolists were less important in themselves than in their influence on twentieth-century art, especially poetry. All of these movements—Realism, Naturalism, Impressionism, and Symbolism—will be elaborated upon in what follows.

LITERATURE

Tennyson, Browning, Longfellow, and other major romantic poets lived well into the post-Civil War era. All of them were aware of the new world of science and of sociological and economic change. Some reacted against it and some tried to adapt to it. Many writers of the period produced great amounts of sentimental and moralizing verse and highly romantic fiction. Poetry of all schools took second place to fiction—especially to the novel—except for the work of a few extraordinary poets such as the Americans Walt Whitman and Emily Dickinson.

Realism

French Fiction. Nineteenth-century realism began with the novels of Honoré de Balzac (1799-1850), a remarkably productive writer who lived and wrote when romanticism was at its height. At around thirty he conceived the enormous work that occupied the rest of his life—a related series of almost one hundred novels and stories (under the general title *The Human Comedy*) meant to reflect the main aspects of the life of his time. He peopled his fiction with over two thousand characters, many of whom appear and reappear in a number of works. Though he created a preponderance of unusual figures, he clearly intended an accurate portrayal of his society; and his disillusioned eye saw a world disintegrating morally, economically, and socially. He seemed to know intimately the social and financial maneuverings of the wealthy and would-be wealthy, such as the merchants, the bankers, and the decadent nobility, and more than anyone else he was responsible for making social status and money two of the major concerns of realistic fiction.

Balzac created many memorable characters that are at once both individuals and types—incarnations of dominant passions such as miserliness, sexual lust, and craving for social status. Among his best works are *Eugénie Grandet,* the story of a gentle girl and her miserly, inhumanly harsh father; *Father Goriot,* the tragedy of a father's obsessive devotion to his daughters; and *Cousin Bette,* whose hate-consumed name character dominates a complex, multilevelled plot.

Balzac's greatest successor in France was Gustave Flaubert (1821-1880). Largely withdrawn from society, Flaubert spent five years or more on each of the few novels he produced. He developed a prose style that is unsurpassed for grace and quiet brilliance and that influenced the work of many followers. Flaubert's first and most famous novel, often considered the purest example

of realistic fiction, is *Madame Bovary*. It is the story of a shallow, sentimental woman who destroys herself and her unimaginative but loyal husband as she searches for a soul-shattering love in a variety of adulterous affairs.

Russian Fiction. Russia's two major contributions to the arts of the Western world were made largely during the second half of the nineteenth century, in music and realistic fiction. Her great literary hero before that time was Pushkin, whose realistic pictures of Russian life in *Eugene Onegin* and other writings (Ch. 13) strongly affected the course of Russian literature.

Pushkin's younger contemporary Nikolai Gogol (1809-1852) combined realism with farcical satire in his delightful comedy, *The Inspector General*. Gogol's masterpiece, an unfinished novel called *Dead Souls*, contains vividly drawn scenes of country life and a number of unusual characters whom we meet as we travel with Chichikov, a wily rogue who buys "dead souls"—serfs who have died since the last census—in order to borrow money on their names. Gogol's humanitarianism and deep social concern color all his works.

Gogol was followed by the three giants of Russian fiction, Turgenev, Dostoevski, and Tolstoy. Like Dante, Milton, and other masters of literature, they were at once superb artists and men of ideas profoundly concerned with the moral and social issues of their time. They employed fiction rather than factual prose partly as a means of attempting (by no means successfully) to escape political censorship. All three were great storytellers who were able to create extended, real-seeming worlds peopled with characters whom the reader is likely never to forget.

A strong vein of poetry runs through the novels of Ivan Turgenev (1818-1883), but he considered himself a complete realist. As such he dealt with Russia's basic problems: with the intellectual conflicts between the westernizers, who believed in assimilating the political and cultural ways of western Europe, and the Slavophiles, who fiercely defended native Russian ways (Turgenev was a westernizer); with the lot of the serfs (he advocated emancipation and humanitarian reforms); and with the conflicts between the czarist autocracy and the growing radical and reform groups. Turgenev produced a series of fine novels in a realistic style much like that of Flaubert—*On the Eve, Fathers and Sons, Smoke, Virgin Soil*, and others. Most famous is *Fathers and Sons*, concerned with the clash of generations but dominated by an intense young radical whose values are put tragically to the test when he falls in love with a beautiful aristocrat.

More powerful than the novels of Turgenev are those of Feodor Dostoevski (1821-1881), whose own life story reads like melodramatic fiction. (A political prisoner, he faced a firing squad but was given a last-minute reprieve.) Though plagued by constant ill health, Dostoevski produced large quantities of political prose and several of the world's great novels, including *The Idiot, The Devils, Crime and Punishment*, and *The Brothers Karamazov*, the latter two his masterpieces. *Crime and Punishment* tells of a young intellectual whose notion that he and other superior persons are above the law leads to his committing a murder and to the long process of his partial redemption through suffering. *The Brothers Karamazov* is a long, engrossing story of a dissolute father and his four sons, each in his own way a powerful character study, and of a murder which once again leads to a fundamental Dostoevskian conclusion: only through suffering and a Christlike abnegation of self can one gain salvation.

Count Leo Tolstoy (1828-1910), as a nobleman, was increasingly unhappy with what he saw in Russia—political oppression, extremes of wealth and poverty, the shallowness of aristocratic life, and the empti-

ness of orthodox religion. He dealt with such problems in his great novels. One of them, *War and Peace,* is a vast, panoramic narrative of the lives of several Russian families and hundreds of other characters—a whole society, in fact—set against the background of the Napoleonic invasion of Russia. The novel is filled with richly drawn scenes of domestic, social, and military life in a great variety of settings, peopled with dozens of carefully individualized characters. Almost as memorable is *Anna Karenina,* a somewhat more dated story of adultery and suicide. *Anna Karenina's* most important character, apart from Anna herself, is Levin, who finds fulfillment in a life of Rousseauian simplicity and a Christian concern for the peasants under his charge.

English and American Fiction. In England the Brontë sisters, Charlotte (1816-1855) and Emily (1818-1848), wrote novels that are romantic, not to say melodramatic, in plot and often in setting, but realistic in their probing of emotional and psychological states. Charlotte's *Jane Eyre* and *Villette* are based in part on her own life, the latter on her experiences as a teacher of English in Belgium. As for Emily's *Wuthering Heights,* many of her contemporaries were repelled by what seemed to them clumsy structure, horrifying incidents of plot, and incredible characterization; but the novel is now regarded as a masterpiece. Modern critics see in it sure-handed artistry and keen psychological insight, along with a sustained dramatic intensity that has made it a popular subject for stage and film presentations.

George Eliot (Mary Ann Evans, 1819-1880) wrote many novels, some of which strike modern readers as overly sentimental. All of them, however, are distinguished by vivid characterization, strong narrative flow, and philosophical depth. (She saw no reason to withhold her reactions to the events in her novels). Among the best-known are *Silas Marner, Adam Bede,* and *The Mill on the Floss,* but her greatest work is *Middlemarch,* a large-scale sociological novel

that creates a fictional world almost as large and wisely observed as that of *Anna Karenina* in Russia.

Of several successful novels by William Makepeace Thackeray (1811-1863), all with distinctive historical and social settings, the most famous is *Vanity Fair.* It is the story, cheerfully satirical and occasionally sentimental, of Becky Sharp, an intriguing and utterly confident social climber who takes on the tradition-bound, money-mad society of early nineteenth-century England.

Charles Dickens (1812-1870) was and probably is the most popular novelist in the language. So skillfully could he capture the "feel," or atmosphere, of his settings—Canterbury, the slum areas of London, and other parts of southeast England—and so unforgettable are his characters and the stories he tells about them, that even cynical modern readers are willing to overlook implausible twists of plot and more than a little sentimentality. Some of his works, including *A Tale of Two Cities,* are historical novels. Some, notably *Oliver Twist* and *The Old Curiosity Shop,* deal melodramatically with the lower strata of London life. Some, such as *Great Expectations,* are dynamic studies of character. Richest and most carefully realized is *David Copperfield,* based in part on Dickens's own early life and filled with memorable characters, some of whose lives unfold over a considerable period of time. Almost all of Dickens's novels helped to jar the conscience of the English-speaking world regarding such matters as child abuse, barbaric penal systems, disgraceful schools, and inefficient legal and judicial practices.

Herman Melville (1819-1891) has come to be recognized as one of America's greatest writers of fiction. In addition to semi-auto-biographical novels of travel and adventure in the South Seas (*Typee* and *Omoo*), numerous short stories, and disturbing psychological novelettes (*Billy Budd* and *Benito Cereno*), Melville created a masterpiece in *Moby Dick,* a symbolic novel of adventure on a whaling ship. Many chapters relating to the lore of whaling are essentially realistic. But as the

great symbolic chase intensifies, the narrative and descriptive prose becomes more and more poetic. The characters, with a few exceptions, are more typical of poetic drama or epic than of realistic fiction—above all, peg-legged Captain Ahab, embodiment of superb courage coupled with an obsessive if unconscious urge for self-destruction in his craving for vengeance on the white whale Moby Dick, symbol of the evil of the universe.

Mark Twain (Samuel L. Clemens, 1835-1910) scoffed at American romanticism and European traditionalism. His *Innocents Abroad* burlesques the American traveler in Europe who is overawed by his guidebooks, his guides, and anything antiquated and European. It also satirizes the brash American who is determined to show contempt for anything he is unfamiliar with. Twain had his own deep vein of sentiment which shows through in most of his work, including *Huckleberry Finn,* once thought of as a children's thriller but now regarded as a major landmark—some would say *the* major landmark—of American fiction.

A listing of even the more important figures of the age of realistic fiction could be considerably extended. Among those who deserve more detailed mention than they can receive here is Joseph Conrad (b. 1857), a Polish-born seaman who learned English in his mature years, developed a subtle and rhythmical prose style in this language, and wrote numerous novels and long stories, including *Lord Jim*, *Victory*, and *Heart of Darkness*. Many of his works are romantic in their Far Eastern and African settings, but realistic in their careful detail and profound explorations of such psychological states as fear and loneliness. Another important realist is the American William Dean Howells, (b. 1837), who demonstrated in such novels as *The Rise of Silas Lapham* and *A Modern Instance* that conventional people with traditional moral standards could make significant material for fiction. Henry James (b. 1843) was an Anglo-American author who wrote about the subtle interplay of mind and emotion of sensitive people in difficult social situations. A recurrent theme in his fiction was that of the American thrown into sophisticated European circles. Many of his novels, especially the later ones, are too cerebral to be widely enjoyed, but several—*The American, The Bostonian, Washington Square, The Portrait of a Lady, The Wings of the Dove*, the short novel *Daisy Miller*, and the psychological thriller *The Turn of the Screw*—are deservedly popular.

Naturalism in the Novel. Naturalism, as we have said, was an attempt by some late nineteenth-century writers, led by Emile Zola and the Goncourt brothers in France, to apply scientific methods to the writing of fiction. The naturalists conceived of the human being as an object of nature like any other animal, a product of biological, chemical, economic, and social forces. There were naturalists who believed that anything, however sordid, brutal, or repellent, that impinged on character could be rightfully included in the novel. Thus developed a far greater frankness regarding sexual matters and biological functions than had appeared before. In theory everything that happened to their characters resulted from the impacts of environment and heredity; in fact some at least of these characters broke the bonds of predetermined destiny and asserted independent wills.

Out of the mechanistic theories of the naturalists came some readable fiction. Zola's novels include *Nana*, the compelling story of a vulgar courtesan, and a greater work, *Germinal*, a moving indictment of social and economic injustice in the coal mining areas of northern France.

The fiction of George Eliot in England was affected by the doctrines of naturalism, but not so much as were the novels of Thomas Hardy (1840-1928). Hardy's determinism was less biological or economic than philosophical. People's destinies, he argued, are determined by what he loosely called fate—by accident, coincidence, the mindless forces of necessity, or even a malicious will that

enjoys its cat-and-mouse game with humanity. Life for most humans, in Hardy's view, is catastrophic; the few who survive and flourish are those who live uncomplicated rural lives, understanding nature and accepting what it inflicts. Many who disagree with Hardy's brand of determinism have been enthralled by his novels—by his impelling if sometimes melodramatic plots, his memorable characters, and his rich, almost unsurpassed sense of place. These qualities permeate *The Return of the Native, Far from the Madding Crowd, Tess of the d'Urbervilles,* and—most darkly pessimistic of all—*Jude the Obscure.*

In America, naturalism found its chief exponents in Stephen Crane and Theodore Dreiser. Crane (1871-1900), a gifted newspaper correspondent, poet, and writer of fiction who died at twenty-nine, produced a number of excellent short stories, including "The Open Boat," and two short novels—*Maggie, a Girl of the Streets* and the remarkable war novel *The Red Badge of Courage*—all in the naturalistic vein. America's most dedicated naturalist was Dreiser (1871-1945). His big novel *An American Tragedy* is the story of a young man whose weak character—a product, Dreiser implies, of forces beyond his control—leads to his committing a murder.

Drama: Realism and Experimentation. Few dramas of lasting importance were written in Europe and America in the earlier part of the nineteenth century. But beginning about 1870, a number of major playwrights emerged. Among them were Henrik Ibsen in Norway, August Strindberg in Sweden, Gerhart Hauptmann in Germany, Anton Chekhov in Russia, Maurice Maeterlinck in Belgium, Oscar Wilde and George Bernard Shaw in Ireland and England, and a group of Irish playwrights led by John M. Synge.

August Strindberg (1849-1912) wrote harrowing naturalistic dramas such as *Miss Julie* and *The Father,* followed by experiments in expressionism in *The Dream Play* and oth-

ers. Gerhardt Hauptmann (1862-1946) spanned a wide range from realism to fantasy—realism in *The Weavers,* which deals with exploitation and abuse in the textile mills of central Europe, and fantasy in the poetic symbolism of *The Sunken Bell.*

The greatest of the nineteenth-century playwrights, however, and possibly the greatest dramatist since Shakespeare, was the Norwegian Henrik Ibsen (1828-1906). After a few poetic dramas that included *Peer Gynt,* a mixture of fantasy and folklore, Ibsen turned to the realistic prose dramas which have affected the course of dramatic art in the past hundred years probably more than any others. His works abound in themes that have a way of reasserting their importance time and again—*A Doll's House,* for instance, which is about women's liberation in a sense but is more deeply concerned with everyone's right to be an individual. In *The Wild Duck,* one of his finest and subtlest plays, he asks whether there is not a kind of ruthless quest for truth, a probing into other people's lives, which is destructive, and whether we should not sometimes be left to cherish our illusions. The conflict between reality and self-deception is a major theme of *The Master Builder,* one of his later masterpieces. Ibsen was a craftsman who knew how to construct gripping plots and create living characters that can never be forgotten.

One of Ibsen's most enthusiastic admirers was the Anglo-Irish playwright George Bernard Shaw (b. 1856). Not as great a dramatist as Ibsen, Shaw used the play as a vehicle for talk—some of it witty, some genuinely funny, some earnest and wise, and some tedious—about social and other problems. Always on the attack against hypocrisy and smugness, Shaw wrote a few plays that are still capable of delighting and sometimes disturbing—*Androcles and the Lion, Pygmalion* (out of which came *My Fair Lady*), *Candida, Arms and the Man,* and one or two others.

Shaw's fellow Irishman Oscar Wilde (1854-1900) wrote one excellent serious play, *Salomé.* As for his others, they are at their best when he lets farcical comedy take

over—*The Importance of Being Earnest*, for one, which is full of ridiculous twists of plot, wit, puns and paradoxes from its title to its last line.

A subtle and strangely moving kind of drama came from the pen of Anton Chekhov, (1860-1904), a Russian physician who was one of his country's greatest authors. In stories and plays that manage to be compelling without being intense or dramatic in the usual sense, he balances humor and pathos—even tragedy—as he depicts the irritating pinpricks, the small joys and sorrows, the loneliness, the sad awareness of change that constitute much of life for human beings. Chekhov's unique blending of comedy and poignancy can best be seen in his masterpiece, *The Cherry Orchard*, as well as in such plays as *The Sea-Gull* and *Three Sisters*.

Poetry in America. Walt Whitman (1819-1892) included Emerson among his early admirers. Most of his contemporaries, however, saw him as undisciplined and willfully unconventional, both in his ideas and in the free verse form of his poetry. Some modern readers, going too far in the other direction, consider him a controlled and disciplined artist. There is much art in Whitman, but there is also much prosaic longwindedness. The art can best be seen in such short war poems as "Beat! Beat! Drums!" and "As Toilsome I Wander'd Virginia's Woods," and in the sustained lyricism of the elegies, including "When Lilacs Last in the Dooryard Bloom'd." His longer poems, though less controlled, contain the substance of his great themes: buoyant optimism, visionary faith in democracy, and a strong current of transcendental thought and religious mysticism. All are essentially romantic themes integrated with the physical, biological world with which the poet strongly identified.

As original in her way as Whitman was Emily Dickinson (1830-1886), a shy New England recluse who wrote hundreds of short poems that have been published since her death. Her work had the good fortune, in one sense at least, of coming to light when there was a reading public prepared for her mannered style and for her paradoxes, cryptic utterances, and balancing of devoutness and skepticism. Paradoxical aphorisms permeate her verse: "I like the look of agony/Because I know it's true"; "Much madness is divinest sense/To a discerning eye." Many of her poems are about death, many about unfulfilled love. Many are short bits of intensely personal philosophy. Perhaps most popular are her statements of faith ("I Never Saw a Moor") and her sharp metaphorical responses to nature: the frost is a "blind assassin"; the snake, a "narrow fellow" that in the grass "occasionally rides."

The Symbolists. The symbolists, who had their beginnings in Paris, were a group of late nineteenth-century poets who rejected realism in favor of a sensory and aesthetic approach to life. Their forerunner was Charles Baudelaire (1821-1867), a perverse, gifted poet and critic whose life ran the gamut from foppishness through degradation to a kind of religious redemption. He employed striking figures of speech, including *synesthesia*, in which one sensation calls up the responses of another—certain sounds, for instance, that bring to the mind's eye certain colors.

In his single volume of verse, *Flowers of Evil*, Baudelaire evoked a strange kind of beauty in ugliness, decadence, and the morbid aspects of death. The symbolists who followed—Verlaine, Mallarmé, and others—expressed a similar sense of hopelessness, with no outlet but sensuousness and artistic sensation. As symbolists they avoided direct statement and went beyond earlier poets who had employed symbols in a manner that could be easily interpreted.

Like Poe, of whom they were fond, the symbolists were enthralled by the sounds of poetry, both of individual words and of whole passages that could be interpreted as symphony-like. The purposes of the symbolists in poetry were closely related to those

of the impressionists in music and painting. It was natural that Debussy, the greatest impressionist composer, should not only write a musical paraphrase of Mallarmé's celebrated symbolist poem, "Afternoon of a Faun," but base an opera on the most famous of symbolist plays, Maeterlinck's *Pelléas and Mélisande*.

MUSIC

Strictly speaking, apart from imitative sounds music can be realistic only through its association with words—poems and their titles, operatic librettos and their titles, and so on. It can be said that music is realistic in its ability to evoke the temper and traditions of a people, as in nationalistic music—Spanish and Slavonic dances, for example—but the feeling of such music is apt to be romantic.

A number of operas that employed realistic or even naturalistic plots and settings—works by Bizet, Mascagni, Leoncavallo, Puccini, and others—were composed in the second half of the century. But most music of the era reflected the romantic attitudes of the earlier 1800s. Impressionism, in some ways a reaction against both realism and romanticism but more closely related to the latter, expressed itself in a small but important movement in music.

Religious Music. Choral groups— choirs and choral societies—have flourished throughout Europe and America for the past two hundred years, and large amounts of choral music, sacred and secular, have been composed for them to perform. After Mendelssohn's great *Elijah*, first presented in 1846, the most memorable oratorio was *The Dream of Gerontius*, an original and moving work composed by Sir Edward Elgar and first performed in 1900.

The mass continued to attract ambitious composers, including the German Anton Bruckner. The two most powerful requiem masses of the century, Verdi's

Requiem and Brahms' *German Requiem*, were mentioned in Ch. 13. In contrast to these is the restrained and quietly moving *Requiem* that Gabriel Fauré, a French composer, presented in 1887 in honor of his father.

The Opera. Verdi's greatest rival in the second half of the century was the German composer Richard Wagner. Some composers, unlike the innovative Wagner, were still using the traditional operatic forms such as arias and ensembles, but finding new, realistic plots that dealt with ordinary people like dockhands, factory workers, dressmakers, and students. Other composers, especially the Russian ones, were exploiting nationalistic themes.

In 1875 the French composer Georges Bizet (1838-1875) gave to the world the opera *Carmen*, based on a lurid, semi-naturalistic short novel by Prosper Mérimée. Bizet lived only a few months more—not long enough to know that his work, which was vilified when it was first presented, was to become one of the two or three most popular of all operas. Mérimée's story tells of a Basque soldier in Seville who succumbs to the seductions of a cigarette-making gypsy girl and ultimately stabs her to death. The operatic version is less sordid than the novel; in Bizet's opera the downfall of the young soldier Don José has tragic overtones. The opera's continuing success rests largely on its exciting music—arias such as Carmen's "Habanera," Don José's "Flower Song," the "Toreador Song" of Don José's rival Escamillo, and stirring ensembles and choruses. Because the characters—soldiers, townspeople, factory workers—are commoners in commonplace settings, *Carmen* is often called a realistic or *veristic* opera.

Carmen was followed by other veristic operas: in France by Charpentier's melodic *Louise*, with a seamstress as its heroine; and in Italy by two celebrated short operas in the style called *verismo* (naturalism): *Cavalleria Rusticana*, by Mascagni, and *I Pagliacci*, by Leoncavallo. Both have to do with commoners involved in melodramatic love tri-

angles that end in violent death, and both have melodic, broadly dramatic scores that their composers were never again to equal.

Mascagni and Leoncavallo were overshadowed by the greatest Italian composer to follow Verdi, his much younger friend Giacomo Puccini (1858–1924). Generally Puccini did not try to rival Verdi's dramatic power; most of his operas lean toward lyricism and verism. Several of his works, however, involve stories of almost brutal intensity. *Tosca*, for instance, is a gripping drama that centers around one of opera's most sinister villains, Baron Scarpia, and ends in tragedy by the walls of Rome's Castel Sant' Angelo. His *Il Tabarro* (The Cloak) is a chilling short opera in *verismo* style.

More widely popular are Puccini's lyrical works such as *La Bohème* and *Madame Butterfly*, ostensibly realistic but actually romantic and sentimental. Permeating all of Puccini's operas are his uniquely beautiful melodies—soaring phrases supported by rich sounds from the orchestra.

The German composer Richard Wagner (1813–1883) was far removed from Puccini and the other veristic composers, who borrowed some of his techniques while they and he scorned each other. Wagner revitalized the idea of a complete blending of words and music, of the use of music to realize the psychological and emotional implications—in a sense the realism—of story and character. He thought of opera as music drama, and he conceived of music drama as total theater, with powerful actor-singers, expanded orchestras and choruses, and the ultimate in elaborate costuming and spectacular scenic effects. A competent scholar and poet, Wagner wrote his own librettos, drawing them largely from the myths and legends of Scandinavia and Germany.

Wagner developed the technique of the *leitmotif* (leading motive or guiding theme), a short musical phrase associated with a person, idea, or emotion. Such a *leitmotif* can anticipate the appearance of a character, accompany his appearance, or remind us of him when he is gone. *Lohengrin*, not the most

complex of Wagner's music dramas, is said to have at least forty-five *leitmotifs*. In his later work, with the exception of his great comic opera *Die Meistersinger*, Wagner largely eliminated the old set forms such as arias and duets, and obliterated the distinction between recitative and song. He made the orchestra an even more expressive instrument than had any of his predecessors in opera.

To the true Wagnerite, one does not know the master unless he or she knows the four huge operas of the *Nibelungen Ring* cycle. The librettos for the operas are based on the *Nibelungenlied*, a medieval German folk epic, and on related Norse myths. Putting it most simply, they tell of the decline and death of the Norse gods and the deliverance of humanity. The underlying philosophy is a complex mixture of paganism and Christian thought, of power politics and pacifism, of pessimism and optimism—about which his admirers still debate warmly. The operas in the *Ring* cycle are *Das Rheingold*, *Die Walküre*, *Siegfried*, and *Die Götterdämmerung* (*The Twilight of the Gods*).

Few have occasion to know the *Ring* cycle well, but it is possible to get a feeling for the work by listening to excerpts from it, such as the solo in *Das Rheingold* that the god Wotan sings as he sees a rainbow bridge leading to his new castle, Valhalla: "Abendlich strahlt der Sonne Auge" ("See How at Eve the Eye of Sunlight"). More immediately accessible to most listeners are Wagner's comic opera *Die Meistersinger* and *Lohengrin*, both less complex in plot structure and both with well-known arias and orchestral pieces.

Wagner had few direct followers (Richard Strauss was one of those few). His titanic themes and sometimes grandiose style did not lend themselves to imitation, though Engelbert Humperdinck, in his *Hansel and Gretel*, made pleasant use of the *leitmotif*. Debussy followed the recitative style of Wagner's *Tristan* and other music dramas. But the influence of Wagner was, finally, a generalized and pervasive one.

Instrumental Forms. Johannes Brahms (1833-1897) had composed many songs, his great *German Requiem,* and much instrumental music such as his *Hungarian Dances* before he produced his four symphonies. All of them demonstrate his adherence to the classical sonata-allegro form, but all have an underlying intensity and emotional power that is distinctly romantic. Each symphony in its way is a distinguished work, and all four are frequently performed. Composed during the same period were Brahms's only violin concerto (one of the finest works in that form) and his two piano concertos. Critics have called the Second Piano Concerto, with its wonderful balancing and blending of solo instrument and orchestra and its powerful climaxes, the greatest of piano concertos.

The symphonic works of Anton Bruckner (1824-1896) were somewhat underrated in his own time but are much admired by today's concertgoers, who are evidently undisturbed by the length and the loose structure of his symphonies and find them, to quote Winthrop Sargent, "fresher, bolder, more innovative, more complex, more moving, and expressive of a larger range of feeling" than those of Brahms. Especially admired are his Fourth and Seventh Symphonies.

The supreme romanticist among later nineteenth-century composers was the Russian Peter Ilyich Tchaikovsky (1840-1893). The point can easily be overstressed; his music was seldom the unrestrained outpouring of emotion that is sometimes assumed. He was a craftsman who paid increasing attention to form and detail, and he wrote some of his brightest and most ingratiating music—the *Nutcracker Suite,* for example—in periods of intense personal difficulty. Emotion does prevail, however, emotion expressed in lush melodies, repeated phrases that rise in pitch and intensity, surging and falling dynamics, and dramatic orchestration.

There are Slavic elements running throughout much of Tchaikovsky's music, especially his one successful opera, *Eugene Onegin,* and his Second Symphony. Each of the greater symphonies—the Fourth, Fifth, and Sixth—has Russian elements, along with the melodic themes that have become so well-known a part of Western music.

Tchaikovsky's ballets and suites and shorter orchestral pieces are among his most familiar works—*The Nutcracker, The Sleeping Beauty, Swan Lake, Romeo and Juliet,* the tone poem *Francesca da Rimini,* and such familiar pieces as the *1812 Overture* and *March Slav.*

Contemporary with Tchaikovsky and much more dedicated than he to preserving and promoting Russian traditions were a group of gifted and ardent nationalists. They included Alexander Borodin (1833-1887) an amateur who composed some thoroughly Russian string quartets and the opera *Prince Igor,* a great, sprawling work based on Russian epic legend. The opera was finished after Borodin's death by Rimsky-Korsakov and others. Rimsky-Korsakov (1844-1908) himself, less a Slavophile than some of his companions, was attracted to the exotic lore of distant places such as Spain and the Orient. His best-known work, *Scheherazade,* is a symphonic suite, vividly colored and suggestive of the Near East. It is based on the moods and atmosphere, if not the actual stories, of the *Arabian Nights.*

Greatest of the Russian nationalists was Modest Moussorgsky (1839-1881). A boldly original composer, Moussorgsky identified himself with the Russian people and used their rough melodies, strange scales, and shifting rhythms. His small output includes a famous satirical solo for basso, "The Song of the Flea," the familiar fantasy for orchestra "A Night on Bald Mountain," and "Pictures at an Exhibition," vivid musical descriptions of watercolors and paintings by a deceased friend. Moussorgsky's masterpiece, *Boris Godunov,* is now regarded as the greatest of Russian operas, with the most demanding and rewarding bass role in all operatic literature. It is notable for its prologue and procession scene, with brasses, clanging bells, and powerful choruses; and a harrow-

ing hallucination scene in which Boris has visions of the young prince he has had murdered.

Other nationalist composers include the Bohemian Bedrich Smetana (1824-1884), who composed a popular comic opera, *The Bartered Bride*, and the familiar symphonic poem *Vltava* (The Moldau); and Antonin Dvořák (1841-1904), also a Bohemian, who is known for his *Slavonic Dances* and for a number of symphonies. These include the familiar Symphony No. 9 in E Minor ("From the New World"), in which Dvořák combines a Czech flavor with the "spirit," as he put it, of American Indian and Negro music. He composed it during a three-year stay in the United States.

The music of Edvard Grieg (1843-1907) reflects the musical traditions of his native Norway. Familiar in themselves and made more so by musicals and films are the melodies of his two *Peer Gynt* suites and those of his Piano Concerto in A Minor, one of the best-known works in the concert repertory.

Spain produced only a few composers of consequence in the period (including Isaac Albéniz and Manuel de Falla). But many others were attracted at least in spirit to that land, which they considered the most exotic and colorful in the Western world. Non-Spanish composers of "Spanish" music include the Russian Rimsky-Korsakov, the French Bizet, and other Frenchmen such as Eduard Lalo (*Symphonie Espagnole*), Maurice Ravel (*Rhapsodie Espagnnole* and *Bolero*), and Claude Debussy (*Iberia*).

Impressionism in Music. Claude Achille Debussy (1862–1918) was influenced almost as much by the theories of poets and painters as by his fellow musicians. He was attracted to Monet and Renoir, who were concentrating on fleeting phenomena of light and color, and to Mallarmé, Verlaine, and other symbolist poets who were using words to suggest rather than to state. Debussy explored a similar ideal in music—to paint impression-

istically with sounds. In striving to create mood and atmosphere he made frequent use of unresolved chords and of chords strictly for their own sake and not as part of a harmonic progression. Though he did not abandon tonality (i.e., an established scale), he often came close to it. He was interested not in power and strong emotion but in an infinite variety of subtle colors, produced primarily by woodwinds, harps, and strings.

Debussy's first major success was his *Afternoon of a Faun*, in which he used Mallarmé's poem as a program to describe the fleeting, sensual experiences of a woodland deity, half-man and half-goat. This work was followed by other impressionistic compositions that are descriptive of constantly changing aspects of nature—clouds (*Nuages*), water (*Reflets dans l'Eau*), moonlight (*Clair de Lune*), and the sea (*La Mer*).

Debussy's greatest work is his operatic setting of Maeterlinck's symbolist drama, *Pelléas and Mélisande*. He used the play almost without change as the libretto for his opera. He followed the natural cadences of the speaking voice, highlighting the meanings of words in a manner that is both melody and talk. The play, a curious blending of fairy tale, medieval romance, and psychological drama, is a love story in the tradition of Tristram and Iseult—the tragedy of a princess who becomes romantically involved with the young brother of the elderly prince to whom she is married. Though the play is not without moral implications, its characters are transparent, guileless beings who reach out for each other in a world of constant change. Symbols of transience abound: water in fountain, stream, and sea; Mélisande's flowing hair; flights of birds and vanishing ships.

Debussy left no school of followers, but many composers have made use of his innovations. Most important of these was Maurice Ravel (1875-1937). Though Ravel is often linked with Debussy as an impressionist, he was probably closer to the classical tradition. In addition to the Spanish-inspired

works mentioned earlier, Ravel is best known for such witty works as the opera *L'Heure Espagnole* and the fantastic opera-pantomime *L'Enfant et Les Sortileges* (*The Child and the Sorceries*); the melodic "Pavanne for a Dead Princess"; and his most Debussy-like work, *Daphnis and Chloe,* composed for Diaghilev's Russian Ballet Company.

ARCHITECTURE

The first buildings erected to suit the needs of the industrial age—factories, warehouses, and similar structures—were mostly shelters and little else. As the century passed, some new buildings incorporated the new materials, especially iron, that the Industrial Revolution made available. In other areas, engineers, who did most of the architectural pioneering, were using iron in graceful and sturdy bridges. Some far-sighted builders adopted innovations such as the use of struc-

tural iron and other new materials, and employed improved methods of heating and lighting. Out of these developments grew the first genuinely new principle in building since the Renaissance—*functionalism* or, as some call it, *realism* in architecture.

One of the most spectacular of the new buildings was the enormous Crystal Palace built in London for the Great Exhibition of 1851 (fig. 14-1). Built mostly of glass and iron, it enclosed nineteen acres of Hyde Park. Its nearly 300,000 panes of glass were made and cut elsewhere, as were its more than 5000 iron columns and girders. They were assembled in the remarkably short time of six months, in one of the first major instances of prefabrication and mass production. The builder was Joseph Paxton, a former gardener.

Even before 1851 a Parisian builder, Henri Labrouste, had made ingenious use of iron and glass in the library of Ste.-Genevieve. Its interior consists of two long, par-

Fig. 14–1. Joseph Paxton, Crystal Palace, London. 1850–51.

allel barrel vaults supported by patterned, arched girders and tall iron Corinthian columns. In the 1890s Labrouste erected a still more pleasing structure, the National Library in Paris (fig. 14-2). Again he used slender cast-iron columns, but this time he suspended over them nine vaulted, sky-lighted domes.

Other iron-and-glass buildings, often decorated in historical styles, were erected during the period. The most spectacular and controversial feat of the time was the erection of the great tower built for the Paris International Exhibition of 1889 by Gustave Eiffel (1832-1923). However nonfunctional it may have been initially—many uses have since been found—it demonstrated the almost limitless possibilities of precisely engineered and prefabricated materials.

America now began to assume the front-running position in architecture that it has since held. The multilevel or skyscraper concept came into being in America in the 1860s when the elevator became practical. America's first prominent architect of the period was Henry H. Richardson (1838-1886), whose massive buildings with round-arched window sections showed his fondness for the Romanesque style. His most influential building, since torn down, was the huge Marshall Field warehouse in Chicago, which, though it had suggestions of both a Romanesque church and a Renaissance palace, was a forerunner of the skyscraper. A number of Richardson-designed buildings, including the impressive Trinity Church in Boston, the Town Hall in Albany, and a number of mansions, have become landmarks of American architecture.

Richardson was a member of the important Chicago school of architecture. Another was Louis Sullivan (1856-1924), a modern architect in the true sense. Some of his early buildings show Richardon's influence, but more original are the "tall buildings" he designed, among them the Guaran-

Fig. 14–2. Henri Labrouste. National Library, Paris. 1854.

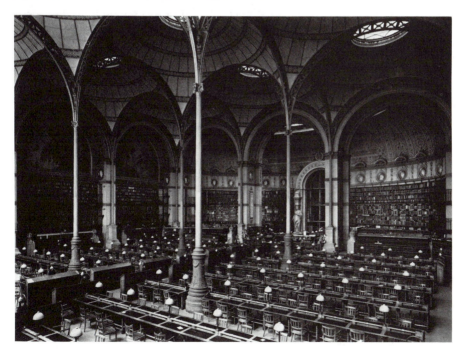

Fig. 14–3. Louis Sullivan, Wainwright Building, St. Louis. 1890–91 (with recent additions by Hastings and Chivetta).

ty Building in Buffalo and the Wainwright Building in St. Louis (fig. 14-3). Frank Lloyd Wright called the latter, now a state office building, "the master key to the skyscraper." In these and in the Carson, Pirie, Scott Building in Chicago he pioneered the practice of using masonry to cover a steel skeleton. Though Sullivan was the first to pronounce the now-commonplace doctrine "Form follows function," he made frequent use of nonfunctional decorative elements around doors and under cornices and windows—intricate wrought-iron, terra cotta, or carved stone tendrils and leaf arrangements.

The latter part of the century, especially in America, was marked by the erection of thousands of homes, ranging from cottages to mansions, in a variety or mixture of historical styles—classical, Gothic, and Oriental, for example. Most often reflecting a taste for the Gothic—turrets, elaborate woodwork inside and out—they are loosely grouped under the label *Victorian*. The scorn that was heaped on their ornate "gingerbread" earlier in this century has largely been replaced by a nostalgic kind of admiration.

SCULPTURE

Large amounts of decorative and commemorative sculpture, such as statuary for parks, cemeteries and public squares, continued to be produced throughout the nineteenth century, in America as well as in Europe. America produced its first important sculptors in the middle years of the century, most of them European-trained. They included Hiram Powers, who carved what came to be a sensationally popular *Slave Girl*; and Horatio Greenough, who did a heroic seated statue of George Washington, now in the Smithsonian Institution—for most Americans, probably, a noble work even though it depicts the first President seminude, posed like Jupiter on a throne.

America's greatest sculptor of the century, Augustus Saint-Gaudens (1848-1907), also studied in Europe. Though commissioned mostly to do huge commemorative works, he was an innovative artist who often turned to native American subjects. His first important work, executed in Rome, was a statue of *Hiawatha*. In America he did a figure of Lincoln for Lincoln Park in Chicago, one of the best of the many sculptured portraits of that president. Equally well known is his *Admiral Farragut* in Madison Square, New York (fig. 14-4), a statue of considerable vitality and majesty. Another of Saint-Gaudens's works is his *Deacon Chapin* in Springfield, Mass., an idealized image of a strong-jawed, cape-clad Puritan, weapon in one hand and Bible in the other.

Another famous *Lincoln*, the huge, brooding figure in the Lincoln Memorial in Washington, D.C. (fig. 14-5) was sculpted by

Fig. 14–4. Augustus Saint-Gaudens. *Admiral Farragut.* 1881. Madison Square, New York. Courtesy National Sculpture Society.

Fig. 14–5. Daniel Chester French. *Abraham Lincoln.* Lincoln Memorial, Washington, D.C. Begun 1915. Marble, approx. 30' high including pedestal. Photo Bill Clark, National Park Service.

Daniel Chester French, a less dynamic but highly popular follower of Saint-Gaudens. French also did the familiar *Minuteman* in Concord, Mass.

Western America brought forth a trio of important sculptors, all European-trained, who leaned almost entirely toward American subjects. Mahonri Young (1877-1957),

grandson of the Mormon leader Brigham Young, was a realist who did large-scale portrait sculptures and monuments but also many action studies, often statuettes, of prizefighters and workmen, such as the *Man with a Pick* (fig. 14-6). Cyrus Dallin (1861-1944) balanced realism and romance in his dignified, often moving studies of Indi-

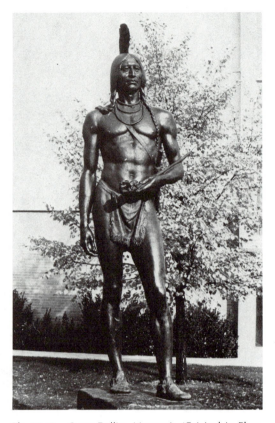

Fig. 14–6. Mahonri Young. *Man with a Pick*. Bronze. The Metropolitan Museum of Art. Gift of Mrs. Edward H. Harriman, 1918.

Fig. 14–7. Cyrus Dallin. *Massasoit*. (Original in Plymouth, Mass., 1920). 9½′ high. Bronze replica, Brigham Young University.

ans, including a great figure of *Massasoit* in Plymouth, Mass. (fig. 14-7). He also created the familiar statue of *Paul Revere* near Boston's Old North Church. A third Westerner, Gutzon Borglum (1871-1941), was a student of Rodin. Borglum's taste for the colossal realized itself in the gigantic faces of Washington, Jefferson, Lincoln, and Theodore Roosevelt (each about sixty feet from hairline to chin) at Mt. Rushmore in South Dakota; and in the earlier stages (others completed the work) of the huge Confederate Memorial at Stone Mountain in Georgia.

Overshadowing all other sculptors of the period was the French artist Auguste Rodin (1840–1917), generally recognized as the greatest sculptor since Michelangelo and Bernini. Rodin made thousands of sketches in ink or clay of details of the human body, usually in motion, as he caught them from a model or group of models moving or posing in his studio. He left the execution of his works, whether in bronze or stone, to artisans who worked from his clay models.

Many of Rodin's works depict only parts of bodies—his famous *Hands of God*, for instance, or *Sorrow*, the grief-stricken face of a girl emerging from a shadowy matrix of stone. His interest in fragments identified him with the impressionists' concern for emerging, momentary effects. He polished or roughened surface textures, deepened

hollows and accentuated details, to create reflections or shadows. Always he was intrigued with motion or gesture.

Rodin is sometimes called a realist, but even his portrait statues are strongly impressionistic—for example, his famous statue of *Balzac*. His greatest single project was a large allegorical portal based in a general way on Dante's *Inferno* and called *The Gates of Hell* (fig. 14-8). From it or from studies for it he derived such famous works as *Adam*, *The Thinker*, and *The Kiss*.

For many, Rodin's masterpiece is a group called *The Burghers of Calais* (fig. 14-9). In it are represented six leading citizens of fourteenth-century Calais, who volunteered to be executed in order to meet the demands of England's Edward III that six citizens give up their lives before he would cease making war on their city. (On the urging of his queen, Edward spared them and gave up the siege.) Rodin's six gaunt but powerful figures are depictions, each carefully individualized, of fear mingled with resignation.

Rodin had a number of followers, including Antoine Bourdelle, Gutzon Borglum, and the American-English Sir Jacob Epstein (Ch. 15). Less influenced by Rodin were the Swedish sculptor Carl Milles (1875-1955), whose highly imaginative, grav-

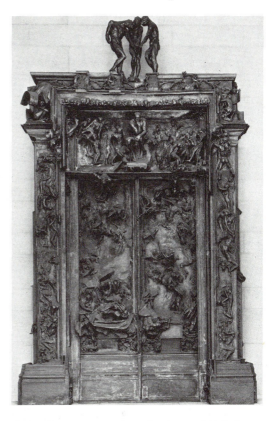

Fig. 14–8. Auguste Rodin. *The Gates of Hell*. Begun 1879. Philadelphia Museum of Art.

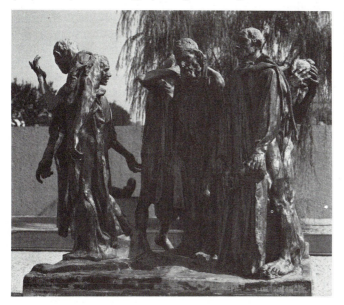

Fig. 14–9. Auguste Rodin. *The Burghers of Calais*. 1886. Bronze, 82 × 95 × 78″. Hirshhorn Museum and Sculpture Garden, Smithsonian Institution.

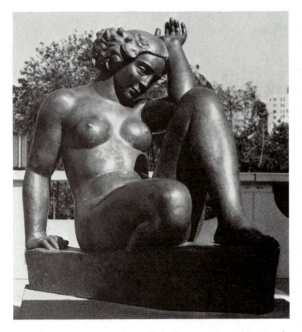

Fig. 14–10. Aristide Maillol. *The Mountain.* 1937. Lead, cast, 65½" high. Norton Simon Inc. Foundation, Pasadena, California.

ity-defying sculptures of such things as trolls on horseback and boys riding dolphins grace parks in Sweden, America, and elsewhere; and the French artist Aristide Maillol (1861-1944), who revived classical ideals in the large-limbed, smooth, serenely beautiful female figures to which he often gave such names as *The Air, The River,* and *The Mountain* (fig. 14-10).

PAINTING

Nowhere, in an era of change, have changes occurred more frequently in the past century and a quarter than in the art of painting. Several of the dozen or more important shifts in style in that period occurred before the turn of the century or shortly after—realism, impressionism, divisionism, postimpressionism, and *art nouveau* among them.

Realism. Many earlier painters, from the van Eycks and Bruegel to Chardin and Goya, were essentially realists. But realism as a movement in modern painting had its beginnings in the lithographs and paintings of Daumier and Courbet in France, and it found a natural home in America in the work of such artists as William Sidney Mount, George Caleb Bingham, Winslow Homer, and Thomas Eakins.

A self-proclaimed "realist," the first prominent painter to use the term, was the French artist Gustave Courbet (1819–1877). He rejected both classicism and romanticism and dedicated himself to painting people and nature as he saw them, with no graceful lines or glowing colors and, in theory at least, with no selection or arrangement of the details of a landscape. An ardent democrat, Courbet first shocked the public with a scene of dire poverty called *The Stonebreakers.* In 1850 he created a second sensation with a huge painting, *Funeral at Ornans* (fig. 14-11), a stark, unromanticized, moving depiction of a peasant funeral. Courbet's most famous work is another large painting, a semi-philosophical one called *The Painter's Studio, a Real Allegory Summarizing a Period of Some Years in My Life.* It shows the painter at work on a landscape, an unglamorized nude model gazing over his shoulder and groups of friends, poor people, and exploiters of the poor looking on or absorbed in themselves.

Honoré Daumier (1808-1879), a quiet, retiring man, made his living as a cartoonist, and his incisive lithographs lampooned the powerful and reflected his pity for the poor. Most famous of his works is *Rue Transonain,* based on an incident during the civil disturbances of 1834 when soldiers shot a group of innocent people in a Paris apartment. The picture shows the bleeding corpse of a man stretched across that of a babe. Daumier's satire is often directed toward what he saw as the emptiness of public and official minds, as in *They Say the Parisians Are Hard to Please* (fig. 14-12). Little known during his lifetime were the strong realistic paintings to which he devoted his later years.

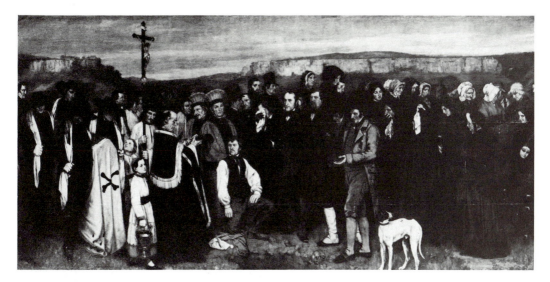

Fig. 14–11. Gustave Courbet. *Funeral at Ornans*. 1849. 10′3″ × 21′9″. The Louvre, Paris.

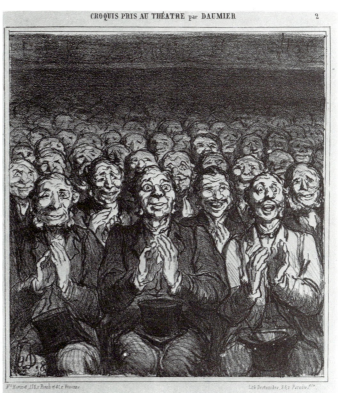

Fig. 14–12. Honoré Daumier. *They Say the Parisians Are Hard to Please.* About 1870. Lithograph. Courtesy Museum of Fine Arts, Boston. Bequest of W. G. Russell Allen.

Though America had its important romantic painters, there was much in this country that encouraged a sharp-eyed, often satirical realism. George Caleb Bingham and William Sidney Mount did excellent genre paintings of riverboat and country life. They were essentially realists, as was John James Audubon, America's most famous naturalist-painter. David Gilmour Blythe, with his biting political cartoons and war paintings, was a lesser Daumier.

Several American realists of major stature emerged after the Civil War. One was Winslow Homer (1836-1910). After an early career as an illustrator and war correspondent for a news magazine, Homer turned to oil painting and produced works based on his war sketches—*Prisoners at the Front*, for instance, which focuses, as do all his war paintings, on the human and personal side of war. Next he painted beach scenes, sunny pictures of children at school and at play, and pictures of farm life in both the North and the South, all warmly realistic. Then came his best-known paintings—hunting scenes and sea paintings, usually with some narrative content—some in oils and many in watercolors. They include the familiar *Gulf Stream* and *Eight Bells* (fig. 14-13). With little romanticizing he stressed the dramatic aspects of his scenes: a black seaman lying aboard a derelict vessel; a canoe shooting boiling rapids; an unconscious woman being rescued by lifeline from a sinking ship. His seas themselves are dramatic ones, painted in strong, rhythmical brush strokes and near-monochromatic colors. Increasingly he omitted human beings from his seascapes

Fig. 14—13. Winslow Homer. *Eight Bells*. About 1883. Courtesy Addison Gallery of American Art, Phillips Academy, Andover, Mass.

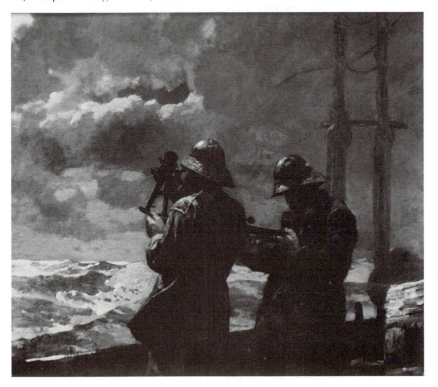

and depicted the elemental power of coastal storms.

The great American painter Thomas Eakins (1844–1916) thought of himself as a scientist as well as a painter. He observed natural phenomena with great care and made careful geometrical studies to determine spatial relationships in his paintings. His best works, however, betray little evidence of a mechanical approach. His unglamorized, insightful portraits and his studies of oarsmen, swimmers, and boxers capture expressions and movements with exceptional fidelity. His most famous work, a modern version of Rembrandt's *Anatomy Lesson*, is *Gross Clinic* (fig. 14-14), a painting whose stark realism offended many of its first viewers.

Several other important American painters of the later nineteenth century can be mentioned only briefly here. One is Albert Pinkham Ryder (1847-1917), whose poetic, semiabstract paintings were some years ahead of their time and have become increasingly popular since his death. They include such visionary paintings as *The Race Track* (or *Death on a Pale Horse*) and *Siegfried and the Rhine Maidens* (fig. 14-15), Ryder's evocation of a scene from Wagner's *Götterdämmerung*. Another is James McNeill Whistler (1834-1903), artist and aesthete, who spent most of his adult life in London. Strongly influenced by Japanese art, he painted elegant, graceful studies of women, such as his lovely *Little White Girl*, which he called *Symphony in White No. 1* (fig. 14-16); and impressionistic studies of London's bridges or of fireworks exploding against a

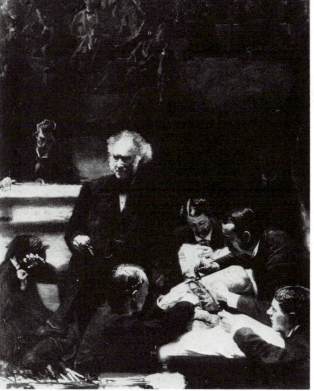

Fig. 14–14. Thomas Eakins. *The Gross Clinic*. 1875. Courtesy of Thomas Jefferson University, Philadelphia.

Fig. 14–15. Albert Pinkham Ryder. *Siegfried and the Rhine Maidens.* 1875–91. 20 × 20″. National Gallery of Art, Washington, D.C.

Fig. 14–16. James McNeill Whistler. *Symphony in White No. 1: The White Girl.* 84½ × 42½″. National Gallery of Art, Washington, D.C. Harris Whittemore Collection.

night sky. Whistler was an artist whose aim was pure beauty—art-for-art's-sake—removed from any philosophical or other intention. Still another, also an expatriate, is John Singer Sargent (1856-1925), a brilliant artist who could paint high society portraits, impressionistic picnic scenes, and mood paintings of the back alleys of Venice with equal skill.

Transitional Painters. The French painters Edouard Manet, Edgar Degas, and Henri Toulouse-Lautrec are often called impressionists, though the label does not fit

well on any of them; Manet, in fact, said he did not like the term. It is true that all were associated with the impressionists, but all retained a nonimpressionistic enthusiasm for careful composition, and seldom did any of them allow their forms to dissolve in light and color.

The earlier painting of Manet (1832-1883) is somewhat like that of Goya in that he employed almost two-dimensional effects—often black- or red-clad figures, painted with little modeling, against shallow backgrounds. After a number of paintings on Spanish subjects, Manet turned to a softer,

Fig. 14–17. Edouard Manet. *A Bar at the Folies Bergère*. 1881–82. 37½ × 51". Courtesy Home House Society Trustees. The Courtauld Collection, London.

more impressionistic style in such happy works as *Boating at Argenteuil*. His culminating work, painted shortly before his death, is a quiet but bright-surfaced painting, *A Bar at the Folies Bergère* (fig. 14-17), which takes liberties with spatial relationships as lights glitter and positions shift around a center of stillness provided by a pensive barmaid.

Though Edgar Degas (1834–1917) shared the impressionists' interest in changefulness, he was concerned not with evanescent lights and colors but with moving forms and changing postures. He believed that human forms could be reduced to what he called "essential gestures." The whole problem was to recognize, remember, and record those gestures that caught the essence of a moment. Over and over again, in a variety of media, he depicted a few subjects that lent themselves to his candid-camera approach: horse races; women ironing, buying millinery, or stooping to bathe themselves in large wooden tubs; lively theater and stage show scenes; and above all ballet dancers on the stage or at the practice bar— "skinny, overworked little girls," says one writer, "striving for effects," but nonetheless with an aura of charm about them (fig. 14-18).

Fig. 14–18. Edgar Degas. *Ballerina and Lady with Fan*. About 1876. Philadelphia Museum of Art. John G. Johnson Collection.

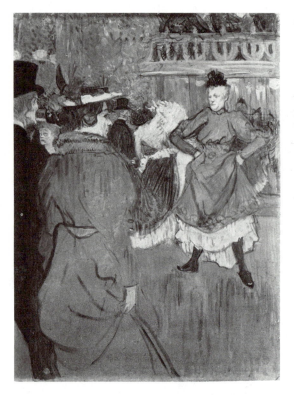

Fig. 14–19. Henri de Toulouse-Lautrec. *Quadrille at the Moulin Rouge.* 1885. Gouache on cardboard, 31½ × 23¾". National Gallery of Art, Washington, D.C. Chester Dale Collection, 1962.

Manet and Degas were among the first to appreciate the possibilities of the camera and also to be intrigued by the unusual angles and flattened perspectives of the Japanese prints that were then becoming popular.

Degas's feeling for the oblique angle, the glimpse of an unguarded moment, also characterized the work of Henri Toulouse-Lautrec (1864-1901), a dwarf-life man described by his friends as "kindness itself." He devoted his brilliant talents to making lithographed posters that capture form and movement with a few sure lines and a minimum of colors; and to recording, as an observer and not a social critic, the gayer and often seamier sides of Paris life—circuses, dancehalls, cafés, and brothels. *Quadrille at the Moulin Rouge* (fig. 14-19) is a record, without comment, of a style of life.

The Impressionists. The term *impressionism* was initially applied to a movement in painting that caught the public eye in the 1870s. Though the movement itself largely died out by the turn of the century, impressionist paintings, originals or reproductions, remain highly popular. The term was first used mockingly by a French journalist who wrote a scathing review, headlined "Exhibition of the Impressionists," of the works of a group of painters who had organized their own exhibit when their works had been refused by the Salon (the government-sponsored exhibition). One of the paintings was a picture by Monet called *Impression: Sunrise.*

One can now see little that seems radical in the aims or the work of the impressionists. Basing their theories in part on scientific studies of the physics of light, they tried to achieve naturalism by depicting the effects of light as it plays on the surface of objects (especially unstable objects such as water and leaves) and as it fills the intervening atmosphere. Scientists had demonstrated that when a color is placed next to its complementary—red next to green, for instance—they tend to intensify each other. Hence it was deduced that the painter could achieve greater intensity by keeping his colors separate, applying them in small dabs and letting the viewer's eye do the "mixing." (Such a practice was not always followed, of course.) The colors of the spectrum as they gleam from a prism were most prized, and black suppressed. Shadows were tinged with the complementary colors of adjacent objects. The effect, in reality, did not often prove to be naturalistic, but it was often beautiful. What the critics and the public objected to, evidently, were the vivid, unacademic brightness of color, the lack of firm outlines, the apparently careless, slapdash technique, and the unclassical, non-narrative subject matter.

Important early members of the French

impressionist movement were Camille Pissarro and Alfred Sisley. Most representative of the impressionists was Claude Monet (1840-1926). "Poor, blind idiots," he said in response to the public reaction to his *Impression: Sunrise;* "they want to see everything clearly, even through the fog." He proceeded to paint a thoroughly foggy picture—the Paris station of Gare St. Lazare as trains moved in and out through heavy smoke and steam. He painted it several times (fig. 14-20 is an example). He adopted the practice of painting a single subject a number of times in varying lights and seasons. Among his "series" subjects are haystacks and his impressions of the façade of Rouen Cathedral. In his old age he worked on his last series—a number of paintings, some of them semiabstract, of his lily pond as he observed it from his indoor-outdoor studio.

Auguste Renoir (1841-1919), when he painted a boating scene, was more interested in the people in the boat than in sparkling surfaces or trembling leaves. In fact, the title *impressionist* applies less accurately to him than to Monet. Even at the height of the movement he was painting his smooth-skinned, cleanly drawn *Bathers,* which have only hints of impressionism in the backgrounds. He enjoyed challenges of form and composition—a gay pattern of umbrellas in a rain shower, for instance. His lifelong delight was humanity—happy and unusually beautiful people, painted simply for their visual appeal. No one ever created a larger gallery of beautiful women and fresh, charming children than Renoir. An example is *Two Girls at the Piano* (fig. 14-21). Another is *At the Seashore* (fig. 14-22), with free painting in the background and the gown, but careful modeling in the serene face of the young women.

Fig. 14–20. Claude Monet. *Old St. Lazare Station, Paris.* 1877. 23½ × 31½". Courtesy of the Art Institute of Chicago. Mr. and Mrs. Martin A. Ryerson Collection.

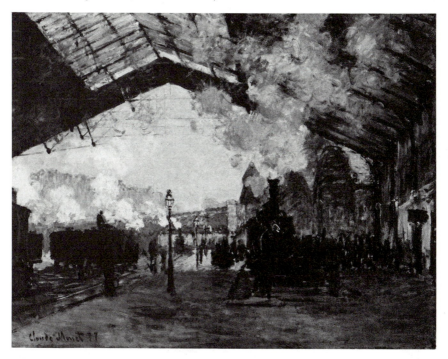

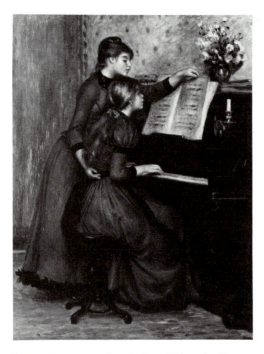

Fig. 14–21. Auguste Renoir. *Two Girls at the Piano.* 1891. Joselyn Art Museum, Omaha.

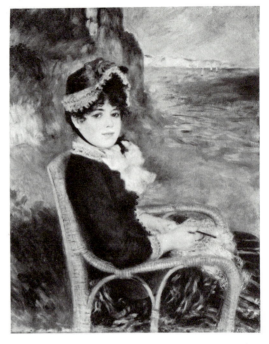

Fig. 14–22. Auguste Renoir. *By the Seashore.* 1883. 36¼ × 28½″. The Metropolitan Museum of Art. Bequest of Mrs. H. O. Havemeyer, 1929. The H. O. Havemeyer Collection.

A number of Americans quickly adopted impressionist techniques; they include Mary Cassatt (who spent most of her life in Paris), Childe Hassam, and Theodore Robinson.

Divisionism (Neo-impressionism). The impressionistic device of separate, eye-blended color was carried to its ultimate by the French artist Georges Seurat (1859-1891). He developed a style of painting called *divisionism* (or *neo-impressionism* or *pointillism*). Seurat defined forms and their nuances by innumerable dots of subtly varying color. Rejecting the impressionists' carefree construction, he evolved a highly formal, "classical" theory of planes and proportions, all meticulously worked out and with figures as static and impersonal as mannequins. His most famous work is *A Sunday Afternoon on the Island of La Grande Jatte* (fig. 14-23). A recent critic has said of it that no veristic film director could ask for "more eloquent images of urban man's loneliness in a crowd." Seurat's technique, usually with modifications, influenced a number of important painters.

Primitivism. The primitives were and are a long line of amateur painters, continuing at least through Grandma Moses in America. Of the now-famous primitives who flourished in the nineteenth century, two are the American Edward Hicks (1780-1849), who painted more than fifty versions of his well-known *Peaceable Kingdom*, and the French painter Henri Rousseau (1844-1910), who made intriguing, sometimes haunting paintings of humans and animals in dream-like jungle settings (fig. 14-24). One writer

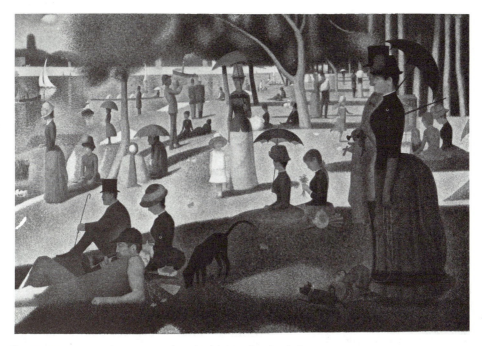

Fig. 14–23. Georges Seurat. *A Sunday Afternoon on the Island of La Grande Jatte.* 1884–86. 81 × 126″. Courtesy of the Art Institute of Chicago. Helen Birch Bartlett Memorial Collection.

Fig. 14–24. Henri Rousseau. *The Dream.* 1910. 6′8″ × 9′9″. The Museum of Modern Art, New York. Gift of Nelson A. Rockefeller.

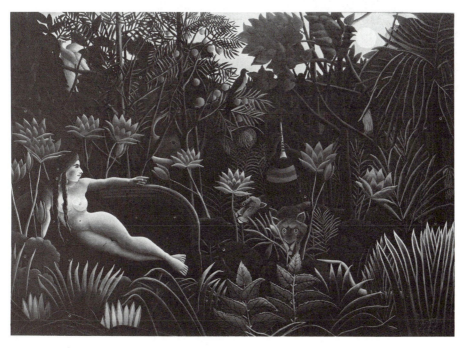

dismisses the primitives as "amateur and other bungling painters . . . in whom technical ignorance and unsophisticated vision are accounted virtues." Others take them more seriously.

Art Nouveau. Another late nineteenth-century style was *art nouveau,* as sophisticated as primitivism was naïve. *Art nouveau* caught something of the essence of the gay or naughty nineties, a flamboyant era that sometimes expressed itself in exotic, often decadent art and literature. Strongly influenced by oriental art and using forms and colors derived from the more exotic aspects of nature—butterfly wings, peacock feathers, curling tendrils—*art nouveau* expressed itself in all manner of arts and crafts, from jewelry, wallpaper, elegant books, and lamps to entire houses. The movement's most famous artist was Aubrey Beardsley (1872-1898), who became famous overnight for his sinuous, faintly sinister black-and-white illustrations for Oscar Wilde's play *Salomé* (fig. 14-25). The movement has had a recent lively revival, especially among those who seek out the Tiffany lamps and other beautifully crafted glassware and jewelry of the period.

Postimpressionism. Called postimpressionists for want of a better name are three of the nineteenth century's greatest painters, Van Gogh, Gauguin, and Cézanne. All three were concerned, not with atmosphere and the play of light but with solid (though not naturalistic) objects and with strong composition. They also turned away from the often superficial subject matter of the impressionists toward more deeply felt and significant themes. Postimpressionism was a forerunner of expressionism, first of the major art movements of the present century.

Vincent Van Gogh (1853-1890) turned seriously to painting after early experiences as a teacher, lay preacher, and art dealer in his native Holland and in Belgium, England, and France. His first paintings, of which *The Potato Eaters* is best known, reflect in their dark tones and homely realism his concern for the peasants and miners of northern Europe. In Paris, after a few works in the dotted, divisionist style of Seurat, he revealed his genius in such paintings as a fine portrait of *Père Tanquy,* an old art dealer posing formally in front of Japanese art objects. Vincent then began an outpouring of paintings, sometimes as many as four a day, that continued with few interruptions until his death four years later. He went to Arles, in southern France. Here, working in largely unblended strokes or applying paint with his palette knife, he painted flowers, fishing boats, peasants, and the Arlesian landscape in sunshine and storm. He painted such emotion-packed scenes as the famous *Starry*

Fig. 14–25. Aubrey Beardsley. *Salomé.* About 1894. Illustration for Oscar Wilde's published drama.

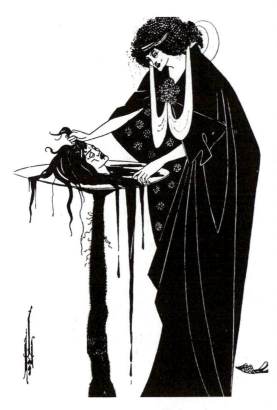

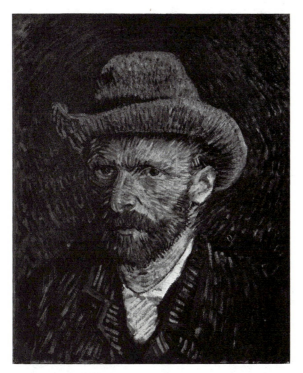

Fig. 14–26. Vincent Van Gogh. *Self-Portrait with Gray Hat.* 1887. Vincent Van Gogh Foundation, National Museum, Amsterdam.

Night and *Night Café* (Colorplate 13). He wrote of the latter, "I have tried to express the terrible passions of humanity by means of red and green I have tried to express the idea that a café is a place where one can ruin one's self, run mad, or commit a crime." His emotional balance, never stable, gave way in 1889 under attacks of a still-unexplained nervous disease. But he continued to paint during his last tormented months of intermittent insanity, spent partly in a hospital at Saint Remy and finally under the care of a physician in a village near Paris where he committed suicide on July 27, 1890.

Self-Portrait with Gray Hat (fig. 14-26) is one of a number of such works Van Gogh painted between 1886 and 1890, employing a remarkable variety of techniques. In this one, the short brush strokes accentuate the strong features and red beard, and radiate in concentric circles from the head with its melancholy but penetrating eyes. ("I would rather paint eyes," said Vincent, "then ca-

thedrals."). It is a portrait that goes beyond realism in its insight and emotional force.

Van Gogh's friend Paul Gauguin (1848-1903) was a French stockbroker who left his family at thirty-five to spend the rest of his life as a painter in Paris, Brittany, Panama, Arles, Tahiti, Paris again, and back to the South Seas, where he died.

Gauguin struck his first distinctive note in such works as *The Yellow Christ*, with large areas of nearly unmodulated color and bold, arbitrary color combinations. His best-known paintings are those he did in the South Seas, His Tahitian landscapes and scenes of native life, some of them cheerful, some sinister, some religious—*Ia Orana Maria* (fig. 14-27), for instance—strike the eye with a powerful sensory impact. His masterpiece, a huge painting on coarse sackcloth called *Where Do We Come From? What Are We? Where Are We Going?* (fig. 14-28), continues to intrigue viewers with its enigmatic religious and allegorical meanings.

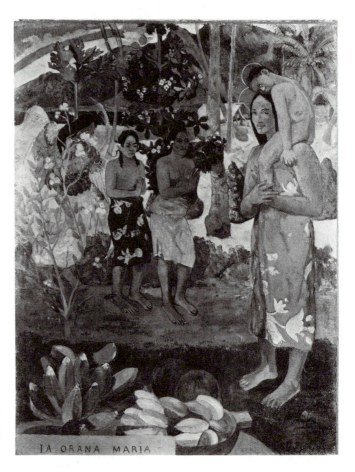

Fig. 14–27. Paul Gauguin. *Ia Orana Maria (I Hail Thee, Mary)*. 1891. The Metropolitan Museum of Art. Bequest of Samuel A. Lewisohn, 1951.

Fig. 14–28. Paul Gauguin. *Where Do We Come From? What Are We? Where Are We Going?* 1897. 54¾ × 147½". Courtesy Museum of Fine Arts, Boston. Tompkins Collection, Arthur Gordon Tompkins Residuary Fund.

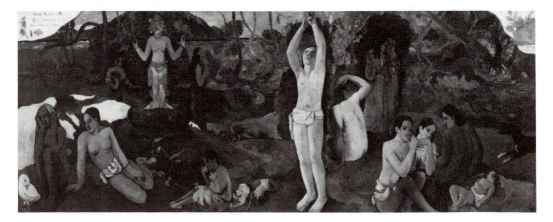

Paul Cézanne (1839-1906) is now considered the principal forerunner of the major art movements of this century. He was one of the first to recognize clearly that a painting is, as a contemporary critic said, "essentially a flat surface covered with colors arranged in a certain order" before being a war horse, a nude woman, or an anecdote. For Cézanne all parts of the canvas are of equal importance; all are illuminated by a permanent, uniform light. He said he wanted no holes in his canvases, meaning no illusions of depth created by linear or aerial perspective. He largely eliminated chiaroscuro. But he did want substance, depth, and solidity. These he achieved, not by lines or modeling but by overlapping objects and by a brilliant use of advancing warm colors and retreating cool ones.

In a celebrated comment, Cézanne said objects in a painting could be reduced to cylinders, spheres, and cones. He was doubtless arguing for simplification, for reducing objects to their nearest geometrical equivalents. In this sense, though he was not an abstract painter in the usual sense, he abstracted—selected and isolated—the structural elements of a pictorial motif.

One of Cézanne's favorite subjects was Mont Ste. Victoire, which he painted dozens of times. Another was the town of Gardanne, which, with its houses seeming to overlap on a steep hillside, lent itself to his kind of perspective treatment (fig. 14-29).

Fig. 14–29. Paul Cézanne. *Village of Gardanne*. 1885–86. 36¼ × 29⅜". Courtesy of the Brooklyn Museum. Ella C. Woodward and A. T. White Memorial Funds.

Fig. 14–30. Paul Cézanne. *The Large Bathers*. 1898–1905. 83 × 98". Philadelphia Museum of Art. Purchased: W. P. Wilstach Collection.

Among his figure studies none is more famous than *The Large Bathers* (fig. 14-30).

Cézanne's painting is seldom conventionally pretty, but it repays study, both in itself and as a forerunner of the principal schools that follow it—the *fauves* (Matisse and others); the cubists, including Braque and Picasso; and the abstractionists, who admired his innovative boldness—the kind of boldness that has asserted itself often and sometimes with striking success in the twentieth century.

15

THE TWENTIETH CENTURY TO 1945

Whatever labels future historians may give to our century, they will doubtless recognize it as one in which change came to be accepted as a norm. Machines, scientific developments, and technology have been the main instruments of change. To the dynamos and telephones of the late nineteenth century have been added innumerable mechanisms that have profoundly modified our lives, from electric lights, central heating, radios, television sets, and other domestic appliances to motion pictures, airplanes, motor vehicles, and dramatic advances in medicines and surgical techniques, on to the computer, with the revolutionary changes it is already making in areas like education, business and recreation. Each of these, of course, is constantly undergoing change; the planes and cars of yesteryear are today's museum pieces or junk. Space exploration and nuclear energy, with promises of change for good or ill that no one can foretell, are only in their early stages.

Future historians may also identify our era as one of paradoxes. Men and women throughout the world have given their best energies to great causes, such as the prevention of conflict through agencies like the United Nations; but two world wars have led only to other conflicts. Enlightened people from many nations have fought against hunger, disease, and illiteracy; but advanced technology has been applied to genocide, the methodical murder of millions of humans. Our century has seen the diminishing of empires and of Western colonialism; but it has also seen the growth of Communist imperialism as Russia has spread its influence throughout the world. In fact, the principal historical reality of our century may prove to be the struggle, with its accompanying fears of nuclear holocaust, between the major Western powers and Communist Russia.

Future historians, pondering the place of religion in our time, may be at a loss to determine whether belief or doubt has been the greater force. Statistics show that the larger religious faiths, both Christian and non-Christian, have essentially held their own in per capita membership, mostly through conversions from folk religions or tribal faiths. But the number of atheists and self-declared nonreligious persons has risen dramatically. Future historians will doubtless also recognize, especially in the period following World War II, a significant modifi-

cation of moral attitudes, particularly those having to do with sexual matters—a tendency on the part of great numbers of people to question (or to discard as puritanical or Victorian) many of the values their forebears espoused. Such changes have profoundly affected the arts of the era and have been strongly influenced by them in turn.

Change and experimentation, as we shall see, have continually characterized twentieth-century arts. But there have also been strong elements of continuity. Attitudes and techniques nurtured by impressionism, *art nouveau*, and postimpressionism made themselves felt in this century, even though the movements themselves largely disappeared. And older tempers and traditions—classicism, romanticism, and realism—have reasserted themselves from time to time in modern dress, often as a counterbalance to experimentation and innovation.

Expressionism and Other Terms. Labels to designate trends and styles in twentieth-century art have proliferated by the dozens. Some need not concern us here. Others, though the movements they name may have disappeared, are historically important. Some of the latter will be defined in connection with specific arts; others, such as those that follow, are broader in their application.

Expressionism designates both a movement—the German expressionist painters and playwrights, about whom more later—and an aesthetic attitude or temper that permeated all of the arts in the first few decades of the century. As the term implies, the artist attempted to *express* inward states—emotions, sensations, normal or abnormal conditions of mind and spirit, sometimes intense political or social convictions—through the devices of art. Such devices included bold outlines and strong, unmodulated colors in painting; distortion in painting and sculpture; out-of-the-ordinary, often tormented characters, unrealistic settings, and warpings of time elements in drama; and dissonance, distortions of rhythm, new and

strange scales in music—all intended, very often, to be interpreted symbolically. Less immediately symbolic but just as expressionistic was the startling and highly personal architecture of the Spaniard Antonio Gaudí.

Elements of expressionism appear in the work of many earlier artists—in Gothic sculpture, for instance, or the paintings of El Greco. The immediate forerunners of modern expressionism in the visual arts were the French postimpressionists, especially Van Gogh, whose heavy outlines, strong colors, and intense emotionalism are in every sense expressionistic. The attitudes of expressionism, which have continued to influence modern arts in many ways, were immeasurably affected by the theories of Freudian psychology, which were beginning to exert their strong hold on Western minds at about the same time. Freudian theories, whether accurately understood or not—theories regarding human sexuality, the free association of ideas, and the effects of unconscious mental forces on conscious life, for example—were immediately seized on by expressionists in all the arts, and they have continued to have a profound and pervasive effect on the art and culture of the world. They have helped, among other things, to make psychology—not Freudian psychology alone—almost a partner of the arts.

Primitive Arts. Early in the century many artists developed a strong interest in the folk arts of so-called primitive peoples—especially in carved dance masks and wooden or stone ancestor figures from central and western Africa and the islands of the Pacific. Artists were intrigued not alone by the ritualistic and religious significance of such works but by their simplified, often powerful forms and by the freedom with which their makers flattened, elongated, or otherwise distorted faces, bodies, and other features—both for expressive reasons and to accommodate the materials they used. Picasso, Braque, and others were quick to incorporate

"primitive" elements into their paintings and sculptures. Primitivism of one kind or another (not to be confused with the primitivism of such painters as Henri Rousseau and Grandma Moses) was taken up by musicians, writers, and other artists. It has continued to influence the art of such recent or current sculptors as Lipchitz and Moore.

Cubism and *abstractionism* (or *abstract art*) are two more terms that have had broad and important application in the arts of the century. Both apply specifically to painting and sculpture, but some writers have found them useful in discussing aspects of architecture and *avant-garde* music and literature. *Cubism* designates a movement, beginning around 1907, that was led by the Spaniard Pablo Picasso (then living in Paris) and his French collaborator Georges Braque. They accepted the revolutionary innovations of Cézanne: strong, simplified forms that included, by implication at least, the cube; distortion for compositional purposes; recognition of the painting as an independent object, not to be judged by how well it represents the physical world; elimination in large part of such traditional devices as chiaroscuro and linear or atmospheric perspective; and the creation of depth and volume by means of color and geometric forms. To these principles the artists added innovations of their own, based first of all on the belief not only that all things are constantly changing, but that *seeing* is a dynamic process, and that an object assumes a greater degree of reality as one sees it from changing points of view. Hence they experimented with breaking down forms—the human body or objects in a room—into their geometrical equivalents (often cubes or other faceted surfaces, but also tubular shapes) and then reformulating them by superimposing successive views of the object seen from different angles. (See, for example, fig. 15–22). The cubist movement, which startled the art world and appalled the public, underwent numerous changes and largely came to an end by 1914. But its effects were enormous, and they continue to be felt.

Abstractionism, a term that came into popular use in the first decades of this century, has taken on two principal meanings. In the first, the artist represents objects from the natural world but simplifies them—abstracts from them their underlying structure. Thus a person can be represented abstractly in a stick figure; a circle with two dots and a curve can represent a face; a cubist painting (again fig. 15–22) is a more sophisticated abstraction of female forms. Given this meaning, the term is relative; the degree to which a work departs from "natural" representation can vary greatly. In this first sense many works of art from past ages—tubular Greek *Heras*, two-dimensional Byzantine mosaic figures, elongated Gothic sculptured saints—can be called abstract. In the second sense the artist does not make reference to objects in the natural world; the forms and colors in his work exist only as forms and colors. Many prefer to call such art *nonobjective, nonfigurative,* or *nonrepresentational.* In this sense the term can be applied to the geometric patterns on archaic Greek vases as well as to the paintings of Kandinsky and many modern artists. (See figs. 15-15, 15-35). This second meaning, though less literally accurate, is probably more common. The two often overlap, and sometimes only the context will indicate which is intended.

LITERATURE

Poetry

Few major poets were making themselves heard during the last years of the nineteenth century. (The poetry of Emily Dickinson and Gerard Manley Hopkins, now the most-discussed poets of the time, did not come to light until after World War I.) But in the early years of the present century the writing of poetry experienced a widespread revival, centered in the English-speaking world but international in its consequences. Hundreds of poets, some of them of permanent importance, participated

in that revival. In this brief survey we can consider only a few.

American and English Poetry. Many young poets followed the lead of Whitman and the symbolists in experimenting with new approaches to form and imagery. Some, especially in America, were caught up by the excitement that artists in other media were finding in the dynamics of the machine age and the explosive growth of big cities and big businesses. Others explored new (or relatively new) concerns such as social change, or the place of the artist in society. And most if not all of them were influenced, some very markedly, by the unfolding theories of Freud, Jung, and other psychologists.

Even the more conservative poets, those who held most closely to nineteenth-century modes, generally adopted such new techniques as these:

1. Virtual elimination of inversions ("Of these am I, who thy protection claim") and of archaic or traditionally poetic words—thou, o'er, erelong, etc.; use of the language of everyday speech.
2. Derivation of images from common, present-day experience; emphasis on the usual rather than the heroic or cosmic.
3. A search for specific, image-evoking words and figures.
4. Flexible, colloquial rhythms; reduction or elimination of end rhymes.

Among British poets who made such techniques a part of their own essentially traditional styles were Thomas Hardy, A. E. Housman, Robert Bridges, Walter de la Mare, John Masefield, and Rudyard Kipling. The Americans included Amy Lowell, Sara Teasdale, Robinson Jeffers, William Carlos Williams, Edna St. Vincent Millay, Langston Hughes, and several others about whom we will say more in a moment.

The more experimental poets adopted such techniques and added several others, including these:

1. A leaping from one image or idea to the next by free association, without logical sequence or the usual transitional devices.
2. Deliberate ambiguity—the use of words capable of meaning two or more things at once (in the manner of Donne and the other metaphysical poets—Ch. 11).
3. Many allusions to—or quotations from—other writers, especially obscure ones.
4. The use of images or figures of speech drawn from the poet's private experience.
5. A fondness for rare or invented words—sistrum, fulvid, undinal, terriculous, concitation—and for nouns used as verbs, verbs used as nouns, etc.
6. Eccentric typography (as in the verse of e. e. cummings); omission or reduction of standard punctuation.

Obviously those poets who made more than moderate use of such techniques limited their audiences to readers who were willing (and able) to accept the reading of poetry as primarily an intellectual exercise. Some of the more daring have been forgotten; others are remembered as minor poets; still others—Hart Crane, Eliot, Pound—are major poets, highly influential ones, who are far more written about than read.

Among the more traditional poets Edward Arlington Robinson (1869–1935), a New Englander, recorded his astute observations regarding human character in poems that range from book-length retellings of Arthurian romances (for example, *Tristram*) in modern pyschological terms to the sonnet "Richard Cory," in which the story of a futile life is told in fourteen lines. "Isaac and Ar-

chibald" blends humor and pathos in the story of two old men, each of whom sees in the other the signs of approaching senility. At once sympathetic and ironical in varying degrees are such poems as "Bewick Finzer," "Miniver Cheevy," and "Mr. Flood's Party," studies of lives saddened by business failure, hopeless romantic dreams, and the loneliness of old age. "Ben Jonson Entertains a Man from Stratford" is a distinguished dramatic monologue in the style of Browning.

Robert Frost (1874–1963) will probably be remembered as the most widely admired poet of the century, American or otherwise. Also from New England, Frost captured the rhythms and accents of speech—simple but educated speech—in poems that deal with chopping wood, building fences, riding horses, and caring for land and animals. The reader first shares with the poet the physical experience—visual or otherwise—and then senses the overtones of the poem and ponders its implications—in "Mending Wall," for instance, the many reasons humans find for erecting fences between each other. Frost's lyrics and meditative poems such as "Stopping by Woods on a Snowy Evening," "The Pasture," "Birches," and "The Tuft of Flowers," as well as longer narrative poems like "The Death of the Hired Man" and the terrifying "Home Burial," are among the most popular poems in the language.

The poetry of Carl Sandburg (1878-1967), written in a free verse form derived largely from Whitman, celebrates Midwest farms and prairies, stockyards and factories—the strength and vitality of American productivity and of the American spirit. Often ignoring any line between poetry and prose, he epitomized his dynamic, optimistic philosophy in the long poem, "The People, Yes." He will probably be remembered, however, for such quieter lyrics as "Fog," "Grass," "Wind Song," and "Cool Tombs." Sandburg also wrote what is probably the best—surely the longest—biography of Abraham Lincoln.

The two most important experimental poets of the period were T. S. Eliot and Ezra Pound, both of whom developed or exploited the techniques mentioned in the second list above. (A third, Hart Crane, who was born in 1899 and committed suicide in 1932, has a considerable body of admirers.) T. S. Eliot (1888–1965) was born in St. Louis but lived most of his adult life in England and became a British citizen. Even before leaving Harvard he displayed the essence of his poetic method in the highly allusive (and for many early readers elusive) dramatic monologue, "The Love Song of J. Alfred Prufrock," which is a remarkable internalization of the empty life of an intellectual and aesthete. The sterility of modern life is a recurring theme in such poems as "The Hollow Men" and "Gerontion." In both of these he makes skillful use of what he calls "objective correlatives"—images such as "headpiece filled with straw," "wind in dry grass," "rats' feet over broken glass," and "Here we go round the prickly pear"—to objectify the concept of spiritual and intellectual sterility. His long poem (actually a series of shorter poems) entitled *The Waste Land* continues the same theme but implies the possibility of regeneration. After his conversion to the Anglican faith, Eliot wrote important religious-philosophical poems such as "Ash Wednesday," "Four Quartets," and the short dramatic monologue, "The Journey of the Magi." His critical writings provided a theoretical foundation for a whole generation of English and American poets.

Ezra Pound (1885–1972), born in Idaho, left America early to spend the rest of his life in England, France, and Italy. In those countries he encouraged many young poets and artists, including Eliot. His early poems include some of the most exquisite lyrics in the language, such as "The River-Merchant's Wife," "A Virginal," and the two-line imagistic poem "In a Station of the Metro." Pound's enthusiasm for the esoteric led him into many unusual corners of world literature, from troubadour ballads to the verses of Li Po and other oriental poets. The

poems of his middle and later years, especially the long "epic" entitled the *Cantos,* are loaded with allusions to, and quotations from, exotic literature (including Chinese ideograms) and other sources, which render them largely unreadable for all but a few specialists. The *Cantos* deal with such political and economic themes as the evils of usury. Pound made speeches for the Italian fascists during World War II and spent some time in a mental hospital in America after the war. He died in Italy.

In England, around the turn of the century, the classical scholar A. E. Housman (1859–1936) wrote short, musical lyrics on a very few themes—loss of faith, the brevity of youth, the transitoriness of beauty. The poems have their settings in the picturesque countryside of Shropshire (now Salop) in western England. They include such familiar poems as "Loveliest of Trees" and "To an Athlete Dying Young." Pessimism based on more profound thought permeates the verses of Thomas Hardy (1840–1928), who turned from writing fiction (Ch. 14) to composing poetry in this century. He produced hundreds of deeply felt if sometimes rough-hewn poems embodying the fatalistic philosophy that runs through the novels. A tentative ray of hope shines through such poems as "The Oxen" and "The Darkling Thrush." Hardy spent his last years writing a long (nineteen-act) poetic drama, *The Dynasts,* which has yet to receive the recognition it deserves.

A number of young English poets, of whom Wilfred Owen was the most gifted, wrote feelingly of their experiences in World War I—of comrades dying in the trenches, of the futile tragedy of war. After the war the poet laureate, Robert Bridges, brought forth the poems of his friend Gerard Manley Hopkins (1844–1889), who had died thirty years before. Hopkins, a convert to Catholicism, had written a number of religious poems in a highly original style—poems that are demanding but that richly repay careful reading. They include the famous mystical sonnet "The Windhover"; exultant poems in praise of God-created beauty such as "God's Grandeur" and "Pied Beauty"; and a warm tribute to a dead friend, the blacksmith "Felix Randal." The style if not the substance of Hopkins' poems had a tremendous impact on aspiring poets in England and America. His mannerisms were widely copied, not always to good effect.

Apart from Hardy, Housman, and Hopkins, all of whom are identified in one way or another with the late nineteenth century, the first great modern British poet—many consider him the greatest—is the Irish poet and playwright William Butler Yeats (1865–1939). Brought up on the lore of Irish mythology, Yeats began his career as a writer of mistily romantic and melodic poems such as "Down by the Salley Gardens," "The Lake Isle of Innisfree," and "The Wild Swans at Coole." Out of his deepening religious convictions came such wise poems as "Prayer for My Daughter." Disillusionment and near-despair led to more difficult symbolic poems, including "Sailing to Byzantium" and "Byzantium." His last works, brought together in *The Tower* and *The Winding Stair,* embody a mystical philosophy expressed in quite personal symbols. Scholars admire these poems, but general readers will value and remember him for his exquisite early lyrics.

W. H. Auden (1907–1973) was the most prominent of a promising group of English poets who emerged after World War I. Readers admired the wit and vigor and versatility of Auden's work. But they discovered that that versatility prevented him from developing an identifiable style or even a recognizable set of attitudes. He eventually came under the influence of the Danish theologian and existentialist Soren Kierkegaard. In his later life he wrote verse dramas, including some religious ones, and opera librettos. Auden's better-known poems include "Letter to Lord Byron," "In Memory of W. B. Yeats," and "Musée des Beaux Arts."

Dylan Thomas (1914–1953) was a gifted Welsh poet and playwright who gained considerable fame during his lifetime, both for

his poetry and for his bohemian way of life. He wrote lines that were emotional and singing, if not always immediately comprehensible; and he was popular, especially in America, as a public reader of his own poetry. His talent extended well beyond the euphony of his verse; such poems as "Fern Hill," "Do Not Go Gentle into that Good Night," and "In My Craft or Sullen Art" demonstrate deep love for the beauty of the world, as well as a rare responsiveness to human feeling.

Continental Poetry. Because much modern Continental poetry, like that of America and England, is complex and highly symbolic, it is even more difficult to translate than is poetry in general. But our century, fortunately, has produced a number of translators who are also skillful poets. As a result of their efforts a number of modern European poets have become well and accurately known to the English-speaking world. These include Rilke, a German, and Lorca, a Spaniard.

Rainer Maria Rilke (1875–1926) is one of the most influential poets of the century. Readers of poetry throughout Europe and America acknowledge his imaginative power and the profundity and originality of his thought. Rilke served for a time as secretary to Rodin, who taught him much about art and about the significance of common objects, the qualities of physical things. The tone of his early verse is highly emotional. His later, more meditative poems express philosophical and religious convictions in concrete terms. His descriptions of animals or inanimate objects incorporate symbolic meanings that extend well beyond their immediate subjects. Rilke's long *Duino Elegies* are intense and rhapsodic; his *Sonnets to Orpheus* are among the greatest of religious affirmations. Among his fine short poems are "The Panther," "Autumn," and "Autumn Day."

The poetry of Federico García Lorca (1899–1936) grows largely out of the life and folklore of his native Spain. He believed that the simple culture of the peasant provided the clearest insights into the meanings of an overly complex age. A versatile artist (he was also a painter and musician), Lorca wrote dramas, lyrics, and ballads, and in all of these he employed at their richest the musical elements of the Spanish language. His most famous poem is "Lament for Ignatio Sánchez Mejías," a long elegy for a matador friend who had been killed in the bullring. Though realistic, the poem explores psychological depths that relate it to surrealism. Lorca was executed by the fascists during the Spanish Civil War.

Drama

The impetus given to drama in the 1880s and 1890s by such great playwrights as Ibsen, Strindberg, and Chekhov (Ch. 14) impelled that art forward and gave it new directions in this century. The expressionism of Strindberg helped to motivate a whole school of playwrights, the German expressionists. More realistic were the dramas of the brilliant Irish playwrights J. M. Synge and Sean O'Casey. The Italian Luigi Pirandello, the American Eugene O'Neill, and the German Bertolt Brecht were expressionistic and realistic by turns.

Luigi Pirandello (1867–1936), probably the foremost Italian writer of this century, received the Nobel Prize for his achievements as novelist and author of expressionistic dramas. He explored, almost to the point of obsession, the shadowy region between reality and illusion, especially the relationship of art and actuality. In his famous *Six Characters in Search of an Author*, a play within a play, a "rehearsal" is interrupted by six additional characters who insist on injecting themselves and their tragicomic story into the play. Pirandello believed that the distinctions we make between reality and fantasy are based only on convention and habit.

Eugene O'Neill (1888–1953), probably the greatest playwright of the century, was the first American dramatist to receive international acclaim. His dramatic method var-

ies from experimental expressionism to strict naturalism. The characters in *Strange Interlude*, a stream-of-consciousness drama, use asides to convey their thoughts, which often contrast ironically with their speech. In *The Great God Brown* the characters use masks part of the time to signify their multiple personalities. O'Neill's best plays, however, are those that deal naturalistically with difficult human relationships. The trilogy *Mourning Becomes Electra*, which has its setting in New England, is a powerful retelling of the ancient tragedy of Agamemnon and his doomed family. *Long Day's Journey into Night*, an autobiographical drama that some consider O'Neill's best, tells the story of his father, a once-successful actor, and his tortured relationships with his family.

The German Bertolt Brecht (1898–1956), the most boldly experimental playright of the period, believed that the chief purpose of drama is to teach and to stimulate thought, especially regarding social issues. He also believed that traditional drama, in its concern with creating illusion, prevents spectators from thinking about the play as play or idea. His dramas, like Pirandello's, urge the audience to remember that the play *is* illusion—though somehow, strangely, he creates a remarkable sense of reality. To serve these purposes Brecht employs what he calls "alienation effects," which include announcing the outcome of a scene before it is played, using slides and banners, and breaking up the continuity of scenes. He called his plays "epic" or "non-Aristotelian" theater. The Brecht play most often performed, a musical comedy of sorts, is the *Three Penny Opera*. His best play, one of the great dramas of the century, is *Mother Courage and Her Children*. Others include *The Life of Galileo* and *The Caucasian Chalk Circle*.

The Novel

Novel-writing, which had flourished in the nineteenth century, continued at an accelerated pace in the twentieth, partly because no other form could reflect so adequately the variety and complexity of the age. Some authors after the turn of the century continued along the lines of naturalism or of allegorical or philosophical realism established by such novelists as Zola, Melville, and Tolstoy. Others, influenced by Freud and his followers and by the devices of modern journalism and drama, wrote novels in a variety of experimental styles such as expressionism and the stream of consciousness.

English and American Novels. Among the most important British authors of the period are E. M. Forster (1879–1970), whose *A Passage to India* sensitively treats the confrontation of British and native Indian cultures; D. H. Lawrence (1885–1930), who attacked puritanism and argued for the primacy of body-consciousness; Aldous Huxley (1894–1963), a prolific writer whose most famous work, *Brave New World*, a satirical inversion of the utopian novel, dramatizes the potential evil of a technology-obsessed society; Virginia Woolf (1882–1941), whose subtle novels are experiments in the stream-of-consciousness technique; and James Joyce (1882–1941), most influential and controversial of experimental novelists. Others whom we can only mention here are Arnold Bennett, Rudyard Kipling, H. G. Wells, John Galsworthy, and Somerset Maugham.

Joyce was acutely sensitive to the sights and sounds of his native Dublin, and to the psychological and sexual relationships of its people. This sensitivity first expressed itself, artistically, in the superb collection of short stories called *Dubliners*. In his early novel, *Portrait of the Artist as a Young Man*, Joyce first employed his revolutionary stream-of-consciousness technique. Related to the Freudian device of free association, this method recounts not only the outward speech and actions of a fictional character, but the actions of his or her mind—a continuous nonlogical flow of half-formed ideas, images, memories, etc., on which the outer and subconscious worlds constantly impinge. His

most famous novel, *Ulysses,* which covers one day in the life of an ordinary Irishman, carries that method to its logical extreme. But Joyce went far beyond ordinary canons of logic in his last novel, *Finnegans Wake,* in which he employed so many eccentric devices—merged words, coined terms, ellipses, and sheer babblings—that it is accessible only to a few specialists.

America produced a number of fine writers of fiction during the period, including Edith Wharton, (1862–1937), whose novels, reflecting the influence of her friend Henry James, concentrated on subtle, often sharply ironical psychological studies. Her best-known works are *Ethan Frome,* a tragic story of life in New England, and *The Age of Innocence.* Several of the best novels by Willa Cather (1876–1947) are sensitive, moving stories that recount the development of a uniquely American temperament in the immigrant pioneers of the nineteenth century. *My Antonia* is a fine example. Her strong sense of place and her quietly beautiful prose style are also evident in such regional novels as *Shadows on the Rock* and *Death Comes for the Archbishop.*

William Faulkner (1897–1962) has probably received more widespread acclaim than any other modern American novelist. On one level his novels and short stories are expositions of the problems of the South, especially in the post-Civil War years. On another level, the imaginary county in Mississippi that is the setting for his fiction—Yoknapatawpha—is a microcosm of a modern world destroyed by greed, hatred, and prejudice. Some of Faulkner's works are starkly realistic. In others, extended sentences and interior monologues, related to the methods of modern psychology and the work of James Joyce, demand much from the reader. Especially admired are *The Sound and the Fury, As I Lay Dying, The Hamlet,* and *Light in August.* Faulkner received the Nobel Prize in 1949.

Another Nobel Prize winner was Ernest Hemingway (1899–1961), whose novels

of war and adventure, along with his carefully cultivated *macho* style of living, caught the imaginations of millions of readers. Perhaps better than any other writer of the time he could capture the "feel" of outdoor adventure—fishing, big game hunting, etc. He rejected abstractions and wrote concrete, terse prose that came to grips with "the real thing." His heroes—soldiers, hunters, bullfighters—are usually individualists striving to avoid the constraints that society and human attachments can impose. *The Sun Also Rises, For Whom the Bell Tolls, A Farewell to Arms,* and a number of distinguished short stories—often better than his novels, in fact—are among his best works.

John Steinbeck (1902–1968), still another Nobel Prize winner, was an uneven writer whose best work deals with the lives of poverty-stricken laborers in southwestern and western America. *Tortilla Flat* and *Cannery Row* are loosely connected, sometimes amusing adventures of Mexican-Americans and other poor workers in Monterey and Salinas, California. Steinbeck's masterpiece, *The Grapes of Wrath,* concerns a family who are forced to give up their drought-stricken farm in Oklahoma and journey to California, where their dreams of finding paradise are soon shattered.

Other major American writers of fiction whose works were published largely or entirely before World War II include Thomas Wolfe (four large autobiographical novels, among them *Look Homeward, Angel* and *You Can't Go Home Again*); John Dos Passos (experimental novels including *Manhattan Transfer* and the triology *U. S. A.*); James T. Farrell (naturalistic fiction—*Studs Lonigan,* etc.—in the manner of Dreiser); Richard Wright (a powerful novel, *Native Son,* and an equally powerful autobiography, *Black Boy*); Ralph Ellison (*Invisible Man,* with its nameless black hero—fiction often compared to that of Kafka); Robert Penn Warren (poetry, criticism, and several important novels, including *Night Rider* and *All the King's Men,* the latter a highly successful novel based on

the life and death of the famous Louisiana political figure Huey Long); and three gifted Southern writers of fiction—Carson McCullers, Flannery O'Connor, and Eudora Welty.

Continental Novels. Important German and French novelists of the period include Thomas Mann, Franz Kafka (who wrote in German), Hermann Hesse, and Marcel Proust.

While still in his twenties, Thomas Mann (1875–1955) wrote his first major novel, *Buddenbrooks,* a complex but absorbing account of the diminishing fortunes, through four generations, of a wealth-obsessed German family. Mann's great novel *The Magic Mountain* has its setting in a mountain sanatorium. Here physical disease symbolizes decadence and corruption of the spirit, but the underlying implication is that people and societies can regenerate themselves. Mann may be best remembered for his quietly absorbing short stories, of which *Death in Venice* and *Tonio Kröger* are famous examples. Mann, one of the greatest literary artists of our century, often asked in his fiction whether an absorption in the arts may not be more soul-destroying—or at least more symptomatic of isolation and moral weakness—than otherwise.

Franz Kafka (1883–1924), who was born in Prague, published only a few short stories during his brief life. These include such astonishing and moving symbolic tales as "A Hunger Artist" and "The Metamorphosis." In the latter, Gregor Samsa, a traveler for a warehouse, awakens one morning to find that he has become a human-sized cockroach. Kafka's three short novels, all unfinished, were published contrary to his instructions after his death. In all three—*Amerika, The Trial,* and *The Castle*—the central characters move through a dream world (or rather, a nightmare world) of alienation and hostility. Kafka's beliefs were strongly influenced by Freud and Kierkegaard, as well as by Christian theology and

his own Jewish heritage. His fiction was suppressed for some time in Germany and Czechoslovakia, but his reputation grew rapidly elsewhere in Europe and in America. He is now thought of as one of the major influences in the development of modern philosophical fiction.

Marcel Proust (1871–1922) is generally considered the foremost French novelist of the period. After several minor works, Proust undertook his major project, the long novel (or series of novels) entitled *Remembrance of Things Past.* The seven sections of this massive work are largely an autobiographical account of his development as an artist. The work is uneven, but some of his evocations of events and objects drawn from his memories of things past are unmatched in modern literature. The later volumes are weighted down by his defense and explanation of his homosexuality. But in depicting characters from all levels of society, as well as in the grace and beauty of his language, Proust has few equals.

MUSIC

The basic traditions of nineteenth-century music continued well into the twentieth. Richard Strauss, Mahler, Sibelius, Rachmaninoff, and other early twentieth-century composers were essentially romanticists. The compositions of the Austrian Gustav Mahler (1860–1911) show clearly the influence of Wagnerian romanticism. His richly orchestrated symphonies, however, adhere less strictly to traditional form than those of his immediate predecessors (Brahms, for example), and they often make use of human voices in solo or chorus. Most of them are programmatic and employ texts derived from German or Asian folk poetry. Mahler also composed a number of distinguished song cycles, including the deeply moving *Kindertotenlieder* ("Songs for Dead Children"), *Des Knaben Wunderhorn* ("The Youth's Magic Horn"), and *Das Lied von der*

Erde ("The Song of the Earth"). The last-named work, often called a symphony, consists of exquisite vocal and orchestral settings of a number of poems translated from the Chinese.

The German composer Richard Strauss (1864–1949) derived his principal form, the tone poem, from the symphonic poems of the arch-romanticist Franz Liszt. They have some of the dramatic qualities of Liszt's music, but they also echo both Brahms and Wagner. Strauss's powerful and subtle orchestrations reflect the narrative and dramatic qualities of the literature which provides inspiration for his music—*Don Quixote*, for example, or *Till Eulenspiegel's Merry Pranks* or *Death and Transfiguration*. One of the major composers of opera in this century, Strauss wrote such works as the bold, brilliantly scored *Salome; Elektra* (based on a tragedy by Sophocles); and the delightful lyrical opera *Der Rosenkavalier*.

Jean Sibelius (1865–1957), best loved of Finnish composers, is most celebrated for his tone poem *Finlandia*, his *Legends from the Kalevala* (including the familiar *Swan of Tuonela*), and other compositions in the nationalistic vein of romanticism, as well as for such favorites as *Romance* and *Valse Triste*. Sibelius is also honored for his seven symphonies, of which the Fifth was his own favorite. He was less concerned with symphonic form than with evoking moods and visual images—an oboe solo against shimmering strings, for instance, to suggest the gliding of a swan.

The Russian composer Sergei Rachmaninoff (1873–1934), an internationally famed pianist, often performed his own compositions, most of them strongly reminiscent of Tchaikovsky. The melodies of his Second Symphony, piano concertos, and solo pieces for piano, many of them hauntingly beautiful, have made his compositions familiar to millions.

With the music of another Russian, Igor Stravinsky (1882–1971), we come fully into the twentieth century. Stravinsky, in fact, probably remains the foremost exemplar of the serious music of our age. His works, still essentially "modern," are performed often, and his influence has been immense. Stravinsky received his early training from Rimsky-Korsakov, but he soon left Russia and Russian romanticism behind him to involve himself in the French world of modern theater and of ballet music. His three early ballets, *The Firebird, Petrushka,* and *The Rite of Spring,* were increasingly dissonant and complex in their harmonies and rhythms. The first performance of *The Rite of Spring,* which depicts an ancient pagan sacrifice in music that makes use of primitive sounds and rhythms, provoked catcalls and shouting that ended in a riot. Such works, though still hardly conventional, are now generally applauded for having injected new blood into the body of serious music.

Though Stravinsky continues to be best known for his early ballets, his style evolved and matured during the next decades. In his neoclassical period he bowed, though in a very modern way, toward the stylistic traditions of the eighteenth century. Later he experimented for a time with the complex and difficult twelve-tone and serial systems developed by Schoenberg and Webern. Among his most important compositions, in addition to the ballets, are *Symphonies for Wind Instruments;* the *Dumbarton Oaks Concerto;* the opera *The Rake's Progress;* and several choral-orchestral works, including the great *Symphony of Psalms.* Stravinsky had the added grace of being able to write wittily and perceptively about music, his own and others'.

Whether the innovations of the Austrian composer Arnold Schoenberg (1874–1951) have had more influence than those of Stravinsky is difficult to assess. Surely his works are performed less often and are more difficult to understand and assimilate. After composing early works in romantic and impressionistic styles, Schoenberg experimented with atonality for a while and then developed what is generally known as twelve-tone music. Continuing to eliminate

tonality (i.e., composing in an established scale or scales), he employed a system in which the twelve tones of the chromatic scale are arranged in a "tone row." This row, consisting of twelve tones in any order, must be used in its entirety before it is repeated. But the composer can use the row in a variety of ways, such as reversing or inverting it, and he can also employ it as the basis for simultaneous intervals or chords. Schoenberg's works include the near-traditional *Transfigured Night; Pierrot Lunaire,* his first authentic twelve-tone composition, a difficult work in which a soprano voice adds her half-spoken song to the instrumental voices of the orchestra; *Variations for Orchestra;* and an incomplete opera, *Moses and Aaron.*

Schoenberg's student Alban Berg (1885–1935) sometimes used the twelve-tone system, but he leaned toward traditional harmonic structures, with less formal control and an intuitive, "stream-of-consciousness" flow of musical ideas. He is best known for his two operas, *Lulu* and *Wozzeck.* The latter, with music that amplifies the wrenching terror of its final act, was an immediate success and remains one of the most important operas of the century.

The Austrian composer Anton Webern (1883–1945), another follower of Schoenberg, added several modifications to the twelve-tone concept in what is called "serial" music. A number of his experimental pieces—seven-minute "cantatas," for instance, and instrumental pieces only a half-minute long—are interesting intellectual exercises. Others, such as the longer and more traditional *Sommerwind,* move the spirit as well. Twelve-tone and serial music have left their imprint. But a number of musicians, including the outstanding contemporary American composer George Rochberg, have experimented with such methods only to abandon them because of their inherent limitations and their rejection of the great traditions of Western music.

Béla Bartók (1881–1945) traveled throughout much of Rumania and his native Hungary collecting folk songs and dances.

He incorporated their harmonies and exciting rhythms, many of which had not been heard before in western Europe, in his own compositions. Though his music is rhythmically intricate and employs dissonances and key changes without modulation, it is based on a foundation of traditional harmonies and scales. His brilliant *Concerto for Orchestra* has proved to be enduringly popular, as have other works that include three piano concertos, the opera *Bluebeard's Castle,* the ballet *The Miraculous Mandarin,* and many piano pieces.

French composers of this century have shown a particular interest in instrumentation and experiments with rhythm. Eric Satie (1866–1925), known almost as much for his whimsical personality as for his highly original compositions, was first influenced by his friend Debussy but was also intrigued by such less-than-ordinary forms as medieval music. He delighted in startling his fellow musicians with unusual chord progressions and abrupt rhythmic shifts. Satie's works, to which he often gave such titles as "In a Horse's Garb" and "Desiccated Embryos," range from the humorous ballet *Parade,* in which he employs sirens and the clacking of a typewriter, to a moving work for soprano and orchestra, *The Death of Socrates,* based on the dialogues of Plato.

Satie's innovations as well as those of Stravinsky influenced such important French composers as Darius Milhaud, Francis Poulenc, and Arthur Honegger. Milhaud (1892–1974), who spent some time in the United States, was enchanted by American jazz and its Afro-American origins. He incorporated its rhythms and (to an extent) its instrumentation in one of his most notable pieces, *The Creation of the World,* a ballet depicting the creation in terms of primitive African folklore. Milhaud joined Varèse and others in exploiting the musical possibilities of percussion instruments. His tone poem *L'Homme et Son Désir* is orchestrated for a small chamber orchestra and nineteen percussion instruments, including a wind machine and a hammer struck on a plank.

Among the important compositions of Arthur Honegger (1892–1955) are a Symphony for Strings; the familiar *Pacific 231,* a musical impression of a locomotive in motion; a moving and dramatic *Christmas Cantata;* and the choral-dramatic works *King David* and *Joan of Arc at the Stake.* Francis Poulenc (1899–1963), whose works are somewhat lighter and more lyrical, composed a number of songs, several operas, *Perpetual Motions* for piano, and some important organ music.

A fourth French composer, one especially admired by present-day musicians, is Edgar Varèse (1885–1965), who came to the United States in 1915 and later became an American citizen. He was important in the development of electronic music and in extending the acoustical possibilities of conventional instruments. His *Ionisation* is scored for forty-one percussion instruments. *Amériques,* a tone poem evoking the sights and sounds of an American metropolis, is another highly percussive piece held together less by melodic themes than by rhythmic motifs. Modern *musique concrète,* which derives its sounds from any and all sources, is in part an outgrowth of the innovations of Varèse.

Sergei Prokofiev (1891–1953) was the foremost Soviet composer of the first half of the century. Though he was evidently loyal to Communist ideals, he was occasionally attacked for writing "nonsocialist" music. In spite of political problems, Prokofiev produced a number of important compositions that have appealed to listeners throughout the Western world. His attraction lies in his ability to employ modern rhythms and dissonances without letting them obscure his striking and often beautiful melodies. He is best known in America for *Peter and the Wolf.* Other memorable works include the operas *The Love for Three Oranges* and *War and Peace;* the ballets *Cinderella* and *Romeo and Juliet;* seven symphonies and five concertos.

Prokofiev was followed by several other important Russian composers, including Kabalevsky, Khatchaturian, and Shosta-

kovich. The first two adhered mainly to the Russian romantic tradition. Dmitri Shostakovich (1906–1975) responded more directly to the influence of Stravinsky and other modernists. His First, Fifth, and Tenth symphonies in particular have enjoyed widespread success; a number of the other twelve are little more than ordinary. Many of his later works, essentially Soviet musical propaganda, have not received much attention outside the Communist world.

The German composers Paul Hindemith and Carl Orff were interested not only in experiments in harmony and rhythm but in extending the educational and social values of music. Hindemith (1895–1963) developed the concept of *Gebrauchmusik,* music for use. Many of his compositions are written for school children or amateurs who are to join in performance. His works outside of this category include an opera and a symphony, both entitled *Mathis der Maler,* based on the life of the early German painter Grünewald. Carl Orff (1895–1982), who also composed music for students, invented several new instruments that employ medieval modes and oriental scales. His major works, though often based on folk melodies, involve complex rhythms and harmonies in the manner of Stravinsky and others. His best-known work is the choral-orchestral composition *Carmina Burana,* an exciting, sometimes amusing work based on the songs of the goliards, medieval traveling students (see Ch. 7).

The principal English composers of the first half of the century, whose very real strengths have only recently come to be recognized, adhered mainly to the romantic tradition. The emotional power of their work is the more real for being carefully controlled. First of these was Sir Edward Elgar (1857–1934), whose oratorio *The Dream of Gerontius* was mentioned in Ch. 14. He is best known for the very familiar *Pomp and Circumstance* and the melodic *Enigma Variations,* a series of musical portraits. Other distinguished works include two symphonies, a cello concerto, and *Falstaff,* a musical char-

acter study at least on a par with the best of Richard Strauss's tone poems.

The work of a second English composer, Gustav Holst (1874–1934), though neglected for some years, is often heard today, especially his large orchestral suite, *The Planets,* which is a fine example of late romantic mysticism. Ralph Vaughan Williams (1872–1958), in his later years the "grand old man" of English music, based many of his compositions on English folk and church music of the sixteenth and seventeenth centuries. His work is consistently lyrical and melodic, with only occasional departures from tradition. In addition to several operas and nine symphonies (the Ninth, composed when he was in his eighties, is a fine example), his *Fantasia on a Theme by Thomas Tallis* and a song cycle based on poems by A. E. Housman are also admired.

The three most notable Spanish composers of the early years of the century were Isaac Albéniz (1860–1909), Enrique Granados (1867–1916), and Manuel de Falla (1876–1946). Albéniz and Granados, both famed concert pianists, often played their own compositions—romantic Spanish pieces such as Albéniz's popular *Córdoba, Sevilla,* and *Tango in D,* and Granados's hauntingly beautiful *Andalusia* (*Spanish Dance No. 5*). Manuel de Falla, who lived until almost midcentury, participated in the development of modern music. But though he was influenced by his friends Debussy and Ravel, he also derived his musical material—often melodic and always highly individualistic—from folk sources. His *Nights in the Gardens of Spain,* for piano and orchestra, and his exciting and amusing ballets *The Three-Cornered Hat* and *El Amor Brujo,* which blend French impressionism with the romantic rhythms of Spain, are often performed.

A number of American composers born in the later 1800s have come more and more to be recognized as major figures. They include Edward MacDowell (1861–1908), who first gained international fame as a pianist. He was long remembered only for such lyrical piano pieces as his *Woodland*

Sketches (including "To a Wild Rose"); but modern orchestras and soloists rather frequently play his *Indian Suite* and his two piano concertos. Among other composers of the era were the gifted black composers Samuel Coleridge-Taylor (*Danse Nègre* and *Hiawatha's Wedding Feast*) and William Grant Still (*Afro-American Symphony*); Howard Hanson (the Pulitzer Prize-winning Symphony No. 4 and the opera *Merry Mount*); and Roy Harris (*Symphony No. 3* and *Folksong Symphony 1940*). George Gershwin (1898–1938), one of the century's most important composers of popular songs and show tunes, also wrote distinguished large-scale compositions such as *Rhapsody in Blue* and *An American in Paris,* both of which successfully bridged the gap between jazz and so-called serious music, and the folklike opera *Porgy and Bess.* Virgil Thomson, who was born in 1896, has lived long enough to have become the dean of American composers. His works range from film music and the quite conventional orchestral suite *Louisiana Story* to the still startlingly unconventional opera *Four Saints in Three Acts.*

Charles Ives (1874–1954), long either ignored or dismissed as a musical primitive or badly trained eccentric, is now recognized as one of America's most important native-born composers. Though he received thorough musical training from his father, who was a professional musician, Ives engaged in a successful career as an an insurance executive and composed largely for his own pleasure. During his years of obscurity he developed a musical style that was well ahead of his time and that may wear longer than those of Schoenberg and other better-publicized innovators. Ives incorporated many native American elements in his music—hymns, folk songs, and dances—but he elaborated them in music filled with startling dissonances and passages of incredible complexity. He made frequent use of polyrhythms (two or more rhythms played simultaneously) and polytonality (instruments or voices performing in two or more keys at once). For instance, the final few minutes of

his exciting *Fourth of July* require the services of two conductors at the same time. Out of all this he made emotionally charged, sometimes amusing and often spiritually moving music. Ives was a prolific composer. Of his four symphonies, the *Holiday Symphony* is perhaps the best introduction to his work. He also wrote a number of piano pieces (including two fine sonatas), choral works, and many songs, some of them settings of his own poems.

ARCHITECTURE

Architecture in the early years of the century was pulling in a number of directions. Many designers of public buildings and large-scale private ones were building in the established styles, often to please their patrons. Late in the nineteenth century prominent American architects, some of whom had studied at the conservative Ecole des Beaux-Arts in Paris, had designed popularly acclaimed all-white plaster façades for the exhibition buildings of the World's Columbian Exposition in Chicago in 1893. With one or two exceptions, most notably one by Louis Sullivan (Ch. 14), who disliked all the others, they were designed in neoclassical and Renaissance styles, and they helped to stimulate a "classic" and beaux-arts vogue that extended beyond the United States.

Moving in another direction, a Spaniard named Antonio Gaudí (1852–1926) had developed in Barcelona an architecture that blended elements from *art nouveau*, Gothic, Islamic, and other styles in flowing and intricate patterns of parabolic arches and of bulbs and other organic forms—most of them covered with a mosaic of broken pieces of varicolored tile. His villas, townhouses, and still-unfinished Church of the Holy Family (fig. 15-1) are too bizarre to be imitated successfully, but they are still discussed and wondered at.

At the same time, from continental Europe to California, neo-Gothic churches were being erected. Some architects were

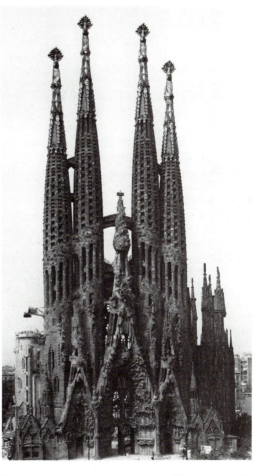

Fig. 15–1. Antonio Gaudí. Church of the Holy Family, Barcelona. Begun 1883.

building college buildings, town halls, and railroad stations in the popular neo-Romanesque style of H. H. Richardson (Ch. 14). Still others were experimenting tentatively with the newly developed skeletal construction for tall buildings, often ornamenting and capping them with Gothic and classical devices.

Even before World War I, however, and especially between the two World Wars, a number of gifted architects were following the lead of such men as Sullivan in utilizing

the new materials (especially reinforced concrete) and striking out in bold new directions. Most prominent of these in America—still America's most famous architect—was Frank Lloyd Wright (1869–1959). Trained as an engineer, he studied for a while with Louis Sullivan and then launched into a career that extended over many years and that saw him advance many theories and erect many innovative structures. Though he spoke out with characteristic self-assurance against sameness and dulling repetition, he extolled machines and their ability to produce modern materials—concrete, metal forms—in large quantities, to shape wood so that its textures would be preserved, and to mass produce his own unique decorative designs. The machine, the symbol of democracy, had dealt a death blow to "art in the grand old sense"—meaning especially the Italian Renaissance architecture of Michelangelo and his fellows, which Wright never tired of deriding.

Wright followed Sullivan in preaching that "Form follows function," but he modified the dictum to read, "Form *is* function." Especially in some of his later work he sometimes subordinated function—the placing of restrooms, storerooms, etc.—to aesthetic considerations. He agreed with Le Corbusier that people should adapt themselves to superior architecture rather than the reverse.

Early in his career Wright advanced his theory of "organic architecture," which he partly derived from Sullivan. Though the metaphor had a number of meanings for him, basically he equated "organic" with "natural"—"true to the nature of the problem, to the nature of the site, of the materials and of those for whom it is built." Early in his career he demonstrated his intentions in the "Prairie Style" homes he built in and near Chicago, including the Robie House (fig. 15-2), completed in 1909. Here he also reflected his interest in Japanese architecture in the strong horizontal lines, the long, low roof and cantilevered porch, and an interior in which he reduced walls to a minimum. His famous Falling Water house (Bear Run) in Ohiopyle, Pennsylvania, demonstrates his fondness for natural settings and materials, as does his Taliesen West in the Arizona desert.

Though Wright scorned the boxlike shapes of many modern buildings, he had a strong affinity for angular forms. Though, too, he spoke slightingly of other architects' tall buildings, he designed several of them himself. And though he derided ornamentation, he added a number of machine-produced ornaments, such as stylized flowers, to the surfaces of his buildings. All three of these—angular forms, the tall building, and stylized ornamentation—are brought to-

Fig. 15–2. Frank Lloyd Wright. Robie House, Chicago. 1907–09.

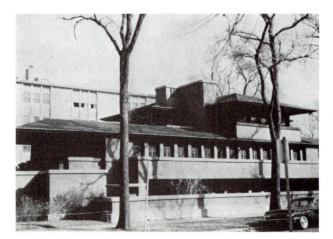

gether in the strikingly beautiful Price Tower, built in the small prairie city of Bartlesville, Oklahoma. His Administration Building (fig. 15-3), built for the S. C. Johnson and Son Company in Racine, Wisconsin, beautifully combines cubelike and rounded forms. The still-controversial Guggenheim Museum building, erected around a sweeping, spiraled interior, is Wright's only structure in New York City.

A dominant figure in European architecture during most of Wright's lifetime was Le Corbusier (1887–1965). This Franco-Swiss architect was among the first to make extensive use of reinforced concrete floors separated by slender pillars of steel, and to re-

duce the function of walls, whether inside or out, simply to that of screens or curtains which do not carry the weight of the floors above them. Hence outside walls, if lighting and air conditioning permit, can be unbroken masonry or—more often—glass joined by thin members of steel or masonry. Le Corbusier delighted in the fact that windows no longer needed to be set in, but could be arranged in long horizontal strips. Like Wright, he had a great enthusiasm for machines. He saw beauty rivaling that of the Parthenon in early biplanes, and he chose to call his apartment houses "machines for living." One such "machine" is the Villa Savoye (fig. 15-4). Built on stilts in a manner he

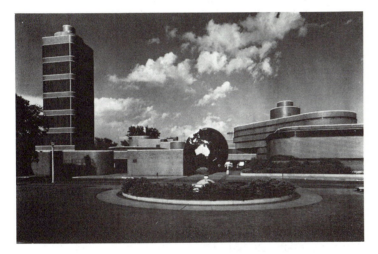

Fig. 15–3. Frank Lloyd Wright. Administration Building and Research Center, S. C. Johnson and Son, Inc., Racine, Wisc. 1936–39. Photo courtesy Johnson Wax.

Fig. 15–4. Le Corbusier. Villa Savoy, Poissy, France. 1929–31.

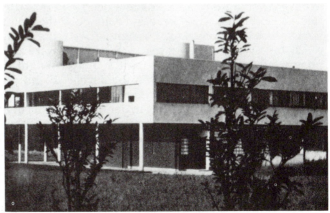

and others adapted to the design of great skyscrapers, it provides ground level space for gardens and other uses.

Not long before his death Le Corbusier turned away, as many were doing, from the severe forms of his earlier work toward a softer, more sculpturesque style, as in his well-known Church of Notre Dame de Haut in France. But he will doubtless be longest remembered for his important part in the development of the International Style of architecture.

The International Style, probably the most important development in modern architecture, dominated that art from about 1922 until fairly recently. Primarily seen in large-scale office and apartment buildings throughout the world, it has been described by Philip Johnson (himself a leading practitioner of the style) as having three main qualities: an effect of volume resulting from the reduction of walls to screen-like elements and from the use of unbroken surfaces, "like a skin stretched over a skeleton"; an effect of regularity in the placement of floors, supporting beams, etc.; and the avoidance of applied decoration. Someone else has described its principal attribute as "faith in the right angle." Admirers of the style find beauty in its shining abstract surfaces, its simplicity, its contrasts of horizontality and verticality, its long, unornamented lines, its sometimes overwhelming massiveness, and (philosophically) its response to functional need. "When a thing responds to a need," said Le Corbusier, "it is beautiful." Its detractors, led by Frank Lloyd Wright, have called the style boxlike, faceless, monotonous, sterile—"coffins for the spirit."

Two Germans important in the development of the International Style were Walter Gropius and Ludwig Mies van der Rohe. Both came to America after having established reputations in Germany. Gropius (1883–1969) had been the director of the Bauhaus, a famous school of design whose building itself (fig. 15-5) had become a key symbol of an industrialized, mass- and machine-produced approach to the arts. In America Gropius was for a time the leading figure of the Harvard University School of Design. Mies van der Rohe (1886–1969) based much of his work on abstract design and geometrical calculation. The functional modern furniture that he designed, including the familiar Barcelona chair, shows the same tendencies. In America his soaring glass and metal skyscrapers such as the Seagram Building in New York (on which he collaborated with Philip Johnson) provided models for many younger architects. The S. R. Crown Hall at the Illinois Institute of Technology (fig. 15-6), where he served as head of the school of architecture, is one of his better-known designs.

Other important architects came to the United States after having begun their careers elsewhere. They included the Hungarian Marcel Breuer (b. 1902). After teaching at the Bauhaus and designing buildings in France and England, Breuer came to America in 1937. Here he soon demonstrated that though he had been a pioneer in the International Style, he could also work in a more personal and relaxed manner, especially in designing smaller houses and distinctive furniture. Examples of his larger works are the striking, double-cantilevered Whitney Museum in New York and the beautiful IBM-France Research Center in La Gaude Ver, France.

Another major architect who immigrated to America was Eliel Saarinen (1873–1950), the leading Finnish architect of the century. Though he was influenced by the International Style, he leaned more toward the organic approach of Frank Lloyd Wright. His restrained modernism became highly popular in the United States. Later he teamed with his son Eero Saarinen (1910–1961) in designing such notable buildings as the Tabernacle Church of Christ in Columbus, Indiana (fig. 15-7). Eero, like his father, tried to avoid repeating himself. His works range from the General Motors Technical Center in Detroit, a large complex of buildings in metal and glass, to the TWA Terminal at Kennedy Airport, in which the sculptural,

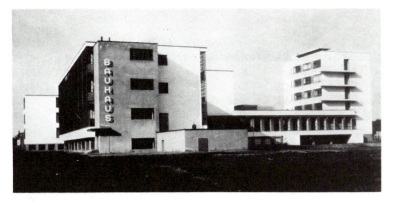

Fig. 15–5. Walter Gropius. Bauhaus Building, Dessau, Germany, 1925–26. Photo courtesy of the Museum of Modern Art, New York.

Fig. 15–6. Mies van der Rohe. S. R. Crown Hall, Illinois Institute of Technology, Chicago. 1952–56.

Fig. 15–7. Eliel and Eero Saarinen. Tabernacle Church of Christ, Columbus, Indiana. 1941–42.

curved forms of ferro-concrete identify themselves with the experience of flight. Eero Saarinen was also the chief designer of the magnificent stainless steel Gateway Arch, which soars skyward in eastern St. Louis.

SCULPTURE

The influence of Auguste Rodin, who died in 1917, continued to be strongly felt in the early years of this century. In addition to the sculptors mentioned in Chapter 14, others such as Wilhelm Lehmbruck and Gaston Lachaise acknowledged their indebtedness to him. At the same time, however, they and other younger sculptors began, for expressive purposes, to carry distortion much farther than Rodin and his older followers. The German sculptor Lehmbruck (1881–1919), who experienced a series of emotional crises that led to his early death by suicide, made dramatic use of distortion through elongation in a manner that harks back to early medieval sculpture. Such works as *Kneeling Woman* and *The Fallen* exemplify the grace, pathos, and spiritual sensitivity of Lehmbruck's sculpture. Carrying distortion in the opposite direction was Gaston Lachaise (1882–1935), a Paris-born sculptor who spent most of his life in the United States. He admired the work of Maillol but projected that artist's smooth female forms into large, voluptuous figures, some of them balancing gracefully if a bit incongruously on tiptoe. The oversized breasts, hips, and thighs are reminiscent of those in primitive cult statues. Lachaise's *Standing Woman* (fig. 15-8) is typical.

There is little grace but much expressiveness in the sculpture of the German Ernst Barlach (1870–1938), whose works have a Gothic intensity. A playwright as well as a sculptor, Barlach expressed in both arts his concern for the economic plight of peasants and factory workers, as well as his mystical religious convictions. He was also a courageous anti-Nazi. As a sculptor Barlach did much of his work in wood. He exploited the expressive possibilities of that medium to their fullest, in strongly tilted or heavily rounded figures with blocklike bodies and emotional faces. He sculptured, among other works, a beggar woman, a wanderer in the wind, an untypical singing man, and *Man in the Stocks* (fig. 15-9).

Other sculptors moved away from basically realistic depiction of the human form and began to apply in sculpture some of the revolutionary principles that were being developed in painting, such as cubism and various forms of abstractionism. Picasso, Matisse, and others, though primarily painters, were leaders in the new sculpture. The Spanish artist Pablo Picasso (1881–1973), merged the faceted forms of cubist painting with elements he derived from African sculptured figures. In a number of his earlier works he constructed *assemblages,* combinations of painted surfaces with other objects such as sheet metal, wire, and the like. He also began toying with "found" objects, various materials (toys, glass, junk) that he assembled and had cast in bronze. *The Glass of Absinthe* (fig. 15-10), made of silver and painted bronze, is a familiar early example. Later he produced more solid but often grotesquely distorted forms of such figures as baboons, goats, and bulls' heads.

Henri Matisse (1869–1954), a French artist also associated with cubist painting, created a number of sculptured figures that demonstrate his interest in the abstracting tendencies of cubism. In a remarkable series of four human backs, sculpted over a period of twenty years, he illustrated clearly the evolving process of reducing volumes to their fundamental elements. Shown in figs. 15-11A and 15-11B are backs No. 1 and No. 4, dated 1909 and 1930.

The Russian artist Alexander Archipenko (1887–1964) was another important early cubist sculptor, though his earlier works, such as the lovely *Black Torso*, were only moving in the direction of cubism; in

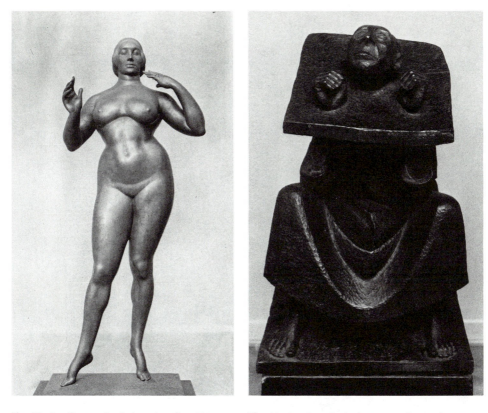

Fig. 15–8. Gaston Lachaise. *Standing Woman.* 1912–27. Bronze, 70″ high. Albright Knox Art Gallery, Buffalo, New York. James G. Forsyth Fund.

Fig. 15–9. Ernst Barlach. *Man in the Stocks.* 1918. Oak. Kunsthalle, Hamburg, Germany.

Fig. 15–10. Pablo Picasso. *Glass of Absinthe.* 1914. Painted bronze and silver, 8½″ high. Collection, The Museum of Modern Art, New York. Gift of Mrs. Bertram Smith.

A B

Fig. 15–11. Henri Matisse. The *Back I,* 1909, and *The Back IV,* 1930. Bronze, both approx. 6'2" high. Collection, The Museum of Modern Art, New York. Mrs. Simon Guggenheim Fund.

such figures he simplified the female form without sacrificing its identity. Later he was among the first to create voids or open spaces in his works, so that they enclosed space in addition to being enclosed by it.

Two other important cubist sculptors were Raymond Duchamp-Villon and Jacques Lipchitz. Duchamp-Villon (1876–1918), brother of two famous French painters (Marcel Duchamp and Jacques Villon), was a talented sculptor who moved rapidly toward abstraction; he produced works which, except for the titles, can seldom be recognized as representing natural objects. In his *Horse* (fig. 15-12), one of the most celebrated works of twentieth-century art, he reduced his subject to a series of planes and curves, in a

skillful application of cubist theory to three-dimensional art. Lipchitz (1891–1973), a highly prolific sculptor and one of the major figures of the century, was born in Lithuania but spent most of his life in Paris and New York. Some of his early works, such as *Reclining Nude with Guitar* (fig. 15-13), with its planes, curves, and open spaces, are at once cubistic and almost nonobjective. In his middle years Lipchitz created powerful, simplified figures inspired by primitive sculpture. His more recent works, on display in parks and other public places throughout the world, are monumental symbolic pieces, often on themes from mythology (Prometheus strangling the vulture, for instance) or from the Bible (Jacob wrestling the angel).

Fig. 15–12. Raymond Duchamp-Villon. *The Great Horse*. 1914. Bronze, 39⅜″ high. Courtesy of the Art Institute of Chicago. Gift of Miss Margaret Fisher.

Constantin Brancusi (1876–1957), a Rumanian-born sculptor, was one of the foremost early abstractionists. Most of his works reduce his subject matter—human heads, for example—to such natural or geometrical forms as teardrops, eggs, cylinders, or cubes. Among his best works are the familiar, highly simplified head of *Mlle. Pogany;* a blocklike limestone double figure called *The Kiss*, one of the first examples of cubist sculpture; and *Bird in Space* (fig. 15-14), a work that he reproduced in various media. The last-named sculpture, of course, only vaguely suggests the wings of a bird; its graceful curves become a symbol of flight.

Constructivism was (and is) a movement in sculpture that developed largely in Russia. Based on the cult of the machine, it extended well beyond sculpture into fields of industrial design, theater and film, and architecture. Applying architectural principles to plastic art, constructivist sculptors moved away from the solid forms of traditional stone or metal sculpture toward open, nonfigurative works constructed from a variety

Fig. 15–13. Jacques Lipchitz. *Reclining Nude with Guitar*. 1928. 16⅛ × 29⅝″. Hirshhorn Museum and Sculpture Garden, Smithsonian Institution.

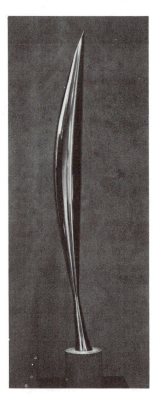

Fig. 15–14. Constin Brancusi. *Bird in Space.* 1928 (?). Bronze, 54" high. Collection, The Museum of Modern Art, New York.

Fig. 15–15. Naum Gabo. Construction. Bijenkorf Department Store. Rotterdam.

Fig. 15–16. Henry Moore. *Three-Piece Reclining Figure No. 2: Bridge Prop.* 1963. Bronze, 41½ × 99 × 44½". Hirshhorn Museum and Sculpture Garden, Smithsonian Institution.

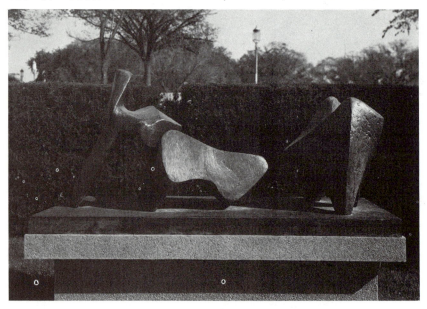

of materials—metal, wood, wire, string, and (later) plastic. Following the lead of such sculptors as Archipenko and Lipchitz, they asserted that the open spaces in such works are as important, aesthetically, as the materials surrounding them. Two Russian brothers, Anton Pevsner (1886–1962) and Naum Gabo (1890–1977), were among the first important constructivists. Pevsner's *Dynamic Projection in the 30th Degree,* over eight feet high, is a complicated series of space-enclosing planes and curves. Gabo created a series of works in plastic and nylon thread that demonstrate as well as anything has ever done the beauty of well-designed non-figurative forms. They have had a great influence on the sculpture of the past several decades. Gabo also anticipated *kinetic* sculpture, sculpture that moves, in constructing a vertical rod vibrated by a motor. One of his most impressive works on a larger scale is an 85-foot-high construction for the Bijenkorf Department Store in Rotterdam (fig. 15-15).

Henry Moore (b. 1898), an outstanding English sculptor, also incorporates open spaces into his figures. But unlike the Russian constructivists, he has concentrated almost entirely on the human figure, alone or in groups and in varying degrees of abstraction. Among his hundreds of monumental works (spread, like those of Lipchitz, throughout the world), are many variations on the subject of the reclining figure—sometimes approaching naturalism but more often in large segments that resemble stone carved by wind and water. Fig. 15-16, though bronze, is a good example.

The gifted painter-sculptor Jean (Hans) Arp (1887–1966), an Alsatian, gained his first notoriety as a member of Dada, a group of young intellectuals and artists who rebelled, much in the manner of the 1960s and 1970s, against conventional art and morality. Their interest in the irrational foreshadowed the surrealists of the next decade. Arp's earlier works were collages and assemblages. Later, influenced by Brancusi, he turned to semi-abstract organic forms, some of them exquisitely designed, with characteristic Dada titles such as *To Be Lost in the Woods* and *Human Lunar Spectral* (fig. 15-17).

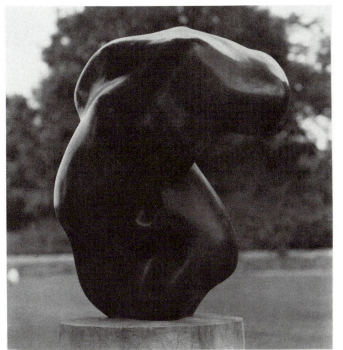

Fig. 15–17. Jean (Hans) Arp. *Human Lunar Spectral* (Torso of a Giant). 1957. Bronze, 45″ high. Hirshhorn Museum and Sculpture Garden, Smithsonian Institution.

An American whose work can perhaps best be called constructivist folk sculpture was Simon Rodia (1879–1965). An immigrant ironworker from Italy, Rodia created in the Watts district in Los Angeles an astonishing group of high, tapering towers (detail, fig. 15-18), arches, and other forms constructed from scrap iron and other found materials. All, including the surrounding concrete wall, are delightfully ornamented with shells, broken tiles, and the forms of horseshoes, hammers, and other objects imprinted in the concrete. Originally scoffed at, the Watts towers have gained many admirers. They stand as a monument of gratitude to America by an untrained but gifted immigrant.

Fig. 15–18. Simon Rodia. Watts Towers, Los Angeles. (Detail).

PAINTING

French postimpressionism—the painting of Van Gogh, Gauguin, Seurat, and Cézanne—provided the stimulus for most innovations in modern painting. Cubism owed much of its impetus to the experiments of Cézanne, and out of it have grown many of the art movements and styles of the rest of the century. Fauvism, a short-lived but important movement inspired in part by the postimpressionists, has in turn proved a stimulus for many modern artists.

Fauvism. The fauves ("wild beasts"), whose unfortunate name came from an offhand comment by a critic, were violent neither in person nor in subject matter. Any violence in their work lay only in their bold use of color and in their moving away from tightly controlled, conventional realism. They seized eagerly on Cézanne's theories of composition, but more importantly they welcomed the liberation of pure, vibrant color that had been set in motion by the impressionists and had been brought to a climax by Van Gogh and especially by Gauguin. But whereas Gauguin and Van Gogh had employed their surprising colors largely for emotional purposes, the fauves used them to create beautiful paintings. Essentially "art-for-art's-sake" painters, they delighted in the animation and vibrancy that adjacent colors could stimulate. (But they did not accept Seurat's divisionist theories; they felt that small adjacent dots of varying color simply neutralize one another.) The fauvist movement as such lasted only from about 1904 to 1907, but its coloristic practices were adopted by a number of other schools, including the expressionists—who returned to the use of color for emotional purposes.

The foremost artist associated with the fauves was Henri Matisse (1869–1954), one of the major figures in twentieth-century art. During his long life, in which he painted over two thousand canvases and created innumerable drawings, pieces of sculpture, and other works, Matisse went through a

series of stylistic developments, of which fauvism was only the first. His fauvist period is exemplified by *Mme. Matisse* (fig. 15-19), a striking portrait with seven or eight patches of color (including one on each side of the face) and a green shadow down the face that most modern observers probably accept without question but that dumbfounded its early viewers. In subsequent periods Matisse painted reclining nudes, clean-edged figures against ornamental backgrounds (he was a superb draftsman), large murals, and near-monochromatic paintings such as *Red Studio* (Colorplate 14), in which depth is suggested by the careful placement of objects that include some of his own familiar paintings. Confined to a wheelchair in his last years, Matisse created a number of strikingly animated paintings (*Icarus, Swimmer in Pool*) composed of figures cut from gouache-painted paper and pasted on colored backgrounds.

Other important fauvist painters were Raoul Dufy, André Derain, and Maurice de Vlaminck.

Cubism. The cubists, whose basic theories and sculpture we have discussed, were led by Pablo Picasso, the dominant figure in twentieth-century art. His early work, in which he first demonstrated his genius as a draftsman, was influenced by Toulouse-Lautrec and other late nineteenth-century painters. After several early phases during which he did (among other things) melancholy studies of the downtrodden (*Frugal Repast*) and brighter paintings of circus performers, he painted his first major cubist work, *Les Demoiselles d'Avignon* (fig. 15-20). Though he was to extend the devices of cubism farther, here we see the intersecting planes of color, the angular, sometimes cubelike forms, the distorted viewpoints (of the table, for instance), and the multiple angles of vision that characterize cubism. Several of the faces combine frontal and half-profile views. The body of the lower right-hand figure is turned away, but the face looks toward us. The two faces at the right (added, some say, after the painting was largely finished) are derived from African masks. Such a work, in which the elements of individual objects are disintegrated or "analyzed" and then reformulated, is called *analytical cubism.*

After World War I Picasso developed what has come to be called *synthetic cubism,* in which various objects, color patterns, and textures are brought together and synthesized. *Three Musicians,* painted in 1921 (fig. 15-21) is a delightful example. The clowns and the monklike figure, at first only complex cut-outs, achieve a remarkable vitality through the overlapping of forms and the ingenious arrangement of color—much brighter color then in Picasso's earlier cubist paintings.

Throughout the rest of his long career Picasso continued to experiment in many

Fig. 15–19. Henri Matisse. *Green Stripe (Madame Matisse).* 1905. 16 × 13". Courtesy of National Museum of Art, Copenhagen.

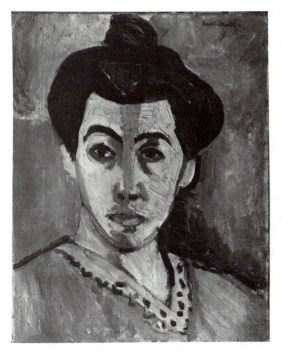

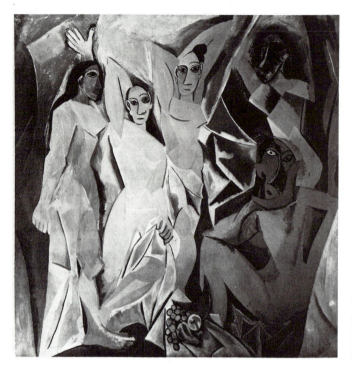

Fig. 15–20. Pablo Picasso. *Les Demoiselles d'Avignon*. 1907. 8′ × 7′8″. Collection, The Museum of Modern Art, New York. Acquired through the Lillie F. Bliss Bequest.

Fig. 15–21. Pablo Picasso. *Three Musicians*. 1921. 81¼ × 75½″. The Philadelphia Museum of Art. A. E. Gallatin Collection.

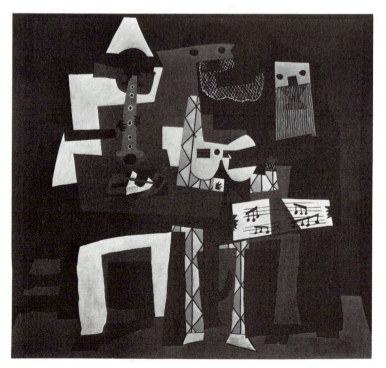

styles, sometimes abstracting almost to the point of nonobjectivity and at other times drawing or painting natural objects with Ingres-like precision. He went through a "classic" period in which both subject matter and style were suggestive of ancient Greek art. He painted a series of portraits of women which carried the techniques of multiple vision—simultaneous profile and frontal views—to their ultimate point. He made thousands of line drawings, ceramic pieces, and linoleum cuts. And he painted what is perhaps his most famous work, the large *Guernica,* a violent painting in gray, black, and white in which he protested the destruction of a Basque town by German bombers during the Spanish Civil War.

Other prominent early cubists are Georges Braque, Juan Gris, and Fernand Léger. Braque (1882–1963) was a close associate of Picasso; his work during one period was almost indistinguishable from the Spaniard's. He painted many still lifes in the synthetic mode of cubism. Braque's *Piano and Mandola* (fig. 15-22) typifies his flat, angular, basically two-dimensional compositions, in subdued tones and with a suggestion of volume produced by color and line. The major contribution of Juan Gris (1887–1927), a Spaniard and a synthetic cubist, was to bring vibrant color to cubism. His *Guitar with Sheet of Music* is one of the masterpieces of cubist art. Fernand Léger (1881–1955), whose work is cubistic only in a special sense, drew his forms largely from machines and construction materials. He arranged them according to cubist theories of perspective and volume to make positive, often lighthearted comments on the industrial age. Leger's *Nude on*

Fig. 15–22. Georges Braque. *Piano and Mandola.* 1909–10. 36 × 17". The Solomon R. Guggenheim Museum, New York. Photo by Robert E. Mates.

Fig. 15–23. Fernand Léger. *Nude on a Red Background.* 1927. 51¼ × 32". Hirshhorn Museum and Sculpture Garden, Smithsonian Institution.

a Red Background (fig. 15-23) strikingly re-
duces the parts of a human body to bur-
nished tubular forms.

Expressionism. Used broadly, the
term *expressionism* does not apply to a single,
organized movement in painting. As we
have seen, expressionist attitudes and tech-
niques have appeared in all the arts of the
century. Much as their work may vary in de-
tails, expressionists have sought to intensify
the expression of emotion by means that de-
part from conventional realism—distortions
of time, place, physical forms, etc.; dramatic,
often bizarre subject matter; and (in paint-
ing) bold, arbitrary use of color.

Van Gogh and Gauguin, as we have
implied, could probably better be called ex-
pressionists than postimpressionists. Fol-

Fig. 15–24. Edvard Munch. *Puberty.* 1894. 59 × 44".
National Gallery, Oslo.

lowing them, the Norwegian painter Edvard
Munch (1863–1944) produced a series of
paintings that express the artist's darker
emotions—sexual anxieties, a neurotic fear
of sickness and death, hysteria, and other
kinds of anguish. In the familiar painting
called *The Cry* or *The Scream,* a wave of terror
seems to pour in a silent scream from a dis-
turbed mind. *Puberty* (fig. 15-24) embodies
the anxieties of a young girl.

Munch lived to be eighty. Though his
color palette and his subject matter both
lightened somewhat with the passing years,
he is best remembered for his somber and
intensely expressionistic paintings done
around the turn of the century. They were
especially admired in Germany. In fact,
Munch was the principal inspiration for the
German school of expressionism, which in-
cluded such painters as Emil Nolde, Max
Beckmann, Franz Marc, and Ernst Kirchner.

The work of Nolde (1867–1956), oldest
of the group, is perhaps most characteristic
of German expressionism. *The Dance Around
the Golden Calf* (fig. 15-25), with its contorted
figures and frenzied colors, suggests both
the emotional content of the Biblical incident
and Nolde's response to it. Franz Marc
(1880–1916), an exceptionally gifted painter
who was killed in World War I, was one of
the leaders of the expressionist group called
Der Blaue Reiter (the Blue Rider). Marc was
fascinated by bold colors and by the broadly
curved forms of animals. His *Blue Horses* is
one of the most familiar and powerful of ex-
pressionist paintings.

The foremost French expressionist was
Georges Rouault (1871–1958), a devout,
moralistic painter whose early training as a
craftsman in stained glass is reflected in
many of his works. His paintings of the head
of a suffering Christ, a Biblical king, or a
mournful clown are characterized by heavy
black outlines and by color that approxi-
mates that of stained glass. These qualities
are well illustrated in *The Old King* (fig.
15–26).

Dada. The dada movement, men-

Fig. 15–25. Emile Nolde. *Dance Around the Golden Calf.* 1910. 35 × 32″. Bayerische Staatsgemäldesammlungen, Munich.

Fig. 15–26. Georges Rouault. *The Old King.* 1916–38. Oil, approx. 30 × 21″. Collection, Museum of Art, Carnegie Institute, Pittsburgh. Patrons Art Fund.

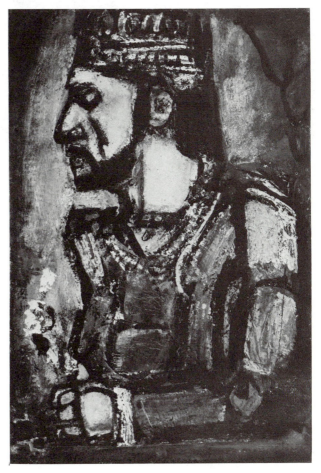

Fig. 15–27. Max Ernst. *Belle of the Night.* 1954. 51 × 35″. Hirshhorn Museum and Sculpture Garden, Smithsonian Institution.

Fig. 15–28. Marcel Duchamp. *Nude Descending a Staircase, No. 2.* 1912. 58 × 35″. The Philadelphia Museum of Art. Louise and Walter Arensberg Collection.

tioned earlier in connection with the sculptor-painter Jean (Hans) Arp, produced several important painters during and after World War I. One was Max Ernst (1891–1976), a German-born painter who later lived in Paris and Arizona. Ernst was an imaginative, highly individualistic artist who experimented in many media (collage, for one) and many styles, ranging from pure abstraction and surrealism to semiabstract landscapes inspired by the mountains of Arizona. His titles heighten the ambiguous humor of many of his works—*The Little Gland That Says Tic Tac,* for example. Ernst's *Belle of the Night* (fig. 15-27) is a blob-like creature that glares balefully at us, perhaps from

the depths of a primordial sea. The Dadaist Marcel Duchamp (1887–1968) spent a large part of his life in America and was responsible for the introduction of Dada to New York. His *Nude Descending a Staircase No. 2* (fig. 15-28), which outraged the public when it was first exhibited in New York, combines elements of cubism and futurism, an Italian movement that attempted to express the speed and intensity of the age of machines.

Surrealism. The surrealist school of painters (*sur* means beyond or above) that emerged in part from Dada was strongly indebted to the work of Sigmund Freud. Freud's theories of the subconscious and of

dream analysis prompted the surrealists to examine in new ways the problem of reality and illusion. Convinced that the unconscious mind conceals true reality but can reveal it more accurately than does the world around us, the surrealists (writers as well as painters) explored the world of dream, fantasy, half-conscious perception. Some, the "magic realists," placed ordinary objects in fantastic, irrational relationships. Others, the "biomorphic surrealists," evoked organic forms ranging from amoebas to foetuses. Both often placed their objects in dreamlike landscapes whose horizons seem to stretch to infinity.

Max Ernst, after the breakup of the short-lived Dada movement, became one of the leaders of the surrealist group in Paris. Other prominent surrealists were René Magritte and Giorgio de Chirico, magic realists; Yves Tanguy, a biomorphic surrealist; and Salvador Dali, essentially a magic surrealist. Others sometimes classified as surrealists are Joan Miró and Marc Chagall.

De Chirico (1888–1978), who was born in Greece of Italian parents, often painted human figures in distorted and empty cityscapes or amid classical ruins, the buildings and figures casting long and ominous shadows. In *Mystery and Melancholy of a Street* (fig. 15-29) the figure of the little girl with the hoop suggests less gaiety than nightmarish terror. The paintings of Salvador Dali (b. 1904), famous Spanish surrealist, are hard to separate from his own flamboyant personality. Some critics dismiss his work as that of a charlatan who has little real understanding of the deeper implications of surrealism. He

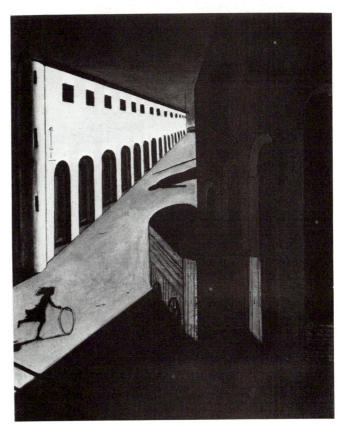

Fig. 15–29. Giorgio de Chirico. *The Mystery and Melancholy of a Street.* 1914. 34¼ × 28⅛". Collection, Mr. and Mrs. Stanley Resor.

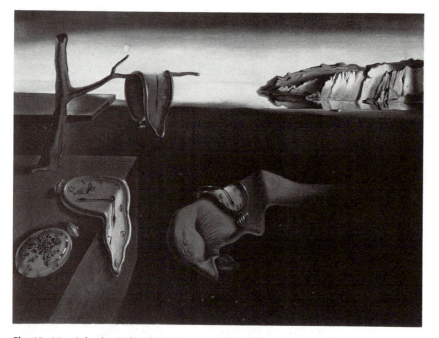

Fig. 15–30. Salvador Dali. *The Persistence of Memory*. 1931. 9½ × 13". Collection, The Museum of Modern Art, New York.

was, however, a member of the founding group; his work demonstrates great technical skill, and his imaginative use of common if distorted objects in a world of dream and fantasy is often brilliant. His famous painting, *The Persistence of Memory* (fig. 15-30) incorporates some of his favorite devices: the distant horizon, the realistic seaside cliffs, and the strangely drooping watches that suggest the illogicalities of time.

Marc Chagall (b. 1887), celebrated Russian-Jewish painter, is often called a surrealist, but his paintings more often than not suggest pleasant, half-waking daydreams—the fantasies of an artist whose mind wanders through memories of his early life in rural Russia. Though some of Chagall's paintings are somber, most of them celebrate in their fantastic way the common joys of life—a fiddler on the roof, a bridegroom perched joyously on his bride's shoulders, Chagall floating through the air to kiss his wife Bella (fig. 15-31).

Paul Klee and Joan Miró combined abstractionism with a fantasy derived from surrealism and other sources. The Swiss painter Klee (1879–1940), though a master of the formal aspects of abstractionism, created fantastic visions that at first glance resemble the uninhibited art work of young children. Believing, as he said, that art should create the same feelings as "a vacation in the country," he painted childlike but actually mature and sometimes symbolic paintings such as *Red Balloon* (fig. 15-32), in which a balloon floats over a misty, semiabstract village. Joan Miró (1893–1983), from Spain, was a highly prolific and widely admired painter whose work is unique in the true sense. He experimented successfully with cubism as well as his own brand of biomorphic surrealism. Perhaps he is best known for his re-renderings of classical paintings—Dutch interiors, for example—in terms of amoeba-shaped dogs and a variety of other fantastic forms, all done with uncommon wit and charm. The *Carnival of*

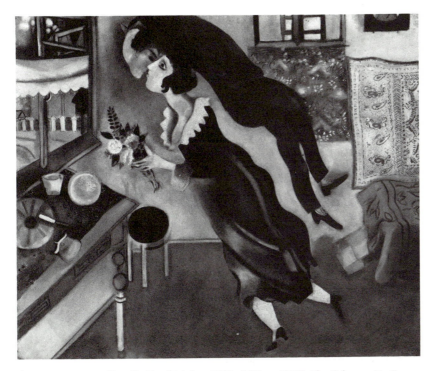

Fig. 15–31. Marc Chagall. *The Birthday*. 1923. 31⅞ × 39½″. The Solomon R. Guggenheim Museum, New York.

Fig. 15–32. Paul Klee. *Red Balloon*. 1922. 12½ × 12¼″. The Solomon R. Guggenheim Museum, New York.

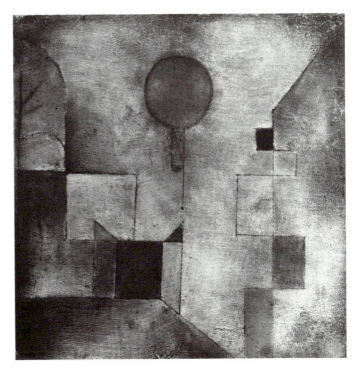

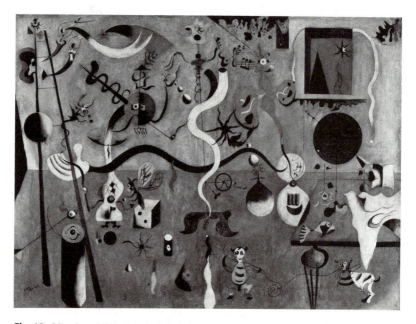

Fig. 15–33. Joan Miró. *Carnival of Harlequin.* 1924–28. 26 × 36⅝". Albright-Knox Art Gallery, Buffalo, New York. Room of Contemporary Art Fund.

Harlequin (fig. 15–33) is typical of Miró's teeming canvases.

Abstractionism (*Nonobjective Painting*). Abstractionism in one sense, as we have said, designates paintings or works of sculpture that do not represent objects in the natural world. Though earlier painters had been moving in the direction of such nonobjective abstraction, the Russian painter Wassily Kandinsky (1866–1944) is generally recognized as the first of the great abstractionists. A central figure in the history of art, Kandinsky was first identified with the German expressionists but gradually moved toward pure abstractionism. An articulate writer and something of a mystic, by 1914 Kandinsky had developed an aesthetic philosophy that argued for the freeing of the visual arts, especially painting, from the domination of subject matter. But he did not think of his abstractions simply as arrangements of form and color. "The harmony of form and color," he said, "must be based solely upon the principle of the proper con-

tact with the human soul." Kandinsky's abstractionism evolved still further—from free and dynamic color forms toward more well-ordered, geometric elements. Most of his paintings have no titles; an exception, *Painting (Winter)* (fig. 15-34), demonstrates how pure abstraction can evoke a mood.

Piet Mondrian (1872–1944), at first a painter of Dutch still lifes and landscapes, moved toward abstractionism in experiments with cubist formulas. He was one of the first to seize on what he considered the new freedom offered by nonobjective painting. He and other Dutch painters, seeking "for clarity, for certainty, and for order," found these qualities in straight lines, grid forms, and rectangles, and in primary and neutral colors. Subject matter was banned, though such titles as *Broadway Boogie-Woogie* encourage one to look for identifiable objects. *Composition with Blue and Yellow* (fig. 15-35) is typical. The influence of such works obviously carried over into the applied arts—textile and tile designs, for instance.

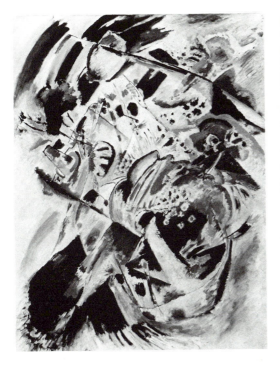

raged, a number of painters and sculptors were encouraged by the exhibit to do their own experimenting and exploring. Stanton Macdonald-Wright and Morgan Russell, for instance, who had been in Europe before 1910, moved from French cubism toward a strongly colorful abstract style they called synchromism.

Many important American painters in the period between the World Wars, however, held largely to one form or another of realism. One group, the regionalists, led by Thomas Hart Benton, Grant Wood, and John Steuart Curry, rejected the cubism and abstractionism they had earlier experimented with to depict the Midwest—its barns, animals, fields, and people—in basically realistic but personal styles. Another group, the precisionists, was led by Charles Sheeler and Charles Demuth. They depicted the automobile plants and grain elevators of middle America in clean-lined, simplified, sometimes near-abstract forms, and in a manner

Fig. 15–34. Wassily Kandinsky. *Painting, No. 199 (Winter).* 1914. 64⅛ × 48⅜″. The Solomon R. Guggenheim Museum, New York.

American Painting. American painters have modified or abandoned academic traditions somewhat less freely than their European counterparts, though one of the major nonobjective movements of the century, abstract expressionism (Ch. 16) developed primarily in the United States. In the first decade of the century a group called the Eight (or the Ashcan School), which included such gifted painters as John Sloan and Robert Henri, turned their backs on romantic landscape painting to depict common American scenes, such as backyards in Greenwich Village, people on ferries, streetcars, and crowds in parks. Another development was the uproar created in New York in 1913 by an exhibit called the Armory Show that featured many of the European artists mentioned in this chapter. Though the public and many artists were amused or out-

Fig. 15–35. Piet Mondrian. *Composition in Blue and Yellow.* 1935. 28¾ × 27¼″. Hirshhorn Museum and Sculpture Garden, Smithsonian Institution.

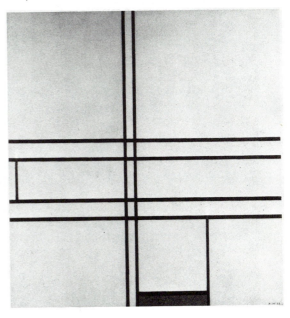

that reflected their admiration for the dynamic aspects of American agriculture and industry. Still another group, the social realists, of whom Ben Shahn was a leader, expressed their intense social and political views in paintings that were often as direct as political cartoons. Related to their outlook if not their techniques were the powerful political works of the Mexican artists Diego Rivera and José Clemente Orozco (fig. 15-36).

Edward Hopper (1882–1967), though not a social realist, depicted in realistic terms what was to him the essential loneliness and recurrent sadness of everyday life. Though he sometimes painted cheerful, brightly lighted views of New England villages or lighthouses, more often his subjects are old, once-elegant houses, boats on deserted beaches, or lonely figures in cafés or rundown hotel rooms—all evoking moods of near-romantic sadness. *Hotel by a Railroad* (fig. 15-37) is Hopper at his best and most evocative.

Three painters who adopted and held to the newer European-oriented trends were Joseph Stella, John Marin, and Stuart Davis. Joseph Stella (1877–1946) is best known for his beautiful semiabstract paintings of New York skyscrapers and of the Brooklyn Bridge, itself a marvel of engineering and abstract art. John Marin (1870–1953) was one of America's foremost watercolorists. His paintings, which carry abstraction farther than do those of Stella, show the influence of Cézanne and the cubists. Many of his works depict New York buildings and bridges, illuminated by brilliant sunbursts and vibrating with diagonal "lines of force." His *Maine Islands* (fig. 15-38) is a semi-abstract seascape with more identifiable objects than appear at first glance. Stuart Davis (1894–1964) moved through a variety of styles but ultimately turned to cubism, which he infused with a personal, often humorous touch that is easily recognizable; he identified it with the spontaneity of American jazz. His subjects range from cubistic gas stations to brightly

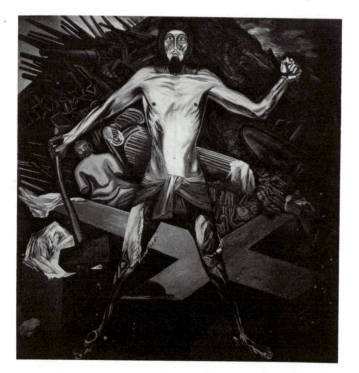

Fig. 15–36. José Clemente Orozco. Panel 14 of the Orozco Frescoes *Modern Migration of the Spirit.* 1934. Courtesy of the Trustees of Dartmouth College.

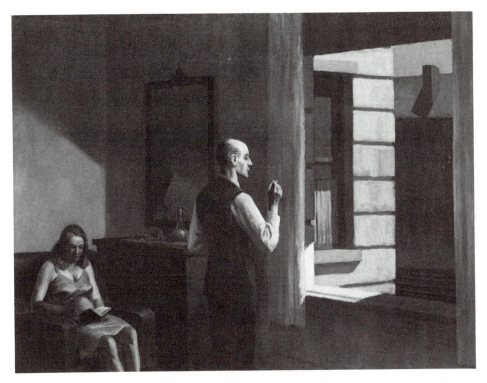

Fig. 15–37. Edward Hopper. *Hotel by a Railroad.* 1952. 31¼ × 40⅛". Hirshhorn Museum and Sculpture Garden, Smithsonian Institution.

Fig. 15–38. John Marin. *Maine Islands.* 1922. Watercolor, 16¾ × 20". The Phillips Collection, Washington, D.C.

Fig. 15–39. Stuart Davis. *Rapt at Rappaport's.* 1952. 52 × 40". Hirshhorn Museum and Sculpture Garden, Smithsonian Institution.

colored, lively near-abstractions such as *Rapt at Rappaport's* (fig. 15-39).

The multitude of styles that developed in European and American painting reflected the diversity and changefulness of Western culture during the first half of the twentieth century. The rapid rise and decline of artistic movements was only a foreshadowing of the breath-taking pace of change in the years that have followed.

16 THE TWENTIETH CENTURY SINCE 1945

The accelerating rate of change has continued to be a constant in the years since World War II—so much so that some observers worry about our ability to cope with it successfully. Where the arts and general culture are concerned, the speed and extent of recent change make it difficult to isolate the characteristics by which a new period or era can be identified.

In artistic matters a new problem in terminology has developed. Most art produced since the early 1900s has been called *modern art*. Since the term becomes less meaningful the longer it is used, some scholars have called more recent arts *postmodern* or *contemporary*—terms which are themselves of only temporary value. Few critics agree as to when the shift from *modernism* to *postmodernism* took place, but there is general agreement that by 1960 the culture of Europe and America was markedly different from that before World War II.

The years since 1945 have been filled with military and political tension. Though the great powers have avoided direct confrontation with each other, several of them have been involved in military action with smaller nations, and most of the world has been divided into armed camps that have frequently engaged in war, cold or hot. Military leaders and civilians alike have lived under the constant threat of atomic warfare that could destroy the world.

Apart from Vietnam and indirect involvement in other conflicts, the United States has had major problems in recent years. In the '60s and '70s agitation for social, racial, and other reforms led to riots, demonstrations, and closed campuses. Passionate involvement became the stance not only of college students but of millions of others. Some observers argued that traditional institutions were no longer capable of responding to the pressures of the time. But others found (and find) America remarkably resilient and flexible—as open to modification as any society in history.

European nations have also experienced basic changes in social, religious, and political attitudes—more deep-seated ones, perhaps, than in America. Two world wars, with their death and destruction, convinced many Europeans that hopes for peace are delusive and that one should grasp whatever pleasures are at hand. Doubt and disillusionment have become widespread; in philo-

sophical and moral terms they have led not only to varieties of hedonism but to an increasing acceptance of one form or another of existentialism.

The term *existentialism* identifies not a unified philosophical school but a number of ideologies. In fact, many leading existentialists have been writers rather than formal philosophers. They range from devout believers such as the Christian existentialist Soren Kierkegaard (1813–1855), some of whose followers believe man can find God in personal experience, to atheists like Jean-Paul Sartre and Albert Camus, who agree with their principal mentor, the German philosopher Nietzsche, that "God is dead." Existentialists do agree on a few basic concepts: people do exist, concretely; people are free; and since they are free, they are responsible for what they do and what they make of themselves. For Kierkegaard that responsibility involves the fear and dread of not choosing God; for Sartre and Camus it involves making personal choices in a meaningless universe—an *absurd* universe, to employ the usual term.

Though it appears that much, perhaps most, contemporary art reflects this darker view of life, there are many who oppose the existentialist notion of the absurdity of life and find meaning, direction, and basic stability, at least in their own lives. In fact, events of the past few years indicate that many people, younger ones in particular, have returned with fervor to long-established religious and social traditions, even though their ways of manifesting that fervor have sometimes been new and startling.

LITERATURE

The experimentation that characterized the literature of the first half of the century has continued to the present. Many of the *avant-garde* writers of the twenties and thirties became the established masters of the postwar period. Eliot, Pound, Sandburg, Frost, Stein-

beck, and Faulkner, as well as Brecht, O'Neill, and Mann, all wrote major works during the 1950s or 1960s. But though they continued to exert influence, differences between their writing and that of the last three-and-a-half decades are significant.

One contemporary school of poets carries even farther than its predecessors a tendency toward obscurity of symbolism and syntax. Another school employs scatological and sexual terminology that would not have passed censorship a generation or two ago. Some recent plays and novels are plotless mélanges of scrambled time sequences that lead to no logical resolutions.

Another school of contemporary literature blurs the distinction between serious and popular writing. Some recent critics argue that writings for noncritical, popular consumption—westerns, mystery thrillers, etc.—are superior to serious literature. A number of European critics insist that comic strips are the real American contribution to literature. Serious novelists have modeled their works on paperback detective stories or spy novels. This deliberate introduction of the banal into serious art, though it was foreshadowed by the Dada movement, is essentially a new development.

The search for personal identity, which has become a major preoccupation of what has been called "the age of introversion," has resulted in a great amount of confessional or semi-autobiographical poetry and fiction. And novelists such as Vonnegut and Barth often inject their personal experiences into otherwise non-autobiographical fiction. The line between life and art has become more and more indistinct.

Poetry

The poets discussed in Chapter 15, as we have indicated, dominated the first years after World War II. In fact, many of them achieved their first widespread acceptance during these years. But new voices also began to attract attention.

American Poetry. The first authentically new style in American poetry was what we have referred to as "confessional" poetry. This kind of verse is essentially a kind of self-psychoanalysis. The approach and subject matter vary considerably, from the poet's inability to relate to his cultural background to very frank and self-revelatory sexual analyses.

Best known of the confessional poets was Robert Lowell (1917–1977). A descendant of one of America's most famous families, Lowell was troubled by his Puritan heritage. His reaction against the darker side of New England's religious traditions led him to reject Protestantism and convert to Roman Catholicism. But neither his conversion nor frequent periods of psychiatric treatment brought him peace of mind. Much of his verse is an account of his personal struggles. At its best it is concise, rhythmic, and sometimes witty. Some of his better poems can be found in his Pulitzer Prize-winning volume *For the Union Dead.* Lowell also made fine translations of Greek tragedy and modern European poetry.

Two poets whose confessional works have drawn much attention are Anne Sexton (b. 1928) and Sylvia Plath (1932–1963). Sexton often assigns intensely personal meanings to external objects. Her poem "Starry Night" uses Van Gogh's famous paintings as a point of departure for introspective responses to death. Plath's poems, often short and poignant, provide insight into the struggles of a gifted and disturbed artist. She committed suicide in her early thirties; her highly acclaimed best-selling novel, *The Bell Jar,* was published after her death.

The first large-scale bohemian movement after the war, the "beatniks" or "beats," produced several poets whose verse gained the attention of literary critics. Among them was Allen Ginsberg (b. 1926), a skilled self-publicizer, who was educated at Columbia and then took to the road. He produced a considerable amount of "beat" verse, much of which he has made a practice of reading in public recitals. He has been called "an amiable pseudo-Zen droll" whose verse, deliberately bad, expresses the dropout's attitude toward society. A more gifted poet is Lawrence Ferlinghetti (b. 1919), whose verse is often lighter, less self-indulgent, and wittier than that of his fellow "beats," more than a thousand of whom published poetry. His collection *A Coney Island of the Mind* includes a number of his best poems, including Number 15 ("Constantly Risking Absurdity"), in which he compares the poet's art to the skill of a tightrope walker.

Continental Poetry. Many of the better continental writers of the prewar period gained international recognition after World War II. Among them was Gottfried Benn (1886–1956), an expressionist and experimenter whose role in German poetry was much like Eliot's in English. A physician, Benn first acquired a limited audience with experimental poems from which verbs and even syntax are largely eliminated. A Nazi for a time, he left the party and was forbidden, first by the Nazis and later by the Allies, to publish. Benn's postwar poems reflect his concern for ethical values in a confused and disturbed age. They are at once more lucid and more pessimistic than his earlier verse. Such poems as "Ah, the Distant Land" are elegiac in tone.

Other German poets who have attracted international attention since the war include Paul Celan (1920–1970), a Rumanian by birth. (His native village was wiped out by the Nazis.) The outstanding German poet of his generation, he wrote in fresh terms of the horrors of Nazi oppression. Celan's poetic method was strongly influenced by surrealism, as was that of Ingeborg Bachmann (1926–1973), an Austrian, best known of modern women poets writing in German. A facile poet who wrote in several styles, Bachmann is best remembered for tender, lyrical verses and for her confessional poems. Günter Grass (b. 1927), Germany's most famous

modern novelist, is also a recognized poet. His verse, like his prose, is energetic but erratic.

Three modern Russian poets who have gained worldwide recognition are Yevgeny Yevtushenko (b. 1933), Andrey Voznesensky (b. 1933), and Boris Pasternak (1890–1960). Yevtushenko first became known during the "thaw" following the death of Stalin, when he published a series of poems denouncing the terrors of the Stalinist era and the Nazi invasion. "Heirs of Stalin," published in 1961, warns against the recurrence of Stalinism. "Babi Yar," in which he identifies himself with the slaughtered Jews of Russia, is perhaps his best-known poem. Andrey Vozsnesensky wrote political poetry during the sixties but has turned more recently to traditional lyric themes—love, marriage, loneliness, and death. His poetry, which resembles that of the traditional poets of western Europe, is more musical than that of Yevtushenko. "Parabolic Ballad" is a good example. Boris Pasternak, author of the famous *Dr. Zhivago*, incorporated some of his fine meditative and religious poems into that novel.

A new form of poetry that has gained some popularity in Europe and America is "concrete" poetry. Concrete poets arrange words in visual designs that are difficult or impossible to read as discourse. It has been suggested that there is a relationship between concrete poetry and oriental calligraphy, but the latter is as much concerned with communication as with visual beauty. Among the best-known concrete poets are John Furnival in England and Rolf-Gunther Dienst and Ferdinand Kriwet in Germany.

Drama

The experimentation that characterized the plays of such dramatists as Brecht and Pirandello continued after World War II. Brecht's finest works, in fact, were written during his long exile from Germany from the time of Hitler until not long before his death

in 1956 (he became an American citizen a few years before his death). During these years new playwrights were building on his innovations and turning to themes that reflected the concerns of contemporary thinkers, such as sexual behavior and psychological and spiritual alienation.

American and English Playwrights. Two postwar playwrights who have established permanent reputations are Arthur Miller (b. 1915) and Tennessee Williams (1914–1983). Miller writes social dramas that he and others consider the equivalent of classical tragedy. His most famous play, *Death of a Salesman*, employs techniques derived from Brecht and the expressionists—flashbacks, dream sequences—to superimpose the past upon the present troubled life of a salesman and his family. Apart from such techniques the play remains a realistic, essentially compassionate study of a salesman whose principal driving force is an almost pathetic desire to sell himself. Willy lacks the stature of a classical hero, but the play is a moving theater piece. Miller's other plays are concerned with such matters as the profit motive in the strong drama *All My Sons* and Puritan witch hunts in the more traditional, Ibsen-like play *The Crucible*. *After the Fall* is an autobiographical drama growing out of Miller's marriage to Marilyn Monroe.

Tennessee Williams wrote a number of plays dealing with a restricted view of life in the South. His characters, typically, are neurotically sensitive people—unstable men and women—who live in dream worlds that alienate them from the realities they must face. Williams gained international fame with his early plays, *The Glass Menagerie* and *A Streetcar Named Desire*, both semipoetic but essentially realistic. *Cat on a Hot Tin Roof* received a Pulitzer Prize. Several of his more recent plays, such as *Night of the Iguana*, have had only marginal success.

Most controversial of recent American playwrights is Edward Albee (b. 1928). In his first plays, many of them one-acters, Albee

experimented with the "theater of the absurd" (see below) and with devices borrowed from German expressionism and Brecht's alienation effects. But in his searing drama *Who's Afraid of Virginia Woolf?* he employed traditional dramatic devices and straightforward, crackling dialogue to develop a theme of marital and social conflict. Since *Virginia Woolf* Albee's plays, such as *Tiny Alice*, have become increasingly loaded with complicated metaphysical symbolism. He won a Pulitzer Prize with *A Delicate Balance.*

The witty poetic dramas of the British playwright Christopher Fry (b. 1907) were widely acclaimed after the war. Their plots are based on medieval or other ancient stories, but their themes are modern. They include *The Lady's Not for Burning* (a comedy with witchcraft as its subject), *A Phoenix Too Frequent*, and *A Sleep of Prisoners*—the last-named a religious drama.

Robert Bolt (b. 1924), another British playwright, has written for both the stage and motion pictures. His play *A Man for All Seasons*, later turned into a film, is based on the life and death of the great English writer and saint, Thomas More. Bolt's intelligent dialogue and sensitive character development make this one of the most memorable of modern plays. Harold Pinter (b. 1930), widely considered the greatest of modern English playwrights, is experimental within carefully maintained boundaries—an "ironic superrealist," he has been called. His plays deal with common situations, and his dialogue, balancing humor and tension, reproduces everyday speech. But he can create a Kafkaesque atmosphere and a suspense that borders on the terrifying. Pinter's most frequently produced plays are *The Caretaker*, *The Birthday Party*, *The Homecoming*, and *No Man's Land.*

Continental Playwrights. Jean Anouilh (b. 1910), least innovative of modern French playwrights, is probably the most popular one. A superb craftsman, Anouilh deals in fresh terms with plots derived from history and from classical drama. In such plays as his modernized version of *Antigone,* an allegory of modern France, he re-examines the timeless problem of preserving integrity and virtue in a corrupt world. He creates realistic characters who become embodiments of his pessimistic philosophy. Among Anouilh's other plays that have gained fame throughout the world are *The Lark,* based on the story of Joan of Arc, and *Becket, or the Honor of God,* which was made into an outstanding motion picture.

Jean-Paul Sartre (1905–1980) and Albert Camus (1913–1960) were active in the French Resistance movement. Their plays, well-known in France during the war, reflect not only the despair of intellectuals in an occupied land but the existentialist philosophy of which they are two of the chief exponents. The best-known plays of Sartre, for most readers more philosophical than dramatic, are *The Flies* and *No Exit.* The first is a retelling of the Orestes legend; the familiar story becomes a background against which Sartre makes a case for the abandonment of the Christian concept of God. *No Exit* puts in a dramatic context the popular existentialist thesis that men are inescapably isolated from one another. Camus is better known as a novelist; his plays include *The Just* and *Caligula,* the latter a dramatic study of the fundamentally absurd life of the Roman tyrant.

The most original and controversial theater movement since World War II is the *theater of the absurd,* which originated in France. The playwrights of this school use techniques that have grown out of Brecht's alienation theories, such as suspending characters above the floor or filling an otherwise empty stage with chairs. But whereas Brecht tried to jolt the audience to greater attention, the absurdists employ irrational elements to support their thesis that the world is out of joint—or jointless.

The best-known absurdist playwrights are Samuel Beckett (b. 1906), Eugène Ionesco (b. 1912), and Jean Genet (b. 1910). Beckett,

an Irish-born dramatist, has lived in France and written in French since 1937. (He claims that writing in French restrains his rhetoric.) Beckett's plays, though sometimes marked by what has been called a vaudeville kind of humor, depict lives deprived of meaning by boredom and cruelty. In *Waiting for Godot*, two tramps spend the first act waiting for someone—God(ot)—who never comes. The second and final act, with slight variations, is a repetition of the first. Beckett, unlike Sartre and Camus, does not promote atheism. But neither does he allow his characters (often Irishmen) to bring to the surface the hope that underlies their lives. Among his other important plays are *Endgame* and *Krapp's Last Tape*. In the latter, perhaps Beckett's best play, an old man plays back tapes that help him remember things past.

Eugène Ionesco, a Rumanian, writes simple, often inane dialogue to force his listeners to the realization that their ways of life are sometimes equally inane. His first famous play, *The Bald Soprano* (which has no soprano, bald or otherwise), was inspired in part by primer sentences he read in an elementary English text for foreigners. A typical scene in this absurdly amusing play shows two characters who, after having discovered that they are from the same city, quarter, street, and address, conclude that they must be husband and wife. Ionesco's most widely performed play is *Rhinoceros*, a funny but frightening play about the people of a community who turn, one by one, into rhinoceroses (symbolically, fascists and nature worshippers).

Two German-language (Swiss) writers of absurdist drama and "black comedy" are Max Frisch (b. 1911) and Friedrich Dürrenmatt (b. 1921), whose plays reflect the influence of Brecht and their own responses to the moral and social devastation wrought by Nazism. In *The Firebugs* Frisch tells the story of a man who is so good-natured that he watches politely as arsonists bring materials to burn down his house—a bitter allegory of the German acceptance of Hitler. Dürrenmatt's plays, on the surface flippant come-

dies, have a somber understructure. *The Visit* tells of a wealthy widow who returns to a small village and offers the inhabitants one billion dollars if they will kill the man who seduced her as a young girl. *The Physicists* is a black comedy set in an insane asylum, where a scientist who has invented the ultimate destructive weapon has had himself committed.

The German playwright Peter Weiss (b. 1916) wrote a famous absurdist drama that does not have the ponderousness its title would imply—*Persecution and Assassination of Jean Paul Marat as Played by the Inmates of the Chareton Asylum under the Direction of the Marquis de Sade*. *Marat/Sade*, as the play is generally called, is a highly sophisticated play within a play. As the title indicates, the inmates produce a drama based on the murder of the French revolutionary leader Marat. The actors playing the inmates depict both madmen and the characters the madmen play. Other actors, playing spectators or guards, debate not with the inmates, but with the characters the inmates portray. In spite of the potentialities for confusion, the play is a successful and innovative piece of theater.

The Novel

Television, which has come into widespread use only since World War II, has in no significant way inhibited either the writers or the readers of fiction, in spite of predictions to the contrary. Popular novels beyond number are produced every year, mostly in paperbacks and mostly in traditional romantic-realistic styles. Many serious novelists have also employed traditional forms; others have adopted a variety of experimental styles, including the stream-of-consciousness techniques of Joyce and Woolf. The more innovative recent novelists have tried, among other things, to develop new ways of dealing with time relationships.

A number of contemporary writers have made the lore and lives of the Jewish people—European Jews, immigrants, and

American Jews—a major area of literary interest. Among them are such eminent writers as Chaim Potok (*My Name Is Asher Lev, The Chosen, The Promise*), Bernard Malamud, Saul Bellow, and Isaac Bashevis Singer. Bernard Malamud (b. 1914) created an unusual but believable hero, a near saint, in his moving novel *The Fixer*, which tells of a poor Jew's nobility and courage in the face of false accusation, torture, and imprisonment in early twentieth-century Russia. Malamud has also written excellent short stories, including those in the collection *The Magic Barrel*. His more recent novels are less successful. Saul Bellow (b. 1915) one of America's most famous contemporary writers and winner of a Nobel Prize, writes with insight, in such novels as *Herzog*, of the American Jew who has lost faith and identity. Bellow's *Henderson the Rain King* is a thought-provoking, sometimes hilarious story of an American whose search for a purpose in life brings him into jarring contact with a tribe of Africans and their philosopher-chief.

One of the great storytellers of our time is the Polish-American novelist and short-story writer Isaac Bashevis Singer (b. 1904). Singer, who writes in Yiddish and helps with the translation of his works into English, comes closer than any other present-day writer to capturing the sweep, intensity, and sense of life and place that characterize the works of the great nineteenth-century Russian novelists. His novels and stories are memorable for their richness of character and incident, and most are set in the Jewish villages of Poland and Russia and in the ghettos of such cities as Warsaw and New York. Their recurring theme is the difficulty of maintaining religious and family traditions in a secularized, skeptical society. *The Manor, The Estate*, and *The Family Moskat* are sagalike novels, on the order of Mann's *Buddenbrooks*, which chronicle the lives of several families of Polish Jews.

Two novelists who have almost become cult figures on American high school and college campuses are William Golding (b. 1911) and J. D. Salinger (b. 1919). Golding, an Englishman who received the Nobel prize in 1983, is best known for his *Lord of the Flies*, the story of a group of boys who are the only survivors of a plane crash on a deserted island and who degenerate into savages in their struggle for survival. Some readers see a strain of Calvinism in this and other Golding novels. Many young readers evidently find it easy to identify with Holden Caulfield, sensitive adolescent hero of Salinger's famous *Catcher in the Rye*. Salinger has also written another best-selling novel, *Franny and Zooey*, and a number of short stories, among them the humorous and tender "For Esmé—with Love and Squalor."

The efforts of Norman Mailer (b. 1923) to publicize his freedom from the constraints of middle-class society have often obscured his gifts as a writer. Mailer achieved early recognition with *The Naked and the Dead*, a well-constructed novel of the war in the South Pacific. Like Mailer's novels in general, it has little depth of characterization, but it depicts effectively the grim realities of war. His *Deer Park*, more explicit in sexual matters, established Mailer for many as a leading proponent of personal freedom, literary and otherwise—of living life according to instinct. He has turned recently to nonfiction in his *Executioner's Song*, an account of the life and death of the murderer Gary Gilmore which Mailer chooses to call a novel.

Other prominent American novelists of the postwar era include Ken Kesey (*One Flew over the Cuckoo's Nest*), Joseph Heller (*Catch-22*), and John Barth (*Giles Goat-Boy* and *Sabbatical: a Romance*). *Cuckoo's Nest* and *Catch-22* have been made into hit movies. Barth loads his novels with devices that play tricks with time, place, and the convolutions of the mind. Beneath the eccentricities lies a stratum of serious thought and of genuine concern for the preservation of values.

England has produced several significant postwar novelists. George Orwell (1903–1950) published two important novels in the late 1940s, *Animal Farm* and *1984*, depictions of imaginary totalitarian societies. Orwell's grim political vision re-

mains as vivid to us today as it was to his own generation. Other postwar English novelists are Graham Greene (*The Heart of the Matter* and a number of fine mysteries); C. P. Snow (a series of novels under the general title *Strangers and Brothers*); Arthur Koestler, a Hungarian-born naturalized Englishman (*Darkness at Noon*); and William Golding (whose *Lord of the Flies* we mentioned earlier).

Continental Novels. For the non-Soviet world, Russia's most important postwar novelists are Boris Pasternak (1890–1960) and Alexander Solzhenitsyn (b. 1918). Pasternak's greatest achievement is *Dr. Zhivago*, a large if somewhat fragmented novel in the nineteenth-century tradition; it embraces a period extending from prerevolutionary times to World War II. The characters of the novel are sensitive humans developed against a background of important historical events. Though the work implies criticism of the Soviet betrayers of communism, its tone is often poetic and essentially optimistic.

Solzhenitsyn's first noteworthy novel was published during the so-called thaw after the death of Stalin, when Khruschev's anti-Stalin campaign allowed some relaxation of Russian censorship. Entitled *One Day in the Life of Ivan Denisovich*, it is a moving and terrifying account of life in a Stalinist labor camp. Its hero is a simple man of a type long popular in Russian fiction. Solzhenitsyn's next two novels, both written under circumstances of great personal stress, reflect his own experiences—a long fight with cancer and eight years' imprisonment for having criticized Stalin. *Cancer Ward*, a realistic but highly symbolic novel, has two especially memorable characters—its rough-hewn but decent and courageous hero, and a self-righteous professional informer, both patients in a cancer ward. The setting of *The First Circle* is one of the "special prisons" set up by Stalin for especially gifted political prisoners who were expected to be productive under soul-destroying circumstances. Solzhenitsyn, since his expulsion from the USSR, has become a symbolic figure himself;

some consider him the greatest man of the century. Both he and Pasternak received Nobel Prizes.

The most prominent postwar novelists of Germany are Günter Grass (b. 1927) and Heinrich Böll (b. 1917). Grass first gained international recognition with his *Tin Drum*, which combines realism and fantasy to relate much of the history of twentieth-century Germany as seen from the perspective of a strange, precocious dwarf. At times moving and gentle, the novel is also outrageous and repulsive; Grass exploits the sensational and shocking to underscore these elements in modern German history. He has published several other novels that have received widespread attention, including *Dog Years*, an allegorical fantasy about a dog that is both Hitler's pet and Walt Disney's Pluto. *Local Anesthetic*, sensational and grossly comic, is at its core a defense of the humanistic values of Western culture.

The novels and stories of Heinrich Böll, recipient of a Nobel Prize, deal chiefly with World War II and the society of West Germany since the war. Böll employs some modern techniques, but basically he is a realist and ironist who tries to record, in simple language and masterful dialogue, the things people really say and do. Critics see in his fiction the storytelling flair of Dickens and the terseness of Hemingway. His best works are *The Clown* and the very recent *Safety Net*—the latter dealing with the erosion of decency in modern society.

Although Albert Camus (1913–1960) is well known as an essayist and playwright, it is largely for his work as a novelist that he was awarded the Nobel Prize three years before his death in an auto accident. Camus's popular existentialist novel, *L' Etranger* (*The Outsider*), was published in 1942, when he was active in the French Resistance movement. Set in Algeria (where Camus was born), it is the story of a Frenchman who kills an Arab, apparently in self-defense. In subtle psychological terms the novel examines the question of his guilt or innocence. Its pessimistic picture of isolation and alienation has become the most familiar literary

statement of atheistic existentialism. Camus continued to ask, in such novels as *The Plague,* whether moral responsibility is possible in the absence of divinely ordained standards. The central character of *The Plague* is a doctor whose "absurd" existence takes on meaning as he helps the victims of a plague in Oran.

The more experimental French novelists of recent years—the "new novelists," as they are called in France—are linked to the existentialists in themes and subject matter, but they experiment with nonliterary or pseudoliterary devices. Michel Butor, for example, uses a city map as the structural element in his novel *The Uses of Time.* Alain Robbe-Grillet develops the Oedipus theme in a dehumanized, deliberately shoddy detective novel called *The Erasers.*

The most prominent postwar novelist in Italy is Alberto Moravia (b. 1907). Less experimental than most of the French and German authors, he is as concerned as they with contemporary moral issues. In matter-of-fact prose Moravia writes about social—especially family—relationships, with genuine concern for the unfortunate. *Conjugal Love* and *Two Women* are typical. In *The Epidemic,* a short allegorical novel, the people of a community persuade themselves that the death stench from a foul epidemic (fascism) is a sweet odor.

A celebrated writer of fiction in Spanish is Jorge Luis Borges (b. 1899), an Argentinian (educated in Switzerland) who lived in America a number of years. Borges has helped to translate into English the hundreds of short (often very short) stories he has published in American magazines and in collections. (The collections include *The Aleph* and *The Book of Imaginary Beings.*) His stories of gangsters, cowboys, and uneducated peasants, often derived from his memories, are deceptively simple; he seeks, says a critic, to overthrow the reader's confidence in external reality. He is a setter of riddles which subtly probe the relationship between imagination and the world.

V. S. Naipal (b. 1932), a distinguished essayist and critic who was born in Trinidad of Hindu parents, has also written several exceptional novels (in English). His experiences in the West Indies, England, Africa, India, and elsewhere have equipped him to write with insight about racial tensions in Third World countries. *A House for Mr. Biswas* is a touching story of an Indian, born in Trinidad to Hindu parents, who is an outsider in the West Indies. The central character of *A Bend in the River* is another Indian, a sensitive young man thrown into the midst of several clashing cultures—European, native, and Indian—in an African town. Naipal has the true novelist's ability to evoke the sights and sounds of unfamiliar parts of the world.

MUSIC

Serious music since World War II ranges even more widely than before—from relatively traditional works through compositions by followers of such composers as Stravinsky and Schoenberg, to computer-composed music, numerous kinds of music produced by other electronic means, accidental or chance music, and music designed to eliminate the gap between traditional musical sounds and everyday noises.

In the Tradition. Among older composers who did important work both before and after World War II are the Americans Roger Sessions, Douglas Moore, Aaron Copland, Samuel Barber, and Elliott Carter; the Italian-American Gian-Carlo Menotti, and the English Benjamin Britten.

Douglas Moore (b. 1893), distinguished music educator and composer, is best known for his operas based on American literature and lore: *The Devil and Daniel Webster* (on the story by Stephen Vincent Benet); *Giants in the Earth* (on a fine regional novel by the Norwegian-American Ole Rolvaag); *The Wings of the Dove* (on one of Henry James's masterpieces); and *The Ballad of Baby Doe* (on the colorful true story of Horace Tabor, a millionaire mine owner in Leadville, Colorado, and Elizabeth "Baby" Doe, a dance hall girl).

Aaron Copland (b. 1900), much-honor-

ed composer and writer on music, began his career as a composer of complex music in twelve-tone and other experimental forms, but he made something of an about-face and spent most of his middle and later years writing fresh, melodic, but never banal music, usually on American subjects and often incorporating bits of American folk music. Popular both as ballets and on the concert stage are *Rodeo*, *Billy the Kid*, and *Appalachian Spring*. Also frequently performed are his *Third Symphony*, the *Lincoln Portrait*, and the suite *El Salón México*.

The music of Samuel Barber (b. 1910), like that of Copland, retains its interest for general listeners. Two of his earliest pieces— *Essay for Orchestra* and the poetic *Adagio for Strings*—continue to be performed often. His more recent works reflect his interest in literary sources: *Hermit Songs*, based on medieval poems; the emotionally intense *Medea Ballet* (and *Suite*), composed for Martha Graham; and *Knoxville: Summer of 1915*, for soprano and orchestra, a lovely, freeflowing setting of a piece of poetic prose by James Agee.

Gian-Carlo Menotti (b. 1911), with the possible exception of Britten the century's most successful composer of operas, was born in Italy but has lived in America since 1928. A child prodigy, he was writing operas when he was eleven. His first success, a sensational one, was *Amelia Goes to the Ball*. It was followed by the delightful comic opera *The Old Maid and the Thief*. The more dramatic operas *The Medium* and *The Consul* followed; then Menotti composed the perennially popular Christmas opera for television, *Amahl and the Night Visitors*. Gifted with a fine sense of theater, Menotti has written most of his own librettos. His music is essentially warm-hearted and romantic, with some touches of the modern.

The outstanding English composer Benjamin Britten (1913–1976), probably as versatile a musician as the century has produced, was a fine conductor, a concert pianist, and a composer in a variety of styles. A prodigy like Menotti, he composed an oratorio when he was nine; and before he was

twenty he had written quite modernistic chamber music—a *Fantasy for Oboe and Strings*, for instance—that is still frequently performed. Britten's greatest achievements are his operas. His first work in this form was *Peter Grimes*, based on a tragic old story of a fisherman twice falsely accused of murder. It was a huge success; the entire English music world, says a critic, was suddenly invigorated. Like Mussorgsky he retained the dramatic intensity and lyricism of romantic-realistic opera and united with them new concepts of tonality and melody. Other memorable operas followed: *Billy Budd* (on Melville's short novel); *The Turn of the Screw* (on Henry James's chilling psychological mystery); and *Death in Venice* (on Thomas Mann's short novel). Other distinguished works include *A War Requiem* and *A Ceremony of Carols*.

Elliott Carter (b. 1908), though slightly older than Barber and Menotti, is hardly "in the tradition." In fact, he is an important transitional figure. His music is complex and experimental. He asserts that early twentieth-century and neoclassical music is static and repetitive, and that its rhythmical routines are extremely restricted. He argues for all kinds of rhythmic variations and for "a fluid changeable continuity." His compositions, extremely difficult to perform, incorporate ideas derived from sources as divergent as "pop" and Balinese and Arabic folk music. Among his compositions are a ballet, *The Minotaur*; a notable *Sonata for Cello and Piano*; and a *Concerto for Piano and Orchestra*. He has won two Pulitzer Prizes.

New Directions in Music. The postwar, postmodern school of innovators has been led by Carter and by John Cage, Milton Babbitt, Henry Brant, Karlheinz Stockhausen, Oliver Messiaen, and others. Earlier composers such as Schoenberg, Webern, and Ives, with their experiments in atonality, twelve-tone and serial music, polyrhythms, and polytonality, for example, provided models and points of departure for the new composers. Soon some of them abandoned

even the restraints of serial music: one group has modified conventional musical instruments or required them to be played in unconventional ways. They have wrapped rags around the strings of a piano or put bolts and rocks in the instrument; or they have required the cellist or harpist to play his or her instrument only by thumping its soundbox. Henry Brant, more conservative, has composed a piece for brass quintet divided into two widely spaced groups, with instructions for the groups to ignore each other while they play. Cage, Stockhausen, and others have led the way in experiments with *concrete* or electronic music, the composition by tape recording of freely selected and treated natural noises—speeded up, slowed down, played backwards, mixed—in "an artistically ordered continuum." *Aleatory* music, music depending on accident or chance and a minimum of control, has also won its supporters. Composers of such music have written a few general instructions for each of several instrumentalists, handed them indiscriminately to the performers, and told them to play. Or they have asked the performers to use the markings—grains, knots, etc.—on unpainted plywood as their score. Cornelius Cardew has required his performers to munch sandwiches during performance as part of the work.

John Cage (b. 1912) has been an articulate spokesman for electronic and aleatory music and an intellectual leader of other *avant-garde* artists such as the writers of absurdist drama, the action painters, and the organizers of "happenings." Cage argues that there should be no distinction between the traditional sounds of music and other sounds—that an alert listener can hear music on any street corner. Even in his formal compositions he welcomes unexpected sounds from any source. He believes, moreover, that a piece of music suffers from being repeated. One of his better-known works is *4' 33"* (four minutes and thirty-three seconds); the performer sits immobile at a closed piano for that period of time. Some of Cage's compositions, not easily distinguishable from

the others, reflect his interest in oriental philosophies. His most frequently performed work is *Fontana Mix*, which has been variously performed by piano, percussion instruments, guitar, and recorded sound material.

Milton Babbitt (b. 1916) and Charles Wuorinen (b. 1938) are important *avant-garde* composers. Babbitt, who has composed complex twelve-tone music, has also done innovative work with synthesizers. His efforts have led to the establishment of electronic music centers at Princeton and Columbia universities. Babbitt rejects Cage's accidental music, but his use of electronic sounds and the complexity of his pitch, timbre, and rhythm series make his music seem as random, at least to the lay listener, as that of the aleatory composers. Charles Wuorinen writes for "synthesized" and "processed synthesized" sound. Synthesized sounds are generated on electronic instruments that allow a maximum range of sound possibilities. Processed synthesized sounds result from varying the original sounds by various processes—speeding them up and slowing them down, for example. Wuorinen's best-known composition, *Time's Encomium*, was developed for recording alone and of course cannot be repeated live.

Karlheinz Stockhausen (b. 1928), most famous of postmodern composers in Germany, led a group of young musicians who followed Webern in serializing all aspects of composition such as rhythm and pitch. Stockhausen employs "sound clusters"—a clarinet, violin, and piano, for instance, in one group, and a clarinet, glockenspiel, and two cellos in another, playing against each other; or two or three orchestras playing against each other in "blocks." He also does much with electronic music. His *Gesang der Jünglinge* (Canticle of the Hebrew Children in the Fiery Furnace) consists of electronic sounds and tapes of a boy's voice, with the recorded singing mechanically altered later and superimposed upon itself.

Poland has produced a number of ex-

perimental composers. The most famous, Krzysztof Penderecki (b. 1933), initially influenced by Bartók, has sought to produce new sounds with string instruments and the human voice. In his *Threnody for the Victims of Hiroshima*, fifty-two strings begin by playing, not from notation, the highest possible pitches. They also produce tone clusters, with every note between two specified pitches being played at once. Penderecki's *Passion According to St. Luke* sets the traditional Latin text to a variety of new effects produced by orchestral instruments and voices. Though highly dissonant, the *Passion* is for many a moving piece of music.

Luciano Berio (b. 1925) received his early training in his native Italy. Since the early '60s he has composed and taught in the United States, especially at the Juilliard School of Music. He employs both electronic and conventional sounds—the latter in unconventional ways. In *Visage* he accompanies the groans, wails, and other unverbalized sounds of a human voice with electronic sounds that imitate vocal inflections. The result is eerie.

Oliver Messiaen (b. 1908), a French veteran of the *avant-garde,* is a well-known teacher and composer. He has moved through a variety of interests and styles—from works in the manner of Debussy through Indian and other Asian music to motifs inspired by bird songs. His more recent works employ both traditional instrumentation and electronic sounds; and he has also experimented with *musique concrète,* the modification of tape-recorded natural sounds.

Messiaen's best-known student is Pierre Boulez (b. 1925), who has gained a following as a brilliant conductor and an interpreter of other modern composers' works. Basing his compositional theories in part on nonmusical sources—modern fiction and poetry, for instance—Boulez has constructed a "labyrinth" theory, which demands that all musical elements—rhythm, tone color, pitch, tempo, etc.—be arranged according to pre-established schemes.

Hence all of his music is highly complex and controlled; but its effect is much like that of chance music.

Because it is difficult and not designed to permeate the memory, the music we have been describing has appealed to a limited audience. But putting aside the fakers and exploiters of sensationalism, significant composers have felt that the resources of conventional music have largely exhausted themselves, that little more can be said by traditional means. Hence they have welcomed new approaches and the great variety of new sounds made available by electronic and other devices. Doubtless some of their work, like that of most pioneering artists, will have a permanent impact on the music of the future.

But a significant number of composers have returned to the traditions of Western music (especially tonality) that have been evolving for centuries. Among them is George Rochberg (b. 1918), a prominent American composer, whose opera *The Confidence Man* was produced in 1982. After experimenting with twelve-tone music Rochberg came to realize, he says, that "the music of the 'old masters' was a living presence, that its spiritual values had not been displaced or destroyed by the new music."

ARCHITECTURE

In the tremendous surge of private and public building that followed World War II, there was no immediate departure from prewar styles. Until fairly recently most of the thousands of high-rises that have altered the skylines of cities throughout the world have been built in one variation or another of the International Style.

Probably the most interesting postwar development has been the creation of new city centers in communities large and small throughout America, Europe, and other parts of the world, often in conjunction with urban renewal projects. Some such developments have consisted largely of governmen-

tal and other public buildings. Others have included office towers, medical centers, hotels, performing arts centers, shopping malls, and so on. In many but not all instances they are carefully integrated not only with each other but with the surrounding areas. Notable examples of such centers abound, from Stockholm to San Francisco to Sydney. One of the most successful designers of city centers is John Portman, Atlanta architect and city planner, who has designed the Embarcadero Plaza in San Francisco, Peachtree Center in Atlanta, and the dazzling new Renaissance Center in Detroit.

Most but by no means all buildings in city centers, as well as most apartment buildings and other high-rises of the postwar era, reflect the earlier styles of Le Corbusier and Mies, and as such they are largely indistinguishable except for an occasional imaginative treatment of materials. But some designers of buildings in city centers, on college campuses, and elsewhere have moved boldly in new directions suggested by Wright, by Le Corbusier's and the Saarinens' more recent work (Ch. 15), or by their own ingenuity. Functionalism has continued to be important, but there has been a strong reaction against the notion that whatever works well is beautiful. Cubes have continued to dominate, but they have been joined by other angular forms, by curves, by arches of all kinds, and by circular and tubular forms.

More recent architects have made extensive use of prestressed concrete and other improved types of reinforced concrete (ferroconcrete), which make possible remarkably extended, unsupported vaulting or overhangs that would not have been feasible even earlier in the century. They have made more dramatic use of light and shadow in recessed window openings and porticoes. They have employed many new materials— cast stone, tinted glass, aluminum and other metals with impregnated colors, ornamental forms in cast stone or concrete, plastics, and other synthetic materials too numerous to mention. And in more recent years they

have renewed the age-old partnership of architecture and the other arts by ornamenting buildings with relief sculpture, tile mosaics, and other decorative and symbolic elements.

For economic and other reasons the United States has led the world in architecture since World War II. Many of the thousands of large structures erected since the war, especially the more innovative variations on the International Style, have been the work of teams of American architects. Among the better-known architectural firms is Skidmore, Owings, and Merrill, designers of such important buildings as the Lever House in New York (1952), a curtain-walled skyscraper in the International Style; and the Alcoa Building in San Francisco (fig. 16-1), which has a diagonal grid of aluminum-covered steel criss-crossing its twenty-five stories. Wallace K. Harrison and Max Abramovitz, two of America's most successful

Fig. 16–1. Skidmore, Owings, and Merrill. Alcoa Building, San Francisco. 1966.

Fig. 16–2. Wallace K. Harrison and others. United Nations Headquarters, New York. 1947–50.

architects, collaborated in designing the striking aluminum-and-glass-sheathed Alcoa Building in Pittsburgh. At the same time Harrison worked with a large group of architects from many countries in designing the United Nations Headquarters in New York (fig. 16-2). Many individual architects have, of course, distinguished themselves since the war, including those that follow.

Non-American Architects. Among several Italian architects who have gained prominence since the war, probably the most eminent is Pier Luigi Nervi (1891– 1979). A fine engineer as well as an architect, Nervi was especially innovative in his handling of ferro-concrete (*ferrocemento*), which he helped to perfect. His striking designs include the Exhibition Hall in Turin, the UNESCO headquarters in Paris, and buildings that housed the 1960 Olympic Games in Rome. His

sports palaces are among the most interesting buildings constructed in ferro-concrete. The dome of SCOPE, a spacious cultural and sports complex in Norfolk, Virginia (fig. 16-3), was designed by Nervi in collaboration with Williams and Tazewell and Associates. It is supported by twenty-four V-shaped beams radiating outside the building in a manner reminiscent of flying buttresses. Nervi was a consultant in the designing of the upward-curving St. Mary's Cathedral in San Francisco, one of the most beautiful of modern church buildings.

Two large projects in Canada have attracted considerable attention. The City Hall in Toronto (fig. 16-4), designed by Viljo Rewell and built in 1956, was too unorthodox to be immediately accepted, but the people of Toronto now consider it a beautiful and impressive symbol of the dynamic spirit of Canada. Equally controversial at first was the Habitat (fig. 16-5), designed for EXPO '67 in Montreal by Israeli architect Moshe Safdie (b. 1939), who was then twenty-eight years old. Critics scoffed at Safdie's complex arrangement of cubicles as a modern version of the cliff dwelling, but it has proved to be a practical and popular residential complex. The skillful arrangement of the cubicles gives each of the 158 apartments a sizeable patio area and a privacy and feeling of openness uncommon in multiple dwellings. Safdie was later involved in the planning of Coldspring, a community near Baltimore.

One of the most spectacular of modern buildings is the Opera House in Sydney, Australia (fig. 16-6). Designed by the Danish architect Joem Utzon, it was started in 1957 and completed in 1971. The gracefully curving, shell-like segments of the roof, reminiscent of the sailing vessels that have occupied Sydney's beautiful harbor, shelter an opera house, a concert hall, several theaters, recording studios, and other facilities. As with the Toronto City Hall complex, what began in a tumult of controversy is now warmly embraced by the people of the city. It has been called one of the finest and most imaginative buildings in the world.

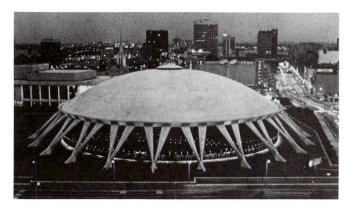

Fig. 16–3. Pier Luigi Nervi, engineer; William Tazewell and Associates, architects. SCOPE, Norfolk, Virginia. 1972.

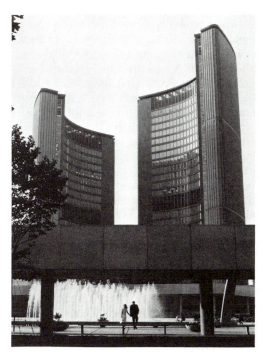

Fig. 16–4. Viljo Rewell. City Hall, Toronto. 1965. Photo courtesy Canadian Government Travel Bureau.

Fig. 16–5. Moshe Safdie. Habitat, EXPO 67, Montreal. 1967. (End view).

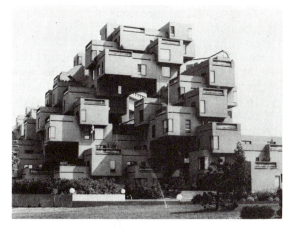

Fig. 16–6. Joam Utzon and others. Opera House, Sydney, Australia. 1957–71.

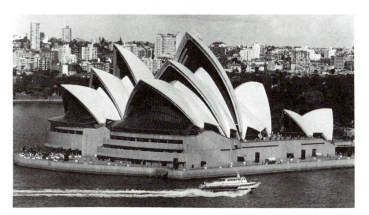

American Architecture. One of the most famous of modern Americans in any field is Buckminster Fuller (1895–1983), educator, poet, lecturer, engineer, map maker, and architect. This "Renaissance man" tried his hand at almost every aspect of design, from three-wheeled cars to flat maps that show the contours of the earth without the usual distortions. Fuller invented a number of advanced engineering devices for climate and lighting control in his machinelike Dymaxion House. He is best known for his geodesic domes, which distribute weight and stress so evenly that they can be made from a variety of materials and to any scale; he insisted that he could cover any inner city with one of his domes. In his famous American Pavilion at EXPO '67 (fig. 16-7) he compensated for changes of sunlight, temperature, etc.

Philip Johnson (b. 1906) was for some years a leading advocate of the steel-and-glass style introduced by Mies van der Rohe; as we have said, he collaborated with Mies in the designing of the Seagram Building (Ch. 15). His own home for a time, his well-known Glass House in Connecticut (fig. 16-8), is the ultimate extension of Mies's principles (including the dictum "Less is more") and of the inside-outside effect some

Fig. 16–7. Buckminster Fuller. United States Pavilion, EXPO 67, Montreal. 1967.

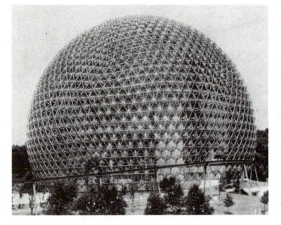

have striven for. Interestingly, Johnson has largely repudiated the International Style, which, he has said, won its case too quickly and ended up "with a bunch of cheap towers." He has also reacted against functionalism by building the most beautiful—and nonfunctional—small building he could conceive of, not far from the Glass House.

The world travels of the Seattle-born architect Minoru Yamasaki (b. 1912)—his first-hand studies of the Taj Mahal, of Gothic cathedrals, and of the graceful curves of oriental buildings—convinced him of "the need for texture and ornamentation in our times . . . for sunlight and shadow, form, ornament, the element of surprise." He embodied his theories in the Federal Trade Building of the Seattle World's Fair in 1952. Its façade is covered with a pattern of intersecting Gothic arches, and the fountain court in front is graced with high, freestanding arches. Yamasaki's long series of cream-colored arches on the façade of his Civil Air Terminal in Saudi Arabia remind one of Moorish architecture; and the curves of his Municipal Airport Terminal in St. Louis, built before Saarinen's TWA Terminal, started a wave of ingeniously designed airport buildings. Even his high-rises have ornamentation—though in the World Trade Center Towers in New York (fig. 16-9) the ornamental elements at top and bottom are largely obscured by the overwhelming size of the buildings; they are 1350 feet high. The outside walls of these towers are load-bearing; they are not simply curtains, as are those of most modern high-rise buildings.

The Chinese-born American architect I. M. Pei (b. 1917) is an unassuming master builder, each of whose fifty major designs, says a fellow architect, could be "a candidate for a list of the very best yet built." Like the buildings of the Saarinens and others, Pei's works are difficult to categorize. Less decorative than Yamasaki's, they range from the laboratories of the National Center for Atmospheric Research near Boulder, Colorado (fig. 16-10), with their jutting elements and bold contrasts of light and shadow, to the

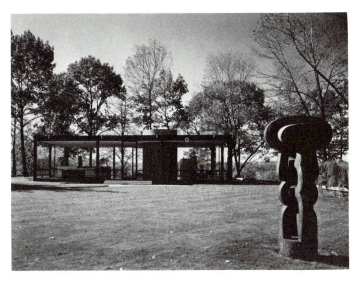

Fig. 16–8. Philip Johnson. Glass House. New Canaan, Conn. 1949. Sculpture by Jacques Lipchitz. Photo by Alexander Georges.

Fig. 16–9. Minoru Yamasaki. World Trade Center, New York, 1970. Photo courtesy the Port Authority of N.Y. and N.J.

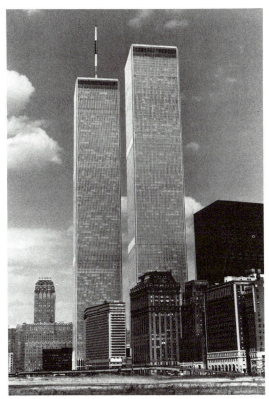

spectacular mirror-glass-sheathed John Hancock Tower in Boston, whose windows reflect such famous adjacent structures as H. H. Richardson's Trinity Church. Other Pei buildings include a much-admired new wing for the National Gallery of Art in Washington, D.C., new museums in Des Moines and Syracuse, and urban housing projects such as Society Hill in Philadelphia. In each instance, he says, his object is to integrate the structure, to make it "a piece of the city."

Three other older American architects who moved away from the International Style are Edward D. Stone, Louis I. Kahn, and Paul Rudolph. Stone (b. 1902) is known for the almost neoclassical design of his buildings, which can be seen, among other places, on many college campuses. For the State University of New York, Albany (fig. 16-11), Stone integrated buildings and open areas in a pattern of squares and rectangles. He softens the exterior surfaces of his buildings by covering them with many-arched screens or decorative cast stone curtains, or by incorporating Roman-arched arcades and portals.

Louis I. Kahn (1901–1974), on the other hand, avoided ornamentation. Perhaps America's most talked-about architect at the time of his death, the Russian-born Kahn

Fig. 16–10. I. M. Pei. National Center for Atmospheric Research, Boulder, Colorado. National Science Foundation. Photo courtesy NCAR.

Fig. 16–11. Edward D. Stone. State University of New York, Albany. Begun 1964.

modeled his buildings after the more massive forms of Roman and medieval architecture such as the Baths of Caracalla and the walled town of Carcassonne. He constructed most of his buildings of brick and concrete, not covering the markings left by the concrete forms. Two of his principles were to deal openly with the traditionally concealed "service" parts of the building—pipes, ducts, etc.—and to pierce his walls with numerous openings, often circular ones, to admit as much natural light as possible. His best-known buildings include the Richards Medical Research Building (fig. 16-12) at the University of Pennsylvania, the staggered, powerfully geometrical office and laboratory buildings of the Salk Institute by the seaside at La Jolla, California, and the somewhat atypical, multivaulted Kimbell Museum in Fort Worth. Paul Rudolph (b. 1918), whose many buildings include the Endo Laboratories in Garden City, N.Y., also echoes earlier forms—medieval and Mayan, for example—and makes bold aesthetic use of the service elements of the building.

Since the sixties a group of younger ar-

Fig. 16–12. Louis I. Kahn. Richards Medical Research Building. University of Pennsylvania, Philadelphia. 1957–61.

chitects who are generally called postmodernists has emerged. Most prominent of them is Michael Graves, a professor of architecture at Princeton; others include Charles Moore and Robert Venturi. They have developed no identifiable postmodern style; in fact, an eclectic freedom of style seems to be their aim. Hence they incorporate whatever they like from the feeling, if not the forms, of Italian Renaissance, German baroque, French château, Las Vegas Strip, or even International styles. They are being challenged by a "neomodern" group who are trying to outdo Gropius, Le Corbusier, and other architects of the '20s and '30s in the severe geometry of their forms.

SCULPTURE

Most sculptors since the war, following in the footsteps of Gabo, Pevsner, and others, have continued to produce abstract sculpture of various kinds and in many media. But others have followed Lachaise, Moore, and other artists in utilizing the oldest and most nearly universal of all subjects, the human body. Even portrait sculpture, largely neglected between the wars, has had something of a revival. Among older figurative sculptors whose international reputations have been largely established since the war are Jacob Epstein, Alberto Giacometti, Marino Marini, Giacomo Manzù, and Leonard Baskin.

Sir Jacob Epstein (1880–1959), an American who lived in England after he was twenty-five, was constantly at odds with British critics and public during his early years because of the almost brutal primitivism of such works as his *Ecce Homo,* a block-like portrayal of Christ crowned with thorns, and his *Adam,* a powerful but barbaric figure. But both public opinion and Epstein's style underwent gradual modification. He is now applauded for the major religious works of his later years (rough-textured, elongated, and highly expressive), including a *Christ in Majesty* in Llandaff, Wales, and a famous *St. Michael and the Devil* on the façade of the beautiful postwar Coventry Cathedral in England (fig. 16-13). Other works by Epstein include portrait busts of many famous persons, including Joseph Conrad and Sir John Gielgud.

The emaciated, intensely expressive figures of the Swiss-born sculptor Alberto Giacometti (1901–1966) caught the fancy of art lovers following World War II. For many they represented, in what was to become a shopworn phrase, "the isolation of modern man," and the existentialist school of thought was quick to claim him as one of its own. His sculptures also represent the process of artistic reduction carried almost to the vanishing point—figures with anguished, gaunt faces and elongated, almost match-

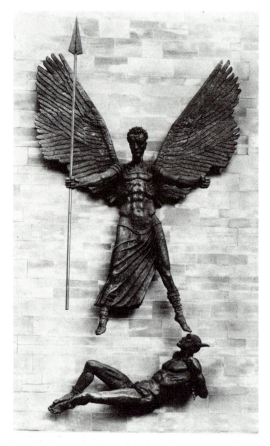

Fig. 16–13. Sir Jacob Epstein. *St. Michael and the Devil.* Coventry Cathedral, England. Courtesy of Richard G. Bailey, Coventry.

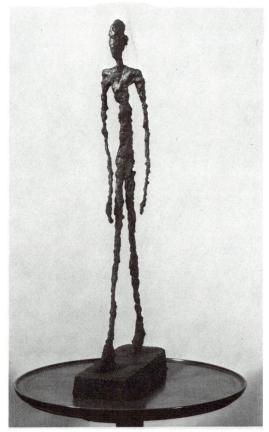

Fig. 16–14. Alberto Giacometti. *Walking Man.* 1947–48. Bronze, 26½ × 11½ × 5″. Hirshhorn Museum and Sculpture Garden, Smithsonian Institution.

stick bodies and limbs, either standing or walking solemnly in a surrealist dream world, as in his *Walking Man* (fig. 16–14). Giacometti's works echo the forms of ancient Etruscan and archaic Greek sculptures, but they reflect more directly the influence of modern neoprimitives such as Picasso, as well as Giacometti's own unique vision.

Marino Marini (b. 1901) and Giacomo Manzù (b. 1908) are important Italian figurative sculptors. Marini is a gifted portrait sculptor, but he is best known for works that develop the theme of the horse and rider. The earlier ones, done in the '30s, are relatively simple and relaxed. But in the later works the subject assumes greater symbolic significance, as both horse and rider become increasingly angular and intense (fig. 16-15). "My equestrian figures," said Marini, "are symbols of the anguish I feel when I survey contemporary events." Giacomo Manzù, perhaps the century's leading religious sculptor, has done beautiful low relief panels in bronze for doors at Salzburg Cathedral and St. Peter's in Rome, as well as a series of stylized, monumental *Cardinal* figures. A lover of the Renaissance who is at home in this century, Manzù reflects the influence of artists as far apart in time as Donatello and Rodin.

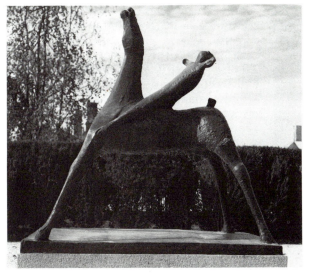

Fig. 16–15. Marino Marini. *Horse and Rider.* 1952–53. Bronze, 82 × 81 × 46½″. Hirshhorn Museum and Sculpture Garden, Smithsonian Institution.

The gifted American graphic artist and sculptor Leonard Baskin (b. 1922) is best known for his large-scale wooden figures of animals, birds, and humans—works that recall the sculptures of Barlach (Ch. 15) in their simplified, rough-textured forms, though Baskin's are more massive and primitive-looking. *Seated Man with Owl* (fig. 16-16) is a fine example of his work.

The constructivist style continues to have its practitioners—artists who construct their largely abstract forms from a variety of materials—wood, sheet metal, plastics, wire, etc. The best-known constructivists in the years immediately following the war were Alexander Calder and David Smith.

Alexander Calder (1898–1976), one of the most popular of all modern artists, is credited with having invented the *mobile*, a type of kinetic or moving sculpture that has proved to be more than a fad. Mobiles, as every school child knows, consist of flat metal, ceramic, or plastic pieces, usually painted (Calder preferred black, white, and red), which are suspended from rods protruding from a central point and balanced so delicately that the slightest breeze moves them (fig. 16-17.) (Earlier, Calder had expressed his love for the fanciful by creating a miniature circus of animals, humans, and equip-

Fig. 16–16. Leonard Baskin. *Seated Man with Owl.* 1959. Cherry wood, 30″ high. Smith College Museum of Art, Northampton, Mass.

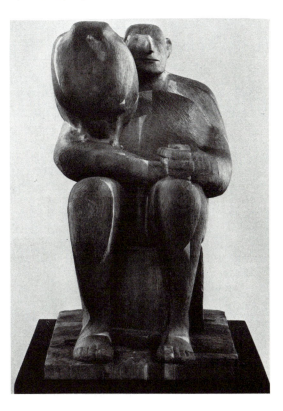

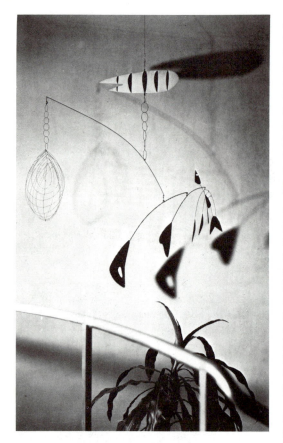

Fig. 16–17. Alexander Calder. *Lobster Trap and Fish Tail.* 1939. Hanging mobile, steel wire and sheet aluminum. Collection, The Museum of Modern Art, New York. Commissioned by the Advisory Committee.

ment made mostly of wire.) In his later years he complemented his mobiles with *stabiles*—heavy, black-painted metal sheets welded together in a variety of forms that suggest animals, spiders, humans (fig. 16-18). Most of them are large and some are immense—for example, his *Man* (built for the Montreal EXPO), which is ninety-four feet high.

David Smith (1905–1965), another of the century's most creative and influential artists, was largely self-taught. His early works, some of them reflections on current social matters, were open and linear—suggestive, for instance, of the flying skeleton of a big bird. His later and more characteristic sculptures are monumental stainless steel constructions in a numbered series called *cubis*—some burnished, some painted. *Cubi XII* (fig. 16-19) is an impressive nine-foot-high construction of asymmetrical but artfully balanced cubes, with surfaces burnished so that changing light alters the appearance of the work. The emotional impact of the cubis is somewhat akin to that of the abstract expressionist painting of the same period.

Other important constructivist sculptors are Reuben Nakian (b. 1897), Theodore Roszak (b. 1907), Seymour Lipton (b. 1903), and Herbert Ferber (b. 1906)—all Americans; and the German Norbert Kricke (b. 1922). A constructivist of a different kind is Richard Lippold (b. 1915), sometimes called a light sculptor. His works (*The Sun*, for instance) are large, intricate geometrical forms made of gold-filled or other shiny wire that catches light in beautiful, glowing patterns. Another interesting light sculptor is Chryssa, a Greek-born American artist; she works especially with neon tubes.

Closely related to the constructivists are the makers of *assemblages* and of *junk sculpture*. The latter in particular have followed Picasso and the Dadaists (especially Marcel Duchamp, who became a cult figure in the '50s and '60s in employing materials taken from any and all sources, as well as in trying to diminish or eliminate traditional distinctions between art and non-art. (Duchamp had shown the way by presenting a urinal in an art exhibit as a piece of sculpture.) Makers of assemblages and of junk sculpture have treated their materials in different ways, from leaving them essentially intact to altering them by combining, welding, or painting them, or by casting them in metal or plastic.

Joseph Cornell (1903–1972) initiated the small box construction, an assemblage of objects in a simple, sometimes glass-covered box. Often he assembled maps, multiple photographs, and other objects that recalled the past—his own or others—in a manner

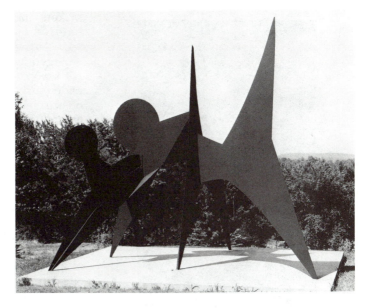

Fig. 16–18. Alexander Calder. *Two Disks (Deux Disques).* 1965. Painted steel plate, 306" high. Hirshhorn Museum and Sculpture Garden, Smithsonian Institution.

Fig. 16–19. David Smith. *Cubi XII.* 1963. Stainless steel, 109" high. Hirshhorn Museum and Sculpture Garden, Smithsonian Institution.

that has been called surrealistic; or, in a fashion widely imitated in recent years, his boxes contain glass jars filled with memorabilia of various kinds. The assemblages of Louise Nevelson (b. 1900), a Russian-born American artist, are much larger. They are boxlike arrangements of shelves that are filled with carefully arranged wooden shapes which the artist has found or made—ovals, balusters, or pieces of furniture, for example. Then the whole is painted, usually in black or gold. In recent years Nevelson has made her assemblages of metal or lucite. Typical of her work is *Black Wall* (fig. 16-20). Isamu Noguchi (b. 1904), American sculptor, has made beautiful abstract assemblages of wood as well as of bone, paper, and string.

One of the early exponents of junk sculpture was Eduardo Paolozzi (b. 1924), an Englishman, who has since become one of his country's most influential artists. In works such as *St. Sebastian No. 2* (fig. 16-21) he welded together wires, wheels, gears, and other machine parts to make monsters which, along with their titles, invite symbolic interpretation. Other junk artists are the American John Chamberlain (b. 1927), who has made sculpture of the multicolored

Fig. 16—20. Louise Nevelson. *Black Wall.* 1964. Painted wood construction, 64¾" high. Hirshhorn Museum and Sculpture Garden, Smithsonian Institution.

parts of old car bodies (*Essex,* for example); and Richard Stankiewicz (b. 1922), who welds junk—pipes, grills, etc.—into amusing pieces such as his *Kabuki Dancer.*

The 1960s saw the emergence of a group of sculptors or multimedia artists who called themselves *object makers,* concerned with making things simply as things, with no philosophical, personal, or other implications. They made such things as large plywood or metal letters (a large *X,* for instance), galvanized iron boxes, large plastic cylinders, or big squares of nylon cloth spread on a gallery floor. Prominent object

makers include Tony Smith and Donald Judd.

At the same time a school of sculptors emerged whom critics generally associate with pop art—though their leader, Claes Oldenburg (b. 1929) prefers to call himself an object maker. Oldenburg's objects, however, are not metal boxes or cylinders but giant red plastic ice bags; large plaster-of-Paris hamburgers and ice cream sundaes; soft plastic drum sets, telephones, toilets, wash basins, and drooping electric fans; five-foot-high three-way plugs (fig. 16-22) and towering wooden clothespins. Whatever Oldenburg's intentions—to narrow the gap between art and non-art, to make the ordinary seem extraordinary, to comment satirically or approvingly, or to make no comment at all—he amuses, stimulates, and perhaps irritates.

Though not closely associated with pop art, the Venezuelan sculptor Marisol (b. 1930) employs some of its techniques. Her multimedia works often combine the three-dimensional effects of sculpture with the flat surfaces of painting. She paints a face—often her own—on a boxlike sculptured form or places a carved head on a painted surface. In her best-known work, *The Family* (fig. 16-23), she puts real shoes on some figures and paints them on others, with amusing effect.

In the mid-sixties Edward Kienholz (b. 1927) created *environments* such as a full-scale interior of a crowded "Sloppy Joe" diner, two horrifying views of a naked patient in a mental hospital, and other bitter works designed, presumably, to shock and to awaken social awareness. Also socially oriented, but on a much milder level, are the figures that George Segal (b. 1924) makes from plaster casts of real people and places in natural environments: a man hanging a sign on a billboard; a woman in a ticket booth; a man looking at a Mondrian painting. The figures, generally all white but sometimes in some other solid color, are at once realistic and a bit mysterious.

The movement toward a new realism

Fig. 16–22. Claes Oldenburg. *Giant Three-Way Plug (Cube Tap)*. Cor-ten steel and bronze, 60″ high. The St. Louis Art Museum. Gift of the Schoenburg Foundation, Inc.

Fig. 16–21. Eduardo Paolozzi. *St. Sebastian, No. 2.* 1957. Bronze, 84¾″ high. The Solomon R. Guggenheim Musem, New York.

Fig. 16–23. Marisol (Marisol Escobar). *The Family.* 1961. Painted wood, etc. 6′10″ high. Collection, The Museum of Modern Art, New York. Advisory Committee Fund.

seen in the work of such artists as Kienholz and Segal has strongly accelerated in the '70s and early '80s. The most talked-about sculptor of the period is Duane Hanson (b. 1925), a "superrealist." Hanson's human figures are probably the closest approximation to physical reality ever created. Molding them in polyvinyl acetate from casts of realistically posed models, he supplies them with accurate skin colors, blemishes, eyes, hair, and clothing to create disconcertingly lifelike sculptures. Using mostly his neighbors and relatives as models, Hanson has created (among other "ordinary people") a supermarket shopper in hair curlers, a tired old woman on a folding chair, middle-aged tourists gazing upward, a drug addict slouched in a corner, and *Man with a Hand Truck* (fig. 16-24). Hanson's comments on his work in-

Fig. 16–24. Duane Hanson. *Man with Hand Truck*. 1975. Polyester/fibreglass, lifesize. Courtesy O. K. Harris Works of Art, New York.

dicate that his intentions are sometimes satirical, sometimes objective, sometimes sympathetic. Some critics, disliking both the process and the product, refuse to accept Hanson's figures as significant works of art; others predict they will outlast most postwar sculpture.

PAINTING

Representational Painting

Among the dozens of styles of painting that have been identified since World War II, most have been variations either of abstraction or of more or less realistic representation. Critics and artists have paid most attention to the abstractionists. But the public, as one would expect, has responded primarily to the hundreds of Western and other regional painters and landscapists, many of them very competent, whose works fill most of the galleries of the land. Some representational artists such as Georgia O'Keeffe and Andrew Wyeth have won the applause of both critics and public. Others such as Francis Bacon and Jean Dubuffet, who have exploited the human form in extraordinary ways, have provided bridges between surrealism and postwar expressionist movements.

Andrew Wyeth (b. 1917), next to Norman Rockwell probably the most popular American painter of the century, demonstrates that a modern, somewhat abstract technique is possible without the abandonment of traditional subject matter. His seemingly unposed portraits of his family and neighbors (the famous *Christina's World,* for example) depict strength of character in an unsentimental manner. His studies of barnyards and weather-beaten houses, with their remarkable textures of wood and stone, have familiarized millions with the countryside of Chadds Ford, Pennsylvania. *February Second* (fig. 16-25) exemplifies the still winter or edge-of-winter moods of many of Wyeth's paintings.

The paintings of Georgia O'Keeffe (b. 1887) were first exhibited in 1916 by the famous photographer Alfred Stieglitz, whom she later married. She has lived for many years in New Mexico, where she has painted semiabstract, often symbolic paintings of silhouetted mountains, desert sunsets, animal skulls, and flowers—the last often single blooms that fill the canvas in an abstract pattern. *Soft Gray, Alcalde Hill* (fig. 16-26) is a scene near her home. Her more recent works are often completely abstract.

Great Britain's most famous postwar painter, described by his friends as a genial Irishman, is Francis Bacon (b. 1910), whose surprisingly dark view of the human condition is expressed in disturbing works. Typically, butchered animals provide backgrounds for deformed human figures with contorted faces and mouths agape in silent screams. *Figure Study II* (fig. 16-27), a bent form under a blue umbrella that is one of Bacon's oft-repeated symbols, is the epitome of tortured grief. Jean Dubuffet (b. 1901), France's most talked-about painter since Matisse, fits only loosely into any classification. He has painted in many styles, one of which is characterized by blob-like human forms in the tradition of biomorphic surrealism, done in paint that contains sand, tar, and other substances; another by huge canvases covered with hundreds of cells con-

Fig. 16–25. Andrew Wyeth. *February Second.* Canajoharie Art Gallery, Canajoharie, New York.

Fig. 16–26. Georgia O'Keeffe. *Soft Gray, Alcalde Hill* (near Alcalde, New Mexico), 1929–30. 10⅛ × 24⅛". Hirshhorn Museum and Sculpture Garden, Smithsonian Institution.

Fig. 16–27. Francis Bacon. *Figure Study II.* 1945–46. 57¼ × 50¾". Kirklees Metropolitan Council, Huddersfield Art Gallery, England.

Fig. 16–28. Jean Dubuffet. *Glass of Water II.* 1967. Cast polyester resin, 94¼" high. Hirshhorn Museum and Sculpture Garden, Smithsonian Institution.

taining humans, buildings, buses, etc.—all painted in a "false naïve" style; and a third by abstract paintings or three-dimensional works, often made of styrofoam, in which empty white areas are outlined in jigsaw fashion by strong black or blue lines. *Glass of Water II* (fig. 16-28) is a good example of the third style.

Abstract Painting

At the end of World War II, leadership in painting shifted from Paris and other European cities to New York City. Not only did a number of prominent European abstract painters settle there, but many talented and innovative American artists were attracted to New York as the major art center.

Abstract Expressionism. New York, following the war, gave birth to America's first internationally recognized school of painting, *abstract expressionism.* The term was originally used to describe the nonobjective but emotionally charged works of Kandinsky and some of his European contemporaries; but it is now applied almost exclusively to painters who worked in America in the late 1940s and the 1950s. Actually several Europeans, some of whom came to America, led the way in the development of the style. One was Hans Hofmann (1880–1966), who came from Germany. A gifted painter and teacher, Hofmann provided, both in his paintings and his lectures, a clear philosophical basis for abstract expressionism. In his Massachusetts studio he produced a number of brilliant, bold canvases that exemplify the term—abstract because they are totally nonobjective, and expressionistic because they convey a sense of personal involvement and emotion. His work, like that of the abstract expressionists who followed, is "painterly"—that is, distinguished by vigorous action of the brush and by heavy paint textures. *Oceanic* (fig. 16-29) illustrates both the brushwork and the strong, interacting colors.

Following Hofmann, major abstract expressionists included Jackson Pollock (1912–

1956) and Willem de Kooning (b. 1904). Pollock, born in Wyoming, was for some time a mural painter but abandoned representation to develop a technique of dripping paint in large, swirling patterns on huge canvases spread on his studio floor. His work, influenced perhaps by the attitudes if not the techniques of surrealism, has been called *action painting* and *automatic* or *accidental* painting. Pollock himself denied the element of accident; he selected his few colors carefully and distributed them more or less evenly (though of course not precisely) over the canvas to produce remarkable effects of light and shadow, thrust and depth. Pollock's abstractions range from the somber to the bright and lyrical. The work titled *Number 25, 1950* (fig. 16-30), though uncharacteristically small, clearly demonstrates his style.

Fig. 16–29. Hans Hofmann. *Oceanic.* 1958. 60¼ × 48". Hirshhorn Museum and Sculpture Garden, Smithsonian Institution.

Fig. 16–30. Jackson Pollock. *Number 25*. 1950. Encaustic, 10⅛ × 38". Hirshhorn Museum and Sculpture Garden, Smithsonian Institution.

Fig. 16–31. Willem de Kooning. *Woman and Bicycle.* 1952–53. 76½ × 49". Collection of Whitney Museum of American Art, New York. Photo by Geoffrey Clements.

Willem de Kooning, veteran Dutch-born American artist, has turned in recent years to total abstractions that are often quietly poetic. But he is best known for the earlier works, in which powerful slashes and swirls of color almost obscure leering, carnivorous females. Sometimes, in order to emphasize the deadliness of his grotesque sex goddesses, he gives them double mouths or other symbolic features. *Woman and Bicycle* (fig. 16-31) is one of his more familiar works. Two other noted American abstract expressionists are Mark Tobey (1890–1976), who painted delicately colored, mystical abstractions; and Franz Kline (1910–1962), whose abstractions typically consist of a few large, powerfully painted strokes of a single color—usually black—on a white ground (the white areas, he said, are as important as the black).

Color-field, Hard-edge, and Optical Painting. In the '60s a number of painters turned away from the loose brushwork, strong colors, and heavily textured paint of the abstract expressionists to produce a more subdued and subtle kind of expressionism called *color-field painting*. Led by Clyfford Still (b. 1904) and Mark Rothko (1903–1973), one group of color-field painters covered their huge canvases—huge because they were intended almost to enclose the spectator in the work—with a unified, thinly painted color or shape sometimes called an "abstract image." Clyfford Still touched his large,

monochromatic but subtly varying color field with a few asymmetrical splotches of another color. Rothko imposed on a rectangle of modulated color—orange, for example—smaller soft-edged rectangles of other colors such as yellow, with the colors shimmering where they merge. Rothko's *Blue, Orange, Red* (Colorplate 15) is typical.

Hard-edge painting, another movement of the '60s, was a variation of color-field painting. But as the name suggests, hard-edge painters such as Josef Albers, Frank Stella, Ellsworth Kelly, and Barnett Newman were careful to delineate color areas more sharply and precisely. Josef Albers (1888–1976), a German-American painter perhaps more meaningfully called a geometrical abstractionist, dedicated himself to a study of form and color relationships. In a large series of paintings called *Homage to the Square* he observed the optical effects of successively smaller squares of color seemingly superimposed one on another (see fig. 16-32). Frank Stella (b. 1936) has worked with flat, sharp-edged bands of contrasting or complementary colors, often in curved forms that suggest the use of a big protractor. Stella has also experimented, in his huge paintings, with shaped canvases, cut to conform to the curves or angles of his painted forms (Colorplate 16). Ellsworth Kelly (b. 1923) places intensely luminous rectangles or other geometrical areas of paint next to each other in paintings that are as much as twenty feet long—his *Blue, Green, Yellow, Orange, and Red*, for example. The impact is often powerful. Kelly dislikes being called a hard-edge painter; he is concerned, he says, with colors, not edges.

Kelly's work is closely related to that of the optical or *op art* painters, abstractionists of the '60s who experimented with the scientific aspects of form and color. They exploited optical illusions, after-images, vibrations set up by adjacent colors, and the shifting of focus—the illusion of motion—induced by such arrangements as wavy lines and circles within circles. Best known of the

Fig. 16–32. Josef Albers. *Homage to the Square: Glow.* 1966. Acrylic, 48 × 48". Hirshhorn Museum and Sculpture Garden, Smithsonian Institution.

Fig. 16–33. Victor Vasarely. *Orion C.* 1962. Oil on paper, 25 × 24". Hirshhorn Museum and Sculpture Garden, Smithsonian Institution.

op artists is Victor Vasarely (b. 1908). *Orion C* (fig. 16-33) is characteristic of his formal studies. Other important op artists are the Japanese painter Tadasky (b. 1935); the English Bridget Riley (b. 1931); and the Americans Larry Poons (b. 1937) and Richard Anuskiewicz (b. 1930).

Return of the Object

Pop Art, Conceptual Art, Superrealism. Reacting against the abstract art of the later '50s and the '60s were a group of younger painters and mixed-media artists who turned in startling ways, as Oldenburg and others were doing in sculpture, to the representation of humans and of every kind of common object. Most sensational, and most skillfully presented to the world by their agents and themselves, were the *pop artists,* led in England by Richard Hamilton and Peter Phillips, and in America by Robert

Rauschenberg, Roy Lichtenstein, Jasper Johns, Andy Warhol, and a number of others. They drew their subject matter from the contemporary scene—supermarkets with their rows of canned and packaged goods; comic books, movie stars and movie advertising; service stations, billboards, the world of salesmanship, etc. The intentions of the pop artists were almost as varied as their subjects: to reflect existentially on contemporary life; to report without comment; to respond with exuberance and amusement to the contemporary scene; to identify the arts more closely with everyday life than abstract art could do; and to satirize the banal, shoddy, overadvertised, repetitious, overmechanized aspects of our time. Someone has described the qualities of pop art as "popular, transitory, exuberant, witty, and sexy."

Broad as their subject matter was, pop artists tended to be narrow specialists. Robert Rauschenberg (b. 1925) made "combines"—collages and montages of materials from copies of masterpieces, scraps of newspapers, etc.—as well as his mixed-media *Bed,* a quilt-covered bed with paint splattered on it, and his famous *Monogram* (fig. 16-34). Roy Lichtenstein (b. 1923), a more skillful artist, has made blownup reproductions, sometimes powerful in their simplicity, of frames from spaceage comic strips (fig. 16-35).

Jasper Johns (b. 1930) has done work in the pop tradition—bronze Ballantine beer cans, for instance—but also paintings of more enduring significance. He works with images of maps, American flags, targets, color charts, and numbers superimposed in varying colors (fig. 16-36) in ways that obliterate their practical uses as signs and give them a heightened reality as art objects. Andy Warhol (b. 1930), best known of the pop artists, first attracted attention with his paintings and sculptures of Coca Cola bottles, Campbell's soup cans (fig. 16-37), and other supermarket products. Warhol, unlike some pop artists, has experimented with

Fig. 16–34. Robert Rauschenberg. *Monogram*. 1955–59. Construction, 42″ high. Collection, Modern Museum, Stockholm.

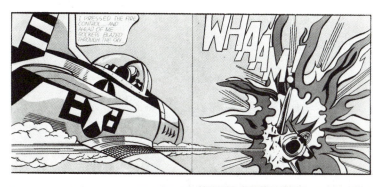

Fig. 16–35. Roy Lichtenstein. *Whaam*. 1963. 68 × 106″. Courtesy of the Tate Gallery, Millbank, London.

Fig. 16–36. Jasper Johns. *0 Through 9*. 1961. Oil and charcoal, 54⅛ × 41⅜″. Hirshhorn Museum and Sculpture Garden, Smithsonian Institution.

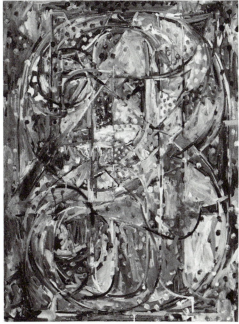

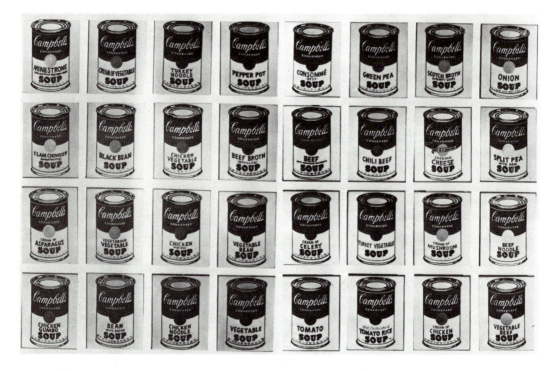

Fig. 16–37. Andy Warhol. *Campbell's Soup Cans.* 1961–62. 32 handpainted panels, each 20 × 16".
Photo by Leo Castelli, New York.

many media, including the production of underground motion pictures. His subject matter has included scenes of violence and large multiple reproductions, in varying degrees of intensity, of such celebrities as Marilyn Monroe. The repetition is evidently meant to confirm Warhol's contention that he is a machine in a machine age. Other members of the pop movement, which has largely died out, are Tom Wesselman, James Rosenquist, and Jim Dine.

Conceptual Art, a movement of the late '60s and the '70s used basically pop materials but reflected the thesis that the most important aspect of a work of art, more important than its actual execution or "realization," is its conception in the mind of the artist. It also carried to the ultimate the dictum, expressed by one of its practitioners, that whatever the artist calls art *is* art. Some

of the earlier conceptualists did "realize" their art: Robert Smithson, an "earth" artist, supervised the construction of a fifteen-hundred-foot spiral jetty that extends into the Great Salt Lake. Another, a "body" artist, rubbed his skin until it bled. And another piled blocks of ice in one of the rooms of a modern museum. The Bulgarian-born Christo, a more imaginative conceptualist, wrapped an entire art museum in canvas, and on another occasion stretched a huge red cloth across a canyon near Rifle, Colorado. Some conceptualists, in the next stage, wrote down their unrealized conceptions (making a head count of every soul on earth, for instance) and sold them to connoisseurs. And others, in perhaps the ideal extension of the theory, kept them in their own minds. The movement, supported by serious artists as well as charlatans, has largely vanished.

As one might expect, the superrealism

of Duane Hanson's sculpture has had its recent equivalent in painting. One school, the *photorealists*, derive their remarkably detailed paintings of cars, drive-ins, and street scenes reflected in store windows, for example, from color slides. The principal exponents of *photorealism*, which is neither more nor less realistic than a color slide shown on a screen, are Richard Estes, Robert Bechtle, Malcolm Morley, Ralph Goings, and Chuck Close. Fig. 16-38, by Malcolm Morley, is a good example.

Another school of superrealists, the *neorealists*, have returned to some of the techniques of the baroque era—dramatic, Caravaggesque lights and shadows, and even allegorical subjects such as the Deadly Sins, in modern dress. Among American neorealists are Alfred Leslie and Jack Beal. Philip Pearlstein, in no sense baroque or allegorical, paints candidly realistic nudes, with limbs partly cropped as in a close-up photo.

This survey of the arts of the Western world has employed and defined many commonly used labels for artistic styles—Hellenism, realism, cubism, abstract expressionism, and so on. Such labels, useful as they are, may imply clear-cut distinctions and a neatly evolving continuity that the facts do not bear out. Different styles and movements have often had important characteristics in common. They have overlapped in time. Sometimes they have developed concurrently—American social realism and European abstraction, for example. Those that have had little more than publicity to sustain them have died a natural death, and quieter and more substantial ones have come to the fore. And always in the background, less acknowledged by the specialists but still important, have been the popular arts that have lain outside the scope of this book—in our century, for instance, the novels of Margaret Mitchell and Colleen McCullough, the paintings of traditional landscapists, the mu-

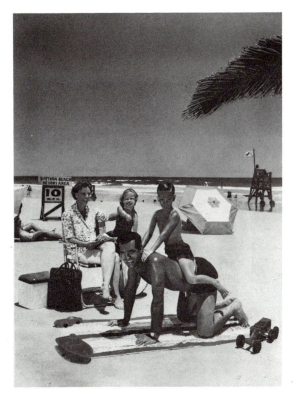

Fig. 16–38. Malcolm Morley. *Beach Scene.* 1968. Acrylic on canvas, 9'2" × 7'6". Hirshhorn Museum and Sculpture Garden, Smithsonian Institution.

sic of Cole Porter and Richard Rodgers—or that of Scott Joplin, Louis Armstrong, Benny Goodman, and Chuck Mangioni, which may prove to be America's most enduring contribution to the musical art of the century.

Troubled as our age has been, the arts continue to flourish. Museums that exhibit the range of Western arts, from the ancient Greeks to the 1980s, draw larger and larger crowds. Concert music, ballets, motion pictures, and theater pieces both traditional and innovative play to capacity audiences. And artists of all kinds continue to create—to enlighten, to challenge, to give pleasure, and to extend the range of human experience.

INDEX